Hanging the Head

PORTRAITURE AND SOCIAL FORMATION IN EIGHTEENTH-CENTURY ENGLAND

MARCIA POINTON

Published for
THE PAUL MELLON CENTRE
FOR STUDIES IN BRITISH ART
by
YALE UNIVERSITY PRESS
NEW HAVEN & LONDON · 1993

Designed by Gillian Malpass
Set in Linotron Bembo by Best-set Typesetter Ltd, Hong Kong
Printed in Hong Kong by Kwong Fat Offset Printing Co.

Library of Congress Cataloging-in-Publication Data

Pointon, Marcia R.
 Hanging the head: portraiture and social formation in eighteenth-
century England/Marcia Pointon.
 p. cm.
 Includes bibliographical references (p. 268) and index.
 ISBN 0-300-05738-5
 1. Portraits – England – History – 18th century. 2. Portraits-
Social aspects – England. I. Title.
N7598.2.P65 1993
704.9′42′094209033 – dc20
92-15841
CIP

A catalogue record for this book is available from The British Library

Frontispiece: Detail of pl. 40, *The Common Council Chamber, The Guildhall, London,* from *The Microcosm of London,* 1808.

For Anna Kerr

CONTENTS

facing page: detail of pl. 64,
Gainsborough, *The Hon.*
Mrs Graham.

ACKNOWLEDGEMENTS

In writing this book, I have benefited from discussions with many scholars who have been exceedingly generous with their time, from the support of several award-making bodies and from the inestimable help of archivists and librarians in Britain and the United States. It is impossible to name all who have provoked me into new thoughts on the ever-fascinating topic of portraiture, or who have contributed to my knowledge of specific details of eighteenth-century cultural practice. I would, none the less, like to acknowledge the assistance of: Kathleen Adler, David Alexander, Malcolm Baker, Mavis Batey, Shelley Bennett, Rachel Bowlby, Colin Brooks, Richard Brilliant, J.B. Bury, Major Ambrose Congreve, Patrick Conner, Robin Cormack, Alan Crawford, Kay Diggens, Judy Egerton, Elizabeth Einberg, Sharon Fermor, P.K. Fox, John Furse, Lucy Gent, Tom Gretton, Richard Green, Anthony Griffiths, Vivien Hart, the Earl of Harrowby, John Hayes, Maurice Howard, Ludmilla Jordanova, Vivien Knight, Michael Kitson, David Landau, Alistair Laing, Susan Lambert, Thomas Lange, Major Charles Liddell, Nigel Llewellyn, Ellen Miles, John Murdoch, John Nash, Gabriel Naughton, Nicholas Plumley, Michael Podro, Paul Quarrie, John Martin Robinson, Charles Saumarez-Smith, Dorothy Scruton, Jacob Simon, Patricia Simons, Lindsay Smith, David Solkin, Karen Stanworth, Robert Stewart, Duncan Thomson, Charlotte Townsend-Gault, John Trevitt, Mrs A.H. Tyler, Clive Wainwright, Robert Wark, Giles Waterfield, Ray Watkinson, Joanna Woodall, Michael Wynne.

I owe a particular debt to John Barrell and Alex Potts for reading the draft mansucript of this book and to John Hayes for reading a substantial part of it, as well as for his encouragement with this project over a long period of time. Valerie Vaughan at the National Portrait Gallery Archive has been invariably patient and helpful, and the epilogue to this book could not have been written without the material that she readily, and often at short notice, made available to me. Gillian Malpass, at Yale University Press, has been a model of critical acumen and creative energy; it has been a pleasure and a privilege to work with her.

The support of the Paul Mellon Centre for Studies in British Art has inestimably enhanced the production of this book. During the course of research and writing, I have been extremely grateful for the financial support offered by the University of Sussex, the Leverhulme Trust, the Huntington Library and the Smithsonian Institution. While it was not, in the end, possible to include in this book the research undertaken in Washington under the auspices of the Smithsonian, what I learned while at the Institution's archives and at the American National Portrait Gallery, has informed many parts of this book.

Some of the material contained in chapters I and VII and in the epilogue formed the basis of the Sir Owen Evans Memorial Lectures at University College, Aberystwyth in 1990. The substance of chapter I, section ii appeared as an article in *Art History*, June 1984; a version of chapter V will be published in J. Barrell, ed., *Painting and the Politics of Culture*, Oxford, 1992; a short account based on the material in chapter IV will be published in K. Adler and M. Pointon, eds, *The Body Imaged: Representations of the Body in Western Art since the Renaissance*, Cambridge, forthcoming.

1. Detail of pl. 58, Romney, *Self-portrait*.

2. Detail of pl. 189,
A Family Group.

INTRODUCTION

On midsummer's day 1710, Lady Wentworth was enjoying the country air at her Thames-side property at Twickenham. She was preoccupied, as indeed she had been for some days past and would be for some time to come, with finding a suitable bride for her son. Accordingly, she sat down to write to her dearest and best of children. After commenting on current affairs at court, she self-deprecatingly turned to matters deemed more appropriate to the feminine mind:

> I know you will laugh at me and say polleticks is not soe fitt for me as to speake in the commendation of your most wunderfull prety table, the fraim of which is very much admired by al that see it.

While disarming her son by implying his superior knowledge of the masculine world of politics, Lady Wentworth contrives to incorporate him (by reference to his pretty table) into the feminine and domestic, her own power base. She then moves with a precision that would be a credit to any diplomat and recreates for her son an incident that, while not political in the sense of the crown or the constitution, none the less provides an insight into the profoundly political sphere of the domestic stage:

> Hear was a lady the other day that has thre very prety daughters, and her favoret she made stand under your Picture you brought from Prutia, and said she never se twoe facis more alyke. Indeed the lady is very pretty, but her face is thinner, the eys is very lyke. She did exspect I would have wisht her my daughter, but indeed I did not, for she has now fortune considerable.[1]

Apart from the question of who might have been the Prussian artist responsible for young Wentworth's portrait, and the fact of the importation of such a work into England at a time when Kneller was setting his stamp on British portraiture, Lady Wentworth's account is interesting for the evidence it provides of how people used portraits. We shall never know whether the two young people did indeed resemble each other, but that is immaterial; the significance of this event lies in the enactment of a ritual that involves a portrait, and the aftermath of that ritual in the equally significant narratization between mother and son across the field of the portrait and its connotations. Portraits as tokens and aids to decision-making in royal marriage negotiations are a familar feature of post-medieval Europe. The dynamics of such exchanges were often complex, as Joanna Woodall has recently demonstrated.[2] Royal portraits are, however, seldom symptomatic; in the case of the Wentworths, it is not the portrait as illustration of a possible marriage partner or as a guarantee of good faith that is at issue. Rather, the extant portrait is exploited (more as idea than as object) by a mother in exercising power over an absent son. The very existence of the portrait of the young man licenses a series of narratives, only one of which concerns possible marriage. The portrait is the stage-set and the frame of reference, but the exchange that takes place exceeds the circumscribed bounds of the portrait as image. The link between seeing and telling, the scripted process whereby the possible marriage partner is positioned beneath the portrait of the absent young man, and the rhetorical comparisons between the painted features of the young man and the living face of the young woman connect artefact and discourse. They open onto a politics of representation in which the historical human subject is not a separate entity from the portrait depiction of him or her, but part of a process through which knowledge is claimed and the social and physical environment is shaped.

This book is about how people used portraits. The empirical question of where portraits were hung and why is explored in the opening chapter. But the issue of portraiture's functions goes much further than this; and I use the term 'portraiture' here to denote all those practices connected with the depiction of human subjects and the theorization, conceptualization and apprehension of portrait representations. At its most abstract, portraiture is a question of the relationship between the self *as* art and the self *in* art. However, the self is historically specific as well as individually determined, and therefore, in writing this book, I have worked in the conviction that an explanation of the importance of portraiture as a

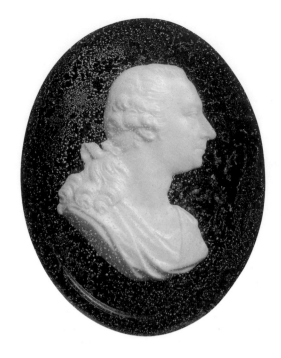

Royal Academy was accused of allowing its walls to be 'stocked with insulted canvases'. In what should be the nation's 'precious temple of art', 'creatures of *high-life* crowd to gaze at flashes of red and yellow, and to compliment each other on their own gaudy countenance'.[4] Danloux vied for clients with a host of other artists, but not all clients were equally welcome to portraitists and publics. The Earl of Fife in 1796, remarked:

> before this century, very few people presented themselves to a painter, except those who were of great families, or remarkable for their actions in the service of their country, or for some other extraordinary circumstance, so that the field for enquiry was not extended, as lately, when every body almost who can afford twenty pounds, has the portraits of himself, wife and children painted. Those, therefore, who collect next century, even with the aid of the annual Exhibition, will hardly be able to find out the numerous bad painters, and the uninteresting obscure persons so represented.[5]

Portraits appeared increasingly on commemorative ceramics, on coins and medals, in live shows with explanatory commentaries, in needlework and other media. The main challenge to the Royal Academy by the 1790s was probably Miss Linwood's exhibition of needlework in a gallery in Leicester Square, an art

concept and as a process in England in the eighteenth century required a microcosmic approach. The chronological and cultural span is defined by two-dimensional portrait imagery and the circumstances of its production in eighteenth-century England. There are, of course, points in this book where – as with John Evelyn's formative ideas on collecting, or the relationship between eighteenth-century child-portraiture and late Victorian imagery – the frame of reference is wider. Furthermore, the epilogue takes the reader into another period and another set of discourses – those generated in the founding of the National Portrait Gallery in London. Scottish artists painting English sitters, English artists painting Irish sitters, and American artists working in London are not excluded, but, while the printed image plays a major part in this account, sculpture and painting in miniature are largely omitted, not because they are unimportant but because their production and dissemination entailed distinct procedures. Drawing is a different matter; many society portrait painters seem to have made few preparatory drawings, but drawing as a medium none the less plays a significant role in this book because it is not only the medium for trying out ideas but also that through which commentary and critique often finds expression.

The production and circulation of portraits in London from the middle of the eighteenth century was notably diverse. The diary of the portrait painter Henry-Pierre Danloux, who fled from Paris in 1792 and lodged with the family of the auctioneer Greenwood, offers evidence of the intense interest in, and competition for, portrait commissions in London at the end of the century.[3] By 1817, the

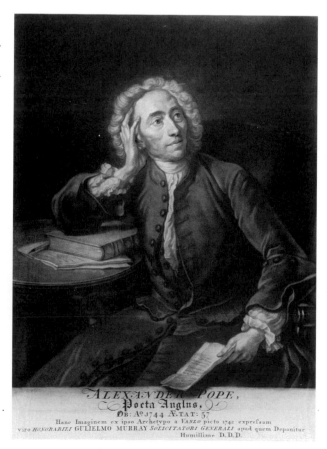

ALEXANDER POPE,
Poeta Anglus.
OB: A° 1744 ÆTAT: 57

form chiefly admired by those who 'delighted to see difficulty surmounted'. The disadvantage of work in a medium 'most grievously exposed to the molestations of moth and dust' did not, however, go unnoticed.[6] In more conventional vein, James Tassie (1735–99) was a modeller who cast copies of ancient gems and produced portraits in paste in the antique style (pl. 3). His success at this was attributed by Nichols to his ability to transmit 'the exact likeness of many eminent men of the present age . . . to posterity as accurately as those of philosophers and great men have been by the ancient statuaries'.[7] Novel ways of presenting the contemporary human subject were constantly being invented: a 'new kind of sculpture', for instance, 'medallions in ivory . . . placed on black velvet, covered with a glass . . . [representing] the heads of some of the great men of the country', was the latest attraction when the German traveller Archenholtz toured the country in the 1790s.[8]

One individual might be represented many times by different artists in different poses, and the portraits distributed among friends and admirers; sixty-six primary types of Alexander Pope's portrait have been

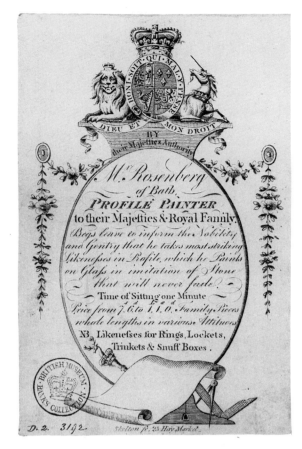

counted (pl. 4).[9] Copyists – who also restored and dealt in old paintings, sold frames, artists' materials and engravings – appear to have been very numerous in London by the end of the century. One such, J. Archer, advertised in 1799: 'Historical Paintings, Landscapes and Portraits, &c. Copied in a most exact manner, cleaned and repaired . . . ever so dirty or spoilt with hard varnish from a peculiar method without the least injury. Brought to their original Purity. Old Paintings Bought or Exchanged' (pl. 5). Another, by the name of Smith, was advertising from the artists' ghetto in Newman Street in 1785 as 'Portrait Painter in Oil. Original Portraits, Landscapes and Historical Paintings copied in the exactest manner. Miniature pictures and profiles' (pl. 6)[10], suggesting the irrelevancy of the academic genre system to this end of the market. The Earl of Fife's view of twenty pounds as the economic ceiling for the new clientele in the portrait trade appears to have been generous, as the going rate, evidenced by trade cards dating from the last two decades of the century, seems to have been in the range of three to eight guineas, and James Northcote was painting clients in and around Portsmouth in 1776 at five guineas a head.[11] In Bath, a Mr Rosenberg claimed to be able to produce striking likenesses in profile from seven shillings and six pence to one guinea, with 'time of sitting one minute' (pl. 7).[12]

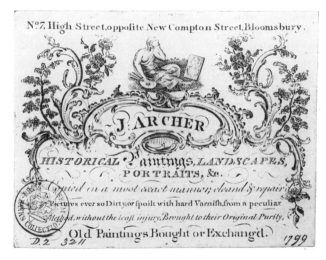

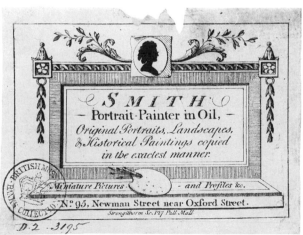

3

One way of assessing the importance of portraiture in eighteenth-century English society is to examine the products that emerged from the studios of London, Bath, Tunbridge Wells and other fashionable centres – for this is, for historical reasons, primarily a metropolitan account. Writing about portraiture as much as about portraits (and relatively little about portrait painters), I have been indebted to much recent research on individual artists from Gainsborough to Reynolds and from Lely to Lawrence. But my starting point was elsewhere than with these important scholarly and museological works. Nearly thirty years ago, when I was a student in the then unfashionable field of British painting, the inimitably acerbic asides in the pages of E.K. Waterhouse exercised a fascination over me. The generation after Kneller is, Waterhouse tells us, the most drab period in the history of British painting, and – of some of Hogarth's contemporaries – he says: 'Of the lesser fry, other than painters of conversation pieces, many names are known and many more portraits survive on which the signature of some otherwise unrecorded painter can give a moment's interest to the curious student. We know enough of the eighteenth century – as we hardly yet do of the seventeenth – to feel sure that they need no mention in a general history.'[13] How, I wondered, might we substitute for this general history an archaeology of portraiture? How might an account be written that would map the competing interests and claims in the production of images and the dissemination of meanings – an account that would not overlook the visual pleasures of portraits as artworks but not be determined by those pleasures? How could portraiture's role in the formation of a sense, not only of history, but also of modern self-identity, of subjectivity, be established?

Whether the commissioning of works from contemporary artists like Gainsborough or Opie is at issue, or the practice of collecting historic portraits as analysed in chapter II, portraiture was – and is – to be understood as one of the ways in which social groups and individuals (collectively and individually) represent themselves to themselves; portraiture – the result of acts of portrayal – is always more than the sum of its parts, as Lady Wentworth's correspondence demonstrates. It is within cultural practices such as portraiture – practices that are never isolated as 'painting', 'collecting', 'carving' or 'biography' but interlock as part of an endless network of communicative acts – that individuals collectively and the state as organism regulate society.[14] If we are to understand how portraits by Reynolds, or Romney, or Gainsborough were apprehended by their contemporaries (as opposed to whom they re-presented and how they were put together), if the extensive and pervasive discursivity of portraiture in

the eighteenth century is to be explained, then it is necessary not only to look closely at individual portraits but also to excavate portraiture as system, as a shaping and defining mechanism in terms of class, rank and gender. The portrait has no unproblematic referent; it cannot be explained as a correlative to the text of a subject's life. Portraiture signified in the eighteenth century in England independently of the sitters or the particular objects that are called portraits. While particular portraits contain symbols and denote individuals, portraiture as a practice and as a theory in this period cannot be understood merely by the application of iconographic procedures and by the identification of sitters. In semiotic terms, portraiture is *langue* and portraits are *parole*. In so far as a linguistic model like this implies ahistoricity, then it is unsatisfactory. It is none the less useful for suggesting portraiture not merely as a national language but also as an ideological mechanism.

A chronological account of the development of portraiture in Britain between, say, 1620 and 1790 might run parallel to an account of biography that postulates a shift from romance to realism. In Ira Bruce Nadel's analysis, 'Walton's *Lives*, Fuller's *History of the Worthies of England* and Aubrey's *Brief Lives* indicate the emergence of realistic detail through the use of records, documentation and interviews which contradict an earlier tradition of impression, remembrance or fabrication. Research and investigation soon become the *sine qua non* for eighteenth- and nineteenth-century biography which relied more heavily on fact than on the identification of values

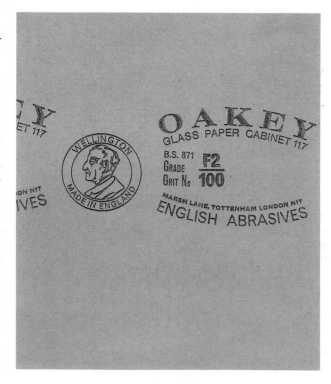

8. Sandpaper bearing the portrait in profile of the Duke of Wellington as a trade mark.

between biographer and subject, or the interpretation of character and narrative presentation.'[15] Similarly, the standard account for visual objects runs from the 'iconic' portraits of Lely to the individualized and personalized portraits of the 'naturalistic' artists of the late eighteenth century.[16] Such an account is, however, predicated upon an imperative of forward movement, a lineal evolution towards a new realism.[17] Portraiture's relationship with its past is always more complicated than this model (where old is discarded for new) would suggest. It is a model that fails to recognize the symbolic function of representation and the structural relationship between objects and their environments, between artefacts and their precursors, and between usage and aspiration. This book deals with systems and with individuals because only by identifying codes and conventions of representation and relating them to individually inventive acts can we reconcile the historical with the regimes of spectacle and discourse.

Portraits carry a guardianship function in post-medieval western societies. While 'likeness' is cited as the defining characteristic of portraits and the measure by which they are evaluated even when dealing with societies and periods where verisimilitude is not an acknowleged criterion, portraits as objects have a high symbolic value. As signifiers, what they signify is often connotative rather than denotative, despite the apparently close relationship between the signifier, an image of a particular human being, and the signified, the idea of the actual human being denoted by that image. Thus, for instance, the Duke of Wellington as he might appear on the reverse side of a piece of sandpaper purchased from a local hardware store (pl. 8) or George Washington transformed into a bottle for the centennial celebrations of 1876 in the U.S.A. are signifiers whose signifieds are much less powerfully the *idea* of the individual person Wellington or Washington than *values* like efficiency or sturdiness.[18]

As with all serious engagement in historical research, the atomization of portraiture in the eighteenth century has much to do with recognizing the dynamics of our own contemporary cultural traditions. The portrait retains a powerful talismanic function, not least in developed western-style societies. We might instance the deployment of portrait photographs by the mothers of missing persons, demonstrating in Argentina in 1986 (pl. 9). Portraits often stand in for the absent person and serve to maintain a link between the dead and the living in much the same manner as the *imago clipeata* of Antiquity, which is discussed in chapter II ii. When a London youth had portraits of the Prince and Princess of Wales inscribed in the hair on the back of his head at the time of the royal wedding (pl. 10), he made himself a mobile representation, a work of art

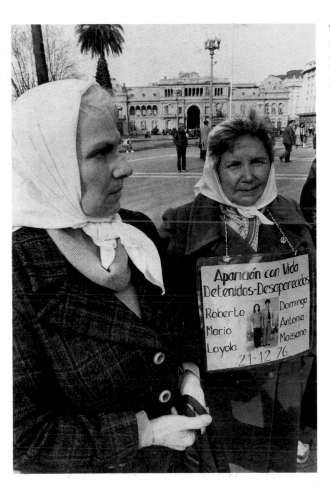

9. A mother of 'detained-disappeared' persons in Argentina, demonstrating by wearing a placard bearing a photographic portrait of the missing individuals. Photograph, the *Guardian*, 24 December 1986.

that states a point of view in much the same way as a soldier carried into battle a shield graven with the image of Alexander the Great.

In writing about portraits of children in chapter VII, I am touching on questions concerning the organization of the family in modern European history, the study of which was pioneered by the *annales* historians. But more than this is at stake here; it may turn out that childhood is an area of problematization for the late twentieth century in ways that Freud had scarcely begun to consider. The discourse of the abused child is one of the conditions of writing for a late twentieth-century art historian. It cannot be otherwise. But this is not to say that we read into the past the preoccupations of the present. Rather, it is to affirm that the historical moment of our own present opens up for us certain imperatives in relation to the past. Eighteenth-century child portraits, by their very nature, raise questions about how the affective relations between adults and children are held in bounds and what the function of imagery might be in the articulation of cross-generational desire. It is perhaps only now that we can recognize these issues and explore these questions.

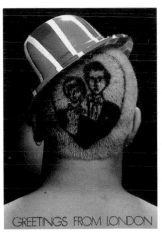

10. *Royal Hair-do*, picture postcard, London.

A youth bears a portrait of the Prince and Princess of Wales in dye on the back of his cropped head, surmounted by a plastic bowler hat decorated with a Union Jack design.

Instances of the repetitive and seemingly timeless functions of the portrait need, however, to be matched by the specific conditions of eighteenth-century portrait production and by recognition of the philosophical and abstract role of portraiture as a powerful process of conceptualization in the period. David Mannings has drawn attention to some of the ways in which portraiture in eighteenth-century England became a vehicle for discursive enquiry. Reynolds's portrait of Garrick, he argues, is a portrait about art, about the confrontation between the grand and the ornamental styles.[19] While the individual portrait – here a brilliantly inventive one – as representation of the particular body, may indeed perform this function, portraiture had a wider significance, enabling and legitimizing forms of conceptualization – and hence of regulation – of the body politic. This process, moreover, is always (albeit tacitly) informed by considerations of gender. Portraiture as concept thus stands in a contradictory relationship to the mythic unified body which is rationalized and re-presented in portrait depictions. The actual practice of portrait painting stages this contradictory relationship: dividing, fragmenting and separating. When one of Pompeo Batoni's sitters, George Lucy, remarked: 'I have shown my face and person . . . to take the likeness thereof',[20] he is conceptualizing a split that was reproduced in actuality in portrait practice where the head (and particularly the face) would be executed by the master, whilst the body and clothing and the background were the responsibility of studio assistants. Such practices were in part the result of economic exigencies, but they were also sanctioned by theory.

In *The Art of Drawing* (1606), Henry Peacham set out to establish the legitimacy of artistic practice for the English gentleman, for it is 'no more disgrace to a Lord to draw a fair picture, then to cut his Hawk's meat, or play footeball with his men'.[21] The object most worthy of attention by the artist is Man, since Man is the worthiest of all creatures, and the place to begin is the head: 'You shall begin to draw a man's face, in which as in al other creatures you must take your beginning at the forehead, and so draw downward till you have finished.'[22] Two hundred years later Sir Charles Bell in *The Anatomy and Philosophy of Expression* (1806) provided for the artist a synthesis of knowledge of human anatomy and physiognomy in relation almost exclusively to the head and the face. Of ten essays in his book seven are devoted to this section of the human body. I examine in part II the implications of a pervasive theoretical body of work based on these premises for the construction of gendered identities. If we are inclined to regard this

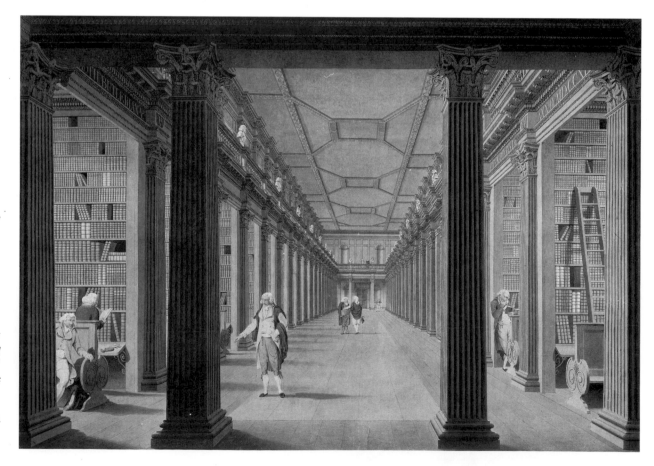

11. James Malton, *View of the interior of the Long Room, Trinity College Library, Dublin*, watercolour on paper, 54 × 78 cm. By permission on the Board, Trinity College, Dublin.

This drawing was engraved in 1793, dedicated to Edmund Burke and published in *A Picturesque and Descriptive View of the City of Dublin*, 1799. Each bay of the 208-foot long library is marked by the bust of a celebrated writer, an emblem of the purpose and function of the space below.

insistence upon the head at the expense of the body as a whole as in some way normal, or merely to be expected, it is worth recalling that western art prior to the sixteenth century did not prioritize the head in this way and that in many non-western cultures the notion of portraiture that is so fundamental to post-Renaissance western art is altogether absent.

That which provided the root form of so many depictions of the human head, the Roman portrait bust, offered in concentrated form a notion of the whole man. As Richard Brilliant has pointed out, the bust synthesized the subject in his or her entirety and stood in for him or her.[23] The eighteenth-century portrait bust had precisely this function. In the Library of Trinity College, Dublin, designed by Thomas Burgh and completed in 1732, a splendid series of marble busts by Scheemakers and Roubiliac marked each bay at gallery level, the authorial presence and authority invoked by conventionally truncated form (pls 11, 12). But the emphasis on the head and face meant that the ideal notion of the Vitruvian man was disrupted. When William Gilpin wished to convey something of the experience of assessing visual imagery he did so by relating parts to a whole on the principle of the ideal body, with resonances of Zeuxis's search for the ideal as recorded by Pliny.[24] But here the principle is reversed, or subverted, because attention to the separate parts of the body may justify those parts while the whole is unacceptable, just as when the whole pleases the parts may offend:

> We consider a print as we do a picture, in a double light, with regard to the *whole*, and with regard to its parts. It may have an agreeable effect as a *whole*, and yet be very culpable in its parts. It may be likewise the reverse. A man may make a good appearance upon the *whole*; tho his *limbs*, examined separately, may be wanting in exact proportion. His *limbs*, on the other hand, may be exactly formed, and yet his person, upon the *whole*, disgusting.[25]

The very concept that the whole may surpass — indeed may negate — the parts legitimates portraiture as a unifying discourse in the eighteenth century. The contradictions and the disparate parts of the human subject/society, whether contemporaneously or with hindsight, can be reconciled. It is a discourse of overview, summary and completion. Portraiture as discourse encapsulates and makes graspable the elusive body. Thus portraiture as a metaphor permeates the fabric of eighteenth-century society and spans its polarities. A correspondent of the Revd James Granger, the influential inventor of systematized collecting of engraved historic portrait heads discussed in chapter II, told him punningly in 1775, 'I seldom enter a palace or a cottage, but if I see

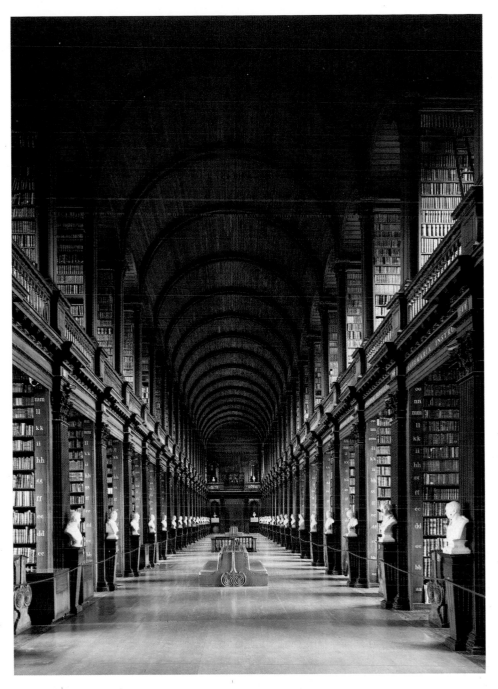

a print upon the walls, I think of you, so that you may imagine you make frequent *impressions* on me.'[26]

A taxonomy of portraiture for the eighteenth century would produce a vast array of classes from collections of engraved portraits, through literary 'portraits', animal and bird portraiture, to the surviving notion of a portrait as a description or depiction of any phenomenon. The use of the terms 'portrait' or 'portraiture' to mean any form of representation was, it has been pointed out, the most common application in the Middle Ages prior to the 'modern' notion of counterfeiting a living face.[27]

12. Trinity College Library, Dublin. By permission of the Board, Trinity College, Dublin.

The library was designed by Thomas Burgh and completed in 1732; the busts which were originally located at gallery level are now in equivalent positions at floor level.

What is less frequently realized is how tenacious this more generalized use of the term would be, pervading the literature long after portraits as likenesses became a dominant form of social practice. In chapter III the importance of the concept of portraiture as a mechanism in political debate will be explored. Here I want only to establish the way in which portraiture as a unifying idea is imbricated in the eighteenth-century's representation of itself. The foreword to Nichols's great accumulation of contemporary knowledge, the *Literary Anecdotes*, sums up the principle, that all representation is fragmented anecdote which can be unified by portraiture: 'The life of a private tradesman, however distinguished as a scholar, cannot be expected to "abound in adventure"; and in fact the Anecdotes of Mr. Bowyer are few when compared to the many that are introduced of his learned friends. But the principal figure of the piece stands everywhere foremost on the canvas . . .'.[28] It is Bowyer who is central, by virtue of the unifying principle of portrayal, even though few of the anecdotes actually concern him.

A hundred years later, at a period when gigantic biographies bursting with minute details were the fashion, an anonymous writer pleaded for a return to this unifying principle of eighteenth-century discourse as he saw it exemplified in Johnson's *Lives of the Poets*: 'We want to see a portrait, not an inventory of the features possessed by the subject.'[29] Historiography is powerfully shaped by this notion of portraiture as a unifying system, as *langue* rather than *parole*. Portraiture, in historiographic terms, is thus often taken to sum up or encapsulate a particular period or a particular place at a particular time. This is more than merely a version of the Carlyleian view of history as constituting the lives of heroes to whom the biographical mode provides access. There are two kinds of argument. One proposes portraiture as a special art form responsive to crisis, a genre through which artists react to their times and as a consequence reflect them. The other argues that portraiture gets at the heart of the individual, *despite the circumstances*, and thus is capable of providing a register for the period. On the one hand, Florence as a centre, it is proposed, 'was not adverse to portraiture'; on the other hand, Holbein sums up Henry VIII's London, Velázquez, Philip IV's Spain. Egon Schiele shows us the 'real' Vienna at the turn of the century where the 'persistence of portraiture' is seen as a special characteristic of an hysterical society, and Hockney, the 'real' California of the 'sixties.[30] The Stuart court can thus be understood to be contained within the axis of its portraiture which offers a register for the times: 'Van Dyck had immortalized the members of the Caroline Court in their splendour and elegance during the high summer of the monarchy. It was left to Dobson to portray the

cavaliers at war in the hour of their defeat.'[31] The relationship between portraiture and the age is thus a tautologous one. For David Smith, writing of Dutch marriage portraits, 'these paintings seem . . . to reflect a broad development in the social history of modern Europe'.[32] Portraiture in this account is valorized by the character of the period and the perceived character of the period is in turn located in its portraiture. It is this circuit of legitimation that has to be broken by investigating structurally the operation of portraiture as a mechanism for an integrated regime of contemporary and historical representation.

When the distinguished team of Italian art historians – Tullio de Mauro, Luigi Grassi and Eugenio Battisti – compiled the entry on portraiture for the *Encyclopedia of World Art* (1958), they concluded their introduction with the comment: 'The new and more complex classifications of portraiture that are needed must be based as much on the varying functions of portraiture as on the changing fashions in iconography.'[33] There have been many attempts to address the problem of establishing genre-based definitions of portraiture, definitions that could be applied historically. Authors such as Breckenridge, Brilliant and, more recently, Wendy Steiner, have sought to define what constitutes a portrait and how it achieves its affectiveness.[34] Steiner identifies what she understands to be the nature of the portrait. It is both a work of art and a document. Positing a subject with a unique, actual essence, it is, she claims, one of the very few arts of the particular. It draws on two antagonistic sets of norms, the aesthetic and the referential.

> The tension between general reference and aesthetic closure is present to a degree in all literature, although it is particularly problematic in the modern period. But in the portrait, the pull towards representation is extreme, for the work not only points to general realms of meaning, but attempts to render a specific, existent element of reality, a specific human being. Thus the portrait poses the general artistic problem of the aesthetic versus the referential as an overt conflict: it represents a real person whose actuality it announces through its title and through 'individualising' detail; at the same time it represents itself as a work of art – framed, highly structured, of interest 'in itself'.[35]

Although manifestly acute, this set of observations fails to recognize the historical specificity of portrait production and dissemination. Nor does it allow for the way in which the discursive and symbolic values of portraiture subsume questions of referentiality. Likeness, in Lady Wentworth's account quoted at the beginning of this introduction, is a shifting com-

modity, not an absolute point of reference; it is an idea to be annexed, rather than a standard by which to measure reality. The notion that portraits 'attempt to render a specific, existent element of reality, a single human being' is highly problematic in most if not all cases if we take into account the ontological problems associated with human identity and its perception. It is evident, moreover, that leaving aside intentionality, in portraits we contemplate open-ended texts for consumption. This is certainly true of the period covered by this book and is probably true also of other cultural situations in which portraiture played a dominant role in shaping society. It is for this reason that the second part of this book is devoted to four detailed forays into precisely and narrowly defined cases of portrait and body imagery. Through the study of the wig as an item of apparel and as a discursive formation, we can disrupt the tyranny imposed by an examination of male portraiture that is linked to artist or sitter, and hence it becomes possible to address questions of masculinity and power. Lady Mary Wortley Montagu is chosen as a subject precisely because it is demonstrably irrelevant in historical terms whether the portraits that she commissioned of herself resembled her or not. Nor is this a question of aesthetic conformity or of the production of genealogical icons. Portraiture is construed in this analysis as an interactive dynamic resulting in portraits (that is, objects) that can be understood only as part of a process involving the bridging of the conscious and the unconscious, the historical and the actual, the real and the imagined. Portraits of children and of family groups in domestic interiors are taken as paradigmatic of how, through varying devices of representation in the widest sense of the word, the intense contradictions concerning generation and gender pertaining to human social relations are formulated and controlled.

What are perceived as broad truths of history often fragment if we examine the margins rather than the centre. This book is written on the basic principle that if we wish to know the meanings of those aspects of society and culture that have traditionally been inscribed as central and influential, we must examine the minutiae of those elements that the dominant culture has discarded, we must look for connections between elements that the academic practices of historians have constructed as discrete, and we must interrogate imagery as representation, not accept it as mimesis. To describe this book as a history from below would be to suggest that it confined its concerns to popular cultural forms. Ephemeral material like Beetham's *Moral Lectures on Heads* (1780), the transcript of a popular show involving wood and pasteboard heads that played to crowded audiences for over three hundred successive nights, is certainly a significant part of this account.

And chapter III is devoted to the political effectiveness of portraiture in challenging and subverting orthodoxies. More precisely, this book adopts the feminist strategy of writing against the patriarchal account; it writes against the grain of an history of eighteenth-century portraiture as the history of the achievements of certain artists or the formative influence of certain institutions like the Royal Academy. The epilogue on the National Portrait Gallery serves effectively to demonstrate how the institution does not merely act as legislative power but gathers to itself and generates discourses belonging to many levels and dimensions of political and social life. The National Portrait Gallery is not to be construed teleologically as the outcome and resolution of the eighteenth-century's contested field of portraiture, or as a solution to the problematic functions of eighteenth-century portrait paintings. Rather, it should be understood to represent the definition of a new – and specifically mid-Victorian – space for the regulation of dangerously subversive issues of nationalism, history, subjectivity, class and gender which had been mapped onto the conceptual and material acts of portraiture and portrayal from the mid-seventeenth century.

That portraiture is the major genre in eighteenth-century England is undeniable, for all that we now recognize the importance of sporting painting, landscape and the grand history pieces of Barry, West and others. It is not my intention in this book to seek to create a new field; it has been my aim to investigate the period in such a way as to demonstrate, by the detailed examination of a range of portrait practices alternative to the aegis of the Royal Academy in part I, and by the close analysis of sets of images in part II, precisely what portraiture meant in terms of eighteenth-century English culture and society. From our current perspective in late twentieth-century Britain, the National Portrait Gallery, founded in the mid-nineteenth century, evinces the mythicization of contemporary heroes and heroines as well as the desire to visualize national history through individuals. Its existence demonstrates the continuing preoccupation with portraiture in national life. It is a fitting conclusion for this book because the aspirations of James Granger in 1769 to establish a biographical history of England, the importance of the distribution of portraits one in relation to another in the interiors of private houses, and the translation of individual identity into public discourse on the part of a subject like Mary Wortley Montagu, all in some sense are replayed within the licensed space of the institution of the National Portrait Gallery. This very English and very nineteenth-century phenomenon is a link between eighteenth-century portraiture and late twentieth-century collective identities.

I BIOGRAPHY: SYSTEM: PORTRAIT

I SPACES OF PORTRAYAL

i *Hanging and Framing*

Attempts to restore historic houses to an approximation of their original condition are now commonly accompanied by efforts not only to install 'authentic' fixtures and fittings but also to reconstitute paintings in the order in which they are understood to have been hung. Nineteenth-century watercolours of country-house interiors and inventories of domestic goods are used as evidence for the reconstruction of a specific period hang. At Kingston Lacy Lely's portraits of the Banks family have been restored to the library, even though in the eighteenth century they were known to have been in the great parlour (now the drawing-room). At Charlecote the National Trust has painstakingly hung the Great Hall and chief reception rooms as they probably were in the first half of the nineteenth century.[1] Elsewhere, as at Beningborough, in the spirit of reconstitution, the National Portrait Gallery has filled the house with eighteenth-century portraits appropriate to the period and class of the house's most distinguished occupancy.

These houses testify to a recognition that the ordering of imagery in particular spaces and settings produces meanings specific to those times and places. The very fact of owning something – even if the objects owned are never to be seen by a public – can serve powerfully to mythicize the owner, as has been the case with a number of significant collectors of whom, perhaps, Richard, 4th Marquess of Hertford, was the most famous. In the majority of cases, however, visibility is a prime factor in the scale of values attached to ownership. Knowing when and where objects were seen, and in relation to which other artefacts they were apprehended, allows the historian to begin to grasp their specific historical meanings. It is not sufficient merely to possess wealth or power. The wealth or power must be put in evidence for, as Veblen says, 'esteem is awarded only on evidence'.[2] The visibility of power is, however, highly complex and always relational. It is thus not only what is possessed that is significant but where and how it is made visible.

The evidence for the arrangements of artefacts is fragmentary, ephemeral and inconclusive. Inventories of houses list works in particular rooms but do not say how they are disposed in relation to one another. Those same inventories may be extremely vague as to the identification of particular works. Thus, for example, the inventory made of the contents of Norfolk House, St James's Square, when it was rebuilt and refurnished for the Howard family in 1753, starts with the garrets and works down to the laundry, itemizing the contents of every room. But just as garret no. 4 contains 'a picture', so the wardrobe over the kitchen was housing what were described merely as '42 pictures of different sorts', as well as a variety of looking-glasses. Even in the Green Damask Room, where items are defined in more detail, we learn only that there were two old heads over the doors; three large pictures of the history of Joseph, of Solomon and of Bathsheba; a picture of Moses in the bullrushes and its companion; two battles; two landskips and two pieces of architecture. All except the heads are cited as being in gilt frames, indicative of the value placed on lavish and expensive framing, something that we will return to shortly.[3]

The acquisition, retention and organization of material goods are indicators of a family's economic status and a measure of their social position. But the values transmitted via property are less easy to grasp than the issue of material wealth. As Bourdieu puts it:

> every material inheritance is, strictly speaking, also a cultural inheritance. Family heirlooms not only bear material witness to the age and continuity of the lineage and so consecrate its social identity, which is inseparable from performance over time; they also contribute in a practical way to its spiritual reproduction, that is, to transmitting the values, virtues and competences which are the basis of legitimate membership in bourgeois dynasties.[4]

It is precisely because they objectify social relations that the contents of houses are always in a state of flux. Paradoxically, it is also the case that objects like paintings which symbolize the ownership of a particular class or institution, enshrining the sense of identity of that group, tend to have a longer and less

13 (p. 10). Detail of pl. 111, *William Sommers*.

14 (facing page). Detail of pl. 25, Beningborough Hall.

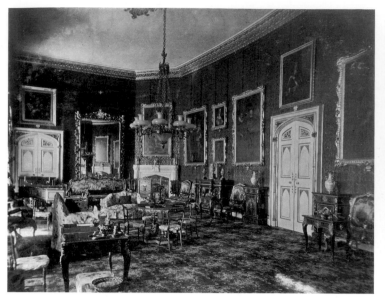

disturbed life than other kinds of household objects. And this is particularly true of portraits.

Family portraits – even when the precise identities of sitters have been forgotten – are often disposed of last when families sell inherited goods. They also remain longer in the same locations. Thus at Arundel Castle, for example, early photographs dating from 1850 through to the present century show the drawing-room furnishings and décor changing from generation to generation but the family portraits remaining in the same place (pls 15, 16). Portraits can provide symbolic continuity, an inhibition against time and change. In this chapter, I shall be examining first a series of particular hangs and offering historical interpretations of those arrangements and second, in section ii, the conditions for the production of those portraits in the penultimate decade of the eighteenth century. Whilst portraits constituted for the owner who hung them, at one and the same time, a material acquisition, a symbol of wealth and position and (sometimes) a source of aesthetic pleasure, for the artists who produced them portraits were, we shall see in section ii, a commodity for sale, but one that implicated the artist as producer in a dense web of commerce and ideology.

The portraits incorporated into the complex interior décor of Strawberry Hill by its owner Horace Walpole are not separable from the overall plan of the house, either physically or symbolically. The total effect is more than the sum of the parts. Objects are placed in an ensemble in such a way, or so Walpole would have us believe, as to make any reversal of the process of construction as impossible as the dismantling of history. Asked by Gough, the medievalist and engraver, in 1792 to lend him a portrait of John Law of Lauriston (1671–1729), the entrepreneurial economist, founder of the Banque Générale and inventor of the Mississipi scheme (which he hoped would rival the East India Company), Walpole replied:

> I have a portrait of Law, and should not object to a copy of it being taken; but I doubt that could be done, being in crayons, by Rosalba, under a glass; and any shaking being very prejudicial to crayons. I fixed the picture in one of the niches of my gallery under a net-work of carving, whence it cannot possibly be removed without pulling the niche to pieces. The picture too being placed over the famous statue of the Eagle, there is no getting near to it, and I certainly could not venture to let a ladder be set against the statue.[5]

The portrait busts in roundels over the gothic bookcases in the library at Strawberry Hill (a series of copies after seventeenth-century portraits) signify through their relationship to the heraldic devices, to the bookcases and to the predella/fireplace (pl. 17). These – as well as the contents of the bookcases which included twelve large folios of English heads, bound in vellum and ranged according to the reign of each king – contributed to a systematic reconstruction of the past, a reconstruction that served to secure and fix the individual historical life, emblematized in portraits, in an overall three-dimensional patterning that also inscribes Walpole the owner into the past and does so irredeemably and for perpetuity.[6]

Whilst Strawberry Hill may present a particularly conspicuous example, what we know of the hanging of portraits in domestic interiors in the eighteenth century suggests that the criteria for the arrangement of portrait galleries is determined by the need to

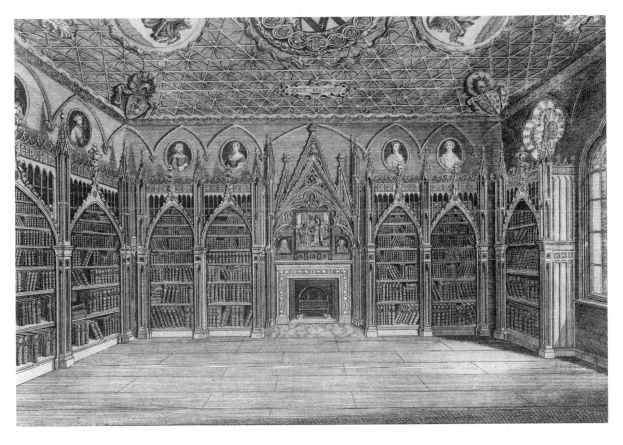

17. *The Library, Strawberry Hill*, engraving from *A Description of the Villa of Mr. Horace Walpole . . . ,* Strawberry Hill, 1784. By permission of the British Library, London.

Walpole's Gothic library incorporates copies after seventeenth-century English portraits as well as heraldic devices and furniture designed after medieval ecclesiastical models.

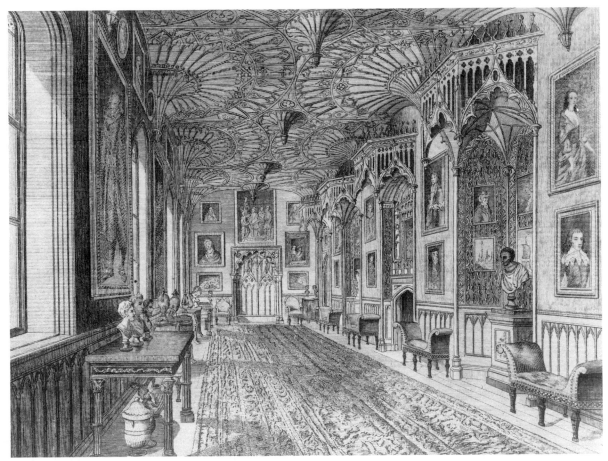

18. *The Gallery, Strawberry Hill*, engraving from *A Description of the Villa of Mr. Horace Walpole . . . ,* Strawberry Hill, 1784. By permission of the British Library, London.

In his Gallery Walpole arranged landscapes and sea-pieces in the bays at a lower level than portraits; large portraits were prominently hung and the dominating end wall above the door was occupied by history painting.

19 (below) and 20. Robert Dighton, *A Real Scene in St. Paul's Church Yard, on a windy day*, watercolour on paper, 32.1 × 24.5, *c*.1783. Courtesy of the Board of Trustees of the Victoria and Albert Museum, London.

This watercolour, printed as a mezzotint in 1783, shows the premises of Carrington Bowles, the print-publisher and print-seller. The confusion of the street, in which a fishmonger's boy tumbles, and people lose their hats and wigs in the gale, is contrasted with the orderly display in the window. The rectangular perfection of the prints is highlighted by the tattered remnants of a notice on the adjacent building advertising (travel by coach) to Portsmouth and Gosport. Within the window the display offers a hierarchy with portraits of divines at the top and caricatures or moral narratives below.

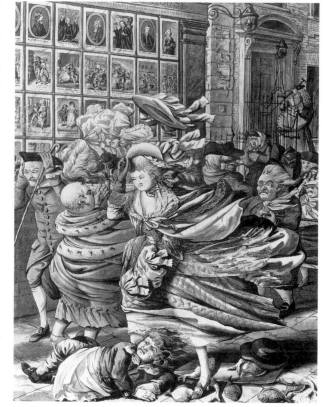

deploy portrait images in ways that ensure a general statement is to be understood, transcending the meaning of any particular image. In Walpole's Gallery, portraits are hung at a higher level than landscapes, and history painting takes pride of place over the door at the end of the room, thus replicating the hierarchy of the genres (pl. 18).[7] But this well-established hierarchy, stated and restated in academic theory, is by no means the only one. Robert Dighton's *A Real Scene in St. Paul's Church Yard, on a windy day* (pl. 20) shows the window of Carrington Bowles, the print dealer. Bowles published the mezzotint of this water colour, and it would have served as an advertisement for his shop. The display, although crowded, is rigidly ordered (pl. 19):[8] the top line of engravings contains portraits of divines, three of them in the act of preaching, while the lower two lines that are visible are occupied by bawdy scenes. Thus the one class is defined by its negative relation to that which hangs above or below it, a visual embodiment of divergent rhetorics of class, morality and social comportment.

Susan Lambert has pointed out that the display of an individual collection of engravings could either facilitate study or serve as an outward emblem of a scholar's inner life. The engraver and historian, George Vertue, chose to commemorate his marriage by depicting himself and his wife in front of a display

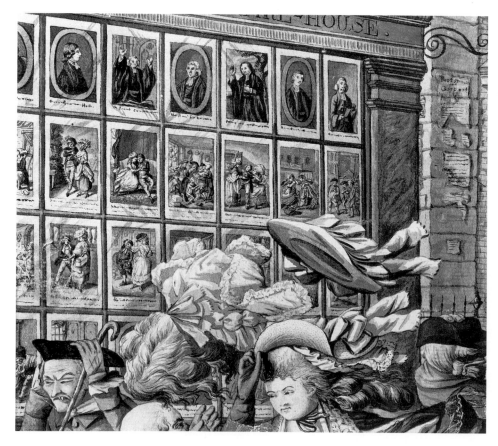

of historic portrait heads engraved by himself and arranged to complement the rhythm of the panelling on which they were hung. Thus he placed his partnership in a lineage (pl. 21), which is not that formed by his own forebears but by the whole of British history as understood at the time. This arrangement, and its representation within the portrait, also serves, therefore, to valorize Vertue's own profession as copyist and engraver of historic portrait heads.[9]

The English country house was organized in ways that replicated the hegemony of the microcosm – the family – that occupied it. Accordingly, portraits of servants, not a common category in the eighteenth century, were hung in corridors or below stairs, as at Uppark before its destruction in 1989.[10] With the passage of time, portraits of the domestic substratum are dignified as antiquarian curiosities; J. Riley's portrait of Bridget Holmes (1688) in the Royal Collection is one such case. The portrait of the Popham family servant attributed to Phelps (active 1760s) now hangs in the Great Hall at Littlecote (pl. 22). In the main apartments only the most important portraits were hung. At Beningborough Hall, a Yorkshire house designed by William Thornton and completed in 1716, portraits of members of the family by John Verelst (1699) were fitted into elaborate overdoors in the State Bedchamber (pls 23, 24). Similar portraits remain *in situ* in the drawing-room.[11]

16

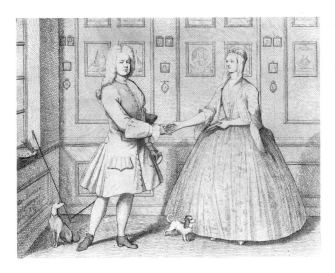

In houses as relatively modest as Beningborough or as grand as Petworth (built 1688–93) portraits were interspersed with valuable pier-glasses. These, as we have noted in the case of Norfolk House, were stored with paintings and thought of as analogous – or even, given the cost of glass, superior – objects. The effects of pier-glasses alternating with portraits, together with the spatial impact of long enfilades of rooms as at Beningborough (pl. 25) and Petworth, produced a very particular impression which (even allowing for period rehanging) it is still possible to grasp. At Petworth (pl. 26) Van Dyck's portraits disappear only to reappear suddenly as a mirror reflection or as a glimpsed figure through an open doorway. Hung portraits were components in a perambulatory experience in which light, space, reflection and image all contributed to the pervasive and cumulative effect of ancestry. As an outsider, J.M.W. Turner was especially sensitive to these effects (pl. 27).

Artists in the eighteenth century painted for specific locations, adjusting tonality to the requirements of a particular situation. 'If the Picture be set in a Place which receives but little light', instructs Thomas Page, author of an artists' manual, 'the Colours must be very clear, as on the contrary very brown if the Place be strongly enlightned, or in the open Air.'[12] It is also interesting, in view of the connections between the hanging of pier-glasses and of portraits, that Page instructed portrait painters to look constantly at their work in a looking-glass placed behind them, 'for that will show you your faults; whether the Masses of the Lights and Shadows, and the Bodies of the Colours be well distributed, and are of one piece'. The looking-glass for the artist, as for the viewer in the saloon, distances the painting.[13] The portrait was thus probably seldom scrutinized in isolation but as part of a spatial dialogue. Heavy hangings, curtains, artificial lighting and judicious distribution could be employed to

modify a work not expressly executed for a particular location, especially as the portrait backgrounds themselves often reproduced and 'mirrored' those features.

Domestic interiors provided ample scope for particular symbolic arrangements. At Littlecote House, Sir Alexander Popham's portrait by Mytens forms the centrepiece for a display of Cromwellian arms in the Great Hall. At Norton Conyers, on the other hand, the portrait of Sir Richard Conyers in the style of Mytens was left in pride of place just inside the Great Hall door during the remodelling of some rooms in the eighteenth century (pl. 28).[14] It hangs surrounded by Civil War armour in an arrangement that affirms its subject's status and political history but that also indicates the symbolic function of portraiture in a complex narrative structure. The coat, the weapons, the armour and the heraldic shield that are placed around the full-length portrait of Sir Richard and his son do not denote particular facts about that individual, nor vice versa. The portrait symbolizes rather than re-presents the heroic presence of the knight who fought for the king at Marston Moor and the armour stands in metonymic relationship to that whole body. A royalist declaration of this kind was of great importance during the reign of Queen Anne; it is a three-dimensional equivalent to the publication in the same period of Clarendon's *History of the Rebellion*.

It is evident that contemporary viewers recognized arrangements of this kind and knew how to 'read'

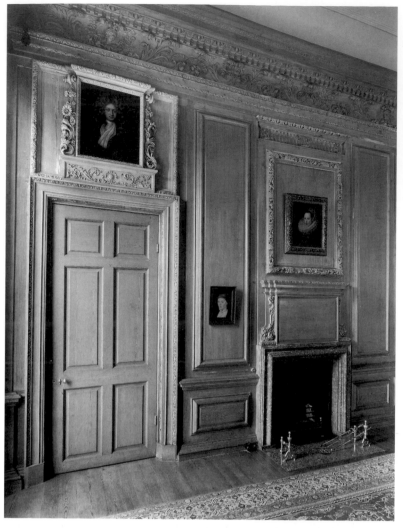

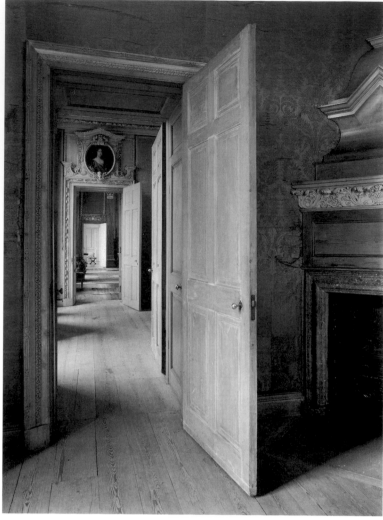

23 (above). The State Bedroom, Beningborough Hall, Yorkshire, completed 1716.

In this house, built by William Thornton for John Bourchier, the state appartment on the ground floor is one of a number of rooms containing elaborate carving incorporating overdoors.

24. Overdoor in the State Bedroom, Beningborough Hall, Yorkshire.

The portrait is by John Verelst and, dated 1699, predates the house. However, portraits as well as the more customary landscapes were situated in overdoors, and it is possible that this arrangement dates from 1716.

25 (above). Beningborough Hall, Yorkshire, first floor view from east to west.

The arrangement of rooms opening one into another creates an ambience in which portraits are experienced in relation to other formal elements (door frames, doors, ceiling panels, pilasters) and in which viewing conditions are determined by natural lighting from the side.

26 (facing page, top left). Petworth House, Sussex, the dining-room.

Reflected in a pier-glass, attributed to James Whittle (c.1754–9) and now hung between the windows, is Van Dyck's portrait of Algernon Percy, 10th Earl of Northumberland, Lady Anne Cecil, his first wife and their daughter, c.1637. Through the doorway is visible one of the classical sculptures assembled between 1750 and 1760 by Charles, 2nd Earl of Egremont. There was much rearranging at Petworth and Egremont House in the 1770s, but although the Van Dycks were not hung in this room at that time, the relationship of painted imagery to reflective surfaces is the result of a standard period arrangement.

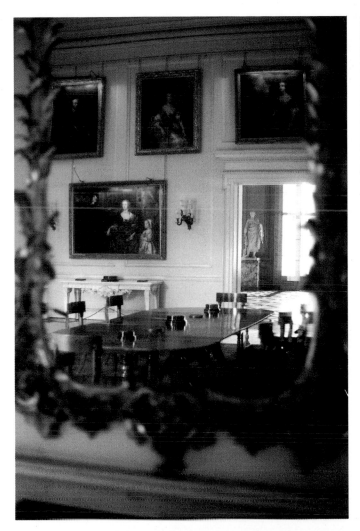

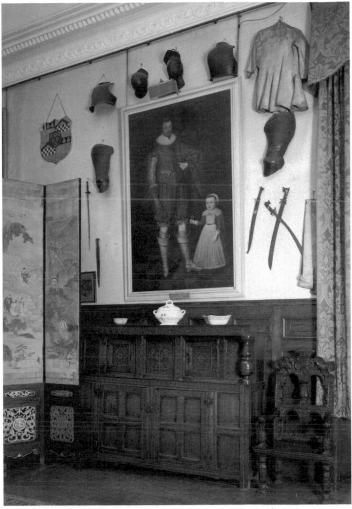

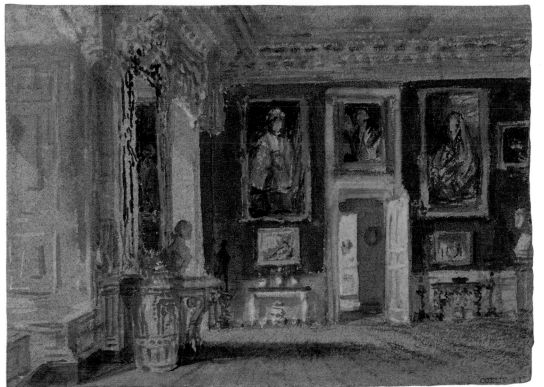

28 (above). The Great Hall, Norton Conyers, Yorkshire.

The portrait which shows Sir Richard Conyers and his son (School of Mytens) is surrounded by royalist armour in an arrangement that survived eighteenth-century reorganization.

27 (left). J.M.W. Turner, *The Red Room at Petworth House*, gouache on blue paper, 13.7 × 19 cm., *c.*1828. Turner Collection, Tate Gallery, London.

Turner explores the experience of viewing portraits in interiors that are also adorned with pier-glasses, an experience that involves shifting centres of focus. The portraits of Sir Robert and Lady Shirley by Van Dyck can be identified on either side of the door (see also pl. 186).

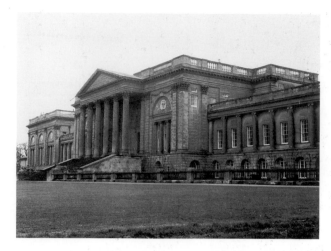

29. Stowe House, Buckinghamshire, south front.

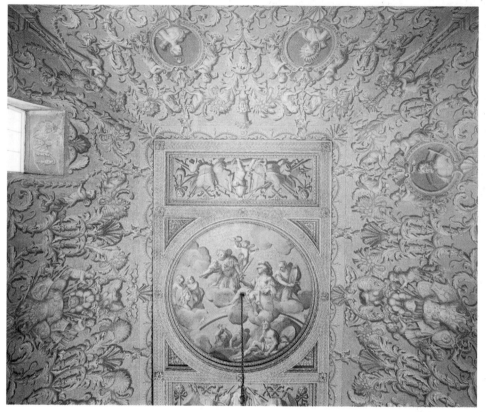

30. Stowe House, Buckinghamshire, the hall ceiling.

Designed and painted by William Kent, the ceiling comprises an elaborate compliment to Viscount Cobham who is portayed in the central compartment receiving a sword from the king.

(I was taken into his study. The portrait of Fox was very noticably placed on the chimney breast. His library . . . seemed to me to consist of parliamentary debates, the writings of Mirabeau, and books that might characterize an opposition member)

Portraiture was an organic part of the grand Baroque interiors of 'private' houses; it also marked out the most intimate and familiar spaces of the great houses and palaces of the eighteenth century. When Gustav Waagen travelled through Britain in the 1830s, he often overlooked, or ignored, the family portraits, devoting most of his time and writing instead to the great masters he saw.[16] But contemporary and early nineteenth-century guidebooks establish the dominant role of portraiture in the dynamics of interior spaces, in the articulation of family histories and national hierarchies. The notion that certain sorts of pictures are appropriate for certain sorts of rooms is grounded in Renaissance theory: Lomazzo established in 1584 the proper parameters for the hanging of works of art, advice that was taken up by Sir Henry Wootton and William Salmon.[17] But the British have regularly deviated, sometimes in eccentric ways, from normative practice of this kind (Horace Walpole is a clear example), and the rule book is not always a useful guide. Family portraits have often survived the dispersal of other family goods, lost portraits have been re-produced, interior arrangements have been determined by a mixture of flux and inertia, tradition and innovation, ostentation and nostalgia, political affirmation and autobiography.

Houses like Stowe were three-dimensional portraits of their owners (pl. 29). Approaching Stowe at the apogee of its fame and splendour, the visitor (instructed by two tiers of textual inscription: the official guide and the carvings and gilt inscriptions *in situ*) mounted a great flight of thirty-one steps adorned with lions taken from the garden vestibule of the Villa Medici. Between statues of Religion and Liberty, the name of Richard Earl Temple and the Year of Grace 1775 was inscribed. Entering the saloon, the visitor was invited to marvel at the decorative ensemble featuring the arms of the late Earl Temple and the present Marquess of Buckingham; many of the ornamental features and figures were collected from Trajan's column and the arches of Severus, Titus and Constantine in overt association with Imperial triumphal architecture. In the hall the visitor looked up to a ceiling (pl. 30) painted by William Kent and showing the seven planets, with Mars – the ruling one – in the likeness of King William, presenting a sword to the late Field Marshal Viscount Cobham, in allusion his having been given a regiment on first entering the army.[18]

them. The French emigré artist, Henri-Pierre Danloux, during his first few days in London in May 1792, visited William Henry Lambton, MP for Durham and an enthusiastic Whig, at his town house in Berkeley Square. His host's political affiliation was instantly *visually* apparent to Danloux who recorded the visit:

On me fit entrer dans son cabinet. Le portrait de Fox (see pl. 114) était placé bien ostensiblement sur la cheminée. Sa bibliothèque . . . me parait composée des debats du Parlement, des discours de Mirabeau et des livres qui peuvent caracteriser un membre de l'opposition.[15]

20

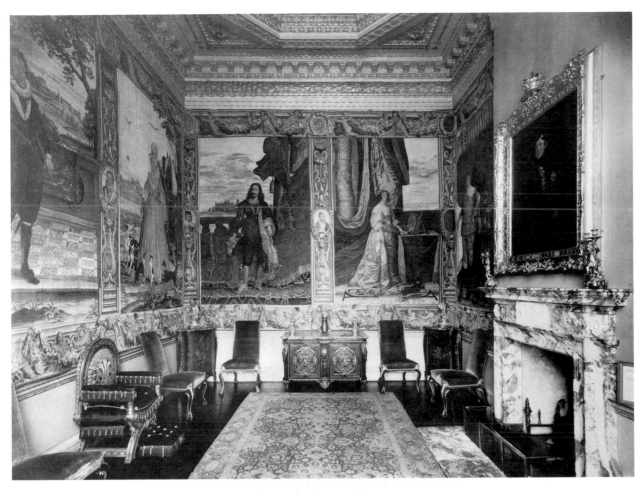

31. Houghton Hall, Norfolk, the Tapestry Room.

The dressing-room (an important room in the eighteenth-century grand house) was hung by Sir Robert Walpole with tapestries based on portraits of the Stuart monarchs by Van Dyck.

Portraits at Stowe were hung predominantly in dressing-rooms and bed-chambers, but the Grenville Room contained a total of forty-six portraits of the Temple and Grenville families from the sixteenth to the eighteenth centuries. The billiard-room contained a further fifty-one portraits, including representations of Nell Gwyn, Luther, Anne Boleyn, Oliver Cromwell and Jonathan Swift.[19] The Stowe sale of 1848, at which the entire contents of the house were dispersed, was seen as a national disaster, for, as *The Times* reported, 'The galleries of family portraits and collections of family memorials seem to connect all the great men and all the great achievements of modern Europe with the name of Chandos, Temple, Cobham and Grenville'.[20]

At Houghton Hall (completed in 1738) Sir Robert Walpole hung the dressing-room before the velvet bed-chamber with gold tapestry after paintings by Van Dyck of whole-length portraits of James I, Queen Anne and Christian IV, King of Denmark and brother to Queen Anne (pl. 31). The borders are decorated with boys bearing festoons and with oval pictures of the children of the royal family. This overt declaration of allegiance to the Protestant succession was carried through the house and into the drawing-room, which contained portraits of Charles I and Henrietta Maria by Van Dyck, supported by Walpole family portraits. The only painting in the library was George I in coronation robes by Kneller. Horace Walpole's *Description* of the picture collection at Houghton was published in 1752 and dedicated to his father in terms that testify to the creation of a house full of treasures as a conceptual portrait of the political and social power and integrity of the owner: 'Your power and your wealth speak themselves in the grandeur of the whole building . . . And give me leave to say, Sir, your enjoying the latter after losing the former, is the brightest proof of how honest were the foundations of both.'[21] These words are accompanied by an elaborate double-spread frontispiece featuring Sir Robert and Lady Walpole (pl. 32). Only twenty-two years after publication, the picture collection was sold to pay off the debts of Horace Walpole's nephew, thereby provoking a national outcry and calls for the creation of a National Gallery from none other than John Wilkes.[22]

At Holkham which, like most grand eighteenth-century houses, was open to respectable visitors, special provision was made for foreigners and artists

21

F. Zinke effig. p. 1744. *G. Vertue del. & sculp. 1748.* *F. Zinke effig. p. 1735.* *G. Vertue del. & sculp. 1748.*

32. Frontispiece to Horace Walpole, *Aedes Walpolianae . . .* , 1752. By permission of the British Library, London.

This grand Baroque frontispiece was designed by Zinke and engraved by Vertue in 1748. It incorporates portraits of Sir Robert and Lady Walpole, a bust of Socrates, the plans of Houghton Hall and a range of heraldic and emblematic devices, thus demonstrating how portraiture was understood in the eighteenth century as a set of over-lapping conceptualizations within which the composite entity of the house was itself a form a self-portraiture.

wishing to view the contents.[23] When Waagen visited Holkham in 1835 he recorded Van Dyck's *Duke of Aremberg* in the saloon and a portrait of Charles James Fox in the manuscript library.[24] But the guide to Holkham published in 1817 describes the Van Dyck in the drawing-room and the portrait of Charles James Fox in pride of place in the saloon. This suggests that the arrangement described by Matthew Brettingham in 1773 survived at least until 1817. A full-length image by John Opie, the portrait of Fox hung opposite a similar image of Thomas William Coke, Esq. by Gainsborough (pl. 33). The Fox portrait, in case there should be any doubt as to its significance in the political affiliations of the household, was inscribed:

A patriots even course he steer'd
Mid factious wildest storms unmov'd
By all, who mark'd his mind, rever'd,
By all, who knew his heart, belov'd.[25]

The eighteenth-century hang at Holkham also incorporated a carefully composed intellectual autobiography in the arrangement of the ante-room leading to the famous manuscript library. Here, alongside an antique alabaster of the Egyptian god Canaphos hung portraits of 'the celebrated Mr Roscoe by Shee', of Dr Parr by Opie and of Mr. Rishton ('one of Mr. Coke's earliest and most valued friends') by Barber. William Roscoe, the Liverpool banker, had been instrumental in the formation of Coke's manuscript collection, and hence his portrait bore the following words:

Long may Liverpool enjoy the pleasure of possessing the *scholar* without pedantry, the *patriot* without reproach – the *Christian* without superstition – the *man* who is an ornament to human nature.[26]

Coke had established at Holkham a particular

22

space for the display of representations of his close friends and the companions of his intellectual self-education. The location was appropriate, and the identity of the sitters, supported by inscriptions, provided both an acknowledgement of his gratitude and an affirmation of his sense of himself as an educated gentleman. But the traditional long picture gallery of the sixteenth- or seventeenth-century house remained a living theatre of family history throughout the eighteenth century. Richard Steele's Sir Roger de Coverley, his imaginary paradigm of the old English aristocrat, displayed the ancestors in his gallery in 1711 in a way that provided the viewer with some gentle humour at his expense.[27] But the creation of galleries of ancestors – something that we might readily associate with nineteenth-century creations, such as Sir Walter Scott's Abbotsford, the Hohenzollern collection at Sigmaringen Castle and Ludwig I's Walhalla near Regensburg – had never lost its popularity in Britain. In the case of the Roman Catholic Arundel family, the dispersal of family portraits due to dramatic vicissitudes in the fortunes of successive earls of Arundel and dukes of Norfolk, was repaired by the careful reconstruction of the family portrait collection, missing items being supplied by copies. The ninth earl, who succeeded in

1732, gradually restored the collection that had been devasted following the Civil War. Several Howard paintings that had been alienated from the family were reacquired: the Poet Earl's portrait by William Scrots (pl. 34) was, for example, purchased at the Stafford House sale in 1720 by Sir Robert Walpole, the then prime minister, who subsequently gave it to the ninth Duke of Norfolk.[28] The latter employed Vertue to engrave a series of family portraits and relics going back to the Middle Ages. The show-pieces of the eighteenth-century restoration of the family prestige via portraiture are Gainsborough's portraits of the eleventh and twelfth dukes in Van Dyck costume which now hang in the drawing-room at Arundel Castle (pls 35, 36). In an access of historicist enthusiasm in the second half of the century, as John Martin Robinson has pointed out, the Duke of Northumberland was restoring Alnwick Castle, George II was attending to Windsor and the dukes of Norfolk were intent upon the restitution of the grandeur of Arundel Castle.[29]

Artists like Biagio Rebecca (1735–1808), who was responsible for most of the copies of ancestral portraits that Sir John Griffin hung in the reorganized saloon at Audley End in the 1770s (pl. 37), enjoyed successful careers on work of this kind.[30] The saloon

33. The saloon, Holkham Hall, Norfolk.

Holkham was designed by William Kent and built between 1734 and 1761. This photograph taken in 1959 shows the portraits of Charles James Fox and Thomas Coke on either side of the door as they were in 1817. Over the door is a large marble antique bust of Juno. Van Dyck's life-size equestrian portrait of the Duke of Aremberg which hung in the drawing-room in the nineteenth century is now also located in the saloon.

34. William Scrots, *Henry Howard, Earl of Surrey*, oil on canvas, 222.4 × 219.9 cm., 1546. National Portrait Gallery, London, on loan to Arundel Castle.

35. Thomas Gainsborough, *Charles Howard, 11th Duke of Norfolk* (when Earl of Surrey), oil on canvas, 232.27 × 152.4 cm., 1783. National Portrait Gallery, London, on loan to Arundel Castle.

Charles Howard was a passionate antiquarian and commissioned these portraits of himself and his third cousin (and heir) as part of an elaborate restoration of the material culture of a family that had suffered dispossession and alienation.

36 (far right). Thomas Gainsborough, *Bernard Edward Howard, 12th Duke of Norfolk*, oil on canvas, 223.5 × 137.1 cm., *c.*1788. By permission of His Grace the Duke of Norfolk.

Portraiture was an historicizing discourse in the eighteenth-century as these images of contemporary figures dressed in seventeenth-century clothing demonstrate.

was described in an early nineteenth-century guidebook: 'here are also full-length portraits of several distinguished persons, copied from Holbein, Kneller, and other masters; and most of the subjects have been connected with this mansion or the history of the estate'. The work was apparently greatly appreciated in its time.[31] Little visual evidence for schemes of this kind survives, since later generations, horrified by, for example, the white-washing of the celebrated Jacobean screen at Audley End, restored the house by reference to what were perceived as more authentic models. The saloon at Audley End remains, however, as a testimony to the deployment of portrait copies in an historicist three-dimensional statement.

The ordering of civic spaces could also be achieved at a symbolic level via the strategic placing of portraits. In Norwich, the early fifteenth-century Blackfriar's Hall (formerly the chancel of the monastic church) had become a public exchange by the late eighteenth century. Around 1774 major alterations were made and a room fitted up over the porch to serve as the city library. In 1786 the hall was opened up for a corn exchange and was used for this purpose every Saturday. Evidently it already contained pictures, for, we are told, when in 1806 the hall was painted, the pictures there were cleaned and varnished. A visitor shortly afterwards described them as 'mostly wretched' but indicated that they included 'some fine specimens of modern art, especially a likeness of the late Lord Suffield by

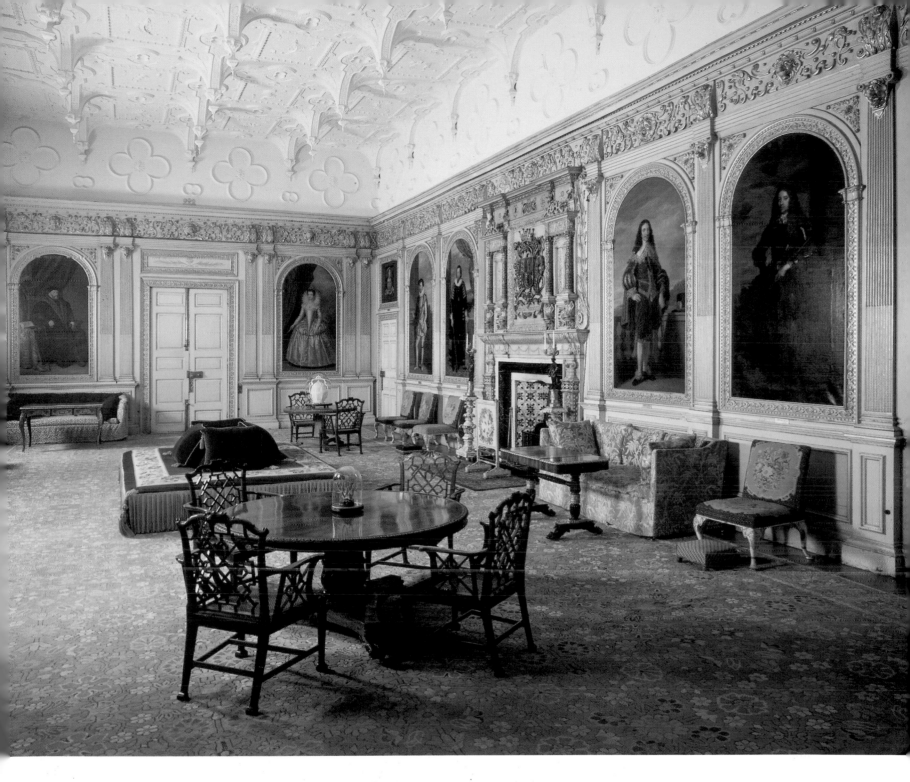

Gainsborough, and one of the late Mr. Windham by Hoppner'.[32] Thus the great aristocratic family, whose residences of Suffield and Gunton Park were in the locality of Norwich, and the city's MP, William Windham of Felbrigg, a renowned Burkeian politician and a local farmer, were both represented in the city's corn exchange.

By the early nineteenth century the dominant position in this chamber was accorded to a portrait of Lord Nelson (a local man), accompanied by the following inscription: 'This best likeness of the illustrious hero, and the last for which he ever sat, was painted after his return from the Battle of the Nile, in the year 1801, by Sir William Beechey, and confers additional lustre on the professional abilities of that eminent artist.' This picture hung at one end of the hall. At the opposite end, 'over the large central window', was displayed 'in a festoon form, the tri-coloured flag of France, being the ensign of the French ship Le Genereux of 74 guns, captured in

37. The saloon, Audley End, Essex.

Portraits of Henry VIII, Queen Elizabeth I and other figures from English history were copied from originals at Hatfield House and elsewhere and incorporated into a decorative scheme in this major public apartment at Audley End in the 1770s.

25

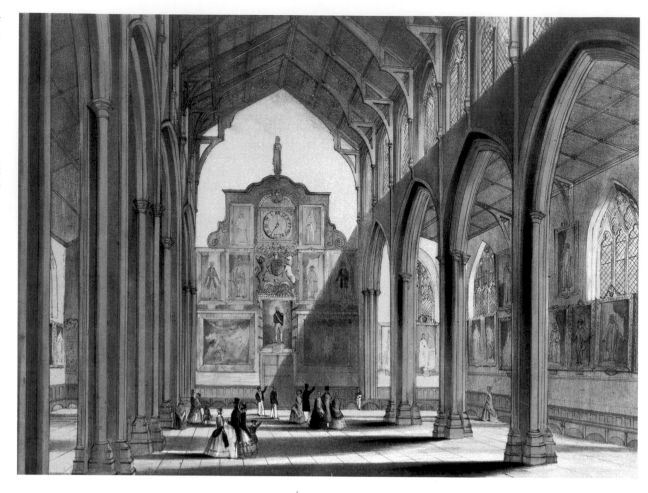

38. C.J. Greenwood, *Interior of St. Andrew's Hall, Norwich*, hand-tinted lithograph, 26.4 × 36.8 cm., Norfolk Museums Service (Norwich Castle Museum).

The centrepiece of the end wall in this nineteenth-century lithograph is Beechey's portrait of Nelson in an elaborate frame superimposed by the lion and unicorn. Down the side walls are visible some of the seventeenth-century civic portraits that contributed to the construction of a visual and three-dimensional statement of civic and nationalist pride.

the Mediterranean by Sir Edward Berry in 1801'.[33] By the mid-nineteenth century, Nelson's portrait had been moved to form the centrepiece of a civic ensemble in the adjacent St Andrew's Hall (formerly the nave of Blackfriar's church) where concerts and civic functions were held (pl. 38).[34] It would appear, from this account, that in the late eighteenth century the merchants of Norwich did their business under the symbolic protection of two of the most powerful men of the town. Following the dangerous period of the wars with France, the iconic presence of Nelson, accompanied by the vestigial sign of the defeated French, took precedence in this symbolically organized environment, local interests giving way to national. With the increased demands of civic ritual in the early years of Queen Victoria's reign, this arrangement was superseded.

Civic organization of portraits of national and local significance, such as the case I have cited in Norwich Blackfriars, would have lent additional conviction to the calls for public patronage in the metropolis. These had gained momentum through the century, from Hogarth's proactive stance in relation to the decoration of public buildings to John Opie's plea for a national gallery of pictures, first published in

a pamphlet in 1792,[35] and to Alderman Boydell's schemes for the Guildhall and the Mansion House.

In 1789 Boydell, whose involvement in the patronage of English art extended well beyond his Shakespeare Gallery and his publishing enterprises, became involved in the interior reconstruction of the Egyptian Hall in the Mansion House, the official residence of the Lord Mayor of London. George Dance the younger was the architect, and while extensive interior alterations were being carried out, Boydell – in an address to the Common Council of London on 31 October 1793 – suggested that the hall be altered in order to become 'a proper place to put Pictures or Statues, such subjects to be chose, that would represent the great and glorious actions, of departed Heroes or of our present commanders by sea and land, that have exerted themselves to the Honour and advantage of our king and country'.[36]

Boydell's plan allied history painting and portraiture in a grand, decorative ensemble specifically intended to impress foreigners as well as to give work to contemporary artists. His formal proposal was evidently the culmination of several years of discussion with artists like Opie and caused considerable alarm in the ranks of Royal Academicians. The

intended to give pleasure to foreigners and the British
public in general, to assist artists and to express
respect for the corporation and fellow citizens. The
donation, some major items of which were destroyed
in enemy action in 1940–1, included Richard Paton's
Lord Mayor's Day on the Water, James Northcote's *Sir
William Walworth killing Wat Tyler*, John Opie's *The
Murder of Rizzio*, and a series of paintings relating to
the Battle of Gibraltar (pl. 40). The hero of this naval
victory, Lord Heathfield, was represented by a copy
of Sir Joshua Reynolds's portrait (pl. 41). Boydell
expected that 'the poor and all in the inferior stations
of life may profit by the advice which many of the
subjects in this collection will impart to them.'[38]
Reynolds's portrait and those of other naval heroes
represented in the Old Council Chamber (like *Admiral
Lord Duncan* by Hoppner and *Admiral Lord Howe*
by Northcote), suggest the extension to three-
dimensional space of the kind of nationalistic
arrangement of history and portraiture that had long
been a feature of grangerized books like Pennant and
Clarendon.[39]

Just as families and civic bodies acquired, re-
acquired, copied and deployed portraits in the
interests of marking continuity in a world of dis-
continuities, so also charity organizations and private
institutions accumulated portraits of founders, ben-
efactors and governors in a continual train of
historical objectification at one and the same time
archival and commemorative. Founded by royal
charter (along with Bridewell and St Thomas the
Apostle) by Edward VI on 26 June 1553, Christ's
Hospital has a long history in different buildings and
on different sites. Its portrait collection, commencing
with a distinguished group of sixteenth century
works, spans a period of great changes and offers a
counterbalance to the lack of continuity caused by
those changes.[40] Events like the complete rebuilding
of the school in Newgate Street, London, according
to plans laid out by John Shaw the elder, were
the occasion for changes and reorganization in the
hanging of portraits.[41]

The uniform frames surrounding a large group of
Christ's Hospital paintings – some pre-nineteenth-
century originals, others copied from works else-
where – appear to date from around 1830, the era of
the Shaw rebuilding. In 1892 it was decided to move
Christ's Hospital from London to Horsham, though
the school did not leave the city until 1902. Although
the locations have changed over the years, the criteria
for hanging the portraits have remained the same.
The Court Room and the Dining Hall have always
been focal points for the collection. The former,
situated in the Counting House (the administrative
heart of the organization), was, and remains, the
venue for meetings of the Court of Governors.
The latter, a medieval Great Hall to all intents

scheme was opposed on the grounds that it involved
portraits rather than history paintings, but it is also
probably the case that this particular kind of arrange-
ment, which had succeeded so well in provincial
town halls, exchanges and assembly rooms, might
be construed as tainted by trade and bad taste when
introduced into the heart of London. James Barry's
paintings for the Adelphi, which might have offered
a precedent, were strictly allegorical and therefore
avoided the kind of aesthetic solecism that incurred
the opprobium of Reynolds and Northcote. In 1791
Reynolds asked Northcote to find out the origins of
an account he had heard from Noel Desenfans (the
entrepreneurial collector, who was also interested
in national galleries) that he, Reynolds, had recom-
mended Lawrence to be employed to paint whole-
length portraits of Lord Mayors for the Mansion
House. The scheme was 'appalling' not only because
portrait rather than history paintings were proposed
but also because it would have involved the now
highly archaic and unfashionable practice of pro-
ducing a sequence of posthumous portraits.[37]

Boydell's involvement with the Guildhall con-
tinued through the 1790s, during which period he
donated a series of paintings on national topics,

40. *The Common Council Chamber, The Guildhall, London*, from *The Microcosm of London*, 1808. By permission of the British Library London.

Drawn and engraved by Rowlandson and Pugin and aquatinted by J. Bluck, this view shows some of the paintings presented by Alderman Boydell between *c.*1792 and *c.*1800. In the centre of the composition is John Singleton Copley's *Defeat of the Floating Batteries at Gibraltar, 1782* (1783–91). The pendentives of the dome are decorated with Rigaud's frescoes, commissioned by Boydell (painted over in 1814). On the left is Opie's *The Murder of Rizzio* (1787) flanked by portraits and, below (?) two of Paton's Gibraltar paintings. Paintings hanging on the right side include Northcote's *Sir William Walworth killing Wat Tyler* (1787), two Patons and two more naval portraits.

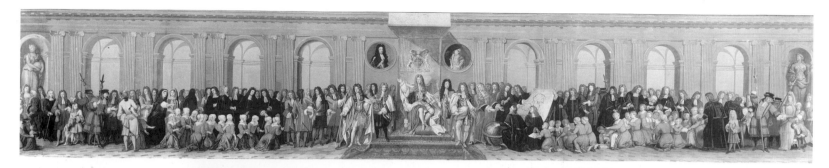

43 (right). *The Great Hall, the Bluecoat School, London,* from *The Microcosm of London,* 1808.

After the fire of London, the Hospital was rebuilt by Wren with this grand hall measuring 130 feet long, 34 feet wide and 44 feet high.

41 (previous page). Sir Joshua Reynolds, *Lord Heathfield,* oil on canvas, 142 × 113.5 cm., 1788. Trustees of the National Gallery, London.

General Elliott (who is shown here with a gigantic key with which he is to lock up Gibraltar) was raised to a peerage for his successful defence of the Rock against the Spanish and the French. The portrait was commissioned by Alderman Boydell from Reynolds in 1787 and presented by Boydell to the Guildhall by 1794. Some time after Boydell's death in 1804, his nephew had it removed (Farington says it would have perished had it remained hung upon a damp wall), and a copy was made by an unknown artist. The copy was substituted for the original which was sent for sale and bought by Sir Thomas Lawrence. It was acquired from his collection by John Julius Angerstein and thence came to the National Gallery.

42 (above). Antonio Verrio, *James II receiving the President of Christ's Hospital, several of the Governors and a number of the Children* (replica), gouache, 44.5 × 238.5 cm. Whereabouts unknown (Sotheby's, 28 November 1974 (49)).

Verrio's 1685 painting is an institutional group portrait on a gigantic scale (approx. 457 × 2,623 cm.) and has dominated the Hall of Christ's Hospital School since its completion. Portraits of Edward II and Charles I are placed in roundels on either side of the throne. This replica, which diverges from the original in minor details, was once in the collection of Samuel Pepys.

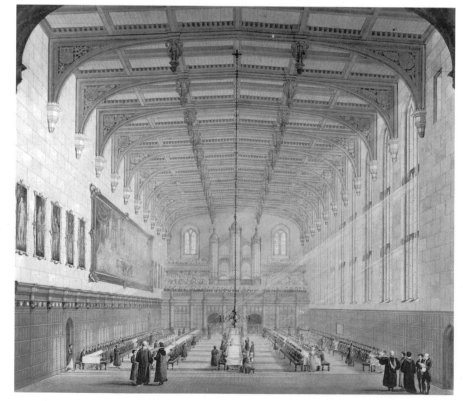

44. A. Shaw, *The Great Hall, Christ's Hospital, Newgate Street,* watercolour, 24 × 26 cm., 1829. Christ's Hospital, Horsham.

The architect of this new neo-Gothic Hall was John Shaw. Tradition was maintained with the hanging of Verrio's large painting but the increased length provided space for a further series of full-length portraits in identical frames.

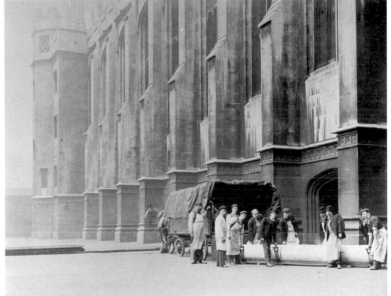

45 (top left). The Great Hall, Christ's Hospital, Newgate Street, photograph, *c*.1900.

46 (top right). Lowering Verrio's painting from the wall of Christ's Hospital Great Hall, photograph, *c*.1902. Christ's Hospital, Horsham.

47 (above). Rolling the Verrio painting, photograph, *c*.1902. Christ's Hospital, Horsham.

49 (right). The Dining Hall of Christ's Hospital, Horsham.

48 (above). Transporting the Verrio painting to Christ's Hospital's new site at Horsham, photograph, *c*.1902. Christ's Hospital, Horsham.

Verrio's group portrait of a moment of royal patronage and an event of major significance in the history of this charitable foundation has, by this time, acquired a powerful symbolic significance, and the very act of recording the transportation of the canvas is testimony to the ritual importance of portraits in the imaginative life of a corporate institution.

50. The Court Room at Christ's Hospital, photograph, *c*.1900. Christ's Hospital, Horsham.

Beneath the royal arms Queen Anne and, below, Edward VI occupy the centre of the main wall in this important chamber, emphasizing the maintenance of royal patronage and the Protestant succession.

Royal Arms

Daniel Colwall, Benefactor 1690	Thomas Stretchley, Benefactor 1692	Queen Anne	Henry Stone, Benefactor 1693	Thomas Parr of Lisbon, Merchant, Benefactor 1783
Charles ll	Edward Vl	Edward Vl	Edward Vl	James ll

Bust of Sir Louis Cavagnari

Fig. 1. The portraits shown on the end wall in the photograph of the Court Room at Christ's Hospital (pl. 50).

and purposes, offers immense wall surfaces for the display of pictures.

The gigantic 86-foot-long painting of King James II surrounded by nobles and receiving the President, Governors and some of the children of Christ's Hospital, which was executed by Antonio Verrio between 1684 and 1690 (pl. 42), remains the prominent feature of the Dining Hall; its dimensions are such that it is hard to imagine its being accommodated anywhere else. It was a celebrated object in a famous location and can be seen in a comparable position in *The Microcosm of London* in 1808 and in A. Shaw's impression of the new hall in London in 1829 (pls 43, 44). In the foreground of the 1829 image grandees and visitors watch the boys supping while the choir sings grace from the gallery. Full-length portraits of benefactors in identical frames hang on either side. Verrio's painting, strictly a ceremonial portrait, commemorates the foundation and endowment within the Hospital of the Royal Mathematical School by James II by letters patent 1673 and 1675. The boys, on the right, dressed in their characteristic blue coats, are presenting their mathematical drawings; the girls, who were educated separately from the boys until very recently, are assembled on the left and look on. It was in fact Charles II who had endowed the Mathematical School, but as he died while the portrait was in process, James II had his own portrait introduced along with that of his Lord Chancellor, Jefferies. The transportation of this huge canvas from London to Horsham and its rehanging in the Hall was recorded in photographs, a moment of ritual significance linking the past to the future (pls 45–9).

In 1820 a writer described the 'handsome' Court Room at Christ's Hospital, with its President's chair at the north end, under a little canopy with the arms of England over it: 'Beneath the arms is a half-length portrait of King Edward, executed by Hans Holbein, in good preservation, the countenance very fair and delicate. On the right side of the above is a half-length of Charles II by Sir Peter Lely, with a more placid countenance than the generality of his portraits.' Also hung in the Court Room, we are told, are portraits of nine presidents and fifteen benefactors.[42] A photograph of the Court Room prior to the move to Horsham (pl. 50) and a drawing of the same location by A. Hugh Fisher, dated 1902 (pl. 51), suggest the maintenance of visual order and the continuing assertion of the importance of royal patronage in the life of the charity. Figure 1 identifies the portraits in Fisher's drawing; the arrangement is close to that described in 1820 which had, in turn, probably been scarcely changed for a century or more. Today the portrait of Edward VI is in the Treasurer's Room and other portraits are in the new Court Room.[43] The photograph suggests that,

as with Blackfriar's Hall, Norwich, the end wall was retained for a rhetorical statement of patriotic loyalty while the side wall was allowed to accumulate portraits in a less obviously ordered way. Christ's Hospital continues to commission portraits of headmasters (and more recently, of headmistresses) and of treasurers. It also, on occasions, acquires historic portraits of benefactors. At meetings of the Court of Governors the miniature attributed to Isaac Oliver of John St Amand, left to Christ's Hospital by his

51. A. Hugh Fisher, *The Court Room at Christ's Hospital*, chalk on paper, 40 × 27 cm., 1901. Christ's Hospital, Horsham.

when attention has been paid to the need to maintain visual dynastic continuity but also allows for the accommodation of copies, replicas or portraits of an inconvenient size into the standard series. In the latter case, allegorized devices ensure a ritualistic reading of the portrait, elevating it towards the status of history. Thus Beechey's portrait of Nelson in Blackfriar's Hall, Norwich, has an elaborate frame comprising an anchor supporting a medallion with cannon balls along the edge, fasces forming the vertical sides, and a decoration of acorn and bay signifying victory and the hearts of oak of the English fleet (see pl. 39).

An almost equally elaborate frame surrounds the portrait of Sir Christopher Clitherow, Knt, by an anonymous seventeenth-century artist which now hangs in the Court Room corridor at Christ's Hospital (pl. 53). Sir Christopher, so the inscription on the frame tells us, was Alderman of London and Lord Mayor (1634), Burgess in Parliament for London (1627), and President of Christ's Hospital (1636–41). This biographical narrative is, however, partially usurped by the frame, commissioned presumably in 1802, which invites us somewhat insistently to notice that the painting was the gift of James Clitherow of Boston House, Middx., Great Grandson of Sir Christopher and one of the Senior Governors of this Hospital in 1802. Accretions of this kind are clear demonstrations of the fact that portraits, hung in specific spaces, are bearers of accumulated messages both semiotic and iconic. With the passage of time the levels of meaning shift and change in relative importance or comprehensibility to generations of viewers.

The frame may offer an interpretative gloss on the subject, and it may be part of the image, as is frequently the case with engraved portraits such as Houbraken's famous series of British worthies. At one level the actual frame (whether wood or plaster with gilt) may flatter the subject, but at another it may serve to appropriate the sitter and, also, to erase the artist. Mary Delany (1700–88) was a member of a famous Tory family, friend of Swift, Pope, Fanny Burney and the Duchess of Portland, court acquaintance of George III and celebrated craftswoman in the production of images of botanical specimens executed in paper mosaic. Opie painted a fine portrait of her *c*.1782, itself a relatively unusual occurrence since portraits of women of advanced age are not common. The portrait appears to have been intended for an oval, but after Mrs Delany's death her image (and by extension, her reputation) was annexed by Horace Walpole who 'framed' her in grand rectangular style (pl. 54). Musical instruments surmount the frame in reference to the supposed harmony of her life and her accomplishments as a musician. At the foot is a palette bearing the fol-

52. Attributed to Isaac Oliver, *John St. Amand*, miniature, 5 cm. oval, mounted in the lid of a box. Christ's Hospital, Horsham.

This miniature is part of a bequest to Christ's Hospital and is germane to the fulfilment of the stringent conditions of St. Amand's will.

grandson as part of a bequest, is to this day formally shown according to the terms of James St Amand's will as it has been since his decease in 1754 (pl. 52).[44] This is an essentially portable object, secured in the lid of a box and ritually revealed to a prescribed group of people according to certain rules.

Most portraits are, however, contained in frames rather than boxes, and the relationship between image and frame had implications for a contemporary viewing of the portrait. While the containment of portraits in uniform frames (such as appear at Arundel Castle, Christ's Hospital and in many other large and long-established collections) signals a form of systematization, the framing of particular portraits in elaborate and individually designed frames calls attention to their pre-eminence in a decorative arrangement, or can rupture an existing harmonious arrangement by its strident individuality. In the case of the former, the process not only marks a moment

lowing inscription: 'Mary Granville/Neice of Lord Lansdown/Correspondent of Dr Swift/Widow of Mr. Pendarvis and of/Dr Delany, Dean of Downe/-Her Piety and Virtues, her excellent understanding/ and her Talents & Taste in Painting and Music/were not only the Merits, Ornaments & Comforts of/an uniform life, but the blessings that crowned/and closed the termination of her existence/at the uncommon age of 88/She died April 15th/1788.' Walpole, having designed the frame and composed the inscription, signed his name prominently on one of the brushes extruding from the palette, inviting viewers to recognize his role as author pre-eminent over artist (in this case a carpenter's son) and subject (in this case female), a claim that operates through the composite materiality of frame and canvas and that demands that the portrait image be read as text.

A rather different instance of the complex interaction between frame and portrait can be found in a somewhat earlier work. Francis Cotes, 'our own Mr. Cotes', as the *Public Advertiser* called him,[45] painted the Hon. Lady Stanhope and the Countess of Effingham as Diana and companion in 1765. This very large (281 × 183 cm.) and ambitious portrait, in which Cotes rivals Reynolds in his fashionable mythologizing of female subjects,[46] is executed in striking shades of pinky mauve, ivory and blue (pl. 55). Its sophistication as a portrait of life-sized, moving figures and its consequent illusionistic aspirations are counterbalanced by the archaizing inscriptions that record in the main picture space the name of each sitter, and by the very elaborate frame into which the portrait has been placed.

What is known of the Hon. Lady Stanhope's life associates her with amateur theatricals and a life of relative independence: she was married very young and separated after two years from a husband forty years her senior.[47] It does not seem, however, that this could be a scene from a play, and it accords fairly closely with the body of fashionable portraiture from the second half of the eighteenth century in which aristocratic female sitters are represented as muses or as inspiring figures from classical mythology. While they are, on one level, conceits – elaborate forms of visual flattery – works like this also invite the viewer to contemplate contemporary womanhood liberated from social constraint, free to enjoy a pastoral life remote from household accounts, difficult servants and even more difficult husbands. The thematics of this genre awaits serious investigation.[48] Less attention has been paid by historians to the Countess of Effingham's role, perhaps because she is subordinate in the composition, little seems to be known about her life and, moreover, the painting descended through the family of Lady Stanhope.

The carved and gilded frame is 'one of the most conspicuous features of the painting';[49] it bears an

armillary sphere with trumpets (top centre), plumed helmets, halberds and swords at the sides and a pistol, cannon barrel and sword at the bottom. The sphere is a symbol of the universe, and all the other motifs are symbols of war. This frame has always been a puzzle as it is one of a series of at least six identical frames in Yorkshire houses. Richard Green has suggested that one frame was made for a portrait of Francis Blake Delaval (relative of Lady Stanhope, née Anne Hussey Delaval), a veteran the Grenadier Guards' landing at St Malo in 1759, and that the other frames were made to correspond. If one thing is clear, it is the fact that the relatives of Lady Stanhope admired her portrait and regarded it of sufficient

53. Anon., *Sir Christopher Clitherow* (d.1641), oil on canvas, 124.5 × 91.4 cm., frame of *c*.1802. Christ's Hospital, Horsham.

This portrait of a London merchant who was a patron of Christ's Hospital was framed and donated by his great-great-grandson who used the occasion to record his own connection with the institution.

54. John Opie, *Mrs Mary Delany*, oil on canvas, 74.9 × 62.2 cm., 1782, frame designed by Horace Walpole, *c.*1789. National Portrait Gallery, London.

to the chaste Diana, the huntress, and her (virgin) companion, the frame alludes to the virtues of Venus, while celebrating the role of British heroes in the defence of the nation. Charles Howard, Baron Howard of Effingham, ancestor of the blue-clad countess (and more distinguished than any of the Delaval ancestry) had been Lord High Admiral under Queen Elizabeth I. An emblematic frame like this was effective in promoting family glory; in linking these specific emblems to this particular image, it served also to subsume the female subjects, Lady Stanhope and the Countess of Effingham, into a frame-work of natural and masculine signifiers. The one plays off against the other: military distinction acquires lustre from association with the fleet-footed goddess of the hunt, and the women of the family are assimilated into a martial discourse. The arts of war and the arts of peace, the naval offensive and the stag hunt, are to be seen as complementary.

ii Portraiture as Business: London in the 1780s

In this section I shall examine the conditions within which portrait painters worked in London during the years of high demand of the 1780s. A savagely competitive world of commercial enterprise, a life of toil, insecurity and the strain of constant public exposure: these were the material conditions generating discourses of portraiture and the corollary to cultivated society and its rituals of self-presentation and re-presentation. The aspiring portraitist arriving in London, like, for example, the American Gilbert Stuart in 1775, sought entrance to an immensely complex system of capitalist enterprise and entrepreneurship. It was a system demanding not merely skill at capturing a likeness (a skill, after all, that many possessed) but business acumen, a disposition capable of regular public performance, a sensitivity to rank and hierarchy, verbal ingenuity, personal charm and authority.

Portrait painting offered one of the greatest opportunities for social mobility of the period. George Romney, who was at the height of his career in 1783 and received a total of 593 sittings in that year,[50] was the son of a Lancashire builder and cabinet-maker.[51] John Opie was the son of a Cornish carpenter; Sir Joshua Reynolds's father had been a Devon parson and village schoolmaster. Reynolds eventually owned his own ostentatious carriage and a villa at Richmond where he entertained friends, as well as substantial premises in London.[52] His studio sale in 1795 contained 41 pictures by artists ranging from Claude to Rembrandt and from Titian to Watteau and fetched a total of £10,226 9s.[53]

Commenting on the comparative merits of British

importance to justify a very expensive and complex frame. The frame is not merely military in its symbolism, however, it is specifically maritime. Along the edges a pattern of flowing waves and sea shells provides an ornate rococo syntax to link the military and naval symbols. While the portrait refers

55. Francis Cotes, *Lady Stanhope and the Countess of Effingham as Diana and Companion*, oil on canvas, 281 × 183 cm. York City Art Gallery.

It is not known who designed and made the carved and gilded frame in which this portrait has for long been hung; the relationship between the image of two women and a frame adorned with heroic maritime motifs is unlikely to have been accidental and should not be overlooked; the frame must always have affected the ways in which the portrait was understood.

For every artist who exhibited in the Royal Academy at the end of the eighteenth century there were probably half a dozen practioners of portraiture in London working on glass with a 'pentagraph', like Charles, or painting on enamel and ivory, and charging as little as two shillings and six pence for a miniature.

This view of the Royal Academy exhibition in the early nineteenth century by Rowlandson and Pugin and aquatinted by Hill suggests that portraits and animal paintings continued to jostle with history paintings for coveted space on the walls. The distinctions between genres that theorists insisted upon had little bearing on visitors' experience of the exhibitions.

and American portrait patronage in the eighteenth century, the pioneer historian of American art William Dunlap claimed:

> It has been observed, that in England, as well as in America, any man, however low in the scale of society, if he has talents, may be lifted to high rank and official power. But with *us* he is lifted by the people, and remains one of them whereas in England, he is exalted by the aristocracy, and is evermore lost to the mass from which he is taken.[54]

A select number of English portrait painters at the end of the eighteenth century did enjoy a privileged form of patronage that came near to assimilating them into the upper echelons of society. They also often adopted a life-style and aspirations modelled on those of the aristocracy. Thus, for example, Reynolds's household was organized on the model of an aristocratic establishment with a hierarchy of pupils and assistants who possessed none of the rights of apprentices and were dependent on the same uncertain and unpredictable mode of patronage as was Reynolds himself.[55]

The prospect of moving upwards within the social hierarchy was undoubtedly attractive, but that very social mobility posed enormous problems for artists from poor provincial backgrounds and, especially, for colonial subjects unfamiliar with European patterns of class and culture. As Amelia Opie, widow of John Opie, bitterly observed:

> Certain it is that the republic of letters and of arts has an aristocratic bias; and many of its members are of such sybaritic habits, such fastidious delicacy, and have such a decided preference for the rich, the polished, and the high born members of its body, that a man of plain, simple, and unobtrusive manners, depending only on his character and his genius for respect, is not likely to be much the object of their notice.[56]

Amelia Opie speaks as a convert to Quakerism but she had, none the less, good reason to know the trials of a portrait painter in London from direct experience of her husband's professional life.

What she does not mention are the additional problems encountered by women portrait painters. It would seem reasonable to suppose that a female portrait painter might have attracted a particular female clientèle, as this would have solved the inherent moral dilemma faced by a woman having to pose to an artist of the oposite sex. Whether artists like Maria Cosway (who has been perhaps too closely associated with the work of her older husband, Richard) depicted a higher proportion of female than male sitters has never been ascertained, although Angelica Kauffmann did more business with female than with male clients. The *Artist's Repository* took up the question in 1788: it argued that women educated as artists could maintain themselves, printing a list of women artists and reproducing the self-portrait of Mrs Grace, a London portrait painter, as proof.[57] Reconstituting the *oeuvre* of eighteenth-century women portrait painters is a task still waiting to be completed; such evidence as is available in other areas suggests that many portraits by women artists are likely to have been falsely attributed to their male colleagues.

The centre of London artistic life in this period was the Royal Academy. The annual exhibition of that institution was dominated by portraits, for all that its president, Sir Joshua Reynolds, insisted in his Discourses on the supremacy of history painting in the hierarchy of the genres. Portraits constituted the largest percentage of works submitted to the Royal Academy between 1781 and 1785, with landscapes not far behind (fig. 2 and pl. 57). In 1783 portraits made up 44.67 per cent of the exhibits at the Academy. If miniatures are taken into account this figure is even higher. History painting, the most elevated and desirable of the genres, as taught by Sir Joshua in England and by Diderot in France, made up only the smallest percentage of works exhibited. It is interesting to observe that whilst the number of

Fig. 2. Royal Academy exhibits: annual percentage by genre (sculpture and miniatures excluded).

	1781	1782	1783	1784	1785
Portraiture	34.70	39.93	44.67	49.36	39.07
History painting, battle pictures and literary subjects	15	9.90	16.49	15.92	15.03
Genre, still-life, animal subjects	15.29	20.79	15.80	10.50	15.03
Landscape	35	29.37	23.02	24.20	30.86

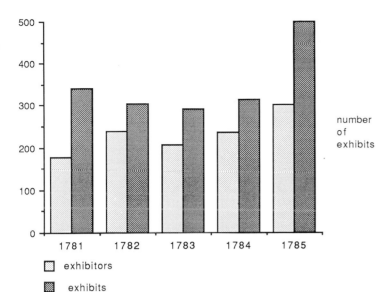

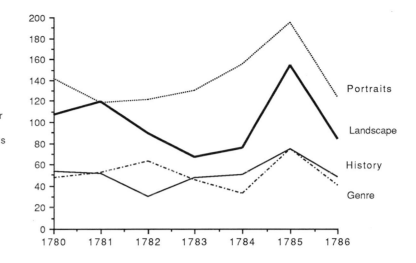

exhibitors
exhibits

Fig. 3. (above left).
Numbers of exhibitors and
total number of exhibits at
the Royal Academy 1781–5.

Fig. 4. (above right). Royal
Academy exhibits, by genre
(miniatures and architectural
projects excluded), 1780–6.

exhibitors and the total number of exhibits fell in 1783 (fig. 3), the number of portraits exhibited continued to rise in a spectacular way. Of all the genres, only portraiture lost no ground at all during the period 1781–5 (fig. 4).

The situation was similar in the French capital where in 1769 a Salon critic complained that, thanks to the century's poor taste, the Salon would be no more than a portrait gallery.[58] Reynolds and Gainsborough featured most prominently in the Royal Academy exhibition of 1783 showing ten and twenty-five portraits respectively. Gainsborough's fifteen royal portraits (ranging from studies of the king and queen through all their children right down to the infant Prince Alfred) were described by Peter Pindar as 'a nest of Royal Heads'.[59] After Reynolds, the greatest number of works exhibited was by Philip James de Loutherbourg who showed eight works.

What, however, is equally important for an examination of the social organization of portraiture as a business is the appearance alongside these star performers of a host of less distinguished and now forgotten painters, artists like 'An American young Lady, H' who exhibited two works in 1783.[60] These exhibitors represented, moreover, only the tip of the iceberg of London's portrait-painting population which included profile-takers and miniaturists (pl. 56). Peter Pindar described the phenomenon in his 'Odes to the Heads': 'The Bard addresseth, in plaintive ditty, the Heads of the Lord knows who, painted by the Lord knows whom, and executed the Lord knows how.'[61]

The provincial artist arriving in London in the last two decades of the eighteenth century faced massive competition. James Northcote, who had been an assistant to Reynolds and who was himself heavily dependent on an income from portraiture, referred to Sir Joshua's view that 'the population of London was

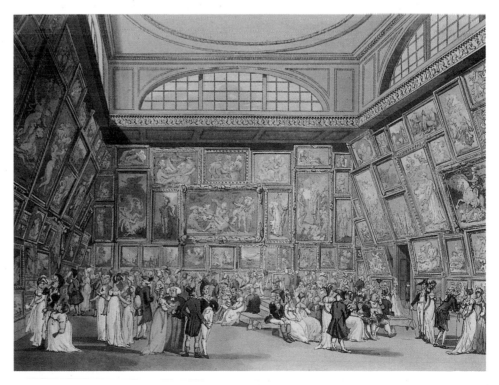

39

58. George Romney, *Self-portrait*, oil on canvas, 125.7 × 99.1 cm., 1782. National Portrait Gallery, London.

It is hard to imagine how Romney found time even to begin a self-portrait at this stage in his life – the fact that it is unfinished allows us to see something of how the artist worked directly onto the canvas, completing the face and upper part of the body and leaving detail and background until later.

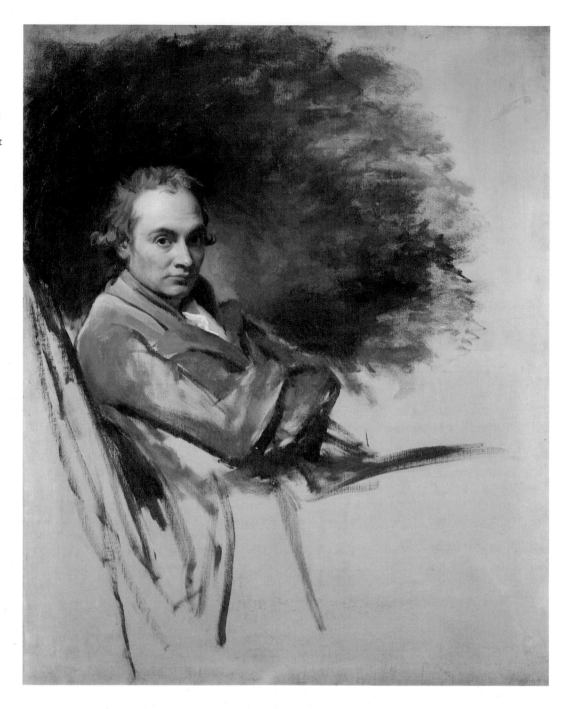

no more than just sufficient to afford a reputable maintenance for eight painters only, and this number to include all the branches of the art', and asked, 'What would he now say when more than eight hundred come forward and claim a maintenance and their number is every day increasing?'[62] There is no way of knowing how many of Northcote's estimated 800 were portrait painters and any assessment in this period prior to the establishment of the census is difficult. A rough calculation based on Samuel Redgrave's entries in *A Dictionary of Artists of the English School* (which is itself mainly confined to exhibiting artists) suggests that there was a minimum of 111 portrait painters active in the capital in the 1780s.[63]

Artists and craftsmen lived in close geographical clusters within certain districts (fig. 5). It was normally part of the portrait painter's responsibility to make arrangements for framing and for any additional copies or versions in miniature and to order transportation. 'I shall certainly be much obliged to you if you will give yourself the trouble to order my portrait to be framed handsomely with all convenient speed', wrote one of Romney's clients in 1779.[64]

Thus Thomas Saunders who began making frames for Romney in 1782 lived and worked at no. 10 Great Castle Street, Cavendish Square, whilst Romney (pl. 58) was living, along with fifteen other exhibitors at the Royal Academy, in Cavendish Square itself.[65] Soho was a popular area for artists and related craftsmen in the eighteenth century though by 1783 Newman Street, Leicester Fields and Oxford Street were more favoured. Gerard Street, Soho, had been the location for the headquarters of the Incorporated Society of Artists which met at the Turk's Head tavern, and James Newman, the colourman, had his shop in Gerard Street until 1801 when he moved to Soho Square.[66]

The successful portrait painter was thus at the centre of a flourishing industry, backed by a series of other crafts and businesses, and he employed the Royal Academy as his chief publicity agent. Publicity was of great importance: the product of his studio was judged more by the recognized quality and status of the subject than by the inherent success of the painting as a work of art. Thus the struggling Gilbert Stuart was assisted in his career by a commission to paint two eminent men from the Quaker medical fraternity, Dr Lettsome and Mr Curtis.[67] The same situation prevailed in the rest of Europe and particularly in Paris where a Salon critic complained in 1775 that if an artist had painted a beer sign featuring a group of renowned people it would immediately have taken pride of place in the exhibition.[68]

Between the artist and the Academy lay a gulf that had to be bridged by personal contact, nepotism, patronage and determination. The studio practice itself was serviced by assistants, pupils, colour merchants and drapery painters. In turn the practice gave employment to carpenters and frame-makers, engravers and carriers, wax-modellers and miniature painters. Romney's account book contains detailed specifications for frames 'Carved and Guilt in Burnish Gold' and packing cases 'dovetail'd grov'd & Tongued' (pl. 59). Gainsborough established a special working relationship with Walter Wiltshire the Bath carrier who operated between the White Swan at Holborn Bridge and Broad Street, Bath, and who was the purchaser of many of the artist's paintings.[69] In the course of preparing for delivery of a specially valuable commission several people would be involved. A memorandum in Romney's sitters' book for 30 July 1787 records how his picture of the Duke and Duchess of Marlborough was sent to Blenheim from the Swan, Holborne Bridge, with a frame and packing case by Saunders and taken care of for the journey by Stephens.[70] Establishing the necessary contacts for the conduct of this kind of business could not have been an easy matter for the outsider.

Engravers worked in a particularly close and inter-dependent partnership with portrait painters. They enjoyed little recognition from the Academy where they were not accorded full membership rights until 1855. But when Reynolds needed to see Bartolozzi, he went to call on the engraver rather than sending for him.[71] He also kept a list of engravers' names and addresses in his sitters' book. Romney's sitters' book reveals a constant flow of pictures to and from leading London engravers: 18 July 1787, 'The picture of Mrs. Crouch was sent to Mr. Heath Engravers Leicester Street, Leicester Fields'; 26 July, 'The picture of the woman and child came home from Mr. Boydal [sic].'[72] This production line also included copyists (though many copies were executed in the studio by the artist or his or her assistants) and artists specializing in miniatures. All these people had their own establishments, and the studio assistants were employed to carry paintings back and forth and to run errands. On 22 January 1796 Richard Williams, one of Romney's assistants, himself recorded in the sitters' book that he had taken the Marquess of Townshend's dress home. On 3 February he delivered Colonel Bristol's 'cloths sword & gorget' to their owner, and on 17 March he performed a similar service for the Bishop of Bangor.[73] These items would all have been retained in the studio for painting in the drapery and finishing the details after the formal sittings had terminated.

The portrait painter's clients normally undertook to sit in the painter's studio. They usually brought with them their friends and relatives, a habit that could turn an artist's studio into a sociable meeting place (pl. 60). Indeed, portrait painting in the eighteenth century, once we look at the processes rather than simply at the products, turns out to have been more a performance art than the deeply psychological dialogue that it is often presented as.

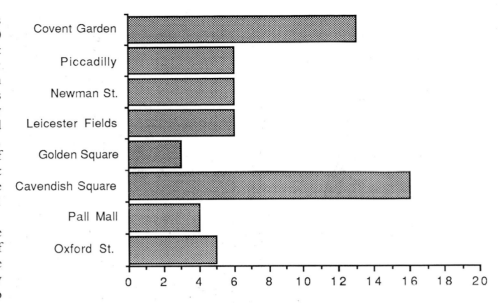

Fig. 5. Distribution of artists' residences in 1783 (as listed in the Royal Academy catalogues).

```
July 4 784
                    Mr. Shadwell
        His Portrait 39 gns.                    21    0
        Received the whole at two different times

July 14         Mr. Barnard
1784            His Portrait (3/4)
Frame           A Fraim from Saunders          3    10
Maker's         a packing Case                      6    9
account         Packing the above Pictures          1

Dec 18          Receiv'd for the Pictures      ------------
<blot>4         and Frame &c                   3    17    9
                                               ------------
July 14         Miss Clive
1784            Her Portrait (1/2)             42

Fraim           a Fraim from Wm Saunders, Carved
Makers          and Guilt in Burnish Gold
Account         Measm. 18ft of 6              5    8
                a Packing Case for the above Picture
                dovetail'd grov'd & tongued Meas.
                5 feet at 3                         14
                Packing the above Picture           1
        Receiv'd this Account in full         ------------
                                               6    3
                                              ------------
                                               42
                                              ------------
                                               48    3
```

59. Page from George Romney's account book, July 1784, MS. National Art Library, London (and transcript).

The left-hand column gives the date of the commission; the middle column announces the object to be produced and its dimensions (1/2 or 3/4) and lists additional items like frame and packing case which the artist was responsible for procuring; the right-hand column itemizes the cost of the painting and the additional items.

Farington's diary entry for 15 March 1794 reads: 'Went to Dance. Lady Susan Bathurst was sitting for a profile – Lady Triphina Bathhurst & Lady Beaumont and Lysons were also there.'[74] Reynolds provided a portfolio in his painting-room containing every print that had been taken from his portraits so that those who came to sit (as well as their relatives and companions) could look through the collection,

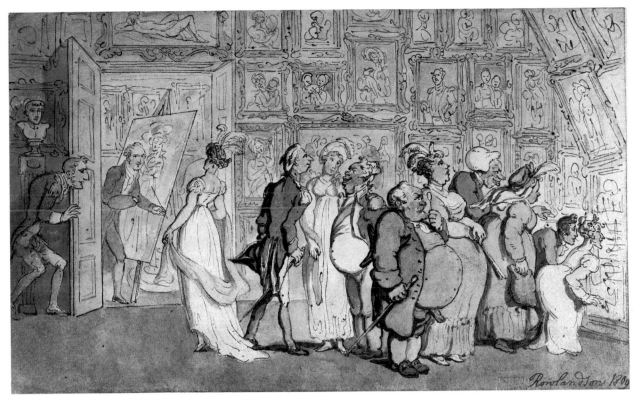

60. Thomas Rowlandson, *A Private View*, pen and watercolour, 12.4 × 20.1 cm., *c*.1802. Ashmolean Museum, Oxford.

Rowlandson executed several versions of this subject (Aukland City Art Gallery, New Zealand, and Sotheby's, 1 April 1976 (85)) in which the social and political relationship of interdependency between portrait painter and a collective clientele is played out.

and if they found any attitude they particularly favoured he would repeat it in their portrait.[75] The system worked rather like one of today's hairdressing salons where the clients might thumb through an album and select a style to be replicated on themselves. As portrait painting was not only sociable but also overtly narcissistic it is scarcely surprising that the performance also not infrequently included suggestions of licentiousness (pl. 61). Portrait painters seeking respectable clientele must have had to work hard to preserve the reputations of their studios. Rowlandson and other graphic artists exploited the idea of the portrait painter's studio as a site of grotesque flattery (pl. 62).[76]

61. Thomas Rowlandson, *The Mutual Attempt to Catch a Likeness*, pen and brown ink and watercolour, 23.8 × 23 cm., *c*.1790. Whereabouts unknown; courtesy of Christie's (15 November 1988 (97)).

The idea of likeness upon which portraiture is predicated is here explored as a fat elderly lawyer fixes his gaze on the captivating features of a young woman who, for her part, attempts to capture with her watercolours the likeness of a classical bust situated above her head.

62 (left). *The Portrait Painter's Studio*, from *The New Bath Guide* by Christopher Anstey, 1807 edition. By permission of the British Library, London.

This gently satirical comment upon polite Bath society accompanied the following verses: 'Or to Painter's we repair,/Meet Sir Peregrine Hatchet there,/Pleas'd the Artist's skill to trace,/In his dear Miss Gorgon's face.'

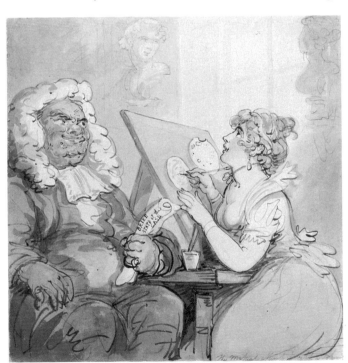

built a 'whimsical structure' chiefly of wood containing a gallery and modest domestic accommodation. The advertisement that appeared when this establishment was sold in 1801 gives an interesting insight into what Romney had regarded as necessary for the practice of his art. Christie advertised for sale:

> A Dwelling House, three stall stable and convenient offices . . . in the occupation of George Romney Esq., erected under his direction, with a suite of large apartments, comprising a painting room with perfect light, and a capacious show room well fitted for the artist; and several small neat convenient apartments from two of which balconies are thrown, which give command of extensive, rich and picturesque prospects.[79]

Romney paid £700 for the original house and garden and spent about £3,000 building his whimsical structure. It was sold with all its appurtenances for only £357.[80]

One of Gilbert Stuart's most pressing problems when he arrived in London was to establish himself in a suitable location. His friend, Dr Waterhouse, found the artist lodgings in an area occupied by Quakers. 'This was the best I could do for my friend', remarks Waterhouse, 'but it was not the most favoured location for a professor of one of the *fine* arts, seeing the Quakers are distinguished more for their attachment to the *plain* arts.'[81] Romney, arriving in London in 1775 after a tour of France and Italy, regarded it as essential that he should set himself up in a large house in the West End. He therefore declined the offer of a tower in Warwick Castle where he would have had 'choice of light, a most delightful workshop, bed-room, study, books and closets for your tools, with all peace and content that solitude and serenity can give you' while he painted companions to 'the very respectable portraits chiefly by Vandyke [*sic*] collected by the Earl'.[82]

Even if he were able find accommodation in the West End, the portrait painter still had to find the means to pay the rent. In 1793 Thomas Lawrence (who was already an Associate of the Royal Academy and enjoying royal patronage) was paying £200 guineas per annum for his lodgings in Bond Street and £300 per annum to his father for the support of his family. But he was able to command high prices: 40 guineas for a three-quarter-length, 80 guineas for a half-length and 160 guineas for a whole-length.[83] Gainsborough paid £150 per annum for one wing of Schomberg House, Pall Mall, after his move to London in 1774 but in 1783 the rent was reduced to £112 and remained at that until 1792 when the artist's widow gave up possession.[84] At the other end of the scale Northcote, a struggling portrait and 'subject' painter, living at 39 Argyle Street, recorded his

In order to create the conditions necessary for patronage it was imperative that the artist find a good studio. Gainsborough's friend, Philip Thicknesse, who helped him look for lodgings in Bath in 1759, specified light and proper access as the main criteria. We are told that Gainsborough was paying £50 per annum in rent at this time.[77] Portraits were priced according to dimensions (pl. 63), and within five years he was able to ask £21 for a three-quarter-length portrait and proportionately more for whole-lengths, so he probably did not have any real difficulty in covering costs. Prices in London were, however, generally higher, and the difficulties of getting suitable accommodation within the fashionable area of the West End were acute. In 1761 Reynolds moved to a house on the west side of Leicester Fields 'to which he added a splendid gallery for the exhibition of his paintings and a commodious and elegant room for his sitters'. He allegedly sunk his entire capital into this development and added a handsome carriage.[78] Romney, on the other hand, was persuaded by his son to move out to Hampstead in 1796. This move may well have contributed to the severe financial difficulties he experienced towards the end of his life. He let the house and garden and

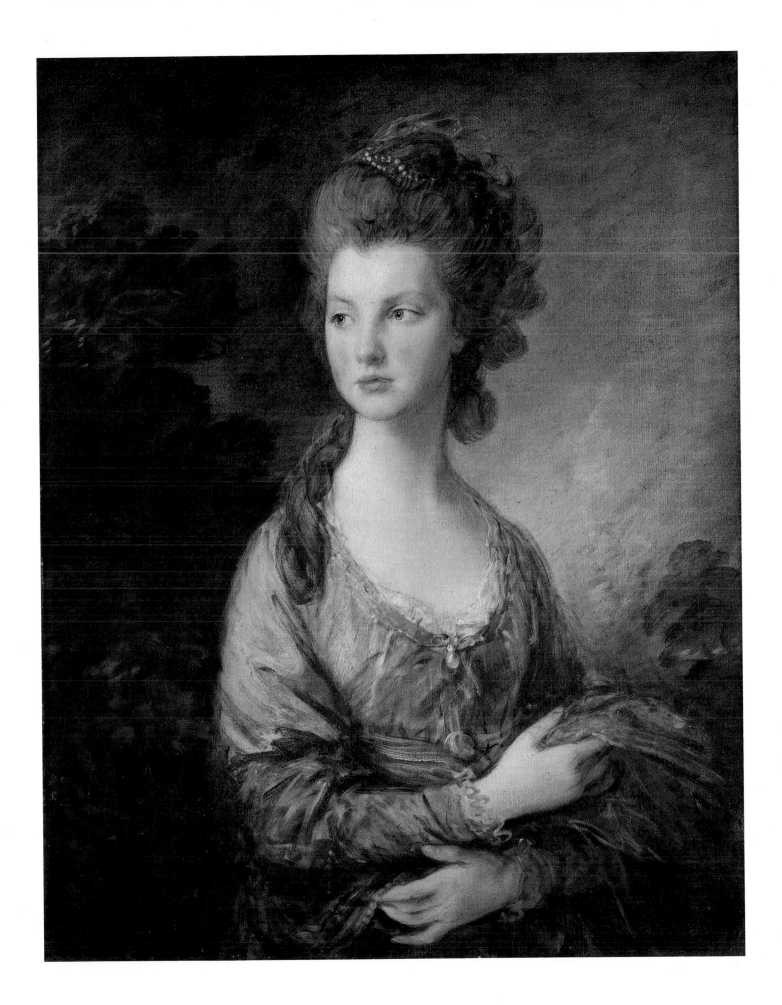

It is seldom possible to deduce from an image the precise circumstances of its production, but this drawing possesses a particularity and a precise but economic manner of execution that suggest a portrait sketch, perhaps of a subject attentive to music or some other performance. The profile format is not usually found in a finished portrait painting.

expenses for 1789–90 which totalled £71 10s. 1d. His largest outlay apart from taxes was for colours.[85]

The precise role of pupils and assistants in the studio is difficult to ascertain. Northcote tells us that in 1763 Reynolds's practice was so great that he employed four pupils to assist him.[86] Theoretically a pupil should have been able to learn all aspects of his master's profession, but Northcote, who certainly assisted Reynolds, insisted that all the master's own preparations of colour 'were most carefully concealed from my sight and knowledge, and perpetually locked secure in his drawers; thus never to be seen or known by anyone but himself'.[87] In a letter written home shortly after he arrived at Reynolds's house Northcote says: 'The first day I went there to paint I saw one of Sir Joshua's pupils, and on conversing with him was much surprised to find that his scholars were absolute strangers to Sir Joshua's manner of working, and that he made use of colours and varnishes that they knew nothing of, and always painted in a room distant from him; that they never saw him unless he wanted to paint a hand or a piece of drapery from them, and then they were always dismissed as soon as he had done with them.'[88] Northcote may have exaggerated out of resentment caused by his own relative lack of success, but there is nevertheless no contrary evidence to suggest that his view of the pupil/assistant (the terms were interchangeable) as merely a hard-working menial who was used for modelling hands and drapery, was in any way false. Only in West's studio is there any indication that a more liberal regime was in place.[89]

It is from the surviving remnants of Romney's studio accounts and from his sitters' books that the clearest picture of the working life of the studio assistant emerges.[90] John Watson and Richard Williams were expected to write up the master's appointments and memoranda in his sitters' book, run errands and take innumerable messages from frequently irascible clients in their master's absence:

> Sir John Poole called and desired that his Pictures may be finished as soon as Mr. Romney returned & that the Whip must be altered and made with a Thong to it. & he must have spurs on and that his clothes must go home with the Pictures.[91]

The studio accounts for spring 1797 were written up in a day book by Richard Williams. Each double page opening is divided into four columns headed: 'Richard's accounts', 'Kitching [*sic*] accounts', 'Common ocurrences' and 'Bills paid & received & memoranda'. One odd page dated 9 January 1797 is written partly in Williams's hand and partly in that of his fellow assistant, John Watson. From this we learn that Watson received £2 per quarter in wages and that Romney owed Griffiths (presumably the colour merchant of that name) the considerable sum of £132

7s. 5d.[92] The assistants' wages were low. Board and lodging were also provided, although the £1 12s. 1½d. spent on the kitchen between 25 March and 1 April does not suggest very lavish provision.[93] Richard Williams was a tidy bookkeeper, spending little on himself apart from the small amounts necessary for the purchase of newspapers at 6d. a time and ale and porter. Not infrequently he records lending his master sums ranging from 3d. to £1 12s. 1½d.

Assistants and pupils were in all likelihood particularly engaged with the copies that formed an important part of studio business. Modern-day criteria of originality and individuality need to be set aside in this discussion, for portraiture was the one genre in which copies increased rather than diminished the standing of the original. The portrait was a utilitarian object and was certainly regarded as such by most artists practising portraiture in this period. The virtuoso performance of a Reynolds or a Gainsborough launched by a sensational display at a Royal Academy exhibition was the exception rather than the rule. The Royal Academy catalogues make it a relatively simple matter for art historians to establish a chronology for the work of an exhibition artist and to discuss the artist's reputation at any given time. But this gives undue weight to Royal Academy exhibits and fails to take into account the importance of copies. The multiplicity of residences used by royalty and by aristocratic families necessitated the replication of the families' leading members. With this in mind the French artist Jean-Marc Nattier

drew up a detailed list of all the royal portraits that he expected to be asked to repeat.[94] The situation was comparable in England. A portrait commission from a distinguished or high born patron obliged the artist to adopt the sort of pictorial conventions of pose, lighting and dress that could easily be repeated in oil or engraved form. A commission, whilst constraining, also ensured publicity. In 1776 Romney was anxious whether or not he could please his clients, but his success with the Duke of Richmond was such that many of the duke's friends ordered copies and the artist's reputation was ensured.[95] Ten years later with a successful practice he evidently did not hesitate to continue to accept commissions for copies.[96]

Relatively few drawings for grand society portraits of this period survive; this may be due to the fact that they were passed to engravers. They may, however, never have existed, artists working directly onto canvas from an outline. Portrait drawings may then be the result of a social exchange or the desire to depict a friend unawares (pl. 65).

Individual artists established a studio environment according to the requirements of their particular style. Daniel Gardner established a female clientele for elegant small-scale works in pastel and gouache which must have been executed at high speed and admired for their ephemeral qualities (pl. 66). It is well known that Gainsborough 'painted standing, and used brushes with handles six feet long'[97] and that he liked to paint his sitters by candlelight. The relation between style and the depiction of character

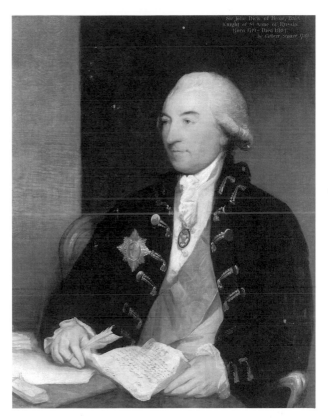

is complex but, whilst acknowledging the mystery of characterization in a Gainsborough portrait, we should be aware that the conditions in which the artist worked, his preoccuations and practical anxieties were often no more directed towards character and personality than towards satisfying the more prosaic demands of the genre. Reynolds's sitters' books contain no notes of an aesthetic nature and nothing to indicate that he was curious about psychology or, indeed, facial appearance and character. What they do contain are notes on details of costume: 'button holes embroidered'; 'little powder . . .';[98] 'The picture of the late Lord R. Manners. The Naval Uniform must have white cuffs & blue lapels.'[99] The only references to faces are the odd recorded measurement: 'nose to eye 4'; '8 from eye to ear'.[100]

Gilbert Stuart told Matthew Jouett of the importance in painting great public figures of physically elevating them (pl. 67),[101] and we know that Reynolds had a chair installed in his octagonal painting-room that was raised on some kind of dais eighteen inches from the floor and turned round on castors.[102] While the need to elevate the sitter necessitated ingenious seating arrangements, fastidious attention was paid also to the question of clothing. Lawrence's studio on his death in 1830 was littered with the personal effects of his sitters,[103] and Hoppner's studio sale in 1823 gives a vivid picture of the established studio machinery within which

the sitter would be accommodated according to character but even more according to status, format and price. As well as easels, paints, brushes, chalks etc., Hoppner's studio contained at the time of his death sundry items like terracotta heads, a guitar in a case, a violin, bow and case and 'an arm chair of elegant shape, the frame of mahogany, handsomely carved, the seat of leather'. So that he could work on his clients' portraits in their absence Hoppner also owned 'a circular platform for a lay figure, covered with green baize, on castors, and with a skreen [sic]'.[104] Northcote owned, at the time of his death, pieces of armour, two swords, a lay figure and circular stand, 'a quantity of plaister casts, hands, arms &c.' and approximately 1,560 prints, most of them after portraits.[105]

Business acumen and expertise in social matters were prerequisites for the successful portrait painter who often had as many as eight or ten paintings in production at the same time. Romney's sitters' book reveals that paintings were entering and leaving the studio daily, while other pictures were being stored for customers. There were constant demands: 'the loan of a picture for my daughters to draw from'; 'To go to bring Mr Thos. Raiter's Picture to have some grease taken out of it'; pictures to be varnished; visitors to be entertained ('Lady Spencer and Mrs How called to see the paintings'). There were alterations to be made to paintings already executed and delivered, and there were detailed instructions for packing and delivery to be followed: 'Mr. Fitch's Picture to be put in a proper case & packed to go to Jamaica the lid to be slightly screwed on – and sent to Mess. Maitland Coleman St.'[106] Above all there were deadlines to be met. Memoranda appear in the sitters' book instructing that paintings are 'to be finished directly' or 'to be finished as soon as possible'. In 1790 between 17 June and 22 July nine pictures were completed in Romney's studio. The length of time between the first sitting and delivery of the finished product was five to six months. For instance, Lord Westmorland began sitting on 10 February 1795, and his portrait, which cost £147, was sent to Ireland on 18 July. Mr and Mrs Egerton began sitting on 21 April 1795 for two Kit-cat-sized pictures which were delivered on 15 October.[107] From 1776, on average Romney took three sitters a day starting at 9 a.m. In later years he occasionally took four. Sometimes an entry reads 'a dog' or 'a sheep', in which case the human presence was not probably required.[108]

Reynolds's prominence in the world of portraiture arguably owed almost as much to his ability to organize his business as to innate artistic talent. From 1755 to 1790 he kept his appointments and memoranda with absolute regularity in a purpose-designed and manufactured Gentleman and Tradesman's Daily Pocket Journal.[109] These volumes helped him to maintain with dignity and efficiency his uneasy position between business transaction and class protocol. The books have a double-page entry for each week with appointments and occasional memoranda down the left-hand side and the week's account on the right. Reynolds seldom used the right-hand page; his accounts he kept very privately in separate ledgers.[110] The left side of the page was full of names of sitters and the times of their appointments, with frequent deletions and amendments which, if they were made at the behest of the sitter, as we may guess, must have made the organization of the working day very difficult. Appointments were at 8 a.m., 10 and 12, or 10 a.m., 12 and 2, and Reynolds worked right through the week including Saturday, taking some sitters even on Sunday. The extensive information provided at the front of the Gentleman and Tradesman's Daily Pocket Journal would have helped Reynolds in matters of finance and etiquette, as employer and employee, since it contained times of dividends and transfer days at the Bank, India and South Sea Houses, foreign exchange rates, a conversion table showing what any salary from £40,000 per annum to £1 per annum came to for a day's work and, most usefully for the portrait painter, an alphabetical list of the members the House of Lords with their town residences and the titles of the eldest sons of the dukes, marquesses and earls, as well as a list of current members of parliament.

Lomazzo, writing of portraiture in his treatise of 1584, had declared that 'The gestures of Honour are to give, and to receive, to sit or to stand in some principal or eminent place for the purpose: as a throne, chair of State, pulpit, &c. where hee may bee admired.'[111] For the London portrait painter of the 1780s the deft handling of a client, in actuality in the studio, and in paint on a canvas, inevitably necessitated flattery. Jonathan Richardson sourly declared in 1715 that 'If a devil were to have his portrait painted, he must be drawn as abstracted from his own evil and stupidly good.'[112] An unwanted commission from a prestigious but unattractive client could, therefore, compromise the artist. Farington recorded on 11 October 1793 that 'the Prince of Wales has desired Dance to paint his portrait which has much embarrassed the latter who was very unwilling to do it'.[113] When Reynolds (who was quite deaf) was confronted with the ancient and complaining Duchess of Bedford insisting that the portrait Reynolds had painted of her daughter was not a true likeness, the artist 'bowed, and, pretending not to hear her distinctly, answered that he was very happy that the picture met with her Grace's approbation'. In the end the duchess left in despair of making herself understood.[114]

Gainsborough, who enjoyed a degree of autonomy

unusual for the period, employed his wit and sharp intelligence in impressive displays of polite but unyielding verbal skirmish. In 1765 he received a firm letter from the Duke of Bedford's agent expressing surprise that the artist had not yet delivered the pictures painted for the duke and duchess and giving him very precise instructions:

Her Grace now directs me to acquaint you that She desires you will immediately send her Picture & that of Lady Mary Fitzpatrick's, & that they need not wait for His Grace's Picture if you have not yet finished the Copies you were to make of it, but if they are done that the original can be spared you will please to send it with the two before-mentioned. Her Grace orders me to add that if it is agreeable to you to come to London & will keep your usual prices she will be answerable for its paying the expence of the journey.[115]

In his reply Gainsborough manages, short of actual insolence, to snub his correspondent and convey a daring degree of disdain for his patrons:

I received the favour of your letter yesterday, and beg you will be so good to let their Graces know that my not sending the Pictures sooner has been owing to some difficulty of pleasing myself in the two Copies of His Grace; but they shall be finished and sent next week without fail to Bedford House. I should be much obliged if you would also acquaint the Duchess that 'tho my Ill health forbids my following Business in London (to which I have frequent invitations) Her Grace may nevertheless command me at any time to paint *any of the Family* there.[116]

Few artists possessed Gainsborough's rash confidence or his verbal dexterity, and many were driven to despair by the treatment they received. Inside the back cover of Northcote's sitters' book is scrawled an anguished and bitter condemnation of the world in which the portrait painter had to function. It provides some indication of the price that was paid by artists who failed to exploit the possibilities for social mobility and presents an arid picture of the disenchanted Northcote alienated from one class and despised by the other:

The neglect of the Art of painting is such in this country that the poor Artists may by long labour and application in giving up their health and lives in Learning a language the which when accomplished they will not find an Auditor [sic]. I cannot with patience see those wretches dancing at a ball on the spoils of a nation who ought to dance from a Gibet in a North East wind or see those carcasses drest out in finery that ought to be droping bone after bone from chains.[117]

The neglect of native art by wealthy English patrons was the subject of bitter invective on the part of Jonathan Richardson and William Hogarth at least a generation before Northcote was writing. By the 1770s English noblemen were no less inclined to buy abroad. Sir John Stanley's household account book for 1772 records purchases from Mr Christie's, Pall Mall, but the founder of the famous auction house then dealt only in household equipment: blankets, tea-boards, beds, pier-glasses, sedan chairs and other similar items. Wishing to furnish his house with works of art, Sir John preferred to pay the all-inclusive price of £129 12s. for a package of goods imported from Italy via Leghorn through the dealer Seguier. The package comprised 200 sculptures, four copies from the Gallery Carach (Carracci), copies of Guercino's Sybil and of his Magdalen (24.60 and 20.50 lire respectively), two portraits 'in taglio' of Sir J. Stanley, a small picture by Sterne and four shell cameos. All this cost less than the price of one full-length portrait by Sir Joshua Reynolds.[118]

With the outbreak of war with France the position of English artists worsened. Romney wrote to his brother John on 17 March 1794:

The situation of affairs will render it necessary for me to alter my place of living. I mean to turn the servants broadways and . . . cut off every expence I can, or else I cannot live, without waisting the little property I have got. No body pays! and when this dreadful war will end, God only knows! not I suppose in my time – if it does cease it will only be for an interval – Tell Mr Holmes that I am in great want of Cash, nobody pay [sic], and I cannot sell out of the stocks, without great loss, therefore I should be very glad if he would take up the Note with my Complements. Hence it is my view to wrap myself in retirement and peruse these plans, as I began to feel I cannot bear trouble of any kind.[119]

The fortunes of the painter could become inextricably bound up with the fortunes of the portrait he had painted. This meant the uncertainties that were an inevitable price of a political career also might afflict the artist who painted political celebrities. Whilst the portraitist could profit from the celebrity of his sitter, he could conversely also fall from favour along with his subject unless his position was remarkably secure. Reynolds was able to weather any storm, but a lesser man might well have suffered an eclipse as a result of the duc d'Orleans's disgrace. Reynolds's portrait of the duc, which had been greatly admired (and compared with the duc himself when he attended an Academy dinner and sat directly beneath it), was painted for the Prince of Wales. It hung in Carlton House until 'the detestable conduct of the Duke in what related to the

late King of France, caused the Prince to have it taken down', and it was then placed 'in some private appartment in Carlton House'.[120] Romney had less cause for confidence. During the anti-Catholic Gordon riots in 1780 he was panic-stricken: he searched through his canvases for any that might bear a Roman Catholic interpretation 'and hurried it away into hiding lest the Protestants should burn down the house'.[121]

Even if he attracted clients in sufficient number, the portrait painter could not rely on payment. In Reynolds's house there was a small room next to his painting-room 'where there were a great number of portraits which had been rejected and were left upon his hands'.[122] Others were simply never paid for.[123] Royalty was one of the worst offenders as the young Opie found out when, having shown the king a picture in a superbly wrought frame which had cost Opie eleven guineas, the king asked the artist to fix a price. Opie said he would leave the terms to the king and received in return via West (who assured him the king was highly satisfied with the bargain) a paper containing nine and a half guineas and sixpence.[124] A large proportion of the portraits entered in Romney's sitters' books were never finished or never reached their destinations. His studio sale contained thirty-four portraits and an additional three specified as unfinished.[125] Farington acted as intermediary in a long and acrimonious debate between Lawrence and Reynolds's heirs, Lord and Lady Inchiquin, between April and October 1794 about payment for finishing some pictures left by Reynolds at his death,[126] whilst Northcote's studio sale contained no less than sixty-five finished and five unfinished portraits.[127]

In view of the financial uncertainty that was a feature of portrait painting, it is not suprising that a system of half payment at first sitting evolved. Gilbert Stuart alleged that he had adopted this practice on the advice of Lord St Vincent, the Duke of Northumberland and Colonel Barre,[128] and Northcote's sitters' book reveals that in the 1780s he also was paid in advance at the first sitting. Portrait prices were standardized according to dimensions and format, and artists, very conscious of the market, rarely increased prices, and then only relative to demand and the comparative cost elsewhere. Reynolds's price for a three-quarter-length portrait was 20 guineas in 1759 and rose to 35 in 1764 and to 50 in 1766. Romney began by asking 15 guineas in 1775 and raised his price to 18 in 1776 and 20 in 1781. Competition came from provincial centres (though artists as distinguished as Gainsborough and Joseph Wright of Derby were rare) and from abroad. In the 1760s Pompeo Batoni, the Roman portrait painter favoured by Grand Tourists, received £25 for a full-length. Joseph Wright was charging £52 10s., and Gainsborough, in Bath, 60 guineas for work of the

same dimensions, while Allan Ramsay in Edinburgh was charging £84, and Reynolds in London, £150.[129] This was a period when Wright could buy half a year's schooling and board for his son for £5 14s. 6d., and Sir John Stanley heated his house between March and July for £14 4s. 11½d.[130] The American artist John Singleton Copley estimated that his income of three hundred guineas a year in America in the 1760s was equal to nine hundred in London.[131] In the 1780s when Reynolds, then in his sixties, was charging £200 for a full-length portrait, Batoni was charging only £50. Northcote at the lower end of the scale raised his prices in 1784 and was still paid only sixteen guineas for a portrait containing two figures, though he received substantial rewards for some of his subject paintings.[132] Lower still down the scale were the dozens of portrait painters who advertised their professional skills at £3 a time with sittings lasting no longer than five minutes for a profile on glass.

Portrait painters do not seem to have entered into formal contracts, so that in the event of a dispute the sitters' book was essential evidence. But even if records were correct, the artist had no legal means of extracting payment from a defaulting client. The determination of aristocrats with gigantic incomes to strike a hard bargain is a feature of the world in which portrait painters operated. When the Marquess of Townshend disputed the price agreed with Romney for portraits of himself and his wife, the artist's son wrote in deferential tones on his father's behalf, invoking the evidence of the sitters' book:

With respect to the price, I have no doubt that your Lordship is right; I however was regulated by the Book w^ch records the time when every picture was begun to be painted & according to that the prices, when her Ladyship's portrait was begun, were the same as stated in my letter to you. But as I know that my father entertains the highest Respect for your Lordship, & as I have frequently heard him express his obligation to you for your kindness & condecension, I am perfectly satisfied that it must be as you present.[133]

Except in the higher reaches of society portraiture, it was undoubtedly far easier and far more secure to earn a living doing sub-contracted work from a portrait painter's studio. Restorers, gilders, frame-makers and copyists earned a steady income and were sometimes paid, proportionately, far more generously than the artist himself. In 1800 Northcote was paid £10 for altering a portrait by Copley and 'painting the drapery anew by order of Mr. Pybus'.[134] When Gainsborough painted Garrick in 1769 for Stratford-upon-Avon Corporation he was paid £63, but an additional £74 4s. went on 'a Carlo Maratti

frame . . . ornament to ditto, burnished gold, lining for picture . . . large case, unloading . . .'.[135]

To the families who commissioned them, portraits were often an item of necessary expenditure. Whilst many clearly thought carefully about choice of artist and location for the portrait in their houses, for others they were not regarded as objects of high value either monetary or aesthetic. Sir John Stanley, as we have seen, spent £129 12s. on imported sculpture and copies of unspecified origins. At the same time he spent £29 8s. on one pier-glass, £42 on a pair of bay geldings and paid his coachman, Joseph Willis, £20 7s. 4d. per annum in wages.[136] The Bedford family spent more in a month on payments to upholsterers and furniture-makers than they paid Gainsborough for a portrait.[137] John Parker at Saltram spent £48 0s. ½d. on materials for a coat on 2 July 1799 and £22 11s. 4d. on meat between 6 and 21 September the same year. At the same time he paid two labourers 4s. 8d. for four days' work thatching on his property. This can be compared with the kind of sum his father, Lord Boringdon, was prepared to pay for family portraits by Reynolds a couple of decades earlier when the family was establishing its country seat. A portrait of Lord Boringdon's wife could be purchased in the 1770s from the top London portrait painter for roughly only twice what John Parker spent on his coat and little more than four times what he spent on meat for two weeks of dinners.[138]

In the mid-1750s the Duke of Bedford paid £4 in wages for men to travel to and from Woburn to make thirty-five picture frames. The cost of making them in Woburn oak was £20 3s., the joiner who travelled to Woburn and put them together received £1 (a gross of screws and half a gross of picture rings that he used cost 15s.). The carving and gilding of 566½ feet of frame was done at 3s. 4d. per foot and amounted to an enormous total of £94 8s. 0d.[139] We do not, unfortunately, know how long it took the men to do the work but the duke was clearly prepared to spend a considerable sum. Isaac Collivoe, who specialized in cleaning pictures charged £29 8s. to clean four upright landscapes for the duke in 1755, but by 1763, having attracted royal patronage, he had so much work on that he was obliged to reject a request from the duke's agent saying,

> My greatest objection is my time, which is greatly taken up with cleaning the king's pictures that I cannot have time hardly for either to breakfast or dine. And after I have finished with the king's must immediately go to Chiswick to do Lord Burlington's which distresses me much. Therefore I hope you will be so good as to excuse, which will be acknowledged as a favour done unto me.[140]

Portraiture as an art form is characterized by con-

tradition. On the one hand the genre is, by its very nature, conservative. On the other hand, over and above any other genre, it depends upon an agreement between two people which extends beyond the contractual. The contract, written or spoken, can never embody the content of the picture and never articulate the reaffirmation or redefinition of class boundaries that is fundamental to the act of portraiture. It is at one and the same time a public art bound by conventions and a supremely intimate act of communication. This combination of factors and the tensions between them rendered the portrait painter especially vulnerable within the artistic community, yet also extremely powerful. Many of the difficulties encountered by portrait painters in England in the late eighteenth century (and discussed in this chapter)

68. George Romney, *Martha Catharine, Lady Aubrey (née Carter)*, oil on canvas, 91.4 × 66.0 cm. Private collection.

The subject was born in 1765 so this portrait probably belongs to the mid-1780s; it typifies the summary treatment by the artist of arms and hands and his recourse to generalized (if atmospheric) landscape backgrounds.

are the immediate result of the necessity of constantly adjusting and readjusting within the economic structure. The demand for portraits generated a huge supply of artists which glutted the market, if Northcote is to be believed. Thus while theoretically and ideologically portraiture remained an inferior genre, actually it was the dominant art form for all classes of society. While patrons paid little for portraits relative to their overall expenditure on household goods, they created an extremely competitive market where reputations could be made and unmade overnight. This encouraged expansion, providing work for a wide range of craftsmen, but also reinforced existing structures and dominant values.

Style must also be understood as a consequence of these market factors. The fluid handling of paint (a feature of Romney's late work, for example) may have evolved as a result of the need for speed of execution as much as because of a latent tendency towards romantic sensibility. The disappearance of feet and hands behind drapery may have much to do with the lack of competence of studio assistants whose job it was to model them, and probably also to paint them. The outdoor setting may be related to the fact that it was simpler to fill in an imaginary open-air landscape than to depict with accuracy an ideal or actual interior, especially when sittings took place in an artist's studio. The highly competitive market and the dominance of the Royal Academy as a forum for display and publicity made it imperative for artists to develop an individual and readily identifiable visual formula as quickly as possible. Thus one might say that the more Reynolds succeeded with florid men, the more Gainsborough was impelled to produce depictions of ephemeral women. Portrait painting in the 1780s was a highly developed business in a buyer's market.

II ILLUSTRIOUS HEADS

i *James Granger and the Politics of Collecting Engraved Historic Portrait Heads*

But no invention has better answered the end of perpetuating the memory of illustrious men, than the modern art of engraving, which I shall, without scruple, prefer to the boasted art of the Egyptians; and I would much rather be possessed of a good collection of prints of my countrymen than a collection of their mummies, though I had a pyramid for its repository.[1]

On 26 December 1767, James Granger, Rector of Shiplake in Oxfordshire, wrote to Sir William Musgrave to say that he intended, in accordance with the advice of Horace Walpole, to alter the title of his forthcoming book in order to promote its sale. Walpole's suggestion was that the work be called 'A History of England, illustrated by Portraits and Characters'. But Granger sought the approval of Musgrave (pls 69, 70), one of the many antiquarian collectors of engraved portraits with whom he had corresponded while preparing his study, for a much longer title: 'A History of England from Egbert the Great to the Revolution, illustrated by Portraits and Characters; intended as an essay towards reducing our biography to system, and containing a methodical catalogue of engraved English heads during the above period; with a preface, shewing their utility in answering the various purposes of medals.'

This diffuse title was passed to Granger's book-seller, Tom Davies, one-time actor and friend of Dr Johnson. According to eighteenth-century commercial practice Davies was responsible for printing the book and distributing it both to individual purchasers and to retail outlets. Naturally Davies had considerable interest in the book's title but also wished not to offend his author. Therefore he replied to Granger's proposal somewhat obliquely, saying:

> A gentleman this day found great fault with the length of your title; the beginning, he says, is involved, perplexed and obscure. He wishes you would shorten it, and proposed an amendment. He would have called it, 'The Characters of English History, from Egbert the Great, to the Revolution.'

Davies no doubt thought the alternative comparatively bald but asked Granger to reflect upon it.

After the latter had replied, somewhat petulantly, Davies quietly but firmly pursued his own proposal, saying on 24 January 1769:

> I am glad you approve the words 'Biographical History of England'. I think we are now almost as right as we could wish to be, but I cannot relish the words *Personal* History. The original meaning of the word is for us [*sic*]; but the sense it has acquired by long custom perverts it to a different meaning. *Domestick, private, Characteristical* are nearly as good as *personal*; and yet I cannot say I much relish any of them.

Shortly afterwards Davies had recourse to his anonymous 'gentleman' in attempting to arrive at a title, telling Granger that 'A gentleman asked me what you mean by reducing Biography to System? I

69. G.S. Facius after L.F. Abbot, *Sir William Musgrave, 6th Bt.*, etching, 1797, mounted in an anonymously grangerized copy of Granger's *Biographical History of England*. By permission of the Provost and Fellows of Eton College.

70. Detail of pl. 69.
Sir William rests his right
elbow on a portfolio of
engravings from which
extrudes the engraved
portrait head of James
Granger which is printed as
the frontispiece to his
*Biographical History of
England*.

told him your general idea was well conveyed by
that word, though perhaps it might not be so easy
to explain how – more was meant than meets the
ear.' Granger's book was finally published, with a
dedication to Walpole, on 16 May 1769. As Davies
commented in July, 'no book has been more
censured, nor more applauded'. Five hundred copies
sold in the first ten months and this was considered
good for a work priced at the very considerable sum
of two guineas, for, as Davies remarked, 'A political
pamphlet, and a quarto book of sober history, are
very different beings.'[2] The title agreed upon was
extremely long and contained a veritable agenda for
eighteenth-century engraved portrait collectors: *A
Biographical History of England, from Egbert the Great
to the Revolution: consisting of Characters disposed in
different Classes, and adapted to a methodical Catalogue of
Engraved British Heads intended as an Essay towards
reducing our Biography to System, and a Help to the
knowledge of Portraits. with a preface showing the utility
of a Collection of Engraved Portraits to supply the Defect,
and answer the various purposes of Medals*.

I have described in some detail how this title was
arrived at because the two-year discussion on the
subject offers the historian traces not of a collective
consciousness of an age, nor of the now silent voice
of an individual from the past, but of a discursive
field in which the relations, the networks of
definition, and the transformations of the idea of the
portrait as a factor in social formation can be recog-
nized. The systematization of portraiture as history
is not, as Davies acknowledged, a matter for expla-
nation, for 'more was meant than meets the ear'.

The Revd James Granger is now chiefly remem-
bered as the eighteenth-century writer whose cata-
logue of engraved British portraits lent impetus to a
fashion for extra-illustrated texts.[3] A grangerized
book is one into which has been bound or mounted
extraneous but thematically related material both
visual and verbal. The practice of grangerizing,
whereby the printed book is personalized, and the
legacy of the Rector of Shiplake's name to a craze that
lasted through most of the nineteenth century, might
suggest that our interest here is with the biography of
Granger. The concern of this chapter is, however,
the competing and related discourses of biography,
portraiture and history which can be located across a
field that is constituted not simply by what Granger
states but by a thematically connected series of texts.
Germane to the argument is the articulation and
ordering of notions of the national past by collecting
and mounting engraved portraits according to the
classification prescribed by Granger.

From the correspondence between Granger and
his bookseller we infer (for the relevant letter from
Granger is missing from the collected correspon-
dence) that at some point it was the author's intention
to use the term 'Personal History' rather than 'Bio-
graphical History'. The personal or the domestic
or private history – for Davies offers these as
synonyms – is the history of the person or character
('charakteristical'). This definition is interesting for
the ways in which it asserts a notion of history
distinct from public life, the collective and society.
'Privacy', it has been remarked, was an eighteenth-
century innovation,[4] and it has often been pointed
out that the formation of a refined, cosmopolitan
public that was internally disciplined took place only
very gradually over decades or even centuries, the
cultural construction of the self-regulating subject
being brought about by processes of symbolic
ordering.[5] As one scholar succinctly puts it: 'One
result of analyzing social interests in all their con-
creteness and particularity is the demonstration that
symbols are needed to bridge the gaps.'[6]

Biographical personal history, mediated through
the discourses of portraiture, bridged the conceptual
gaps between the identification of the personal and
definitions of the social. Moreover, it functioned as
part of a wider symbolic structure of regulation
through which the public – and by extension the
national – were defined and understood. The con-
struction of a visual history according to Granger's
system, and how this history contributed to the
ways in which late seventeenth- and eighteenth-
century society saw itself are explored in this chapter.
What did it mean to emulate a collector of 'heads' as
avid as Elias Ashmole, whose 'mind was so eager to
obtain all faces, that he would buy the book, tear it
[the portrait] out, paste it in his blank book, and

write under it from whence he had taken it'?[7] How is the circumscribing of history – from Egbert the Great to the Revolution – an ordering process, the systematic principle of which is predicated not only upon the named portrait but more specifically upon the named portrait head?

The engravings that were amassed in the eighteenth century both before and after Granger's publication were frequently contemporary reproductions (by Vertue and others) of earlier original paintings and engravings, or were simply invented. The relationship between this kind of collecting and, for instance, the illustrated catalogue of a great collection, the first of which was that issued by the Habsburg Archduke Leopold William in 1646–56, is not close.[8] This is a venture that has more in common with an imaginative search for the past than with the history of cataloguing. The objects sought and preserved were, in Reigl's terms, high in age-value, that is they possessed the merit of association.[9] Granger's scheme could not, however, have succeeded in such a spectacular way had not the conditions been right.

As a consequence of the work of portrait painters and of engravers, Britain was understood by the 1730s to have compensated for its shortcomings in comparison with other European nations, and made up for some of its alleged cultural backwardness. The alliance between leading portrait painters and engravers was particularly productive: Kneller's regard for John Smith, the mezzotint engraver, is evinced in the portrait he painted of him as a gift as early as 1696. In 1716 Smith engraved this image which shows him holding his earlier print of Kneller. Smith, by way of return, dedicated to Kneller, the translation of Le Brun's *Conférence* . . . (pl. 71) which he published in 1701.[10] Kneller's Kit-Cat Club portraits were engraved in mezzotint by John Faber (1733–5); the overwhelming effect of this widely distributed series when hung *en masse* can be judged from the State Dressing-Room at Beningborough where the entire collection can be viewed close-hung on the panelled walls of this important chamber.[11] Moreover engravings were cheaper than paintings, and a gentleman choosing pictures for his house at the end of the seventeenth century might well select good prints as a handsome show.[12] Prints were also deemed demotic, as the anonymous author of *Sculptura-Historico-Technica* made clear when he recommended in 1747 that, since it required 'a large Fortune to make a fine Collection of Paintings and great Judgement to avoid Imposition', it was better to collect prints which cost much less than paintings 'and the knowledge of them is more easily attained'.[13] Thomas Atkinson was thus able to state in 1736 that 'Britain now so much abounds with Engravers for all sorts of Work, that were Mr. Evelyn to have now first published his Parallel of Architecture, he would

not have complained as he did, that he was obliged to get the Plates engraved in Holland, not finding any English Artist to do them.'[14] It is indicative of the status that prints acquired during the eighteenth century that it was thought appropriate to present each of the gentlemen who attended Sir Joshua Reynolds's funeral with an elegant engraving by Bartolozzi of an elegaic allegorical composition.[15]

Granger's most immediate precursor, however, was Joseph Ames, Secretary to the Society of Antiquarics, and Fellow of the Royal Society. In 1747 he published *A Catalogue of English Heads* . . . which sought to document around two thousand English engraved portrait heads.[16] This volume was dedicated to the Hon. James West, 'to perpetuate the Memory of such English Persons, as has [sic] been collected by Mr. Nickolls, FRS well knowing, that if ever these encrease to another volume, it must be from your valuable Treasure'. The stress on the Englishness

THE

CONFERENCE

O F

MONSIEUR LE BRUN,

CHEIF PAINTER

TO THE

FRENCH KING,

CHANCELLOR and DIRECTOR

OF THE

ACADEMY

O F

PAINTING and SCULPTURE;

Upon EXPRESSION, General and Particular.

Translated from the French, and Adorned with 43 Copper-Plates.

LONDON,

Printed for *John Smith* at the *Lion* and *Crown* in *Ruffel-ftreet* in *Covent-Garden*, *Edward Cooper* at the *Three Pidgeons* in *Bedford-ftreet*, and *David Mortier*, Bookfeller in the *Strand*, at the Sign of *Erafmus's* Head. 1701.

71. Title-page to *The Conférence of M. Le Brun . . .*, London, 1701.

John Smith, the mezzotint engraver, translated and sold the first English edition of Le Brun's *Conférence* on expression. It was dedicated to the grand old man of English portraiture, the immigrant artist Sir Godfrey Kneller.

of this history, the perpetuation of the memory of *English* persons, has powerful resonances in Hanoverian England when French was the court language and the Stuart succession remained a contentious issue. When the collection of James West, President of the Royal Society, was auctioned in 1774 – an extremely memorable event owing to the vast quantity of items sold – the preface to catalogue 5 covering the Bibliotheca Westiana and written by Samuel Paterson included a kind of manifesto for the collector of English heads:

> In an Age of general Inquiry, like the present – when studies less interesting give place to the most laudable Curiosity and Thirst after investigating every Particular relative to the History and Literature of our own Country; nothing less than an elaborate Digest of this valuable Library could be expected; and, as a Supplement to the History of English Books, more desired ... The Lovers of engraved English Portraits – a Species of modern Connoisseurship (which appear to have been started by the late noble Earl of Oxford; afterwards taken up by Mr. West, Mr. Nickolls, Editor of O. Cromwell's State-Papers, Mr. Ames, &c and since perfected by the Muse of Strawberry Hill, the Reverend Mr. Grainger [*sic*] of Shiplake, and some few more ingenious Collectors) may here look to find a considerable Number of Singular and Scarce Heads, and will not be disappointed in their Search.[17]

Granger's *Biographical History*, building on the work of Joseph Ames, was intended to fulfil a function in the encyclopaedic library, enabling gaps in a gentleman's coin collection to be filled in, as Evelyn had suggested in *Numismata* (1697). Richard Bull's grangerized *Biographical History*, for one, included a page of coins and medals for each of the reigns covered by Granger, a literal illustration of the principle (pl. 72).[18] None the less, we should also notice in Paterson's use of the standard term 'Heads' for what were, in fact, often engravings after full-length portraits, the implied division of the mythic body that ensues from this methodical systematization, this reducing of Biography to System. For the head – and above all the face – with its cognitive and physiognomical particularities, stands in metonymic relation to the body as a whole. If the system and the collecting practice serve to separate head from body, indeed privilege the head over and above the body, that symbolic structure must be understood in its relation to a hierarchical process in which society's disparate parts are inscribed in a hegemonic order. Underlying such a structure in the eighteenth century is a long tradition originating in the medieval bio-political schema of the *corpus Christianum*.[19] One site of this inscription is, precisely,

the collections of engraved portraits. Granger's text and its aftermath (intended to serve those collections) reinscribes that order both by its emphasis on 'Heads' and by its prescriptive scheme for carving up history into periods, and ranking social groups according to a hegemonic order of 'Classes' on the following plan:

Class I Kings, Queens, Princes, Princesses, &c. of the Royal Family.

Class II Great Officers of State, & of the Household.

Class III Peers, ranked according to their precedence & such commoners as have Titles of Peerage; namely, Sons of Dukes &c and Irish Nobility.

Class IV Archbishops & Bishops, Dignitaries of the Church, & inferior Clergymen. To this class are subjoined the Nonconforming Divines, and Priests of the Church of Rome.

Class V Commoners who have borne great Employments; namely, Secretaries of State, Privy-Counsellors, Ambassadors, and such Members of the House of Commons as do not fall under other classes.

Class VI Men of the Robe; including Chancellors, Judges, and all Lawyers.

Class VII Men of the Sword; all officers of the Army and Navy.

Class VIII Sons of Peers without Titles, Baronets, Knights, ordinary Gentlemen, and those who have enjoyed inferior civil Employments.

Class IX Physicians, Poets, and other ingenious Persons, who have distinguished themselves by their Writings.

Class X Painters, Artificers, Mechanics, and all of inferior Professions, not included in the other Classes.

Class XI Ladies and others, of the Female Sex, according to their Rank, &c.

Class XII Persons of both Sexes, chiefly of the lowest Order of the People, remarkable from only one Circumstance in their Lives; namely such as lived to a great Age, deformed Persons, Convicts, &c.

While Granger's classes replicate the body politic, the activity of collecting portrait heads may also be construed as symptomatic. In 1743 a 'most noted collector' is reported to have said 'that his own collection must needs be large and good as it rested on six points: 1. I buy; 2. I borrow; 3. I beg; 4. I exchange; 5. I steal; 6. I sell.'[20] The practice of print collecting in the eighteenth century may thus be seen as replicating the market economy of urbanized western society. London in the eighteenth century was the largest town in Europe with an ever-increasing population (it numbered 860,000 at the end of the century), and its economy, for all the

72. The great seal and medals from the reign of William and Mary, engravings cut and mounted by Richard Bull in a grangerized copy of Granger's *Biographical History of England*. Huntington Library, San Marino, California.

concern of men like Defoe with the defining characteristics of the tradesman, was structured less on trade than on patronage and the crown, a system that necessarily was characterized by a vast underbelly of begging, borrowing and stealing.[21] The practice of collecting portrait heads, a practice that related at one extreme to patronage in its more elevated form of the creation of a private collection of great works, but which at its other extreme was closer to modern-day stamp-collecting, offers a paradigm of capitalist entrepreneurship with its emphasis on acquisition and exchange value. Once formed, a collection could be sold for a considerable sum; Richard Bull, whose collection will be looked at in more detail later, sold his grangerized *Biographical History* privately to Lord Mountstuart in 1774 for the considerable sum of £1,000.[22]

The economy of collecting 'heads' is interesting historiographically for, whilst undoubtedly individual collectors gained great pleasure from browsing among their albums of pasted engravings, the dynamics of collecting were determined more by a notion of plenitude, by a desire to fill in all the gaps and produce a complete map which, like the world of plants, would be open to taxonomic investigation. As Granger explains in his preface, a single engraved portrait accompanied by all the available relevant information about artist, engraver and subject 'may become a rich and plenteous banquet, a full spread table of choice and useful communications, not only most delightful to the eye but most instructive to the mind'. The attentive observer is able, by following Granger's system, to have access to what he terms 'synchronism'. For 'by studying such a collection, together with the . . . [*Biographical History*], the personal history of the illustrious in every rank, and in every profession, will be referred to its proper place; and statesmen, heroes, patriots, divines, lawyers, poets, and celebrated artists, will occupy their respective stations, and be remembered in the several periods in which they really flourished'.[23] The collecting of 'heads' is thus an epistemology that can be understood as ordering society and making visible the body politic.

In practice, as a result of Granger's work, engraved heads and information relating to engraved heads circulated in the market causing fluctuations in supply, demand and price. An ideology created its own market. Horace Walpole, to whom Granger dedicated his work, told Thomas Mann in 1770 that he had been collecting engraved English portraits for over thirty years and originally never paid more than one or two shillings for a mezzotint, but that since the publication of a catalogue he had helped to compile (surely a reference to Granger) scarce heads not worth three pence would sell for five guineas.[24] Knowledge was a commodity, and those who

possessed it could sell it. George Vertue (pl. 73), whose notebooks acquired by Walpole provided the material for the *Anecdotes of Painting in England* (1762–80) and whose engravings for the Society of Antiquaries provide the backbone of the historic portrait engraving trade in the eighteenth century,[25] typically acted as adviser in 1743–4 in the establishment of a 'curious collection of prints.' Vertue seems

M. Gauci Lithog. Printed by C.Hullmandel.

Fac Simile of a Drawing in the Possession of the Publisher.

London. Pub.ᵈ by A.Molteno, 20 Pall Mall. Dec.ʳ 1821.

frequently to have acted in this capacity; the word 'adviser' is, however, something of a misnomer, since it is evident that he assembled the entire collection himself, writing to his client, Dr Ducarel, in January 1744 to say 'Your Collection of Prints under my care has made some progress.' By July he was able to tell Ducarel that:

Your two volumes of Collections are now done and bound, which, I may venture to affirm, are the most considerable Collection of the kind in England; and contain more curiosity and variety

73. George Vertue, *Self-portrait*, 1741, lithographed by M. Gauci, 1821, and published by Hullmandel. National Portrait Gallery, London.

As with plate 21, Vertue employs the portrait medium to make a complex autobiographical statement: he holds a miniature of his patron Edward Harley, Earl of Oxford, his right hand rests on his plate of the Chandos portrait of Shakespeare (see pl. 271) and over the cupboard on the right is a small replica of a lost portrait bust by Bernini of Charles I.

58

than can be seen in any gentleman's possession; which I wish you long to enjoy the pleasure of viewing, as you have had the pleasure of collecting. What remains towards another volume (I doubt not) you soon will increase, with ease and less trouble.[26]

James Granger performed a similar service for Lord Mountstuart in 1773 or 1774 when he accompanied him on a tour of Holland. As a Roman Catholic, Vertue may not have been acceptable to all clients; Granger, on the other hand (perhaps partly in response to Vertue's very active role earlier in the century), takes great care to insist upon the Protestant and national character of his system which 'will serve as a visible representation of past events, become a kind of *speaking chronicle*, and carry that sort of intelligence into civil story, that in popish times was almost the sole support of religion'. Unlike those 'lying legends', the collection of portraits will, by short and accurate inscriptions, offer real instruction.[27] The correspondence of Vertue, Walpole, Granger and other antiquarians throughout the eighteenth century testifies to the continual circulation of prints and information on their identity and iconography, a vast network of correction and amendment.[28]

The supplement to Granger's book, published in octavo with corrections and additions in 1774 was printed only on one paper (i.e. one side). Davies also repeated the practice established with the first edition of printing twenty sets with blank pages interleaved, 'for the convenience of such gentlemen as may chuse to place the heads near the lives in your work'.[29] By this process, a reference work was transformed into something akin to a scrap-book. Publication of Granger's *Biographical History* stimulated the market to such a degree that books ornamented with engraved portraits rose in price to five times their original value and few could be found unmutilated. Granger told his friend and correspondent, Richard Bull (1721–1805), in 1770, that he wished all the books from which he had taken his frontispieces were in some lumber room and that he would go a hundred miles to see them if they were, since they would contain crucial information for his research. Four years later Bull himself was complaining to Granger that Shropshire's print shop was charging extravagant prices for portrait prints but was none the less 'filled with buyers'. Who, asks Bull, is to blame?[30] What has been described as a tendency in seventeenth-century France for portrait engravings to escape from the books that served them as support to become independent entities was occurring literally in eighteenth-century England.[31] In the words of Henry Bromley, Granger's posthumous editor, 'to such a height of enthusiasm'

did the passion for collecting arrive with the publication of the *Biographical History*, 'that old legends and chronicles, and curious pieces in the black letter, were considered, either by the buyer or the seller, of little value compared with the *pictures* they contained'.[32] The boxes of unmounted 'heads' that survive today in the Print Room of the Victoria and Albert Museum testify to the mad spoliation of frontispieces and bookplates, and to the failure of collectors to complete their projects. Reports of illustrated copies of Granger's work running to twenty-seven volumes and containing thousands of engraved heads are not uncommon. The passion continued unabated, and as late as 1828 Henry Angelo bemoaned the fact that fine engravings by Strange, Sharpe and Woollett and 'beautiful specimens of the Boydell School of calcography are lying worthless lumber upon the shelves of the print merchants', while men of degenerate taste 'contend for a base head-piece to a penny licentious ballad, of the age of Charles the Second, at any price'.[33]

It is clear from booksellers' catalogues of the period, which speak of Gentlemen '*completing* their collections',[34] that quality and originality were less important than achieving saturation. This plenitude was attained by means of pasting into the blank pages copies, forgeries or modern imitations. Printsellers aged the paper of some of their prints to avoid 'the glare or strong charge of a new print'.[35] Indeed, as early as 1737, Vertue was complaining about forgeries:

> So many hands and so many heads are daily employed, and have been, to deceive and forge imaginary names or portraitures of remarkable persons, that it becomes now a trade or artifice not to be explored or censured by truth, judgement, or knowledge, it is so universally practised. Therefore, now I find it the most ungrateful science that any man can be possessed of; when ill-will, hatred, and corruption is the reward. This has given rise to reflections which I dare not publish.[36]

The collection of 'heads' was not, we have established, the same as the creation of a scientific catalogue. Nor was it, like the modern museum, essentially concerned with quality. Homogeneity of a different sort was its purpose. Its ostensible function was to impose order on disorder and to regulate the present by means of the past. Customarily pasted into folio volumes, engraved portrait 'heads' were part of the gentleman's library and were arranged along the same lines as topographical albums. They were an extension of, or substitute for, the busts that commonly adorned libraries (as at Trinity College, Cambridge and Trinity College, Dublin;

see pls 11, 12).[37] In Gabriel Naudé's instructive book about making a library, published in Evelyn's translation in 1661, fancy bindings and fragments of old statues are repudiated in favour of

> good Copies drawn from such as are most famous in the Profession of Letters; that thereby a man may at once make judgement of the wit of the Authors by their Books, and by their bodies; figure; and physiognomy by these Pictures and Images, which joyn'd to the description which may have been made of their lives, may serve, in my opinion, as a puissant Spurre to excite a generous and well-born Soul to follow their Track . . .[38]

Thus a representation of an individual, like that of a country seat or an ancient castle, would be classified according to its period in history, its relative importance in terms of rank, wealth and prestige, and its geographical location. As a general principle, portraits were seen in the eighteenth century as pertaining to locations; the Earl of Fife declared, 'I have always considered the Coins, Medals, and Portraits, of different ages, as very intimately connected with the History of the countries to which they belong. To the lovers of History and of the Fine Arts, they must be peculiarly interesting.'[39] The magnificently grangerized edition of Pennant's *Some Account of London . . .* , now in the British Museum, includes engraved portraits of distinguished residents alongside the views of particular locations with which they were associated.[40]

Undoubtedly the wittiest, if not the most discerning, testimony to the range and extent of grangerizing is to be found in the poem *Chalcographimania* by Satiricus Sculptor, Esq., dedicated to the collector James Bindley and published in 1813 with the provision of two very copious indexes, since 'it is not unlikely that the rage for illustrating may extend itself even to the present volume'. The voluble hero of the poem is Catalogus:

'Ah!' would he cry; – 'could I but boast,
A Musgrave's fame, though now a ghost,
Was I not as I am, a stranger
To deep intricacies of *Granger*,
But Caulfield-like who claims oblation,
Was vers'd in godlike *Illustration*,
Of *Burnet*, *Clarendon*, and *Pennant*
Then Wisdom's mansion I should tenant';

But all is not lost, and Catalogus rushes off to purchase the necessary volumes of Granger:

Granger – whose biographic page,
Hath prov'd for years so much the rage;
That scarce one book its portrait graces,
Torn out alas! each author's face is.[41]

Granger's system proved effective in the marketplace; it also had major implications for portraiture as a mechanism for shaping the past and making sense of the present. More precisely, *A Biographical History* established an epistemological framework within which English history could be ordered. Egbert was said to have named the nation in a general council held at Winchester in 829, and, as first English king, he marks the point of origin also of Granger's history. The Glorious Revolution provided the terminal point. History, chronologically ordered between these two selected events, is also subjected by Granger to an internal ordering by class. The twelve classes into which the collector is instructed to organize the engraved 'heads', commencing with the monarchy and concluding with the 'lowest Order

74. *John Selman*, anonymous woodcut, printed 1612, mounted by Richard Bull in his grangerized copy of Granger's *Biographical History of England*. Huntington Library, San Marino, California.

This popular print of a criminal, a much sought-after type in the eighteenth century, is reputedly inscribed with the subject's signature.

75 (facing page). A grangerized page of distinguished foreigners, engravings by various hands of Gerard Mercartor and Simon Vouet, cut and mounted anonymously. By permission of the Provost and Fellows of Eton College.

60

of the People', reinscribe those very distinctions between stations and professions that eighteenth-century London no longer securely offered in forms of daily self-presentation.

The ill-effects of the dislocations of rank that eighteenth-century urban society suffered with the effective demise of sumptuary laws and the influx of labour and aliens are apparent in the anxieties around the question of servants' dressing in their master's or mistress's clothes, a regular topos in the eighteenth-century novel. It is significant that John Selman, a pickpocket hanged in the reign of James I, is described in an eighteenth-century text (accompanying an engraved portrait bearing what purports to be his own signature (pl. 74)) as having suffered as a consequence of the tenfold exaggeration of his crime because he was dressed like a Gentleman.[42] These dislocations could be counteracted by ritual and symbol: Granger's system, which eventually allowed for the inclusion of distinguished foreigners (pl. 75), provided the arena for such ritualized forms of associative control.[43] People's histories and national identities could no longer be taken for granted – in 1732 the government revived the Courts of Honour to identify those who falsely claimed coats of arms. As Richard Sennett has argued, the yardstick of hierarchy 'as a clear measure of the relations between strangers' was eroded by the economy of the capital city as it was associated with demographic changes.[44] Sennett explores the shifting domains of public and private and the means – behaviour, dress, deportment – through which society negotiated these unstable boundaries. The problem of 'strangers', as is suggested by Chesterfield's celebrated advice to his son that 'one cannot keep one's own private affairs too secret', was that they could not be 'placed' by virtue of their material circumstances.[45] This process of ritualized ordering and identification – to which Granger's system and its practitioners contributed a retrospective view – may be detected also, towards the end of the century, in George III's historicizing and nationalistic gestures in enlarging the Order of Bath in 1772, extending the Order of the Garter in 1788 and in 1805, and in founding the Order of St Patrick in 1783. Linda Colley sees these as part of the apotheosis of George III, but they are surely, also, part of the continuing eighteenth-century formation of a visual rhetoric through which a clearly identifiable and personalized national history might be established.[46]

By the eighteenth century the practice of portrait representation in general contributed importantly to the process of recognizing a person. Indeed, it might be said that the portrait painter began to exercise a special authority by virtue of his highly developed visual memory: Kneller claimed that James II's son was indisputably legitimate on the basis that the child's father and mother had sat to him thirty-six times a piece, and there was not a feature in his face that did not belong to one or other of them.[47] Portrayal allowed also for the expression of an

increased individual autonomy, for it would be wrong to see portraiture as merely a form of coercive social control. It is, therefore, unsurprising that the century saw an enormous increase in interest in portraiture. Collecting historic 'heads' is not unrelated to the commissioning of portraits of contemporaries: if history was to be read through representations of individuals, it was important to ensure that portraits were supplied for the records of future generations. The popularity of portraiture as a social activity rather than, exclusively, as an art form led to the production of portrait imagery in virtually every medium.

ii Ordering the Past: the Origins of Granger's System

This section concerns the origins of Granger's system and investigates the relationship between that system and other forms of collecting – bibliographic and numismatic. The practice of honouring distinguished men in portrait galleries was popular in Antiquity. Pliny speaks of 'the rooms and halls of private houses becoming so many public places [as] clients begin to honour their patrons in this way'.[48] The practice was maintained in the family portrait galleries of the late Middle Ages[49] and revived in the Renaissance (with particular emphasis on the heroic). Thereafter it continued as a popular model in western art. Pliny's statement affirms the function of the portrait in eliding the public and private, a social action that is embedded in a system of public signification.

Collections of written biographies and images of *viri illustres* or *uomini famosi* were the outcome of the commitment of Renaissance culture to the revival not merely of ideas but of the revered figures who embodied them. In Randolph Starn's words: 'Such works have an authentic Renaissance founder in Petrarch and a proper culmination in Paolo Giovio's sixteenth-century portrait gallery.'[50] Castagno's frescoes of Famous Men and Women were, like Giovio's gallery, the visual equivalents of Boccaccio's *De Casibus Virorum Illustrium* and *De Claris Mulieribus*. The published gallery of illustrious men remained popular in England throughout the seventeenth and well into the eighteenth century with many publications along the lines of Henry Holland's *Herwologia Anglica* of 1620 (commencing with Henry VIII, each short biography being accompanied by an engraved portrait), *Icones Virorum Illustrium* of 1650 (a collection of engraved head-and-shoulders portraits in plain frames), the immensely popular *Heads of Illustrious Persons of Great Britain* of 1743–51 (engraved by Houbraken and apparently intended to be hung on walls rather than collected in volumes[51]), and *The Portraits of the Most Eminent painters and other famous artists, that have flourished in Europe . . . of* 1739. The format was popularized at the end of the eighteenth century in works like *The Biographical Magazine*, 'containing Portraits and Characters of Eminent and Ingenious Persons of every Age and Nation', published in 1794. *The Biographical Mirrour*, published by S. and E. Harding in 1795 and *The British Cabinet*, 'containing Portraits of illustrious personages, engraved from original pictures: with biographical memoirs', published by T. Bensley for E. Harding in 1799, were confined to British subjects.

In many instances the same engravings were replicated in these volumes time and time again. The market for such ventures collapsed around the second decade of the nineteenth century, though the survival of a grangerized copy of Granger's *Biographical History*, incorporating material printed in the 1860s and formed probably in Leicester, suggests that interest survived among some collectors much later.[52] *Portraits of Characters Illustrious in British History . . .*, engraved in mezzotint by Richard Earlom and Charles Turner, appeared in 1811 but was abandoned after the first volume, suggesting a decline in interest around this time.[53] Other later manifestations are the series of heads of poets that William Blake was commissioned to execute for the library of his patron William Hayley at Felpham and, considerably later, George Frederick Watts's Hall of Fame.[54]

It has been argued by Richard Brilliant that the programmatic nature of these galleries of Antiquity with their anterior schema encouraged the development of different images of a single subject that could be identified under the name of a specific personage.[55] In other words, whether we are speaking of 'types' of Homer or of Blake's imaginary construction of the head of the Spanish poet Alonso de Ercilla y Zuniga, system and plenitude are always pre-eminent over and above questions of likeness in the tradition of the gallery of portraits of famous men or women. The thrust of this argument is, however, misplaced. Programmatic situations like portrait galleries of noble families Brilliant sees as weakening 'the autonomy of the private portrait'.[56] The distinction between personage and private person with which Brilliant works is useful in addressing Antique sculpture but fails to address the essentially public nature of all portraiture.

Once portraiture is acknowledged as a mechanism to bridge the chasm between material existence and the interiority of the individual rather than as a means of recording the physical appearance of a particular historical personage, we can begin to explain the fascination with the collecting of 'heads'. Classical scholars have a variety of explanations for variant likenesses of celebrated figures in Antiquity; their concerns are with questions of convention and ideal-

ization, with the approximation of heroes to gods, with typology and the conservatism of posthumous portraiture. Thus, for example, it is proposed that the 'likeness' of Socrates was 'revised' by later generations as the earlier image was found unsatisfactory because of its lack of expressiveness.[57] The eighteenth century sought other explanations. D'Hancarville, for instance, considering the question of two portraits of Homer at the same age but with quite different appearances, argues that it is not possible to view these as the species of which Homer is the genre. On the contrary, the difference in appearance represents the difference in the works of the master: 'c'est qu'on a voulu exprimer par elles les différentes *constitutions* des poèmes d'Homère, la différente *impression* qui résulte de leur lecture, enfin les deux différentes idées qu'ils donnent de leur auteur.' ('What was desired was to express by them [the portraits] how the poems of Homer are differently constituted, the different impression that results from reading them, finally the different ideas they give of their author.')[58] Deprived of originals, the argument goes, Art created a means of representing the *idea* of Homer. The author of the *Iliad* is given a different appearance from the author of the *Odyssey*; the two portraits offering different ideas of Homer (whose genius as poet was equal to the reputation of two great men) provide distinct forms which the world recognizes equally as Homer.

D'Hancarville's argument not only rationalizes variant portrait types – a prerequisite for the collecting of historic portrait heads – it proposes a model in which the depiction re-presents not the individual likeness of the object but the experience of the reader/subject. A portrait, according to this model, constitutes a correlative for the work or reputation of an historic person rather than a re–presentation of their appearance. It is in this context that the accumulation of heads to fulfil the imperatives of Granger's system may be understood. The image stands in symbolic relation to the subject, not in representation of it.[59]

Nor is Granger's system unique: it is part of a network of ordering discourses that include, for example, the discourse of taste as manifest in Hugh Blair's *Lectures on Rhetoric and Belles Lettres* (1783) (in which, by examining style and grammar, he seeks to establish 'a system for the pleasures of taste'[60]), Burke's essay on the Sublime,[61] debates about the Picturesque, and all those practices of structuring, ordering and representing of which Foucault has written.[62] But the Granger system differs from its antecedents in the arena of portraiture by virtue of its insistence upon a hierarchy defined by class in which gender is subsumed. Moreover, as a physical entity, the *Biographical History* provided a space, actual as well as symbolic, within which the fragmentary

traces of a disordered and chaotic past could be seized. The significance of this actual space – defined by the pages to which collectors would attach historic portrait heads – is evinced by the attempt in the 1790s to provide a ready-made Granger. Published by W. Baynes in three volumes, this collection of 310 engraved portrait reproductions solved the problem of the extreme rarity of some of Granger's listed engravings that rendered 'it almost the work of one person's life to get them together'.[63]

Jan Van der Waals in a study of Pepys's print collection unique of its kind, argues that from the seventeenth century there were three kinds of portrait collection. In the first place the portrait collection as part of the libary could serve, as Naudé suggests, as a pictorial catalogue of the books in it, authors being represented by a portrait print either framed or mounted in an album. A collection of portrait prints could also be a cheap substitute for a medal collection (medals were themselves less expensive than sculpture for which they provided an economic substitute), or, as Evelyn and Granger suggested, as supplementary to a medal collection enabling historical comprehensiveness to be achieved. The third kind of portrait collection is the ideal collection, consisting of lists of illustrious, renowned and famous people worthy of the honour of a medal.[64] In *Numismata* (1697) Evelyn provides a survey of those whose portraits it is desirable to possess. It is, however, important to notice that he does not rank these individuals and that he includes both the notorious and the honourable:

> I mention the Names of those that are Conspicuous for their Virtue and Worthy, as well as Notorious for their Villanies and Ambition; all of them Matter and Argument for *Medal* of great Use in good History and by no means to be neglected or slighted of the curious and diligent Collector, as Occasion or Opportunity may one time or other present them, and for the Reasons I produce.[65]

Pepys inscribed on the title-page of the first volume of his collection: 'My Collection of heads in Taille-douce & Drawings [Pepys's portrait] Originally designed for & principally re-strained to Natives of England, but occasionally taking-in some of other nations. Put together Anno Domni 1,700.' On f. 2 recto he provides a list of the order and subject of the several classes of heads. This consists of fourteen classes which in some ways correspond to Granger's but which are less comprehensive: Pepys constructs a convenient set of categories for his private collection, whereas Granger constructs a hierarchical system for public dissemination and use. None the less, there are some interesting differences which perhaps point up the changes in priorities. In Granger, the Church is fourth (out of twelve classes), in Pepys it is eighth out of fourteen. Granger has no

separate class for physicians, chirugiens and chymists but puts them alongside poets and other distinguished writers. Most notable is the fact that Pepys has a class labelled 'Ladys and Virtuosa' which is fifth out of his fourteen, whereas Granger has only 'ladies and others of the female sex', relegated to eleventh class out of twelve.[66]

The success of Granger's system lay in its elision of the portrait collection (as substitute for a medal collection) with the ideal collection which aspired to comprehensiveness; it thus obviated the need for a gallery of worthies. But it is also characteristic of the powerful rhetoric of Granger's hierarchy that worthies and unworthies are carefully separated out. *A Biographical History* – updated through subsequent editions – provided for the comprehensive accommodation of a collection for which it also provided the authoritative biographical dictionary. It thus constituted a considerable modification of the approach to classification exercised by men like Evelyn, Aubrey and Pepys.

It has been suggested by Piggott that what distinguished Aubrey's work of the 1670s (when he was writing *Monumenta Britannica*) 'is that it assembled and set out antiquarian data for its own sake, and not to illustrate a fictitious or quasi-historical account . . . applying to this material the same classificatory method and presentation as his colleagues in the Royal Society were using in the natural sciences . . .'.[67] He argues that archaeological studies were liberated by the end of the seventeenth century from a dependence on literary sources of dubious validity and from any entanglement in the quest for antecedents.[68] He notes, moreover, a collapse in standards of research after about 1730 when the British foundation myths were rewritten.[69] The significant movement from the seventeenth to the end of the eighteenth century is, however, not one from a positivist position to one of fable and romance but from a mapping of knowledge across an entire terrain of human learning to a hierarchical ordering in which portraiture is acknowledged as a system independent of other systems and organized, not according to the laws of the Cabinet of Curiosities with its encyclopaedic wonders, but according to the hegemonic divisions in society itself. The county histories continued to offer 'portraitures' as part of their account in texts that were beautified also by 'maps and prospects'. And this continues and survives in twentieth-century Shell Guides and similar publications. But portraiture had already become an independent and powerful discourse in the eighteenth century.

The collecting of images as part of an encyclopaedic Cabinet of Curiosities is exemplified by the famous Abbot of Villeloin, M. de Marolles. Quoting from the abbé's memoirs, Evelyn points out that

not only *children*, but even striplings well advanced in age, might receive incredible advantages, preparatory to their entrance into the school intellectual, by an universal and choice collection of *prints* and *cuts* well designed, engraven and disposed, much after the manner and method of the above named Villeloin; which should contain, as it were, a kind of *encyclopaedia* of all intelligible and memorable things that either are or have been in rerum natura.[70]

It has been pointed out that the modern-day museologist's distinction between fine engravings and popular prints was not one that was applied in the seventeenth century. The abbé de Marolles owned seventy thousand engravings, and when he sold his collection to the king in 1699 it included the *Cris de Paris* and the *Plus illustres proverbes* of Lagniet as well as a large number of fine prints. The royal librarian had the popular prints as sumptuously bound as the works of Rembrandt or Nanteuil.[71] The abbé's own description of his collection was quoted by John Evelyn as a model of the encyclopaedic collection. It is noteworthy that, according to de Marolles's plan, portraits of eminent persons form a sub-section on their own, whilst 'portraitures' that are delineations of objects or of individuals unworthy of emulation are part of an overall survey of all subjects in human experience. It is this sub-section that is taken over and sub-divided in Granger's work to produce a system capable of encompassing all of British history.

I am greatly obliged to God, that though I have ever had a singular affection to *images*, I was never in my life superstitutious; I have yet made a *collection* so prodigious, that they amount to no less than *seventy thousand* . . . but they are all *copper cuts* and *engravings* of all sorts of subjects imaginable. I began to be addicted to this kind of curiosity but since the year MDCXLI; but have so cherished the humour, that I may truly affirm, without the least exaggeration, that I have some *prints* of all the *masters* that are any where to be found, as well *gravers* as *designers* and *inventors*, to the number of above four hundred, and these are ranged in *Books* of *charts* and *maps*, *calligraphy, architecture, fortification, tactics, sieges, circumnavigations, battles, single combats, naval fights, maritime pieces, landschapes, towns, castles, seas, rivers, fountains, vasa, gardening, flowers, ruins, perspective, clocks, watches, machines, goldsmith's works, joiners and workers in iron, copper, embroidery, laces, grotesque, animals, habits of several countries, anatomies, portraitures, cartouches and compartments, antiques, basso relievos, statues, catafalcos, tombs, epitaphs, funeral pomps, entries, cavalcados, devices, medals, emblems, ships, cabinet pieces, trees, fruits, stones, dances, comedies, bacchanalia, huntings,*

armories, tournaments, massacres, executions, torments, sports, heroic and moral fables, histories, lives of saints and martyrs, pieces of the Bible, religious orders, theses, and above ten thousand *portraits* of renowned persons, without counting (amongst these) above six score *volumes* of masters . . .[72]

Thus portraits are merely one class in a vast panoply of natural phenomena. From this to Granger's system for the classification of portraiture is a great leap.

In *Numismata*, Evelyn argued (as we have seen) that engravings can supplement a coin or medal collection, thus emphasizing the intersection of biography and engraved portrait. While engraved heads lack the emblematic reverse side of coins or medals, 'they seldom or never appear without Inscriptions of the Names, Qualities, Virtues, most Signal Works and Actions of the Persons whom they represent, which makes up the defect of the *Reverses*'.[73] If M. de Marolles offered portraits as merely one item in the great scheme of things, Evelyn projects what Jan Van de Waals calls the 'ideal collection'. Arguably Evelyn's compilation is less a shopping list and more an embryonic dictionary of biography. Significantly Pepys appears not to have used Evelyn's list but rather the *Bibliographia historica* (no. 132 in his library) published by Van Beughem in 1685.[74] The list that Evelyn offers in *Numismata* (chapter VII, 'Of Heads and Effigies in Print and Taille-Douce') is organized generically and not hierarchically. Indeed it is notable that emperors, kings and others distinguished by birth or title are at first overlooked by him and added apologetically:

I had taken the pains of Collecting the Names of the most Renowned, Famous and Illustrious of our own, and other Nations worthy the Honor of *Medal*, or at least of Some Memory, as might in any sort upon one occasion or *other*, possibly contribute to the History of the Times and Persons under the Titles of *Scholars* and *Divines; Historians, Chronologers, Antiquaries, Rhetoricians, Grammarians Critics, Orators, Poets*, and extraordinary *Wits, Philologers, Philosophers, Physicians*, and *Naturalists, Chymists, Botanists, Mathematicians, Musicians, Juris-Consults* and *Lawyers, Great travellers* and Discoverers, worthy Benefactors, Persons Famous, or Pretenders to Curious Arts, *Painters, Sculptors* and *Mechanicians* of all sorts; Sectaries, Enthusiasts, Emposters, Conspirators, bold *Usurpers* and Famous for any desperate *Villany* of either Sex, Virtuous, Learned or Lewd; *Comedians, Mountebanks, Juglers* and other Persons Remarkable for any Extraordinary Accident of *Age, Stature, Strength, Shape*, &c. but especially (and what indeed I should have named in the first place) the *Heads and Effigies of Emperors, Kings, Princes and other renowned Persons, conspicuous for their Birth, Title, Courage, Counsel and Policy, or any Famous and Heroic Exploites by Sea or Land; and in Church or State, &c. which amounted to a very considerable number of Prints, well chosen and properly dispos'd of in this, or some other Method and in Books; to which might be farther added, short Notes pertinent to the Persons*

In creating an ideal compendium of image types which is to be complemented by written notes, Evelyn offers an important point of intersection between two discourses. In Antiquity and in the Renaissance the collection of images of illustrious men was, in general, complementary to the writtn life. Thus the collection of portraits in the library was a biographical discourse in visual form, an equivalent to the written biography rather than dependent upon it. While there may in actuality have been exceptions to this and instances of written biography and portrait occupying the same space of signification, it is with the seventeenth century that the interdependency of these modes is recognized. This is, however, by no means the only form of complementarity at work in the collecting of engraved portraits, and particularly of engraved portrait heads.

Taking up Evelyn's observations on the relationship between engraved portraits and the coin collection, it should be noted that since medals usually depict only heads, not bodies, the corollary would be that engravers similarly concentrated on heads. But whilst the importance of coins in offering a regulated and usually sequential set of heads of monarchs has often been recognized by scholars of portraiture (providing stylistic yardsticks and, allowing for the conservatism of the art form, offering some indication of the interests of the ruler and the visual characteristics of the age), closer examination of the relationship between coins and engraved portraits suggests that a different tradition, that of the *imago clipeata*, authorizes the head as the dominant type for the systematized gallery or collection.

The *imago clipeata* was annexed for numismatic purposes, but it is not a medium or a genre but rather a concept. Bastien suggests that the principle of the *clipeus* is associated with the shield as circle, and that this, by extension to the sun and the circular world, became an image of cosmic significance. Images of ancestors or emperors could be incised on shields. When soldiers marched forth bearing shields inscribed with the emperor's head, they were armed with a device that imaged the literal bearing-forth of the emperor that occurred when, in victory, they raised the body of the emperor on their shields. The *clipeus* is thus, by this argument, intimately connected with the idea of the sun-emperor (*empéreur-*

soleil).[75] What is interesting from our point of view is that this tradition – thought to originate in the last centuries of the Roman Empire and to have continued into the Middle Ages – offers a paradigm for the depiction of the head in an oval or a roundel in such a way that the wresting of the portrait image from any kind of context and the absence of any coherent visual connections between it and its neighbours are seen to be part of the intrinsic structure of that image. Thus the *clipeus* as type can explain the contradictions and the disjunctures that characterize the collections of engraved heads in the eighteenth century. It may also help to account for the persistence of a suggested oval or circular framing device (the so-called 'feigned oval') within rectangular portraits by artists as different from each other as Ramsay and Gainsborough.

The significance of a collected medal or a coin lay in its coherence and its propriety: face and reverse worked together to produce meaning, each coin related to the previous and the successive minting. In Pope's words, 'The medal, faithful to its charge of fame, / Through climes and ages bears each form and name / In one short view, subjected to our eye, / Gods, emperors, heroes, sages, beauties lie'.[76] On the other hand, to open the pages of, say, the British Library's grangerized edition of Clarendon's *History of the Rebellion* (see pl. 91) or to look at a page of one of Pepys's albums is to experience shock at the disjunctures, at the independent assertiveness of each portrait. A precedent for these characteristics may be found in the use of *imagines clipeatae* in imperial Rome and in Byzantium where they frequently brought together different individuals, some living, some dead, some human, some divine, in a structure not dissimilar to the grangerized collection.

Most interestingly the *clipeus* is used to indicate absence: the device draws together those absent and those present. The absent is invisible to human eyes and is therefore represented in *clipeus*. It was thus a format frequently used for Christ in early Christian art.[77] Grabar speaks of galleries of Christian portraits in *imago clipeata* from the fourth century, and we may see the principle still at work in the mosaics of S. Demetrios, Salonika, where images of dead saints appear in medallions alongside those of the living (pl. 76). In the eighteenth century the device remained familiar both in history painting and in portraiture, even though its name and origins had been forgotten. It is, for example, used in Zoffany's famous depiction of the Royal Academicians (pl. 77), in which the two women founder members, Mary Moser and Angelica Kauffmann, whose presence in the life class was prohibited on account of their sex, are imaged in *clipeata* on the back wall (pl. 78). The concept of *imago clipeata* with its long tradition and its connection with coins functioned as an unwritten theory, an unspoken principle lending coherence to what now appears incoherent. On the one hand it justified the uniting of those absent with those present, or of the long dead with the recent dead, and on the other it provided invisible connections between objects that now appear disparate to us as visual signs.

iii The Grangerized Book

Granger's system ultimately led to the creation of bound volumes in which portraits were mounted. This section examines some particular instances of grangerizing and assesses how meanings are produced through the construction of particular physical objects – volumes (usually very large in format) containing pasted ensembles of text and image. The first question, that of authenticity, increasingly perplexed collectors and pasters. A major shift from the idealism of the classical model to an insistent materialism is intimated in the course of the eighteenth century as collectors became preoccupied with matters of authenticity. Nevertheless, the dominant empiricism that underpins the formation of the National Portrait Gallery in the mid nineteenth century manifests itself only in the last years of the eighteenth century. It is most clearly articulated by Charles John Smith who published an autographical equivalent to Granger in 1829. Smith believed that 'by the perusal of history an interest in its prominent actors is excited, which leads to enquiries into their origin, their family connexions, their private circumstances and habits, and, their individual characters'. Smith attributes to 'natural curiosity' the wish to know the personal appearance of figures from the past. The lack of portraits of eminent characters from the earlier periods of English history can be compensated for by reference to autographs, once 'the art of writing was no longer left to the professional

76. W.S. George, *Mosaics in the North Inner Aisle of S. Demetrios, Salonika*, watercolour, 1909. British School at Athens.

Circular and oval forms are common in Byzantine art; here they are used to represent dead saints alongside living ones.

77. Johann Zoffany, *The Academicians of the Royal Academy*, oil on canvas, 100.7 × 147.3 cm., 1771. The Royal Collection, St James's Palace. Her Majesty the Queen.

The painting commemorates the gift in 1771 of rooms in Old Somerset House to house the schools of the Academy. The absent female members (who were excluded from the life class) are represented in oval head-and-shoulder format on the walls.

scribe. . . . Next to a portrait . . . the Autograph of a great man is the most valuable notice of him.'[78] The collecting of autographs marks the shift from a concern with the sign for the historic person to an interest in the trace of that person's actual existence. Whereas Richard Bull's grangerized *Biographical History* contains much written material, virtually all of it is produced by Bull himself or by his close associates and offers, therefore, a commentary upon the visual material rather than an extension of it. On the other hand autographs were an integral part of the nascent National Portrait Gallery and were exhibited in glass-topped cases alongside portraits in the South Kensington Museum in the 1870s.[79] As Smith expresses it:

> Our curiosity tempts us to approach yet more closely, and we are desirous to learn what more individual relics of the personages themselves, the still remaining vestiges of their actual existence, are now to be contemplated. This feeling, indeed, is a popular one; and it has met with much popular respect. Very prevalent has been the custom of preserving articles intrinsically worthless, and treasuring them as mementoes of the great departed. The arms they wore, the weapons they wielded, the seats and furniture they used, and

trifles of all descriptions, have been esteemed worthy of preservation, and even of respect.[80]

This preoccupation with authenticity, informing Smith's account, originates in the eighteenth century and may be seen as a legacy of the antiquarian researches of men like Aubrey, Ashmole and Dugdale. George Vertue went to considerable lengths in 1730 to authenticate Milton's portrait. He visited the poet's daughter, taking with him 'two or three different prints of Milton's picture, which she immediately knew to be like her father'. He showed her the painting he had to engrave, 'which she believe[ed] not to be her father's picture, it being of a brown complexion, and black hair, and curled locks. On the contrary, he was of a fair complexion, a little red in his cheeks, and light brown lank hair.'[81] It was precisely this kind of enquiry that was conducted – though at a greater distance in time – by George Scharf as Keeper and Secretary of the emergent National Portrait Gallery in the 1860s.[82]

James Bindley, one of the best-known collectors of 'heads', wrote to Granger in 1775: 'I do not love doubtful portraits, much less then such as I know cannot have any sort of resemblance; for my part, I do not ambition a very numerous collection; but I wish to have such as I collect genuine, and in the best

78. Detail of pl. 77 showing portraits of Moser and Kauffmann.

Angelica Kauffmann and Mary Moser were founder members of the Royal Academy.

79. School of Crispin Van de Passe I, *The Gunpowder Conspirators*, engraving, 1606. Trustees of the British Museum, London.

In this broadsheet with text in German and French the narrative of the gunpowder conspiracy is set out and each of the participants represented and named.

81 (facing page bottom left). *The Gunpowder Conspirators*, engraving published October 1794 by Herbert and Caulfield, from J. Caulfield, *Portraits, Memoirs and Characters of Remarkable Persons . . .*, 1794. By permission of the British Library, London.

Caulfield follows the Van de Passe engraving closely, but all the major elements are exaggerated: the faces are coarser and fiercer, Bates's hair is more abundant and unruly and the jewels and feathers in the conspirators' hats are more conspicuous.

82 (facing page bottom right). *Guy Fawkes*, engraving published 1 April 1794 by J. Caulfield, from J. Caulfield, *Portraits, Memoirs and Characters of Remarkable Persons . . .*, 1794. By permission of the British Library, London.

The process from broadsheet to 'portrait' is complete with the extraction by Caulfield of the figure of Guy Fawkes who is now seen alone and in three-quarter-length.

condition . . .'.[83] Bindley's declaration suggests that authenticity had become an issue by the 1770s as a result of the increase in collecting, exchange and dissemination of prints, many of which were recognized by the discerning as counterfeit. Born in 1737, Bindley was the son of a Smithfield distiller; as Senior Commissioner of Stamp Duties, he was entitled to spacious apartments in Somerset House, and here he housed the collection of books, engravings and antiquarian objects for which he became renowned and which, we may guess, he purchased mainly with his earned income rather than with any inherited wealth. Bindley was a great friend of Nichols but it is from Mark Noble, author of the continuation of Granger published in 1806, that we have an unusually detailed description of a collector of this class:

The apartments were as much enriched with ancient Books and other valuables as a gentleman's

well could be. The many antique volumes did in their original bindings dazzle the eyes, but they well bore perusal. His engraved portraits were select beyond example. His coins marbles and seals were very valuable. He was indefatigable and always generous. When I have enquired after curiosities the answer has often been we save all for Mr. Bindley: he comes, views, chooses, and lays down more than we should have desired to ask. His ample income, his having no family, and his parents prudent habits all contributed to enable him to be beneficent in these respects to himself and generous to others. A more amiable man did not live. The learned and the curious were received with a friendly politeness but he gave no dinners or suppers. The tea pot was common property to any who claimed it . . . His dress was the fashion of his younger days, the hair was tied behind in a knob with long curls at his ears. Ruffles adorned his hands, his cloaths were plain but good and of a cut

68

which the Taylor could find no other pattern but the preceding suit. He appeared as a respectable gentleman of other days . . . It is singular that he never as far as I know wrote upon any subject though very intelligent upon many.[84]

Among the volumes admired by Noble was the 'Bindley Granger', an 'assemblage of extraordinary and unique Portraits unrivalled for excellency of preservation and brilliancy of impression interspersed with numerous elegant drawings in colours from curious original pictures'.[85] Bindley's collection has not survived, but we know it to have included, for all his declaration to Granger on the virtues of the authentic, such 'doubtful' prints as 'Damnable, Mother Damnable' in a unique impression of 1676.[86]

James Caulfield's *Portraits, Memoirs and Characters of Remarkable Persons . . .* (1794) was made possible by the loan of scarce prints from Bindley's Collection; he is acknowledged in the advertisement to this book which claims to have collected 'from the most authentic accounts extant'. But Caulfield, for his part, experienced no dilemma in manufacturing a portrait where comprehensiveness required one but none existed. Elsewhere images are appropriated from a readily available pool of familiar types. The gunpowder conspirators is a case in point (pls 79, 80). Caulfield offers in volume two a portrait of the conspirators as a group signed by Herbert Caulfield (pl. 81) and, extrapolated from this group, a single image of Guy Fawkes (pl. 82). The group is derived from a detail of an anonymous broadsheet describing and depicting the stages of events leading up to, and subsequent to, the gunpowder plot. It is dated 1606 with a text in German and French. Although

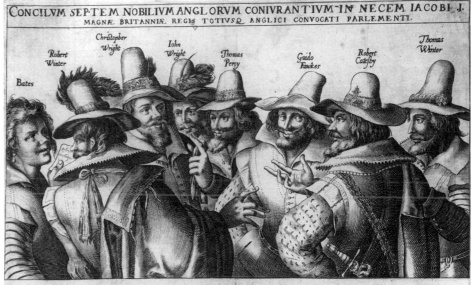

there is no evidence for the authority of this early seventeenth-century portrait of the conspirators, a print of the detail showing only the group, displayed in the National Portrait Gallery, further endorses its authenticity (pl. 80). The composition with which this filiation originates is thought to be from the workshop of Crispin Van de Passe the Elder and seems to have been copied and adapted many times.[87]

Grangerizing became a craze in a period in which the elegantly printed book with the single frontis-

80. Detail of pl. 79.

The central group, all of whom have standarized faces and villainous expressions, became the authoritative type for the 'portrayal' of the conspirators and was published on its own with minor changes.

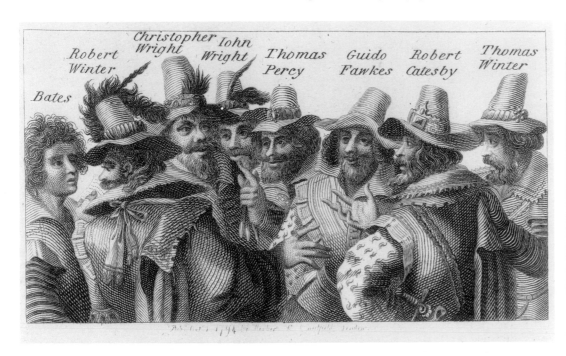

GUY FAWKES.
Executed in the Year 1606,
for the GUNPOWDER PLOT.

69

by examining how the grangerized text produces a range of meanings through the dynamic relationship of text to image.

Richard Bull was probably unusual only in the extent of his print collecting and in his formation of extra-illustrated books (in all he filled 250 volumes), and in the providential survival of two of his collections virtually intact.[88] The nineteen large folio volumes of Granger's *Biographical History* are supplemented by a further sixteen volumes, taking the series up to and including the reign of George III, though here Bull was working without the assistance of Granger's listings. The 'Granger' is regarded as extremely exhibitable and both Bull and his friend, Granger, would have been unsurprised to learn that organizers of historical exhibitions in the late twentieth century turn with frequency to their collection when in need of historical portrait illustrations.

Bull, an MP, devoted boring sessions in the House of Commons to writing letters about historic portrait heads. At home, his daughters assisted him in pasting up his prints; Granger's biographical text was usually cut out and pasted underneath. Where several images occupy a page they, and the biographical inscription, are connected by printed linked chains which are also cut out and pasted on, care being taken illusionistically to connect the end of the chain to the inner frame. This kind of fancy decoration was available from print-sellers for collectors who stuck their prints onto walls and embellished them with frames and borders. Sometimes one of Granger's marginal glosses will be transcribed by Bull in ink, and occasionally he adds biographical material of his own. He seems, for example, to have admired the Emperor Charles V (admissible as an important foreigner) and appends to his portrait a long and animated commentary on his life and death.[89] Each reign commences with an elaborate title-page compiled from engravings and hand-lettering (pl. 83). A typical page during the earlier periods, where Granger's listings are few, will contain three or four linked engravings and perhaps a 'wild card', or unauthenticated engraving, left free-standing, as with the dignitaries of the Church under Henry VIII (pl. 84).[90] The frames are drawn in black ink and washed in with pale brown. The overall effect is of the text linked to the images, rather like a cartouche under an oil painting, and the images linked one to another in an established succession.

This collecting and pasting process was by no means slavish, and Bull happily included individuals not listed in Granger.[91] Extremely rarely engravings other than portraits are inserted: volume four includes a number of views and ground-plans of Audley End. Throughout are to be found marginal comments by Bull in tiny letters: 'very scarce', 'very rare', along

83. The Reign of Queen Elizabeth, engravings cut and mounted, title-page to volume 3 of Richard Bull's grangerized copy of Granger's *Biographical History of England*. Huntington Library, San Marino, California.

piece was the norm. It must have appeared a megalomaniac's pleasure then. Today, in an age of mass printing and publishers' house styles, grangerizing offers texts that appear to lack all coherence, to be constantly breaking their bounds. Based on a classifying principle, they defy classification. Are they unique artefacts or are they printed and therefore repeatable items? It is this apparent aesthetic subversion of the principle of order and system that will be addressed in the conclusion of this section,

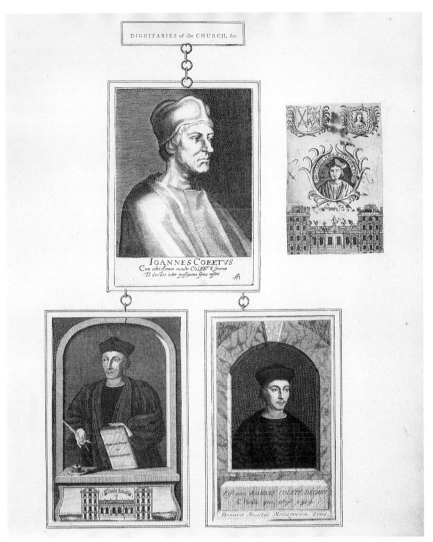

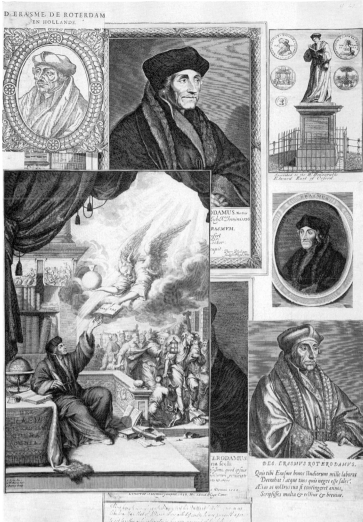

with prices he has paid for prints marked in the corners. Under *The Duke of Buckingham on horseback* by Webb he has written: 'I gave five guineas for this Print. A very middling one sold at Mr. West's auction for five pounds, ten shillings.'[92] Collecting was fiercely competitive. Under *Henry, Viscount Falkland* by Barra after Van Somer, Bull has written: 'This print is extremely scarce: I know of one more only, w[h] is in Mr. Walpole's collection'. Then in pencil he has added on a scrap of paper: 'NB I bought 1,200 prints of Mr. Ridley, for the sake of this one – I am now assured that Mr. Walpole has it not – if so I know of none other.'[93]

The ordered impression given by a page of visually linked dignitaries of the Church under Henry VIII completely breaks down with the inclusion of an internationally celebrated figure like Erasmus (pl. 85), and the imagery runs riot – both sides of the folio page swamped and engravings overlapped, interleaved and even sometimes (in desperation?) dropped in. An ordered page may connote propriety

84. Dignitaries of the Church from the reign of Henry VIII, engravings cut and mounted by Richard Bull in his grangerized copy of Granger's *Biographical History of England*. Huntington Library, San Marino, California.

85. Erasmus of Rotterdam, engravings cut and mounted by Richard Bull in his grangerized copy of Granger's *Biographical History of England*. Huntington Library, San Marino, California.

Bull's orderly system of arranging each page with engraved chain links connecting images breaks down in the case of Erasmus for whom he collected twenty-six portrait images which he was obliged to mount overlapping each other.

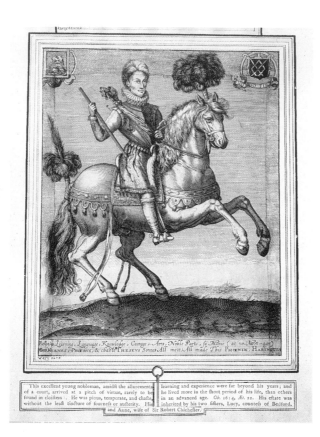

and control, but here the relationship of each image to its neighbour is ignored. Thus profile portraits face in different directions, producing a haphazard impression in a seemingly ordered space. Similarly there is no regard for stylistic distinction. Indeed the entire production appears to repudiate the aesthetic in favour of the symbolic. In the case of a figure like Erasmus (where Granger lists seven images and Bull has collected twenty-six), the very profusion and the unwieldiness of the pages consequent upon such a mass of pasting speaks not of the studied likeness but of a formalized attempt to contain in the folio page the immeasurable confusion of the past.

The age-value was of paramount importance in Bull's grangerizing; the curatorial respect pertaining to modern-day collecting of rare items is entirely absent. Accordingly, when faced with a badly cropped image, Bull (or, more likely, his daughters) set to work to complete the missing parts. Thus John Harrington, Baron of Exton, a rare print, had been acquired by Bull in a mutilated state (pl. 86).[94] Two and a half centimetres are missing from the top margin and slightly less from both sides. Amusingly this has the effect of removing the top of Harrington's head and most of the armorial bearings from the corners. All this is meticulously (if, in the case of the bearings, uncertainly) reconstructed in ink to produce, at a superficial glance, a complete image (pl. 87). This is, literally, to reconstruct the past.

While grangerizing Granger had to take place properly within the framework of those engravings listed by Granger, those who chose to add supplementary portraits to other books had to exercise great independence of judgement and produce unique copy. Edward Hyde, First Earl of Clarendon wrote *The History of the Rebellion* between 1646 and 1672. The history of Clarendon's manuscript is inextricably bound up with the history of the Tory party and, through its association with Oxford, also with the history of publishing via the foundation of the Oxford Press. The first edition was dedicated to Queen Anne and published between 1702 and 1704.[95] It is a book that became a best-seller in the eighteenth century and has fascinated historians and biographers for nearly three centuries. Clarendon's *History* had also, even before its publication, been associated with the principle of portraiture. Richard Wendorf has pointed out that Clarendon took little interest in the outward appearances of men in the character sketches he wrote in *The History of the Rebellion*.[96] But this is to address Clarendon's intention and in so doing to overlook the issue of effect and the cultural context in which the text was written – leaving aside the history of its reception. Clarendon, as is well-known, formed a major collection of portraits at the time he was writing his *History*.[97] Evelyn recorded the collection of pictures of great Englishmen at Clarendon House in 1668,[98] and, when he came to write *Numismata* in 1697, he proposed a visual history of the English civil war through portraiture as one of the most worthy objects for a collector of portrait prints.[99]

It seems clear that, from its inception, *The History of the Rebellion* was tied to a notion of the portraits of the men whose history it was understood to be. This

element was, however, neglected in the three-volume first edition which contains a solitary portrait of Clarendon himself (repeated in each volume).[100] Elsewhere the text is ornamented by allegorical head- and tail-pieces and elaborate historiated initials (pl. 89). The events were uncomfortably close and the raising of spectres from the past in the form of

individuals' portraits might be deemed dangerous: allegorical references were thought more fitting to the political uncertainties of the age than heroic portrait heads. This is born out by the tone of the dedications and prefaces (probably by Laurence Hyde):

> Comparisons of Times may be as odious as that of Persons; and therefore no more shall be said here on that Subject, than that since the Restoration, and some few years after it, given up to joy, and the forgetfulness of past Miseries, there hath been no time that brought so much hope of quiet, and so general a satisfaction to these Kingdoms, as that on which we saw your Majesty so happily seated.[101]

THE
History of the Rebellion, &c.
BOOK VI.

Isa. XVIII. 2.

Go, ye swift Messengers, to a Nation scattered and peeled, to a People terrible from their beginning hitherto; a Nation meted out and troden down, whose Land the Rivers have spoiled.

Isa. XIX. 13, 14.

The Princes of Zoan are become fools.
The Lord hath mingled a perverse Spirit in the midst thereof.

HEN the King set up his Standard at Nottingham, which was on the 25th of *August*, as is before remember'd, he found the place much emptier than he thought the fame of his Standard would have suffer'd it to be; and receiv'd Intelligence the next day, that the Rebel's Army, for such now he had declared them, was Horse, Foot, and Cannon, at *Northampton*; besides that Party which, in the end of the Fifth Book, we left at *Coventry*: whereas His few Cannon and Ammunition were still at *York*, being neither yet in an equipage to march, though Sr *John Heydon*, his Majesties faithful Lieutenant of the Ordnance, used all possible diligence to form and prepare it; neither were there Foot enough levied to guard it: and at *Nottingham*, besides some few of the Train'd-bands, which Sr *John Digby*, the active Sheriff of that County, drew into the old ruinous Castle there, there were not of Foot levied for the Service Yet three hundred Men. So that they who were not over much given to fear, finding very many places in that great River, which was looked upon as the only strength and security of the Town, to be easily fordable, and nothing towards an Army for defence but the Standard set up, begun sadly to apprehend the danger of the Kings own Person. Insomuch that Sr *Jacob Ashley*, his Serjeant-Major-General of his intended Army, told him, "that he could not give any assurance against his Ma-"jesties

The King's condition at Nottingham.

Vol. 2. A

When Thomas Salmon came to publish his *Chronological Historian* in 1733, he criticized 'even that well-wrote History of the Lord Clarendon's' for its failure to be sufficiently particular in ascertaining the dates at which some of the things he relates took place.[102]

Salmon's account is illustrated with portraits by Vertue (pl. 88) and demonstrates the importance of the relationship between image and text in establishing a correct and lucid understanding of chronology: the Norman and Saxon kings, for example, are defined through a chronological chart supported by a page of roundel portraits which were created by Vertue allegedly from manuscripts and effigies. The effect of veracity is established thus by visual means.[103]

In 1732 a new edition of Clarendon's *History* was published. This contained the same frontispiece and title-page as the first edition but also included portraits, some of which are engraved after paintings in the Clarendon collection or have common sources (pl. 90).[104] These are simply grouped four to a page and inserted into this publication without attempt to co-ordinate them in any way. Thus the variations in scale and in framing devices produce an extremely haphazard effect. Their purpose was, however, in all likelihood to stabilize the reputations of the individuals featuring in the account. The editors were concerned to correct any impression of untruth: 'We are not ignorant that there are Accounts, contained in this following History, of some Eminent Persons in those Times, that do not agree with the relations we have met with of the same persons, published in other Authors.' The reader is assured, however, 'by the Candor, and Impartiality of what he relates' that Clarendon 'may be believed not to have made any wilful mistakes'.[105]

The anonymous print-seller who set about grangerizing Clarendon's *History* in 1796 had, in Salmon and in the 1732 edition of the *History*, precedents for an illustrated historical account.[106] But the eight volumes that resulted from his endeavours and which are now in the British Museum reveal the way in which Granger's practice was extended as an act of interpretation in the telling of history. The pages of the first edition are cut and mounted in Royal-size sheets of paper. The images are arranged facing the text or distributed about it (pl. 91). The act of reading involves an apprehension of image and word in integral relationship. In the preface to volume one, for example, the passage concerning Clarendon's fall from favour concludes with the observation that 'there are always in Courts Secret Engines, that Actually consummate the Mischiefs, that others, in a more publick way, have been long in bringing to pass: And in this case there were two principal ones: The one, the Interest of some of the Zealots of the Popish Party, who knew this Minister had too much credit . . . The other, the Faction of the Ladys, too prevalent at that time with the king . . .'. The reader is obliged to turn the page at the end of the reference to the Popish Party and instantly sees a mezzotint by Valck after Lely of the Duchess of Portsmouth, Charles II's French-born, Roman Catholic mistress,

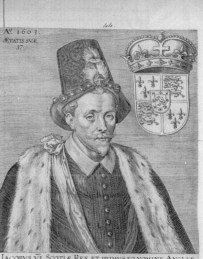
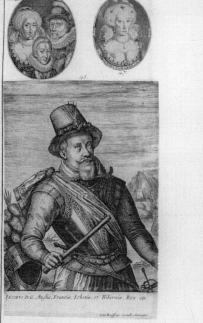

90 (facing page). Illustration from Clarendon's *History of the Rebellion and Civil Wars in England*, 1732. By permission of the British Library, London.

This illustration which appears in volume 2 facing page 351 consists of four portraits crudely copied from other engraved images with no adjustment for their relocation. Only the portrait of the Earl of Carnarvon is at all close to the relevant text reference.

91. Page from Clarendon's *History of the Rebellion and Civil Wars in England*, anonymous grangerized copy of first edition, 1702–4. Trustees of the British Museum, London.

Page 5 in volume 1 incorporates a dynastic array of images of Queen Elizabeth and James I. The reader is invited to move around this large format folio volume to examine the images inserted side on at the top and bottom of the page.

93 (facing page top). Detail of pl. 92.

Grangerizing affects the reading of a text. In this instance the effect of the arrangement of portraits of women associated with the king – especially as the Duchess of Portsmouth's image has been daubed with paint – is to stress the 'Faction of the Ladys'.

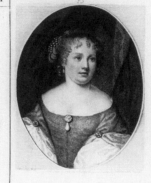

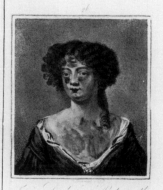

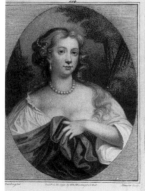

NELL GWYN

92. Page from Clarendon's *History of the Rebellion and Civil Wars in England,* anonymous grangerized copy of the first edition, preface, p. xxi. Trustees of the British Museum, London.

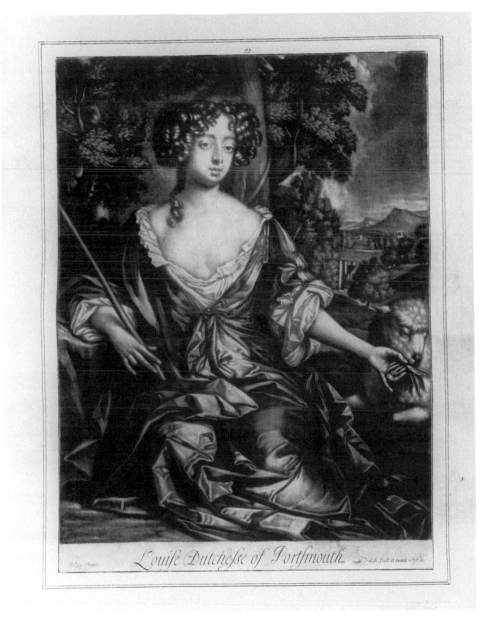

were being augmented and endorsed by a wealth of portrait images, the project to update Granger by supplementing the catalogue was undertaken by Henry Bromley. Published in 1793, this indicates contemporary interests at the opposite extreme to the narratization of the Glorious Revolution. Now the number of convicts' and monsters' images recorded in period VII (1728–60) almost equals those of the female sex in its entirety. Bromley's catalogue, moreover, was advertised with a frontispiece that features the heads of British poets in medallions, placed on a rocky outcrop down which a waterfall thunders, while overhead Pegasus, favourite of the Muses, gallops through the sky, an image that contrasts notably with the taxonomic preoccupations of an earlier generation (pl. 95).

as a shepherdess (pl. 94). On the facing page the reader encounters the 'Faction of the Ladies' and discovers in more detail how Clarendon 'fell a Sacrifice to the Ambition, and Malice of all sorts of Enemies, who were desirous of getting new places to themselves in the Court'. This passage is embedded in a sequence of images of Nell Gwyn, Mrs Davis (an actress mistress of Charles II) and the Duchess of Portsmouth (crudely over-painted or defaced) (pls 92, 93). The effect of these pages is overwhelming: the reader (who was probably extremely familiar with Clarendon's account) could have concluded only that female culpability was all-embracing and inescapable.

Elsewhere the narrative of an individual's life is expanded (for example, the Duke of Buckingham's) and characters who are relatively insignificant in Clarendon's account are accompanied by a fanfare of portrait images that promote their role in the account to extents that far exceed the textual space allotted them. Sir Edward Coke is mentioned by Clarendon merely for having called the Duke of Buckingham blasphemously 'Our Saviour', but he gets five portraits.[107]

At roughly the same time as the pages of Clarendon

95. Frontispiece to
H. Bromley, *A Catalogue of
Engraved British Portraits*,
1793, engraved by Richard
Earlom and published by
Boydell. Huntington
Library, San Marino,
California.

As this print does not appear
in the three-volume edition
in the British Library and
elsewhere, it seems that it
may have been either a
luxury edition or a pre-
publication advertisement.

96. J.R. Smith, *Sir William
Musgrave*, mezzotint, 1783,
second state. Trustees of the
British Museum, London.

J.R. Smith's signature has
been removed from this
portrait in which Musgrave
looks older than in plate 69.
Here he holds Granger's
portrait in his left hand, and
behind him a shelved set of
grangerized volumes of
Granger's *Biographical History
of England* is visible.

Whereas Evelyn was a highly educated *virtuoso* and Granger a country clergyman, Henry Bromley was born Anthony Wilson in 1750 in Wigan and is presumed to have called himself Bromley after the distinguished family of engravers. He was assisted in the compilation of the catalogue by many leading antiquarians, including Sir William Musgrave (pl. 96) and James Bindley.[108] Indeed it seems that he worked more as an employed researcher than as a self-employed scholar of independent means. Thus the reinscription of Granger's system at the turn of the century occurs in circumstances that are shaped by those very factors of difference that the systematization of portrait-collecting and the ordering of the concepts of portraiture helped to bring about. None the less, Bromley maintained some of the traditions of predecessors like Ashmole and Pepys. He acquired his knowledge of engravings by frequenting the sale rooms of Nathanial Smith (father of the antiquary John Thomas Smith) and by attending Hutchins's auction rooms where he was detected on one occasion stealing prints.[109]

III SIGNIFICANT AND INSIGNIFICANT LIVES

i *Likeness and Genre*

Evelyn's enthusiasm for sectaries, enthusiasts, imposters, conspirators and 'bold Usurpers', set out in the previous chapter, raises questions about portraiture as pre-eminently a discourse of the exemplary and virtuous life. Portrait painting, as we saw in chapter Iii, is an innately conservative practice, controlled by the strict requirements of a contractual relationship between artist and patron (who is frequently also subject). Scholars have paid special attention to portraits as a part of the *oeuvre* of a particularly distinguished artist (as with, say, Rembrandt's self-portraits or Ingres's portraits of female sitters), or when the sitter has been known to be powerful and the portrait can be seen as offering access to an understanding of that person's position (as with Partridge and Starn's study of Raphael's portrait of Pope Julius II).[1]

In either instance, the 'good' portrait is largely seen as the one that departs from convention and offers apparently original solutions to the intractable problem of the representation of the human subject for consumption in that subject's own social and political milieu. In the eighteenth century Reynolds's *Commodore Keppel* (London, National Maritime Museum) and Hogarth's *Captain Coram* (London, Thomas Coram Foundation) stand as monuments to excellence of this kind, the first for the way in which it mobilizes the theory of imitation that Reynolds himself had so forcefully promoted in the *Discourses* to offer a novel solution to the problem of rendering the full-length figure with verve whilst endowing it with the dignity of classical allusion. The second is notable for its break with conventions of pose and handling and its ability to provide a startlingly original image.[2]

It is extremely doubtful whether eighteenth-century audiences evaluated portraits in this way. However, whilst ingenuity in achieving a solution to a problem of pose or of lighting may have been admired by *cognoscenti* and members of the Royal Academy, the general notion of what makes a good portrait was somewhat different. Historians are dependent upon the comments of contemporary observers for evidence that a given portrait was a good likeness of the sitter. 'Capturing' a likeness was regarded by the Ancients as neither more nor less than miraculous. The eighteenth century, however, tried to find systematic procedures for what was wonderful in Antiquity. Thus a writer can describe 'an excellent painter who succeeded very ill in his likenesses . . . , he made bad portraits, and good pictures'.[3] This distinction between likeness and other artistic qualities echoes the judgements of Dryden and Pepys when dealing with Lely's Beauties[4] and suggests a division in the ways portraits were read in the eighteenth century.

This is confirmed in reading between the convolutions of Anthony Pasquin's prose, which distinguishes between likeness as a quality readily achieved and general effect which is more significant and more elusive. Thus he says of Gainsborough Dupont's *Mr Quick in the Character of Spade*, painted for Mr Harris's gallery of the principal performers at Covent Garden:

> This is a spirited likeness of that excellent comedian, but executed too much in imitation of the late Mr. Gainsborough: the general outline is nearly faithful; but the affection, visible in those scratches of the hogtool or fitch, over the visage, is disgusting because it is unnatural.[5]

It remains difficult to get a sense even from a populist work like Walpole's *Anecdotes of Painting* how portraits were read in the eighteenth century, and this remains true even after the foundation of the Royal Academy in 1768; an artist like Charles Jervas (who painted virtually exclusively in the field of portraiture) is rated according to his abilities in drawing, colouring and composition, qualities of a general kind that are not particular to the art of portraiture.[6] Eighteenth-century collectors of historical portraits were, as we have seen, not primarily concerned with likeness. A 'good picture' of the Duchess of Richmond is described by the Revd Robert Masters in about 1762 as

97. Henri-Pierre Danloux, *Adam Viscount Duncan*, oil on canvas, 76.2 × 62.2 cm., 1792, National Portrait Gallery, London.

Duncan had distinguished himself at the relief of Gibraltar and was made Vice-Admiral the year after this portrait was painted. Both the pose and the clarity of line of Danloux's portrait evince his national origins.

Half length, with this inscription on the frame: *Frances Duchess of Richmond and Lenox, daughter of Thomas Lord Howard of Bindon, who was second son to Thomas. Duke of Norfolke, whose mother was the Lady Elizabeth Stafford, eldest daughter of Edward Duke of Buckingham. Her Grace was born 27 July 1577. London 1633.* She is drawn in black with a very fine lawn ruff and handkerchief, and many strings of pearls; on her left side hangs a miniature, probably of her husband, exceedingly well done; her right side is supported by her fan, and on a small table on the other side is placed her coronet.[7]

Quality is here construed in terms of a secure provenance (through inscription) and good craftsmanship (the miniature well done). Reference to the face or to likeness are notably absent.

In the case of portraits produced in the period, we would expect likeness to be an overriding factor. We know, for example, that Gainsborough was picked out by William Whitehead in 1758 on account of his ability to secure a likeness, and that this was valued even where other qualities were found lacking: 'We have a painter here who takes the most exact likeness I ever saw. His painting is coarse and slight, but has ease and spirit.'[8] There are recorded cases of patrons refusing to pay on the grounds that the artist had failed to achieve a satisfactory likeness; other sitters resigned themselves to a flattering likeness that reduced their age. Lady Jerningham told her daughter in 1800 that she had been sitting to Opie, 'dressed d'après le Breste, in Black velvet and gold fringe, my French veil over my hair – leaving out the Cap underneath'. Everybody, she says, finds it very like, and she believes it is so, 'only with 10 or 13 years taken off, so that it will do for posterity'. Flattery she does not dislike, 'as it makes a decent picture'.[9]

The overall visual effect of the portrait, its stylishness and its dramatic impact, were also major considerations, at least by the last decade of the century. Danloux admired Romney 'malgré la ressemblance vraiment defectueuse de ses modèles', because 'toutes les têtes sont bien placées, gracieuses, et comme sa touche semble facile' ('despite the truly defective likeness of his models . . . all his heads are well placed, gracious, and like his touch seem easy'). According to Danloux, English artists kept their exhibition rooms dark so that their paintings could be advantageously lit. His overall judgement of the qualities valued in English portraiture at the end of the eighteenth century was that 'tout dans ce pays-ci cède a l'apparence: les anglais ne pensent pas que ce qui est beau et bon puisse se montrer simple et modeste' ('Everything in this country yields to appearance: the English don't believe that what is beautiful and good can show itself to be simple and modest').[10]

In theory, questions of effect were not paramount. Jonathan Richardson's account of portraiture from the first quarter of the century lays specific emphasis on the 'Noblest, and Most Beautiful part of Humane Nature, the Face'.[11] He offers a clearly articulated view of the objectives of portraiture which, not suprisingly in view of his own practice, he regards as scarcely less honourable than those of history painting:

To be a good Face-Painter, a degree of the Historical, and Poetical Genius is requisite, and a great Measure of the other Talents, and Advantages which a good History-Painter must possess: Nay some of them, particularly Colouring, he ought to have in greater Perfection than is absolutely necessary for a History-Painter.

'Tis not enough to make a Tame, insipid Resemblance of the Features, so that everybody shall know who the Picture was intended for, nor even to make the Picture what is often said to be prodigious Like: (This is often done by the lowest of Face-Painters, but then 'tis ever with the Air of a Fool, and an Unbred Person;) A Portrait-Painter must understand Mankind, and enter into their Characters, and express their Minds as well as their Faces: And as his Business is chiefly with People of Condition, he must Think as a Gentleman, and a Man of Sense, or 'twill be impossible to give Such their True, and Proper Resemblances.[12]

Debates about the relationships between the ideal

and the actual, biography and portraiture, experience and representation were the medium of eighteenth-century philosophical aesthetics.[13] It is tempting to regard writings such as Richardson's treatise, Reynolds's *Discourses* or Hogarth's *Analysis of Beauty* as paradigmatic: the theoretical investigations of Johnson's contemporaries link them with their immediate predecessors Dryden and Shaftesbury and, by direct inheritance, with Classical Antiquity. But it must be recognized that the task of such accounts is to accommodate into a generalization, rather than to address, the specific historical problems posed by questions such as likeness. The theorization of beauty and the ideal in the eighteenth century is constructed out of a context of representational practice, a practice that is darkly alluded to in Richardson's reference to 'Lowest of Face-Painters . . . Air of a Fool . . . Unbred Person'. Likeness as a concept must be historically specific; the emphasis on the face in Richardson's theory, as well as the identification of portrait painting at a theoretical level with history painting, allows us to by-pass the historical questions of what likeness might mean, how the portrayal of the body as an entity might work, how portraiture functions in a particular society where Fools and Unbred persons abound and where the painter 'must understand Mankind'.

It is acknowledged that the process of recognition upon which the concept of likeness is dependent is highly complex. A psychologist's definition of the field (which by its very nature is ahistorical but may none the less be useful) runs as follows:

> Although potentially reliable keys to identity, faces form a class of objects whose recognition poses a far from trivial problem of visual pattern classification. All faces must resemble each other to some extent because they have evolved to subserve such a variety of functions, which include the bearing of sense organs at appropriate places and the provision of an entry point for food, as well as the more obvious communicative functions . . . Individual facial identity must be superimposed upon the basic pattern of the face in a way which does not impede vision, digestion, or communication, and yet makes the face unique. The result is that faces form a rather homogenous set of patterns in which there may be very subtle differences between one individual's face and the next.[14]

'Likeness' is that which enables the viewer to match a representation with a given human subject. But this is never an isolated activity; such processes of reading are culturally determined. There is, to draw again on the psychologist's argument, an 'essentially arbitrary relationship between the surface form of a face, or a name, and its identity specific semantics'.[15] We have to know what the face means in order to identify it.

The act of identifying a familiar face can be compared quite naturally with that of understanding a word – readers need to know more than that the word has been seen before; they must know what it means. A person viewing a photograph of Ronald Reagan, or the words 'Ronald Reagan,' must in both instances get from the visual pattern to a semantic level to do with America, presidents, and Republicanism. In both cases the shapes of the pattern are not themselves sufficient to determine this semantic interpretation. (A face like Reagan's could be that of a bus-driver, bank manager, or ageing sportsman.)[16]

These questions were also discussed as part of medical-theological discourses in the seventeenth and eighteenth centuries. John Ray, writing in 1691, observes that while man is always mending and altering his works, 'Nature observes the same tenor, because her works are so perfect, that there is no place for amendments: nothing that can be reprehended'. By this token, a fashionable portrait invites contemplation of Nature's constancy (in the form of its figure of a man), and man's inevitable tendency to mend and alter manifests itself in the clothing, wig and surroundings in which he is represented. But for all that Nature observes the same tenor – and thus produces all human beings with the same parts - no two individuals are alike. The differences in arteries, veins as well as in facial features is, for Ray, a manifestation of Nature's playfulness: 'Were Nature a blind Architect, I see not but the Faces of some Men might be as like, as Eggs laid by the same Hen . . .'.[17] Imagining a situation in which all faces were the same leads Ray to meditate upon the extreme inconvenience that would ensue: 'What a Subversion of all Trade and Commerce? What hazard in all Judicial Proceedings?' The connection between a concern with the differentiation of faces for the proper ordering of society and a concern with portraiture is not hard to make.

One of the functions that engraved contemporary portraiture fulfilled in the eighteenth century was to familiarize audiences with the patterning of facial features. The publication and circulation of collections such as *Parliamentary portraits; or, Characters of the British Senate* . . .[18] served to acquaint the public with the appearance of a whole range of public figures long before the perfected art of wood engraving made available the features of 'our public men' to Victorian audiences via the pages of the *Illustrated London News*.[19] The success of the caricatures of Gillray and Rowlandson would have depended on

a familiarity derived from the dissemination of engraved portraits, a familiarity that they also served to reinforce.

As the practice of inscribing the name and the age of the sitter on the canvas gradually lost favour in Britain during the course of the seventeenth century[20] (such inscriptions would have challenged the illusionism of the Grand Style portrait), the need for clues as to the subject's identity increased. But whilst iconographers are sometimes able to recover the lost identities of portraits by reading the accessories and attributes of the sitter, it seems likely that the process of recognition for a contemporary audience involved far less specific and more general semantic codes.

The experiments of psychologists indicate that the reading of faces in terms of personality or character is related to the background context in a way that the reading of faces in terms of physical features is not.[21] This simply bears out the art-historical evidence that it is factors such as composition, background, pose and the handling of paint that enable readings of character to take place. It has also been argued that we more readily recognize those like us than those unlike us; thus, for example, we find it easier to recognize people of the same sex as ourselves. Such findings have implications for portrait reception in the eighteenth century. If the audience is adult, then what of child portraits? If the audience is male – and public taste was by definition male – then female portraits have to carry much more distinctive signifiers than male portraits if they are to be readily recognized. The tendency for female subjects to be treated with a greater degree of elaboration and with more complex background detail may be to some extent accounted for by this factor. These questions will be further explored in later chapters.

The question of peer-group recognition is most pertinent to the intractable historical problem of seemingly indistinguishable groups of portraits. Lely's Hampton Court 'Beauties' in the seventeenth century, or the scores of apparently identical be-wigged gentlemen in the eighteenth century, represented in three-quarter and half-length standard formats (Kit-cats) are difficult for subsequent generations to acknowledge as individuals, just as are the participants in, for example, the photographs of modern sporting teams, regiments or company outings. The semantic content is particular to the group or to the society and, paradoxically, likeness is posited then as residing precisely in that process of conforming to type that renders the evaluation of likeness as a construct so difficult for historians. A particularly self-conscious group like the Society of Dilettanti in the eighteenth century exploited this paradox. The same artist, George Knapton, was employed to paint twenty-three members. The collective identity is maintained by format, by artist

98. George Knapton, *John Howe, 4th Baron Chedworth*, oil on canvas, 76.4 × 63.5 cm. Society of Dilettanti, London.

Baron Chedworth, in this 'club' portrait, is distinguished by his Elizabethan costume and the whimsical accoutrements of a pair of compasses and a globe on a stand treated as a receptacle for wine. The baron's portrait conforms to a type but its syntax is difficult to decipher when one is not part of the group.

and by a common location for their display. On the other hand, by representing many of them in masquerade costume, 'in character', a notion of individuality is superimposed onto that of the group (pl. 98).

It is precisely those forms of schematization that societies deploy in order to establish a register of permanent characteristics against which likeness can be measured (as well as group affiliations established) that are seized upon and replicated to provide a visual cypher of a culture for a future generation. As Barthes observes apropos of our twentieth-century access to power structures in the Roman Empire via representation:

Dans le *Jules César* de Mankiewicz, tous les personnages ont une frange sur le front. Les uns l'ont frisée, d'autres filiforme, d'autres huppée, d'autres huilées, tous l'ont bien peignée, et les chauves ne sont pas admis, bien que l'Histoire romaine en ait fourni un bon nombre. Ceux qui ont peu de cheveux n'ont pas été quittés a si bon compte, et le coiffeur, artisan principal du film, a su toujours leur soutirer une dernière mèche, qui a rejoint elle aussi le bord du front, de ces fronts romains, dont l'exiguité a de tous temps signalé un mélange specifique de droit, de vertu et de conquête.[22]

(In Mankiewicz's Julius Caesar, all the characters

82

have a fringe over their foreheads. Some have it curled, others wear it straight, some crested, others oiled, all are well combed, and those·who are bald are not admitted even though Roman history has furnished a great many bald men. Those with little hair have not been let off for all that, and the hairdresser, principal craftsperson of the film, has still known how to draw out a last lock, which duly reaches the top of the forehead, one of those Roman foreheads the smallness of which has for all time signalled a specific mixture of self-righteousness, virtue and conquest.)

It has been shown in chapter II that the collecting of engraved historic portrait heads and the systematic classification of those engravings was a discursive practice in the eighteenth century, serving to establish order, continuity and wholeness in a fragmented society, marking boundaries that were threatened and reinforcing a class hierarchy. If, as proposed here, portraits of contemporary subjects are produced in eighteenth-century England within powerful imperatives to conformity, whether imperatives of pictorial convention or imperatives of likeness (and the two are, of course, connected, since convention provides the appropriate environment of familiarity necessary for the recognition of likeness), then the question arises as to where – if at all – that conformity is challenged or subverted. If portrait practice is, like the collection of heads, significantly a controlling and ordering process, does it not carry within its opposite? Is disorder – the anarchic presence of society's deviants – accommodated within the systematic practice of portraiture? Where was the measure by which Richardson could invoke Fools and Unbred Persons enforced?

The rupturing of convention that occurs at a moment of 'originality' with, for example, the invention of a novel portrait composition or the adaptation of a type from one genre in the production of work in another (as with Reynolds's *Three Ladies adorning a Term of Hymen* (pl. 99)), does not constitute subversion of the system – rather it serves to reinforce it. John Graham's allegorical portrait of Alderman Boydell was described thus by a contemporary: 'the colouring of this picture is good, and the likeness excellent; but the introduction of allegory on the same canvas with a portrait cannot but be considered as an unpardonable deviation from propriety'.[23] The view was widely shared:

As the intention of a portrait is to preserve to posterity the likeness of a person, it appears . . . to be the effect of a vicious taste, when any one is painted as it were in masquerade. What has the character of Minerva falling through the air to do with a modern lady? Or that of a Gypsy, or Turkish dresses, or any foreign ornament?[24]

The genre system, as an orthodoxy, is perpetually under threat: genres are upwardly mobile, forever seeking to annex characteristics of the genre positioned at a higher point in the scale (landscape attaining epic-narrative status, portraiture acquiring allegorical features, etc.). Portraiture posed a particular threat to the genre system, since the origins of painting ostensibly lay, according to the story of the Corinthian maid who traced her lover's profile in silhouette on the wall, not with narrative art but with portraiture and likeness.[25] Portraiture upholds the perpetual paradox of a genre that, like biography, serves crucially a society's need to construct tangible heroes who may then be emulated for their originality and genius, but that is, by its very nature, permanently excluded from the category of originality and genius. This paradox is enshrined in the contradictory meanings of the word 'portrait'. In his essay on genius and originality published in 1767, William Duff uses the term portrait in its general sense of representation and links it, as a consequence, with genius, since

original genius is distinguished from every other degree of this quality, by a more vivid and a more comprehensive Imagination, which enables it both to take in a greater number of objects, and to conceive them more distinctly . . . so that with surprising readiness it combines at once every homogeneous and corresponding idea, in such a manner as to present a complete portrait of the object it attempts to describe.[26]

99. Sir Joshua Reynolds, *Three Ladies adorning a Term of Hymen*, oil on canvas, 233.6 × 291 cm., 1773. Tate Gallery, London.

The painting represents the three Montgomery sisters. A number of writers, including Edgar Wind and E.H. Gombrich have explored Reynolds's appropriation of mythological sources for portraiture. In this instance, Reynolds made use of a range of motifs from Old Masters, including Poussin and Rubens.

100. *The Life and Death of the Duke of Berwick*, ballad (late eighteenth or early nineteenth century), printed and sold by John White, Newcastle. By permission of the British Library, London.

The essential components of the illusionistic grand equestrian or military portrait are here reorganized into an unambiguous and readily legible cypher. The figure is armed and has his hand ready on his sword, he has boots and spurs and a prancing horse. His name is clearly inscribed. The need to accommodate the text has presumably led to the loss of the duke's feet.

However, later in the same essay, Duff is bound to exclude both portraiture and descriptive poetry from his category of original genius, since neither contains any invention and can therefore be regarded only as the most 'complete copies' of the 'true originals':

We may observe in general, that as the power of INVENTION is the distinguishing ingredient of ORIGINAL GENIUS in all the fine Arts, as well as in Science; so, in whatever degree INVENTION is displayed in either of these, in the same degree ORIGINALITY of Genius will always be discovered. This distinction will exclude all PORTRAITS in Painting, however excellent, and many DESCRIPTIVE PIECES in Poetry, though copied from nature, from any pretensions to ORIGINALITY, strictly considered.[27]

It is furthermore the case that portraiture, unlike landscape, spans an axis running from the icon of absolutism (Van Dyck's portrait of Charles I, London, National Gallery, or Gainsborough's *George II*, Windsor Castle) to inn signs or the headpieces of popular ballads. Ballads like *The Last Good Night of the Valiant Johnny Armstrong* or *The Life and Death of the Duke of Berwick* (pl. 100) were circulated in the eighteenth century in the form of broadsheets, a major component of which was usually a portrait of the subject, often adapted from 'High Art' forms, from court portraits, which may or may not have had any connection with the subject. Portraiture was, therefore, also under threat from 'below'.

In the Introduction the dissemination of portraits through a vast array of media in the eighteenth century was mentioned. The application of portraits and other works to decorative and utilitarian objects threatened the hegemony of the Royal Academy, firstly because meanings could not be secured within the framework of academic discourse when imagery familiar from the walls of the RA exhibitions crept onto snuff boxes and tea-cups (as trade cards and advertisements in the period indicate), but also because this apparent debasement threatened to corrupt academic painting. In accusing Matthew William Peters of exhibiting pictures that seem to have been copied from Birmingham teaboards (see pl. 221), Pasquin is worried not about Birmingham but about Somerset House.[28] Images of distinguished citizens produced in a controlled studio environment and determined by established convention could, by this process, be mediated in multiple ways through sequences of transformations and appropriations with consequent shifts in meaning.

To look at the problem in a different context, human images derived from portraits were incorporated into the decoration of ceramic jars in fifteenth-century Italy. But neither the origins of the images nor the meanings that are produced with their

transference to this specific context are very clear. A portrait of a man in a tall hat in the medallion on a pharmacy jar resembles a Florentine engraving of c.1460 captioned 'El Gran Turco', perhaps after Pollaiuolo. The iconography, we are told, goes back to Pisanello's medal of the Emperor of Constantinople, John VIII Palaeologus.[29] What this transmutation represents is the movement from the particular to the generic, from the representation of an individual to that of a type, 'El Gran Turco'. As applied to a storage jar such an image may well have suggested something about the contents or the function of the jar. By contrast, the pair of gloves inscribed 'Imperishable their fame' underneath a roundel containing portraits of Washington and Lafayette (now at Winterthur Museum) is altogether easier to understand. Gloves as an item of apparel have a complicated currency, connoting personal insignia in the manner of medieval chivalry and serving moreover as emblems of death and mourning; they are also an extremely mundane and routine part of a gentleman's wardrobe and liable to much wear and tear. The inscription and the portraits as applied

to this particular item combine to suggest talismanic protection through absorption of the powerful icon into the vernacular. The wearer declares his devotion to these heroes in all public places, the imagery guards the garment that covers the hands from decay, the hands that are the instruments of man's will bear the emblem of the powerful alliance that will ensure that human achievement can be maintained. Transitions such as those described above point up the instability of the genre system and the tendency of successful images to proliferate; this very proliferation in turn threatens the defining categories that served to promote those images in the first place.

ii The Unfortunate Brave

Where, then, might genuinely subversive elements be identified, both for ourselves and for an eighteenth-century audience, in the systematic ordering of portraiture in the eighteenth century? The disruptive and defining role of hair and wigs and its relation to society portraiture will be discussed in the second part of this book. There, problems of sexuality, sin and bodily function pertaining to portraiture and its conventions will be examined in one specific instance. Here, the pictorial tradition through which the unimportant life is promoted will be considered. The gallery of rogues offers an anti-type to the gallery of illustrious men, hypostatizing in carnivalesque fashion the grotesque in place of the ideal, and subverting the discourse of plenitude which, as we have seen, dominates the field of portraiture in the eighteenth century.[30]

It has been suggested that 'an age so patently interested in mock-heroic has little interest in the heroic itself' and that therefore 'the eighteenth-century hero . . . is more likely to be Yorick than Hamlet, Tristram Shandy than Sir Tristram', and that we may be faced here with a *hero absconditus*.[31] The collection of essays that these words preface then goes on to argue that the eighteenth century had so many heroes – generals, patriots, scholars and biblical and classical figures – that it was difficult to know where the attributes of the hero really lay. The poet, it is proposed, is a new hero for the age. Moreover, biography, and its sister art of portraiture, in the eighteenth century attained such widespread currency that it was deemed to be in danger of devaluation. The attention given to the Primrose family's portrait in *The Vicar of Wakefield* and the selling of family portraits in *A School for Scandal* suggest the popular preoccupation with the demotic uses of portraiture. Johnson's view that 'he that recounts the life of another, commonly dwells most upon conspicuous events, lessens the familiarity of his tale to increase its dignity, shews his favourite at a distance decorated and magnified like the ancient actors in their tragic dress, and endeavours to hide the man that he may produce a hero',[32] undoubtedly continued to wield authority until the reformulation by Carlyle in the nineteenth century. None the less a different discourse is already identifiable in Johnson's lifetime. By the end of the eighteenth century, the representation of the unimportant life was not only tolerated but likened to genre paintings that show virtuous cottagers about their business:

> The advantages and use of Biography have of late been so often mentioned, and are now so universally allowed, that it is needless for any modern author to set them forth. That department of writing, however, has been of late years so much cultivated, that it has fared with Biography as with every other art; it has lost much of its dignity in its commonness, and many lives have been presented to the publick, from which little instruction or amusement could be drawn . . . Yet there are few even of those comparatively insignificant lives, in which men of a serious and thinking cast do not feel a certain degree of interest. A pensive mind can trace, in seemingly trivial incidents and common situations, something to feed reflection, and to foster thought; as the solitary Naturalist culls the trodden leaves, and discovers, in their form and texture, the principles of vegetative Nature . . . Like those familiar paintings that shew the inside of cottages, and the exercise of village duties, such narrations come home to the bosoms of the worthy, who feel the relationship of Virtue, and acknowledge her family wherever it is found . . . The Hero, the Statesman, the Poet, or the Painter, demand, and frequently, as such, deserve our admiration; but it is only to the man of domestic worth and social excellence, that the hommage of the virtuous heart will ever be offered.[33]

This establishes the framework for the dignified appreciation of a Morland or a Wheatley or, indeed, for narratives of virtuous or heroic individuals of low birth. But a portrait (as opposed to a genre scene) of the insignificant life could tell nothing of that life unless, of course, something extraordinary had occurred in it. The gallery of rogues, the collection of individuals that so fascinated Evelyn, is omitted from accounts of the functions of literary biography. Henry Bromley records for period VII (that is 1728–1760) Granger's category XII (now category X and encompassing 'Phenomena, convicts, monsters etc.') almost as many engraved portraits as for category IX, 'The female sex'. This considerable increase suggests that the hero of the eighteenth century was not absent, nor merely domesticated, but that he/she was inscribed in negative form within

the order of portraiture. This negativity was a necessary (but dangerously subversive) mechanism in the maintenance of law and order.

When John Ray meditated upon the disturbances that would necessarily have followed should nature have failed to make faces distinctively recognizable, he most immediately thought of law and order:

What hazards in all Judicial Proceedings? in all Assaults and Batteries, in all Murthers and Assassinations, in Thefts and Robberies, what Security would there be to Malefactors? Who could swear that such and such were the Persons that committed the Facts, though they saw them never so clearly?[34]

The enthusiasm with which Lavater's physiognomic theories were welcomed after publication of the first English edition of his *Essays on Physiognomy*[35] can be understood in the context of this desire to be able to identify and recognize society's deviants and thereby establish a taxonomy. The portraits of criminals, 'monsters' and imposters engraved by and after established artists like Gravelot and Laguerre belong nevertheless not to the tradition of physiognomic representation with its emphasis on profile, but rather to the field of society portraiture.[36] The need, acknowledged by John Ray, to recognize fraudulent people like Mary Toft or criminals like Jack Shepherd justified the portrayal of them on a grand scale by established society artists. But this very exercise led to the heroicization of these deviant individuals. It is this process of heroicization that is examined here in relation to the portraits of Jack Shepherd and Mary Toft, for while broadsheets and ballads, caricature and visual satire worked in a structural relationship to society portraiture that reinforced rather than undermined it, the representation on this scale, within the conventions of society portraiture, of Granger's bottom-class set up a subversive discourse that only the foundation of an Academy patronized by royalty would be able to contest. Indeed, it can be argued that controlling the unruly genre of portraiture was one item on the unwritten agenda for the Royal Academy, and it was an undertaking that its first president would triumphantly discharge.

To emphasize the point more narrowly, it was through body gestures and physiognomy that plebian, disorderly or deviant individuals were visually recognizable. Caricatures, as John Brewer and others have pointed out, drew on texts like those of Le Brun and Gérard de Lairesse both to establish social and political superiority and, by transposing the grotesque features and body dispositions of the lower classes to aristocratic or upper-class subjects, to satirize the personal and political weaknesses of those subjects in a visual language that was well understood.[37] What is notable about the series of

portraits of criminals executed and widely disseminated in the first half of the eighteenth century is, however, that they display subjects whose external features and demeanour show no sign of their supposedly diseased characters. They do not, therefore, come within the eighteenth-century definition of caricature as 'a likeness of any person; but loaded, exaggerated, heightened, and rendered generally ridiculous'.[38] Portraits of criminals constitute thus the site where popular enthusiasm and sympathy for forms of social deviancy is legitimized and, moreover, where the mechanism is established that ensures their widest possible consumption. Such portraits threatened the decorum that Jonathan Richardson, for one, strove to maintain in face painting.

The case of Mary Toft (sometimes spelt Tofts) is best known on account of Hogarth's interest in her as an emblem of credulity and superstition. She appears in the foreground of his anti-Methodist engraving *Credulity, Superstition and Fanaticism* (pl. 101).

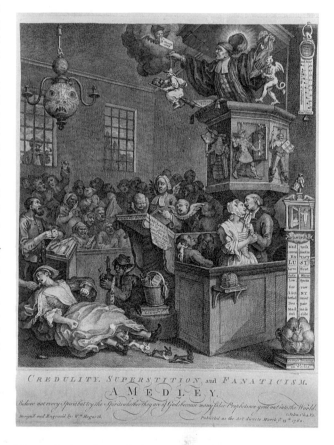

CREDULITY, SUPERSTITION, and FANATICISM.
A MEDLEY.

Her role in Hogarth is as one of the 'great female imposters of the century'.[39] Publishing this work in 1762, Hogarth was keeping alive an interest that dated back nearly forty years. In 1726 the story of Mrs Toft occupied the newswriters and pamphleteers: it concerned a woman of Godalming, in Surrey, who had allegedly given birth to a series of rabbits.

101. William Hogarth, *Credulity, Superstition and Fanaticism*, engraving, 1762. Collection of the author.

The woman being delivered of rabbits in the left foreground is based on an event alleged to have happened in 1726.

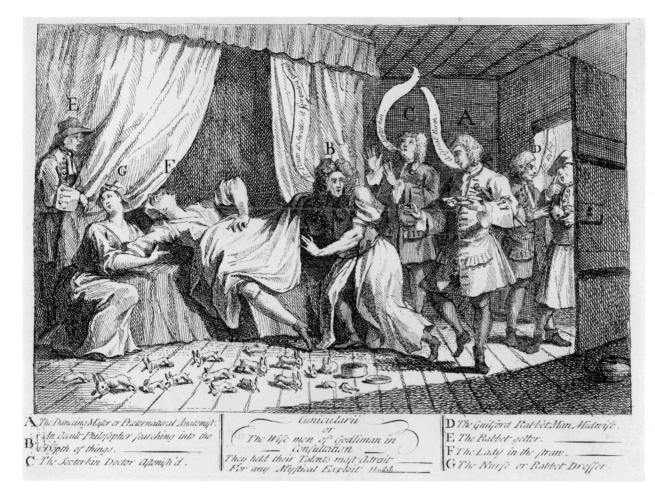

Hogarth's print *Cunicularii, or The Wise Men of Godliman* (pl. 102) was published on 24 December 1726, over a week after Mary Toft had confessed and in the midst of a flurry of pamphlets as well as a stage entertainment, *The Surrey Wonder*, described as 'an anatomical farce'.[40] At the same time Jacques Laguerre published a mezzotint portrait of Toft, engraved by J. Faber (pl. 103). Only here is the woman of Godliman, as she is known throughout the episode, given her name.

Whereas in Hogarth's works, Mary Toft lies in a delivery position, while rabbits run from under her skirt, her portrait by Laguerre shows a dignified three-quarter-length view of a woman holding a rabbit on her knee. (The composition may have been the inspiration for Hogarth's portrait of the murderess Sarah Malcolm (pl. 105).) To the uninformed eye Laguerre's portrait does not differ, except perhaps in the modest style of the dress, from, say, a work by Greuze or from one of a number of paintings executed by Rosalba Carriera of a woman with rabbits or hares (pl. 104).[41] The major feature of the incident is nowhere alluded to by Laguerre, nor even by Hogarth: the rabbits were delivered in fragments without blood or water. In other words,

what people claimed to have seen, and what was extensively described, was a woman in labour who delivered at intervals over several weeks, a succession of pieces of rabbit carcass.[42]

The absence of feet and claws in this delivery of flesh was one of the things which aroused the suspicion of the newly professionalised medical men. The other major aspect of the case, which is ignored by Laguerre and receives only a restrained allusion in Hogarth, is that of the perpetual internal examination that this woman allegedly underwent and which dominates the literary accounts of the event. The male midwives attending, Messrs Howard and St André, claimed to have examined Mary Toft and found: 'The Orifice of the Uterus so far closed, as not to admit of the little finger'. Further pain shortly after this is followed by the delivery of a rabbit skin squeezed into a ball.[43] One of the gentlemen who arrived from court to try to establish the veracity of the accounts that were circulating, left this report in his diary: 'Mr. John Howard brought us, wrapt in a paper, a Piece of Membrane, which he said he had just taken from the Woman and shew'd it to us. I told him he ought to have sent for me, that I might have taken it away myself, being come down for that

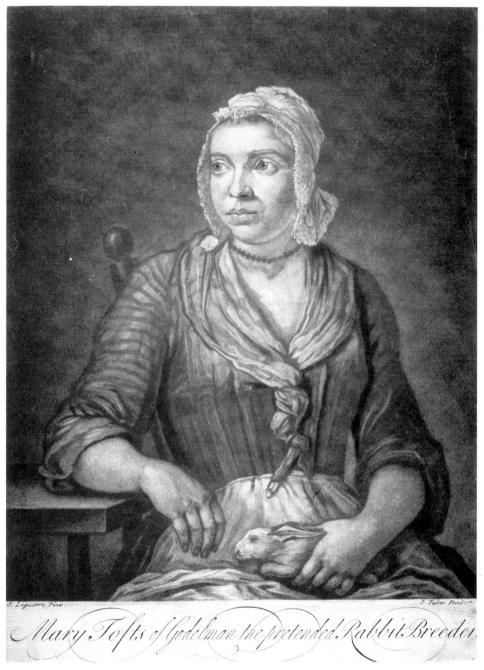

Mary Tofts of Godelman the pretended Rabbit Breeder.

103. J. Faber after
J. Laguerre, *Mary Tofts of
Godelman the pretended Rabbit
Breeder*, mezzotint, 1727.
Huntington Library, San
Marino, California.

These accounts are repeated many times in different publications[45] and the power of the imagery circulated in these verbal texts was remarked on by a writer under the pseudonym of Lemuel Gulliver who lamented 'the great Detriment like to accrue to our Nation by the Stir which has been made about this foul Imposture, both by the Actors and Examiners of it'. The Warreners and Poulterers, he reports, had equally suffered because the consumption of rabbits was reduced by two thirds. Moreover, it was deplorable that 'obscene and indecent Images . . . for more than these nine Days last past, beyond all Example, have fill'd the Minds, and furnish'd out the Conversation of People of all Ranks, Ages and Conditions'.[46]

There is clearly a profound disturbance in these discourses of parturition and imposition: it is as though woman's reproductive capacity, that element of her being that ensures for her a role in genealogical history and grand family portraiture, has here revealed itself as the site of every anxiety about nature, veracity, quackery, knowledge and the desirable boundaries between the various orders of existence. All these boundaries are ruptured in a chaotic and terrifying discourse through which woman's body is demonized. Doctors turn rabbits and burrow (literally and metaphorically) into the female body in search of the knowledge that will legitimize their professionalism. But we should remember when we look at the restorative calm of Laguerre's portrait of Mary Toft, a calm that reimposes social order on this chaos, that one of woman's functions was to represent the inchoate, what was ever likely to break its bounds. This is evident not least in the discourse of portraiture. Thus in *Sculptura-Historico-Technica* (1747), the anonymous author sets out a system for collecting engravings, one that suggests some prefiguration of Granger's. A collection should have three principal parts: Historical Subjects; Subjects of Morality; and the Progress of the Arts of Painting, Sculpture and Ingraving. The fourth part should deal with 'mixed subjects' which would be covered in this order:

1. Women of the Old and New Testaments.
2. Holy Virgins and Martyrs, female saints and beatified nuns.
3. and 4. Christian Empresses, Queens and Illustrious Women of different Nations.
5. Roman ladies taken from Antique statues
6. Pagan goddesses
7. Portraits of women who were mad or prostitutes
8. Hunting, Fishing and Fowling Pieces.
9. Humorous and Grotesque Pieces.[47]

Woman was thus regarded as a 'mixed subject'. The celebrated fraud case of Mary Toft, in which the search for a truth and its origins became literally

purpose. To which he reply'd, 't'was true' but that he believ'd there was more to come, which I should take away . . . Upon examining the Membrane which he brought, it appeared to me like a piece of bladder . . .'. Howard insisted that it was membrane from the uterus whereupon Sir John Manningham, the narrator, felt in the vagina and found a piece of skin. He tried to see if it came from the uterus but found it closed. He then removed what remained in the vagina and, on examining it, found it to be a piece of hog's bladder. When he said he did not believe it came from the uterus, Mary Toft wept because she thought he considered her a cheat.[44]

the internal examination of the female generative organs, stages the impossibility of generically classifying woman just as the discourse of portraiture represents her as dangerously subversive. The portrait by Laguerre (a portrait in the fashionable and softening technique of mezzotint) succeeds not only in removing from the narrative all sordid physiological details but also in disciplining woman and the natural world by applying the conventions of society portraiture. In these conventions a young woman might, quite legitimately, be portrayed alongside small furry animals.

Jack Shepherd (or Sheppard) was hanged on 16 November 1724. He had been convicted and sentenced the previous August for robbery and had been imprisoned in Newgate, from which he twice escaped – on the second occasion by what seemed to contemporaries to be almost miraculous means. Drawn by Thornhill,[48] whose portait was then engraved by George White (another distinguished team), Shepherd is presented as a young martyr in soft mezzotint (pl. 106) in the pictorial tradition that looks back to engravings of Charles the Martyr and forward to the depiction of the French royal family in prison and of cult figures like Thomas Chatterton.

The case of Thornhill's portrait offers a clear illustration of how portraiture can determine the contours of biography and is the crucial factor in some forms of mythology. There is no doubt that Shepherd was a popular hero, if not from the

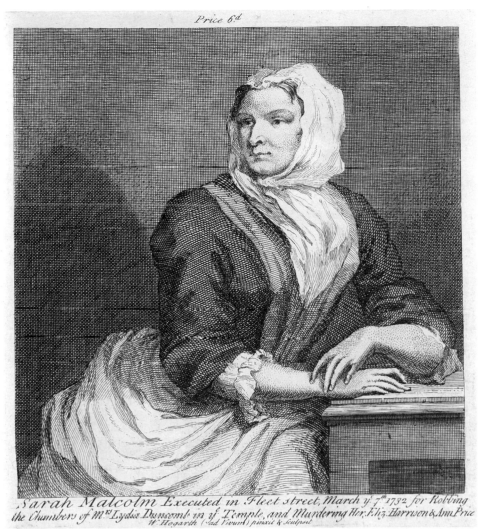

105. William Hogarth, *Sarah Malcolm Executed in Fleet street, March y^e 7^th 1732 for Robbing the Chambers of M^rs Lydia Duncomb in y^e Temple, and Murdering Her, Eliz Harrison & Ann Price*, engraving, 1732. Trustees of the British Museum, London.

Hogarth follows the compositional type established by Laguerre for the portrayal from life of a female criminal.

104. Circle of Rosalba Carriera, *Young woman holding a Hare*, pastel, 62 × 49.5 cm. Sotheby's, 22 November 1985 (943).

Images that associated young women with vulnerable and appealing animals were commonplace in an eighteenth-century European repertoire of popular representation in media such as pastel and engraving.

89

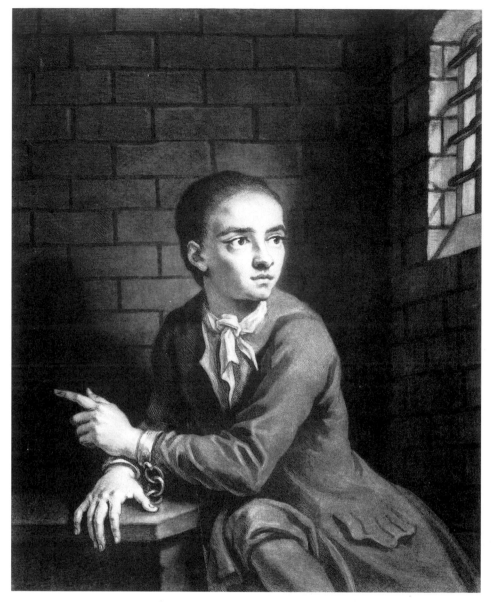

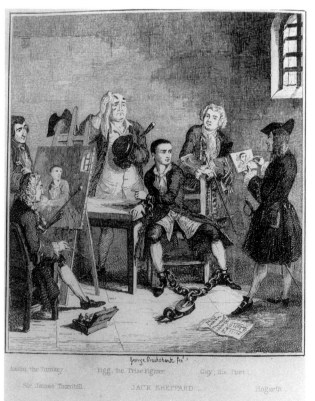

Tho' Life in vain the Wretch implores,
An Exile to the Farthest Shores,
Thy Pencil brings a kind Reprieve,
And bids the dying Robber live.

This Piece to latest Time shall stand,
And shew the Wonders of thy Hand.
Thus, former Master's grac'd their Name,
And gave egregious Robbers Fame.

Appelles Alexander drew,
Caesar is to *Aurellius* due,
Cromwell in Lely's Works doth shine,
And *Sheppard, Thornhill*, lives in thine.[50]

This poetic testimony was reprinted in 1824, on the anniversary of Shepherd's execution, in the *Newgate Calendar* where a sanitized Jack Shepherd featured prominently.[51] And this in turn provided the basis for Harrison Ainsworth's novel *Jack Shepherd*, published in 1839 and adapted for stage the same year.[52] Ainsworth's illustrator, George Cruikshank, frequently produced settings for the novels' characters in which historic portraits hanging on the walls guide, in Hogarthian fashion, the readers' interpretation of the scene. Chapter sixteen, 'How Jack Sheppard's Portrait was painted', tells of the visit paid to Jack in prison by Sir James Thornhill, 'historical painter to His Majesty, and the greatest artist of the day', in the company of John Gay the poet, Figg the prize-fighter and William Hogarth.

106. G. White after J. Thornhill, *John Sheppard* mezzotint, 1724. Huntington Library, San Marino, California.

John, or Jack, Shepherd was twenty-two at the time of his trial. This portrait, through its mystical and religious overtones, alludes to Shepherd's apparently miraculous powers.

moment of his trial then certainly from the moment of his execution. But eighteenth-century accounts of Shepherd stressed the 'Idle and Industrious Apprentice' theme, telling how young men who leave the paths of industry and honesty will come to an untimely end.[49] Only days after his execution, Shepherd's portrait by Thornhill was eulogized in the *British Journal* in verses that lend the portrait the power of reprieve that society has denied the young reprobate. Moreover, in portraying Shepherd, Thornhill by this interpretation becomes, in the process of mythicization, associated with the hero, as was Apelles with Alexander and Lely Cromwell:

> *Thornhill*, 'tis thine to gild with Fame
> th'obscure, and raise the humble Name;
> To make the Form elude the Grave,
> And *Sheppard* from Oblivion save.

Cruikshank's illustration of this scene (pl. 107), titled simply 'The Portrait', is more than an embellishment to a popular novel: it declares Cruikshank's position as heir to an eighteenth-century artistic tradition that productively allied high and low, portraiture and documentary, text and image, likeness and satire. The common ground for this gesture of affiliation is the portrait. Thornhill, seated on the left, works in oil on a portrait of Shepherd which the modern reader knows to be fictitious because only the mezzotint (and a drawing) exists. Hogarth simultaneously draws a head-and-shoulders, though he is not known to have executed such a work. On the floor in the foreground lies the *Daily Journal* for 15 October 1724 in which was published the report of the appearance at the Old Bailey of the criminals Blewskin, John Shepherd and William Field. This was also the night of Shepherd's last and most spectacular escape, accounts of which were offered for sale on 22 October.[53] Thornhill's visit actually postdated this (it did not take place until 10 November).

Cruikshank's illustration is a testimony to the mythicizing role of popular engraved portraiture, of the heroicization over a long period of a criminal who was 'for a considerable time, the principal subject of conversation in all ranks of society'.[54] It is also evidence of the way in which the 'alternative' portrait, that of the celebrated rogue who played such an important part in the hierarchical economy of eighteenth-century portrait ideology, was by the third decade of the nineteenth century relegated to the pages of romance and the world of visual fiction.

Representations of criminals had by this time found their place in a widely circulated publication. Between 1790 and 1795 James Caulfield published *Portraits, Memoirs and Characters of Remarkable Persons* and in so doing made instantly available to the reading public the monsters, contortionists and criminals illustrated in Granger's final class, reproduced from rare prints. Here, finally, this ultimate category of humanity was recognized as deserving independent treatment. Caulfield's own life is symptomatic of the eclectic range of commercial enterprises generated by a portrait culture. A passionate print-buyer, he was set up in business by his father, a music engraver. His line was popular antiquarianism and included publications on the Gunpowder Plot and on Cromwell; he was also responsible for the *Eccentric Magazine* that featured the lives and portraits of people described as 'dwarfs and murderers &c'. The stock and coppers of *Portraits, Memoirs and Characters of Remarkable Persons* passed into other hands in 1799. Originally published at fifty shillings, it became so much sought after that copies were fetching 7 guineas each, and R.S. Kirby arranged with Caulfield to produce a new edition in 1813.[55]

The advertisement for Caulfield's book tells us that 'of the twelve different classes of Engraved Portraits arranged by the late ingenious Mr Granger; there is not one so difficult to perfect, with original prints, as that which relates to persons of the lowest description'. At the same time, the witch finders, Mall Cut-Purse, Archibald Armstrong (jester to James I) and Mull'd Sack, the Chimney Sweep (pl. 108) are worthy of inclusion in the collection by virtue of forms of transgressive behaviour or deviant physical characteristics that not only distinguish them from the ordered social hierarchy of humanity but also from the portrayal of criminals according to the conventions of society portraiture. Caulfield's book reproduces some of the material he had published probably slightly earlier in *Blackguardiana* (1793) in a format clearly intended for a superior market. Tiffin records the sale of a print (or cut) of a whole-length portrait of Mull'd Sack, thought at the time to be unique, for sixty pounds and twelve shillings.[56] In *Portraits, Memoirs and Characters* engravings are accompanied by biographical passages and recorded inscriptions in the manner of Granger.

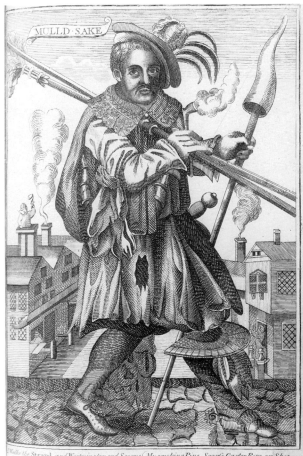

107 (facing page bottom). 'The Portrait', from Harrison Ainsworth, *Jack Sheppard*, drawn and engraved by George Cruikshank, 1839. Collection of the author.

Thornhill is seated at an easel in a cell at Newgate while Hogarth stands at the right sketching Jack Shepherd.

108. *Mull'd Sack, the Chimney Sweep*, engraving, 1794, by Caulfield and Herbert, from J. Caulfield, *Portraits, Memoirs and Characters of Remarkable Persons . . .*, 1794. By permission of the British Library, London.

This image belongs to Class XII in Granger's *Biographical History of England*, that to which are consigned 'Persons of both Sexes, chiefly of the lowest Order of the People, remarkable from only one Circumstance in their Lives; namely such as lived to a great Age, deformed Persons, Convicts, &c'.

The arrangement is chronological and the book is paginated. *Blackguardiana*, on the other hand, acknowledges no debt to Granger but presents itself as a 'Dictionary of Rogues, Bawds, Pimps, Whores . . . illustrated with eighteen Portraits of the most remarkable Professors in every Species of Villany.' It is modelled upon Le Roux's *Dictionnaire comique, satyrique, critique, burlesque, libre & proverbial* (published in Amsterdam, 1718 and going into many editions in the eighteenth century) but lacks the serious and scholarly framework of Le Roux.[57]

The interest in portraying murderers awaiting trial or execution became, as we have seen, a serious preoccupation by the end of the eighteenth century.[58] In *Blackguardiana* murderers take their place alongside other forms of deviancy: procuresses, highwaymen, Quakers, and 'Mary Frith or Mall Cut-Purse, a woman of masculine spirit or make, who was commonly supposed to have been an hermaphrodite, practised . . . almost every crime, and wild frolick, which is notorious in the most abandoned and eccentric of both sexes.'[59] Frith wore male attire, lived luxuriously and smoked. Characters like Mall Cut-Purse existed – and thrived – in public imagination through portraits, for only the visual could do justice to their physical peculiarities. And it is testimony to the power of this underbelly of portraiture that the eminently respectable *Artist's Repository* found it necessary to challenge the authenticity of one of the popular representations of hermaphrodites, questioning whether such an image could be a genuine portrait of an actual person.[60] It is, moreover, significant that representations like these depend not on the facial characteristics of the individual represented but on the entire ensemble of body, clothing and other attributes; they should not be understood as part of the discourse of physiognomy, which concentrates upon facial feature, but as simultaneously both aping and subverting fashionable upper-class portraiture.[61] Etiquette books, such as the popular *Rudiments of Genteel Behaviour* (1737), stressed that anyone could learn genteel deportment provided they studied the visual images incorporated into the text, and those wishing to attain these agreeable faculties would need to employ their whole bodies.[62] The body, as visually represented (here in plates by Dandridge, engraved by Boitard), provided the key to polite deportment which, in turn, offered the opening to social success (pls 109, 110). It was the 'alternative body' in Caulfield's collection that served to remind readers, also through portraiture, of the antithesis of polite society.

Caulfield's *Portraits, Memoirs and Characters* is organized in a more or less coherent manner and, like Granger's *Biographical History*, claims to offer an historical narrative. Therefore it not only serves to parody the conventions of polite society portraiture but also critiques the systematization of portraiture as

109. L.P. Boitard after Bartholomew Dandridge, *Walking*, from F. Nivelon, *Rudiments of Genteel Behavior*, 1737. By permission of the British Library, London.

110. Joseph Highmore, *Mrs Newport*, oil on canvas, 124.5 × 96.9 cm., Sotheby's 13 December 1972 (103)

Mrs Newport is portrayed in an elegant and fashionable posture as reccomended in etiquette books such as Nivelon's *Rudiments of Genteel Behavior*.

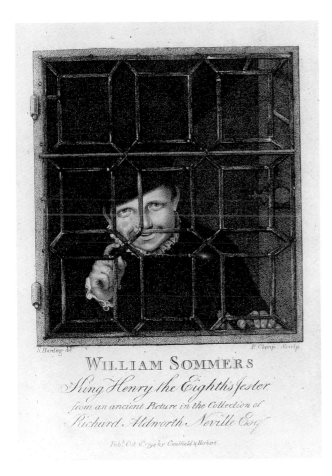

WILLIAM SOMMERS

King Henry the Eighth's Jester

from an ancient Picture in the Collection of

Richard Aldworth Neville Esq.

Pub.^d Oct. 6th 1794 by Caulfield & Herbert.

Biographical History stressed constitutional antecedents and constructs of Church and State, Caulfield's sets up notions of difference. But the chronological framework established by Granger here also provides a sphere in which every convention of portraiture can be challenged and every boundary crossed. Antiquarian documentation is deployed here not to establish the ancient lineage and genealogy of British kings or the practices of the Druids but to identify an engraving as Mme Bourignon who was born in 1616, was very deformed and avoided marriage by masquerading as a friar and running away. The illustrations, while they purport to come from original engravings in the collection of the author, augmented by loans from James Bindley's collection, appear often to be the invention of Caulfield himself.

The visual and verbal languages of society portraiture – heraldry, birth, clothing and hair, gender, national identity, class – are appropriated and subverted by Caulfield. For example, he provides an engraving of 'Mother Louse' (pl. 112) which is accompanied by the following memoir:

> The original print, which is well executed and very much like the person represented, gained the engraver, David Loggan, who was employed at Oxford in engraving views of public buildings, a considerable share of his reputation. It was drawn from the life, at Louse Hall, an alehouse near Oxford, which was kept by this matron, who was well known to the gentlemen of that university, who called her Mother Louse.
>
> She was probably the last woman in England who wore a ruff.[65]

history. At one level, this compendium of portraits of 'characters' is part of an age-old tradition – quasi-mythological, quasi-medical – for the depiction of 'monsters', of people with terrible growths, with two heads, or people who live to an incredible age. Alongside this is what Vertue/Walpole describes as a particular British penchant. Describing the work of the engraver, J. Savage, responsible for a 'set of heroes, whom Prior calls "the unfortunate brave"', Walpole declares: 'No country preserves the images and anecdotes of such worthies with such care as England. The rigour of the law is here a passport to fame. From the infringers of Magna Carta to the collectors on the road, from Charles I to Maclean, every sufferer becomes the idol of the mob.'[63]

It is not suprising that the century that produced *Gulliver's Travels* should have enjoyed reading about – and looking at – portraits alleged to depict Henry VIII's jester (pl. 111) or Joseph Clark, the posture master to James II, a man 'able to exhibit almost any species of deformity and dislocation'.[64] By re-presenting the past – and particularly the previous century – as peopled with witches, witch masters, imposters, jesters, court dwarfs and dissenters, an ideological space is created between the disordered courts of the Stuart monarchs and the sobriety of the Hanoverian rule. Whereas Granger's

The image deploys heraldry, clothing and a profile format in satirical relationship with society portraits. It also constitutes a parody of the endeavours of Aubrey or Vertue. This subversive effect is reinforced by the accompanying passage in which may be discerned questions of likeness, the artist's *oeuvre* and the place of this particular work in his development, as well as a degree of antiquarian empiricism in identifying location and dating clothing. It is unclear from the passage whether Mother Louse's claim to fame lies in her alehouse or in the fact that she is allegedly the last woman in England to wear a ruff. An uneasy ambivalence is established that allows us to see Mother Louse as at one and the same time distinguished, conservative, an upholder of a once worthy and now defunct ritual (ruff-wearing) *and* bearer of a name suggesting a parasitic existence in a . medium of filth.

iii The Fantastic Gallery: Portraiture and Political Strategy

The organization of individuals into opposing factions, allocating public figures to one or other side of a perceived divide and re-presenting those factions in black and white, is an essential part of the modern political process and one that played a major part in the last years of the eighteenth century when parliamentary debate evolved as a significant public interest. Physiognomic theory ensured that the characters of individuals in public life – whether virtuous or evil – could be read from their faces. Faces were imbued with meanings (pl. 113): 'Say who art thou devoid of grace, with round and dull unmeaning face?' questions the satirical poet Peter Pindar.[66] The high Tory historian and genealogist Edmund Lodge, who perhaps more than anyone was responsible for disseminating a taste for Tudor portraits in the early years of the nineteenth century,[67] presented his project on illustrations of British history as counteracting the popular practice of physiognomic interpretation, and in so doing testified to its extensive influence:

It is . . . from the combination of portraits and biography that we reap the utmost degree of utility and pleasure which can be derived from them: as in contemplating the portrait of an eminent person we long to be instructed in his history, so in considering his actions we are anxious to behold his countenance. So earnest is this desire, that the imagination is generally ready to coin a set of features, or to conceive a character, to supply the painful absence of the one or the other. All sensible

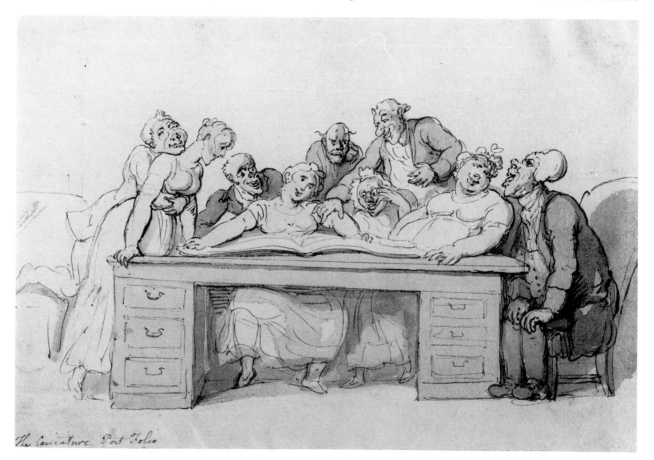

113. Thomas Rowlandson, *The Caricature Port Folio*, pen and watercolour, 11 × 16 cm. Trustees of the British Museum, London.

These figures, who are themselves caricatured, enjoy a good laugh over an album of caricatures. Thus Rowlandson explores both the contemporary belief in the face as a yardstick of character and the interactive, collusive, dynamic of caricature as communication.

94

minds have experienced these illusions, and from a morbid excess of this interesting feeling have arisen the errors and extravagencies of the theory of physiognomy.[68]

Diana Donald has drawn attention to the importance of a repertoire of ideal types used in portraits, suggesting that the categories used by print-sellers might provide a framework for assessing the typology of Reynolds's portraiture.[69] The print-sellers, however, derived their categories primarily from Granger's system which, as we have seen, has roots in the more distant past. It is admittedly important to recognize that the conditions for reading Reynolds's portraits were provided, at least in part, by the classificatory discourses of the collecting of portrait heads. But Lodge's concern to correct the physiognomic by reference to the biographical suggests a theory of the social and political function of portraiture rather than a set of ideal types. Character and morality were, like taste, public virtues. The obsessive recurrence of stereotypes, noted by Donald, should not be understood only in terms of 'an approximation of individuals to recognizable types'. The image was one component only in the communicative act to which viewers brought knowledge acquired from different sources, including the inverse world of caricature, as well as from narratives of other kinds. The typololological factor was one among many that ensured that portraits were, indeed, effective in communicating contradictory and contrasting political allusions and nuances.

With the rise of factional politics under the Hanoverians, the opposition – especially during the reign of George III – became ever more vociferous and vituperative, and its onslaught against conservative incompetence in national and foreign affairs took the form of a vast wave of political caricature and pamphleteering. The numbers of publishers and print shops in London greatly increased during the period 1727–63, releasing a flood of political caricature.[70] In the 1760s and 1770s the production of overtly political prints produced each year was always higher than the number of prints imaging (apparently uncritically) social events and situations. After 1788 the situation was reversed. Gradually political prints became recognized, and by the 1780s nearly all were signed, in contrast with the 1760s when most were anonymous. The majority sold about 500 copies each, with circulation probably limited to the political élite and the propertied middle classes of London and Westminster.[71]

Not all political prints of the period depended on portraiture, but most entailed recognition of the facial features of a public figure. The dramatic involvement of individuals in political events, such as Wilkes in 1770 and Fox and Pitt in 1784, produced an unprecedented volume of caricature.[72] Such prints drew on the notion of appearance as an indication of character, a notion deeply embedded in the western Platonic and Christian traditions and perpetuated through cultural and critical forms and conventions. In Roman art, for example, a grotesque physiognomy and a bent posture marked the presence of fools and servants.[73] Artists and biographers, like actors, worked according to the conviction that 'the Idea prints the Look: . . . the Look adapts the muscles'. The face and its expressions – the focus of the portrait – could be read as the measure of the idea. As a treatise on the art of acting expressed it,

> When Imagination forms those *Images*, which it takes *Name* from forming, that is to say, in any strong Emotion it would paint, has fix'd itself upon the clear *Idea*, it is, then the FACE, that of Necessity, receives the first Transmission of this Image: and, from the Face, immediately, in sure, and not to be avoided Confirmation, the *Voice*, *also*, is compell'd to take a *Tone* exactly correspondent.[74]

But caricature, like stage drama, required the demarcation of a distance between viewer and spectacle. One way in which caricature established this distance was through the use of profile. A schematic rendering of the human head, the profile has often been employed to effect distance between subject and viewer (as with the medals of Antiquity and the Renaissance) and thus to suggest immortalization. In the case of caricature, the profile could also be mobilized to facilitate criticism owing to the apparent abnormality of viewing people from the side.[75]

The *notion* of the portrait as re-presentation of the individual, summing up the entire character in a single view, operates in eighteenth-century cultural production as something distinct from the narrative form to which even the epigrammatic brief lives of Johnson belong. Swift's unpublished 'Of Mean and Great Figures Made by Several Persons' adopts a portrait mode through which the author seeks to focus on some particular action or circumstance of each of the subjects' lives.[76] The Figures (the depersonalized term is significant for indicating the awareness of public life as performance) are seen in terms of black and white contrasts. Their greatness or meanness is summed up pictorially and theatrically. Charles I and Cromwell number in a list 'of those who have made a mean and contemptible Figure in some Action or Circumstance of their Life'. An historical individual could, by this account, be summed up by one particular action in their lives. Once imaged, an historical individual could be understood, through portraiture, to epitomize an age. Furthermore, portraiture as a concept functions

to provide eighteenth-century writers with the means not only to access the past but also to image a political party. Thus Sir Nathanial Wraxall could write in 1787: 'When I have thus finish'd the portrait of the Minister, I may be said to have comprehended almost the whole administration.'[77]

As E.H. Gombrich has observed, 'it is not really the perception of likeness for which we are originally programmed, but the noticing of unlikeness, the departure from the norm which stands out and sticks in the mind'.[78] Gombrich distinguishes between the mask and the face, the mask standing for the crude distinction, the deviations from the norm which mark one person out from others. The caricature exploits the mask and depends on Toepffer's law that 'any configuration which we can interpret as a face, however badly drawn, will *ipso facto* have such an expression and individuality'.[79] Interpreting expression, according to Gombrich, depends on separating permanent from mobile features. Physiognomical studies paid exclusive attention to the permanent traits and emphasized 'the human reaction to the permanent features of non-human physiognomies'. The point to stress here is that portraiture and caricature, drawing on theories of expression and of physiognomy, are situated along a single axis that connects individuals in the public gaze. As Diana Donald has pointed out, the works of Reynolds and of satirists were bought by the same powerful and wealthy élite, and mezzotints after Reynolds's portraits (pl. 114) were on sale in the print shops alongside Gillray's caricatures.[80] Moreover, there were often formal connections in so far as caricaturists who parodied well-known portraits and history paintings also set up print exhibitions that parodied the Royal Academy's exhibitions.[81] But, even when there was no formal connection, portraiture was intimately linked with caricature through its audiences and through the conceptual practices that placed portraiture at the heart of political discourse.

The major role of caricature in eighteenth-century politics has been well charted; what is under discussion here is the way in which portraiture, not only as artefact but also as concept, appears to have functioned as a mechanism in political debate in the eighteenth century. The effectiveness of representation in black and white had been established both literally and metaphorically by Hogarth, with the result that during the fierce competition between Fox and Pitt in 1783, following the death of the prime minister, Rockingham, the two men were contrasted as the idle and industrious apprentices after Hogarth's famous series.[82] In his popular *Lecture upon Heads*, G.A. Stevens defined 'Party' as an agency accustomed to painting people with two heads, suggesting that the importance of portraiture to party politics was well understood:

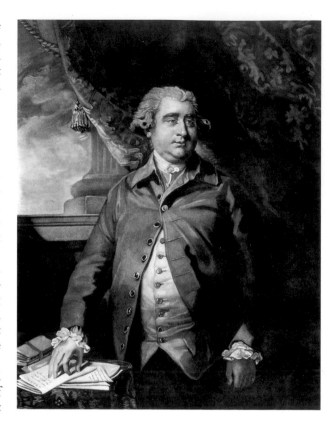

Here is the head of *Somebody*. He has two faces; because somebody is supposed to carry two faces: one is passable, the other a little discomposed. *Party* is accustomed thus to paint people. For we think those people frights, who won't say as we say, and do as we do. The other face is meant as a hint to that part of mankind, *who are well with Somebody*.[83]

Other forms of satirical practice also depended upon the conceptualization of portraiture as an art form while not ignoring the sharp edge of political caricature. Sometimes the concept of the portrait is used as a conceit to signal the nature of the particular publication, as with *The Contrast or Two Portraits of the Right Honourable Charles James Fox. The First taken in 1771, the Second in 1792 and 1793, dedicated, without permission, to that Right Honourable Gentleman . . . by a Cleaner of Faded Portraits*.[84] The conceit is extended to a metaphor encompassing painting techniques, formats and exhibition practice in *A Small Whole-Length of Dr. Priestly* (1792).[85] The author, having sat down to sketch his whole-length, taken from the life, hopes that the colours will stand and proposes to display his work in the present exhibition at the usual price of one shilling.[86] The phantom portrait gallery permitted a concentrated critique of character and reputation in a highly schematized format with the advantage of avoiding all risk of libel.

Texts like these cannot be contained within a

generalized definition of the portrait as biography. Nor do they qualify as caricature in so far as they do not strictly address physical appearance. Rather they parody the physical properties and the connotative power of paintings. Thereby they critique portraiture as a genre – and thus question the very foundations of representation as a social practice – while at the same time exploiting popular familiarity with the genre and its social and political connotations. They suggest not merely an interesting link between society portraiture on the one hand and caricature on the other, they serve also to problematize a relationship which has seemed on the historical level to be primarily one of opposites. Moreover they suggest that the *idea* of portraiture, and the *idea* particularly of the public display of portraits in artists' exhibition rooms, in salerooms and in the recently established Royal Academy exhibition, had permeated to all levels of society and all parts of the country by the last three decades of the century. The fictitious exhibition is not exclusively the art of those 'Improper Persons' excluded by entrance fees from the Royal Academy exhibitions.[87] Certainly imaginary exhibitions were given form in the pages of periodical journals such as the *Middlesex Journal*, but they also have a role to play in monograph publications, assuming a familiarity with precisely those discourses and spaces for display that they seek to parody. They were less 'a radical alternative to painting' than a mode of representation that capitalized on the dominant art form and served to reinforce it, extending by fantasy and metaphor the power of portraiture in shaping public life.

Portraiture as a conceptual tool thus defines individual careers and shapes political events in a way that, though originating in portrait practice, is quite separate from actual portrait depictions. In particular,

the development of party-political machinery can be seen to have been served by the discourse of portraiture. The review that prefaces *Parliamentary Portraits; or Characters of the British Senate* of 1795 quotes Burke's definition of party as a concurrence of men in a laudable and honest cause, having a just end in view, as opposed to faction, which is indifferent to its end.[88] The eulogy to common sense contained in this series of biographical sketches is authenticated by the language of portraiture which underpins the project. Phrases like 'drawing his materials from sources of genuine information, and delineating his characters according to public opionion' are effectively metaphorical.[89] Moreover, these publications also realized their objectives by offering actual portrait images to the reader. *British Public Characters*, published annually from 1798 to 1807 claimed to present 'the distinguished personages who now fill up the drama of public life in the British Empire'.[90] At the beginning of each volume, a foldout page offers outline drawings arranged in three tiers that are said to be 'striking likenesses as any that have appeared and all of them strongly characteristic' (pl. 115).[91] The page presents a portrait gallery in schematized form. Publications of this kind served to lay before the public the portraits (images and biographies) of leading members of the Lords and the Commons in response to increased interest in parliament, as opposed to court. They were informed by a notion of portraiture as a medium of expression appropriate to the political arena and calculated to enhance the reputations for dependability and good judgement of those figured within them.

However, the idea of the portrait could also be used to subvert popular ideological models. References to the British Senate served to evoke the ambience of Roman governance in late eighteenth-

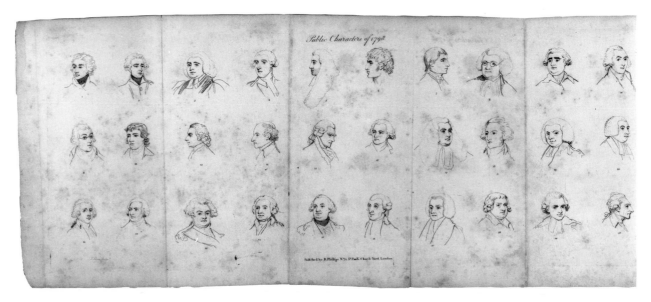

115. *Public Characters of 1798*, from *British Public Characters*, 1798. By permission of the British Library, London.

This pull-out frontispiece served a purpose similar to that of press photography today; it enabled readers to familiarize themselves with the appearance of figures prominent in the public view.

century Britain. In appealing to Classical Antiquity in this way, texts such as those discussed above bring into play a set of references that determined how representations of public figures were read. Since portraiture was the paramount public art form of Republican Rome, portraiture as a genre could be employed to carry overtones of Classical Antiquity. As Solkin has pointed out, the wealthy landowners of eighteenth-century Britain who took particular pride in their knowledge of classical culture often liked to think of themselves as the fabled patricians of ancient Rome. Solkin has shown how Burke was depicted as 'The British Cicero' and how in the 1770s in an effort to stem the popularity of John Wilkes, Cicero's oratory and his person were invoked in defence of true liberty.[92]

The connection between Burke and Cicero is further explored in a publication that typifies the phantom portrait gallery, employing exclusively verbal descriptions and containing no visual imagery. *Sketches from Nature in High Preservation by the Most Honorable Masters, containing upwards of one Hundred Portraits, or characters of the most conspicuous persons in the kingdom* employs the notional gallery of portrait paintings as a critique of contemporary art practice and as a commentary upon notable personages of the day. It therefore stands in direct relation to the texts already discussed. The method of this book, which ran into thirteen editions by 1780, is ingenious. The object of criticism is the named (or nearly named) artist who is also identifiable with the individual under scrutiny; the painting for which he is responsible is described in such a way as to constitute a commentary upon the painter/subject who has failed to achieve the standard required to depict the antique model. Thus 'Mr. B[ur]ke' is the artist responsible for *Cicero declaiming against civil commotion.* The painting is described in terms that are clearly intended to discredit the identification of Burke with Cicero:

> The orator appears to have well studied the justice of his cause, and is happy in the disposition of his limbs. His expression of features borders too much on the ludicrous, but, on the whole, is far from being deficient or unnatural. We cannot speak so favourably in regard to his figure. The painter has done too much for him, and Nature little, for he has neither dignity nor height sufficient to recommend him in the character he has assumed. To speak impartially, the artist has made him what Cicero might, not what Cicero should have been.[93]

Burke is also held responsible for *Longinus . . . taken from an Antique*, a painting that 'fails' because of the faults of 'too young and vacant a face'.

The method appeals equally to classical learning and to a liking for scurrilous satirical attacks. Viscount B[olin]g[bro]ke is the artist of *The Spendthrift and the Swallow*, while the Earl of B[u]te has three paintings on display: *The Arms of Scotland Supported by Pride and Tyranny, A State-Repeater, on a new construction* (i.e., a watch desiged as 'a concealment of the grand machine') and *Aeneas bearing his father from Troy.* The Duke of A[rgy]ll exhibits *A Family piece: the Colors faded.* This is described as follows:

> A miserable performance! We know not which deserves the greater blame, the family for suffering themselves to be so mangled, or the painter for abusing so many of God's creatures. The lady and her daughters seem to have some remains of decency visible here and there, though the eldest of the latter has the figure of a rake, if not something worse. We hinted at the impropriety of marking the features so strongly to the noble artist, but his grace excused it, by saying the lady had required some alterations in her person since marriage. The gentleman is most wretchedly bedaubed, and seems to be rather consulting the tinsel of his wife'e dress than her person.[94]

The seventh edition of *Sketches from Nature* included a lengthy dedication to Sir Joshua Reynolds which plays on the profitability of the president's portrait practice and the flattery that is seen as an endemic to portraiture:

> Apprised as I am that you are not only an excellent but a liberal and generous artist, I open this exhibition to you in the hopes you will applaud where you can, and condemn with candor. Of all the painters in the kingdom you have the reputation of being the best judge of symmetry. It is in this that I court your criticism, and as deformity is not without its rules, wherever you behold it in a picture you may depend on it that the artist did not lose sight of it in the original. The adage is too common for you to be reminded that every human being, however hideous in feature or figure, considers itself handsome. It is from hence very well accounted for that you have so much business; because it is not beauty alone you live by; but deformity in all its shapes.[95]

The author of *Sketches from Nature*, unlike Reynolds, claims to represent the inward man in *vrai semblance*. Here we have evidence of where Reynolds's theory and the Grand Style portrait are situated in contemporary cultural production. The publication is instructive both for what it reveals about popular responses to Reynolds and for the way in which it demonstrates the ability of a literate audience to envisage a series of non-existent artefacts. Here is further evidence of the centrality of portraiture to social and political definitions. It is within these

definitions that commissioned portraits, exhibited at the Royal Academy, also signified.

The making of political reputations involved the visualization of character through sets of contradictory values articulated through a series of interchangeable signifiers. Distinguished figures were constructed within sites that were never discrete. Thus Thomas Hickey's portrait *Edmund Burke in conversation with his friend Charles James Fox* (pl. 116) employs its title to convey a unity that its imagery contradicts.[96] In the painting Fox and Burke stand before a statue of Cicero which immediately establishes the topos. The background of a landscaped park connotes the stability of a patrician class and its long-term investment. The heaps of papers lying around suggest the legislative responsibilities of the class. However, against these familiar signifiers, the figures of Burke and Fox are unstable, in movement and dynamically opposed one to the other. Fox's clothing is untidy, his person dishevelled; Burke on the other hand – his magnifying glass around his neck – fixes his eyes on the distance and, or so the implication might be, upon the future which, with or without the aid of optical agency, he commands. The rhetoric of friendship which is conceptually and stylistically linked to notions of Republican virtue is the framework for constructing and mediating reputations. Contemporaries brought to the reading of such an image familiarity with discourses of Antiquity, of dress, of land management and of portraiture.

An acknowledgment of friendship as a rhetorical device permits us to recognize that it is against such prevalent ideology (which, formulated as a portrait type, goes back to Van Dyck's celebrated double portraits of, for example, Killigrew and Carew) that the idea of political and personal enmity is to be measured. Difference could most effectively be conveyed by invoking portraiture, since portraiture was a site for conflicting discourses. And nowhere does this become more apparent than in the construction of Fox and Pitt as opposing forces.

The identity of the younger Pitt was formulated by reference to an Antique mould of Father and Son, a Periclean relationship of claim and acceptance. In particular, the figures of Fox and Pitt in their domination of the House of Commons in the 1780s were seen as actors in an Antique drama. The combat was understood, as Gibbon put it in 1785, as one between 'Achilles Pitt and Hector Fox'.[97] Like the Emperor Augustus, Pitt was the subject of a large number of portrait representations, most of which were not done from the life and many of which were posthumous.[98] Pitt emerged into public prominence at the Westminster election of 1784; his youth was still an issue in 1789 when an engraving after a drawing of 1779 by John Singleton Copley of Pitt

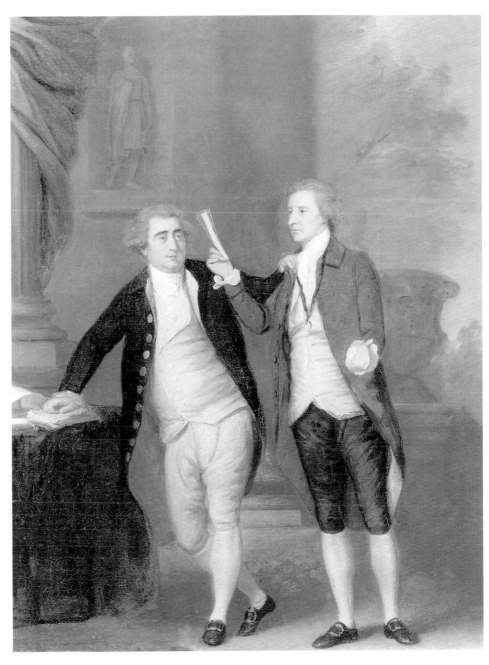

aged twenty was published. By one reckoning, eleven separate depictions were made by Gainsborough in 1788, and the following year eleven portraits overall are recorded. After Pitt's death in 1806 there was further flurry of activity, and he continued to be a popular portrait subject, culminating in the colossal bronze statue by Chantrey which was erected in Hanover Square in 1831 despite attempts to pull it down while the workmen responsible were having breakfast.[99]

Fox and Pitt were established as subjects in binary opposition: Fox was regularly characterized as vulpine in distinction to Pitt who was presented as the true patriot. Contrast was the essence of satire

116. Thomas Hickey, *Edmund Burke in conversation with his friend Charles James Fox*, oil on canvas, 80 × 59 cm. National Gallery of Ireland, Dublin.

and underpins a multiplicity of political/visual commentary from this period. Swift had structured his historical account in terms of 'great' or 'mean' persons; by the 1770s the principle of binary opposition was established at all levels of political commentary. G.A. Stevens in his live comedy entertainment, performed from behind a long table covered with green cloth and backed by screens, exhibited contrasting busts: 'As there was a head in high taste, so here is one in low taste. This is the head of a LONDON BLOOD, taken from the life . . . he is a terror to modest women! and a dupe to women of the town! Of the latter this is exhibited as a portrait.' The show's running commentary was published and went into several editions.[100] The same principle informs Rowlandson's satirical images (pl. 117), the 'contrast' prints of the 1790s (such as England and France contrasted)[101] and the political tokens and medals that circulated as alternative currency in the 1790s. These not only invited comparison with official coinage but also offered contrasting, or complementary, sides.[102]

The great clash between Fox and Pitt at the Westminster election of 1788 occasioned the production of another phantom portrait exhibition. John Horne Tooke, describing himself as 'An Elector of Westminster', published *Two Pair of Portraits presented*

117. Thomas Rowlandson, *The Beauty and The Beast*, pen and watercolour, 15.8 × 11.3 cm. Trustees of the British Museum, London.

Contrast is central to political and social satire; here the alliance of money and looks is projected as a contrast between Beauty and the Beast of the fairy tale.

THE BEAUTY AND THE BEAST.

to all the unbiassed electors of Westminster. There is nothing unusual about this publication featuring Fox and Pitt; it is fairly typical of the great mass of polemic that characterized the series of elections in the Westminster constituency at the end of the century.[103] It is precisely its typicalness that is significant: it offers a point of access to a pattern of communication which on the one hand was conditioned by the genre of portraiture and its practice and on the other hand itself served to shape that genre and its signification.

Westminster was a very particular constituency because every resident male householder had the right to vote, as opposed to the shires where suffrage was limited. Thus Westminster could offer a better chance of securing an expression of popular will than any other constituency in the kingdom.[104] The 1788 by-election is regarded as particularly significant for the evolution of the modern political party. The structures set in place by the supporters of Townshend (the Whig candidate backed by Fox) and Hood (the government candidate backed by Pitt) were then put to the test in the 1790 General Election.[105] Historians have been mainly concerned with the development of an opposition-party organization which negotiated funds and used them to seek out and secure new seats and to run as a campaign through clubs and through the press. But Fox's development of these strategies was in response to Pitt's party machinery which was financed by the Treasury and intended to rescue Westminster from the Whigs. Employing George Smith, proprietor of the Star and Garter tavern, and previously convicted of brewing beer for sale without a license, to keep an open house on Hood's behalf was a Tory initiative familiar from Hogarthian narratives.[106]

Horne Tooke was described by Hazlitt as a political leader belonging to 'the class of *trimmers*'.[107] It is, however, to his mercurial abilities that the portrait painted by Richard Brompton whilst he was in prison in 1777 invites us to refer (pl. 118).[108] Tooke was employed by Hood's committee and left a statement to the effect that twenty thousand pounds was collected from men in his office and the remainder supplied by the Treasury.[109] Much of these funds must have been devoted to subsidies to newspapers and to the publishing of pamphlets, which was increasingly becoming a feature of the parliamentary arena in the late eighteenth century.[110]

The model of the portrait gallery enabled Tooke to compare and contrast two generations and four politicians. Imitating both the language and the lay-out of a sale or exhibition catalogue, Horne Tooke sustained the metaphor of portraiture throughout this document, which not merely reflects the shrewdness of an experienced electioneer but offers the kind of sophisticated (and at the same time ac-

cessible) analysis one would expect from a man who had been a supporter of John Wilkes, spent time in prison, helped to found the Society for Constitutional Information in 1780 and worked as a journalist and pamphleteer. He would himself oppose Fox for the Westminster seat in 1790 and stand acquitted in the treason trials in 1794. In *Two Pair of Portraits*, portraiture is deployed as a ruling-class institution in support of government. The pamphlet opens with an evocation of imaginary pendant portraits of William Pitt, Lord Chatham, and Henry Fox, Lord Holland, the fathers of the opponents. While both men began as commoners and finished as peers, they were diametrically opposite in principles and practices. The second pair of portraits, those of the sons, are defined in pictorial terms:

> These two, though not *whole lengths*, and left for some younger hand hereafter to finish have yet (each of them respectively) a strong family likeness to the former pair.[111]

The fiction of the artist who will leave the portraits to be completed and turned into full-lengths by a successor is a conceit that appeals to an understanding of political reputations as culturally constructed, just as paintings are created by more than one hand and their credentials established over a period of time.

The symmetry established between the two pairs is maintained by attention being drawn to the fact that

both Pitt and Fox were second sons. Portraiture, genealogy made pictorial, provides the framework for producing and regulating the reputation of the individual in political life. The difference that is marked in the fathers is thus carried through to the sons, proceeding through their careers with the object of applauding Pitt and denigrating Fox. Included are detailed accounts of episodes from the lives of Fox and Pitt and, in conclusion, a substantial disquisition upon proportional representation. Appearing within a narrative of mock pictorial depiction, references to 'the present system of mock representation . . .' compound the conceit.

The British Library copy of Horne Tooke's pamphlet contains annotations inside the front and back covers that indicate the publisher's distribution plans: the numbers ordered are listed and the names of individuals involved in distributing copies are noted. The publishers were Johnson and Stockdale, and between 20 and 22 August the annotator appears to have disposed of 142 copies from Johnson, of which 82 were stitched and 60 bound, and a further 65 from Stockdale. In October Stockdale would advertise in all the country papers; it appears from the annotations that it was also intended to print the essay in full in the same newspapers. A number of print-sellers are listed, perhaps because they would be selling a special edition 'to be beautified with engraved heads of Pitt and Chatham & ornamented. Done on vellum. Presented to Parishes etc.'. The author is to be presented with one of these superior bound copies. Among the names of those who are to receive copies of the text are John Wilkes, Dr Richard Brocklesby (a friend of Burke and Johnson), Samuel Vaughan, a West India merchant, and three of his sons, including Ben Vaughan who was Lord Shelburne's private secretary.

The government lost the 1788 election, but what is demonstrated by the episode of *Two Pair of Portraits* and by the group of men whose names are connected with its distribution, is just how vital to political activism was the very concept of portraiture by the last two decades of the eighteenth century. It is also significant – as well as nicely ironic in view of Horne Tooke's care to leave his portraits of the younger Fox and Pitt to be completed by some later hand – that ten years after publication, the *Anti-Jacobin* reprinted Tooke's pamphlet illustrated by two satirical prints by Gillray.[112] In the first of these (pl. 119), Horne Tooke, in an uncaricatured depiction, is portrayed as an artist in his studio working on three-quarter-length images of Fox and Pitt the younger. Fox's hand rests on a pedestal inscribed *Deceit* and Pitt's on one inscribed *Truth*. From the painter's pocket projects a pamphlet: *Sketches of Patriotic Views – a Pension. A Mouth Stopper a Place*. On the floor nearby and neatly juxtaposed are half-length portraits of

118. Richard Brompton, *John Horne Tooke,* oil on canvas, 126.5 × 102.7 cm. Manchester City Art Galleries.

Horne Tooke's most famous publication, *The Diversions of Purley* (vol. 1, 1786), concerned philology and had a Greek title translated as 'Winged Words'. Hermes, the originator of language, is shown removing his winged anklets in the frontispiece to this work. In Brompton's portrait the wings are attached to the helmet which covers the brain – presumably a reference to the owner's fleetness of intellect. The statue is unidentified but is probably a Roman Republican hero admired by the republican Horne Tooke.

Two Pair of Portraits; — presented to all the unbiassed Electors of Great Britain," by John Horne Tooke.

Lord Holland and Chatham, corresponding to the relative positions of their sons and holding documents. Holland's is labelled 'Unaccounted Millions' while Chatham's is 'Rewards of a Grateful Nation'. On the table is a portfolio of *Studies from French Masters* from which protrude sketches inscribed 'from Robertspierre', 'from Tallien', 'from Marat'. The wall behind Horne Tooke's easel is embellished with a bust of Machiavelli and a series of prints including *A Sketch for an English Directory* (four members of the London Corresponding Society), a framed half-length of Wilkes, a profile in silhouette and a framed picture, *View from the Windmill at Wimbleton* (Horne Tooke's house). The two upper

sails are 'Divinity' and 'Politicks', the lower, 'Treason' and 'Atheism'. There is also a placard: 'Just publish'd The Art of Political Painting extracted from the works of the most celebrated Jacobin Professors – pro-bono-publico', and part of a landscape, *Parsonage of Brentford*.

Gillray expands and underlines Horne Tooke's contrasting, verbal portraits and turns the conceit into actuality by representing Tooke as a portrait painter. His satire would have resurrected for Horne Tooke in the 1790s – when Fox was himself standing against Horne Tooke – an embarrassing past, reminding him that he had taken Fox seriously in 1788. In the second print, *Doublures of Characters*

(pl. 120), Gillray reinforces the principle of contrast and affirms the interdependency of portraiture and physiognomic theory in the process of reading and recognizing political caricature.[113] Drawing on Lavater (who, however, had analysed Fox's physiognomy in flattering terms),[114] Gillray demonstrates how portrait images can turn into contrasts or counter-images. No. 1 is Fox, 'The Patron of Liberty', his double is 'The Arch Fiend' with a snake round his neck. Flames illuminate the pair. The sequence continues with Sheridan, the Duke of Norfolk, Tierney, Burdett, Lord Derby and the Duke of Bedford.

The uses of portraiture in the Fox-Pitt contests were legion. In a further interesting print, this time by James Sayers, Fox looks in a mirror and sees instead of his own reflected image the half-length of Oliver Cromwell.[115] The centrality of the concept of portrayal to the political process was further reinforced by frequent puns on 'canvass' and 'canvas'.[116]

Horne Tooke's *Two Pair of Portraits* was evidently aimed at an educated, well-informed readership. But the fictitious portrait as a medium of party-political discourse manifests itself at all levels of communi-cation. Orme's *New Puzzles of Portraits*, issued in the 1790s, included Two Princes (the Prince of Wales and the Duke of York), two Senators (Pitt and Fox), two great Admirals (the Duke of Clarence and Lord Hood), two great men (Lord Thurlow and Burke) and, breaking with this crocodile procession, a great politician (Sheridan) and the Empress of Russia along with the Grand Turk. One set offers 'a striking likeness of the King and Queen of England and the late Unfortunate King and Queen of France'. What is provided, however, is not a portrait in the sense of a human figure but two emblems and a key by which they may be read. Two vipers and a fleur de lys signify 'the Viper of envy (or Rebellion) destroying the Heart of Royalty; the Sceptre of which, & the sword of Justice are broken and disregarded'. The mis-shapen crowned urn and roses represent the king and queen of England. The rose and thistle in full bloom (England and Scotland) are an expression of the flourishing state of the union. The crown supported on an urn alludes to the great veneration with which it is regarded.[117] If the portrait, to twentieth-century audiences, appears an unproblem-atic genre, it seems evident that for eighteenth-century consumers it was a vehicle for politically

119 (facing page). James Gillray, *'Two Pair of Portraits': – presented to all the unbiased Electors of Great Britain, by John Horne Tooke,* engraving, from the *Anti-Jacobin Review,* 1 December 1798. Huntington Library, San Marino, California.

Gillray's caricature refers to the pamphlet written by Horne Tooke in 1788 in which he had compared Fox and Pitt through the medium of imaginary portraits. By 1798 Horne Tooke was himself standing in political opposition to Fox.

DOUBLÛRES of Characters; — or — striking Resemblances in Phisiognomy. — "If you would know Mens Hearts, look in their Faces." Lavater.

I. The Patron of Liberty. Doublûre. The Arch-Fiend. | II. A Friend to his Country. Doubᵗ. Judas selling his Master. | III. Character of High Birth. Doubᵗ. Silenus debauching. | IV. A Finish'd Patriot. Doubᵗ. The lowest Spirit of Hell. | V. Arbiter Elegantiarum. Doubᵗ. Sixteen-string Jack. | VI. Strong Sense. Doubᵗ. A Baboon. | VII. A Pillar of the State. Doubᵗ. A Newmarket Jockey.

120. James Gillray, *Doublures of Characters; or Striking Resemblances in Phisiognomy,* engraving, from the *Anti-Jacobin Review,* 1 November 1798.

Drawing on popular theories of physiognomy, Gillray suggests that every portrait image can slide into its countertype so that Fox (top left), the Patron of Liberty, becomes by contrast the Arch-Fiend.

disputatious issues, a genre characterized by ambiguity and controversy.

The discourse of portraiture was, by the 1780s, crucial to the political process. The fantasy or fictitious portrait gallery could, however, gradually be explained away by reference to unhealthy illusions. Thus when Lodge introduced his *Portraits of Illustrious Personages of Great Britain* in 1821 (quoted in full at the opening of this section) and insisted upon the paramount importance of 'authentic pictures' from 'galleries of the nobility',[118] he did so not only as a strategy to counteract the now popular science of physiognomy which, he claimed, resulted from 'morbid excess', but also to combat the pervasive influence of the fictitious portrait gallery. The success of Lodge in reasserting the patrician values of portraiture can be judged by the fact that the 1821 folio edition at two hundred guineas, intended 'exclusively for the Libraries of the Great' was republished in smaller format in 1829 for a wider audience. The whole series was exhibited at no. 4, Pall Mall East and within a month of the appearance of the first number above 2,000 subscribers were obtained. Demand was so great that the plates were exhausted and an entirely new set had to be engraved. Among those whose 'ardent passion for acquiring a knowledge of the most exalted characters of our country', whose wish to know 'whatever is most important in its history',[119] impelled them to subscribe was Walter Scott. The reconstruction of a family history that Scott arranged for himself at Abbotsford involved the deployment of fictitious portraiture in a way that looks back to Vertue and forward to the agitation for a national gallery of portraits at the end of the nineteenth century.

II THE PORTRAIT AND ITS SUBJECT

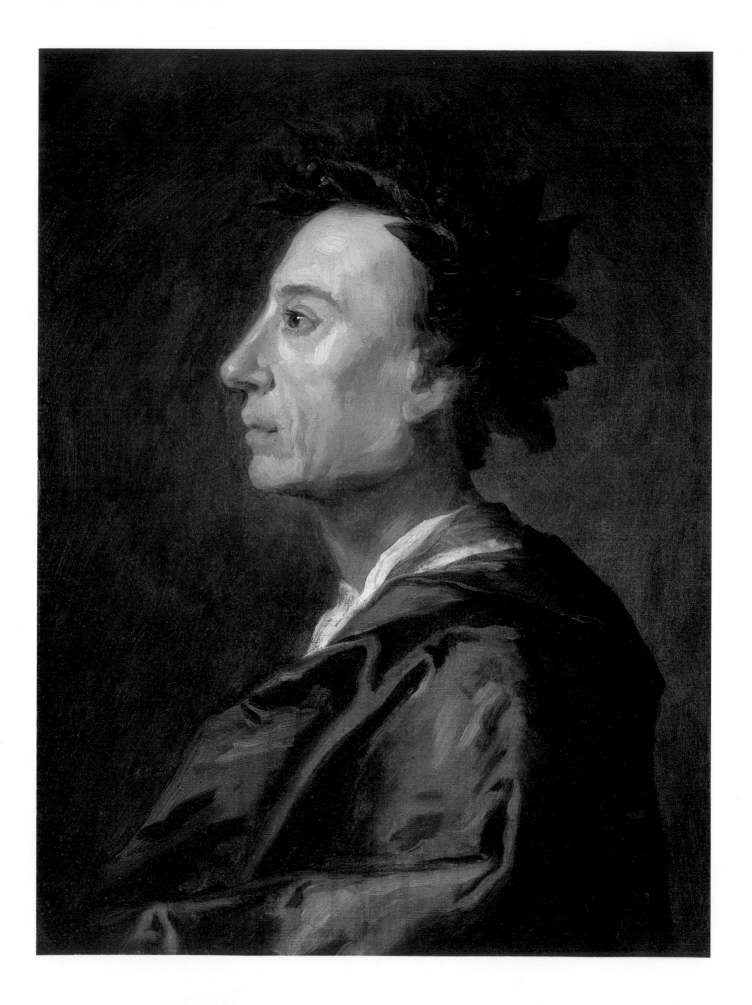

IV DANGEROUS EXCRESCENCES: WIGS, HAIR AND MASCULINITY

The ruffled hairs on fretful perukes rise,
Like quills on hedge-hog, when he roll'd up lies;
Their knots on either side the tyes unfold,
And pendant midmost stands erectly bold.
So when Medusa's head bore snakes for hair,
(Curl'd like the Têtes our dames of fashion wear)
Their folds untwisting, with amaze and dread
They struck the foe, and instant star'd him dead.[1]

A WALK AROUND THE EIGHTEENTH-CENTURY rooms of the National Portrait Gallery in London (where surviving Kit-cat Club portraits are exhibited in their original frames)[2] or a glance through the catalogue of an exhibition dealing with eighteenth-century painting (such as *Painting in Scotland: the Golden Age* or *Manners and Morals: Hogarth and British Painting 1700–1760* (London, Tate Gallery, 1986 and 1987) creates an impression of massed portraits of gentlemen stiffly posed and formally presented and – almost without exception – wearing wigs: the Knellers, the Hudsons, the Highmores, the Devises, the Romneys, Ramsays and Gainsboroughs. There are also portraits of female sitters, some of them powdered and some – for all we know – wearing wigs or hair-pieces. But the split between male and female portraits is, in this matter of the head, definitive. Men who wear their own hair and who appear in public places, that is in portraits, without a wig are defined by that absence. Such, for example, are Alexander Pope portrayed by Jonathan Richardson *c*.1737 as a poet of Antiquity (pl. 121), George Frederick Handel in Roubiliac's statue (1738, Victoria and Albert Museum), Dr Johnson in Reynolds's portrait of 1769 (Houghton Library, Harvard University), or Romney in his relaxed self-portrait of 1782 (pl. 58).[3] In political caricature such distinctions are clearly underlined: in prints of Fox's 1784 campaign Sam House, a publican, is identified by his shaved head and absence of wig as a member of the rabble with which Fox notoriously consorted.

Wigs were certainly available for women: Rowlandson's *Six Stages of Mending a Face* of 1791 clearly shows a woman, with shaved head, donning a wig. But this should not be construed as evidence that the wig was associated equally with male and female identity; it is precisely its masculine connotations that work here to reinforce the unnaturalness of 'mending the face': the woman's action is proper to a man, not to a woman. Even the most elaborately dressed heads of Reynolds's most fashionable sitters of the 1770s, like the Duchess of Marlborough, appear to be created at least superficially from the owner's own growing hair (pl. 122).[4] Doubtless, art assisted to create the impressive pile of the duchess's *coiffure*, but the viewer was intended to see it as part of her natural endowment (pl. 123), whilst the duke, in the same painting, is unmistakably bewigged (pl. 124).

It is worth pausing to remind ourselves of the actual differences in men's and women's dress in the eighteenth century. Ritchie's treatise on hair of 1720 claims that:

Women study dress only to add to their beauty; whereas men should dress suitable to their various ranks in life, whether as a magistrate, statesman, warrior, man of pleasure, &c. for the hair, either natural or artificial, may be dress'd to produce in us different ideas of the qualities of men, which may be seen by actors, who alter their dress according to the different characters they are to perform.[5]

Men and women were instructed how to combine the natural hair of the head with toupees and half-wigs, but for ladies additional hair is recommended chiefly when their own hair is too thin or too short or for convenience when out of town. Men who were balding could disguise this by various forms of top-piece, tower- or half-wig,[6] but gentlemen who wore bag-wigs needed to have their hair shaved or very short.

Thus while the fashionable man covered his entire head with a wig and had his own hair shaved better to accommodate false hair, women added to their own hair as prescribed by Ritchie, or for special occasions. When Mary Welch married the sculptor Joseph Nollekens in 1772 she was extravagently

121. *Alexander Pope*, attributed to Jonathan Richardson, oil on canvas, 61.3 × 45.7 cm., *c*.1737, National Portrait Gallery, London.

Pope is presented here as a timeless modern equivalent of an antique poet or philosopher, the profile format evoking medals and cameos and the laurel garland suggesting the honour of his profession. He is very much not a contemporary fashionable figure.

122 (following page). Sir Joshua Reynolds, *The Marlborough Family*, oil on canvas, 318 × 289 cm., R.A. 1778. Red Drawing Room, Blenheim Palace. By kind permission of His Grace the Duke of Marlborough.

George DUKE of MARLBOROUGH~Caroline D.ss of MARLBOROUGH~George MARQUISS of BLANDFORD~LORD Henry Spencer~LADY Caroline Spencer~LADY Eliz.th Spencer~LADY Charlotte Spencer~LADY Anne Spencer.

The practice of supplementing the natural head of hair rather than replacing it did not, however, preclude accusations of offences against nature. Cowper's attack on the way the town 'has tinged the country', published in *The Task*, Book iii, in 1783, focuses on the loss of the type of the rural lass. In her place is an adorned woman whose head exemplifies the falsity of her life:

> Her head adorned with lappets pinned aloft
> And ribands streaming gay, superbly raised
> And magnified beyond all human size,
> Indebted to some smart wig-weaver's hand
> For more than half the tresses it sustains.

Whereas an elaborate head of hair, natural or artificial, connoted vanity or fashionable aspiration for a woman, it was universally recognized that masculine authority was vested in the wig. Wigs thus feature prominently in one of the popular live entertainments in London in the late eighteenth century and were evidently a familiar subject of humour directed at a fragile masculinity. G.A. Stevens's celebrated satirical *Lecture on Heads* was first published in 1764 but may have been an attraction on the London stage for some time prior to this.[8] It was still

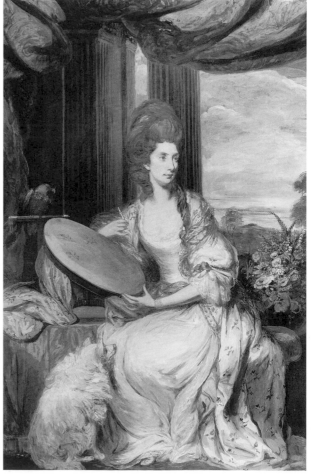

124. Detail of pl. 122, Reynolds, *The Marlborough Family*.

123 (previous page). Detail of pl. 122, Reynolds, *The Marlborough Family*.

125 (right). Daniel Gardner, *Lady Frances Tollemache*, gouache, pastel and crayon, 83.9 × 53.3 cm. The Lord Tollemache.

prepared: tall *coiffures* for women were the height of fashion, and the bride's 'beautiful auburn hair, which she never disguised by the use of powder, according to the fashion of the day, was . . . arranged over a cushion made to fit the head to a considerable height, with large round curls on either side; the whole being surmounted by a small cap of point lace, with plaited flaps to correspond with the apron and ruffles'.[7] A fashionable hair-do of this kind, in which the sitter's own hair is raised over a pad, is a feature of Daniel Gardner's portrait of Lady Frances Tollemache (pl. 125). Here the medium, which lends itself to effects of spontaneity, combines with a series of well-chosen motifs (dog, parrot, bouquet of wild flowers and the floral design of Lady Tollemache's embroidery) to suggest stylish femininity as natural.

running successfully in 1772. In Act I Stevens, demonstrating with models, would announce: 'Wigs, as well as books, are furniture for the head, and both equally voluminous. *This* (a *full buckle*) we may suppose a huge Quarto in large paper. And *this* (a *jockey's*) a Duodecimo in small print.'[9] The head was perceived as a field of inscription (as well as a container to be furnished with book-learning) and was commonly understood as capable of transformation according to class or gender. It was a detachable item, the 'furniture' of which consisted of a sequence of signifying components from which a narrative could be read, and chief among these was the wig.

Stevens's show was succeeded by that of Edward Beetham, who in a performance that allegedly ran for three hundred successive nights before crowded audiences, used to tell how the 'modern custom of embellishing the whole head' derived from 'the ancient custom of adorning the temples' and 'hence arose the wig manufactory' (pl. 126). The consequences of this are then demonstrated using wood and pasteboard models:

> No. 6. Here is a head [*a counsellor's head*] and only a head; a plain, simple, naked unimbellished appearance; which, in its present situation conveys to us no other idea, than that of a bruiser preparing to fight at Broughton's. Behold now naked, how simple a thing nature is! But behold how luxuriant is [*a large tye wig upon the head*] No. 7. Art! What importance is now seated on those brows! What reverence the features demand![10]

Beetham's humorous exposure of human vulnerability through the contrast between the familiar, bewigged authority and the naked, exposed head suggests not only that the wig was (as Ritchie also asserts) necessary to the establishing of masculine identity, but also that a man without a wig was an object of universal contempt, as the man who has lost his trousers became the butt of music-hall humour in the early twentieth century.

Art history has largely dealt with personal apparel and with contingent questions of fashion in one of two ways. In a narrow line of enquiry the portrait is assumed to be a direct and unmediated equivalent for the self, and the clothing and personal accoutrements re-presented are assumed to be those worn by the subject in a given combination, a precise effect on a particular day. The historian of fashion is then invited to date and to estimate the expense and the social connotations of the particular items of apparel. The resulting information is then employed in identifying the sitter and dating the painting. The second approach is less a method than an assumption. It rests on the idea of a sliding scale from informality to formality in matters of dress and comportment.

The equation between dress, pose and 'mood' is one that is often judged ahistorically, without recourse to knowledge of contemporary gestures and body language.[11] Thus Highmore's portrait of Thomas Emerson of 1731 is described in one of the aforementioned exhibition catalogues as carrying 'the Kneller tradition forward to a new era, and in its own more restrained fashion, conferring as much dignity on a commoner and a civic benefactor as does Hogarth's later "Captain Coram"'.[12] There is an assumed correlation here between the centralized bewigged three-quarter-length figure in black with judiciously revealed white linen at cuffs and throat, posed against shelves of substantial books, and the ephemeral notion of 'dignity'.[13]

126. Fold-out frontispiece to E. Beetham, *Moral Lectures on Heads*, 1780. By permission of the British Library, London.

Beetham's popular show involved transforming dummy heads into different characters by changing their head-gear while he discoursed upon their attributes. He includes a self-portrait at top left.

127. Detail of pl. 126.

What can be learned of portraiture as a medium of communication exploited by popular stage performers is that forms of clothing – particularly headgear – are not read as naturalistic attributes of an individual in eighteenth-century society but understood as components in a language, in a vast repertoire of signifiers. The frontispiece to Beetham's *Lectures*, which also incorporates a self-portrait of Beetham in the top left corner (pl. 127), sets out for us in numbered succession some of the many possibilities. At one level this can be seen as part of the growing interest in physiognomy at the end of the eighteenth century. But from another point of view it demonstrates the refusal to recognize boundaries between notions of representation and notions of actuality, a refusal that provides the conditions for the kinds of political prints discussed in the previous chapter. It also provides for a more accurate understanding of how society portraits were invested with, or intent upon avoiding, specific associations with particular social groups and practices. Stevens and Beetham invite their audiences to imagine themselves looking simultaneously at named individuals *and* at representations of types. They are at one and the same time fictitious portraits and generic social specimens.

These shifting boundaries between actuality and representation are also explored in two-dimensional art forms. An anonymous Irish artist at the end of the eighteenth century painted in *trompe l'oeil* an engraved portrait of the artist Lowry (pl. 128) on which was superimposed a key hanging on a hook,

a device that foregrounds the artifice of portrait representation while demonstrating its capacity to deceive. John Russell's portrait of an anonymous sign-writer (pl. 130) plays on a comparable conceit, further demonstrating the head as an artefact open to appropriation, rather than an unproblematic physiological entity for which the portrait serves as analogue. The writer of signs is enmeshed in signs: wigless and wearing a cap, he is workmanlike in the manner of Vanderbank's portrait of Rysbrack (pl. 129) or Rysbrack's bust of Hogarth of 1740 (National Portrait Gallery, London). But just as the head in the composition is an iconic sign equivalent to the graphic sign (made by the sign-writer) that occupies the corresponding corner, lower left, so the head is as socially incomplete as the insignia is unfinished, awaiting a wig to transform it from workshop to public and social space.

The seemingly unproblematic (and ultimately iconographically undistinguished) formality of eighteenth-century male portraiture is, therefore, a formality defined within the period by implicit contrast with that to which it is other, by its hieratic and symbolic separation from the grotesque disorder into which – without the perpetual replication of these ordered and dignified representations of the idea of social man – it would disintegrate. By concentrating on that item of fashionable male apparel, the wig, this investigation recognizes it as a discursive formation from the seventeenth through the eighteenth centuries. The wig possesses a life of its own as a patterning far beyond the bounds of questions of dress and manners. It is invested with a powerful symbolic significance and becomes widespread currency in ways that cannot be summed up by the material object of the wig to which, however, this symbolic life always ultimately refers.

Portraits, as we have established, are part of a symbolic structure: the subject of the portrait participates in the production of meanings that are not defined by reference to standards of likeness. There is no 'natural' self against which the portrait as re-presentation of that self can be measured.[14] The body is, as Elizabeth Wilson suggests, an organism in culture, a cultural artefact of which the boundaries are unclear.[15] In discussing the wig as a symbolic system it is necessary to disregard the boundaries that academic disciplines have used to separate actuality from representation as well as those that separate different kinds of artefacts. The wig is an artefact and the wearing of a wig is a form of self-enactment. At one level its value is that it serves as voucher for a life of non-strenuous and non-manual labour, a life in which all movement is premeditated and leisure is unearned.[16]

In linguistic terms the wig is a signifier whose meanings are determined by the context in which it

128. *Lowry, trompe l'oeil* of an engraving by an anonymous Irish artist, oil on canvas, 56 × 43 cm., *c.*1800. National Gallery of Ireland, Dublin.

The subject seems to be the engraver Wilson Lowry (1762–1824). *Trompe l'oeil* still-life scenes were a popular seventeenth-century genre but here, by imaging an engraving which is itself a reproduction, the artist subverts the mimetic qualities of portraiture as genre by turning it into still life.

Lowry

works. The appearance of a wig in a visual image may well be accounted for by the fact that the particular subject owned and wore a wig, but it must also be read as contributing to a symbolic structure that is not controlled or determined by a division between 'life' or 'history' on the one hand and representation and its conventions on the other. In a discursive practice, the wig signifies across an entire field: the wearing of a wig by a particular individual at a particular time is implicated with the wig as depicted in portraits, just as the portraits are themselves implicated in the fashion for wearing wigs. Similarly, the recurrence of the wig across a range of visual imagery – from Hogarth's *A Midnight Modern Conversation* (pl. 131) or his *Election* series (pl. 141) to Thomas Hudson's *Theodore Jacobsen* (pl. 132) – overrides the autonomies of artist, genre or mode of production. It is at the symbolic level of communication that the rhetorical language of the body most clearly articulates power: the surfaces of the body are backgrounds on which items of apparel as objects in themselves are inscribed. When the body is understood to be an artefact, the boundaries between self as represented in visual imagery and self as mobile representation cease to operate and imagery may be seen to inform the productions of meaning in life as well as the reverse.

It is not necessary to construct an empirical account of eighteenth-century urbanized life to recognize the importance of fashion: the ambiguities of fashion are

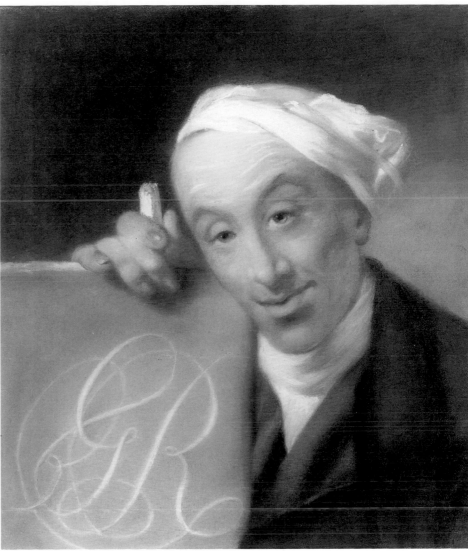

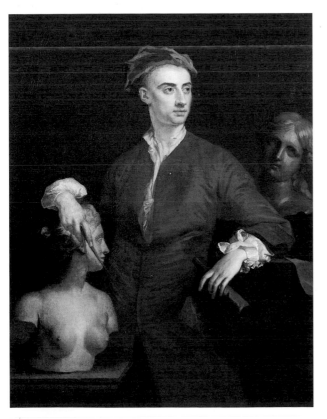

mapped by Elizabeth Wilson when she points out that 'to dress fashionably is both to stand out and to merge with the crowd, to lay claim to the exclusive and to follow the herd'.[17] These ambiguities are by no means a twentieth-century interpretative gloss. They are enshrined in eighteenth-century theory. It is, therefore, interesting to take two conflicting views that address the ambiguities Wilson identifies as typical of fashion. Both are implicated in the principle of metonymy, whereby the part substitutes itself for the whole.

Fuseli, discussing historical painting in one of his lectures to the Royal Academy, insists that in the interests of an academic theory of the ideal, 'transient modes' are inadmissible but defects can be useful provided they are inherent in the character and thus strengthen rather than diminish the fascination of the man. The deformity of Richard III adds to his terror and therefore can be represented, but special attention may not be drawn, presumably, to the

130. John Russell, *The Sign-Writer*, pastel, 61.0 × 45.7 cm. Courtauld Institute Galleries, London.

The interrogatory gaze of the sign-writer, whose face appears on the same plane as his sign, invites us to engage with the question of graphic art's legibility.

129. John Vanderbank, *John Michael Rysbrack*, oil on canvas, 125.7 × 100.3 cm., *c.*1728. National Portrait Gallery, London.

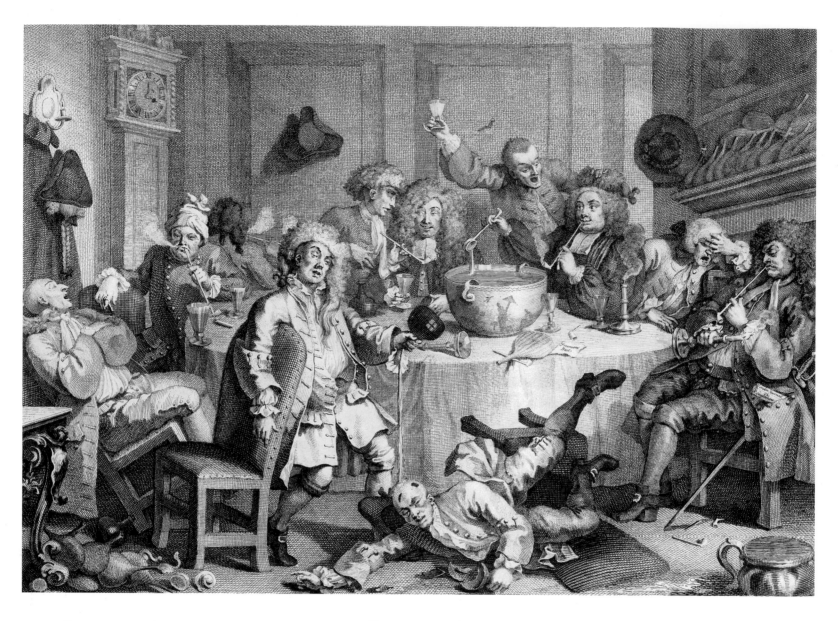

131. William Hogarth, *A Midnight Modern Conversation*, engraving, March 1732/3. Trustees of the British Museum, London.

A variety of wigs, some of them very much out of fashion by this date, are to be seen in the image of revelry; several members of the group have lost – or are about to lose – their wigs, and the figure at the centre rear has torn his off in raucous mood as he makes a toast.

particular doublet that he wore.[18] William Gilpin, on the other hand, discussing Hogarth, recognizes how the peculiarities of air and gesture that every profession develops become characteristic of the whole. But the very insignia of individuality serve to render such professions, as a group, ridiculous, and they should therefore avoid those particularities whether they be lawyers, usurers or undertakers (pl. 133).[19] The debate between Gainsborough and Lord Dartmouth about the appropriateness of contemporary fashion in a portrait, and the differences in the practice of Reynolds and Gainsborough in this respect, are not explicable by reference to the individual predilections of the particular artists and clients concerned: they are part of a complex debate about self-fashioning and the manifestation of constructed individuality.[20]

* * *

The *Oxford English Dictionary* notes that 'wig' is a shortened form of 'periwig'. It defines the wig as 'an artificial covering of hair for the head, worn to conceal baldness or to cover the inadequacy of the natural hair, as a part of ceremonial, or formerly fashionable, costume (as still by judges and barristers, formerly also by bishops and other clergymen) or as a disguise (as by actors on the stage)'. By elision, the word 'wig' can come to mean the head of natural hair, as with calling a child 'curly-wig' and as with receiving a scolding or wigging from someone whose authority is symbolized by their wearing a wig – and being a 'bigwig'. Wigs were commonplace in Ancient Egypt and were also worn in Roman society, but the peruke, as it is most familiar in western culture, was first worn in France and Italy about 1620 and introduced into England around 1660 where it remained in widespread use until about

114

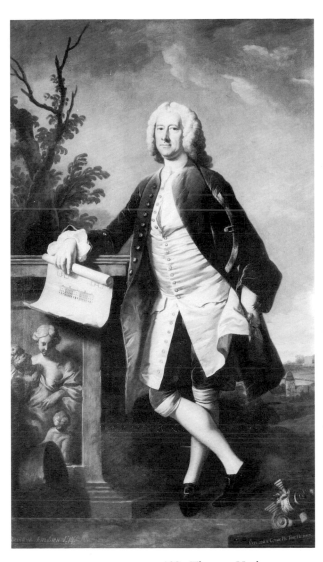

132. Thomas Hudson, *Theodore Jacobsen*, oil on canvas, 236.2 × 137.1 cm., 1746. Thomas Coram Foundation for Children, London.

This very large portrait represents a founder Governor of the London Foundling Hospital holding the architect's plans. His pose and attire are that of the fashionable metropolitan male whose wealth and status derived in no small part from the landed property in which he stands.

1810. Although women at Elizabeth's court wore wigs, it was overwhelmingly an item of male fashion from the late seventeenth century.

Our knowledge about wigs comes from a variety of anecdotal and documentary sources and also from a number of treatises on wig-making. Diderot's *Encyclopédie* (1751–65), for example, systematically illustrated not only the art of wig-making (pl. 134) but also catalogued the wigs available at the time (pl. 136), including knots and spiral curls, earlocks and pigtails, abbé's wigs with a tonsure left open

133. William Hogarth, *The Company of Undertakers*, engraving, 3 March 1736. Trustees of the British Museum, London.

According to William Gilpin, the distinguishing characteristics of a profession which may in the singular spell distinction, in the group will invite ridicule.

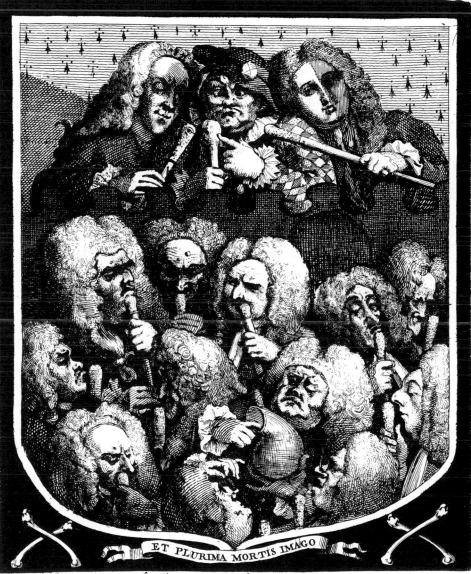

The **Company** *of* Undertakers

Bearth Sable, an Urinal proper, between 12 Quack-Heads of the Second & 12 Cane Heads Or, Consultant. On a Chief Nebulæ, Ermine, One Compleat Doctor issuant, checkie Sustaining in his Right Hand a Baton of the Second. On his Dexter & Sinister sides two Demi-Doctors, issuant of the second, & two Cane Heads issuant of the third; The first having One Eye conchant, towards the Dexter Side of the Escocheon; the Second Faced per pale proper & Gules, Guardent. — With this Motto — Et Plurima Mortis Imago.

Published by W. Hogarth . March the 3.ᵈ 1736

Price Six pence

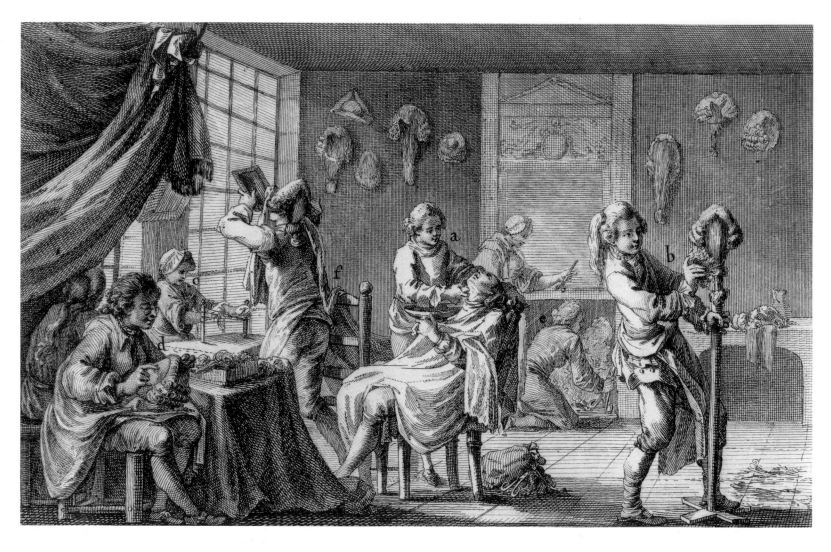

134. Bernard after Lucotte, *A Perruquier's Atelier*, from D. Diderot *et al.*, *Encyclopédie*, 1751–65, vol. 25, pl. I. By permission of the British Library, London.

Various activities involved with wig-making are shown, including heating up the tongues, preparing the hair and – in the case of the man by the window – removing powder from the face after a fitting.

135. Bag-wig owned by Sir Thomas Worsley, *c.*1780, Manchester City Art Galleries, Platt Hall.

in the crown and bag-wigs (which included a rectangular bag with drawstrings at the back in which the hair was contained (pl. 135)). De Garsault's *Art du Perruquier* (1767) offered an authoritative account of an art and a fashion in which France was well established by the 1720s (pl. 137).[21] Hogarth's famous parody of the Vitruvian architectural orders (*The Five Orders of Periwigs*, first state, November 1761; pl. 138) plays on systematizing representations like these and, more immediately, parodies earlier English representation systems like *The Exact Dress of the Head, drawn from the Life at Court, Opera, Theatre, Park &c by Bernard Lens in Years 1725 & 1726 from the Quality & Gentry of Y^e British Nation* (pl. 139).[22] Like all forms of personal adornment subject to the laws of fashion, the wig was a powerful signifier capable of extremely diverse and contradictory connotations. The seventeenth-century legal wigs that Hogarth isolated in an essay on caricature (pl. 140), thereby offering a critique on the pretensions of the legal profession, and those of classicizing *cognoscenti* were, like the orders of Classical Antiquity, archaisms. But

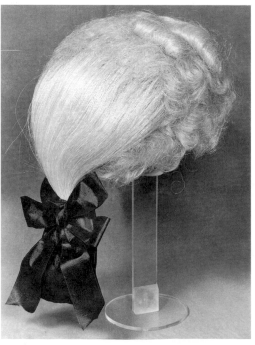

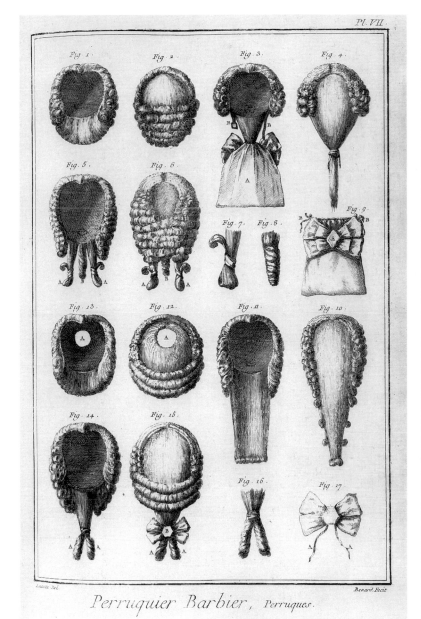

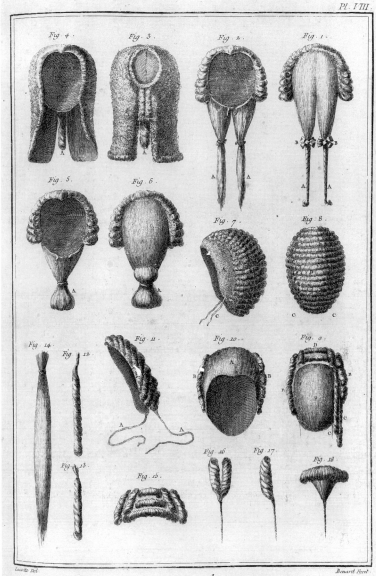

136. Bernard after Lucotte, *The Interiors and exteriors of a range of wigs and some details*, from D. Diderot *et al.*, *Encyclopédie*, 1751–65, vol. 25, pls VII and VIII. By permission of the British Library, London.

just as the Palladian style symbolized the exercise of patrician power, the legal wig, coupled with wealth, eloquent speech and the authority to command death, was also the visual embodiment of an historic and established exercise of power. As Hay points out, the courts were platforms for addressing 'the multitude' and contemporaries testify that 'in the court room the judge's every action was governed by the importance of spectacle'.[23] That the wig was invested with concepts of masculine and institutional power is further evinced in the verses that form the prelude to this chapter. In the battle for professional power between apothecaries and physicians, it is the wig that metonymically stands in for the representative of the profession.[24]

Once it became customary for gentlemen to wear

wigs, to appear without one was to expose oneself as eccentric, exceptional or deviant. It has been shown that wearing a wig involved the shaving of the head for close fitting, and many of Hogarth's subjects (see, for example, the *Election* series) create effects of anarchy by introducing a naked shaved head into a crowd. The loss of the wig is a recurrent theme in literature and in art, connotative of loss of masculinity and potency. In the painting *An Election Entertainment* (pl. 141) Hogarth fully exploits the play on whig and wig: the Whigs' wigs are all awry. In the foreground a Whig has his injured shaven pate treated – he is wigless – while the Whig attorney who has been registering votes in a book has just been knocked senseless by a brick and his wig falls from his head. In a tailpiece showing a drunk under a

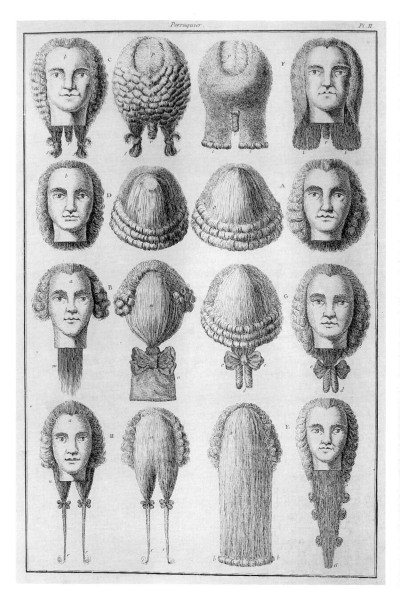

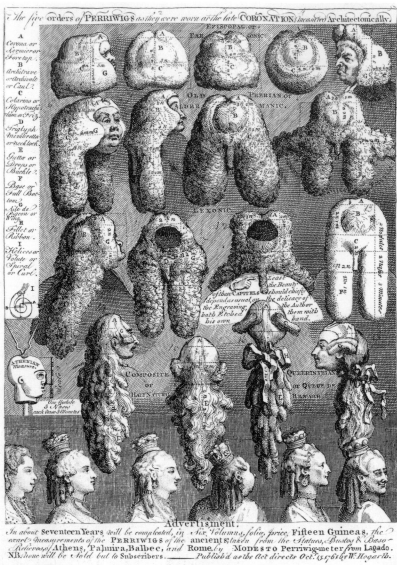

137 (above left). *A Selection of Wigs*, from M. de Garsault, *Art du Perruquier . . .* , 1767. By permission of the British Library, London.

139. Bernard Lens, *The Exact Dress of the Head, drawn from the Life*, book of drawings in pen, ink and grey wash on white wove paper, 8.5 × 14.2 cm., 1725–6. Courtesy of the Board of Trustees of the Victoria and Albert Museum, London.

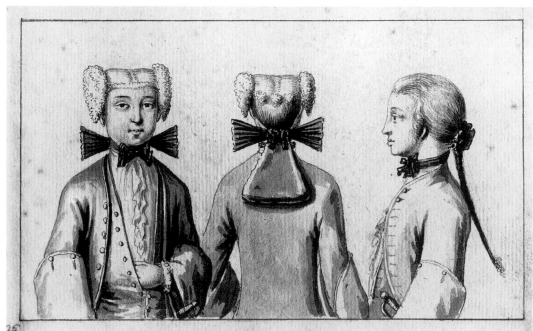

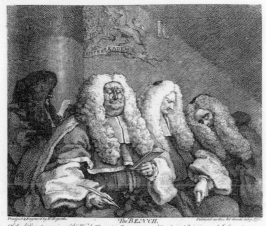

140 (far left). William Hogarth, *The Bench*, engraving, 4 September 1758. Trustees of the British Museum, London.

142 (left). Thomas Bewick, *A drunk under a hedge*, wood engraving, tailpiece vignette, 11 × 19 cm., 4 June 1795, from T. Bewick, *The History of British Birds*, 1797. By permission of the British Library, London.

The man appears to have fallen from his horse, his hat has fallen from his head and his wig is about to go the same way.

138 (facing page top right). William Hogarth, *The Five orders of Perriwigs as they were worn at the late Coronation measured Architectonically*, engraving, 15 October 1761. Trustees of the British Museum, London.

Hogarth's witty engraving satirizes the passion for wigs among gentlemen (women's more modest head-dress is shown along the bottom line) and the practice of representing them (see pls 136, 137) by reference to the Vitruvian architectural orders. The episcopal or Parsonic wig is accompanied by the Peerian or Manic and the Queerinthian or Queue de Renard.

hedge (pl. 142), William Bewick chooses to show the man with his wig slipping off – the sign of his loss of dignity.[25] Similarly the denouement in Colley Cibber's play *The Careless Husband*, painted by Philip Mercier and engraved in 1739, occurs when the virtuous Lady Easy returns home early and discovers to her great shock her neglectful and errant husband in post-coital slumber in the company of her maid (pl. 143). Crucial to the audience's (and our) understanding of the sexual implications of the state in which he is observed by Lady Easy is the fact that he is bare-headed. Such is her goodness and devotion

141 (left). William Hogarth, *An Election Entertainment*, oil on canvas, 101.5 × 127 cm., *c*.1762. The Trustees of Sir John Soane's Museum, London.

Hogarth exploits the pun on wig/Whig in this painting of the entertainment given to the mayor and citizens of Guzzletown by two Whig candidates. The opposition is active outside in the street.

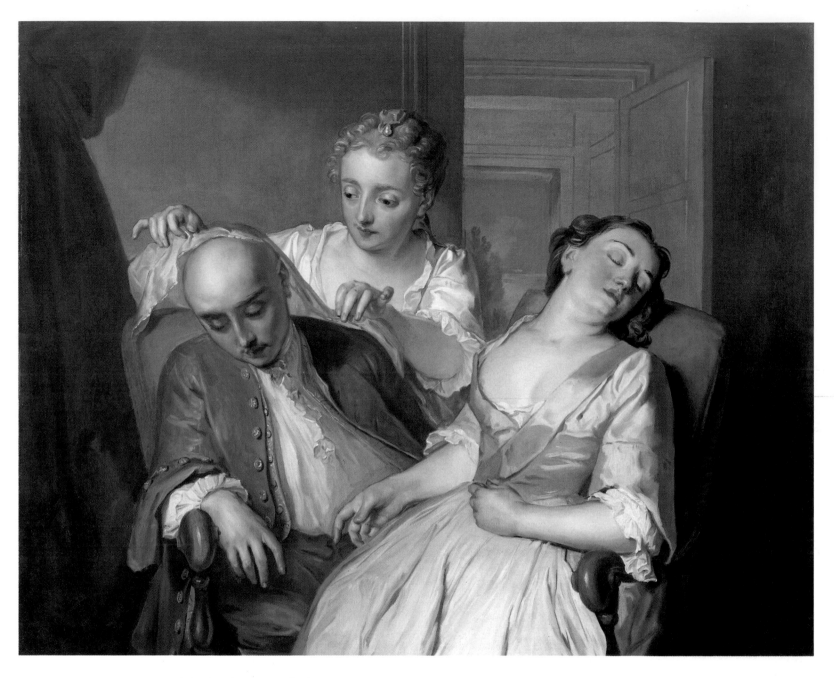

143. Philip Mercier, *A Scene from Colley Cibber's 'The Careless Husband'*, oil on canvas, 101.6 × 127.0 cm., 1738. York City Art Gallery.

In this, the denouement of the play, the betrayed wife finds her errant husband asleep in the company of her maid; the absence of his wig reveals not only his shaven head but also his guilt.

that Lady Easy covers her husband's smooth head with her handkerchief, lest 'while thus exposed to th'unwholesome Air/ . . . Heav'n offended may o'ertake his Crime,/And, in some languishing Distemper, leave him/A severe Example of its violated Laws.'[26] Whether biblical authority in the form of the story of the cutting off of Samson's hair and his consequent loss of strength,[27] or Freudian castration theory is invoked, it is clear that the loss of hair – like the loss of teeth – has powerful meanings in the nexus of sexuality and power.[28]

Wigs were often the most expensive item in a gentleman's wardrobe and organized theft was commonplace.[29] Loss of a wig threatened social

chaos since the owner could not appear in polite society without one. In August 1789 Boswell was obliged to share a room in an inn and next morning found his wig was missing: 'I was obliged to go all day in my night-cap and absent myself from a party of ladies and gentlemen who went and dined with the Earl on the banks of a lake . . . I was in a ludicrous situation.' Not wishing to remain 'an object of laughter', he went to Carlisle, twenty-five miles away, to obtain another. Conversely, the acquisition of a 'good handsome bob' is a prerequisite to Roderick Random's transition from provincial to London society.[30]

As a literary topos, the removal or loss of wig is

synonymous with exposure, causing a break-down of social order and the threat of sexual disturbance. In Fanny Burney's *Cecilia: Or Memoirs of an Heiress* (1782), Mr Briggs arrives at a ball in Portman Square to mix in society with his ward, Cecilia Beverley. Feeling very hot, he takes off his wig to wipe his head, 'to the utter consternation of the company', an action that occasions 'such universal horror' that people flee the scene. Captain Aresby, being applied to by some of the ladies, remonstrates with Mr Briggs and entreats him to put on his wig, for 'the ladies are extremely inconvenienced by these sort of sights, and we make it a principle they should never be *accablées* with them'. The captain concludes that Mr Briggs is 'the most petrifying fellow I ever was *obsédé* by!'[31] The action of removing the wig is not only anti-social, it is gender-specific, and the shock caused derives from the act's being committed in mixed company and in a public (social) space rather than in the private (though communal) space of the dressing-room.

Captain Aresby's French affectations open up a certain ambivalence towards the standards of manners that are implied by his defence of the ladies' sensibilities. This ambivalence indicates that the wig was capable of connotations other than those of the strictly respectable and the maintenance of social order. Indeed, at the other extreme wigs could represent not upright masculinity but the very reverse: 'flaring, flounced periwigs, low dangled down with love-locks' were derided by Thomas Nash in 1593,[32] and although the wig worn by Mr Briggs would have been a very different affair from Nash's love-locks, wigs constantly posed the threat of excess and, particularly, of effeminacy. In the 1770s the *macaronis* in their exuberant wigs and theatrical clothing caused particular alarm.

Wigs were not confined to adults, nor to the head: children frequently wore them,[33] and although evidence concerning the use of the merkin or pubic wig is, for obvious reasons, not readily available, it is interesting to note that its very existence suggests hair and counterfeit hair as a focus of particular sexual attention in the eighteenth century.[34] Yet for all its multifarious applications the wig was profoundly significant in the maintenance of social order. The appearance of the Polynesian Omai (who was so brilliantly portrayed by Reynolds in 'native' habitat; pl. 184) wearing a bag-wig at court in 1773 must have been a memorable moment in the ritual annexation of the oriental 'other' and the affirmation of western metropolitan order.[35] The wig was crucial to conformity but simultaneously capable of subverting its own orthodoxy and being presented as a site of danger both actual and symbolic.

The contradictions around questions of function – the wig as visible sign of order, an order which is gendered, *and* the wig as the site of disturbance social and sexual – are manifest also in the manufacture of the objects themselves and in the discourses produced by the process of production. While various attempts were made to manufacture synthetic wigs (Lady Mary Wortley Montagu's son wore an iron wig purchased in Paris and Dr Lettsome wore a wig made of glass wool[36]), most were made either from horse hair (the cheapest) or from human hair (the most desirable).[37] The hair of country girls was specially sought after as it was regarded as untainted by the miasma of the city. The transferrence of human detritus from one individual to another, as well as the elision of class and gender boundaries implied by the manufacture of wigs from the hair of poor country girls for the heads of city gentlemen, lent the wig a power of association despite the fact that artistry and fashion united to disguise it. Fear that one might be wearing a wig made from the hair of harlots, cadavers or plague victims was common.[38] The fears of infection were not completely unfounded; the famous Quaker surgeon, Dr John Fothergill, used to tell in 1778 of a medical wig that conveyed smallpox from London to Plymouth. Another doctor is said to have failed to fumigate his wig after visiting a smallpox hospital and consequently to have given his daughter the disease.[39]

Wigs, worn by many (like Pepys, for example) to avoid the troublesome business of keeping a clean head, could themselves after long use become more loathsome objects than any item of dress, an encapsulation of human filth and a carrier of disease. Describing an antiquarian of some eccentricity whom she is obliged to entertain at her dinner table in 1739, Miss Talbot describes the gentleman's ancient suit of clothes and a great-coat transmitted from generation to generation ever since Noah. But her greatest opprobium is reserved for his wig:

> He came to dine with us in a tie wig, that exceeds indeed all description. 'Tis a tie-wig (the very colour is inexpressible) that he has had, he says, these nine years; and of late it has lain by at his barber's, never to be put on but once a year, in honour of the Bishop of Gloucester's birthday.[40]

Through these associations, the wig acquired a capacity to symbolize human filth and corruption that was widely exploited. One account, for example, tells of a journey in a stage coach in the company of a pretty young Quaker woman 'in all the elegance of cleanliness', the whiteness of her arms taking advantage from the 'sober coloured stuff in which she had cloathed herself', and a dirty beau, dressed in a suit saturated in old powder and a costly periwig cast over his shoulders 'in so slovenly a manner that it seemed not to have been combed since the year 1712'.[41] The structural relationship between the

failed masculinity of a dirty, uncombed wig and the purity of unadorned femininity points up the function of the wig as an index of social power.

The wig held, it seems, a special place in the economy of the body and possessed as a consequence powerful symbolic values. It might be seen as a register of socialized masculinity from the seventeenth to the beginning of the nineteenth century; as such it was also heavily ideologically invested. By the end of the eighteenth century – when it was suggested that there were 50,000 hairdressers in the kingdom – men were wearing their own hair powdered to imitate a wig. The powder for heads was made from flour and when, in 1795, a tax was introduced on hair powder, the wearing of an unpowdered wig or of cropped hair (by 'croppers') became a sign of republicanism. When Walter Savage Landor and Robert Southey adopted this stance in Oxford[42] they were engaging in a highly complex form of ritualized self-presentation. Throughout the eighteenth century wigs were unmistakably associated with French court fashion, so to parade an unpowdered wig would not have been entirely unequivocal. The wig not only played a part in signalling political affiliation, but was understood to be germane to defining the body politically. When a drayman described John Wilkes in 1768 as 'free from

What is understood to be Wilkes's character as potentially both diabolical and feeble is suggested by a wig that forms the shape of horns.

cock to wig', it is not only an indication that every action of the person of Wilkes had, of necessity, a symbolic or public character,[43] it is also evidence of the correlation between phallus and wig as bearers of symbolic encoded meanings concerning male potency in sex and political authority. It is this connection that empowers Hogarth's portrait of Wilkes as ambiguous upholder of Liberty (pl. 144); he is portrayed in a wig formed into a shape that suggests a pair of horns, which connotes both devil and cuckold.

The sexual connotations of the wig open up a field of innuendo and the metonymic relationship of the wig to the body as a social vehicle endow it with powerful resonances throughout the period. Two quotations will illustrate this. At the beginning of the wig's reign of popularity, the prologue to the play *The Ordinary* (1670–71) offered this view of the audience:

Some come with lusty burgundy half drunk,
t'eat Chine Oranges, make love to Punk;
And briskly mount a bench when th'Act is done,
And comb their much-lov'd Periwigs to the tune
And can sit out a Play of three hours long,
Minding no part of't but the Dance or Song.[44]

When John Thomas Smith was writing *Nollekens and his Times* (1828), wig-dandies were a phenomenon still within living memory; it was possible for his older readers to recall the rearranging in public of large, expensive wigs with the aid of precious tortoise-shell combs.[45] Such forms of public preening are, perhaps, always to be seen as analogously auto-erotic. In representation these associations are reinforced; in the passage quoted, the play on possible ambiguities between 'act' as in a play and sexual 'act' is sustained by 'mount a bench' and then by the combing of 'much-lov'd Periwigs'.

By 1862, when Victor Hugo published *Les Misérables*, the wig was the prerogative of the legal profession. It had faded from fashion in the second half of the eighteenth century – a decline signalled in 1765 when the peruke makers petitioned the king because of the recession in their business.[46] But the professions of Medicine, the Church and the Law retained their wigs and today it is still possible to detect the symbolic value of the wig as an indicator of its wearer's status from the relative sizes of the wigs worn by the judiciary.

Long after wigs had ceased to be worn except on ritual occasions by members of the professions, the metonymic relationship between the wig and the profession of its wearer persisted. Hugo brings together this relationship, (which Hogarth had exploited and which Gilpin had commented upon) and the connotations of filth, disease and corrupt sexual practice which we have also remarked. The

sewer is described by Hugo as 'the conscience of the town where all things converge and clash'. Here,

the spittle of Caiaphas encounters the vomit of Falstaff, the gold piece from the gaming house rattles against a nail from which the suicide hung, a livid foetus is wrapped in the spangles, which last Shrove Tuesday danced at the Opera, a wig which passed judgement on men wallows near the decay which was the skirt of Margoton, It is more than fraternity, it is close intimacy.[47]

For Ruskin, similarly, the wig was one of a series of unnatural excrescences that epitomized the previous century's banishment of beauty, 'as far as human effort could succeed in doing so, from the face of the earth and from the form of man'. In *Modern Painters* III (1856) he proclaimed that powdering the hair and patching the cheek, hooping the body and buckling the foot 'were all part and parcel of the same system which reduced streets to brick walls and pictures to brown stains. One desert of ugliness was extended before the eyes of mankind; and their pursuit of the beautiful, so recklessly continued, received unexpected consummation in high-heeled shoes and periwigs, – Gower Street, and Gaspar Poussin.'[48]

* * *

The focus of psychic and social attention on the head – not for its physical features but as a field of inscription – augmented the fundamental ambivalence towards image-making in western Christian culture. The first commandment, 'thou shalt not carve images, or fashion the likeness of anything in heaven above, or on earth beneath, or in the waters under the earth, to bow down and worship it',[49] apparently designed to prevent idolatry, could be read literally as a prohibition upon the manufacture of any image of any type. The iconoclasm of the sixteenth and seventeenth centuries was fresh in people's minds.

'Painting the face' could mean portraiture or face-painting, that is, the use of cosmetics, which were commonplace (and medically dangerous) in the eighteenth century. William Cowper was one who discoursed upon the topic in a letter of 1784, and, significantly in view of the notions of national purity that such debates will be seen to have embodied, he draws a distinction between French women painting their faces and the practice as indulged by his own countrywomen. Since, it is suggested, French women have neither white nor red in their complexions, painting is not an act of intentional deception but an acknowledgement of a defect. Only when it is an imitative art is it to be condemned on moral and religious grounds. The French woman who paints is as innocent as the 'wild Indian who draws a circle round her face, and makes two spots, perhaps blue perhaps white, in the middle of it'.[50] The literature on the subject originates very much earlier and has its roots in the teachings of the Church Fathers. Nigel Llewellyn has drawn attention to the elision between painting and lax morals as part of a code in which painters and poets are purveyors of lewd deceits.[51] Thomas Tuke's *Treatise against Painting and Tincturing of men and women* (1616) was one of a long succession of diatribes against the blasphemous practice of amending nature, of changing the physical features of the human subject who was, after all, made in God's image.[52]

The chaotic and anarchic narratives (visual and verbal) of wigs in the eighteenth century need to be understood within a theological as well as a social framework. Thomas Hall's *The Loathsomeness of Long Hair* (1653) typifies the problematics of bodily excrescence in which the eighteenth-century discourse of the wig is grounded. The creeds of nonconformist religious groups like Calvinists reinforced existing doctrines; the Council of Rouen in 1096 decreed that all who wore long hair should be shut out of the Church during life and not prayed for after death.[53] Hall ostensibly preaches against the 'unnatural' body. Long hair for woman is natural, it is a covering provided for her by God but this hair should be bound up in the manner of a modest matron and not lasciviously hung out. Long hair in men and the painting and disguising of faces are offences against God in Hall's thesis and an emblem of the corruption of society.[54] While his diatribe is directed against the excessively elaborate hair-styles of the Stuart court, the text typically sets out the equation between hair and sexuality and the consequent correlation between the corruption of the individual body and the condition of the body politic. The state is threatened by dissipation and 'unnatural' fashions and that threat is mediated in particular through any practice that confuses the division between sexes: 'The Lord expressly forbids the confounding of Sexes . . . by wearing of that which is not proper to each sex.'[55] The threat that fashion – and especially the fashion in hair – poses to the stability of society is formulated in the preface:

How many do I daily see
Given up to Muliebritie!
A female head for a male face
Is marryed now in every place.

The duty of those at the head of the body politic is to present an exemplary head to the inferior part of the body:

Shall you my Counsell practise then
Ile say you have the Heads of men

123

Then being from that Cumb'rance freed
You may attend the parts that need
Your utmost care, the Heart and Brain;
Then also will that numerous Train
Of your Inferiours suddenly
Be cured of their deformity.
For whatever you Gallants doe
They Gallant think, and follow you.

Hall's claim that 'the haire in itself hath not any intrinsicall sinne or malice in it (as some maliciously suggest) no more then our Nailes, Meate, Drinke, Cloathes, and all which are good in themselves, but accidentally they become sinfull when abused by us',[56] is contradicted by a marginal gloss to the text which is introduced in order to demonstrate how 'National sins . . . will bring forth National Plagues'. The passage mediates the myth of Medusa, with its powerful connotations of castration, through a pseudo-medical account of a terrible plague that afflicts women (the marginal and, therefore, dangerous group).[57] It is known to have spread through Poland and it causes loss of sight and, ultimately, attacks the whole body:

A most loathsome and horrible disease in the haire, unheard of in former times; bred by modern luxury & excess. It seizeth specially upon women; and by reason of a viscous venomous humour glues together (as it were) the haire of the head with a prodigious ugly implication and intanglement; sometimes taking the forme of a great snake, sometimes many little serpents: full of nastiness, vermin and noysome smell. And that which is most to be admired, and never eye saw before, pricked with a needle they yield bloody drops. And at the first spreading of this dreadfull disease in Poland, all that cut off this horrible and snaky haire, lost their eyes, or the humour falling downe upon other parts of the body; turned them extremely.[58]

Hall provides a set of standards by which to judge when the hair is too long; they provide a useful register for the social disposition of the body in the seventeenth century, a register against which portraiture can be measured. The hair is too long when it is an impediment and hinders a person in his calling; when it covers the eyes, the cheeks, the countenance, because God has ordained those parts to be visible, 'for the face is a special glass wherein the glory & Image of God (in respect of the body) doth shine forth . . .';[59] when it lies on the back and shoulders, because hair is given to cover the head and clothes are intended for the body; when it is scandalous and offensive; and when it is contrary to the civil customs of civilized nations. While Stuart portraiture perpetually offends against the dictum

prohibiting long hair, the face invariably remains visible, something which is not the case in subsequent reconstructions of the fashionable long-haired male, for example, Mick Jagger in the 1960s.

Hair, in Hall's account, carries the symbolic potential for unleashed and disordered sexuality – and the Medusa head threat from foreign lands clearly implies this correlation – it must therefore be strictly regulated in the interests of the body politic. The wig carries a further danger; that of inverting the natural order. Not only do people turn white hair into black by powdering it (turning age into youth) thus forgetting that bodies are themselves potentially dust or powder, they also wear the hair of another and, most dangerously because it challenges gender distinctions and raises questions of sexuality, that other may be a woman and may be a whore. In the words of Thomas Hall:

Lastly, as no man may weare his owne haire excessively long, so he may not weare the long haire of another, be it of a man, a woman, or it may be of some harlot, who is now in Hell, lamenting there the abuse of that excrement. These Periwigs of false-coloured haire (which begin to be rife, even amongst Schollars in the Universities) are utterly unlawfull, and are condemned by Christ himself, Mat. 5, 36 'No man can make one haire, black or white'; but wee have those in our dayes that can do both; by powdring their haire, they can make that white which was black (the powder forgets the dust) others by Periwigs and false haire, can make themselves black or white, even what please themselves; what is this but to correct God's handy work.[60]

The artistry involved in wig-making further problematizes the question of hair.[61] While Hall indicates that it is permissible to use an artificial limb since people do not lose their limbs by the natural process of ageing, the use of a wig to conceal baldness constituted a denial of nature's agency. When we address portraits of men in wigs, it is important to recognize that the hair is a sign of masculinity within discourses that are specific to the period c.1650–c.1800, but the wig is also a sign of artistry. If paintings representing particular human beings signified within a framework that included an element of total proscription ('face-painting' being linked to idolatry), then wigs as worn by the subjects of paintings and imaged within portraits (and costing in most instances a considerable amount more than the paintings themselves)[62] connoted a further level of transgression from the laws of nature. One may well ask why, in view of these powerful prohibitions, did the wig maintain its central position in actuality and in discourse? One answer is that it allowed conflicting discourses of gender, of masculinity, of

sexuality and of class to be stabilized even if not resolved. Two further texts will substantiate this, one published in 1677, the other written *c.*1775 and published in 1819.

John Mulliner's account of his conversion to Quakerism in 1677 and the consequent discarding of his profession of wig-making brings together the problems of artistry and self-image within the arena of the Christian conscience. The testimony of non-conformist religious practitioners is particularly useful for the historian of social laws as it frequently focuses upon dominant practices and enables areas of anxiety and psychic stress to be identified. The declarations of members of these groups often constitute challenges to existing power structures. Mulliner was a barber of Northampton who, he tells us, left off his employment of Border- and Periwig-making and joined the people of God, scornfully called Quakers. His problem lay in the conflicting imperatives of the religious conscience on the one hand and professional integrity and respectabilty on the other. His case vividly points up the ambiguity of the wig in relation to social and moral practice.

Mulliner had been immensely proud of his trade: he had used to think that to deny that profession and become a Quaker would be to become a fool. 'I have made of myself a Town and Country talk', he declares.[63] The making of wigs thus epitomized social respectability; at the opposite extreme lie the absurdities of non-conformist religious practice. Quakers and Anabaptists (pl. 145) featured several

THOMAS VENNER,
ORATOR CONVENTICULORUM REGNI MILLENARII ET LIBERTINORUM. SEDUCTOR et CAPITANEUS SEDITIOSOR... ANABAPTISTARUM ET QVACKERORUM IN CIVITAT. LONDINENS.
Decollat, in quatuor partes dissectus D. 19. Jan. Anno 1661.

times in Granger's lowest class, that which included 'deformed Persons,, Convicts, etc.' They also notably often refused to wear wigs and were marked by peculiarities of dress and manner: 'And before I joyned with them, it was very hard for me to deny myself and become a Fool, by reason of my Trade: I thought I did not care if I had been of any Religion so I had not been of that.'[64] Music was Mulliner's leisure occupation and in his testimony symbolizes harmony as opposed to the dissent of Quakerism. Having tried burning all his musical instruments in the hope of gaining peace of mind, but to no avail, Mulliner turns to his professional activities:

> Then as to my Employment of *Periwig-Making*; it is more then twelve years since I began to make them & much might be said for the making of them by some years, so that at some times I have been troubled when I have been making of them, and I could not tell what was the Reason of my Trouble, except that was; and sometimes when I have seen some of my Friends [Quakers] come in I have been ready to put them out of my sight, and could not go on with any Content, but Trouble, so long as they were looking on me, and some have spoken to me, and told me, They thought I did not do well in making of them; & to this purpose they have spoken, and many times I have reasoned with myself after this manner, what need I make such ado and be so much concerned, there is hardly any man but is desirous of a good Head of Hair, and if Nature doth not afford it, if there be Art to make a decent Wig or Border, what harm is that?[65]

Playing on instruments and periwig-making are synonymous with artifice, which is deemed sinful. But wig-making is also linked to masculinity ('there is hardly any man but is desirous of a good Head of Hair'). The conflict is resolved only in an act of high ritual, carried out in public since his profession had been conducted in public and since – significantly – the wig is an item of apparel connoting public order and respectability. Mulliner summons his two apprentices, takes a wig and burns it before them 'as a Testimony for God against them'.[66]

Notions of decency, respectability and the fear of ridicule function socially as a means of effectively policing the boundaries of gender and class. In Gawen Hamilton's portrait *The Porten family* (pl. 146) the servant moves across the room behind the family members bearing a teapot. Not only is he the only figure in the painting, apart from the black boy playing with a monkey in the foreground, who is seen in profile, he is the only figure whose head is uncovered, for the men all wear wigs and the women caps. This reinforces the effect of the ruddy bulbousness of his visage and his servile actions and, in fact,

145. *Thomas Venner,* anonymous engraving, 1661, from *Anabaptisticum et Enthusiasticum,* 1702. Reproduced with permission of the Library Committee of the Religious Society of Friends.

Thomas Venner was one of the Fifth-Monarchy Men involved in the insurrectionist plot of 1657. In this engraving Anabaptists and Quakers are lumped together as seditious, heretical and immoral sects.

125

models – a matrix providing infinite possibilities for interpretation – is evinced in an etching attributed to him that has survived as an experimental portrayal (pl. 147).)

In *The Flying Dragon and the Man of Heaton*, a story written by the Lancashire dialect poet Tim Bobbin towards the end of the eighteenth century, the wig is separated from its rightful context (on the head of a person of the appropriate sex and class) and exposed as an absurd object (pl. 148).[69] The discourse here is patriotic rather than, as in the case of Thomas Hall, religious, but it none the less is underscored by definitions of the natural that have already been encountered in seventeenth-century texts on the hair. The loss of wig is a familiar topos but in this fanciful narrative the wig takes on a life of its own; it assumes a different appearance according to the class of person observing it. The Argument runs as follows:

A Lancashire beau being at London, fell in love with the large pigtails and ear-locks, and consequently brought the French toys with him to Lancaster; business calling him to Sunderland on that day being uncommonly boisterous, he mounts his courser, dressed in the pig-tail, earlocks, &c a-la-mode francois. The toy rolled on his shoulders till the blasts blew away both that and the ear-locks, they being fastened to the tail with black ribbons. A countryman coming that way, and seeing them blown about in the lane, takes the French medley for a FLYING DRAGON, and after mature deliberaton, resolved to kill it [pl. 149]. This produced three battles; at the latter end of which (the wind ceasing, and the pig-tail lying still) he thought he had manfully performed. Elated with the exploit, he twists his stick in the ear-locks, and carries all before him aloft in the air, as boys commonly do adders; till meeting the Rector of Heysham, he was with much ado convinced [pl. 150]; and then in great confusion sneaked away, leaving his reverence in possession of the monster, who still keeps it at Heysham, and often shews it with much diversion to his friends.[70]

Much of the humour of Tim Bobbin's story depends upon sexual innuendo: the beau falling in love with large pigtails, bringing French toys to Lancashire, mounting his courser and so on, until the moment when he is unmanned and his pigtail blows away. The countryman manfully performs and twists his stick, carrying all aloft. And the reference to snakes here links the text with the dreadful plague from Poland so feared by Thomas Hall.

To some extent the phallic imagery is to be construed as commonplace bawdy, yet this drollery hardly conceals the existence of power structures. On the one hand the story of the beau concerns a young man from the provinces seduced not only by

146. Gawen Hamilton, *The Porten Family*, oil on canvas, 125.7 × 100.4 cm., *c*.1736. Museum of Fine Arts, Springfield, Mass., James Philip Gray Collection.

147 (facing page top). *Alexander Pope*, attributed to Jonathan Richardson, unlettered proof etching. Trustees of the British Museum, London.

Pope's celebrated head can be, like Beetham's dummies (see pl. 126), rendered in character according to its accessories.

distinguishes him as servant.[67] Alexander Pope, in the guise of inspired poet, was regularly depicted with a wig in need of arranging, unceremoniously pushed back from the temples, as in Jonathan Richardson's portrait of *c*.1718 (collection of the Viscount Cobham)[68] and in J.B. Van Loo's painting of 1742, engraved by J. Faber in 1744 (pl. 4). But masculinity – and class – is secured in the former image by the prominent position given in the composition to Pope's huge dog, whose name 'Bounce', signalling unbounded energy, is inscribed on his collar. In the latter, Pope's profession, and thereby his license to irregularities of dress, is clearly signalled by the books he leans on with one hand and the papers he holds with the other. (The way in which Richardson was able to treat Pope's head almost like one of Stevens's or Beetham's wooden

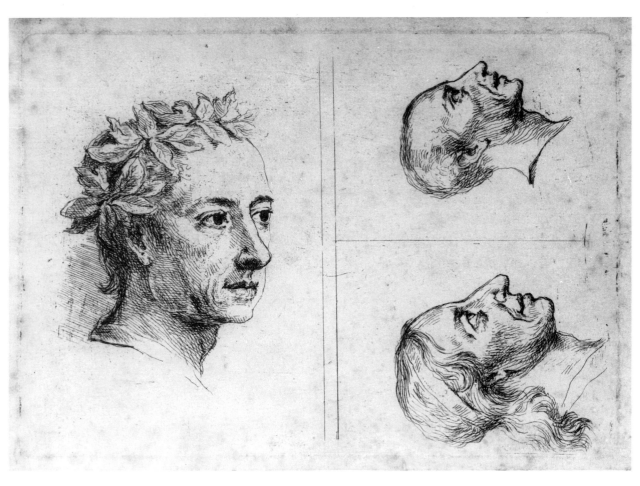

148 (below left).
Frontispiece to Tim Bobbin,
*The Flying Dragon and the
Man of Heaton*, 1819.

The relatively commonplace
pigtail is here set out
diagrammatically in the
manner of a perruquier's
text. It is this object that, lost
by a young beau, undergoes a
series of transmutations in
the course of the story.

149 (below centre).
Illustration from Tim
Bobbin, *The Flying Dragon
and the Man of Heaton*, 1819.

Here the countryman
discovers the lost pigtail and,
taking it to be a dragon,
attacks it with a stick.

150. Illustration from Tim
Bobbin, *The Flying Dragon
and the Man of Heaton* 1819.

The Man of Heaton carries
the pigtail aloft, 'as boys
commonly do adders' but is
persuaded by the Rector to
relinquish his prey.

a a Represents a silken string that goes from the Locks round
the fore part of the Head under the Hat.
 b b The ends of the Ribband platted with the hair of the
tail, and fastens it to the hair of the Head.
 c c A thread that goes to ye back of the Head to fix the Locks
 d The end of the Tail which is ty'd to the hair of the Head
by the Ribband b b. e e The Ear-locks.

London life but by French fashions. There is thus a nationalist discourse at work here. But the powerful connotations of hair in relation to gender and sexuality that have already been remarked are here exploited in a discourse of class. The young man loses his pigtail (is unmanned) by visiting the city corrupted by foreign fashion. The Old Man of Heaton – a member of a less elevated class – encounters the wig which is the hallmark of high society. He attacks the earlocks in a symbolic violation of the ruling class, setting out to kill it and concluding with a Medusa-like ritual that hints at the dangers of such actions, whatever the absurdities that provoked them. The impropriety of the situation is tempered by the fact that the beau retains the basic wig, losing only the 'French' excrescences and by the fact that the Church (which is itself modestly bewigged according to Tim Bobbin's illustration to the story) becomes guardian to this socially and politically dangerous object. In overcoming the dragon the countryman overcomes foolish French fashion without knowing it. But in topsy-turvey style, the reversed order that has served to expose folly has to be righted again by good sense and religion. And so the Old Man of Heaton is left as foolish as the beau who lost his pigtail.

The conversation between the Old Man and the parson is hard to resist:

'Why Oamfrey, man! What have you got
Upon your stick?' 'That I know not'
'Where did you find the tawdry thing?'
'Tawdry!' quoth *Noamp*, 'Why't hath a sting,'
'A sting man! – nay, no more than you.'
'By th' mass, good parson, that's naw true;
Look at its tung; it's stings ith' tele,
Or else I'm sure my senses fail.'
'True' quoth his rev'rence, 'that may be;
And in that point we both agree;
But if my eyes, like thine, don't fail,
It is, tho' large, a French pig-tail.'[71]

The wig as we have suggested is at one and the same time a sign of respectability *and* the site of subversive elements in social relations, threatening the orders of class and gender. Here, then, is the wig fetishized – appearing as one thing to one protagonist and as another to the other. It is simultaneously 'a tawdry thing' and, like Hall's threatened disease, a beast with a sting in its tail ('a long, black thing, with wings and tail'). If, then, the terrible flying pigtail is a fetish, the fearfulness and loathsomeness of long hair is again invoked. The fetish is the substitute for the woman's (mother's) penis that the male child once believed in, a belief he does not want to surrender. It provides the possibility of a compromise between what is known and the counter-wish, which preserves the individual from the fear of castration. The

fetish 'remains a token of triumph over the threat of castration and a protection against it'.[72]

* * *

The dilemma generated by the wig (which may not have been consciously or individually experienced) was critical; it was the dilemma of a masculinity that required the artificial covering of the head as a sign of virility, station and decency but that was simultaneously threatened by the connotations – religious, moral and sexual – of the only item that could secure that signification. In actuality the dilemma manifested itself in the fact that by 1760 many men were wearing their own hair while using grease, tongs and powder to make it appear as though they were wearing wigs.[73] In representation the function of wig as fetish – like the genuine head of hair but not it, of the body but separable from it – becomes obvious. The overt similarities of appearance between the penis and the pigtail as well as between the shaved head and the head of the penis – similarities that are exploited consciously and unconsciously by writers, artists and caricaturists alike – signal the relationship of wig to phallus. The wig was both the essential component in the maintenance of a social order for which the economy of the fashionable male body provided a metaphor *and* the vulnerable part of the body through which authority and power could be undermined or destroyed. It is to this prosthetic ambiguity that its particular power in discourse is owed. Equally we may recognize in the vulnerability of the wigless head exposed by Beetham, by Colley Cibber and by Hogarth, the male member exposed to the castrating gaze of public scrutiny. The disjuncture between the hairless head and the phallic wig from which all these accounts derive their narrative climax is the gap between masculine identity endowed by culture and the nameless state of what is constructed as the natural body.

The wig's prevalence as a major item of male attire for over a hundred years, and its dominance in visual representation of the period, must therefore be understood within the context of forms of self-enactment that served to define masculinity politically and culturally. Moreover, it is not accidental that the rise of portraiture as a major genre in Europe coincides with the evolution of the wig as an essential item of masculine attire.[74] Society portraiture required strict mechanisms of control both to guard representation of male subjects against the dubious connotations of excess and effeminacy and to exploit the potential of the portrait to perpetuate a proper masculine decorum.

The head as a particular field of inscription exploited by performance artists and caricaturists in the eighteenth century, and what has been learned

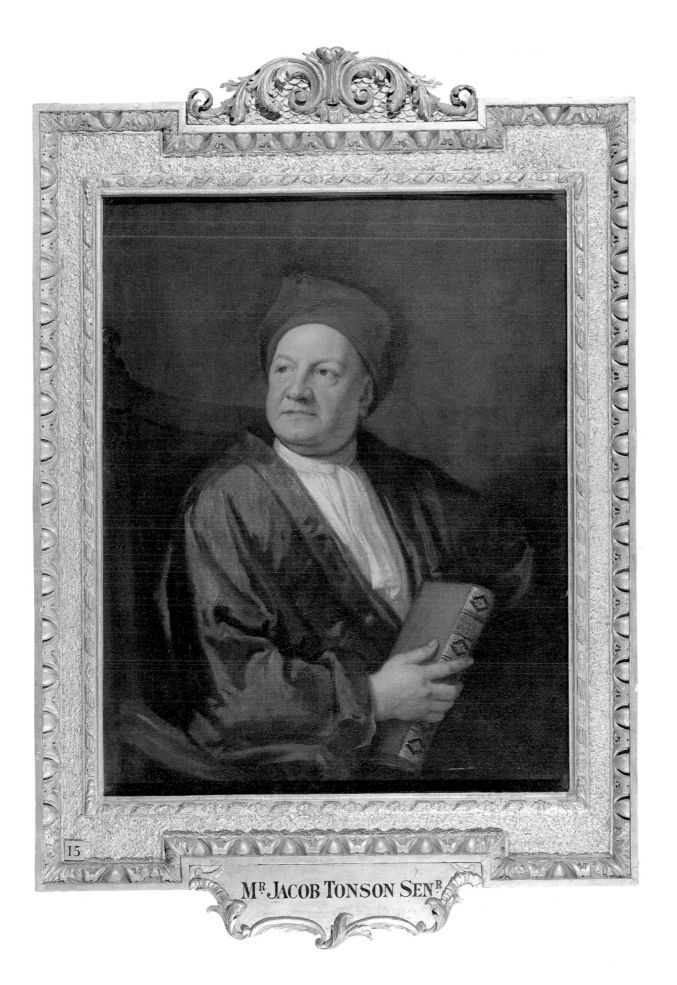

M^R. JACOB TONSON SEN^R

152 (above left). Sir Godfrey Kneller, *Daniel Finch, 2nd Earl of Nottingham and 7th Earl of Winchelsea*, oil on canvas, 78.7 × 104.1 cm., *c.*1720. National Portrait Gallery, London.

Kneller's male society portraits in which splendid wigs are frequently a striking feature evidently commenced with studies of the head without its fashionable attire.

153. *Richard Boyle, 3rd Earl of Burlington*, attributed to Jonathan Richardson, oil on canvas, 146.1 × 116.8 cm., *c.*1717–19. National Portrait Gallery, London.

154 (right). Joshua Reynolds, *A Caricature: Lord Bruce, Mr Ward, Joseph Leeson Jnr. and Joseph Henry*, oil on canvas, 63 × 49 cm., 1751, National Gallery of Ireland.

about the wig as an item of fashion endowed with mythic and symbolic properties, justify reconsideration of the prevalence of the 'head-and-shoulders' format in male portraiture. Expense was certainly a consideration (full-length portraits being more costly); but if the head is the bearer of meaning and the signifier of masculinity, there is no need for the rest of the body to be portrayed. On the other hand, if the head was to be read as masculinity rather than as the individual (and potentially disorderly) site of sexuality, it was necessary to reduce the emphasis of the wig as a pictorial item in representation. Thus in Kneller's Kit-cat Club portraits, the sitters appear contained by the set of conventions determining format: dimensions, pose, and dress. The faces of those sitters who wear wigs (Jacob Tonson, the Secretary, is shown in a cap (pl. 151)) are framed by uniform periwigs which have neither undue prominence, nor any fancy excrescences. The order and the repetitiveness are an insurance against the connotations of dirt and excess that could attach to the bewigged head. Studio practice dictated that the face was executed first and the wig, like the clothing, added later, a uniform addition to the head rather than an intrinsic element in likeness. Kneller's three studies of the head of Daniel Finch, 2nd Earl of Nottingham and 7th Earl of Winchelsea (pl. 152) confirms that the wig was viewed by the portrait painter as a separate, independent adjunct to the head, just as it was by Stevens and Beetham. It was, of course, common studio practice to enforce a division of labour of this kind, with the face executed

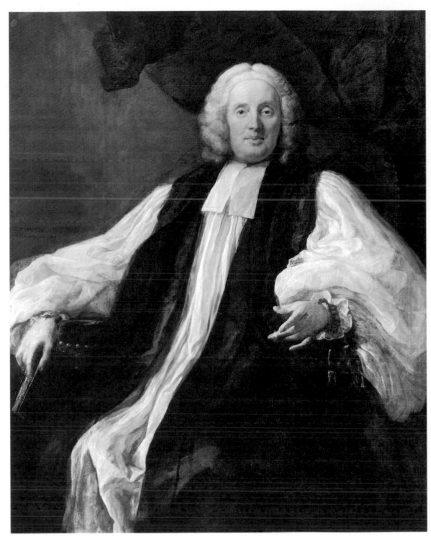

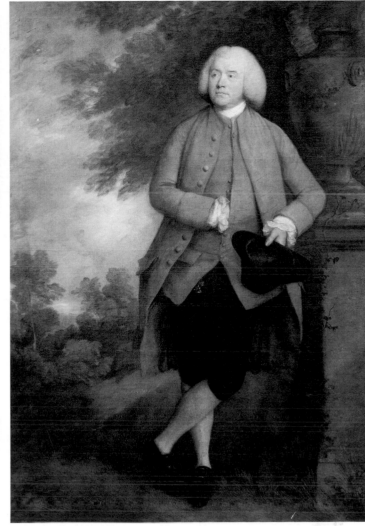

part of the body (the wig or hair) that in life attracted intense scrutiny and was understood as a powerful signifier of moral values. The effect of the standardization of wigs in this series is to stress the solidarity of the group at the expense of the individuality of its members. Any variations in the personal appearance of the head – baldness, ginger hair, thinning crown, bushy hair – are annihilated. As a consequence, a monolithic and phallic uniformity is produced.

A departure from the standard and understated wig image often connoted individuality. Thus in Richardson's portrait, Richard Boyle, 3rd Earl of Burlington wears a crimson coat and matching cap in a striking ensemble (pl. 153). However, when (as is customary) male subjects were portrayed in wigs, composition and pose were often controlled to ensure that the wig did not play too prominent a part in the visual register. This may explain a preference for full-face or slightly turned heads as opposed to profile or complete three-quarter face male portraits. In profile, the defective lower jaw that resulted from

loss of teeth and bone for a majority of people prior to the advent of satisfactory dentures in the late nineteenth century would also have been all too apparent.[75] The central figure of the successful candidate in Hogarth's *Chairing the Member* (Sir John Soane's Museum, London) is shown in profile wig-view, as are two of Reynolds's equally despised four learned milordi (pl. 154). By contrast, portraits were able to present the male subject, especially when viewed from a low vantage point and depicted full-face (or near full-face), in such a way as to evade the wig as focus of attention. Hogarth's *Thomas Herring, Bishop of York* (and, later, Archbishop of Canterbury) has a viewpoint that offers a minimal framing view of the wig that the bishop is wearing (pl. 155). In his earlier work, Gainsborough was sometimes unable to reconcile the freedom of handling in dress, flesh and background with the need to display a controlling hand in the depiction of the wig. In *Charles Tudway* (pl. 156) the wig is given a clear, sharp outline and painted with a myriad of small

155. William Hogarth, *Thomas Herring, Bishop of York*, oil on canvas, 127 × 101.6 cm., 1744. Tate Gallery, London.

156. Thomas Gainsborough, *Charles Tudway*, oil on canvas, 231 × 155.2 cm., c.1765. Courtauld Institute Galleries, London.

Tudway was MP for Wells in 1754; his expensive wig would have been a prominent part of his wardrobe. Gainsborough adopts a particular handling of paint in this area of the canvas.

131

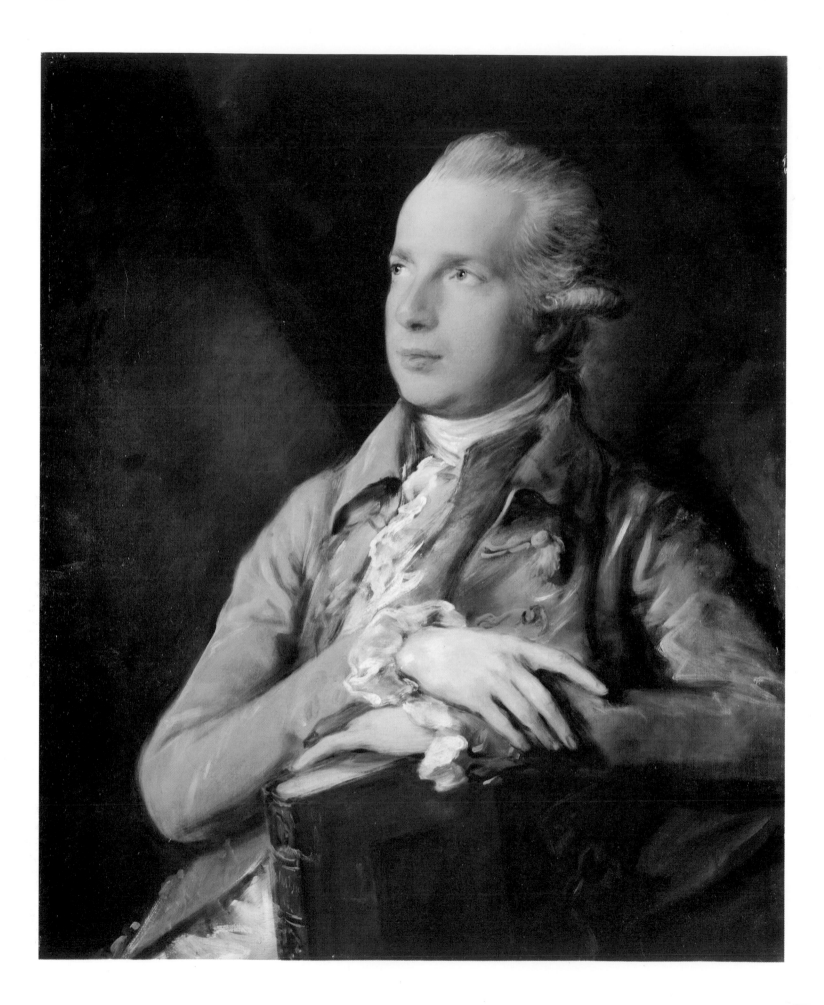

almost hatched parallel strokes, greatly at odds with the remainder of the facture. Gainsborough often painted male subjects three-quarter-face, but subjects like George Colman (pl. 157), Samuel Linley (pl. 158) or Sir Henry Bate Dudley (pl. 159) either wear their own hair arranged in a wig-imitation or the artist's handling is calculated to divert attention from this feature. The faces are tilted slightly, their contours picked out against the light. The hair-line or wig-line is unmarked in a characteristic technique of sweeping brush-strokes that merges hair with temples and underplays the three-dimensionality of the head (pl. 160).

Artists, conscious of the changing fashions in wig shapes and careful of decorum, organized pose and composition to accommodate these valuable items of apparel. A variety of solutions are apparent: Thomas Hudson's portrait of Dr Isaac Schomberg (pl. 161) is one of those early eighteenth-century portraits that, whilst assertively rectangular in format, incorporates the mysterious ghostly suggestions of an oval frame, the residual trace of another set of compositional possibilities, sometimes referred to as a 'feigned' oval. Here the evidence of the (discarded) oval frame around the lower margin of the painting serves to echo and thus to accentuate the curves of Dr Schomberg's magnificent tye-wig (a mark of his

profession as well as his status as fashionable gentleman). The shadows cast on the wall behind, the modelling of the face and the fall of light on the impeccable grey-coat contribute to a highly controlled performance. Allan Ramsay, on the other hand, evolves a more oblique strategy in his portrait of John Sargent (pl. 162). Here the figure is actually inscribed in a clear-cut, window-like oval, his hands – like those of Dr Schomberg – conveniently concealed in the interests of a series of uninterrupted curves. The carefully constrained curls of John Sargent's bag-wig (the ribbon of which is just visible over his right shoulder) orchestrate a series of repeats in the embroidery on his waistcoat, its prominent buttons, the shadows down his right sleeve which have the effect of ruching and the elegant curve of his eyebrows. The mix-and-match effect of grey-coats worn with powdered wigs is calculated to produce an effect of overall containment with which the louche and potentially chaotic appearance of Sir Thomas Lawrence's unwigged subjects a generation later stands in stark contrast. William Brabazon, 1st Baron Ponsonby, painted by Lawrence in 1805 (pl. 163), for example, exhibits an interrupted line with his crinkled left sleeve, his right hand exerting pressure, his unbuttoned coat and dishevelled hair – masculinity reconstructed for a new era.

157 (facing page). Thomas Gainsborough, *George Colman*, oil on canvas, 72.4 × 59.1 cm., *c*.1778. National Portrait Gallery, London.

Over twenty years after his portrait of Tudway, gentlemen's hair styles had changed but so also had the artist's manner of posing and representing the head and its covering.

160 (following page). Detail of pl. 157, Gainsborough, *George Colman*.

158. Thomas Gainsborough, *Samuel Linley*, oil on canvas, 76.4 × 63.5 cm., 1777–8. Dulwich Picture Gallery.

159. Thomas Gainsborough, *Sir Henry Bate Dudley*, oil on canvas, 72 × 57.4 cm., *c*.1780. Tate Gallery, London.

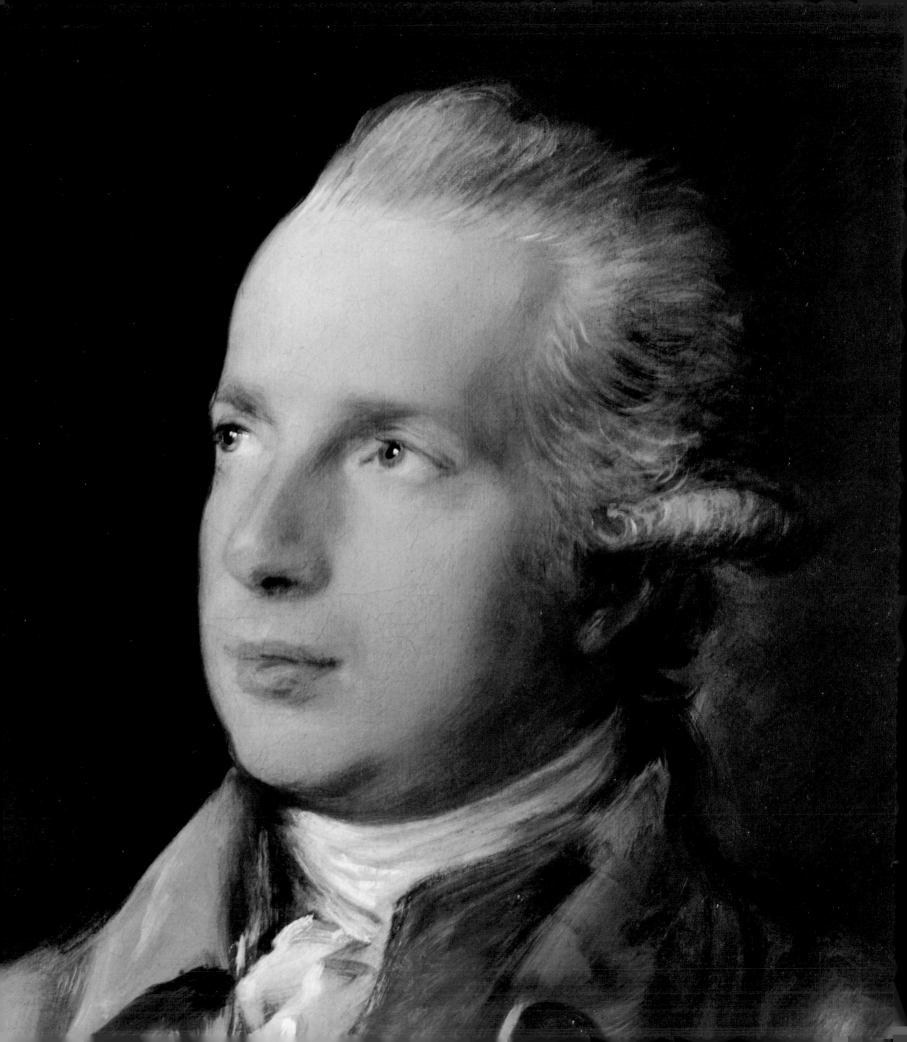

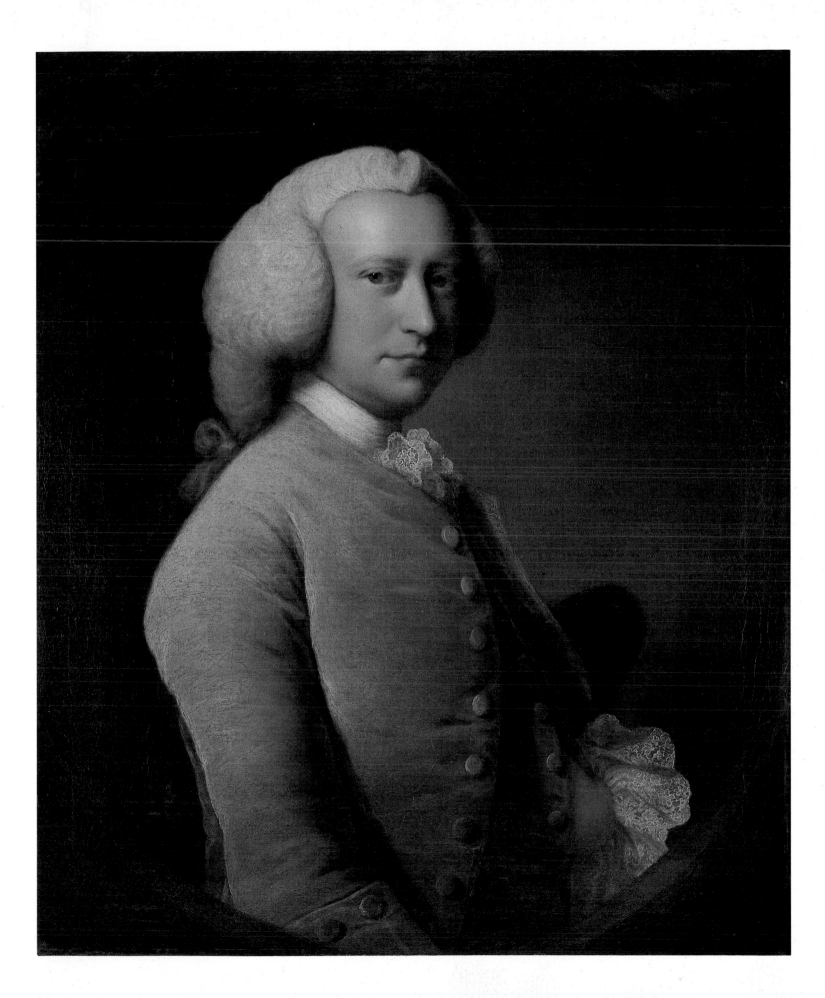

161 (previous page).
Thomas Hudson, *Dr Isaac
Schomberg*, oil on canvas,
76.4 × 63.5 cm. Huntington
Library, San Marino,
California.

Portrait painters learned rules about lighting, as about all other matters. As one instruction manual tells its readers: the light must be fair and as it were composed, 'not broad and scattering, but collected, free from the Shadows of Trees or Houses, all clear sky light; let it be Northerly, not Southerly, the which is most steadfast, less varying, and serenely free from sun-beams'.[76] But artists varied their lighting to control the wig and ensure that it did not intrude upon the equilibrium that is central to the image of eighteenth-century masculinity. Reynolds allows the sharply lit bewigged head, but it is invariably off-set by carefully diposed distractions, as with *The Hon. Charles Sloane Cadogan, MP* (pl. 164), whose rich fur-trimmed robe is far more tactile than his wig, or *Lord Middleton* (pl. 165), whose head is reduced in size by contrast with a framing curtain and elaborate state robes. Bewigged heads are seldom highlighted: they frequently feature well-lit faces and shadowy craniums. In *Garrick and his Wife* (pls 166, 167) Hogarth – who more than any artist of his age had demonstrated the potential of the wig as a sign of disorder – tilts Garrick's head back, enframes it with his own and his wife's hands, and juxtaposes a froth of lace from the latter's sleeve to diminish the prominence of a white powdered wig that was likely to have cost more than both sitters' clothes and the price of the portrait together.

162 (facing page top left). Allan Ramsay, *John Sargent Jnr.*, oil on canvas, 76.7 × 62.9 cm., 1749, Holburne of Menstries Collection, Bath.

163 (facing page bottom left). Thomas Lawrence, *William Brabazon, 1st Baron Ponsonby*, oil on canvas, 122.5 × 100 cm., *c.*1805. Leicester City Art Gallery.

164 (facing page right). Sir Joshua Reynolds, *The Hon. Charles Sloane Cadogan, MP*, 91 × 78.5 cm., 1755. Earl Cadogan.

165 (left). Sir Joshua Reynolds, *Lord Middleton*, oil on canvas, 236 × 145 cm., 1762. Private collection.

166 and 167 (following pages). William Hogarth, *Garrick and his Wife*, oil on canvas, 132.7 × 104.1 cm., *c.*1757. Royal Collection, St James's Palace. Her Majesty the Queen.

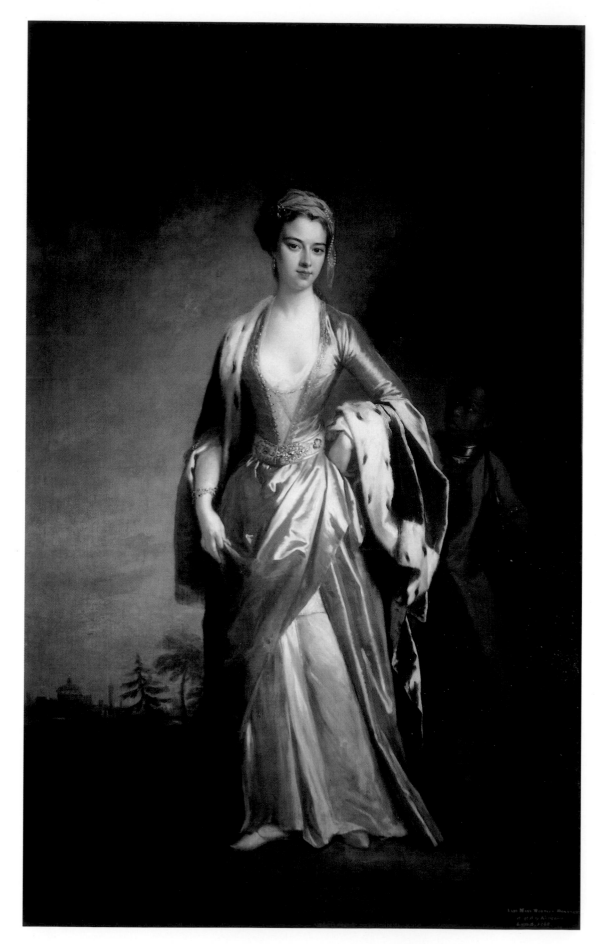

168. *Lady Mary Wortley Montagu*, attributed to Jonathan Richardson, oil on canvas, 94 × 57 cm., *c.*1725. By courtesy of the Earl of Harrowby.

V GOING TURKISH IN EIGHTEENTH-CENTURY LONDON: LADY MARY WORTLEY MONTAGU AND HER PORTRAITS

The full-length portrait of Lady Mary Wortley Montagu attributed to Jonathan Richardson shows her regally attired in Turkish style, accompanied by a black servant, and with a view of Constantinople in the background (pl. 168).[1] She displays a perfect complexion from her forehead to her scarcely concealed breasts. Her brown hair is loosely arranged under a turban-like headdress made of loops of pearls and adorned with a feather. Her eyes are clear and bright and her expression – solemn rather than amused – conforms to the view expressed by Addison that the pleasure experienced in viewing 'the Picture of a Face that is beautiful . . . is still greater, if the Beauty be softened with an Air of Melancholy or Sorrow'.[2]

In writing thus I am responding in my own time and culture to an image produced in another time and culture and viewed by a succession of audiences from that time to this. In writing I interpret because there is no way of describing an image that is not also already an act of interpretation. Paintings of people, and, in particular, portraits of individuals known to have lived in the past, apear to invite us to understand them as visual biographies. Thus, if we were to read that Montagu was not very happily married, we might see, in the full but unsmiling mouth, an image of this fact – though as I have suggested, it could just as well be accounted for by reference to a popular aesthetic. However, the known facts of an individual's life, if unreliable in terms of illustration, may serve in the process of defining the relational character of an imagery of class and sex, the cultural evaluation of which must depend upon an understanding of that to which it is other.

This portrait is thought to have been painted around 1725 when Montagu was thirty-six, an advanced age in a period when girls were married at fifteen. She was worried about her age, wishing she were ten years younger and anxiously examining her wrinkles.[3] In 1715 she had suffered and survived an attack of smallpox; it left her with a severely pitted skin and no eyelashes. People thought that her 'good eyes' would compensate for her scarred face,[4] but those eyes, in that worn face, were by 1725 frequently the cause of fatigue and distress to their owner as she struggled to write her already celebrated letters in inadequate lighting.[5]

Two contrasting bodies which define each other through opposing terms in a relationship of interdependency are on offer. On the one hand, there is a mythicized and idealized body that is recognized in the portrait and that has helped to define the historical personality of Montagu (it is one of a group of portrait images frequently reproduced in biographies). On the other hand, there is a biological body subject to decay, a body that is apparently 'natural' but that is equally the site of interpretation and projection. In the one is a faultless complexion, in the other a badly scarred skin. In the one are 'limpid orbs', in the other, bad eyesight. In the one there is eternal youth, in the other, advancing age. At an empirical level the first might be dismissed under the general heading of flattery – a social imperative in eighteenth-century portraiture – and the second, as reality, as truth. It is, however, the 'realities' of the biological body (for such truths are also subject to encoding and interpretation as forms of historical knowledge) that are to be understood in relation to the mythic body that is staged in portraiture. Those 'realities', retrieved by the present from the traces of a past life, gain currency and power because the fiction, in working against them, also defines them conceptually and historically, just as they serve to inform the fiction.

Lady Mary Wortley Montagu is chiefly remembered for her letters (and particularly for those she wrote when accompanying her husband to Constantinople) and for her introduction of smallpox inoculation into England from the Ottoman territories. Her brother had died of the disease only a

few years before she herself contracted it. The horror of this illness and its symptoms are hard now to imagine:

> On the third day the characteristic eruption begins to make its appearance. It is almost always first seen on the face, particularly about the forehead and roots of the hair, in the form of a general redness . . . The eruption, which is accompanied by heat and itching, spreads over the face, trunk and extremities in the course of a few hours – continuing, however, to come out more abundantly for one or two days. It is always most marked on the exposed parts . . . On the third day after its appearance the eruption undergoes a change – the pocks become vesicles filled with a clear fluid. These vesicles attain to about the size of a pea, and in the ircentre there is a light depression, giving the characteristic umbilicated appearance to the pock. The clear contents of these vesicles gradually become turbid, and by the eighth or ninth day they are changed into pustules containing yellow matter, while at the same time they increase still further in size and lose the central depression. Accompanying this change there are great surrounding inflammation and swelling of the skin, which, where the eruption is thickly set, produce much disfigurement and render the features unrecognizable, while the affected parts emit an offensive odour, particularly if, as often happens the pustules break. The eruption is present not only on the skin but on mucous membranes, that of the mouth and throat being affected at an early period . . . The voice is hoarse and a copious flow of saliva comes from the mouth . . . On the eleventh or twelfth day the pustules show signs of drying up (dessication) and along with this the febrile symptoms decline. Great itching of the skin attends this stage. The scabs produced by the dried pustules gradually fall off and a reddish brown spot remains which, according to the depth of skin involved in the disease, leaves a permanent white depressed scar – this 'pitting' so characteristic of the smallpox being specially marked on the face.[6]

The appalling experience of smallpox, the body distorted as it is invaded by sickness, was transposed into art by the patient in one of her *Six Town Eclogues*, written and circulated 1715–17 and published in 1747. Here the looking-glass and the portrait appear as analogues and both are rejected: the one shows a face the author can no longer bear to look upon while the other reveals a lost resemblance which by comparison serves only to underscore her pain. As a consequence the mirror must be hidden and the portrait must be disfigured to match its subject:

> The wretched FLAVIA on her couch reclin'd,
> Thus breath'd the anguish of a wounded mind;
> A glass revers'd in her right hand she bore,
> For now she shunn'd the face she sought before. . . .
>
> As round the room I turn my weeping eyes,
> New unaffected scenes of sorrow rise!
> Far from my sight that killing picture bear,
> The face disfigure, and the canvas tear!
> That picture which with pride I us'd to show,
> The lost resemblance but upbraids me now. . . .
>
> Ye cruel Chymists, what with-held your aid!
> Could no pomatums save a trembling maid?
> How false and trifling is that art ye boast;
> No art can give me back my beauty lost.[7]

Montagu has long been acknowledged as a significant figure in whig society, a beautiful bluestocking who 'held sway not only over men's hearts but also over their intellects',[8] as one of a trio of feminist Marys (the others being Astell and Wollstonecraft), but one who 'did not enunciate feminist principles in boldly signed pamphlets and books . . . yet states or clearly implies this doctrine in her private correspondence . . . '.[9] What is significant, however, are not those personal qualities and gifts that entitled her to 'a place in European "Enlightenment"',[10] but the network of representation – of her by others, of others by her – which while particular rather than general, may none the less permit access to a set of relations that are typical rather than unusual. In other words, it is proposed that though Montagu's travels, which made her name, were unique, and though her education, which enabled her to profit from those experiences, was unusual, her situation was in other ways typical of a woman of her class. She is a woman about whom, unusually, we know a considerable amount, but that knowledge may enable us to ask questions paradigmatic to women's history, questions that pivot upon the complex link between society and enduring psychic structures.[11] This network of representation permits, therefore, an assessment of the relational nature of woman's position in regard to sex and class in the early eighteenth century and how that position was ideologically produced and reproduced.

* * *

The body, as has been established in the previous chapter, was a work of art in eighteenth-century ruling-class society: how one wore one's patches, how one held one's fan, the cut of one's clothes, the shape of one's wig – all these made of the body a mobile cluster of signifiers indicating party-political affiliation, class, gender and sexuality. The body was strictly differentiated for indoor or outdoor wear,

formal or informal, court dress or 'at home' attire. The boundaries were clearly defined and the crossing of those boundaries constituted trangressions that could sometimes become orthodoxies. Thus the gradual adoption in women's fashion of loose clothing represented the inscription into the regulations of fashion of what had commenced as an act of daring.[12] But if the body in its signifying apparel, performing significant motions, was the site of public discourse, at another level this body also claimed the power of sight and hence also of knowledge. The oscillation between possessing the power of the gaze and being the object of the gaze depends upon a narcissistic relationship between viewer and her or his own body. This relationship was not only private and personal, it was collective and coercive, and was experienced through orthodox modes of representation (pl. 169).[13] It is the breakdown of that relationship that is recounted with such anguish by Flavia as she recovers from smallpox. This relationship held for masculine as well as feminine subjects, but in a society where woman generically was powerless – she had no right to own anything, no vote, no access to education and no place in the rationale of civic humanism that governed matters of taste – the intricate balance between exercising sight and controlling how one was seen was crucial.[14]

Appropriating the right to look, articulating and interpreting the seen, was one way in which woman could exert power. It was, after all, Montagu's interpretation of what she saw that made her reputation. But, arguably, the conditions that made that attainment possible were prepared by her reproduction of herself in society. And the question of representation was always overdetermined. At a theoretical level the pre-eminence of sight was established by Addison in 1712 in 'The Pleasures of the Imagination' when he pointed out that 'our sight is the most perfect and most delightful of all our Senses'.[15] Sight is important in Addison's scheme of things because it furnishes the imagination with its ideas, 'so that by the Pleasures of the Imagination or Fancy (which I shall use promiscuously) I here mean such as arise from visible Objects, either when we have them actually in our View, or when we call up their Ideas into our Minds by Paintings, Statues, Descriptions, or any the like Occasion'.

In political terms, seeing and being seen was crucially important, whether this meant appearing at the right occasion at court or the circulation of an engraved image of a particular person in the interests of a particular cause. The theological implications of these processes were, however, never far from people's minds. In *The Vanity of Human Wishes* (1749) Johnson uses the vicissitudes of the portrait as an image of the making and unmaking of worldly reputations:

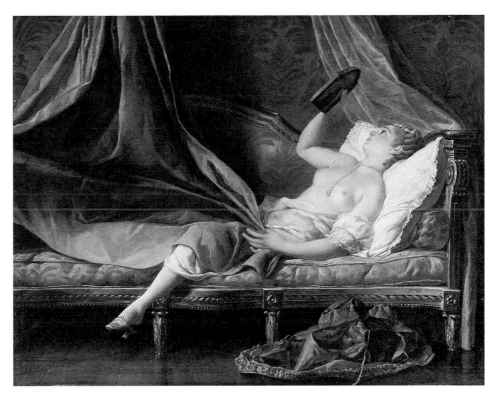

From every Room descends the painted Face,
That hung the bright Palladium of the Place,
And smoak'd in Kitchens, or in Auctions sold,
To better Features yields the Frame of Gold;
For now no more we trace in ev'ry Line
Heroic Worth, Benevolence Divine:
The Form distorted justifies the Fall,
And Detestation rids th'indignant Wall [16]

The human subject and its representation are equally redundant. The form that is distorted is both the portrait painted in a now unfashionable style and the human subject whose distortion from the Divine (and benevolent) model is a measure both of the fall of reputations and of the Fall that resulted in the explusion of Adam and Eve from Paradise.

Woman had a particular commodity value in a system where appearances counted for so much, her beauty both being her own possession and having a sign value in the system of exchange between her father and her husband.[17] Montagu's suitor and father – locked in this exchange system – haggled unsuccessfully over the question of her dowry, and in the end she and Edward Wortley Montagu eloped. One of the most frequently repeated stories of Montagu's early years, and one that has exercised a fascination over biographers and artists, tells of the seven-year-old Lady Mary exhibited and toasted at the newly formed Kit-cat Club (pls 170, 171).[18] It is a story that brings together patriarchy in its most undiluted cultural rituals and patriarchy in its familial and sexual manifestations: the pre-pubescent female

169. Charles André van Loo, *Woman on a Couch*, oil on canvas, 53.3 × 68.6 cm. The Metropolitan Museum of Art, Gift of Forsyth Wickes, 1957.

The allusions here are to Venus (the flowers in the hair, the mirror and the pearls around the neck), but the coiffure, slippers and *chaise* are contemporary. This slippage between mythology and documentation serves to reinforce the construction of woman as object of her own narcissistic gaze.

the painted portraits of Montagu in Turkish dress offer is an extended or restaged form of misrecognition, a solution that re-empowers the subject not only by the actual restoration of her beauty in paint but by that beauty's allusions to the oriental other. It is through this second misrecognition that the subject, scarred (misrecognized) and ego-damaged, re-entered the public domain, and in triumph.

Just as the idealization of Montagu in the portrait attributed to Richardson is more than what is (and was) popularly understood to be the flattery necessarily accompanying society portrayals, so also the question of orientalism in the network of representation through which Montagu is historically defined cannot be explained by reference to notions of the importation of taste, of fancy dress, of an appetite for the exotic, or indeed by the assumption that colonialist power is homogeneous and undifferentiated. But first a little more needs to be said about Richardson's portrait and its subject.

Questions of patronage have been paramount in the forms of historical analysis that have characterized recent discussion of eighteenth-century painting.[23] Under the terms of those investigations, what has been so far suggested here would be liable to the criticism that there is no evidence available as to who

170. Andrew Garrick Gow, *The Duke of Kingston introducing his Daughter, Lady Mary Montagu as Toast to the Members of the Kit-cat Club*, oil on canvas, 1873. Whereabouts unknown; Witt Library photograph.

On the walls is displayed a series of Kit-cat Club portraits, while the circular mirror on the end wall perhaps alludes to the Arnolfini marriage portrait which had been acquired by Sir Charles Eastlake for the National Gallery in 1842.

171. Aubrey Hammond, *Lady Mary Montagu toasted by Members of the Kit-cat Club*, frontispiece to L. Melville, *Lady Mary Wortley Montagu, her Life and Letters*, London, 1925.

This Beardsleyesque rendering presents a somewhat equivocal interpretation of the event; the severe and ominously threatening expressions belie the apparent revelry.

child is paraded by her father for a company of ruling fathers and translated into symbol by the masculine ritual of a toast to her beauty. The event of the smallpox and the consequent destruction of Montagu's face was construed as rendering her unsuitable as an object of the (ultimate patriarchal) royal gaze, which she had already begun to attract by her beauty and by her witty poetry. The damage was not understood to be to herself but rather to her husband who was reported 'inconsolable for the disappointment this gives him in the [career] he had chalked out for his fortunes'.[19]

We might read Flavia's command in the poem that the 'killing picture' be removed from her sight and then disfigured and mutilated as an act of vicarious self-mutilation, lacerating the mythic body and subjecting it to effects analogous to those that disease has upon the physical body, and upon the face in particular, which as neo-platonic philosophy and psychoanalysis both aver is where the subject's sense of selfhood resides.[20] It is interesting to note here that the word 'face' derives from *facere*, meaning to make, or from a root *fa-*, meaning appear. The face can be made and unmade; in an era when the possibility of a grammar of human expression was widely explored, the face was a chosen site of knowledge. No art could give back the beauty lost – certainly not the art of medicine (though Montagu was to try a renowned cosmetic remedy in Turkey to no avail[21]), and the mirror which made available the self to the self is (as in Flavia's sick-room) reversed. What, however, is implicitly acknowledged in Montagu's poem is the power of representation and its function in the formation and well-being of the individual. If, as Lacan has argued, misrecognition is a crucial stage in the construction of identity,[22] what

directed the portrait painter in this instance, who controlled the commission. At the level of issues of identity and identification such a question is not germane, but it is none the less worth observing that women of the ruling class in the eighteenth century do seem to have been actively involved in the commissioning of portraits. Moreover, inscribed in the literature of the age was an assumption that the subject to some degree determined the composition of a portrait. Lady Wentworth in 1711 commissioned a series of portraits from Charles Jervas and so disliked the results that she refused to take delivery unless the paintings were reworked or improved.[24] In the same year Steele has Sir Roger de Coverley discoursing on the portraits of ancestors in his gallery, one of which shows a 'soft Gentleman'. Sir Roger instructs his visitor to 'Observe the small Buttons, the little Boots, the Laces, the Slashes about his Cloaths, and above all the Posture he is drawn in (*which to be sure was his own chusing*)'.[25] It is apparent from Montagu's letters that she was well informed about painting; she also sent her own portrait 'wrapped up in poetry without Fiction' to Algarotti in the course of her intense relationship with him in 1736.[26] It is, therefore, possible that Montagu at some level controlled the images of her produced by Richardson and by other established society artists who depicted her as a mature adult.

The format of the 'Richardson' painting (pl. 168) conforms to the pattern of full-length society portraits established by Kneller, though in this case the *plein-air* setting, the low horizon and the dramatic lighting anticipate the work of Ramsay and Reynolds in the 1750s. The sitter's dress consists of a Europeanized version of Ottoman costume as popularized through engravings after Vanmour, first published in Paris in 1712 and frequently reissued (pls 172, 173).[27] The foundation is an ankle-length white silk *salvar* from beneath which Montagu's embroidered slippers with turned-up toes emerge. Over this is worn the close-fitting *anteri* in a gold colour with slashed sleeves and a deep 'V' neck into which a 'modesty piece' is inserted. The filling of the cleavage ensures that the dress approximates more closely to the waisted appearance of English female fashion at the time, as does the side rather than central opening to the *anteri*. The finishing touches are provided by the deep jewelled belt and the *kirk*, a kind of ankle-length fur-lined coat with short sleeves. The fact that Montagu's *kirk* is lined with ermine lends the portrait a regal air. The dress depicted differs in precise details from that which the sitter described herself wearing in Constantinople, especially in that the *salvar* seems to be in the form of a skirt rather than a pair of drawers and that the material of her *anteri* is a stiff kind of lustrous satin rather than a white and gold patterned damask. Moreover, the shape of the

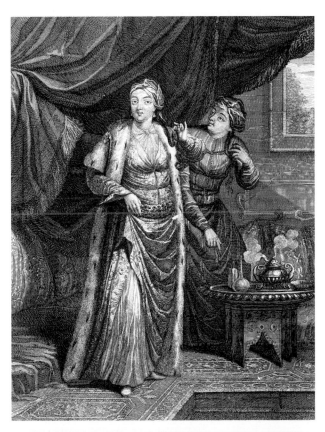

172. G. Scotin after J.-B. Vanmour, *La Sultane Asseki, ou Sultane Reine*, engraving, pl. 3 from *Explication des Cent Estampes*, 1714–15. Courtesy of the Board of Trustees of the Victoria and Albert Museum, London.

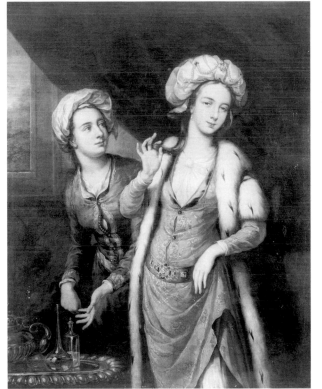

173. George Knapton, *Portrait of a Lady (called Lady Mary Wortley Montagu)*, oil on canvas, 126.0 × 98.1 cm. Courtesy of Christie's (18 April 1986 (106)).

This portrait by a pupil of Richardson testifies to the popular currency of Vanmour's engravings as a source of information and inspiration.

costume in the portrait does not fit as closely to the body as her description suggests.[28]

But the most noticeable difference between the

145

'Richardson' portrait and the images of Ottoman women engraved in collections like Le Bruyn's *A Voyage to the Levant* (1702) and *Recueil de Cent Estampes* (1712–13)[29] lies in the relative restraint of the headdress and in the slenderness of Montagu's fashionable figure in contrast to the corpulent figures represented in the travel books. The overall effect of the dress in the 'Richardson' portrait is, however, highly distinctive, suggesting in its varying layers and levels a degree of undress that would have been striking if not titillating at this time. Defoe's description of the heroine of his novel *Roxana*, 'dressed in the Habit of *a Turkish Princess*' and dancing in a figure she had learned in France but which the company all thought was Turkish, was first published in 1724. The erotic charge of the description must have depended partly on its novelty, and provides some indication of how the kind of attire adopted by Montagu in the 'Richardson' portrait of *c.*1725 might have been viewed well before the wearing of Turqueries as masquerade dress became the rage.[30]

The regal air noted above is reinforced by the second figure in the portrait: Montagu is accompanied by a black slave bearing a parasol. Hugh Honour, pointing out that by the 1760s England had a population of blacks estimated at around 15,000 – by far the largest of any European country – and that slavery arguably remained legal in Great Britain until 1833, remarks that 'whether the blacks dressed in smart livery in English portrait groups were technically slaves or free servants is indeterminate and was probably of little concern to their painters'.[31] But this begs the question; the boy depicted in the 'Richardson' painting wears a metal collar and, given the setting, imparts grandeur to Montagu through his position of inferiority, in the manner of Van Dyck's *Henrietta of Lorraine* (pl. 174).[32] He connotes slavish devotion and, by extension, slavery. Pictorially he serves as the ideal complement to Montagu: situated in shadow behind her, the red of his coat and stockings setting off the brilliance of her clothing, his dark skin contrasting with her faultless white complexion, forming a visual trope in which white woman is empowered in colonial and sexual terms.[33]

The introduction of a black slave (rather than the more appropriate Circassian slave) into a portrait in which the subject wears a specifically Turkish costume deprives the painting of something of its aura of ethnicity; it Europeanizes the image and further serves to enhance the subject's status as a woman of great wealth and power, for it was upon the traffic in blacks – the buying and selling of African peoples and their enforced labour – that eighteenth-century British commerce was based.[34] While trade with the Ottoman Empire was important,[35] the connotations of Turkey for British audiences were

essentially those of pleasure rather than commerce, of amusement rather than the exercise of power, of fancy, rather than reason.[36] Mozart's *Die Entführung aus dem Serail*, written for the Archduke Maximilian in 1782, manifests an ease with an enemy culture that had threatened Europe at least since Mehmet Fatih conquered Constantinople in 1453, and reinforces through its courtly medium the idea of the Ottoman Empire as a pleasure ground.[37] In the sphere of

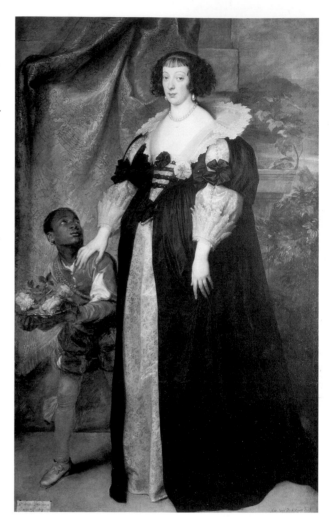

174. Anthony Van Dyck, *Henrietta of Lorraine*, oil on canvas, 211.5 × 155.2 cm., 1634. English Heritage: Iveagh Bequest, Kenwood House.

literature, contemporary beliefs about the origin of pastoral also directed attention to the east as a location of pleasure. It was thought that pastoral had originated in the east and had been transplanted by the Muses to Greece. The poet William Collins not only defended this theory but sought to compensate for the lack of oriental compositions from pastoral's pre-history by composing a sequence of eclogues spoken by characters such as Selim the shepherd and Abra the Georgian sultan.[38] In Adrianople (now Edirne) on the borders of Bulgaria and present-day Turkey, Montagu discovered – in a city founded by

Hadrian – the seductive home of pastoral. Writing in flirtatious vein to Pope from a house on the banks of the Hebrus, she describes the cooing of turtle doves:

> How naturally do boughs and vows come into my head at this minute? And must not you confess to my praise that tis more than ordinary Discretion that can resist the wicked Suggestions of Poetry in a place where Truth once furnishes all the Ideas of Pastorall . . . I no longer look upon Theocritus as a Romantic Writer; he has given a plain image of the Way of Life amongst the Peasants of his Country, which before oppression had reduc'd them to want, were I suppose all employ'd as the better sort of 'em are now.[39]

* * *

Access to 'Montagu' has always been via her letters. A word about these is therefore necessary. Her letters from the Ottoman Empire have been seen variously as a combination of truth and fiction,[40] as a major

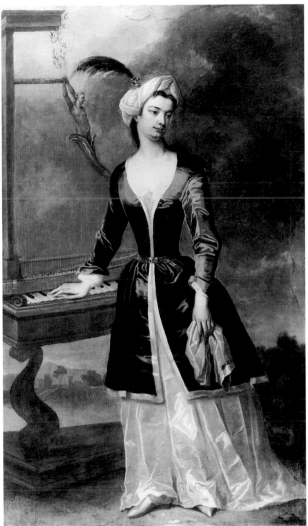

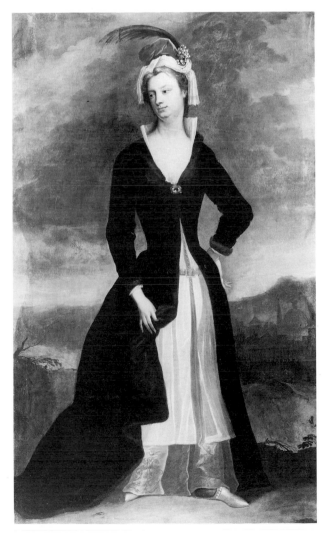

source for orientalist artists of the nineteenth century and, particularly, as a source for Ingres's *Le Bain turque*.[41] She is regarded as 'interpreting Moslem culture for Western Europe',[42] as 'a pioneer woman traveller and/or feminist',[43] as 'one of the earliest Ethnographers of Middle Eastern Women . . . remarkably free of ethnocentrism'[44] and as a philosopher encountering at a peculiarly transitional moment a culture of contradiction and contrast.[45] The letters, and particularly the letter describing the women's public baths at Sophia,[46] have often been used as an authenticating device or as a foil against which the orientalist extravagence of artists can be measured.[47]

The account of the Ottoman Empire offered by Montagu became available from the moment her voluminous correspondence left her pen and was dispatched by land and sea to her correspondents in London and Paris.[48] There it was circulated 'privately' and thus became public knowledge among the literati of both capitals. Publication took place

176. Charles Jervas, *Portrait of a Lady (called Lady Mary Wortley Montagu)*, oil on canvas, 203.2 × 116.8 cm., *c.*1730. National Gallery of Ireland, Dublin.

175. Charles Jervas, *Portrait of a Lady (called Lady Mary Wortley Montagu)*, oil on canvas, 203.2 × 116.8 cm., *c.*1730. National Gallery of Ireland, Dublin.

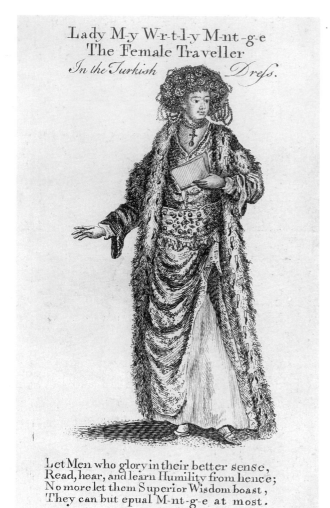

Lady M-y W-r-t-l-y M-nt-g-e
The Female Traveller
In the Turkish Dress.

Let Men who glory in their better sense,
Read, hear, and learn Humility from hence;
No more let them Superior Wisdom boast,
They can but equal M-nt-g-e at most.

Astell declares: 'I confess, I am malicious enough to desire, that the world should see, to how much better purpose the LADIES travel than their LORDS; and that, whilst it is surfeited with *Male-Travels*, all in the same tone, and stuft with the same trifles; a lady has the skill to strike out a new path, and to embellish a worn-out subject, with variety of fresh and elegant entertainment.'[52] It is a popular engraving of Montagu as 'The Female Traveller' (pl. 177) that I want to pause over for a moment.[53]

Unlike the portraits by Vanmour (pl. 180)[54] and 'Richardson' in which Montagu appears slender with much of her breasts exposed, the engraving – based on figures in the *Recueil de Cent Estampes* (pl. 178) – shows a solid, if not corpulent figure, well-covered by her garments and wearing an extremely elaborate headdress copied from a plate in Le Bruyn's *A Voyage*

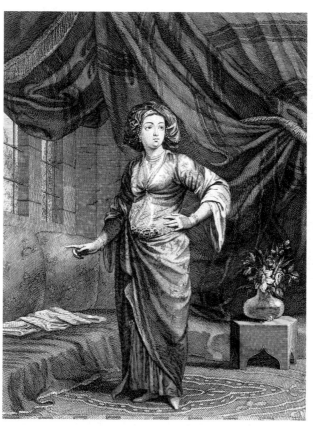

to the Levant (pl. 179).[55] It seems likely that this anonymous engraving was executed posthumously and that it is part of the Montagu cult that grew up in the years immediately after her death, a cult of which the unauthorized publication of her letters is the most obvious manifestation. It might, therefore, be taken as some measure of the success of Montagu – and of allies like Astell – in colluding with her portraitists in the production of her image. A most interesting feature of this engraving – and one that is unusual in

posthumously in a controversial manner,[49] but by that time the view of the Ottoman territories that she had constructed had served also to define her. In addition to the portrait attributed to Richardson, there are at least seven portraits of Montagu in Turkish-style dress authenticated by provenance and executed during her lifetime. Kerslake lists six false portraits, but in fact there are a multitude of these, as almost every unidentified portrait of a woman in Turkish dress that comes up at auction tends to be labelled 'Lady Mary Wortley Montagu', a testimony to the powerful mythology of the subject.[50] A pair of pendants in the National Gallery of Ireland, for example (pls 175, 176), one with a view of Constantinople in the background and the other showing the subject with her right hand resting on a mechanical harp, are typical of the family of Montagu portraits deriving from Charles Jervas which show her in a close-fitting black *anteri* with a stand-up white collar.[51]

From the start the letters were also highly invested in terms of gender. In her preface to them, Mary

eighteenth-century female portraiture – is the pose. Montagu is shown in this engraving in the classical senatorial pose, one foot slightly forward, right hand outstretched and a paper or book in her other hand, her eyes fixed upon a distant audience. Identified in an accompanying inscription as 'The Female Traveller. In the Turkish Dress', the image endows its subject with sight and with speech, and hence also with power. The verse at the foot reinforces these connotations, constructing the subject as in command of knowledge:

> Let Men who glory in their better sense,
> Read, hear, and learn Humility from hence;
> No more let them Superior Wisdom boast,
> They can but equal M-nt-g-e at most.

By a curious but perhaps not accidental congruence,

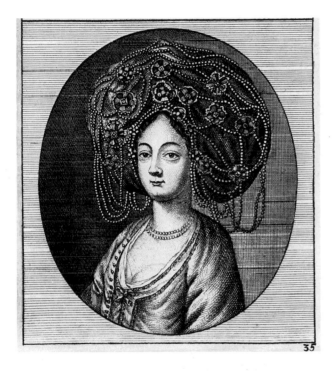

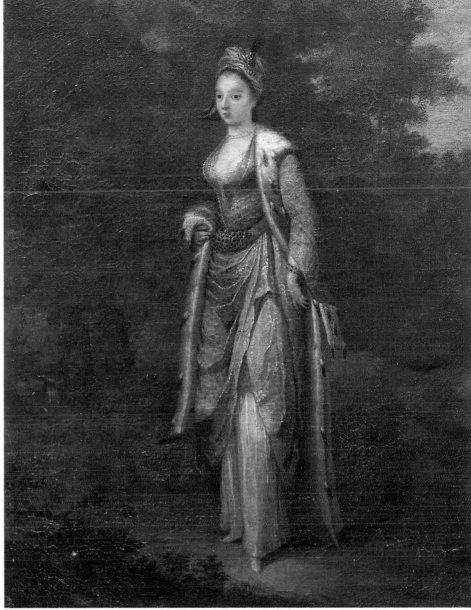

the reduction of the name Montagu to M-nt-g-e produces a formula from which the name Montaigne, a father of *belles lettristes*, could equally be construed.

It might be argued, therefore, that the Ottomanized portrait of Montagu could serve both as a further objectification of the female subject (woman as twice other – as female and as oriental) and as the bearer of colonial power through knowledge, a sign of national greatness whether or not accompanied by a black slave. At its most literal (at the level of the popular print), this articulation requires a set of masculine signifiers – the senatorial pose, the gestures of speech, the analogue with a French male philosopher.

An historical and psychic relationship was suggested above between the damaged biological body of the female subject, Mary Wortley Montagu, and the fantasized orientalized body as portrayed in the portrait attributed to Richardson. At an individual level the process of portrayal may be understood as reparation – women possessed some degree of control over the images produced of them – but at an ideological level portraiture is none the less yet another mechanism for the appropriation of the female body. Accompanied by a black slave dressed in eighteenth-century European clothing, the body of Montagu clad in Turkish-style dress is invested in the 'Richardson' portrait as a sign of the colonial 'right' to appropriate foreign bodies and foreign culture. At the same time the body of woman is

180 (above right). *Lady Mary Wortley Montagu*, attributed to J.-B. Vanmour, oil on canvas, 33 × 25.5 cm., 1713–16. Sotheby's, 13 July 1988 (32).

Vanmour was in Constantinople from 1699 and Painter-in-Ordinary to the Sultan from 1725; this image is related to the portrait of Lady Mary with her son (pl. 188).

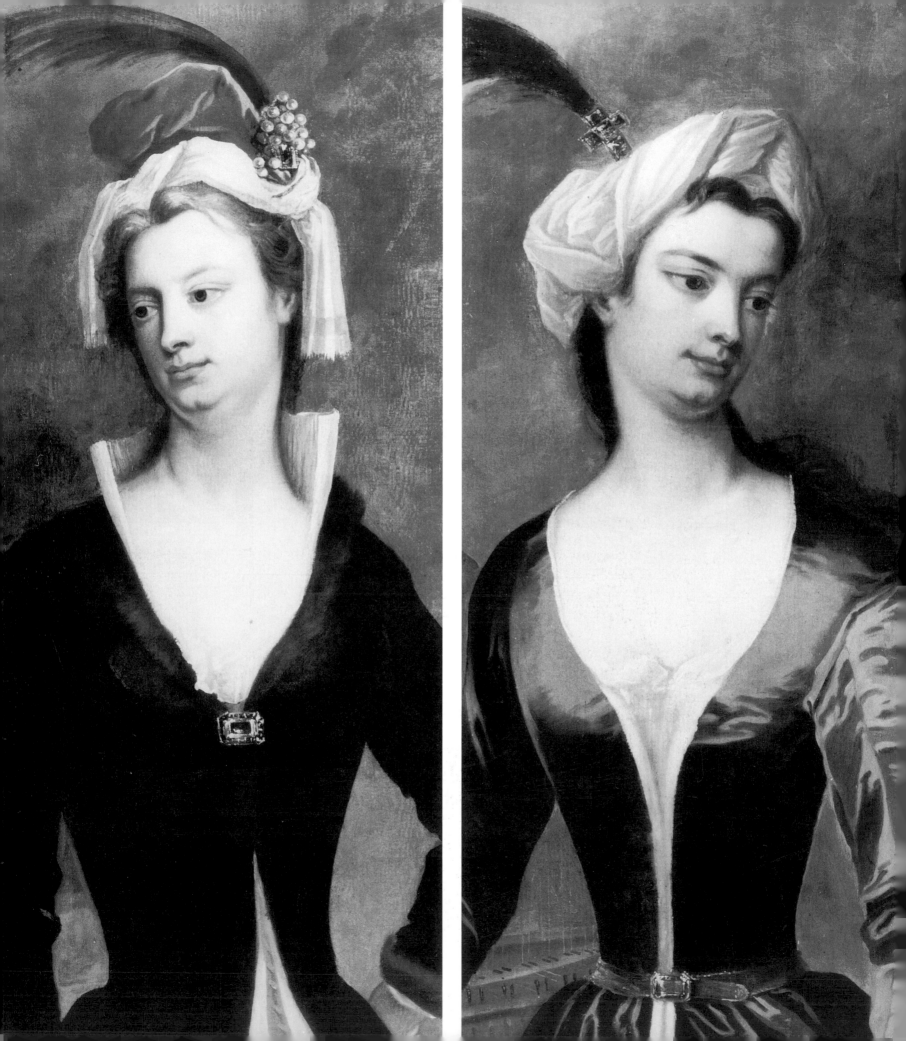

historically and metaphorically invested as nation-hood gendered (and possessed). In colonial discourse the concept of nation is not only feminized but specifically sexualised, and woman in this discourse can function as a metaphor for the degeneration of the violated nation while simultaneously standing as sign of the conqueror.[56]

What is under consideration is, however, the process whereby woman as colonizer might seize this process of feminizing and, more precisely, sexualising, to exploit the set of relationships between the individual body and notions of national identity. The appropriation of the discourse of colonial power by the female subject – in this case Montagu – does not, of course, rescue her from the implications of that extended metaphor through which she represents the violated nation; we can still argue that the conclusion of the episode is a representation of a European female figure in Turkish-style clothing that is circulated in the west as an emblem of masculine power over female subjects and the superiority of west over east. The object of this chapter is none the less to challenge the reductiveness of this position. Linda Nochlin's statement that 'woman's body has never "counted" in itself, only with what the male artist could fill it with, and that, it seems, has always been himself and his desires. . . . it is a totally asymmetrical privilege; no such entry is provided for women artists',[57] does not allow any manner of organizing function for woman in the production and deployment of her own image. It is the question of this function that is here being investigated.

* * *

As this chapter is concerned not only with the female subject in art but with the historical construction of femininity through art, a closer examination of the question of Montagu's representation of Turkey as a site of pleasure is required. This issue was raised in the first part of the chapter as one of general cultural valorization. Now I want to ask how did one who had, through the person of Flavia – victim of small-pox – rejected the mirror, negotiate the relationship between the actual and the idealized female body by holding up (for the first time) a mirror to Turkish womanhood? This relationship, as has been observed, was a matter of political and personal difficulty; portrayal as an act (as well as portraits as objects) was deeply implicated in its resolution.

Montagu is popularly understood to have corrected the widespread notions disseminated in guidebooks of the period, in which Turkish women were represented as abject slaves, by establishing the paradoxical concept that they enjoyed more liberty than western women.[58] Certainly the facts that

Ottoman women had rights over their own property and that divorce was available were attractive propositions and ones about which she wrote. That the practice of veiling enabled Ottoman women to move around public spaces incognito (pl. 183) was also seen to be advantageous – an early manifestation of the now familiar notion that the regulations imposed by Islam on women are no more oppressive than the constraints of western liberalism.

It is the western encounter with a culture in which portraiture has no place that requires recognition; it was, furthermore, a culture in which the female face, so valued in private, had no currency in public. The loss of a husband's career prospects as a result of the

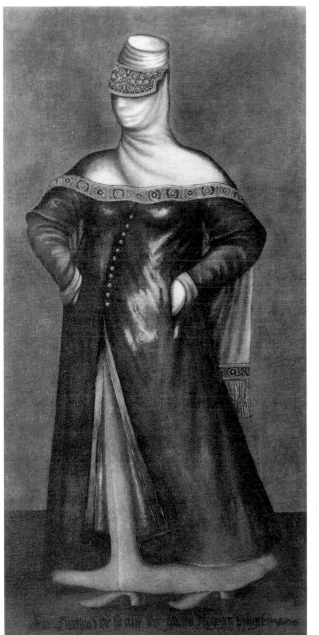

181. Detail of pl. 175, Jervas, *Portrait of a Lady*.

182. Detail of pl. 176, Jervas, *Portrait of a Lady*.

183. Anonymous Austrian artist, *A Turkish Lady dressed for the Street*, oil on canvas, 227 × 115 cm., *c*.1630–40. By courtesy of Hazlitt, Gooden and Fox, London.

In contrast to what women were represented as wearing inside the Harem, the exterior dress for women of the Ottoman empire is here shown to involve the complete veiling of the face.

destruction of his wife's face would be an impossible concept in Montagu's Turkey even though female beauty was highly prized by ruling males. Montagu, recounting the opportunities for freedom among Turkish women, reports that caught out in infidelity they might suffer death at the hands of a husband. She tells how the body of such a woman was discovered not far from her house, bleeding from two knife-wounds, naked and wrapped in a coarse sheet:

> She was not yet quite cold, and so suprizingly Beautifull that there were very few men in Pera that did not go to look upon her, but it was not possible for any body to know her, no woman's face being known. She was suppos'd to be brought in dead of night from the Constantinople side and laid there. Very little enquiry was made about the Murderer, and the corps privately bury'd without noise.[59]

In a culture where by this account it was impossible to identify a woman in public – no woman's face being known – the western power structure that linked physical appearance to identity and thus valorized the individual through the representation of the body could be understood to have no purchase. At one level, of course, this means simply that we recognize portraits such as those we have been discussing as self-declared artifice, like the western masques and entertainments they resemble. But at another level the power of sight, which the female traveller uniquely wields (or so the narratives she and others constructed would have us believe), and which is a part of the orientalist discourse through which the west shaped and understood the east,[60] makes visible what is otherwise unseen. By virtue of her sex Montagu represents the unrepresentable not, as the ethnographic account proposes, in the interests of a 'truthful' view of a hitherto unseen society, but by a reconstruction of woman (herself) as object of her own pleasure. The killing picture and the reversed looking-glass of the European sick-room can be replaced by the fantasy other – also a woman and therefore also herself – of the Baths of the Harem.

The spectacle of Ottoman culture – of feminized Ottoman culture – enabled Montagu to be both viewer and viewed, to bridge the gap between self as object of another's pleasure and self as narcissistic, a gap that was a powerful ingredient of eighteenth-century social discourse and social function. At a personal level the veil, which Montagu found 'very easy and agreeable'[61] and in which western artists had long portrayed eastern women, freed her to move around as she wished; it also would have obscured her ruined complexion and demoted her physical appearance, relieving her of the burden of acting as bearer of western signs of status and making her distinguishable only from all men and undistinguishable from any woman. The actual veiling of herself – the adoption of Turkish dress – allowed Montagu freedom of access to the public spaces of Adrianople and Constantinople. More importantly the symbolic obliteration of herself – the decision to visit the Hot Baths at Sophia incognito, as well as the decision to engage with Ottoman culture at the level of practical experience – provided the site (as well as the sight) for the construction of the female body as object of narcissistic pleasure.

It is important in this respect to notice how carefully Montagu chose her dress; while 'going Turkish' enabled her to act the *flâneur* in the streets of Constantinople, when visiting the Baths at Sophia she wore European riding dress, and she wore Viennese court habit to visit the Grand Vizier's Lady and the Kahya's Lady in Adrianople. On both occasions, however, she travelled incognito in a Turkish coach.[62] Viennese court habit was, as she herself pointed out, much more magnificent than the English equivalent and must have connoted extraordinary power given that the Austrians were on the point of war with the Ottomans. Riding habits were a version of the masculine suit worn by English women for riding, walking and travelling, so Montagu entered the Baths at Sophia not only as a European woman but as a masculinized European woman.[63] In both instances the dress served to establish the symbolic distance crucial to the narcissistic gaze.[64] She would be seeing woman like herself but different by culture, culture in this instance being articulated in terms of the body's dress and covering.

Montagu's account of the Baths at Sophia is so well-known as scarcely to need rehearsal. Yet it is worth quoting at length a passage that has been so often used to demonstrate historical truths in order to comment upon the way it is structured:

> I was in my travelling Habit, which is a rideing dress, and certainly appear's very extraordinary to them, yet there was not one of 'em that shew'd the least suprize or impertinent Curiosity, but receiv'd me with all the obliging civillity possible. I know no European Court where the Ladys would have behav'd them selves in so polite a manner to a stranger.
>
> I believe in the whole there were 200 Women and yet none of those disdainfull smiles or satyric whispers that never fail in our assemblys when any body appears that is not dress'd exactly in fashion. They repeated over and over to me, Uzelle, pek uzelle, which is nothing but, charming, very charming. The first sofas were cover'd with Cushions and rich Carpets, on which sat the Ladys, and on the 2nd their slaves behind 'em, but without any distinction of rank by their dress,

all being in the state of nature, that is, in plain English, stark naked, without any Beauty or deffect conceal'd, yet there was not the least wanton smile or immodest Gesture amongst 'em. They Walk'd and mov'd with the same majestic Grace which Milton describes of our General Mother. There were many amongst them as exactly proportion'd as ever any Goddess was drawn by the pencil of Guido or Titian, and most of their skins shineingly white, only adorn'd by their Beautifull Hair divided into many tresses hanging on their shoulders, braided either with pearl or riband, perfectly representing the figures of the Graces. I was here convinc'd of the Truth of a Refflexion that I had often made, that if twas the fashion to go naked, the face would be hardly observ'd. I perceiv'd the Ladys with the finest skins and most delicate shapes had the greatest share of my admiration, tho their faces were sometimes less beautifull than those of their companions. To tell you the truth, I had the wickedness enough to wish secretly that Mr. Gervase could have been there invisible. I fancy it would have very much improv'd his art to see so many fine Women naked in different postures, some in conversation, some working, others drinking Coffee or sherbet, and many negligently lying on their Cushions while their slaves (generally pritty girls of 17 or 18) were employ'd in braiding their hair in several pritty manners. In short, tis the Women's coffee house, where all the news of the Town is told, Scandal invented, etc. They generally take this Diversion once a week, and stay there at least 4 or 5 hours without geting cold by immediate coming out of the hot bath into the cool room, which was very supriszing to me. The Lady that seem'd the most considerable amongst them entreated me to sit by her and would fain have undress'd me for the bath. I excus'd myself with some difficulty, they being all so earnest in perswading me. I was at last forc'd to open my skirt and shew them my stays, which satisy'd 'em very well, for I saw they beleiv'd I was so lock'd up in that machine that it was not in my power to open it, which contrivance they attributed to my Husband. I was charmed with their civillity and Beauty and should have been very glad to pass more time with them, but Mr. W[ortley] resolving to persue his Journey the next morning early, I was in haste to see the ruins of Justinian's church, which did not afford me so agreable a prospect as I had left, being little more than a heap of stones.

Adieu, Madam. I am sure I have now entertained you with an Account of such a sight as you never saw in your Life and what no book of travells could inform you of. 'Tis no less than Death for a Man to be found in one of these places.[65]

The framework for this account is that of the clothed European body and its signifying gestures; against this is constructed naked eastern woman sexualised via a series of allusions that are all western not eastern. The passage from Milton is a *locus classicus* of female sexuality. While the reference to 'majestic grace' may refer to *Paradise Lost*, book IV, line 290 – 'With native Honour clad/in naked Majestie' – the reader would be led on to the celebrated passage a few lines later where Eve is described:

She as a vail down to the slender waste
Her unadorned golden tresses wore
Dissheveld, but in wanton ringlets wav'd
As the Vine curles her tendrils, which impli'd
Subjection, but requir'd with gentle sway,
And by her yielded, by him best receiv'd,
Yielded with coy submission, modest pride,
And sweet reluctant amorous delay.[66]

The women in the Baths are like goddesses drawn by Guido Reni and Titian, that is pagan goddesses such as Venus, depicted by artists renowned for the sensuousness of their handling.[67] The troublesome face is forgotten in the pleasure of the naked body, and a situation in which 'the face would hardly be observed' is ruefully imagined as the writer admires the finest skins and most delicate shapes. The problem of the face suggests the name of the face-painter, Charles Jervas, an artist whose reputation Pope subsequently inflated in an epistle that specifically mentioned his portrait of Montagu.[68]

The slide from portraiture to the nude and back is an interesting one, suggesting tacit investment in the sexual within the reading of portraits at the time. The name of Jervas seems here to be connected in a somewhat sniggering way with the representation of female sexuality;[69] Montagu implies that studying the female nude might ensure that Jervas paints better portraits, but the implication is also that his name somehow is the appropriate one to invoke in this theatre of female flesh. Jervas was known personally to the writer, and the sale of his studio contents included (among 2,128 pictures prints and drawings) an enormous number of engravings after allegorical Old Master paintings and one substantial lot described as 'Drawings. Nudities from the Life'.[70] Montagu represents the women in the Baths at Sophia by invoking a portrait painter and, by implication, contemporary western acts of portrayal that constructed femininity as sexual and as desirable.

Montagu's account concludes, after her explanation of the social function of the Baths, with the revelation of what lies under her own skirt. At this point her western body is found sealed in its clothing by patriarchal law; the interpretation of the stays is, of course, attributed by Montagu to the women

bathers, but the sense that she is implicated in this interpretation is compounded when we learn that this same patriarchal law imposes the itinerary and the schedule and demands, therefore, that she leave.

In her visit to the Kahya's Lady, Montagu reverses the commonplace notion of an art that vies with nature and finds, rather, life that is more wonderful than art:

> The Gravest writers have spoken with great warmth of some celebrated Pictures and Statues. The Workmanship of Heaven certainly excells all our weak Imitations, and I think has a much better claim to our Praise. For me, I am not asham'd to own I took more pleasure in looking on the beauteous Fatima than the finest piece of Sculpture could have given me ... Her fair Maids were rang'd below the Sofa to the number of 20, and put me in Mind of the pictures of the ancient Nymphs. I did not think all Nature could have furnished such a Scene of Beauty.[71]

When the maids begin to dance Montagu finds the spectacle sexually arousing, declaring:

> Nothing could be more artful or more proper to raise certain Ideas, the Tunes so soft, the motions so Languishing, accompanying with pauses and dying Eyes, halfe falling back and then recovering themselves in so artfull a Manner that I am possitive the coldest and most rigid Prude upon Earth could not have look'd upon them without thinking of something not to be spoke of.

In writing about dancing maids in this way, Montagu (like Daniel Defoe) is merely following earlier travel accounts which make great capital out of the erotic spectacle of Turkish dancing. Moreover, the sofa, which features in her account and which was to become an emblem of decadence in Cowper's *The Task* (1783) where the healthy outdoor life is offered in contrast, was already a stock item in orientalist writing. None the less, it is appropriate here to go beyond these explanations and to hypothesize a relationship between life and art that will enable us to understand the related aspects of the definitions of femininity that Montagu was constructing and by which she was identified. Study of the individual subject as well as of social organization is needed if we are better to understand how gender works. The relations between the individual and social organization and between men and women are interconnected in ways that cannot be untangled except at the level of the psychic and the mythic.

In the Khaya's Lady's presence, Montagu finds life superior to art, and life assisted by art (dancing) offers extreme forms of pleasure of a kind that cannot be re-presented and can only be alluded to. Thus the controlling relationship between femininity, sexuality and the art of image-making (which determined Montagu's viewing of the Baths at Sophia) is here broken down and she is able to grasp the pleasure in looking and make it complete. For there is no intrusion here of patriarchal law and Montagu terminates the visit (and the account) only when she has enjoyed her fill of looking. The art of representation can henceforth be the individual's tool rather than her master, for Montagu has seized the power of sight (as well as the power of speech) in order to articulate her own pleasure. 'I took more pleasure', she affirms, in looking at the women of the harem than in the sight of 'the finest piece of sculpture'. The pagan goddess is overthrown not by Christianity but by the actuality of Islam, and the 'killing picture[s]' of European social systems of representation – now understood to be 'weak Imitations' – cease to be a threat.

* * *

In 1776, Reynolds reminded London audiences of one of the 'finest pieces of sculpture' with his image of the noble savage (pl. 184). The Tahitian 'Omai', brought to London by Captain Cook, was portrayed in a toga-like garment and in a pose reminiscent of the *Apollo Belvedere*, which served more than once as an icon of masculinity in eighteenth-century portraiture.[72] By contrast, in paintings and engravings of her, Montagu was a European portrayed in orientalized costume. And that costume – as Montagu's accounts of Ottoman femininity evince – carried connotations of sexual pleasure quite removed from the world of Classical Antiquity and the 'finest pieces of sculpture'. Those connotations are balanced by Montagu's pose, which in all the portraits of her lacks any suggestion of dancing and ranges from the permissibly langorous (as with the Kneller commissioned by Pope (pl. 185)) to the sedate (as with the 'Richardson' and the Vanmour (pls 168 and 180)). The portraits of her attributed to Vanmour construct a subject that is highly distinctive (pl. 188); it bears neither the masque/fancy-dress associations of works of a generation or so earlier, such as Van Dyck's *Teresia, Lady Shirley* (pl. 186), nor the anecdotal quality of nineteenth-century orientalist painters like Gleyre in France and Thomas Allom in England. Moreover, the erotic associations of dress are counterbalanced by the statuesque pose. Compared with George Willison's portrait of Nancy Parsons in Turkish dress (pl. 187) or with Liotard's portrait said to be Mary Gunning, Duchess of Coventry, both of which show women seated on sofas, the images of Montagu are extremely formal. Vanmour produced two portraits featuring her, one a single figure and the other a group including the same figure in the company of her son and two servants.[73] In these

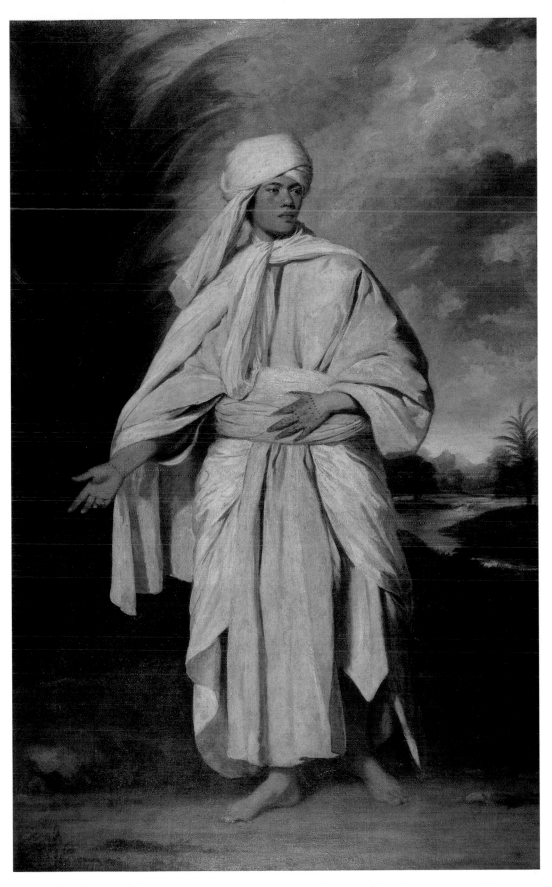

184. Sir Joshua Reynolds, *Omai*, oil on canvas, 236.2 × 144.8 cm., R.A. 1776. Rt. Hon. Simon Howard.

Omai aroused great interest in London as a living example of the oriental 'other'. He was portrayed by Reynolds in a classical pose which enables him to display his tattooed hands. He is known, however, to have worn fashionable European clothing during his sojourn in England. Lady Mary Wortley Montagu, by contrast, is a European portrayed as an oriental.

185. Caroline Watson after Sir Godfrey Kneller, *Lady Mary Wortley Montagu*, stipple engraving, 1720, frontispiece to Lady Mary Wortley Montagu's *Works*, 1803.

This portrait was commissioned by Alexander Pope who was a close friend of the subject, although he subsequently quarrelled with her.

187 (far right). George Willison, *Nancy Parsons in Turkish Dress*, oil on copper, 57 × 47.5 cm., *c.*1771. By courtesy of the Yale Center for British Art, New Haven, Paul Mellon Collection.

The subject is posed on a sofa, a fashionable item of furniture imported from the east in the eighteenth century. Her work basket contains oriental embroidery and a mirror. The composition is similar to that in a number of works by the Swiss artist, Jean-Etienne Liotard.

186. Sir Anthony Van Dyck, *Teresia, Lady Shirley*, oil on canvas, 197.5 × 138.75 cm., 1622. National Trust: Petworth House.

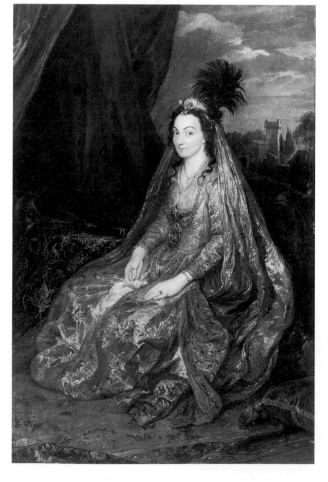

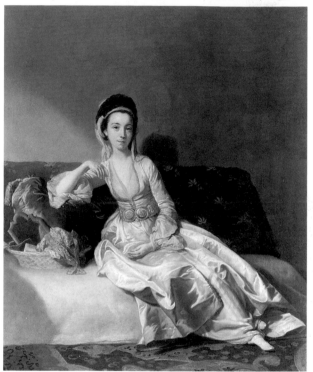

portraits Montagu appears in possession of herself and at ease in her body-hugging Turkish garments. If this impression is the result of the persuasiveness of her writing, then all the more reason to acknowledge the process of cultural appropriation and refinement that moves from word to image and back, operating to reconstruct and empower the damaged self as sexualized, feminine body.

Woman's fertility was, Montagu pointed out, greatly valued in Ottoman society. She herself acquired considerable kudos by giving birth to her second child in Constantinople.[74] It is, therefore, entirely appropriate that Vanmour should reproduce Montagu with her son, the evidence of her own reproduction. The painting offers a strangely disconnected composition in which Montagu holds the hand of young Edward who is, like her, dressed in Turkish-style clothing. The lower part of the image is occupied by an expanse of tiled floor with a raised area covered with an elaborately patterned carpet. From the right an old man enters bearing a letter in one hand and holding a pipe in the other, while on the left a young woman is seated cross-legged on a sofa playing a *tehegour*. In the background there is a view of Constantinople. The painting is thus full of motifs of which Montagu writes and through which Turkey is constructed and processed for the west. We may take the letter that is being delivered as a sort of professional imprimatur – a reminder of Montagu's

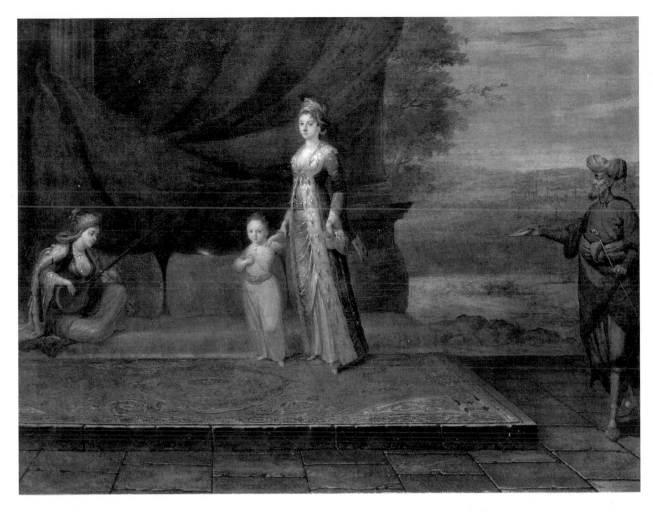

188. *Lady Mary Wortley Montagu and her Son*, attributed to J.-B. Vanmour, oil on canvas, 68.6 × 90.2 cm. National Portrait Gallery, London.

role as correspondent. None the less, the association would also have been with the Turkish love-letter, a topic particularly dear to English audiences and one about which Montagu wrote in response to enquiries from home in March 1718.[75] In Dutch seventeenth-century painting or in British nineteenth-century painting, the arrival of a letter is often a key to the unfolding of the narrative.[76] Here, however, the status of the letter that the attendant holds forth is indeterminate. The complicity of the subject in the production of an image of self that may be Turkish or may be English (may contain a love-letter or a business document) is, like the wearing of a riding habit into the Women's Baths at Sophia, capable of mis-recognition. The power of knowing is denied the viewer. It is, therefore, the viewed that holds the balance of power, poised between east and west, between letter and music, business and pleasure. The female subject is thus constructed in a relationship of power to the viewer. The mirror is restored.

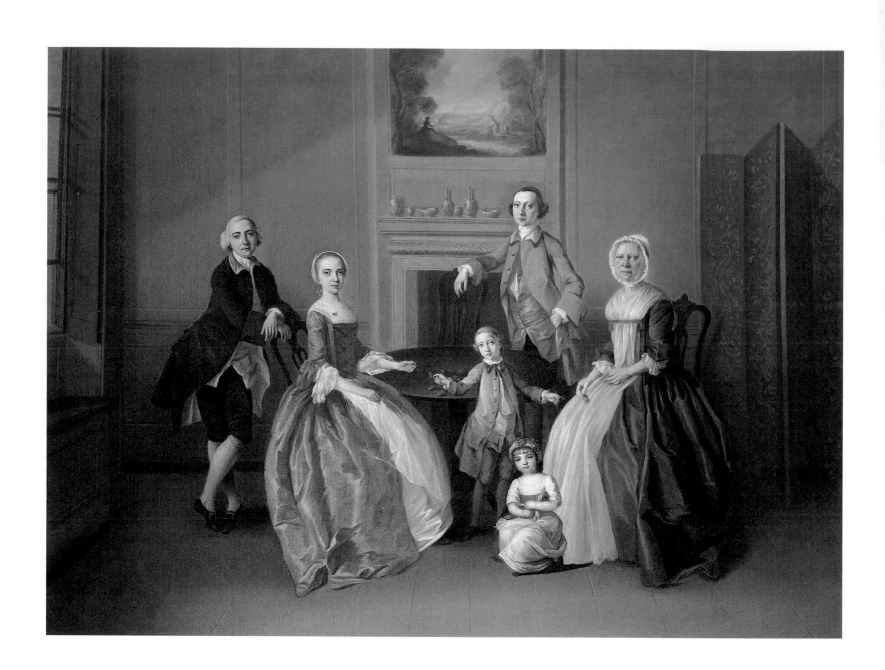

VI THE CONVERSATION PIECE: GENERATION, GENDER AND GENEALOGY

Ever since the pioneering work of Roy Strong in the 1960s on dynastic Tudor portraiture, it has been well understood that the relationship between the pictorial composing of portrait subjects in an illusory spatial setting, and the position in which the portrait was hung relative to the ceremonial use of internal architectural spaces, served to determine how such portraits signified contemporaneously. Strong's examination of Holbein's portrait of the family of Henry VIII as it must have been seen in the Presence Chamber at Whitehall is an exemplary exploration of this question.[1] In chapter I above, some of the ways in which particular hangs generated historical narratives both individual and collective was assessed. One of the genres of portraiture that flourished in eighteenth-century England was the conversation piece, in which the external conditions outlined in chapter I – the spatial organization of domestic interior space – are frequently reproduced and reformulated illusionistically. Alongside the family groups with their servants and domestic pets posed in parklands, on terraces and in verdant gardens by the Devises, Stubbs, Wheatley and others, are the pristine family gatherings in elegantly furnished interiors. So-called conversation pieces (or 'family pieces', the eighteenth-century term[2]) have not been the subject of a particularly illuminating analysis. The kind of painting that E.K. Waterhouse dismissed as the 'smug' middle-class conversation piece[3] and Ralph Edwards thought deficient in the 'qualities and attributes of great imaginative art'[4] has generally been admired more for its execution or its presumed historical accuracy than for its content.[5]

A common feature of interior conversation pieces in the period under discussion is the stillness of the figures and the minute attention to details of furnishing and interior decoration from which we are invited to construct narratives across time relating to those still figures. In a large family group from the late 1740s (pls 2, 189), for example, the hazel nuts on the table and in the grandmother's hands indicate a nutting expedition completed. The small girl, with legs crossed in imitation of an adult, nurses a doll that is worn and battered. Both nuts and dolls suggest socially controlled pursuits in a world where adult fantasy is confined to the merest sign in the form of the landscape caprice with a fishing scene that hangs on the wall.

Conversation pieces were sites for the articulation of social and familial propriety. James Russel, for instance, urged his brother to have numerous children so that:

> it may yield me the opportunity of displaying the utmost of my art in a conversation piece. In which my sister [-in-law] and you must be the principal figures, with a group of my nephews and nieces, on each side, represented at employments or diversions proper to their age and sex.[6]

At the same time the social situations imaged in the conversation piece constituted a network of disconnected signs relating to discourses of culture and politics. When Zoffany painted the Princess Royal carrying a doll dressed in blue that looks significantly like one of Gainsborough's female sitters (pl. 190), he was not only producing an agreeable family group informed by contemporary notions of natural parenting but also claiming pre-eminence in a 'natural' form of portraiture which we are invited to understand as contrasting with the artifice of his competitor, Thomas Gainsborough.

Russel's exhortation to his brother to produce lots of children points to the connection between conversation pieces and family power that I shall explore in this chapter. I shall be suggesting that the interior domestic elements – and particularly the pictorial imagery and other forms of representation that are reproduced within the paintings – play a particular role in the construction of genealogical narratives. Genealogy, relating to family lineage, and therefore connected also with progeny on the one hand and with property on the other, is never divorced from gender. And I use the term gender to define the social relations between the sexes, relations that are not fixed. One sex is defined in its relations with the other sex – and therefore with society – through the

189. Anon., *A Family Group*, oil on canvas, 88.7 × 119.7 cm., late 1740s. Courtauld Institute Galleries, London.

190. Johann Zoffany, *Queen Charlotte with Members of her Family*, oil on canvas, 105.1 × 127 cm., R.A. 1773. Royal Collection, St James's Palace. Her Majesty the Queen.

The group consists of the queen with Princess Charlotte holding a doll, Prince William standing on a bench wearing the star of the Order of the Thistle. Behind the bench the royal governess, Lady Charlotte Finch, holds a baby. To the left and right are the queen's two brothers. The group is organized around the incident of the need to restrain Prince William, with the tension of the composition deriving from the location on ground which slopes away from under the feet of the group and the conflicting motions and gestures of the individuals.

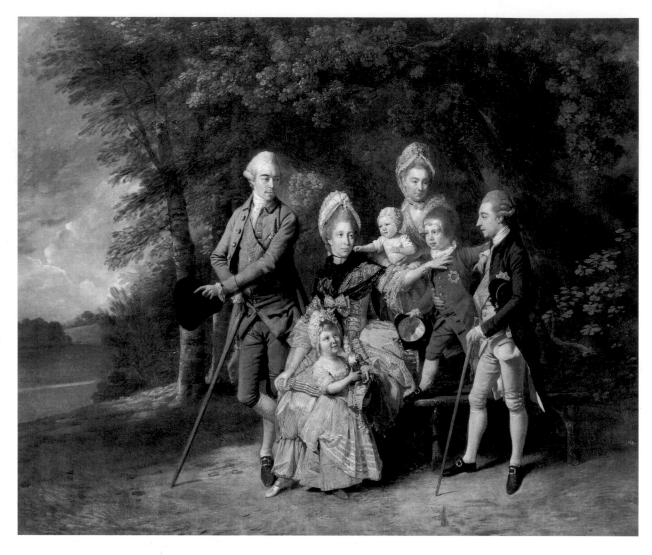

cultural identities that the structuring concepts of gender produce. At one level any group of beautiful women and children, richly attired and posed in a well-furnished interior, stands as sign of the status, property and power of succession of the father and householder. But the matter does not end here and there is much to be learned from images of women who are not widows, who are posed with their children, but without their husbands. The absence of the father/husband in these images is a deliberate narrative device that sharpens our perception of the patriarchal. The object of this chapter is to demonstrate, after perusing two such portraits, precisely the unnaturalness of an art form that has often been construed as part of a move away from 'formal' and 'public' portraiture in the eighteenth century to a celebration of the intimacy of family relations.[7]

It has much to do with the success of the conversation piece (and particularly of the group posed in an interior space) in exercising patriarchal authority that the dominant view has been that such paintings 'grasped the charm of English domestic life in a unique fashion'.[8] The continuing twentieth-century investment in the idea of the family as a uniquely licensed power base, an ideological investment that runs counter to much of the evidence of how people actually live, has assigned to the interior conversation piece a powerful position in the dynamics of visualizing our antecedents. The interior conversation piece has never lost its hold on the English imagination; it was continually reinscribed first in nineteenth-century painting and then through photography. It informs the ethos of today's 'English Heritage' style of interior design which has determined the appearance of so many historic interiors from the Landmark Trust to the Crest Forte Hotel chain. The conversation pieces of Zoffany, for example, were quoted by Millais in his portraits of James Wyatt (pl. 191) and of Mrs Wyatt in 1849 and 1850. It was works like this that set parameters for the composition of the twentieth-century family photograph.

The conversation piece was a highly adaptable genre and was employed by the aristocracy as well as the gentry; one image from each class will be examined. It does not, however, in any way represent a levelling process. Just as the gentry perpetually assimilated the habits and fashions of the aristocracy in the eighteenth century, so we see the format through which one class had itself represented being annexed by a different class for the articulation of generational and gender difference, and for the assertion of the power of succession.

A conversation piece is to be understood as a visualization of the last will and testament, an imaged set of domestic commands for future generations produced at the behest of an individual who will no longer be alive when the text is read. Wills are attempts to ensure that the individual, through an act of inscription, can determine succession and the distribution of material wealth from beyond the grave. Conversation pieces insert a particular statement of familial power relations into the narrative of succession, a statement intended to fix family members in their relationships with another. Portraits have themselves often been specified in wills in an attempt to govern the behaviour of future generations. For example, the classical scholar and antiquarian James St Amand, who died in 1754, left his books, coins and prints to the Bodleian Library. The residue of the estate was bequeathed to Christ's Hospital, together with a miniature set in gold of his grandfather, John St Amand, on condition that the treasurer sent a note to the executors promising never to alienate the picture (see pl. 52). Each new treasurer has to repeat this process. The portrait was required to be kept in the Treasury and produced in public at the first General Court held after 1 January each year. The portrait was also to be shown once anually to whomever the Vice Chancellor of Oxford sent to the Hospital to demand a sight of it. If sight of the portrait were to be refused, all the bequests to the Hospital would immediately cease.[9]

Pictorial imagery does not, of course, constitute a legally enforcible instruction like a will, but the will does not operate only in terms of definitions of the law; it is also a text with a capacity for the affective. The moment of reading the will is a moment when the chief protagonist is absent – a conundrum that fascinated artists and writers.[10] The will embodies the undeclared as well as the declared. The idea of being named (or not named) in a will contributes to a patriarchal mythology, biblical in its authority, no matter who the deceased may be. It is a call from beyond the grave that renders the living recipients (and non-recipients) helpless children before a God-like exercise of power. In conversation pieces, a constructive axis between visibility and invisibility determines the distribution of power. The clarity

of depiction that is a feature of eighteenth-century conversation pieces in the work of artists like the Devises, Stubbs, Zoffany and others is not only an aesthetic element but a device to render legible and, furthermore, to foreground the very idea of legibility. Relatives are omitted from wills, just as they sometimes are from family portraits, but rarely by accident. And nobody has any use for an illegible will; to be effective as a document it must be concentrated and unequivocal – the past, present and future subsumed into a single act of communication that will hold sway over a particular social grouping for ever. Such also is the conversation piece.

It may be argued that the appearance of conversation pieces is the result of a combination of stylistic and economic factors. Zoffany, it has been pointed out, was able to adapt a genre, popular in his native Germany among relatively humble artists, to satisfy the aspirations of courtly patrons. Exactness of rendering was a convention of German portraiture. The necessity for the inclusion of several figures, given more or less equal prominence and grouped around an interesting action, determined, it is argued, the format. Moreover, since payment was calculated on a *pro-rata* basis for the number of sitters, artists must have looked on a commission for a 'family piece' as highly desirable.[11] None of this explains precisely why the 'family piece' was reinvented in the late eighteenth century in a nation where 'there was no distinct social caste of nobility, claiming its own extensive, separate legal privileges

as against the rest'.[12] Mario Praz proposes that since there have always been families, it is incongruous that the portrait of a family group with the particular characteristics of a conversation piece began to appear only at a certain epoch.[13] But this is to suppose that the family is a static unit, whereas (as detailed in the following chapter) from the early modern period in Europe the family becomes a shifting concept rather than a fixed formation.

Chapter II above considered how the systematic processes of structuring history through biography constituted a means of visibly establishing order and difference. The conversation piece, it will be argued in this chapter, is a form of imagery in which the notion of social distinction and familial coherence could be secured and perpetuated. The details of furnishing and décor in Zoffany's work has often been shown to be a mixture of authenticity and invention. In Reinagle's portrait of the Congreve family that will shortly be discussed (pl. 199), the paintings that are represented on the walls are familiar because they have survived, but it is impossible to assert that the furnishings and dress are accurate. The recognition that such paintings combine invention and mimesis might seem to shift the onus away from the family and its aspirations, thus challenging the proposition that they resemble wills. But artists such as Zoffany and Reinagle were inventing modes of portrayal in response to an unarticulated set of demands. The interaction between artist and commissioner of painting operates not only as contractual specification but also at a level of intuitive response and unconscious challenge. The painting – with its vividly material description of house-contents – is not only inventory but also fantasy.

It is also worth noting that Zoffany was a German immigrant and probably specially sensitive to the freedom with which persons of different ranks associated in the clubs and coffee-houses of London, a familiarity and openness unique in Europe. It was his compatriot, W. Von Archenholtz, after all, who, in his graphic (if perhaps sometimes overenthusiastic) account of England in the second half of the eighteenth century, spoke of

the sentiment of liberty and the ever-active protection of the laws [that] are the causes why the common people testify but little consideration for persons of quality, and even for persons in office, except they have gained their affection by affable and popular manners. That perfect equality which nature hath at all times established among men, presents itself but too forcibly to the minds of these haughty islanders; and neither dignities nor wealth are capable of effacing it. Even the Majesty of the throne is often not sufficiently respected.

The Englishman considers his Sovereign only as the first of the magistrates in his pay.[14]

Attempts to recognize economic forces translated into visual metaphor should rightly be regarded with great caution. None the less, it is worth drawing a connection between our knowledge to date concerning the distribution of income as a result of economic growth in the eighteenth century and the imagery of ownership and material wealth. The conversation piece offered – as no other historical document did – the possibility of publicly enumerating material possession to the point of fetishization. It is significant that the genre held sway among the aristocracy while simultaneously extending to fulfil the needs of the gentry. To talk of new classes of society is potentially misleading, but while in terms of absolute income the upper echelons of society preserved their overwhelming share to 1800 and beyond, there was a new group that could begin to equal the lower rungs, and sometimes the middle rungs, of the traditional income distribution.[15] In such a situation 'faithfulness to local colour, occasionally with the effect of making . . . pictures seem like clever combinations of isolated elements'[16] has to be understood as being a matter of more than aesthetic importance.

Zoffany came to England in 1760, a year before Sophia of Mecklenburg-Strelitz arrived to be married to George III, whom she met for the first time the day before her wedding. Thus the conversation piece that Zoffany painted late in 1764 of Queen Charlotte (as she became) and her two eldest sons (pl. 192) was in one sense the consequence of the meeting of aliens of different ranks grafted onto English society by exigencies beyond their control. The coincidence of the German-born artist painting the German-born queen should not be limited to speculation that the artist was selected because he could speak in her own language to a young woman who, on her arrival, knew no English whatsoever. It should also lead us to examine the way in which an English queen and her progeny are visually constructed within a discourse of difference.

The English royal lineage is constructed in Zoffany's conversation piece of Queen Charlotte and her two eldest sons from a mass of imported and gifted goods – forms of cultural annexation. The queen's sons wear fancy dress: a diary entry by the royal governess, Lady Charlotte Finch, records the order and arrival in September 1764 of 'a Telemachus Dress for the Prince of Wales and a Turk's for Prince Frederick'.[17] But these are merely the most spectacular of the forms of masquerade displayed in this image. The sumptuous stuff that masks the toilet-table is 'Superfine Flanders point', the carpet is Turkish, the clock with its figure

of Father Time is French, the gilt toilet service is probably of German origin, laquered Chinese mandarins flank the ornate mirror behind the queen, and through the first-floor window of the queen's dressing-room in Buckingham House a solitary flamingo can be seen elegantly poised on the cut turf (pl. 193). The visual geography extends in time and place from ancient Rome to the English court and from the Far East to the defeated ever-threatening neighbour, France. The apparent informality of the queen as mother entertaining her children and caressing her pet is not an illusion but is supported by a pictorial organization through which otherness is identified only to be assimilated. The British monarchy as rulers of the world (prefiguring the colonial plenitude of the Great Exhibition) and as a proper parent to its children are simultaneously imposed on the viewer's attention. The connotations are clear. The greatness bestowed on the queen by the absent king, father to the son who is heir to the

193. Detail of pl. 192, Zoffany, *Queen Charlotte with her two Eldest Sons.*

The idea of the exotic is sustained in the view of nature.

194 (facing page). Detail of pl. 192, Zoffany, *Queen Charlotte with her two Eldest Sons.*

Laquered Chinese imports, themselves 'realistic' models, are illusionistically re-presented by Zoffany.

throne and to his brother who is next in line, bears with it the gifts of all nations; it also carries the responsibility of taming and containing children and animals, as well as (if by default) Chinese and Turks. The distinction between public and private insisted upon by writers on the conversation piece can here be seen to be untenable; all portraiture is public, and the questions of power that are formulated on the domestic stage are subtly insistent precisely because they are articulated indirectly rather than overtly as they tend to be in the court arena.

Conversation pieces are often thought of as direct, full-frontal, literal kinds of portrayal. In Zoffany's conversation piece everything is oblique, and nothing is as it seems. The queen sits at an angle to the main axis of the painting, her toilet-table with its strong connotations of female ritual (compare the import-ance of Belinda's dressing-table in *The Rape of the Lock*) is placed parallel to the window embrasure, and its mirror offers us a reflected image of the queen's profile, disembodied like the head on an antique gem, an emblem of femininity against which the queen herself must be apprehended as actuality. Her head is flanked by the Chinese laquered figures who also flank a second mirror (pl. 194). In this is reflected the open door of an adjoining room and a rococo overdoor which seems to match the one over the doorway that faces us directly we look at the painting. The visible (rather than reflected) door opens into a suite of rooms where small framed paintings hang upon walls, a bowl of fresh flowers stands by an unshuttered window and the upper part of a maid's body is reflected in a mirror (pl. 195). Here the elaborately patterned Turkish carpet gives way to polished boards and the heavy dark green curtains, one of which darkens the room in which the queen sits, yield to clear unimpeded daylight.

Verisimilitude may demand that some, if not all, of these features are present in Zoffany's portrait. It does not, however, require that the material and cultural plenitude that dominates the queen's dressing-room be counterbalanced by the spatial clarity of the adjoining room on one side and the isolation of a single exotic bird in an ordered garden on the other. These are deliberate choices. Why should the reflected face of a young servant be represented in the adjoining room? Queen Charlotte's reflected profile, her head dressed with pearls, hangs in her dressing-table mirror surmounting a rich display of luxurious artifice (pl. 196); in the next room, unseen by us and by the sitters is a servant, and the reflected profile of her white-capped head surmounts a simple glass vase of fresh flowers. In between – in the shadows – stands Time with his sickle. Military dominance and cultural conquest as well as child-bearing and child-rearing are all subject to time. Far from conveying intimacy, domesticity

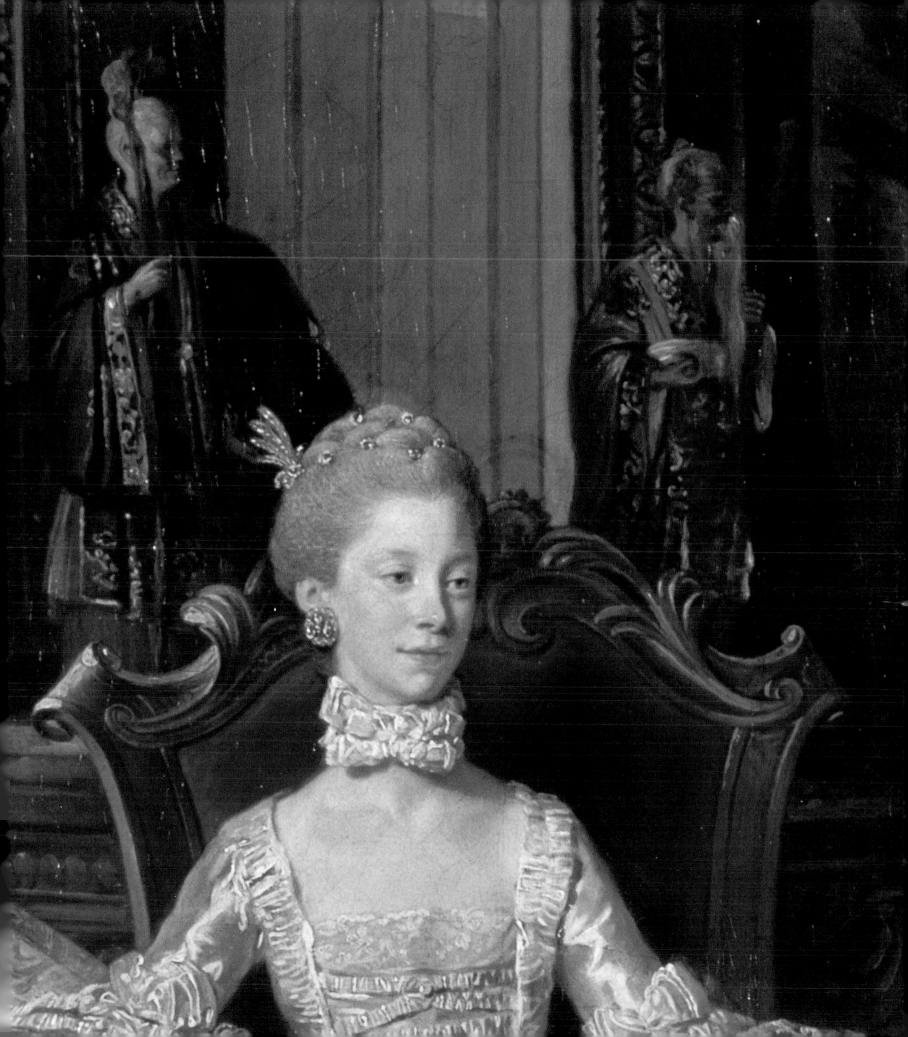

195. Detail of pl. 192, Zoffany, *Queen Charlotte with her two Eldest Sons.*

The reflected image of a maid in a mirror in a distant room suggests this is, perhaps, a home with its largely invisible army of domestic servants; at the same time it unsettles the conviction that reality is where the queen herself is seated.

The iconography of the half-visible overdoor is obscure, but, as it shows a helmeted figure and his companion emerging from the water to be greeted by scantily clad nymphs on a shore, it may represent Ulysses who emerged from the sea and confronted Nausicaa and her maids at a river-mouth (*Odyssey*, Books v–vi). This was the last port of call for Telemachus' father before his journey home.

196 (facing page). Detail of pl. 192, Zoffany, *Queen Charlotte with her two Eldest Sons.*

or individuality as abstract values, Zoffany's conversation piece ruthlessly inscribes the queen as individual into a discourse of military and cultural supremacy in the preservation of which she plays a crucial role as mother of sons. Her position in the narrative of inheritance and succession – as well as the symbolic role she plays as consort to the British monarch – is underscored by the pictorial device of reflective mirror surfaces. Her profile reflection is a reminder that the queen is always more than herself – always reducible, or elevated, to emblem. The mirror guarded by the Chinese mandarins displays the open door through which the major portagonist of the painting, the invisible and absent monarch, may enter. The mirror in the adjoining room reveals the face of an anonymous female servant, a sign of the vast substratum of domestic service upon which the eighteenth-century aristocratic household was predicated. The servant's gender is significant because the queen, for all that she may manifest her fertility, by virtue of her royal connection can never be apprehended as anonymous or merely as a woman.

The accession of George I in 1705 had further enhanced the authority of parliament: the exercise of the royal prerogative was, from that day, limited, and the British monarchy possessed no absolute powers. Royalty could no longer assume its total supremacy. In depicting Queen Charlotte in her dressing-room, Zoffany offers a view of the queen and her offspring in an apparently spontaneous moment and an informal setting appropriate to George III's court and its authority. But this cannot be read without attention to the complex layerings of meaning conveyed by a well-travelled European, an artist sensitive to the nuances of family and constitutional power. Since the conversation piece bears some of the function of the written will, the final word should rest with the chief legatee, the Prince of Wales dressed as Telemachus.

Drum and flag lie abandoned on the chair in the left foregroud while the infant Telemachus, forefinger of his right hand through the dog's collar and still bearing his spear, prepares to greet his mother (pl. 198). Telemachus was the son of Ulysses and Penelope – a nice compliment to the royal couple on the hoped-for fidelity and longevity of their union – whose task was to search for his father after the end of the Trojan wars and to deliver his mother from the importunities of her suitors. Fancy-dress for adults and children was a fashionable pastime at court (the delight in Turqueries discussed in chapter V is apparent here also in the young Prince Frederick's costume). But it is as much a belief in the portrait image as formally constituted safeguard – an exertion of individual will in determining future events despite Father Time and his sickle – that puts the heir to the throne in the role of protecting the interests

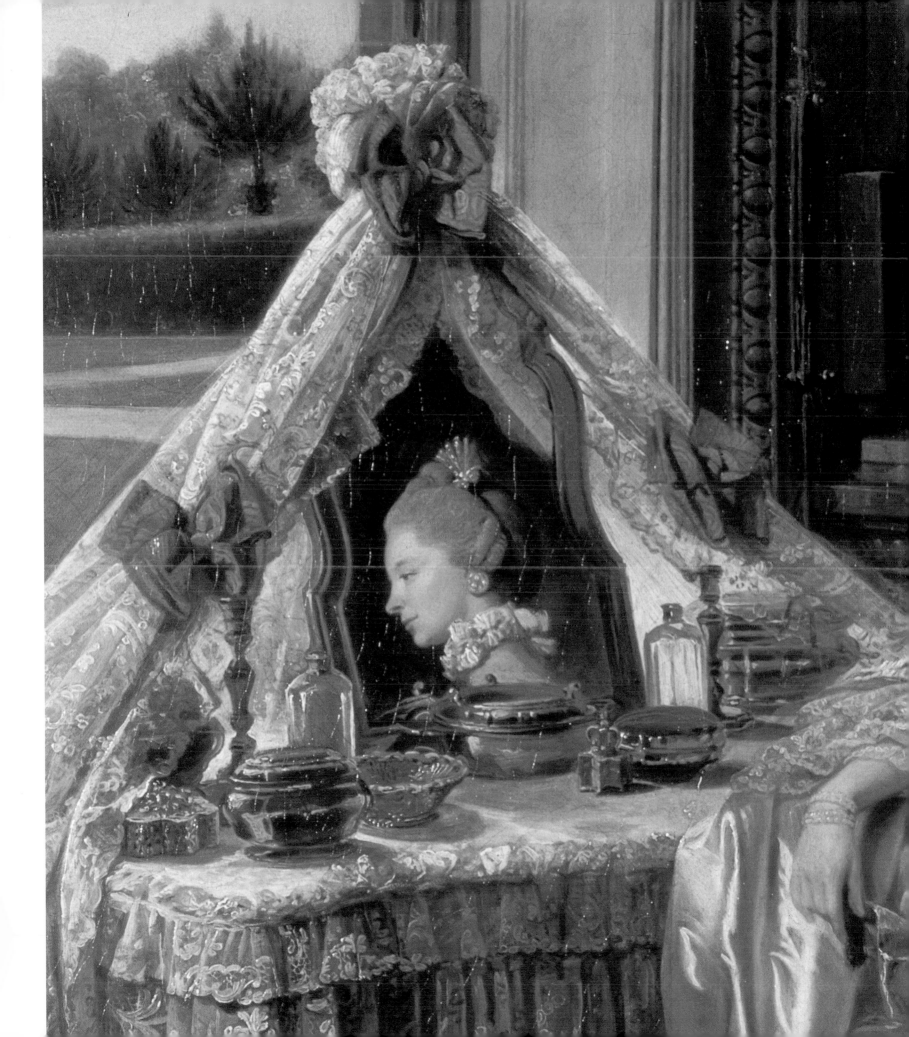

Book. I.

THE

ADVENTURES

OF

TELEMACHUS,

THE

SON OF ULYSSES.

BOOK I.

The ARGUMENT.

Telemachus, led by Minerva under the Shape of Mentor, having suffer'd Shipwreck, lands in the Island of the Goddess Calypso, who was still lamenting the Departure of Ulysses. She gives him a kind Reception, is smitten with Love of him, offers to make him immortal, and desires to know his Adventures. He relates his Voyage to Pylos and

of his father and the chastity of his mother, a matter of no mean importance to the Hanoverian succession and to the future of the nation. The queen's chastity, as the cases of Queen Caroline and of Marie-Antoinette would subsequently prove, was no private question.

Just as Telemachus stood in for his missing father, so the prince represents the absent king. (And contemporary audiences would have fully understood this point.[18]) Similarly, the author of a will is, by the very nature of the event, excluded from the reading of the will. The king who exercises power, and who was directly or indirectly responsible for commissioning the portrait, is also absent from this visual demonstration of the responsibilities, as well as the privileges, of genealogical succession. Just as the will as document writes power and possession into provisions for a future, so the conversation piece inscribes the instructions of the absent monarch for the conduct of his affairs, which are those of family and state inextricably allied.

* * *

A group of portraits reassembled in the National Gallery of Ireland point to the complexity in the interplay of representation in family narratives among the gentry, as opposed to the aristocracy, in the eighteenth century. It is not merely a question of whether a portrait hung in a prominent position in a saloon or whether it was commissioned to complement a particular decorative scheme, important though these things may be. The frequently rebuilt domestic space was a theatre of representation in the eighteenth century in which narratives of family structures are reshaped and sustained. In the case of the pair of portraits of the Congreve family[19] by Philip Reinagle (pls 199, 203), we do not have an 'independent' description or a view of the interior represented by some later watercolourist or photographer. Such representations are themselves in any case informed by codes and conventions and do not offer a true picture against which other images can be measured. They cannot indicate how space was experienced. Nor is the absence of documentation concerning the commissions or the artist's intentions a grave impediment to interpretation. In approaching this image it is important to remember that the

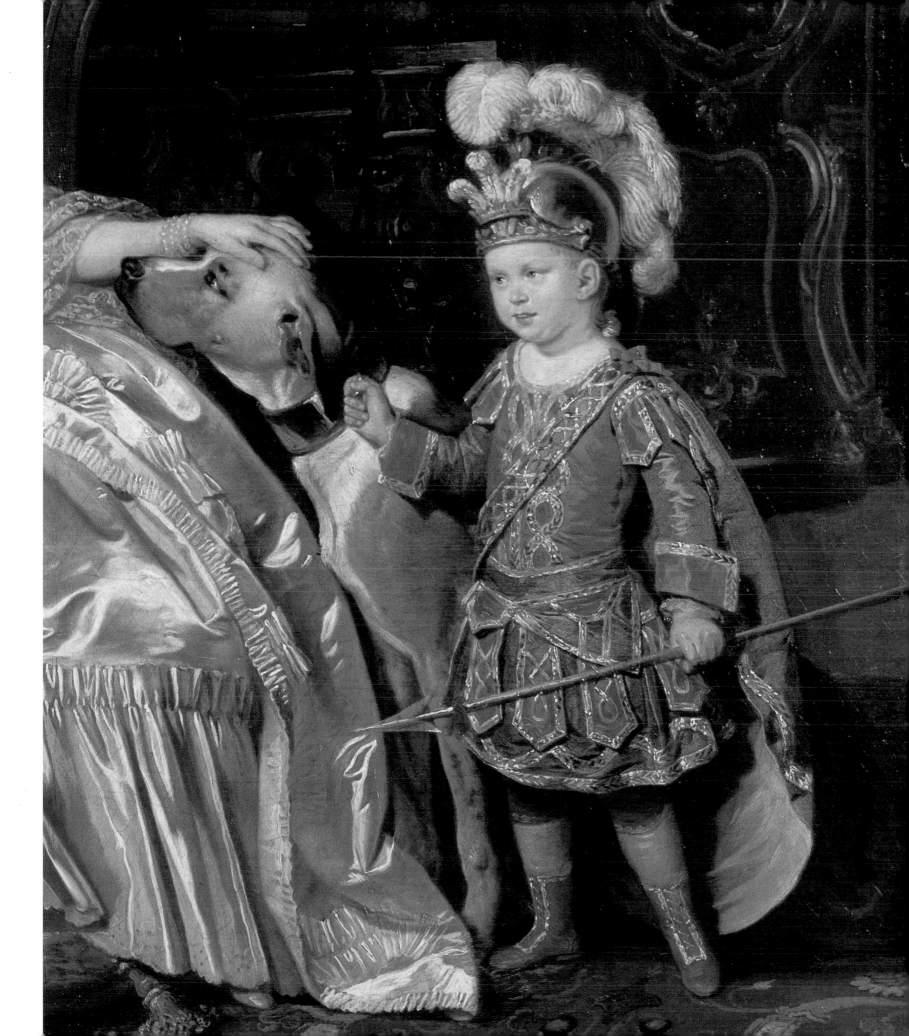

199. Philip Reinagle, *Mrs Congreve with her Children*, oil on canvas, 80.5 × 106 cm., 1782. National Gallery of Ireland, Dublin.

Mrs Congreve's drawing-room is hung with portraits of her husband and his ancestors.

apparently innocent act of portraiture is part of what anthropologists call 'thick description', in which cultural forms find articulation.[20]

Mrs Congreve (née Rebecca Elmstone), wife of Captain William Congreve (1741–1814), is represented seated in the centre of a well-furnished drawing-room close to a work-table placed upon a richly patterned carpet (pl. 199).[21] Her two daughters stand one on either side of her, the elder (Charlotte) holding a book, the younger (Ann Catherine Penelope), a toy squirrel on a string. On Mrs Congreve's knee is seated her youngest child (Thomas Ralph) who reaches to play with a toy mortar on the table next to his mother's embroidery.[22] The location is probably Eastcombe House, half way between Charlton and Greenwich, to which Captain

Congreve moved with his family in 1779. The drawing-room is illuminated from the left, a fire burns in the grate at the right, and the walls are hung with portraits and pier-glasses. Some of the portraits hung in the drawing-room have been identified. Above the fireplace is Kneller's painting of the dramatist William Congreve, ancestor of Captain William Congreve (pl. 200).[23] Richard Congreve, the dramatist's grandfather, was a cavalier named for the Order of the Royal Oak, and his wife was Anne Fitzherbert; their son, also William, was an officer who became agent for the estates of the Earl of Cork which is where the Irish connection commences. On the back wall are hanging, uppermost, three-quarter-length portraits of Councillor Thomas Niccols (born 1596), inscribed 1647, and his wife, Maria, dated

170

1636. They were the great-grandparents of Captain William Congreve. Immediately beneath these two seventeenth-century portraits are depicted Charles Phillips's portraits of Thomas Congreve (1714–39) (right; pl. 202) and Mrs Thomas Congreve (née Anne Handasyde) (left; pl. 201), both painted in 1739, the year of the couple's betrothal, and both now in the National Gallery of Ireland. They represent Captain

William Congreve's grandparents. Each is shown full-length, standing in a landscape, accompanied by a horse and a groom. Considerably larger than these four paintings and hanging centrally between them is a portrait of Captain William Congreve, and his son, William, by Reinagle. This portrait of father and son is also now in the National Gallery in Dublin (pl. 203). Captain Congreve rests his arm on a cannon which has been hauled up an embankment. He and his son are depicted in favourite eighteenth-century poses, as Hugh Belsey has pointed out – the one in that of George I's state portrait by Ramsay (which Reinagle subsequently copied), the other in that of the *Apollo Belvedere*.[24] Behind the captain a group of soldiers is engaged in the process of hauling another cannon from the ditch up onto the high point of the embankment. His son points back to this cannon and looks up to his father as though to pose a question. All this is legible in the representation of this painting which appears in the portrait of the captain's wife and daughters.

On examination, this group of portraits and portraits within portraits demonstrates how misleading the notion of domestic conversation pieces as an unproblematic bourgeois genre can be. The pendant portraits of Captain Congreve and his wife suggest a range of complex solutions to the problems of representing generation and gender within a structure of familial authority. They also indicate that the question of hanging, of spatial arrangement, that is part of the self-presentation of the aristocratic collector extends as an issue of representation to the middle-ranking gentry. Captain William Congreve (later lieutenant-colonel, then major-general and ultimately baronet in 1812) was a distinguished

200. Sir Godfrey Kneller, *William Congreve*, oil on canvas, 91.4 × 71.1 cm., 1709. National Portrait Gallery, London.

This portrait of the celebrated dramatist, ancestor of Sir William Congreve, was painted for the Kit-cat Club.

201. Charles Phillips, *Mrs Thomas Congreve*, 47.0 × 59.7 cm., 1739. National Gallery of Ireland, Dublin.

This pair of pendant portraits (pls 201 and 202), executed for the couple's bethrothal, provide an interesting contrast with later fashions in family portraiture as exemplified in plate 199.

202. Charles Phillips, *Thomas Congreve*, oil on canvas, 47.0 × 59.7 cm., 1739. National Gallery of Ireland, Dublin.

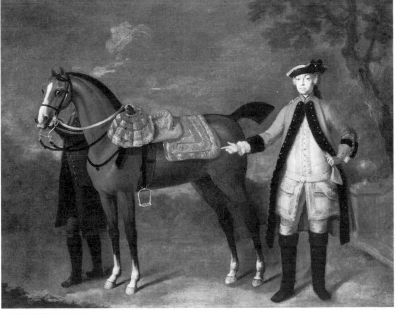

specialist in artillery, organizer of an instruction school at Woolwich called the Royal Military Repository, and Controller of the Royal Laboratory. The portrait of him and his son has been dated to late 1782/early 1783 from a number of internal clues. Congreve invented the block trail for gun carriages in 1792, and these do not appear in the painting. His uniform can be dated prior to October 1782 when lace was discarded from the coat and the red lining gave place to white. Congreve was not promoted to major before March 1783. His son was born in 1772 (and, as an adult, achieved considerable fame as the inventor of a rocket). A date of around 1782, at which time the boy would be ten, seems to be correct for this painting and, since the two are so closely thematically connected, also for the pendant.

If we take the portrait of Captain Congreve and its pendant portrait of Mrs Congreve as a repository of images, the ensemble offers a fascinating history of the development of style and composition in Anglo-Irish portraiture from the first half of the seventeenth century to the late eighteenth century. Particularly noticeable is the way in which, in the case of Captain William Congreve and his wife, narrative portraiture has replaced the pairs of marriage portraits of previous generations and the Kit-cat Club portrait of the playwright. Moreover, the location for family portraiture is no longer a long gallery but a family drawing-room; the subjects of this genealogical filiation are landed gentry rather aristocracy. These changes also signal the enhanced social function of portraiture as a mechanism in the discourse of cultural politics.

Mrs Congreve and her children occupy a stage-like space, a deliberately constructed box. They are overseen by the portrait of Captain Congreve and his son, absent father and brother/son. For which audience do the female members of the house pose against a background of patrilinear ancestry? They pose bearing signifiers of informality (toys, needlework, etc.) in a structure that is none the less formal because it is so strictly controlled. The absent father, whose authority has not only provided the material wealth manifest in the clothes worn by the females and in the things around them, but also commanded the painting to be executed (just as he must have commanded the cannon to be raised), is present in the painting of his wife and daughters at the level of representation (his portrait on the wall). His absence is confirmed (and consequently his existence affirmed) in what the viewer is invited to understand as actuality by the empty chair drawn up by the fire and by the presence of his bicorne hat and his sword. The one lies on the table at the left and the other rests in the angle of the table and the wall. Furthermore, his profession and the mark of his distinction in that profession is emblematized in the toy cannon with which the youngest child is playing.

Reinagle's portrait of Mrs Congreve and her daughters – the maternal and female line – embodies through the portrait paintings represented within it a narrative of the name of Congreve, the line of descent to the continuation of which woman is essential but within which she is subsumed. Hence, through the mechanism of representation (pictures on walls) and through signifiers of masculinity (swords and empty chairs) Mrs Congreve occupies a space that is at one and the same time central and utterly marginal. The painting is not in any serious sense about her and her daughters; it is about the continuation of the male line and the maintenance of the estate and property within which she is posed and to which she is a decorative accretion. The superficial informality of a portrait like this no more threatens the structure of control that it replicates and in which it plays a symbolic function than the notion of the companionate marriage affected the legal status or the conditions of life for married women in Britain in the eighteenth century.[25] At the same time, given the presence of an unbreeched boy child on Mrs Congreve's knee, both the pendant formula and the compositional organization that separate the family into two groups serve to emphasize the gulf not only between masculinity and femininity but also between ungendered infancy and gendered youth.

The portrait of Mrs Congreve and her children sets into play, therefore, a series of binary oppositions through which the family is culturally positioned as central, as the pivot around which these oppositions turn. This is one of portraiture's functions: to enable the psychic and mythic security of family status and continuity to be sustained. Thus Captain Congreve and his son are outside, the wife and children inside; he is concerned with matters of war, she with peaceful pursuits; he with protection of the realm, she with embroidery and child-rearing. But most interestingly these familiar sets of gender-determined binaries that so commonly underlie representation are here extended into the field of representation since she is present and he is absent, she apparently 'real' and he apparently illusory. This seeming threat to the balance of power is, however, instantly counteracted when we take into account the role of representation in the narrative of this image. Portraiture is here construed *as* representation; the painting of Mrs Congreve foregrounds the act of portrayal for we are invited to experience the room in which Mrs Congreve and her children are posed as 'real' in relation firstly to the absent husband, secondly to the husband as represented, and thirdly to the forebears as represented. The stylistic distinctions of the various sets of portraits serve to reinforce the sense

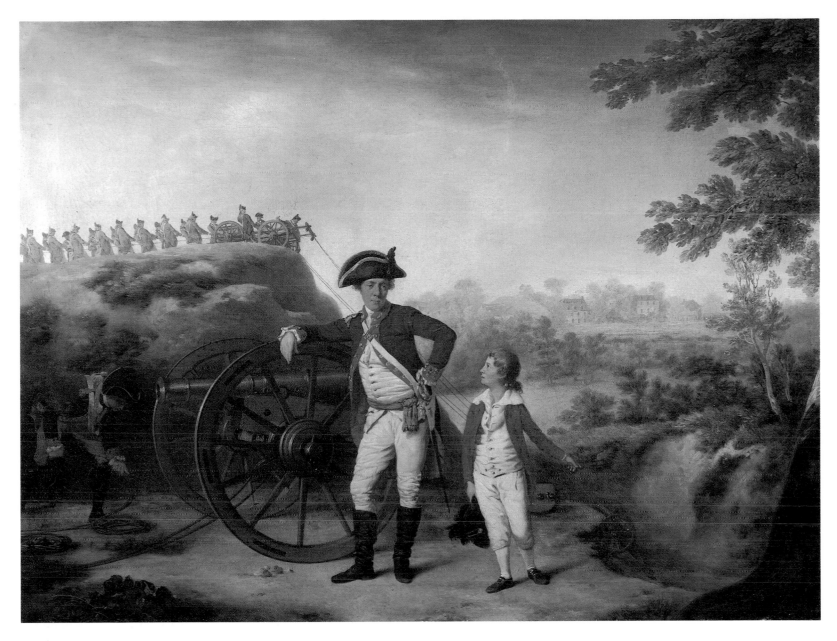

that the last in the chain, with its expensive carpet and its glistening silk dresses, offers unmediated and superior reality.

But what of Captain Congreve's apparent marginalization? If the captain is present by virtue of his portrait in the portrait, then he exists by virtue of an ostensible act of representation. Therefore the presence of his personal property (his sword by the table and his bicorne upon it) and his empty chair by the fire insist upon a different kind of space outside the space of representation. In other words, the captain's sword, which we know to be represented (i.e., a painted object) we must simultaneously believe to be real, because it appears in a space that also contains an image of that sword as worn by the captain. The absent captain thus stands at the centre and controls unseen the unfolding narrative. The illusion here involves both re-presenting a real person in pictorial form and re-presenting the family generation by generation as each generation replicates the earlier one, thus continuing the chain uninterrupted to the present. Captain Congreve controls it by means of his portrait – which we know is *not* him because we see his sword and his empty chair – and by the fact that his wife and daughters appear in realistically defined space in the present (a present that will become the past only when the absent father re-enters). The captain's implied presence/absence both confirms and denies the illusory nature of portraiture as likeness, as mimesis.

203. Philip Reinagle, *Captain William Congreve with his Son*, oil on canvas, 81 × 106 cm., 1782, National Gallery of Ireland, Dublin.

Captain Congreve was a specialist in artillery; in this portrait, which is represented within the portrait of his wife and other children (pl. 199), his accomplishments and authority – both paternal and military – are stressed.

204. Philip Hussey, *An Interior with Members of a Family*, oil on canvas, 62 × 76 cm., *c.*1780, National Gallery of Ireland, Dublin.

No portraits distract attention from the luxurious and expensive painted wallpaper in this interior; only a pier-glass reflects the elaborate pattern of architectural motifs.

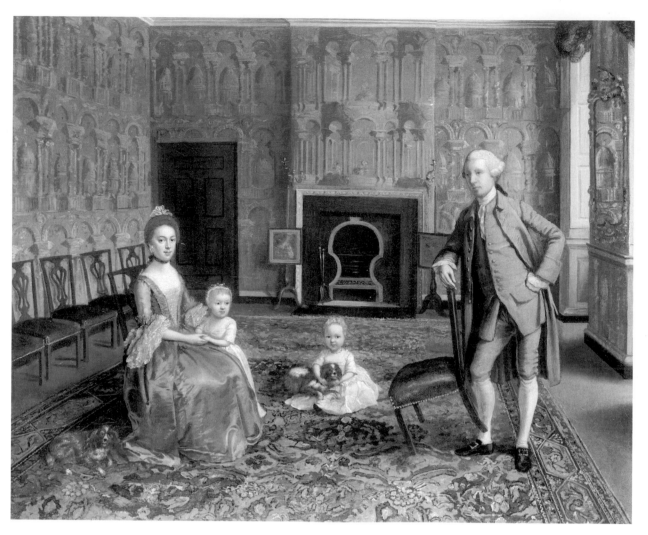

If he were to be himself represented in the painting this would confirm the portrait as mere painting, no more nor less than representation. The dimension of the 'real' outside the room would then be forfeited.

* * *

The notion of the conversation piece – whether the subjects are royalty or gentry – as a form of quasi-legal genealogical statement goes some way towards accounting for its widespread popularity in Europe (and particularly in France and Germany) at a time when ancient common laws of inheritance – laws that had been virtually unchallenged since feudalism – were being eroded by mercantilist aspirations and by contestation in the courts. The issue of the legal construction of a technically flawed will which arose in the 1760s led to a major and extended debate upon the relative merits of ancient feudal policy and the requirements of contemporary society, particularly with regard to the alienation of property.[26] The

law regarding property (that is, landed property) was distinct from that regarding real estate or moveables.[27] While the genre of landscape pertains to property, the conversation piece allowed for the advertisement of the importance of real estate and chattels.

In the *Progress* engravings, Hogarth's spectacular exposure of the ruthless exploitation of the marriage contract as a means of material gain articulates popular anxiety about the unreliability of orthodox methods of securing a succession. In conversation pieces, one of the principles at work is iconographic conservatism. The imaging of interiors with particular portraits and other decorative accessories have the effect of ordering and temporally fixing the material world, stressing the permanence of objects. While art historians may wish to see the conversation piece as introducing a new form of sentiment and informality into portraiture, the dependence of these images on material detail – and particularly on portraits – is noticeably at odds with what dominant contemporary tastes dictated. Reinagle's portrait of

Mrs Congreve and her children suggests that historic portraits were appreciated in the late eighteenth century; indeed, it suggests that they were essential to the articulation of family continuity. Such appreciation was by no means universal. Walpole expressed the view that it was 'almost as necessary that the representations of men should perish and quit the scene to their successors, as that the human race should give place to rising generations',[28] and Reynolds, when asked how it was that the portraits of celebrated people painted by Jervas, Hudson and others were no longer to be seen, is said to have replied, 'because, madam, they are all up in the garrets'.[29] Their places were filled by fashionable wall-paper, as the Earl of Fife noticed in 1798:

It is surprising how often curious old portraits are found in places where nobody almost would ever think of looking for them. They are found thrown out of many houses for lumber, the name of the Artist, and Person represented, being unknown; or are sold to pay debts, or to make way for the modern fashion of papering rooms [pl. 204]. I know many houses, where very fine Portraits are put up to garrets, and neglected, while their places are supplied with an eight-penny paper.[30]

Papering over genealogy was one way of being modern. But genealogical preoccupations produced other manifestations, including the focus on the child as subject, which is the topic of the next chapter.

VII THE STATE OF A CHILD

i *Infancy, Femininity and the Child-Portrait in Romney and Reynolds*

All that are born into the world being surrounded with bodies that perpetually and diversely affect them; variety of ideas, whether care be taken of it or no, are imprinted on the minds of children.[1]

Work by social and economic historians investigating demographic trends and regional histories has offered comparative views of family structures and practices in early modern Europe.[2] But children, by and large, are spoken for: declarations are made, by adults, on their behalfs. The problems of gaining an historical understanding of the state we now know as child-hood have been highlighted by discussions following the publication of Aries' *Centuries of Childhood* in 1972. Attention has been drawn to the difficulties of extrapolating general conclusions from widely divergent forms of local evidence and to the dangers of interpreting rhetorical forms as the transparent expressions of sentiment.[3] At the same time, the problems of dealing with visual evidence have begun to be recognized and its immensely seductive qualities for historians acknowledged.

This chapter does not add to this steadily growing literature whose aim is to chart the replacement of the putto by the little perisher – to use Schama's phrase[4] – and the substitution in England in the eighteenth century of a child-centred ideology for a genealogical one. The framework for this chapter is the recognition of the child-portrait in the eighteenth and nineteenth centuries as being crucially different in social function from that of the previous two centuries. Holbein's *Edward VI as a Child* (pl. 206) belongs to a different world from Hogarth's *The Graham Children* (pl. 207). The shift from a dynastic culture to one characterized by bourgeois values has left its mark on such objects just as the production and valuation of those objects has contributed to the effecting of these changes. Portraiture is a highly conservative art form, and the model of Rubens and Van Dyck – as writers on art continually insist – was as important in the construction of an eighteenth- and nineteenth-century portrait imagery (pls 208, 209, 210) as the admittedly significant changes in the view of the relative conditions of childhood

and adulthood. The problem that must be addressed concerns the interstices between the survival of artistic convention and the known changes in the perception of children's particular condition. This chapter is, therefore, concerned with the close reading of a group of texts; by working from the inside out it is possible to consider questions of signification that are largely overlooked in an anxiety to chart large patterns of historical change.

Portraits of children in this period share with portraits of women the dubious distinction of being categorized as a sub-genre or a special case. Children are understood to be simple, uncomplicated subjects to which our common humanity gives us ready access. Empathy takes the place of analysis, and common sense is the most frequently invoked strategy. Reynolds's portraits of children were recently described as 'captivating not only because of their spirited and mischievous expressions, but also because of the seriousness which Reynolds respected in children'. Nicholas Penny moves into the present tense to write of the children in Reynolds's *The Marlborough Family* (pl. 122): 'here dogs (two of them are Blenheim spaniels) and the youngest members of the family, excited, teasing but also frightened, contrast with the exalted but careful air of the mother and the oldest daughter, and also with the serious manner in which the Duke examines his son'.[5] This commentary works to convey an air of naturalness and transparent authenticity, establishing the impression of a timeless actuality transmitted to us as indisputable fact rather than interpretation.

Writing like this insidiously undermines our awareness not only that painting is artifice (a fact that this author recognizes elsewhere in the same essay), but also that 'family' and 'childhood' are culturally and historically specific notions. A family is no more a static and apprehendable entity than is childhood itself.[6] And youth, we have learned, at least in pre-industrial Europe, was a very long transition period lasting from the point at which a young child became somewhat independent of its family at around seven or eight to the point of complete independence at marriage.[7] Ideological concepts such as 'adult',

205. Detail of pl. 207, Hogarth, *The Graham Children*.

206. Hans Holbein the Younger, *Edward VI as a Child*, oil on wood, 56.8 × 44.1 cm., 1538. National Gallery of Art, Washington, D.C., Andrew W. Mellon Collection.

The inscription reads in translation:

> Little one, emulate thy
> father and be heir of
> his virtue;
> the world contains
> nothing greater.
> heaven and earth could
> scarcely produce a son
> whose glory
> would surpass that of
> such a father.
> Do but equal the deeds
> of thy parent and men
> can ask
> no more. Shouldst thou
> surpass him,
> Thou has outstript all
> kings the world has
> revered in ages past.

Independent portraits of children (without their parents) are relatively rare in the sixteenth century. There is a special reason for the portrayal of this child, as the verses make clear. A portrait of an heir to the throne would always be likely to be invested with dynastic meanings – the child being in this instance more than an individual infant.

207 (facing page). William Hogarth, *The Graham Children*, oil on canvas 161.5 × 181 cm., 1742. Trustees of the National Gallery, London.

These children are not royal – they are the children of Daniel Graham, apothecary to Chelsea Hospital – and therefore some difference of treatment would be expected in comparison with the portrayal of a royal child. But portraits of children of this class, treated with this degree of informality, evince an interest in the state of the child that is unique to the eighteenth century.

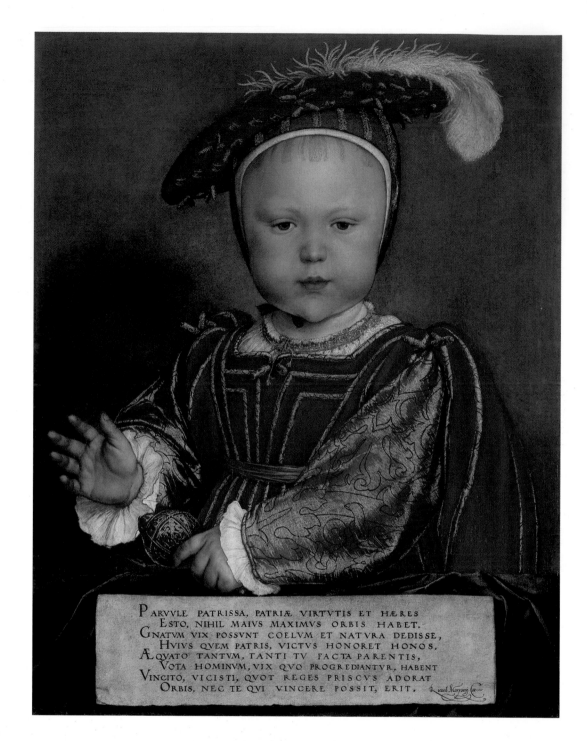

PARVVLE PATRISSA, PATRIÆ VIRTVTIS ET HÆRES
 ESTO, NIHIL MAIVS MAXIMVS ORBIS HABET.
GNATVM VIX POSSVNT COELVM ET NATVRA DEDISSE,
 HVIVS QVEM PATRIS, VICTVS HONORET HONOS.
ÆQVATO TANTVM, TANTI TV FACTA PARENTIS,
 VOTA HOMINVM, VIX QVO PROGREDIANTVR, HABENT
VINCITO, VICISTI, QVOT REGES PRISCVS ADORAT
 ORBIS, NEC TE QVI VINCERE POSSIT, ERIT.

'youth', 'child', 'infant' and 'family', which are never secure in prescribed and uniformly observed boundaries, determine the pictorial construction of members of families and individual children. As Ludmilla Jordanova has pointed out, '"Childhood" is an abstraction, a concept of such generality that it is hard to imagine how any object could embody it except by a device like personification.'[8] Yet it is frequently invoked as a universal quality, as though there were a concensus as to what childhood pan-

historically might mean. Children as depicted are always there for ulterior reasons, whether the intention appears to be that of portraiture, or of what are generally known as fancy or genre paintings (which are, indeed, often personifications). Children do not commission portraits, and their presence in them is the result of negotiated relationships in the adult world designed, consciously and unconsciously, to produce a set of explicit and implicit meanings.

178

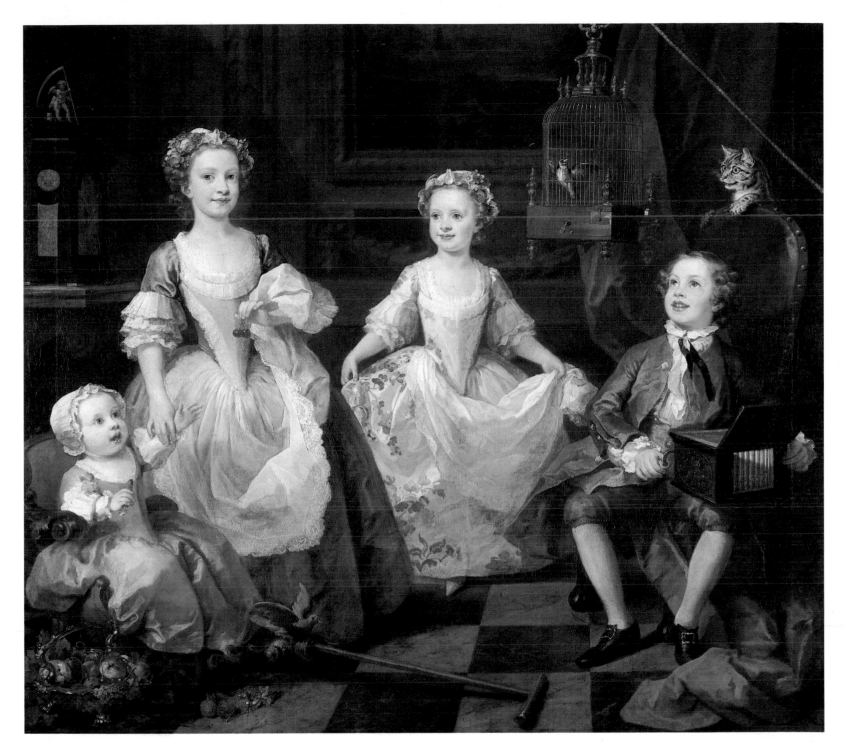

The message of emblems is often conveyed by active, playing children (putti).[9] That Cupid is the most famous child apart from Christ, the child enacting western culture's most intense phantasies from Eros to Agape, suggests moreover that the child possesses a particularly powerful connotative capacity in narrative and myth. The childrens' illustrated books that Newbery, Marshall and others began to publish after the middle of the eighteenth century drew on moralizing and allegorizing visual traditions which represented children without necessarily addressing them (pl. 211). Children – relatives of the putti of Antiquity – were used frequently until the middle of the nineteenth century to represent the various arts and the different mechanical skills required to master those arts (pl. 212).[10] On account of the centrality of the child to traditions of moral narrative, it was extremely easy for portraits of

208. Peter Paul Rubens, *The Chapeau de Paille (Portrait of Susanna Lunden)*, oil on oak, 79 × 54. Trustees of the National Gallery, London.

Portraits by Rubens and Rembrandt were quoted throughout the eighteenth century. No engravings are recorded of this work before 1818, but the painting was well known: Reynolds saw it in 1781 and Elizabeth Vigée Lebrun modelled a self-portrait on Rubens's composition.

210 (far right). Angelica Kauffmann, *Thomas Noel Hill, 2nd Lord Berwick*, oil on canvas, 219 × 143 cm., 1793. National Trust: Attingham Park.

The young Lord Berwick's portrait was painted in Rome, but he is represented as a melancholy cavalier of the Stuart era.

209. Joseph Wright of Derby, *Anne Hanway (née Stowe)*, oil on canvas, 76.4 × 62.8 cm., *c*.1760. courtesy of Christie's (22 November 1985 (115)).

Mrs Hanway exemplifies the fashionable Rubensian look of the 1760s that is found also in portraits by, for example, Thomas Hudson (*Mary, Duchess of Ancaster*, Huntington Library).

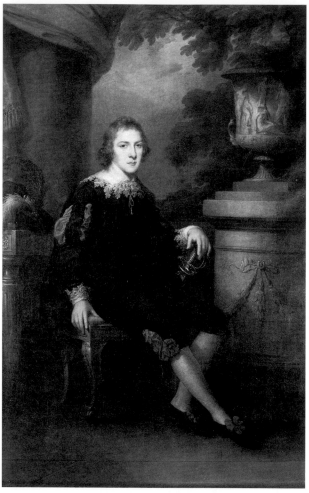

children to become bearers of the values society held most dear while still denoting the particular offspring of particular parents.

While the child in a portrait may connote simplicity and clarity, the signifying act through which a twentieth-century viewer apprehends these qualities is neither simple nor clear. One of the few scholars to have addressed the child-portrait is Edgar Wind. He drew a contrast between Gainsborough as a natural painter and Reynolds as a painter of ideas; while this contrast is hard in itself to sustain,[11] in his discussion of the latter's work, Wind invokes Shaftesbury's theory of the pregnant moment and Burke's concern with obscurity and mystery as a necessary condition of the sublime in order to explain the affective nature of portraits like *Master Crewe as Henry VIII* (pl. 213). The contrast between infancy and maturity is used as a means of raising the subject to heroic status and introducing a note of mystery. But in consequence these works, it is argued, cease to be portraits and become 'depictions of a legendary childhood, freely invented, *ex post facto*, as it were, in celebration of a

famous man'.[12] In Reynolds's portraits of girls, Wind finds the same principle at work with an 'interplay between the two stages of the subject's life, in which the condition of the grown-up person is projected back into the mind of the child whose pose and expression prophetically, as it were, hint at her future situation'.[13] Thus *The Age of Innocence* (pl. 214) is seen to function by making viewers think of 'maidenhood threatened and preserved', reminders or anticipations of a stage of life not actually shown in the picture and only indirectly attributable to the child. Because such a theory seems in conflict with the notion that a portrait represents a particular individual at a particular moment, Wind goes on to state that the line is not clear in Reynolds's child-portraits between metaphorical portraiture and genre proper; the names of the child sitters were noted by contemporaries even when the paintings were exhibited with genre titles. *The Age of Innocence* was, for example, thought to be a portrait of the artist's favourite niece.[14] One might add that the inter-changeability was even more far-reaching. The child was recognized (and was meant to be so) in the genre paintings while, in the case of a portrait known as *The Little Marchioness*, the subject was mistaken on at least one occasion for a beggar-girl.[15]

Wind is correct to suggest that the qualities connoted by Reynolds's child-portraits are not to be understood as attributes of the actual child. But by locating the issues of sexuality and chastity in a narrative of the individual life, he fails to recognize that these issues signified for a contemporary audience (and hence made Reynolds highly successful) not because they complimented individual sitters (or their parents), or because they contributed to a tradition for the representation of heroes, but because they highlighted questions that were of profound political importance, questions that were related to society's ability to maintain its patriarchal ordering function. As Locke had said,

the first society was between man and wife, which gave beginning to that between parents and chil-dren; to which, in time, that between master and servant came to be added; and though all these might, and commonly did meet together, and make up but one family, wherein the master or mistress of it had some sort of rule proper to a family; each of these, or all together, came short of political society, as we shall see, if we consider the different ends, ties, and bounds of each of these.[16]

The notion of a concatenation between God, father, family, children, servants, all of them part of society and yet society not being contained by them – and the implications of this notion for rule and good government both personal and national – binds the representation of any child into an economy that is

FRONTISPIECE.

Instruction
in the Use of Colours.

London, Pub. Sep.5.1788, by C Taylor N°30 near Castle Street, Holborn.

always greater than either its own particular existence or any set of visual conventions, however much these may be mobilized to make the necessary thematic connections.

In an acute observation, Wind remarked that Reynolds's *Angels' Heads* (pl. 215) could be read as portraits of a single child, in the manner of the three heads of Charles I by Van Dyck, and that Reynolds added to the repertoire of symbolic characterization by introducing playful physiognomic resemblances. Boys are likened to heroes and gods, girls to angels or kittens. Moreover, he found it remarkable that 'just when eighteenth-century English portraiture revived the allegorical and historical portrait to compete with the late Dutch and French tradition, it limited the type to pictures of women'.[17] He offered no explanation for this phenomenon. The elision between portraiture and genre or fancy painting – as well as what Wind thought of as the exclusive application of allegory to female (and child-) portraits – is, however, explicable if Wind's hermeneutic method is taken further; this method was adopted when he realized that it was a con-tradiction between iconographical elements in the image and the sets of associations that contextually these set in train that produced meanings for an eighteenth-century audience. The girl sitter is, pre-sumably, as innocent as ideology in the latter part of the eighteenth century (in contrast to the seventeenth-century stress on original sin) insisted she should be. But what makes paintings of young girls exciting and

211. Frontispiece to *Fables in Monosyllables by Mrs. Teachwell, to which are added Morals in Dialogues between a Mother and Children*, London: John Marshall, 1787. Courtesy of the Board of Trustees of the Victoria and Albert Museum, London.

212. *Instruction in the Use of Colours*, illustration to *The Artist's Repository and Drawing Magazine*, c.1788, vol. 4.

This instruction manual is illustrated by personifications of praxis who are either female or child. According to the accompanying text this represents, 'DESIGN (holding his port-folio, with a drawing of Apollo Pythias, and his port-crayon) in conversation with COLOURING (who is composing various tints on his palette)'.

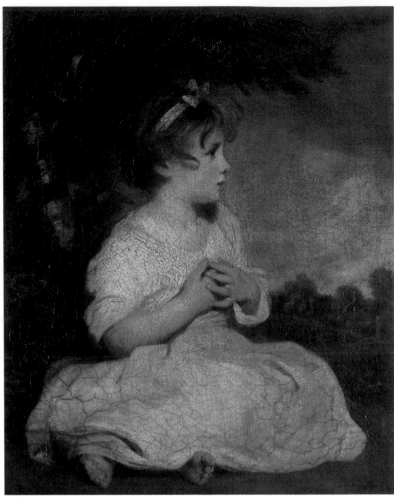

213. Sir Joshua Reynolds, *Master Crewe as Henry VIII*, oil on canvas, 139.7 × 110.5 cm., 1776. Private collection.

Master Crewe wears a costume popular in eighteenth-century masquerades, and it has been pointed out that Reynolds's source was probably Thomas Jefferys's *A Collection of the Dresses of Different Nations, Antient and Modern, particularly after the Designs of Holbein, Vandyke, Hollar and others*, 1757 and 1772.

214. Sir Joshua Reynolds, *The Age of Innocence*, oil on canvas, 76.4 × 63.5 cm., 1788. Tate Gallery, London.

visually significant is the contrast between that presumed innocence and something that is not shown and that might generally be understood to endanger it. This chapter addresses itself particularly to portrait/genre paintings that deal with young female subjects in relation to these dangers real and phantasized.

Because of the tendency to view Reynolds as an outstanding (international) exception to the general run of British eighteenth-century portrait painters, it is useful to look first at a late eighteenth-century portrait of a female child by George Romney. The temptation to see portraits of children as though they are actual children with whose childish qualities we, as viewers, empathize across the centuries, must first be set aside. Like many of her 'brothers' and 'sisters', Miss Juliana Willoughby (pl. 216) is posed alone in open and somewhat wild countryside under a stormy sky. She wears a straw hat and a short-sleeved dress and is painted in that combination of pinks, blues and whites laid in broad, flat areas that Romney invented so successfully for the depiction of women and children. Literally speaking, that a child of this class

should have been permitted, unsupervised by an adult and unprotected from the elements, to wander in hilly open countryside and, by implication, to encounter strangers (the artist/the spectator) is unthinkable. Though we know, of course, that such portraits were painted in studios with the landscape background added by studio assistants, we need to remind ourselves of the fiction that the ensemble sets out to produce. Equally untenable as a reflected image of actuality is the pubescent Sarah Barrett Moulton in her flimsy gown on a remote hillside (pl. 236) in an age when, as Fanny Burney's exemplary paternal figure – the Rev Mr Villars – euphemistically puts it, 'nothing is so delicate as the reputation of a woman: it is, at once, the most beautiful and the most brittle of all human things'.[18]

The answer to the questions raised by child-portraits does not lie in an ever more assiduous contextualization. Knowledge of the lives of sitters, their income, their station, their expectations, their future careers and their marriages along with information on frames, sittings, preparatory drawings and related imagery can throw up interesting infor-

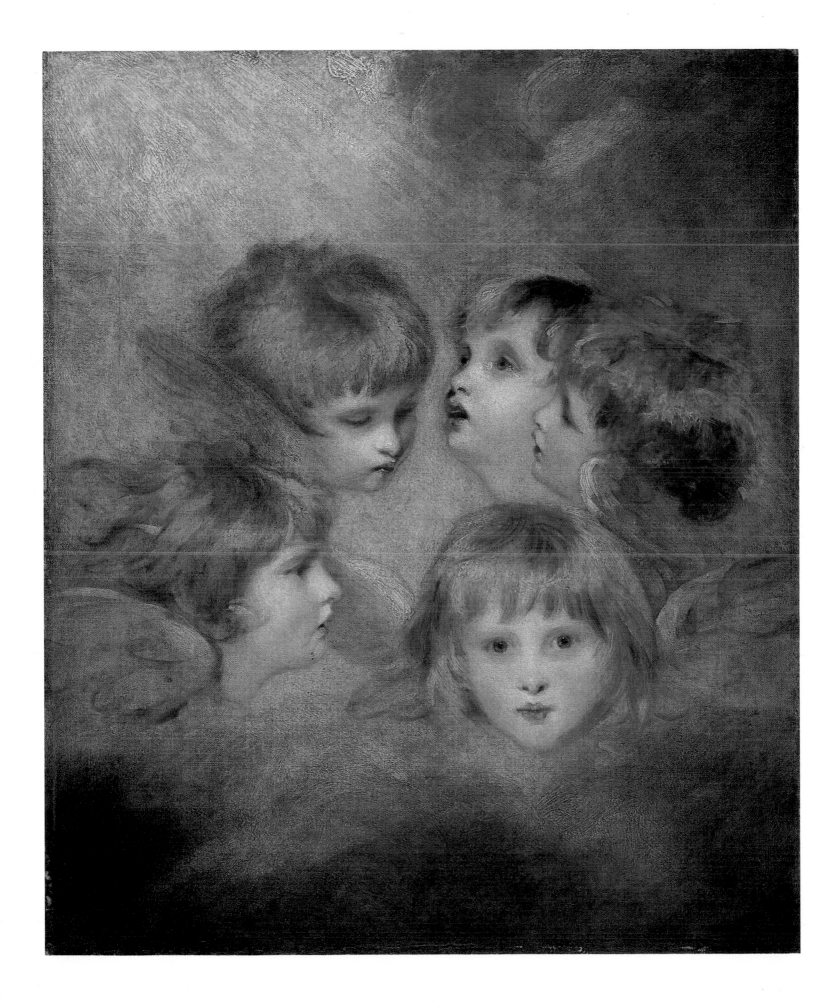

mation, but the context is no more transparent than the text and cannot be invoked as referential purity. The complex communicative act can be obliterated by the enumeration of empirical data, the organization of which is intended to demonstrate that things are, indeed, what they seem to be. Interpretation – and readings are always accompanied by an attitude to interpretation – is the single way by which we might begin to understand the complete annexation of childish 'innocence' by adults (children as angels as well as beggars, as historical personages and as adults), bearing in mind that representations of this kind constitute a mode in which adults have imaginatively recreated and rearticulated the world.

Portrait painting, like consultations with doctors or lawyers, involves a relationship of unequal parties in a contention for power. The distribution of power in this relationship is determined by questions of money, status and need; the painter may be more powerful than the sitter by virtue of reputation, or the opposite may be the case. The power may shift in the course of the sitting as a result of the dynamics of inter-personal relations, or the intervention of external events, or the effectiveness of the environment constructed by the artist (or in the case of exceptional subjects, like royalty, by the sitter). This relationship of power is further influenced by gender and age. In this relationship, women are a special instance and children are a separate yet related case. To understand the case of the child sitter it is important for historical and theoretical reasons to understand the case of the female sitter.

Art historians have been reluctant to explore the possibility that for a male portraitist to paint a female sitter, in a period when virtually no respectable woman had any degree of independence, is to work in different conditions from those prevailing with a sitter of the same sex.[19] These conditions, created by diverse factors,[20] empower the male artist; yet writers have shown reluctance to move beyond merely defining portraits of women, like portraits of children, as a special category. Wind, with some justification, noticed that the allegorizing structures that operated in portraits of women and children in the eighteenth century did not seem to extend to portraits of men.[21] But more generally impressionistic statements, with no foundation in empirical or theoretical thinking, are used implicitly to define female portraiture as generically different from (and often by implication inferior to) male portraiture. 'In general women's portraits show less character than men's portraits', we are told.[22] Giorgione's male portraits, it is said, are an accurate record of the individual for posterity, whereas with his female sitters it is more difficult to decide how much is *paragone*, or ideal model of ugliness or beauty.[23] Portraiture is understood 'to widen our under-

standing of man in general', meaning more particularly, either 'distinguished traits that are common to members of a discrete group or that belong trans-historically and transculturally to members of widely differing social groups or social, political, and psychological relationships that are also either group-specific or group-transcendent'.[24] These sorts of definitions, like the assumptions of lack of character and individuality cited above, replicate the power-lessness of woman whose sex excludes her from those social and political groups.

The ambivalence that commentators feel before portraits of women has long antecedents in the critical literature, is not confined to any one European nation and is, perhaps, endemic. A reviewer of the 1784 Salon complained that representing society women as chaste vestal virgins (when by definition they were not) corrupted the essence of things,[25] while Flaxman is reported to have said of Romney's portraits: 'the male were decided and grand, the female lovely'.[26] The implication is again that portraits of women are unquantifiable and dangerously prone to disrupt the natural order. Women have been disenfranchised in discussions of portraiture by an unconscious use of controlling language. While some writers, like Michael Levey, indulge in flights of rhetoric to establish the artist's power to capture the femininity of the subject (of all subjects?),[27] statements such as, 'the sensuality is less fleeting and as robust and wholesome as a gaudy piece of cake' (on Ghezzi's *Portrait of a Lady as a Shepherdess*)[28] or 'it seems there is nothing to exceed the plasticity of man except of course the plasticity of woman',[29] manifest a profound suspicion (and hostility?) towards female portrait subjects.

Through formulations such as these, historians and critics have evaded addressing the question of power relations, the issue of the fissure opened up by gender and by age in portraiture in the early modern period. Women were infantilized both in practice and in theory, and portraiture of women and children is one of the disciplines where representation, linking theory and practice, establishes the analogous relationship that equates femininity and childhood. When John Burnet, writing in 1850 but looking back with undisguised adulation to the age of Reynolds, says, 'the ruddy, wet character of a child's mouth after taking its food, is very characteristic and beautiful (pl. 217); so, likewise is the roseate hue of a young female, where we see combined the health and innocence of childhood'[30] (pls 218, 219), he is reinscribing a visual (and sexual) construction of femininity as infantile. This looks back to the identification of virtuous femininity (the *only* femininity in a scheme of things in which loss of virtue is loss of what is truly feminine) with what is perpetually fearful, in danger and essentially childlike, as exemp-

215 (previous page). Sir Joshua Reynolds, *A Child's portrait in different views: 'Angels' Heads'*, oil on canvas, 74.7 × 62.9 cm., 1786–7. Tate Gallery, London.

Just as *The Age of Innocence* (pl. 214) was reported to be a 'portrait' of a particular child, so this representation of angels' heads demonstrates the elision between portraiture and fantasy in relation to the child subject.

216. George Romney, *Miss Juliana Willoughby*, oil on canvas, 92.1 × 71.5 cm., 1781–3. National Gallery of Art, Washington, D.C., Andrew W. Mellon Collection.

184

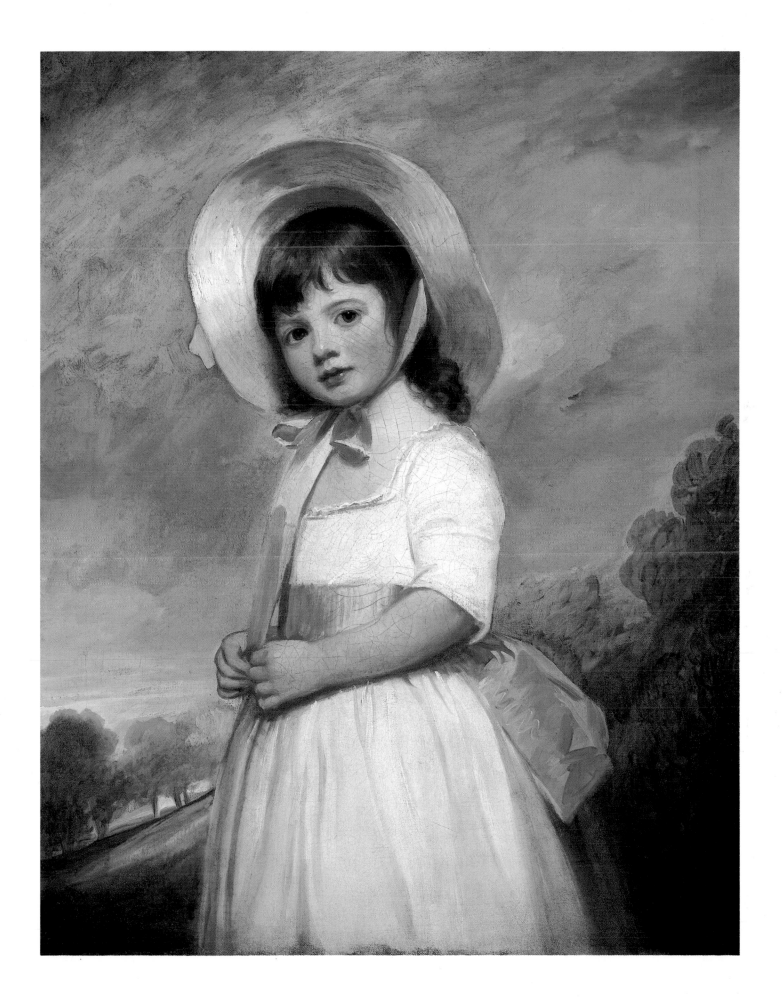

217. J. Burnet, *Practical Hints on Portrait Painting, illustrated by examples from the works of Van Dyck and other masters*, 1850, pl. I.

Burnet uses the example of Reynolds to demonstrate what he views as the peculiarities of formation in the child's mouth.

219 (far right). George Romney, *Mrs Ralph Willett*, oil on canvas, 75.4 × 62.9 cm. Huntington Library, San Marino, California.

Romney's composition and his technique of broad flat areas of colour and bold contrasts draws attention to the sitter's mouth. The idea of representing a female subject with her eyes shaded by her hat was employed to great effect also by Reynolds in his portrait of Catherine Moore (1752).

218. J. Burnet, *Practical Hints on Portrait Painting, illustrated by examples from the works of Van Dyck and other masters*, 1850, pl. II.

Here, Burnet presents, for comparison, a series of mouths taken from antique sculptures of female subjects. Lavatar had isolated the mouth as a significant body part in his *Essays on Physiognomy* (1792).

lified by the heroines of Fanny Burney's novels. It also looks forward to what Lynda Nead has described as a mixture of support and dependency in the normative construction of femininity in the 1860s.[31]

If the nature of femininity – with its intrinsic sexual connotations – is construed as childlike in the eighteenth century, what implications might this have for portraits of children, and particularly female children? The key role played by Reynolds's representations of children in the nineteenth-century aesthetic discourse of the child might be explicable by reference to the particularly powerful sexual

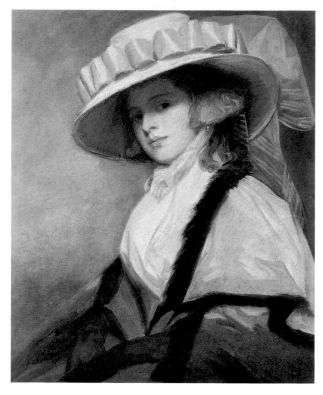

connotations of paintings like *Cupid as Link Boy* (pl. 220)[32] and *The Strawberry Girl* (pl. 222). Wind's proposal that a distinction between portraits and genre paintings is artifical and anachronistic when dealing with child-paintings of this kind gains support from the evidence of the critical aftermath. C.R. Leslie, in his popular *Handbook for Young Artists* undoubtedly voices a critical orthodoxy when he says of Reynolds's angel heads (pl. 215): 'call them merely beautiful children, if you will. We know they are but portraits, in different views, of one child.'[33] By the same token, the painting known as the Van der Gucht children (pl. 223) must always have operated less as a representation of two particular children (if, indeed, it ever was that) than as an eroticized image of children's oral pleasures in the manner of that master of the academic sensual, Matthew Peters, whose Royal Academy diploma

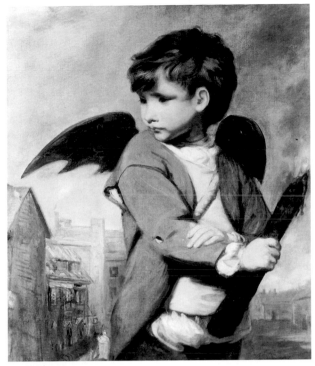

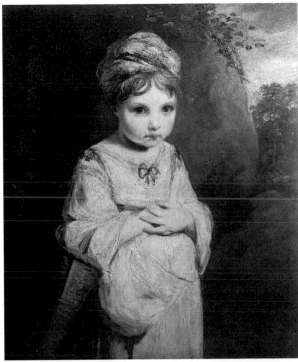

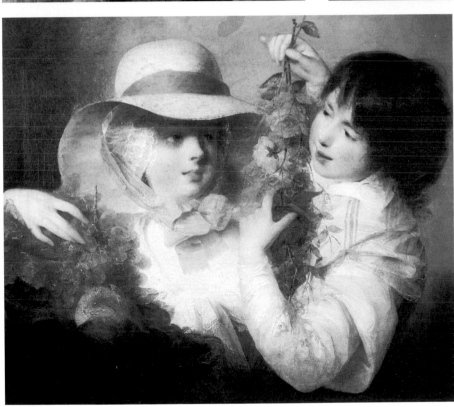

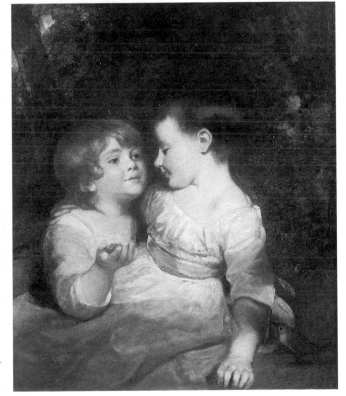

painting of 1777 gives a distinct idea of the appeal of his work (pl. 221).

The adaptation of Reynolds's parodies for further parodic portraits in the nineteenth century[34] strengthened the elision between portraiture and genre in the representation of women and children.[35] Moreover, the reworking of Van Dyck, Reynolds and Gainsborough which is evident in the cabinet paintings of early Victorian artists like W.P. Frith, Augustus Egg and G.S. Newton is attributable not merely to a powerful allegiance to what was perceived as a first flowering of the English School but also to this process of elision. Reynolds made it permissible to see children as angels and angels as children, and in so doing negotiated a territory that, as Patricia Crown has pointed out, was in real life brutally and diametrically opposed.[36] That negotiation produced an ideal image of the child that was not only feminine (by virtue of the structural relationship between femininity and childishness) but which was further degraded by virtue of association with poverty. The sexual exploitation of lower-class women and children was a feature of eighteenth- and nineteenth-century life.[37] The legacy of Reynolds's construction of child-portraiture to the nineteenth century allowed the co-existence of the apparently contradictory states of innocence and sexualization, angelic cleanliness and pathetic poverty.

This construction can help to explain the child as the site of intense and conflicting values in the Victorian England of Lewis Carroll, John Ruskin and Sir John Everett Millais. Another contemporary, Charles Kingsley, is best known today for *The Water Babies* (1863) in which the nineteenth-century equivalent of Reynolds's sad Cupid-Link-Boy is overtly both an object of desire and an object of degradation and, saved by divine intervention, is elevated to the status of one of Reynolds's angels. Kingsley made the nexus of art/childhood/death/sensual pleasure grippingly available much earlier, however, when he described the pleasures of the National Gallery for the benefit of working-men living in squalid urban spaces who, he hoped, might prefer to slip into a gallery rather than organize a riot:

Believe it, toil-worn worker, in spite of thy foul alley, thy crowded lodging, thy grimed clothing, thy ill-fed children, thy thin, pale wife – believe it, thou too, and thine, will some day have *your* share of beauty. God made you love beautiful things only because He intends hereafter to give you your fill of them. That pictured face on the wall is lovely, but lovelier still may be the wife of thy bosom when she meets thee on the resurrection morn! Those baby cherubs in the old Italian Painting – how gracefully they flutter and sport among the soft clouds, full of rich young life and baby joy! Yes, beautiful, indeed, but just such a one at this very moment is that once pining, deformed child of thine, over whose death-cradle thou wast weeping a month ago; now a child-angel, whom thou shall meet again never to part.[38]

This brief digression has permitted us to see the extent to which power relations based on gender, class and age, which are endemic to the eighteenth-century child-portrait, generated a complex discourse of childhood. To return to the studio situation, it is possible to see that a portrait of a female child by a male artist must result from a power relationship in which the subject of the painting – the object of the artist's and the viewer's attention – is twice removed. To express this succinctly, the tripartite relationship implied by a portrait contract (a relationship between artist-subject-viewer) breaks down when the subject is female, and when the subject is a female child it is further disrupted; age as well as gender widens and complicates the psychic space within which the representation functions. The male child carries some of this charge (though many of Reynolds's child subjects are androgynous in appearance) but it is offset by the genealogical responsibilities that portraits of male children bear, and by the filiation that images of boys set in train in patriarchal society. The female child thus distanced becomes a strong signifier of those human preoccupations that the portrait, viewed empirically, always raises and never satisfies: sexuality, love, growth and evolution, memory, time. A series of diagrams may make this clearer though they should not be taken literally, for the child (and particularly the female child) also works to animate, to disrupt or to excite at symbolic and psychic levels those group portraits in which she appears.[39]

The portrait 'contract': male artist; adult male sitter; adult male viewer

The portrait 'contract': male artist; adult female sitter; adult male viewer

The portrait 'contract': male artist; female child sitter; adult male viewer

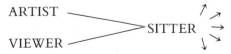

224. Sir Joshua Reynolds, *Lady Caroline Howard*, oil on canvas, 142.9 × 113 cm., *c.*1778. National Gallery of Art, Washington, D.C., Andrew W. Mellon Collection.

Two child portraits by Reynolds enlarge upon the points made above. *Lady Caroline Howard* (pl. 224) displays a child who kneels on the grass by an urn in which a rose bush is growing. She is preparing to pluck a rose with a hand that is carefully and expensively gloved to preserve the whiteness of her arms and hands, thus ensuring that she will in due course be marriageable by virtue of beauty as well as wealth. Unlike adult male sitters who generally move in their landscapes, Caroline Howard appears placed there at someone else's direction. Her left arm is oddly lifeless and her attention is fixed on the rose bush, strengthening the identification between girl-child and rose. The notion that the rose Lady Caroline prepares to pluck compliments her own budding beauty[40] is a benign interpretation and depends on a conventional – or even debased – repertoire of feminine allusion and metaphor. The stormy sky serves to offset the child's white cap; it also, however, lends the painting a somewhat threatening tone. The urn, suggestive of a landscaped park or garden, fails to counteract this sinister suggestion as it is placed not in a carefully controlled and planted 'natural' environment but in a rough landscape containing, at the right, a chalk escarpment and solitary tree of an uncouth appearance—anathema to such as Capability Brown. Moreover, while pink scarcely opening rosebuds offer a flattering analogy to the physical attributes of a seven-year-old female child, the plucking of a rose has quite other connotations. A plucked flower is a de-flowered woman and the metaphor (still in common parlance) was a commonplace in the English literary tradition.

> It was not in the winter
> Our loving lot was cast!
> It was the time of roses,
> We plucked them as we passed![41]

wrote Thomas Hood, a generation later, echoing the centuries-old metaphor which – at its most intense (as in the *Roman de la Rose*[42]) equates the female genitals with the scarcely opened rose. But a rose, as the authors of the *Roman* were quick to point out, also carries thorns and, like the tree of life, its fruits can produce bitter consequences. Once plucked it can never be replaced, as Othello recognizes when about to murder Desdemona:

> When I have pluck'd the rose,
> I cannot give it vital growth again,
> It needs must wither.[43]

Any educated Englishman in Reynolds's age would have been familiar with Milton's celebrated description of man's downfall:

> Her rash hand in evil hour
> Forth reaching to the fruit, she plucked she eat:

Earth felt the wound, and Nature from her seat
Sighing through all her works gave signs of woe
That all was lost.[44]

Locke may have ushered in an age that no longer adhered to original sin, but a degree of ambiguity remained. The wild, gashed landscape, the thorny rose bush, the about-to-be-plucked flower, all speak of the ambivalence towards that very idyll of childish innocence that the painting's iconography strives to convey.

In the second painting, Master Parker and his sister, Theresa, sit on a log in a gloomy landscape (pl. 226), and while she sits primly with hands and feet together, he leans towards her, legs apart, and clasps her torso in such a way that his right hand is placed over her left breast. A relative, referring to the painting says: 'It will not be finished for some time, but will be a very fine picture, and very like. I cannot well describe the composition of it, but they are very near kissing – an attitude they are often in.'[45] The difficulty in describing it perhaps indicates that the composition was unusual or disturbing. Rembrandt's *The Jewish Bride* (Amsterdam, Rijksmuseum), which the composition closely resembles, was not, it seems, known in England at this time, but the adult pose is none the less unmistakable. If the pose is adult, the composition is at some level a witty joke *at the expense of* the children who are the subject. The genre of image summoned up by Master Parker's gesture is unquestionably that of the seduction scene, which was largely associated with French engravings and the decorative arts. Similar compositions are to be found, for example, in French eighteenth-century designs for the lids of snuff boxes, items that gentlemen kept about their persons and ladies left in convenient corners of their escritoires (pl. 225). John Parker was seven when the portrait was painted, still a child but only just; Lord Chesterfield expected *his* son to display adult manners and learning prior to his

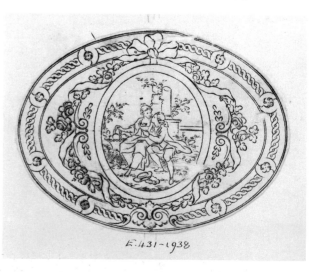

225. Gabriel St Aubin, *Design for a snuff box lid*, pen and ink, watercolour and wash, 3.7 × 7.6 cm., before 1780. Courtesy of the Board of Trustees of the Victoria and Albert Museum, London.

226 (facing page). Sir Joshua Reynolds, *Master Parker and his Sister*, oil on canvas, 142 × 111 cm., 1779. National Trust: Saltram.

'I cannot well describe the composition of it, but they are very near kissing – an attitude they are often in', wrote a relative of the sitters, having observed Reynolds at work on this portrait.

190

ninth birthday in 1741.[46] Despite attempts in the last twenty years of the seventeenth century to introduce changes in the marriage laws of England, relative to the legal age of consent of minors and the powers of guardians over the marriage of their wards, vested family interest as regards the rights of children concerning marriage continued through the eighteenth century and into the next.[47] Lawrence Stone has suggested tentatively that the genital stage of sexuality was free from repression at this period, and that adults, prior to the preoccupation with masturbation that became a feature of the control of children in the nineteenth century, found childhood sexuality amusing rather than horrifying.[48] The encouragement of sexual play, he proposes, may have been no more than one aspect of a general tendency to treat children in their early years as amusing and entertaining pets.

The child portrayed to amuse adults may be largely Reynolds's invention, though children have been associated with humour from Antiquity onward. He established a mode that, as we have seen, informed child-portraiture in the nineteenth century. Its influence is seen not only in direct parodies such as Lewis Carroll's photograph of Alexandra Kitchin posed as Penelope Boothby and Millais's *Cherry Ripe* (pls 260, 262),[49] but also in portraits such as Millais's *Portrait of a Gentleman* (Royal Academy, 1856) which shows Henry Goulburn Chetwynd-Stapylton, a small boy sitting with one of John Leech's sketchbooks on his knees. A work such as this plays (via the title and the subject) upon the superior knowledge of adult artist and viewer in their relationship with the child sitter.[50] Portraits such as Reynolds's *Lady Caroline Scott as 'Winter'* (pl. 227) work through the implied exploitation of a powerless child in the production of meanings of which she, herself, cannot be cognizant. Thus the very large hat and the invisibility of the child's hands diminish the supposed capacity of the child for independent movement. The element of personification depends upon the humorous antithesis between the warmly clad bundle of a child and the idea of winter, as well as between the allegorical invocation of the seasons as commonly found in sophisticated courtly art, poetry and music[51] and the unformed features of a small child. 'Winter' had been the first part of Thomson's *The Seasons* to have been published (1726); by the 1770s, there had been many reprints and many editions (the final complete revised text appeared in 1746), and the poem was established as arguably the most popular in the English language. While Caroline Scott is not a direct commentary upon Thomson's *The Seasons*, the status of the poem reinforced an affectivity that functions by virtue of the hiatus between our understanding as adults of allegorical modes and personification and the child's ignorance of them.

Master Parker and his Sister presents a similar case. Whilst not denying the probability that these infants hugged and kissed each other in real life, just as equally they also probably hit and scratched each other, the visual inscription of the event of the physical caress, organized in a way that is adult in the formality of its licentious gesture and the range of its iconographic associations, cannot be explained by reference to real life. Perhaps these children, as their aunt seems to imply, spent more time physically handling each other than most, and perhaps this was the origin of Reynolds's idea for the portrait as he observed them during his visits to Saltram. But this does not account for the import of such an embrace as re-presented in paint in the conventional medium of a full-length portrait in oil. The children ape the stereotypic and gender specific behaviour of the adult world where manly boys were expected to be sexually assertive and feminine girls were demure and passive.[52]

The trope of male mastery and female passivity is familiar in child-portraiture of this period. Romney's nearly contemporary portrait of the Clavering children (pl. 228), in which the male child grandly imitates the pose of the *Apollo Belvedere* while the female child moves with balletic symmetry, hands crossed in an angelic Flaxmanesque gesture (see pl. 237), exploits the energetic dogs and the vertical line of the lead with which the boy holds them, establishing a controlling movement that compensates for his inferiority of age. His elder sister, by

227. Sir Joshua Reynolds, *Lady Caroline Scott as 'Winter'*, oil on canvas, 141 × 112 cm., R.A. 1777. Duke of Buccleuch and Queensberry KT.

The companion to this portrait represents Lady Scott's brother, Charles, Earl of Dalkeith, dressed in an approximation to seventeenth-century costume and posed with an owl and a spaniel in a summer landscape.

contrast, eyes downcast, cradles a puppy in her arms. But the sexual innuendo that the portrait of Master Parker and his sister creates is peculiar to Reynolds and operates as 'innocent' humour through a mechanism that Freud identified in relation to history in his classic work on jokes and the unconcious. Jokes, Freud proposes, are dependent on the formal conditions of refined education in developed societies. Smut is transformed into a joke and is tolerated only as such. Allusion is the technical method that is usually employed, that is 'replacement by something small, something remotely connected, which the hearer reconstructs in his imagination into a straightforward obscenity'. The greater the discrepancy, Freud argues, between what is given directly in the form of smut and what it necessarily evokes in the hearer, the more refined becomes the joke and the higher the echelons of society where it will be adopted.[53]

Reynolds's portrait of the Parker children demonstrates the way in which children, 'small' and 'remotely connected', become a focus for sexual innuendo through and within the languages of courtly behaviour. We are familiar with the idea of the harmless joke, and this image inflects just such attitudes, inviting us to contemplate an affectionate and entertaining family memento. The psychic investment in terms of a familial interplay of power, which both protects by its affectionate recording and exploits by the sexualization of its objects of desire, is an aspect of the historical document fully deserving exegesis.

ii Allan Ramsay's Mansel and Blackwood Group and Thomas Lawrence's 'Pinkie'

Allan Ramsay's portrait of Thomas, 2nd Baron Mansel of Margam with his Blackwood half-brothers and sisters was painted in 1742 (pl. 230). It has been described as the masterpiece of the early and enormously successful period of Ramsay's career when his 'elegant internationalism captured the aristocratic market and dominated it until the rise of Reynolds the following decade'.[54] The young man with the gun is Thomas, 2nd Baron Mansel, then aged about twenty-two. His mother Anne, a daughter of Admiral Sir Cloudsley Shovel, had married as her second husband John Blackwood Esq. of Charlton in Kent. Shovel (c.1728–1810) is the eldest of the young Baron Mansel's half-siblings; Mary is the name of the girl portrayed, and the youngest child is John. Baron Mansel died in January 1744 two years after the completion of the portrait. His mother had died in October 1741, and it has been suggested that the portrait, which is seen as particularly tender, may be a monument to her

achievement as a mother, with the frame, ornamented with a shell cartouche and a helmeted mermaid, as peculiarly appropriate to an admiral's daughter.[55]

Ramsay is known to have painted other portraits of young adolescents: the Hon. Rachel Hamilton and her brother, Charles, of 1740 (collection of the Earl of Haddington) is a case in point, as is Philip, Viscount Mahon, painted in 1763 around the age of seventeen (collection of Earl Stanhope). The Mansel and Blackwood group seems, however, to be unique in Ramsay's *oeuvre* in its representation of a range of ages from childhood to young adulthood and in the way it handles gender difference. The composition ingeniously draws the disparate group together. A strong linear construction with diagonals formed from top right to lower left (along the axis formed by the right shoulders and upper arms of the baron,

228. George Romney, *The Clavering Children*, oil on canvas, 152.4 × 122.0 cm., 1777. Huntington Library, San Marino, California.

Mary and John and reiterated by the gun), and from lower right to upper left (through the line that connects Mary's left hand with the profile of her nose and forehead). The colour, which ranges from the rich green with crimson lining of the baron's coat to the startling silvery white of Mary's dress, is subtly complementary, the unifying theme of response to the legitimately felled bird providing a central focal point for the composition.

The central position of Mary is explicable by reference to her place both literally and symbolically as representative of her dead mother: literally in so far as she acts as substitute mother to her younger brother, symbolically because she is the only feminine presence and therefore the direct link to her mother. But the consequences of this centrality in terms of the sets of relationships that the image proposes disturb that equilibrium and can be explained only by reference both to processes of cultural engendering in the eighteenth century and to the particular family drama staged here. Gender difference was understood at this time to be a structural determinant in the issue of representation of the human form in general. It has been suggested that this portrait may derive some of its impact from a relationship with images of the five senses in which touch is a focal point.[56] What is more apparent is its connection with another systematizing tradition, that which deals with the very task of representing the human figure.

In the period prior to the acceleration of interest in physiognomical theories which followed the publication of Lavater's work from 1772,[57] changes in the human face and head, relative to the age of the individual, became the object of analysis. The child also played a crucial role in the evolutionary system about which Hogarth wrote in *The Analysis of Beauty* and which is repeated throughout the eighteenth and nineteenth centuries. The specific characteristics of the child's face in infancy are described by Hogarth, and the changes in proportion are noted as the child grows older.[58] 'From infancy till the body has done growing', Hogarth tells his readers,

> the contents both of the body and face, and every part of their surface, are daily changing into more variety, till they obtain a certain medium . . . from which medium, . . . if we return back to infancy, we shall see the variety decreasing, till by degrees that simplicity in the form, which gave variety its due limits, deviates into sameness; so that all the parts of the face may be circumscribed in several circles . . .[59]

Some of this replicates fairly closely the rules for human proportion laid down by Dürer in 1528, but Dürer does not discuss the evolution of the adult figure from that of the child and makes no distinction between male and female children (pl. 229). Dürer

offers the child merely by contrast with male and female adult forms, and it is invariably a male putto.[60] Central to Hogarth's analysis, however, is a differentiation in terms of sex. In a passage that lays down guidelines for the representation of sexual difference based on relative childishness of appearance, Hogarth at the same time acknowledges that what he is suggesting to artists may well not mirror nature, which he believes tends to fly in the face of order. We may also notice here the elision between femininity and childishness of appearance which was discussed in the previous section:

> In infancy the faces of boys and girls have no visible difference, but as they grow up the features of the boy get the start, and grow faster in proportion to the ring of the eye, than those of the girl, which shews the distinction of the sex in the face. Boys who have larger features than ordinary, in proportion to the rings of their eyes, are what we call manly-featured children; as those who have the contrary, look more childish and younger than they really are. It is this proportion of the features with the eyes, that makes women, when they are dressed in mens-cloathes, look so young and boyish: but as nature doth not always stick close to these particulars, we may be mistaken both in sexes and ages.[61]

ALBERT DVRER DE LA

FIN DV PREMIER LIVRE.

229. Plate from *Les Quatres Livres d'Albrecht Duerer* (1528) 1557. By permission of the British Library, London.

230 (facing page). Allan Ramsay, *Thomas, 2nd Baron Mansel of Margam with his Blackwood half-brothers and sisters*, oil on canvas, 124.5 × 100.3 cm., 1742. Tate Gallery, London.

194

232 (facing page). Detail of pl. 230, Ramsay, *Thomas, 2nd Baron Mansel of margam with his Blackwood half-brothers and sisters.*

Mary's position between her adult half-brother and her childish younger brother is one that reproduces what was regarded as the demonstrable link in the laws of human physical development; it demonstrates also the laws of representation that distinguish femininity in relation to childhood. Thus Mary's face represents a stage between childhood as seen in the youngest child and adulthood as seen in Baron Mansel. But her position also indicates that, as female, she is closer in physical type to the child than to her older brother or her half-brother. This structure does not preclude other links of a psychic nature.

The concern to establish laws for the differentiation in representation of the sexes amounts to something of an anxiety. In 1788 a writer in *The Artists' Repository* described character as that which 'expresses that peculiar and distinguishing appearance of person, features and deportment, which is proper to any, and to every individual. By character we determine the sex, the time of life, the country or family, the mental disposition, the natural or acquired habit, and even (frequently) the possessions and pursuits of those with whom we are conversant.'[62] The first element that the writer chooses to investigate at some length in this considerable agenda is the distinct character of the sexes. After rehearsing the distinctions established by Hogarth, a pressing case is made:

> The artist must distinguish the sexes even in children; and though it is not uncommon for them to be mistaken for each other by casual observers, yet in a picture there should be no ambiguity in this matter ... Boys are generally more robust than girls; their heads broader, and ears larger; have usually a greater quantity of hair, more frequently

231. *Age and Infancy*, from Charles Bell, *The Anatomy and Philosophy of Expression* (1806), 7th edn, 1886.

Page 42

AGE AND INFANCY

curled; girls may have loose flying locks; their hair longer than that of boys. Girls discover a certain sprightliness and vivacity, which is not equally strong in boys, though ever so wanton and playful. Attention should be paid to the natural disposition of the sexes: a doll, which as a toy well enough becomes a girl, is improper for a boy: as manly exercises, horses, or arms, which are the delight of boys, are not pleasing in the softer sex.[63]

The implication in Hogarth's statement that nature may confound the best-conceived system is here replaced by an insistence on clear distinctions defined by social practice. Hogarth has much to say on shyness, posture and ways of preventing children from drawing their chins into their necks[64] but is uninterested in the rigorous cultural distinctions that are described here. In Hogarth, nature can send off false signals about gender, but in *The Artists' Repository* clear distinction *is* the natural order and deviation (in the form of cross-dressing or other kinds of sex-change behaviour) is a legitimate target of control:

> When adolescence and youth have arrived at MATURITY, there is no longer any difficulty in discovering the sex; for though some few of either sex might impersonate the other, yet, as it is the intention of Nature they should be distinct, it exceeds our power to controul that intention; although in some instances we may attempt it.[65]

It is hard to imagine a modern book on figure drawing that advised readers of the difficulty of recognizing female impersonators or transvestites. Inscribed in these texts is an attempt to establish systematic methods for representation which would secure the sexes as indubitably different and separate. Childhood is here an area of difficulty and insecurity; it also holds the key to the origins of the physical development that will secure the difference in representation that may, in turn, assist in policing deceptive gendering.

The emphasis on establishing laws for distinguishing sex in childhood seems to have been overlaid in the nineteenth century by increasing educational provision for artists in anatomy and physiology. In place of the preoccupation with sexual difference as the key to gendered differentiation (the one being biological, the other cultural), Charles Bell is concerned with bone structure and the relationship of flesh to bone in the child of no specified sex and in relation to an old age that is equally unspecific (pl. 231).[66]

Although the publication of Hogarth's *The Analysis of Beauty* (1753) postdates Ramsay's painting by a decade, it is clear that Hogarth formulated ideas that were already being discussed at the time. Indeed,

196

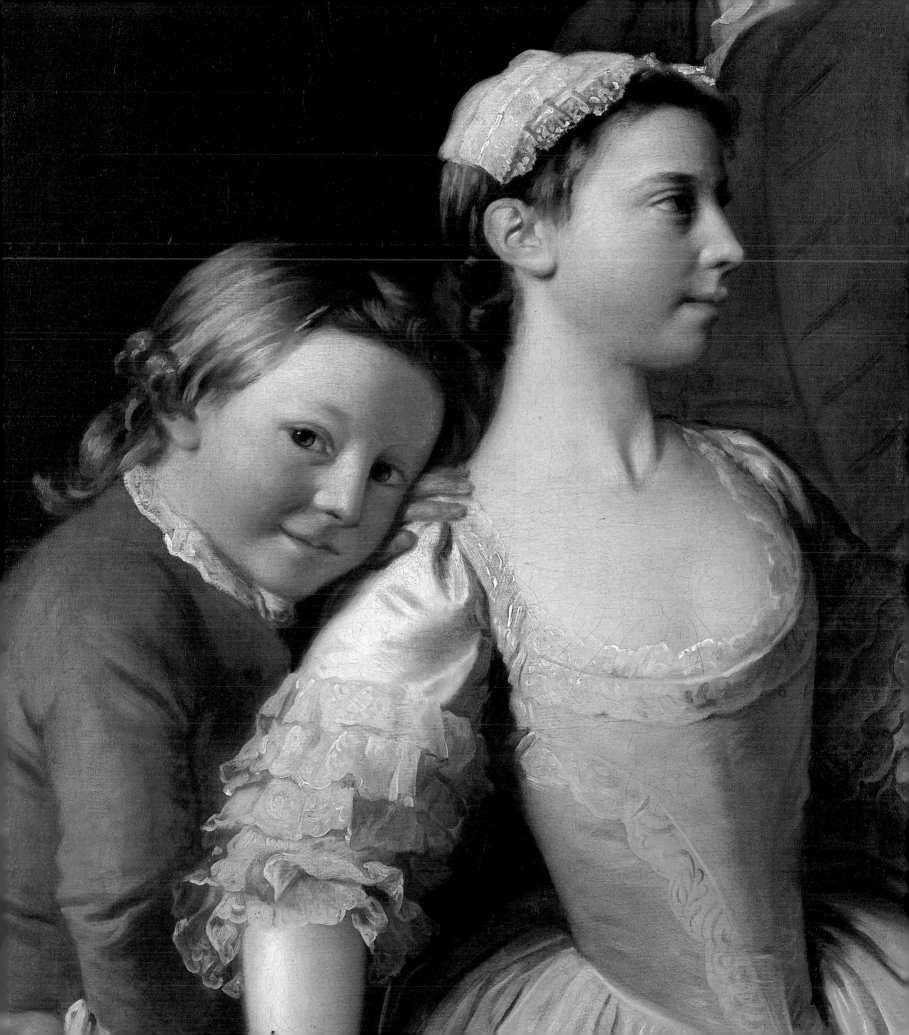

233. William Hogarth, *The Analysis of Beauty*, 1753, pl. 2.

234. Detail of pl. 233.

tion of a visual system for clarifying difference in age, sex and gender may be one response to an area of collective anxiety; another response is the projection of those anxieties onto a visual narrative of social construction. There is no doubt that this particular portrait is discursive; in terms of gesture, thematization and facture it deploys all the most sophisticated mechanisms of visual narration from the French tradition of Mercier and Chardin to the English tradition of narratives of field sports and other masculine pastimes.

One of the most striking – and puzzling – aspects of the portrait is the baron's expression. We may *guess* that it is one of amused tolerance at the action of his young half-sister at whom he directs his downcast eyes. An artist as travelled and fashionable as Ramsay at this date would certainly have known of Le Brun's treatise on expression. Baron Mansel's striking and particular facial expression is not unremote from the early part of Le Brun's specifications for 'Esteem'. In the first English translation of 1701 the emotion is described as follows:

> *Esteem* cannot be represented, but by Attention, and by the Motion of the parts of the Face, which seem fixed upon the Object causing the Attention; for then the Eyebrows will appear advanced over the Eyes, being depressed next the Nose, and the other ends a little rising, the Eye very open, and the Eyeball turned upwards. The veins and muscles of the Front, and about the Eyes, will appear a little swelled; the Nostrils drawing downwards; the cheeks will be moderately sunk in about the Jaws; the Mouth a little open, the corners drawing back, and hanging downward.[68]

The apparent alliance between Baron Mansel and his half-sister would seem clearly to suggest that he represents manly, out-of-door, active accomplishments and that she represents feminine sensibility as she lays her white hand on the still-warm breast of the dead bird (pl. 235), a gesture that thematically connects the painting both with the new-found eighteenth-century feeling for the animal world[69] and with the painting of sentiment by artists like Greuze and Nattier in France and Wheatley in England later in the century. For such artists the conjunction of youthful femininity and dead animals was particularly effective; it served to establish an analogue between the helpless vulnerability of the animal or bird and the assumed characteristics of the girl.[70] In this instance, the bird's bloody wound, over which the hands of the young girl and her half-brother meet, stands also as a displaced image of the female genitals.

The Mansel and Blackwood portrait may, as we have established, be a commemorative portrait. In this case it seems possible that the dead bird stands

the run-up period to publication may have been considerable. It is, therefore, not unreasonable to see the Mansel and Blackwood group by Ramsay as an essay in the comparative evolutionary study of the human subject as differentiated by age and by sex. It might also be read as a progressive sequence from left to right, rather in the manner in which people read figures 110 to 113 in plate 2 of Hogarth's *The Analysis of Beauty* (pls 233, 234), thus underlining on the one hand the differentiated characteristics and obligations of the stages of life from infancy and childhood to youth and maturity, and on the other hand the differentiation of sex and gender. Baron Mansel as a young unmarried man marks the extremity of what was understood to be youth in the eighteenth century, a stage of life 'very different from anything we know as "youth" or "adolescence" today'.[67]

The clarity of this account is appealing but that clarity must be balanced by attention to the ambiguities and uncertainties in the relations, as depicted, between the members of this group. The construc-

metaphorically for the dead mother, linking mother and daughter by this powerfully affective image. At the 'heart' of the painting (the compositional centre and the place where feeling is denoted) is death. The bird possibly served as an acceptable (because conventionalized) reminder of the recently dead mother who was the common factor to all four subjects and thus the real reason for the painting's assumed unity. Deceased parents were represented in Dutch seventeenth-century portraits in the background behind 'living' children; they also appeared in eighteenth-century British portraits (as will be discussed in the next section of this chapter). Here, however, death is invoked by the pathos of the bloody breast, reminiscent of the mystical self-wounding pelican that cares for its young with its own blood. So if the bird marks the boundaries and separates the members of the group, it also joins them, just as death in separating the children from their mother has also bonded them.

The theoretical separation of the male sphere from the female sphere that is invoked by this image was not, despite the apparent lack of ambiguity in the systematic organization of the members of the group, a matter of unquestioned orthodoxy. Nor, of course, was it ever in practice a dichotomy. The careful articulation of the relationship between the personae of this portrait testifies to the difficulty of establishing a balanced masculine mean between the extremes of vulgar brutishness and unmanly effeminacy. Mary's action is crucial to the maintenance of that balance. The debate on the appropriate education for the sexes, which had maintained its momentum through the novels of Richardson and Fielding and through essays in the *Spectator* and the *Tatler*,[71] was still being enacted in the 1760s, often through the medium of the fictitious letter, a mode that personalized the conduct proposed in a manner that approximates to the mode of signification in portraiture. The principal aim of one such correspondent in educating a girl was 'to make her a conversable companion to a Man of Sense, and an useful Mother to her Children'.[72] Boys, on the other hand, do not always benefit from being 'resigned over to the care and direction' of the parent of the same sex. 'My young squire', declares another correspondent, 'is put upon a little horse before he can well walk, and becomes (as his father was before him) the pupil and companion of the groom and the game keeper.' The dangerous consequences of this practice are not confined to the private, since 'the country squire seldom fails of seeing his son as dull and awkward a booby as himself; while the debauched or foppish man of quality breeds up a rake or an empty coxcomb, who brings new diseases into the family and fresh mortgages onto the estate'.[73] Baron Mansel must, by his comportment and by his dress and surroundings, suggest neither of these extremes; his elegant clothing and his regard for the female subject ensure that he does not fall into the 'awkward booby' category, while his gun and the equivocal character of his smile ensure for him the cast of easy masculinity devoid of any foppish associations.

The moment is, however, potentially unsettling and dangerous. As the young girl (fully feminized and therefore sexualized by virtue of the contrast with the boy-child brother and by her role as bearer of *sensibilité*) lays her hand upon the bird's breast; she also lays it on the hand of her handsome half-brother. Touch when accompanied by the visual underscoring of gender is sexually charged.[74] To imagine this group without Mary's two brothers is to discover connotations of courtship. As it is, they are counteracted by the serious and upright stance of Shovel, Mary's fourteen-year-old brother, and by the dog whose approaching muzzle weakens the power of this physical proximity.

What we admire as outstanding qualities of composition, handling and characterization in the Mansel and Blackwood portrait, what charms us by its apparent immediacy, its capacity to engage us as viewers, is actually a studied equilibrium which ensures both the social acceptance of the portrait as a record and its power to communicate uniquely a set of relationships that are both particular and general, inviting both celebration and anxiety. The excitement of Ramsay's portrait is thus explicable by factors that bring together the aesthetic and the social, the psychic and the historical.

* * *

Nothing better demonstrates the fact that portraits of children are made to please adults than Thomas Lawrence's depiction of the ten-year-old Sarah Goodin Barrett Moulton (pl. 236). From the circumstances of its commission to the centrality of its role in the popularization of a nostalgic view of late eighteenth-century childhood, 'Pinkie' exemplifies the mythologizing function of portraiture in the ideology of childhood.[75] Commissioned by the subject's grandmother after the girl had been sent from her home in Barbados to school in England, the painting was completed in 1792 and shown at the Royal Academy in 1795. By the time the exhibition opened the child was dead.[76] While there *may* be a correlation between adults' appreciation of the delicacy and vulnerability of their children and the commissioning of portraits of those children, there is certainly a relationship between the pathos of these records of children whose promise was unfulfilled and even the most guarded critical response to those works ever since.[77]

235. Detail of pl. 230, Ramsay, *Thomas, 2nd Baron Mansel of Margam with his Blackwood half-brothers and sisters.*

Even while regretting the 'saccharine air about the picture' which is created by popular reproductions and the context in which they appear, it is possible for *Sarah Moulton* to be designated the embodiment of the very spirit of English childhood.[78] 'Pinkie' was Sarah Moulton's family nick-name; the painting was originally exhibited, however, as *Portrait of a Young Lady* (Royal Academy, 1795, no. 75), and the popular adoption of the child's pet name to identify the portrait has reinforced the process of transposing the idea of a particular individual (one with a legal name and an independent existence) into a sentimental generality that can become public property.

What little we know about the production of Lawrence's portrait of Sarah Moulton suggests that the painting is part of the remarkable liberalization in attitudes to children that took place in Britain from the middle years of the eighteenth century in a period when the ideas of Locke, extended by Rousseau's work on education, had become normative in child-rearing and pedagogic practice. As J.H. Plumb has established, children's literature (designed to be bought by adults and projecting an image of the virtues parents wished to inculcate in their children) became a genre in its own right from the 1740s with the publications of Newbery and others, and developed an enormously successful market by the end of the century. The manufacture of games, amusements, curiosities and childrens' fashions, and the spread of schools for boys and girls are, it has been pointed out, new features of life in London and the provinces in the second half of the eighteenth century. In the words of Plumb, 'children, in a sense, had become luxury objects upon which their mothers and fathers were willing to spend larger and larger sums of money, not only for their education, but also for their entertainment and amusement'.[79]

Sarah Moulton is dressed fashionably. She was attending one of the successful schools for girls in the rural perimeters of London at the time of the sitting,[80] and her grandmother asked for her to be represented in 'an easy Careless attitude'.[81] Sarah's pose – a pose that Lawrence never repeated – suggests a dance routine. 'Possibly', says Robert Wark, 'Pinkie was caught in a private little dance that would have special meaning for her grandmother.'[82] Most people would probably recognize and share this response, knowing what a real child might be doing in this position. But this overlooks the possibility that representation, as visual rhetoric, communicates not actuality but ideology. The portrait of Sarah Barrett Moulton is a deception, the weaving of which spans the centuries and links viewers with the bereaved grandmother, the commissioning aunt, an artist so intent upon pursuit of his career that he overrode the grandmother's wishes in order to secure the painting for exhibition under his name in the

Royal Academy.[83] But it is part of the deception and our willing participation in it that we apprehend the image as summing up and, therefore, in some sense also as explaining away childhood. But no childhood is ever simply over and done with, and portraits of children, particularly objects that have acquired cult cultural status like Lawrence's portrait of Sarah Moulton, raise as many questions about the childhood of the spectators as they do about the childhood of the subject.[84]

What is intended by representing a 'private' dance in so public a context as a full-length portrait? This question suggests a set of contradictory reponses. To dance on a high hillside above a wonderful pastoral landscape (the Thames valley at Greenwich, perhaps, where the girl is known to have been at school) is to be associated with the untrammelled and liberated outdoor life of childhood as fictionalized by adults like Rousseau. The dance takes place with touching solemnity and promising poise. This is the visual language through which childhood is here enunciated. But Rousseau's educational aspirations were not for girls but boys. Girls' education was different from and inferior to boys'. If dance, which was taught as one of the key components in the curriculum of girls' schools, connotes for us self-expression and freedom of movement, it is also one of those rituals of female self-compliance through which girls were shaped for a life that was still expected to be one of subjection and childish deference. Woman and man joined in dance signified matrimony.[85] In the eighteenth century this remained true in the sense that dance represented a visible model of the abstract harmony to which marriage, as one of the sacraments, aspired; it was also true in the sense that good society matched young women with marriage partners via the ritual of the private and public ball. The English novel from Fanny Burney to Jane Austen testifies to the dance as the crucial testing time of a heroine's ability to acquire a husband, a process that depends upon birth, personal appearance and upon familiarity with the unwritten rules of society. Sarah Moulton has no partner for her dance – or so it would seem – but the portrait places her in a narrative that requires an implicit audience of male adults and, at the final count, of potential husbands.

Sarah Moulton's fluttering ribbons and diaphanous swirling skirt, her prettily placed feet and carefully controlled hands work to construct her as an ideal, virtuous young female subject, a child-woman who will, it is promised, become a wholly acceptable woman-child. The importance of this elision between childishness and femininity must be stressed. Sarah Moulton was ten at the time of her portrait but her contours, her rounded arms and shapely legs, are womanly. One leg, anatomically improbable, is

236. Sir Thomas Lawrence, *Sarah Barrett Moulton ('Pinkie')*, oil on canvas, 145.9 × 97.5 cm., 1794. Huntington Library, San Marino, California.

Exhibited at the Royal Academy in 1795 as *Portrait of a Young Lady*, this painting has become universally known by the subject's pet name.

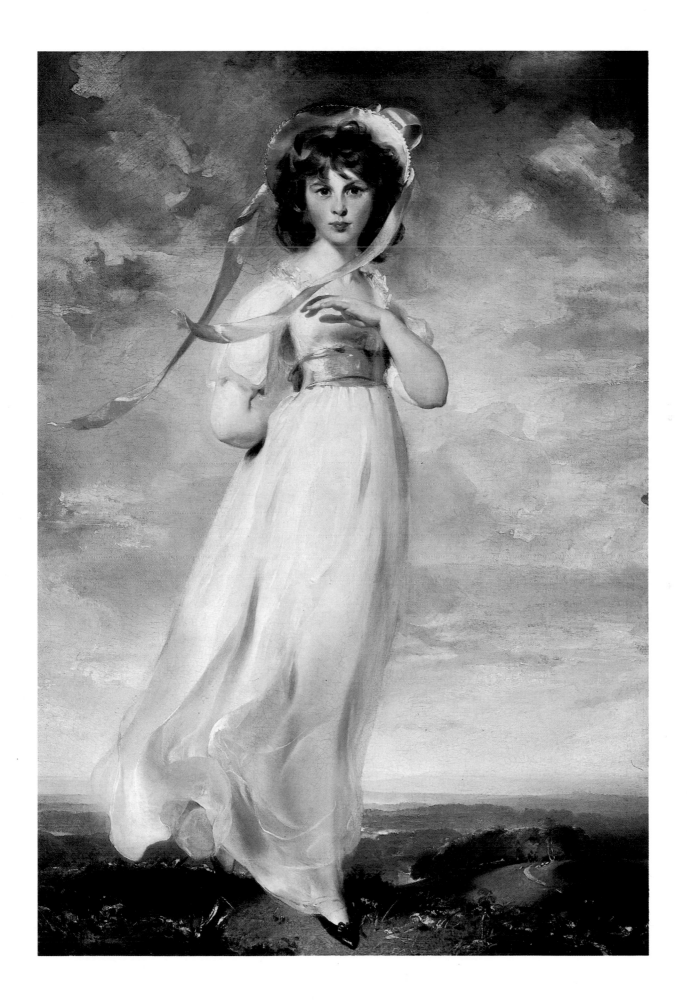

238. Johann Heinrich Fuseli, *Prince Arthur and the Fairy Queen*, oil on canvas, 102.5 × 109 cm., *c*.1788, Oeffentliche Kunstsammlung Basel, Kunstmuseum.

Like his contemporary, Fuseli, Lawrence adopted a low viewpoint and depicted models with delicate feet and ankles but strong, curvaceous legs and arms.

half-revealed through the semi-transparent folds of her dress. The dash of vermilion on her left elbow and on her wrist just where her hand transforms into the plump lower arm, are points of visual arousal, spots of flesh suggestive of warmth. Her left hand is carefully arranged to conceal the upper part of her torso as though covering her growing breasts, an action that (like the famous *pudicitia* of the *Venus de' Medici*) draws attention to that which it claims to hide. Stylistically the image hovers between divergent rhetorical strategies. On the one hand the folds of drapery picked out in sharp white lines with an upward flicker are reminiscent of Flaxman's controlled image of the floating and apparently timeless female body (pl. 237). On the other hand the angle of vision suggests Fuseli's intensely voyeuristic evocation of the unique momentary view of the, equally floating, female figure passing an anonymous male spectator in a nameless country place,[86] or the vision of female beauty experienced by a young man (pl. 238). Lawrence's arrangement thus allows a certain ambiguity about the subject's sexuality as about her movements. It is an ambiguity that is inscribed also in, for example, Fanny Burney's heroine Evelina, who is introduced to the reader as gentle in manner and graceful in motion:

237. John Flaxman, *Design for a wall monument*, pencil, pen and ink and colour wash, 31.1 × 20.5 cm., *c*.1800. Courtesy of the Board of Trustees of the Victoria and Albert Museum, London.

Flaxman and Lawrence were contemporaries and well acquainted with each other's work; differences in function, medium and genre do not obscure similarities in the invention of a visual syntax for the representation of feminity.

Her character seems truly ingenuous and simple; and, at the same time that nature has blessed her with an excellent understanding, and great quickness of parts, she has a certain air of inexperience and innocency that is extremely interesting.[87]

Evelina, like all Burney's heroines – and indeed like Burney herself – was controlled by fears that originate in the child's dependent condition.[88] The proper line of conduct is not the same for both sexes. Men guide and instruct; women are guided and instructed, and Evelina quite explicitly seeks a husband who will fill the role of father. She assumes, in Patricia Spacks's words 'the utter propriety of remaining as much as possible a child: ignorant, innocent, fearful, and irresponsible'.[89] And if the evidence derived from the novel appears unreliable, we might find confirmation for this view from a range of late eighteenth- and early nineteenth-century treatises on behaviour and etiquette. *The Christian Minister's Affectionate Advice to a New Married Couple* (1821) repudiated 'that sort of treatment, by which a wife sees herself rated merely as a kind of domestic animal'. But the relationship that is recommended is certainly not one of equality, and the ideal wife is constructed as *by nature* childish. The wife must not, we are told, be too ready to consider her husband's behaviour as expressive of indifference: 'A woman must guard against the tormenting disappointments to which childish expectations render her liable. For there is a childishness in her expecting always to be fondled . . .'.[90]

A contemporary critique of those rituals of female self-compliance to which Lawrence's portrait of Sarah Moulton contributes can be found in the work of Mary Wollstonecraft, who herself set up a school in Islington in 1784 and who published *Vindication of*

the *Rights of Woman* in 1792.[91] The low viewpoint of Lawrence's portrait of Sarah Moulton serves to elevate the girl in decorative isolation, freezing her in the easy carelessness of the social grace prescribed for her sex in general and specified for her in particular; it also metaphorically reproduces the positioning of women so vehemently defined by Wollstonecraft. 'Exalted by their inferiority', she states, 'they constantly demand homage as women, though experience should teach them that the men who pride themselves upon paying this arbitrary insolent respect to the sex, with the most scrupulous exactness, are most inclined to despise the very weakness they cherish.'[92] To quote Wollstonecraft is not, of course, to state a direct relationship, nor to imply a conscious organization on the part of the artist. It is, rather, to suggest that text and context interact in the production at an ideological level of a set of social relations within which actual girls and women lived their lives. When Wollstonecraft asks whether women should be 'treated like queens only to be deluded by hollow respect, till they are led to resign, or not to assume their natural prerogatives', when she describes them as 'confined . . . in cages like the feathered race', having 'nothing to do but plume themselves, and stalk with mock majesty from perch to perch', she is not describing portraits of women and girls by society painters like Lawrence, but she is addressing (and reacting to) a cultural milieu that determined the status of femininity as at one and the same time elevated and constrained to submission. That cultural milieu was constructed from and sustained by rhetorical devices, among which not the least were the brilliantly stylish and boldly executed paintings of Wollstonecraft's young contemporary, Thomas Lawrence.[93]

The important historical point to emerge from this comparison is the recognition of the portrait as a certain kind of specifically directed artifice which appeals to a set of responses – responses that cannot be reduced to either the aesthetic or the familial, but which function at the public level of social relations, responses that define and confirm gender and its role in society. Rhetoric – a formally constituted and public language of affirmation – offers a view of the world in which its unified discourse is contradicted by another, different message that is opened up in the interstices of that language. The visual rhetorical mode is here constituted by elements such as composition (effective through a combination of familiar convention and allusion and novel usage), colour (the pinks and pale blues) and handling (the celebrated Lawrencian panache with the brush). An example from our own time illuminates this process.

Lawrence's image is constituted around discourses of freedom, movement, lightness and openness. The Department of Education and Science launched an advertisement in 1990 for the recruitment of teachers structured around discourses of enabling and caring (pl. 239). The visual and verbal rhetoric of this advertisement invites us to understand that, if we respond to this set of signifiers, we will be disinterestedly helping children. But the image, in isolating and objectifying a girl whose loosely flowing hair falls around her face like a fashion model's, in surrounding this figure with fragmentary verbal messages such as 'become familiar', 'world of feelings and identify emotion', 'enjoy most find hardest', and by offering a bold-type caption suggesting the reader has the power and the licence to make this girl interesting to herself (the use of the subjunctive is particularly suggestive) enunciates a different kind of message. The viewer is licensed to claim intimacy with – as well as authority over – the subject. It is a text that, like the eighteenth-century child-portrait, signifies via an unequal relationship of power.

Lawrence's portrait of Sarah Moulton, when understood as a cultural artefact signifying in the context of a particular period of patriarchy different from, yet comparable with, our own, can be seen as visual rhetoric rather than as a moment of instinctual

239. *Teaching brings out the Best in People*, Dept. of Education and Science teacher-recruitment poster, the *Guardian*, 29 May 1990.

The propagandist deployment of child-portraiture in the contemporary medium of photography and graphics points up some long-standing ambiguities surrounding the representation of young female subjects.

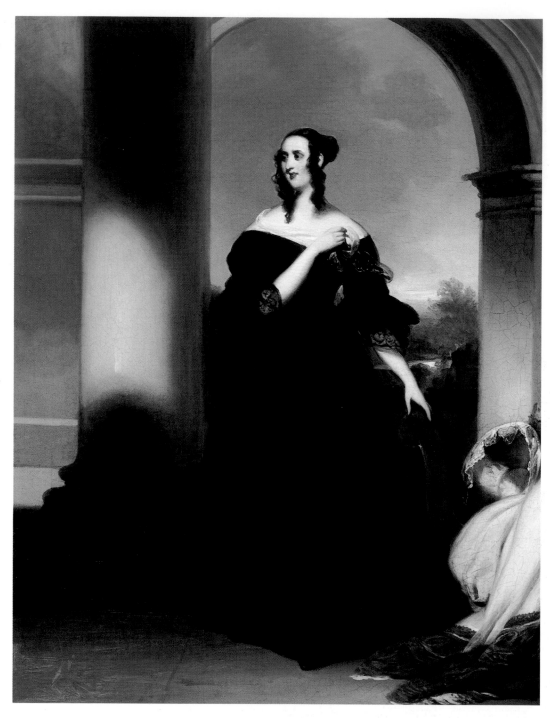

240. George Chinnery,
Portrait of a Lady, oil on
canvas, 62.9 × 48.4 cm., after
1825. Martyn Gregory,
London.

engagement. The more accomplished the artist and the more beautiful the painting, the more effective the rhetoric. By the same measure the DES advertisement, working through the twentieth-century's most sophisticated media of photography and typography, produces a text that, for all its overt message of disinterested liberation of the individual, confirms a patriarchal structure in which the female subject, the young female subject entering womanhood, is presented as typically educable through the personal intervention of the reader who – since the conno-

tations of the verbal message, if not sexual, are at least sensual – is probably constructed as male. It is hard, within our own cultures, to imagine this advertisement having the same impact if the figure were a teenage boy, for the whole point is that at the level of implicit assumptions men have knowledge and girls can be helped to be themselves by men with that knowledge. Similarly it is hard to imagine Master Lambton (pl. 241) dancing or Sarah Moulton seated like a young philosopher.

In his textbook for portrait painters, John Burnet

204

advises that certain techniques are appropriate to the painting of women and children. He admires especially Lawrence's representation of the female eye: 'the delicate varieties of the outline, the lustrous brilliancy of the highlight brought into contact with the dark pupil, and the thin thread of watery fluid trembling within the under eyelid . . .'.[94] Scholars have regularly remarked on the 'flashiness' of Lawrence's technique; the dash of carmine in the nostrils and at the corners of the eyes are often dazzlingly effective and, as Kenueth Garlick has observed, the confident juxtaposition of the pinks and the whites and the bravura of some of Lawrence's landscape backgrounds are produced almost with the abstraction of a Peter Lanyon.[95] These techniques, which were construed as gender-specific by Burnet, became part of a set of rhetorical possibilities common to a generation of artists who drew on and thus reinforced the effectiveness of this public language of paint. Arguably it was not invented by Lawrence; Richard Cosway's *Mrs Joseph Smith* (pl. 242), for example, has the moist feminine eye that was admired by Burnet (and which is here associated with the sentimental act of letter-reading). George Chinnery's female portraits also construct their subjects through the rhetoric of the liquid eye and the boldly brushed landscape background, the foregrounding of paint as liquid, malleable and moist, and the flung 'freedom' of drapery (pls 240,

242. Richard Cosway, *Mrs Joseph Smith*, oil on canvas, 91.4 × 69.7 cm., 1787. Huntington Library, San Marino, California.

We are invited to understand that the wistful expression and moist eyes of Mrs Smith relate to the letter she has been reading which, in turn, relates to the portrait of a young woman that lies in her lap. Cosway thus provides a blameless narrative explanation for what was widely held to be a gender-specific physiological state.

243). Whilst they are less competent than Lawrence's portraits, they demonstrate the widespread currency of this formal language of gender.

Sarah Moulton's gender and status is conferred by the iconography of a fashionably dressed girlish form, but it is confirmed by the manner in which the eyes and the mouth are painted. Burnet's advice to artists might almost have been derived from a close look at a portrait like Lawrence's Sarah Moulton:

The seat of sweet, soft, feminine character lies in the outer corner of the eyes, especially the lower eyelid, and the corners of the mouth: this the painter should catch, towards completion, with a few delicate touches. Dignity lies in the under-lip and chin, and the upper orbit of the eye and forehead: to give the one without a simper, and the other without a frown, requires the nicest feeling of the artist.[96]

iii The Psychodynamics of Childhood: Hogarth and Lewis Carroll

Portraiture is the elaboration of absence. From its earliest manifestations, the portrait has stood for an absent human being. Definitions of portraiture have hung upon the issue of the nature of the human subject commemorated and the function served by the image.[97] Funerary imagery has often been

243. Detail of pl. 240, Chinnery, *Portrait of a Lady*.

241. Samuel Cousins after Sir Thomas Lawrence, *Master Lambton*, mezzotint, 1827. P. & D. Colnaghi & Co. Ltd.

205

excluded because it was deemed to represent not the livng body – body and soul as one – but an empty shell awaiting animation. 'True portraiture' has, by this account, been confined to those images where, it can be proven, the subject is represented for his or her own sake.[98] This adherence to a philosophical purism is historically unproductive; it is simply not possible to state that Queen Elizabeth I, in keeping her portrait miniatures in a special cabinet in her bed-chamber, held Leicester's image (when we know the man himself was also present) 'for his own sake'.[99] Portraits may substitute for individuals who are temporarily absent or permanenly absent through death; they may also invoke absence in so far as they provide for an absence that is anticipated; Queen Elizabeth's possession of Leicester's portrait may be understood in this category. To some degree, therefore, portraits always imply the ultimate separation that is death.

The space between the presumed real of life (in its private and family forms) and the still, immobile authority of the image that enshrines it, has intrigued historians of photography since Walter Benjamin expressed the view that the cult of remembrance of loved ones, absent or dead, offered a last refuge for the cult value of the picture.[100] Furthermore, photography has been understood to have been implicated in myths of the cohesion of the modern family. We have tended to accept unquestioningly the narrative of photography's conquest of portraiture in the nineteenth century; equally unquestioned has been the assumption that photography is the starting place for these preoccupations. With regard to the issue of representation as surveillance, or of image as fetish, the notion that the photographic case is the first and only one is equally misleading.[101] What photography and the historical critique of photography have achieved is a foregrounding of the theoretical con-nection between death and image-making. Not only does the photographic 'shot' draw attention to the immediacy and definitiveness of the act that is, like death, irredeemable, but recent photographers have explored the implications of this in self-portraits that enact their deaths, thus becoming active participants of that process in which they are the passive sub-ject.[102] But the question of the relationship between representation and absence, between the mythol-ogization of family and the static image, and between definitions of gender and visual representation are much older than photographic history implies and are arguably as old as representation itself.[103]

Portraits of children intensify these questions. To begin with, the state of childhood is, both by its nature and by cultural definition, particularly ephemeral in the ordinary life-cycle. Child and adolescent mortality in western Europe was high until the mid-nineteenth century and remained a problem until the virtual eradication of tuberculosis, diphtheria and other childhood diseases. There are, therefore, empirical reasons for associating portraits of children with the absolute separation that death produced. Portraits were painted and photographs were – and are – taken of dead children to provide compensating mementos for bereaved parents.[104] Even allowing for debates about the precise period when affective relations between parents and children commence,[105] it is reasonable to assume that from the seventeenth century when parents could still not expect even the majority of their children to survive to adulthood, portraits of children fulfilled the role of an emotional insurance policy. At a psychic level, of course, the fetish that means both loss (symbolic castration) and protection against loss is an anthro-pological and psychoanalytical tool that can help to explain how portraits of children work for indi-viduals and groups in societies. Furthermore, aspects of English culture from the late eighteenth century were deeply preoccupied with the relationship of childhood to adult life and, particularly, with the adult's separation from the experiences of childhood. It was Wordsworth, not Freud, who said 'The Child is father of the man' and who preferred death to the loss of his childlike joy in creation.[106]

This section will explore separation: the notion that portraits of children stage separation, temporary and absolute, and that this staging articulates at the symbolic level experiences of adult separation from childhood, memories of childhood separation and anxiety about parental separation. The alliance of adult fears, whether of artist, parent and/or viewer, underpins the production of images of children which often fulfilled the very role that had been ritually or subconsciously assigned to them. In 'What is an Author?' (1969) Foucault explored writing's relationship to death, drawing attention to the fact that Greek epic redeemed the collectively accepted death of one who had died young; he notes the way in which the theme and pretext of Arabian narratives was the eluding of death – the telling of stories postponing the day of reckoning that would silence the narrator. His main interest is, however, in the proposition that the relationship between writing and death is also manifested in the effacement of the writing subject's individual characteristics so that the writer is reduced to nothing more than the singularity of his absence.[107] While acknowledging that all art in some sense redeems the death of the artist, I want to suggest that in the portrait of a child, the artist is aligned with all other adults in staging a state of otherness from which all adults are always separated but to which all have also belonged. This disjuncture is metaphorically reproduced as analogue to the gulf that separates the living from the dead.

* * *

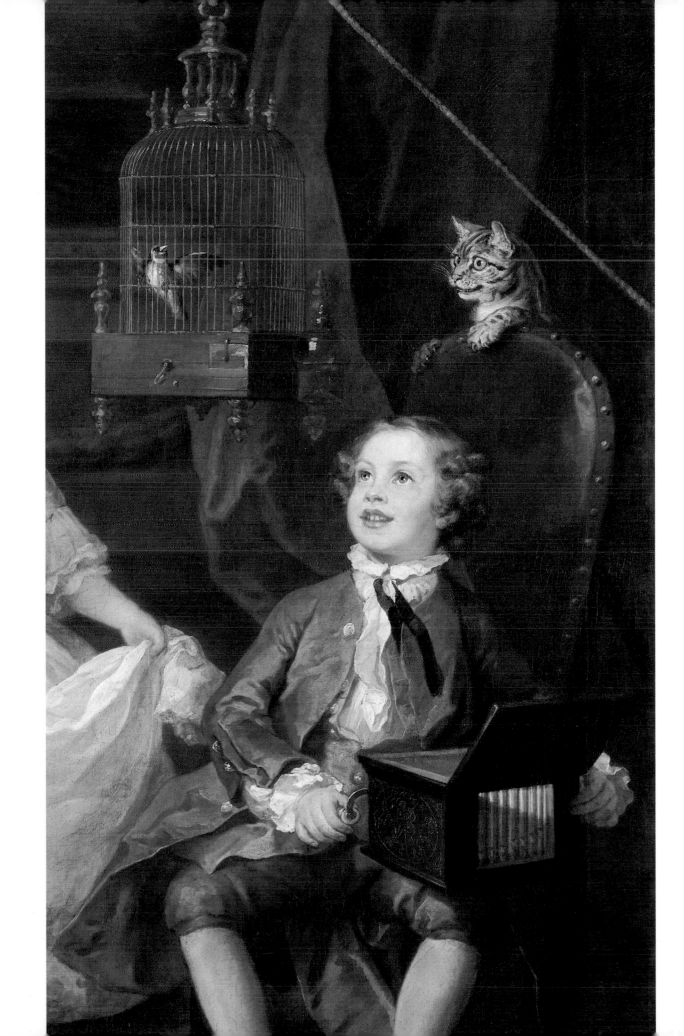

244. Detail of pl. 207,
Hogarth, *The Graham
Children*.

245. William Hogarth, *Ashley Cowper with his Wife and Daughter*, oil on canvas, 53.3 × 60.6 cm., 1731. Tate Gallery, London.

This was originally a portrait of Hogarth's friend, the barrister Ashley Cowper and his wife; their child was born in 1731 and added later.

246. William Hogarth, *A Fishing Party*, oil on canvas, 54.9 × 48.1 cm., *c*.1730, Dulwich Picture Gallery.

A group of portraits painted by Hogarth in the 1730s appears to offer to posterity a simultaneously idyllic and naturalistic view of family life among the upper classes in England in the first half of the eighteenth century. A significant number of these works incorporate children apparently engaged in childish activities. In 1731 Hogarth painted Ashley Cowper and his wife in a park posed beside an antique urn, he with his dog. Later their daughter, born in 1731, was added (pl. 245). About the same time he painted *A Fishing Party*, showing a small child, struggling with a full-sized fishing-rod, with her parents and nurse by an ornamental lake (pl. 246). *The Conquest of Mexico* (pl. 248) shows child actors performing Dryden's *Indian Emperor or the Conquest of Mexico* staged at St James's Palace before the younger members of the royal family on 27 April 1732, on the suggestion of the Duke of Cumberland, who is included in the painting. Perhaps most notably, *The Cholmondeley Family* (pl. 247) depicts an interior where two adults who are still living and one who is recently deceased share room space with two rumbustious little boys and a baby who is supported in her perch on the edge of a table by her dead mother. The putti above the mother's head indicate, according to established convention, that this member of the group is depicted posthumously. Hogarth's boldness of conception in this portrait has often been remarked. The derivation of the stiff figure of the dead mother from an earlier portrait has attracted

attention, and Hogarth's success in negotiating the apparently irreconcilable (daring actuality in the behaviour of the boys and a non-naturalistic convention for the depiction of the mother) has been equally admired.

While there do not appear to be other images in this group that go this far in uniting the dead and the living in an environment of family fun, there are curious aspects to some of the other paintings which have been overlooked in the account of Hogarth's spectacular conquest of the 'naturalistic' conversation piece. For example, in *The Jones Family* (collection of Ann Lady Boothby, Fonmon Castle) there appears between the five dignified adults in the foreground (one of whom is clearly widowed and consequently unpartnered) and the haymakers in the background a barefoot boy with wild eyes struggling with a monkey to whom Mary Jones draws attention with a gesture of the hand. This is a surreal touch – a moment of violence in an image of civility – which commentators looking exclusively to the empirical have found difficult to explain. *The Conquest of Mexico* (pl. 248) invites a disputatious response not merely from the point of view of its primary function – is it a portrait or a painting of an event that happens to include some portraits? The theatrical event is certainly its framework, but within this, 'childhood' is (literally) staged. The children are on the stage where they perform the roles of adults; the foreground is a second stage on which children, who

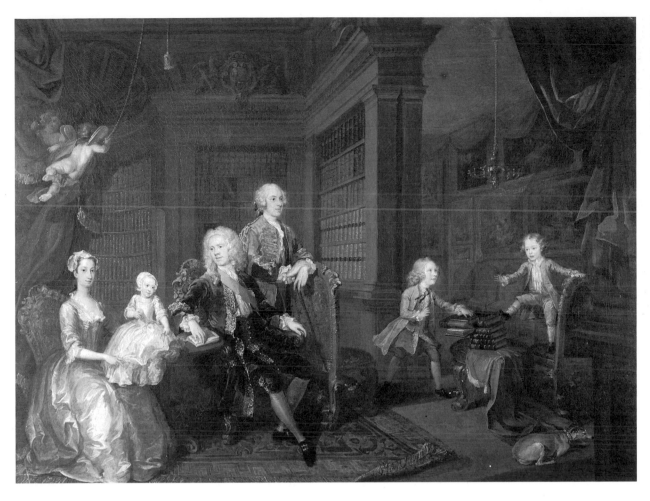

247. William Hogarth, *The Cholmondeley Family*, oil on canvas, 71.0 × 90.8 cm., 1732. Lord Cholmondeley.

The hovering putti indicate that the mother of this family had died by the time the portrait was painted.

behave like children despite – or because of – the fact that they are royal, attract the attention of their governess who is foremost in the picture space. The host and hostess are represented by their portraits on the wall. A bust of Isaac Newton stands on a mantlepiece ornamented with a relief of little boys with attributes symbolic of Newton's achievements. Closest to the stage is the carved figure of Pan, symbol of fecundity and the world principle, playing his pipes at the foot of a female statue. However learned the commissioner of the painting, John Conduitt, Master of the Mint, may have been, this mass of symbols raises wider questions. Jane Austen recognized that acting was a dangerous pursuit, and just as amateur theatricals could upset the social order by encouraging participants to think themselves other than they were,[108] so the representation of acting raises questions about the stability of the adult world, about the feigning of innocence and the enactment of maturity, about the distance (here literally depicted) between playing (and all acting is a sophisticated form of play) and watching, between children and adults.[109] *The Conquest of Mexico*, which the children perform, is a play concerned with generational and cultural transition. Dryden's

explanation of the play's connection to its forerunner, *The Indian Queen*, makes this clear.[110] No wonder, then, the portraits of the hosts and the bust of Newton were required to counteract the bacchanalian disorder that Pan provokes.

Portraits of children by Hogarth executed in the

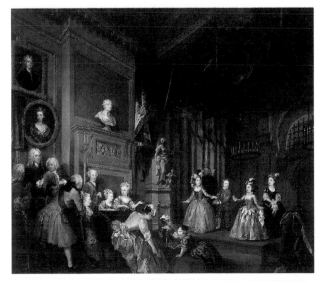

248. William Hogarth, *The Conquest of Mexico*, oil on canvas, 130.7 × 145.8 cm., 1731–2. Private collection.

Whereas in plate 247 the children perform informally for the viewer without attracting the attention of their elder brother and parents, here childhood is placed centre-stage as children act the parts of adults in a play by Dryden.

209

249. William Hogarth, *The House of Cards*, oil on canvas, 63.5 × 76.4 cm., 1730. National Museum of Wales, Cardiff.

early 1730s are ambiguous objects, texts that suggest a degree of disturbance in the representation of apparently commonplace subjects. It is, therefore, necessary to ask questions about the meaning of two group portraits, *The House of Cards* and *A Children's Party (The Tea Party)* (pls 249, 250), which date from 1730 and belong in terms of subject matter and style to the group of paintings discussed above. They have never been identified as portraits, but given their relationship to the conversation pieces, and the loss of identity of represented child subjects with the passing of time, it is appropriate to discuss them

here.[111] Of the same dimensions, in the same medium, from the same collection and depicting at least some of the same subjects, these are evidently pendants. Their relationship to each other is, however, as complex in terms of narrative as that of the plates in *The Harlot's Progress* of 1732 to which they bear at least one resemblance. The doll's tea-table overturned by the dog in the second canvas (pl. 252) is a motif that reappeared in plate 2 of *The Harlot's Progress*. *The House of Cards* and *The Tea Party* are not sequential, however, but interdependent. In both the events take place in a park where the trees open up to

the left to reveal a view of a distant house. But a different part of the house is seen in each case (pl. 257), and in the *The Tea Party* the children play out their drama beneath a large antique urn surmounting a pedestal. While *The House of Cards* contains two boys and three girls, in *The Tea Party* the older of the two boys is absent. *The House of Cards* has been seen as the first painting and *The Tea Party* as the second;[112] but it is not clear why this should be so unless in response to the absence of the older boy. The effect of such a relation is to impose an historical time sequence upon a pair of images that seems to

work by partial repetition in a spatial but not an historical dimension. Setting aside any idea that they are a sequence, they will be examined here as synchronic rather than diachronic.

Children were frequently portrayed with their toys in the eighteenth century. Upper-class children owned more toys than in previous eras, but their portrayal at play can also be attributed to a vogue for increasingly relaxed portraits of children, emphasizing their charming ways rather than their roles as heirs to name and property (pls 254, 256). Yet even in Hogarth's most engaging depictions of childhood

250. William Hogarth, *A Children's Party* (*The Tea Party*), oil on canvas, 63.5 × 76.4 cm., 1730. National Museum of Wales, Cardiff.

211

his tendency to 'comment on the human condition in general, employing a whole range of traditional emblems' is not avoided.[113] The notion that the Graham children (pl. 207) are watched over by love rather than time in a painting that contains plucked flowers, a musical box, a caged goldfinch watched by an excited cat and a clock surmounted by a Cupid figure carrying a scythe and an hourglass seems questionable (pl. 244). If the children inhabit a 'protected world', it is one in which the enemy is already within the gates, especially if we take into account the fact that the baby (pl. 205) died during the course of the painting's execution.[114] This is a more elaborately cosmopolitan rendering than Hogarth achieved in the 1730s, but the sophistication of the emblematic allusions and the elegance of the brushwork do not obscure the fact that Love's alliance with Death, and the threat of savage destruction while the music plays, are intrinsic to the painting. They are not a background to the figures; the figures engage with these events and help to make them happen.[115]

So while the toys being played with in *The House of Cards* and *The Tea Party* may be naturalistic props or emblems – the house of cards has a particularly popular currency (pls 253, 255) – they can also be seen to influence the way the children are themselves apprehended. Here the relationship between the two canvases becomes important. The children are the same children – yet they are different. Enough is the same to make us think we are looking at 'like', but what is like here? What changes far more than the children themselves are their toys and their environment. Different toys are played with – with different consequences – in a different part of the same location. And there are two different dogs: a hard-working pug and an unruly spaniel. Of the children, the two who remain most like are the little boy and the small girl who watches with alarm for the house of cards to fall and who holds up the mirror. In *The Tea Party* the small boy carries a flag, in *The House of Cards* he beats his drum (pls 250, 257). In the one he is standard-bearer, in the other he beats the retreat, or so we may surmise. These are complementary acts which establish a spatial relationship between the two images. The central act of play in *The House of Cards* is the skilled, dangerous and ultimately futile work of erecting an edifice that will certainly fall.[116] In *The Tea Party*, the rigid and peculiarly human-looking doll (pl. 251) is about to be left presiding over an upset table and a heap of broken china. This event takes place in the shadow of a huge funereal urn adorned with swags of flowers and a limp ribbon, and surmounting a chipped pedestal. Like the house in the background, this belongs in the adult world. But there are also flowers to be seen in *The House of Cards*, for here the elder

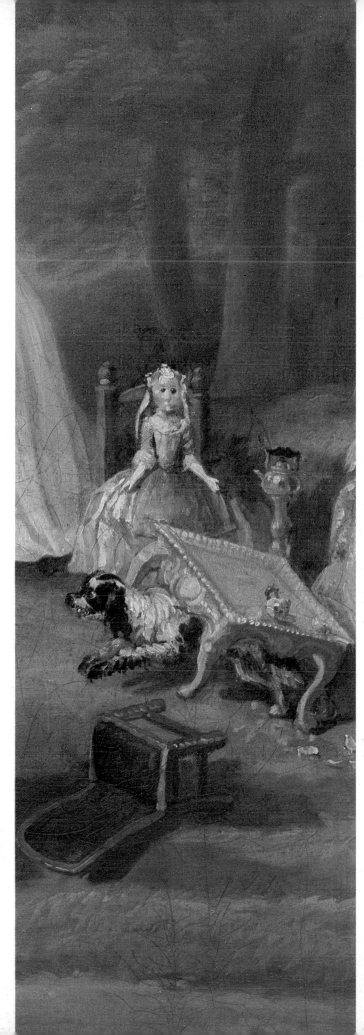

251 (facing page). Detail of pl. 250, Hogarth, *A Children's Party* (*The Tea Party*).

252. Detail of pl. 250, Hogarth, *A Children's Party* (*The Tea Party*).

The overturned tea-table reappears in *The Harlot's Progress*.

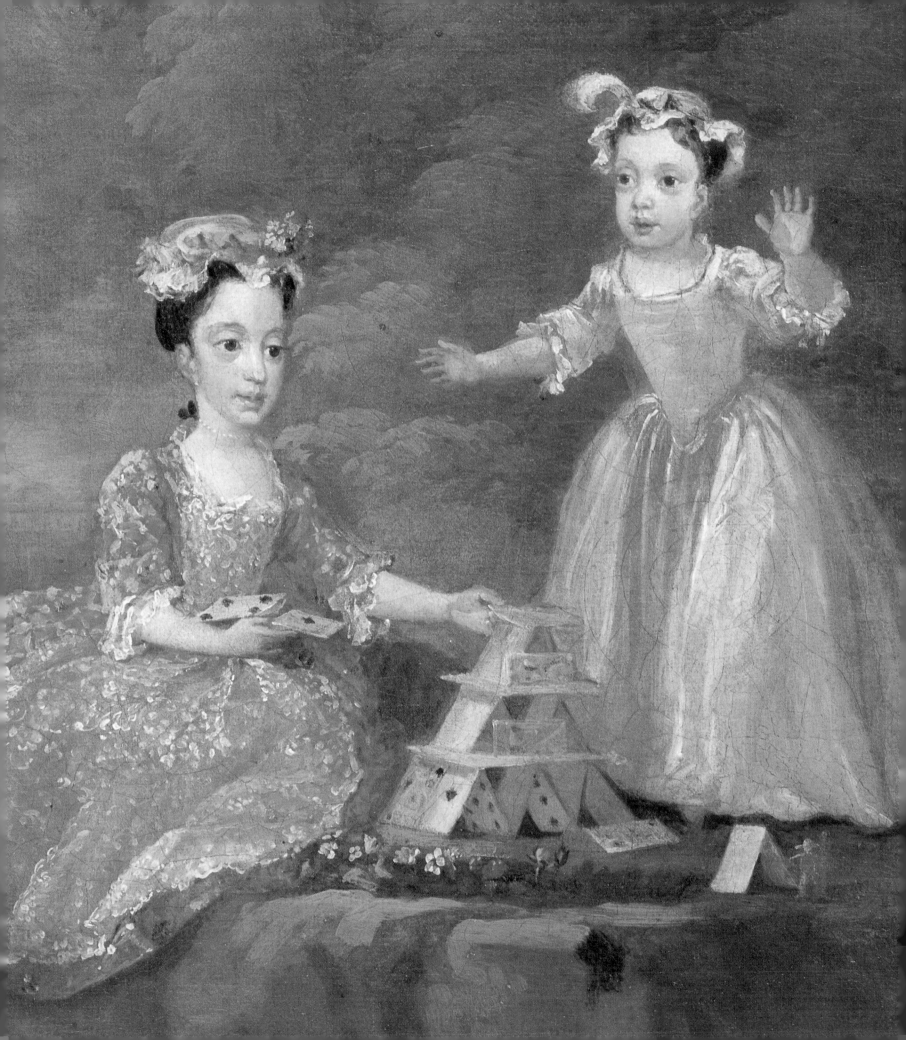

254 (far left). Joseph Wright of Derby, *Richard Arkwright and his Wife and Child*, oil on canvas, 243.8 × 158.7 cm., 1790. Private collection.

A child-centred portrait in which the sitters are not only represented as fashionably dressed but also as fashionably affectionate and indulgent towards their child.

256 (left). Joseph Wright of Derby, *Two Girls and a Negro Servant*, oil on canvas, 127 × 101.6 cm., 1769–70. Private collection, on loan to the National Museum of Wales, Cardiff.

boy in his crimson stockings and one of the girls exchange floral gifts in an act of courtship in the right foreground.

For the adult viewer, the objects of play in these paintings function as more than emblems: they are, to use Baudrillard's term, bygone objects that fulfil the need to be a definitive and complete being. Bygone objects are indistinguishable from and relative to other elements as signs, but in so far as they present themselves as totality, as authentic presence (the toy kettle, the child's drum) they have special psychological status. 'The bygone object is always, in the full sense of the term, a "family portrait". It immemorialises a prior being in the form of a concrete object – a process equivalent, in the imaginary order, to the elision of time.'[117] In so far as the bygone objects, the objects of play that ape the adult world but are always anterior to it, are here represented in paint on canvas for an adult audience as part of the ritual of portraiture, the process of objectification is intensified and their psychological status clearly signalled. Nor are these works by Hogarth an isolated instance. The association of children with large (and by their very nature commemorative, if not funerary, urns) is found also, for example, in Joseph Wright of Derby's *Two Girls and a Negro Servant* (pl. 256), where the bygone object of the flower-filled urn beneath which the girls kneel

255. *Girl Building a House of Cards*, attributed to George Knapton, 76.5 × 64.1 cm., before 1778. Metropolitan Museum of Art, New York; gift of Henry G. Marquand, 1890. Marquand Collection (91.26.1).

253 (facing page). Detail of pl. 249, Hogarth, *The House of Cards*.

Children and their toys are increasingly commonplace as a theme in eighteenth-century portraiture, but the apparent interest in naturalism should not distract us from the emblematic import of these scenes.

emphasizes the distance of time between infancy and maturity, as it also invokes a chronology from Antiquity to the present. Furthermore, the portrayal of the black child servant presents other, comparable, differences of race and class. Such a portrait echoes the formal conventions of seventeenth-century portrait types, in which non-European slaves and servants endorse the status of the sitter. But taking Lely's *Lady Charlotte Fitzroy* (pl. 258) as an example, it is evident that the display of flattery mobilized by Lely's arrangement is replaced in the eighteenth-century by a cryptic set of relations.

By the time he had completed this pair of paintings, Hogarth had demonstrated himself to be a master of group compositions.[118] Yet here he chose to present a fragmented and *staccato* view which is particularly disturbing because of likenesses that are not quite likenesses and narrative elements that fail to tell a story. Childhood always remains with us as part of our subconscious life; the 'dream' quality of *The House of Cards* and *The Tea Party* relate both to the artist's own memories of childhood and to the uncertainties that children raised in adult viewers in a period when many children died before maturity. The paintings do not lend themselves to iconographical readings although, as has often been remarked, they contain motifs that are part of familiar symbolic codes.

It is now recognized that children experience fierce rivalry with their parents – they possess powerful instincts to equal the achievement of adults – and that

phantasies of reversal in which children are strong and parents weak are a part of 'normal' growing up.[119] In individuals with strong ambitions and creative drives the destructive impulses are often marked. The missing boy in *The Tea Party* functions in the painting as a sign of loss, absence and deprivation. This may be understood as death (or fear of death), as feelings of separation from childhood experienced by an adult, or as a growing up and moving on on the part of the artist and/or viewer. It is significant that the absent figure (because of his death?) is allied here (as in *The Graham Children* (pl. 207)) with love (suggested by the courtship ritual of exchanging flowers). The destructiveness and danger that are a marked part of both scenes are explicable if we understand these pendants as self-reinforcing and self-referential phantasies of reversal. It is for this reason that the small girl holds up a mirror in *The Tea Party*; this does not work primarily as a *vanitas* symbol because she holds it away from herself (pl. 259). It is directed towards the adult world, deflecting the gaze of that world so that viewers (adult) in looking at the paintings would see themselves. It is the mirror of self-knowledge that Hogarth presents, not the mirror of Narcissus. In the adult, the phantasy of the powerful child works to overcome feelings of inadequacy and to strengthen ambition, which, as we know, Hogarth did not lack.

* * *

Lewis Carroll and Alice Liddell are universally known. Alice is Carroll's creation and he, in an important sense, is hers. *Alice in Wonderland* was created *for* Alice Liddell but also *about* Alice Liddell,

259. Detail of pl. 250, Hogarth, *A Children's Party* (*The Tea Party*).

The girl points to a mirror which she turns to the viewer, suggesting the means to self-knowledge rather than a *vanitas* symbol.

257 (facing page). Detail of pl. 249, Hogarth, *The House of Cards*.

Different views within the mysterious landscaped park are offered; the distant house suggests the adult world which the children's activities replicate.

258. Sir Peter Lely, *Lady Charlotte Fitzroy with an Indian Servant*, oil on canvas, 127 × 101.5 cm., *c.*1674. York City Art Gallery.

The use of fragments of Classical Antiquity – urns, sarcophaguses, reliefs – in combination with the representation of servants who are racially other than the children portrayed – produces an effect of distancing both of time and of place.

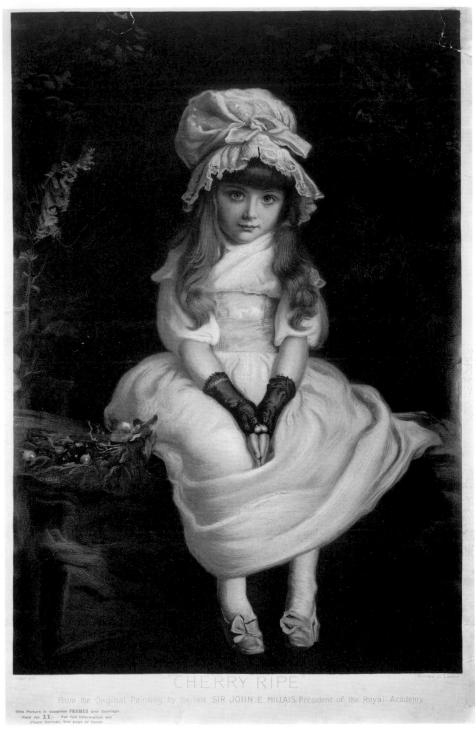

CHERRY RIPE

From the Original Painting by the late SIR JOHN E. MILLAIS, President of the Royal Academy.

This Picture is supplied FRAMED and Carriage
Paid for 11/-. For full information see
Pears' Annual, 2nd page of Cover.

a strange relationship that replicates at some level the procedures of portraiture – but a portraiture ostensibly freed of its conventions. Child-portraiture, as indicated above, implied a collusion between adults (artists and parents) at the expense of the child. In the case of Lewis Carroll and Alice Liddell, the implied parental presence was erased. Carroll's photographs of Alice have made his reputation as a photographer at the same time as they have popularly unmade the Revd Charles Dodgson's reputation as a 'respectable mature adult'. Alice Liddell, like Christopher Robin, as a human being in time has no existence beyond her childhood. No act of biography can erase the inscription of Alice into cultural history as a permanent child. In this final section another Alice, an Alice not created by Lewis Carroll, will be examined. Though it may bear traces of Carroll's Alice, it minimizes those traces in the interests of its own separate account. Again, it is an image of children created by and for adults, but first it would be useful to look at those cultural and political imperatives through which the child became a major site of individual and collective phantasy particularly in the second half of the nineteenth century.

In 1879 a French critic visited the studio of Sir John Everett Millais, patriarch of the British art establishment.[120] 'Mr. Millais is, after Reynolds and Gainsborough, the first painter of his country', he declared. Millais was engaged in a portrait of a child which Duranty described as 'the most wonderful production' (pl. 260):

> One day, when I was in the artist's studio, his latest model was brought in, a charming little girl of five years, wearing the costume of a child of the beginning of the present century. She was dressed all in white with one of those large bonnets styled in France 'Charlotte Corday' and a pink bow in it, with black mittens and rose-coloured shoes, and a beautiful sash of the same colour.[121]

The child, posed on a fallen tree trunk with the toes of her feet, as the critic was quick to remark, charmingly turned inward (that unmistakable sign of the miniature calculated to underscore the difference between the dignity of adulthood and the charm of childhood), is reproduced in J.G. Millais's biography of his father. *Cherry Ripe* is there described as 'the first of the many beautiful child pictures that came from Millais' easel during this and the next fifteen years, and quite amazing was the hold it took upon public fancy'.[122] The elision between portrait and genre around the child subject, the construction of a fantasized past and a rural identity, and the identification of national genius with the production of these qualities is here, again, assembled. We have seen in the first section of this chapter how these questions were central to Reynolds's and

260. Sir John Everett Millais, *Cherry Ripe* (1879), chromolithograph reproduced for *Pears' Annual*, Christmas 1897, image size 71 × 48.5 cm. Courtesy of the Board of Trustees of the Victoria and Albert Museum, London.

The inscription reads, 'This picture is supplied FRAMED and carriage paid for 11/-. For full information see Pears' Annual, 2nd page of Cover.' The painting was a portrait of Miss Edie Ramage who had attended a fancy-dress ball as Penelope Boothby in 1879.

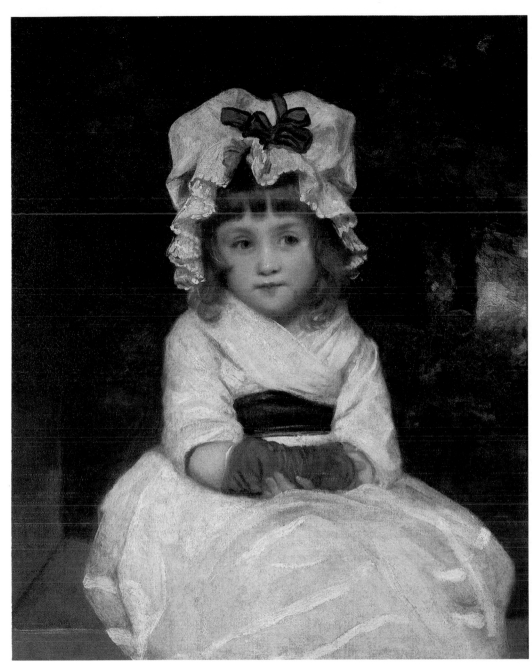

261 (left). Sir Joshua Reynolds, *Penelope Boothby*, oil on canvas, 75 × 62 cm., 1788. Private collection.

262. Charles Dodgson (Lewis Carroll), *Xie Kitchin dressed in the manner of Penelope Boothby*, photograph, *c*.1875. Gernsheim Collection, Harry Ransome Humanities Research Center, University of Texas at Austin.

The combination of mob-cap and fichu tied across the chest create, as with Millais's rendering (pl. 260) the effect of a young person dressed in borrowed clothes from a previous era.

Gainsborough's painting of child-subjects in the eighteenth century. The establishment of Millais as heir to Reynolds and Gainsborough legitimized the production of images of children that were at one and the same time portraits of particular parents' children and paintings of children as personifications that could be possessed by adults at large. Millais was described as the 'true successor to Gainsborough and Reynolds',[123] and his studies of 'the beauty and sweetness of childhood alone would', it was claimed, 'win for him a place beside the painter of Penelope Boothby' (pl. 261) even if 'nineteen-twentieths of his work were swept away by accident'.[124]

That Reynolds and Gainsborough should provide the measure of an achievement in British art in the late nineteenth century is not, perhaps, surprising. But it is notable that the child-portraits and fancy paintings of these artists, which had been widely disseminated through reproductions in a variety of media, were what attracted particular attention. Depictions of children became, in an important sense, identified with the very act of mediation, with the question of the uniqueness of representation in the age of photography and chromolithography. Writing in 1872 about wood- and metal-engraving, Ruskin pointed out to his readers the importance of

219

engraving to the artist's reputation. At the same time he delivered a warning. Wishing to define design as 'that power in any art-work which has a purpose other than that of imitation, and which is "designed", composed, separated to that end . . .', implying 'the rejection of some things, and the insistence upon others, with a given object', he selected a group of 'prettily dressed peasant children by a modern artist' which, he suggested, could be rendered as well or better by a photograph. The privileged position of art (as opposed to imitation) is demonstrated by comparing these, as it were, ordinary children with Gainsborough's children, by setting them alongside an ' "artful" little country girl' in a sketch by Gainsborough:

> You never saw her like before. Never will again, now that Gainsborough is dead. No photography, – no science, – no industry, will touch or reach for an instant this super-naturalness. You will look vainly through the summer fields for such a child. 'Nor up the lawn, nor by the wood,' is she. Whence do you think this marvellous charm has come? Alas! if we knew, would not we all be Gainsboroughs? This only you may practically ascertain, as surely as that a flower will die if you cut its root away, that you cannot alter a single touch in Gainsborough's work without injury to the whole . . . If you alter one wave of the hair of Gainsborough's girl, the child is gone.[125]

By a symptomatic process of elision the artist, Gainsborough, is identified with the assumed reality he has depicted. Both are gone, and the image of the vanished female child stands as substitute, at one and the same time, for an age that has passed and for the intuitive and inviolable act of creation in an age of mass reproduction.

A rash of popular publications from mid-century onwards testifies to what amounts to a cult of Reynolds and Gainsborough in which images of children and women held a special place. The popularization of Reynolds's work through engravings began with Graves and Cronin in 1849. John Burnet's *Life of Reynolds* was published in 1856, illustrated with a combination of photographs and engravings.[126] C.R. Leslie's *Life and Times of Sir Joshua Reynolds* appeared in 1865. Published two years later, F.G. Stephens's *English Children as painted by Sir Joshua Reynolds* (London, 1867) actually addresses portraits of women as much as portraits of children, offering further evidence of the relationship between the two established earlier in this chapter. Sarah Tytler's *Childhood a Hundred Years Ago* (London, 1877) was illustrated with chromographs after paintings by Sir Joshua Reynolds. This book is organized into chapters with titles such as 'Little Lords and Ladies', 'Children of the Middle Class',

'The Little Lad and Lass of Low Degree' and 'The Typical Child'. In her introduction, the author says she has before her copies from portraits of children by Reynolds selected from a multitude of reproductions of works which were once private property but now gladden the hearts and eyes of many. Reynolds's literary works were edited and published in 1878.[127]

People in London whose interest had been aroused in the British School of painting by the efforts of George Scharf at the recently established National Portrait Gallery, also had the chance to see original works and to buy catalogues containing detailed entries by F.G. Stephens. Stephens also wrote the entries for Millais's Grosvenor Gallery exhibition of 1880. In 1883–4 a big exhibition of Reynolds's work at the Grosvenor Gallery included *Master Wynn as the Infant St John, Muscipula* (exhibited, it was claimed, for the first time, though much loved from engravings by Jones, Watson, Bartolozzi and S.W. Reynolds), *Lord Henry and Lady Spence or 'The Young Fortune Teller'*, *The Strawberry Girl*, *Miss Hester Frances Cholmondeley or 'Crossing the Brook'* and many other child-portraits.[128] In 1885 a similar exhibition of Gainsborough's work was organized at the Grosvenor. When Millais's *Cherry Ripe* (1879), published in an edition of the *Graphic* in 1880, sold 600,000 copies in a few days,[129] it was because it appealed to an existing market for such images.

In addition to fulfilling his general role as heir to Reynolds and Gainsborough, Millais frequently produced parodies of their portraits which were themselves often already parodying earlier art forms, styles of dress and visual motifs. Spielmann suggested, among others, that *Hearts are Trumps* was based on Reynolds's *Ladies Waldegrave* (a common assumption), *Cherry Ripe* on *Penelope Boothby*, *Little Miss Muffet* on *The Age of Innocence*, *Master Anthony Rothschild* on Gainsborough's *Blue Boy*, *Clarissa* on Gainsborough's *The Hon. Mrs Graham* and *Hon. John Nevil Manners* on Lawrence's *Master Lambton*.[130]

Portraits and costume paintings of children dressed in past fashions and reminiscent of the work of eighteenth-century artists who themselves were often quoting from the past served to deepen the conceptual gulf between adult life, which is in the present, and childhood which is now doubly in the past: past because all childhood is understood at a conscious level to be then and not now, and past by virtue of being visually historicized. If the eighteenth-century child-portrait was empirically linked with death, those conditions that made such a connection necessary no longer pertained so pressingly by the end of the nineteenth century when children's life expectancy – at least for the children of those classes by whom portraits were commissioned – was considerably higher. Children were invited to

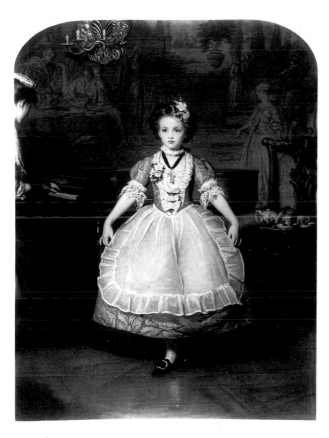

Hall Sixty Years After (1886) to Arnold's Scholar-Gipsy (1853), the invocation of childhood serves to make present and visible the passage of time which, to an adult subject, brings with it the prospect of their own decease.

In earlier periods adults were the winners over life's most lethal periods, gaining their maturity,[133] but by the late nineteenth century the notion of the child, a notion that was powerful at the level of fantasy, was organized within a variety of controlling discourses: of medicine, of sexuality or of labour. The historicist discourse was one that also effectively policed this threatening notion. But portraits of children also imaged objects of desire – sometimes perhaps to an obsessional degree. There are instances in the photography of Lewis Carroll or Julia Margaret Cameron, and in some of Millais's child portraits, of repetitions and thematic recurrences that suggest an overdetermined relationship of artist to subject. Making the child twice other by locating him or her in another time and/or another culture safeguarded the desirability of the object of the gaze, requiring the adult spectator's knowing engagement with a past that is neither his or her own nor that of the portrait subject (pl. 263).

The household of Henry Liddell, Dean of Christchurch and father of Alice Liddell, was described by William Blake Richmond as 'of quite exceptional beauty'.[134] Richmond met the family some time around the year 1861 when he was in Oxford painting the portrait of Dr Henry Acland and about five years after Lewis Carroll's first recorded meeting with the Liddell children which took place in 1856. Richmond lived with the Liddells for about six or seven weeks, most of which seems to have been spent at their holiday home near Llandudno. Richmond described himself as 'a kind of tame cat in the family'.[135] While Carroll photographed Alice Liddell alone as a beggar or, accompanied by her elder sister, dressed in Chinese costume, Richmond painted Lorina, Edith and Alice posed in dresses inspired by Italian art of the fifteenth century against the barren landscape of Great Orme's Head (pl. 265). Excluded from the group were Harry (three years older than Lorina) and the youngest child, Rhoda, whom Richmond painted separately.[136] Richmond depicted Lorina seated with an illuminated book on her lap, her younger sisters on either side of her. Alice is kneeling in a pose that is an approximate quotation of an angel by Perugino, though it also has overtones of Reynolds's angel heads (pl. 215). The three girls were the favoured grouping from the family, and photographs show them arranged in similar fashion (pl. 264).

Richmond's biographer articulates the relationships and identities in terms of the subjects' later life: the eldest sister is now Mrs Skene and the second, 'in

confront the terrors of death and mortality through a literature specifically designed for their improvement,[131] while being celebrated in fashionable pictorial constructions that located them in the era of their great-grandparents.

The literature of the second half of the nineteenth century in England is rich in the thematization of memories of lost childhood and youth. Women played a very particular role in this thematization. Informing women that their children ('more helpless than the bird in its nest, or the lamb in the fold') will learn from their mothers whether they agree to it or not, that 'your looks and example, your words and actions, will all help to form its character for time and eternity', a writer in the *Mother's Friend* offers a veritable agenda for paintings like Hunt's *The Awakening Conscience* in which memory is the trigger for revelation: 'the remembrance of other days will creep over the soul, it may be at the evening hour, when listening to some melody we heard in other years; memory bears us back to childhood's scenes . . .'.[132] Novels featured major celebrations of childhood (particularly Dickens's many child heroes and heroines), but significantly the exploration of loss of childhood is also found in the more speculative genre of poetry. Here Browning, Tennyson and Matthew Arnold dealt with questions of psychic import and, particularly, with questions of sexuality. From Tennyson's *Locksley Hall* (1842) and *Locksley*

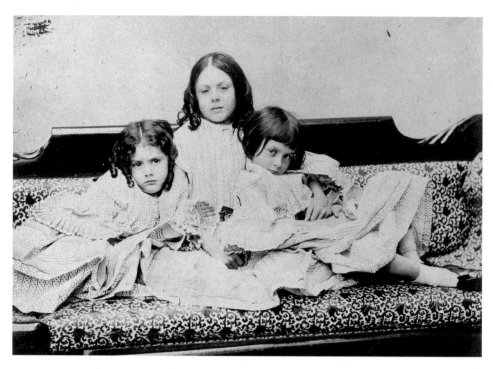

264. *Lorina, Edith and Alice Liddell*, anonymous photograph, *c.*1857. Photography collection, Harry Ransome Humanities Research Center, University of Texas at Austin.

265. W.B. Richmond, *Lorina, Edith and Alice Liddell*, oil on canvas, 90.2 × 74.9 cm., 1864. Private collection.

the gravity of whose demeanour an imaginative onlooker might fancy some premonition of the tragedy which awaited her', died of appendicitis. The painting, which became Lorina's property in adult life, thus testifies to a unity that could never be reproduced. Alice, however is described as beyond representation, the privileged object of the gaze, 'to whose pretty face and lively colouring no reproduction can do justice'.[137] When Ruskin saw the painting he protested about Lorina's dainty buckled shoes, suggesting that Richmond should have painted her bare feet and declaring that Perugino would never have committed such an error. This incident points up a paradox to which Lindsay Smith has drawn attention. Costume pictures of children, she argues, are always children in costume. Therefore the dilemma faced by Carroll (or by Millais or Richmond, and also by us) in defining the status of the images produced – whether they were or were not child portraits – cannot be answered by reference merely to costume. In other words, historic costume complexifies child subjects but does not absorb them. The bare feet requested by Ruskin would have further historicized the image, emphasizing its pictorial antecedents at the expense of its contemporaneity. It would also have foregrounded the issue that Smith has identified in relation to those costumed child-portraits by Lewis Carroll that Gernsheim dismissed as banal, namely that these children, 'who have been unclothed to be re-clothed in the garb of various cultural fantasies', enact questions of sexuality.[138]

Lewis Carroll's photographs of children, accord-

ing to Smith, frequently display the child as captive (literally against a wall), the focal point always being the child's body in a composition that represents an assumed space necessary both for the geometral binary relation and for the space of male fantasy. Richmond (who frankly described his child subjects as victims),[139] on the other hand, produced an image that refuses the idea of focus by its uniformly dispersed detail of treatment, and that places the viewer at a point well below – and very close to – the group. Richmond construed himself as a 'tame cat' and his subjects as 'victims' in a correspondence that, whilst being full of social trivia, is none the less revealing in so far as it reflects the ambiguous power relations of artist to child subject in commissions of this kind.

More puzzling are the two cultural references that Richmond invokes in his attempt to describe both the process of painting the three eldest Liddell sisters and the appearance of the painting he was making. He tells us that the girls were dressed most picturesquely by their mother, 'leaving nothing for me to design in the way of garments'. Presumably it was, then, Mrs Liddell who chose to cut Alice's hair in such a way as to suggest the form of a quattrocento angel. Richmond, faced with this 'ready-made', claims that he demanded sittings that commenced before seven in the morning and that he worked seven or eight hours a day. 'While painting', he says, 'I had much in mind the beautiful Saint Jerome in the National Gallery (pl. 267). I aimed at great clearness and purity of colouring, and that is the merit of the picture.' While Richmond was working on the painting, Tennyson's *Enoch Arden* was published (pl. 266), and the Dean read it aloud in the evenings along with the other poems in the volume while Richmond drew and the girls sewed. 'He read very splendidly', Richmond recalls, 'with restrained, dramatic force, and great feeling. He especially admired the sermon in Aylmer's Fields; and when Enoch comes back, looks in at the window, and sees the new husband and the wife of his youth among their children, he fairly broke down; the strong, stern man was moved beyond his power of restraint . . .'.[140]

It might be possible to interpret the reference to St Jerome in terms merely of a model of clearness and purity of colouring, for at this period Domenichino, the artist of the painting referred to, was a popular model for height of colouring.[141] Similarly, the family poetry-reading might appear a commonplace of the Victorian household and yet one more testimony to the capacity of Tennyson to move his contemporaries to tears. The account is, moreover, constructed by a third party from Richmond's reminiscences written ramblingly in old age. In terms of intertextuality – the interrelationship and consequent transformation of different texts – we have an account of a past that was shaped as the official

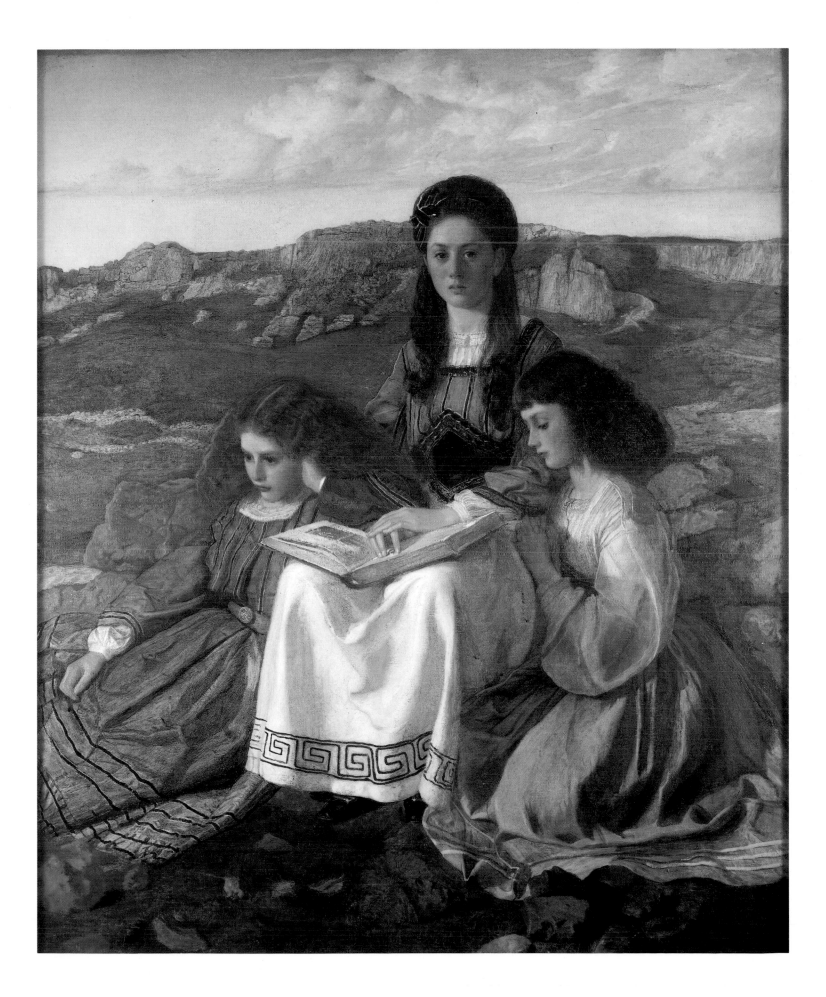

267 (right). Domenichino, *The Vision of St Jerome*, oil on canvas, 51.1 × 39.8 cm., before 1603. National Gallery, London.

This painting, which had been in the national collection since 1831, offered Richmond a model for 'great clearness and purity of colouring'.

266. Illustration to *Enoch Arden* by Alfred Tennyson, designed by Arthur Hughes, published by E. Moxon & Co., 1866.

The poignant narrative of domestic happiness and its loss which Tennyson recounts in *Enoch Arden* was a part of the conditions within which Richmond, by his own account, produced his portrait of the Liddell sisters.

(biographical) account and that invites us to understand the emergence of a child-portrait out of a particular intertwining of personal and cultural imperatives. Richmond is presented both as the author (and authenticator) of the picture and of its production as historical truth; he is also positioned in the account as object of the reader's scrutiny, as a subject in history. Two significant cultural products establish the *locus in quo* of the painting's production. *St Jerome*, part of the Revd Holwell Carr's 1831

bequest to the National Gallery, places Richmond's endeavours in a long tradition of great painting, a tradition that the foundation of the National Gallery earlier in the century illustrates and whose survival on British soil it also ensures. Tennyson's reputation as the greatest poet of the age was secure by 1864 when *Enoch Arden* was published. The ability of his verse to move the stern Oxford don established a paradigm of what art might and must do.

It is problematical to attempt to discover any *direct*

268. Detail of pl. 265,
Richmond, *Lorina, Edith and
Alice Lidell*.

relationship between Richmond's portrait of the Liddell daughters and these two points of cultural reference; yet they do not, on further examination, appear to be accidental. They are prominent in the account which concludes with Richmond's liberation from youth and his personal advance into adult professional life. 'I knew', he wrote, 'that that picture marked the end of the first period of my work as an artist – that I should never do the like again. I had come to the end of a tether which bound me directly to my boyhood.'[142] St Jerome in the desert with his lion – the model of the learned hermit – is shown by Domenichino writing, while turning to look at an angel who brings him divine inspiration. While painting these children of quite exceptional beauty Richmond thought about the image of this great model of stoicism and celibacy. While living in the comfortable circumstances of the Liddell holiday home, he thought of a representation of a hermit in the desert. While painting three young girls, he thought of an image of an old male saint. *Enoch Arden* is a poem that dwells painfully upon the loss of the promise of childhood and the power of 'things seen' over 'things heard'. Enoch Arden, Philip Ray and Annie Lee were childhood friends, both boys in love with Annie; Enoch wins Annie and marries her, but when he is shipwrecked and disappears for ten years, Annie, now poverty-stricken, eventually agrees to marry Philip. The scene where Enoch returns and sees the family through the window but decides to leave unobserved and (like St Jerome) to return to a desert of self-denial, is the episode that moved Dean Liddell to tears.

The importance of these imaginative moments of psychic drama in an ostensibly controlled account of the maturation of a Victorian artist is that they occur around the production of a portrait of female children. The loss of childhood is, in *Enoch Arden*, linked to a moment of vision from which the subject is excluded. Enoch is the voyeur who, like the artist, looks in on the scene of domestic happiness, a scene that is inerradicably linked with his own lost childhood, and that having looked upon he must leave. St Jerome offers the counterpoint to this experience in the model of the divine gift and the life of self-denial. And Domenichino's *St Jerome* provides the guarantee not only that it is worthwhile – that the dedicated artist can produce objects of great beauty that hang in national galleries – but also that clearness and purity of colouring (the 'great merit' of Richmond's picture as well as of Domenichino's) can be employed to re-present and therefore to control the tame cat's victims who might otherwise transform themselves, like Dodgson's young friends, into Lewis Carroll's little girls.

EPILOGUE
'SAVED FROM THE HOUSEKEEPER'S ROOM': THE FOUNDATION OF THE NATIONAL PORTRAIT GALLERY, LONDON

Universal History, the history of what man has accomplished in this world, is at
bottom the History of the Great men, those great ones; the modellers, patterns,
and in a wide sense creators, of whatsoever the general mass of men contrived to
do or to attain.[1]

What a variety of natural thoughts are conjured up by the sight of a portrait!
Tender, pathetic, grave, gay, humorous, every feeling of the heart, every quality
of the mind, may be excited by portraits.[2]

In June 1864, George Scharf, the first Secretary and Keeper to the National Portrait Gallery, London, wrote to the chairman of the Gallery's trustees. Summing up for the Earl Stanhope the duties that he had performed (many of which he regarded as voluntary), he describes how, in addition to the work of correspondence, registering, collecting biographical notes, preparing catalogues and superintending the apartments and servants, he has, from the first, 'made it an invariable rule to sketch, trace and minutely describe every picture that has been brought under the notice of the Trustees' (pl. 269).[3] Scharf's notebooks (the property of the Gallery) also contain visual data on corporate and private collections he visited and on portraits he saw in salerooms. In 1860–61 he visited Windsor, took tracings at Hampton Court, took 'cabs to all parts of London to inspect portraits' and purchased engraved portraits for reference portfolios.[4] He visited Blenheim, Knole, Arundel, Welbeck and Gorhambury as well as countless other country seats, a practice he was to continue throughout his life.

Son of the Bavarian-born draftsman of the same name, Scharf was probably a more talented artist than George Vertue,[5] but the procedures the two men adopted were not dissimilar. What Vertue had begun as an obsessional private activity (though he came to earn his living by it), Scharf completed as a civil servant. When Vertue went to a sale of pic-

tures in Covent Garden in April 1730 and saw a Hoogstraten of 1663, he noted down the details (pl. 270): 'a still life painting . . . an Almanack. 1663 gold medal. hanging & the picture of the Author a black ebony frame his hair long & reddish'; and drew in the margin alongside an ink sketch of the self-portrait contained in the still life.[6] Visiting Knole in September 1874, Scharf had the advantage of reference works like Redgrave's *Dictionary* (which he rather unreasonably criticized for not including

269. Portrait of John Milton, traced by George Scharf in 1863, pencil, George Scharf's notebooks. National Portrait Gallery Library, London.

Scharf has annotated his tracing to indicate inscriptions on the panel and colour. Later, in 1882, when the painting was sold he recorded the information in ink on the drawing.

270. Detail from George Vertue's notebook, April 1730, MS. By permission of the British Library, London.

Vanloo and Speiring).[7] But above all, Scharf could – and did – make use of James Granger's *Biographical History of England*. Granger provided a means for the processes of authentication that occupied much of Scharf's time. Centralizing and institutionalizing the discourses of national history, the foundation of the National Portrait Gallery made public, ideological and pedagogic the Rector of Shiplake's interests.[8] Granger and Bromley had succeeded in systematizing and popularizing the collecting of engraved portrait heads, shifting the emphasis from the acquistion of antiquarian knowledge by individuals to notions of a national history that was accessible to all. Moreover, they had established a major reference collection: although the National Portrait Gallery trustees sought oil paintings in the first instance, the project was heavily indebted to Granger for his narrative of a national biographical history and for his detailed recording of particular historic portraits. A century before Scharf, Granger had established a network of correspondents and informants, visiting country houses and recording details of their collections. W.F. Erwin, writing to Granger in September 1770, described a tour in which he had managed to see the residue of the Clarendon collection at Lord Hide's (*sic*) and also to visit Lord Salisbury's, 'where there are many good pictures perishing by neglect', Lord Bute's, Lord Essex's and Kings Weston, 'which abounds with portraits'.[9] The concern with conservation, the interest in provenance and the willingness to pool information are also familiar characteristics of the hubbub of activity that the nascent National Portrait Gallery generated in the 1860s and 1870s.

Granger's *Biographical History* was of immense practical use and remained the first measure and standard for matters of identification and authentication. Thus Scharf set his clerk, Goodison, the task

of marking the engravings in the National Portrait Gallery's portfolios when he found them described in Granger.[10] Granger was also the standard reference for more general discussions of portrait history and is frequently invoked in mid-century by writers on portraiture.[11] In 1841 the Granger Society was established 'for the publication of Ancient Portraits and Family Pictures'; the president was the Marquess of Salisbury, and it boasted fifteen local secretaries from Glasgow to Yarmouth. Claiming that 'our possessions of this description have never been adequately appreciated or sufficiently made known, or preserved with becoming care', the object of the Society's 295 members was to produce annually an engraving of an historic family portrait, to be published without alteration.[12] The Society seems to have been in competition with the project organized by G.P. Harding, the Colnaghis and the Smiths and patronized by the Marquess of Northampton, which had commenced in 1840 with similar objectives and which in 1843 took over the Granger Society.[13]

The national portrait gallery is a phenomenon exclusive to the industrialized west, to the English-speaking nations, and to the modern period commencing around the mid-nineteenth century, a period characterized in Britain by increasing parliamentary power, constitutional debate and colonial expansion. Portrait galleries were founded as state-controlled enterprises in London in 1856, Edinburgh in 1882 and Dublin in 1884. The National Portrait Gallery in Washington which opened in 1968 has been described as 'a twentieth-century afterthought',[14] but it is in fact very much in the tradition of the nineteenth-century galleries in terms of its founders' aspirations and the politics of its establishment.

Attempts are often made – not least by the original

228

advocates of these foundations – to establish precedents for national portrait galleries. While the notion of a national Pantheon, a Valhalla, or an Athenian or Florentine collection of *uomini famosi* provides a source of inspiration, the national portrait gallery is a distinctive organism. It does not (like a Pantheon or a Valhalla) provide the burial place for heroes, nor does it properly (like Stowe's Temple of Worthies) contain posthumously depicted subjects. Moreover, although some would have liked the National Portrait Gallery in London to be a temple of worthies (excluding celebrated but morally unworthy subjects) the trustees would insist that great faults and errors would not be sufficient ground for excluding a subject if they were thought to be valuable as illustrating the history of the nation. Those who advocated a policy of exclusion on moral grounds differed markedly from the position adopted by Evelyn or Walpole for whom, as we have seen, infamous and notorious characters were part of an overall structure, their presence a vital counterpoint to, and diversion from, the exemplary life. Unlike family galleries such as Sir Walter Scott's at Abbotsford, the National Portrait Gallery is not shaped by a particular dynastic ideal, and unlike the humanist portrait gallery formed, for example, by Lord Clarendon or Sir Robert Peel,[15] it is not a private collection but designed from its inception for mass public consumption. It is also to be distinguished from what was regarded as the largest modern collection of portraits, the Versailles Museum, which contained thousands of portraits of individuals of varying nationalities, battle paintings, memorials and other mementos.[16] Scharf visited this collection in 1868 but dismissed Louis Philippe's efforts to create for his reign a visual reconstruction of the past, saying that he observed there 'many rooms . . . filled with large whole-length and purely imaginary portraits of kings, constables, grand marshals, and various commanders prominent in French history'.[17]

In many instances, the portraits in the national portrait galleries come direct from family picture collections of great antiquity, but their transference into the public, state-controlled domain effects a transformation in their meaning and use value, as a consequence of which those family affiliations and histories are commoditized for regulated public consumption. The foundation of the portrait galleries thus manifests the two-way process whereby in the nineteenth century the ancient landed families responded to the reformist and democratizing appeal of legislative moves like the Reform bills, by laying forth their family treasures (as for instance at the Manchester Art Treasures exhibition in 1857) and, at the same time, allowing those very objects consumed in the public domain to reinforce the strength and separateness of ancient hierarchies of power whose members were visibly and tangibly present in the objects before the public gaze. And this was, perhaps, particularly true of the series of great portrait exhibitions at South Kensington in the late 1860s which helped to ensure the formal and permanent foundation London's National Portrait Gallery.

* * *

The first formal proposal for a national portrait gallery as a part of the state apparatus coincides with the rise of Napoleon, whose cultural imperialism made a considerable impact this side of the channel. In 1799 Noel Desenfans, an entrepreneurial (French-born) picture dealer whose bequest to the painter François Bourgeois (of Swiss birth), now in the Dulwich College Gallery, provided the impetus to what was effectively England's first public picture gallery,[18] published a plan to preserve portraits of the most distinguished characters of England, Scotland and Ireland.[19] His essay included a review of the fine arts and a plea to collectors to patronize British artists and to enrich London with pictures and other objects that could be made publicly available. Central to Desenfans's argument is, however, the need for a national portrait gallery.[20] It is the commemoration of military heroes that provides the initial impetus for Desenfans's scheme. Monuments to various military figures are about to be erected in St Pauls,[21] and this, Desenfans argues, is an auspicious moment at which to recognize the need for 'a public gallery appropriated to the portraits of our distinguished characters'. Europe does not possess such a gallery, and 'Great Britain, ever eager to exalt merit [and] set other nations the example of an establishment which cannot fail proving a stimulus to emulation in every class', should rectify the situation without delay.[22] The relationship between military commemorative art and national portraiture underlies the foundation of all national portrait galleries.[23] George Frederick Watts's Hall of Fame originated in the artist's concern to record men who had served in the Crimean War,[24] and ideas for an American national portrait gallery were first seriously mooted following the First World War. It is also clear that the Director of the National Portrait Gallery in London during the crisis in the Balkans prior to the outbreak of the First World War perceived a particular relationship between the defence of democratic ideals and the encouragement of a sense of national (and European) history.[25]

Beginning with the reign of George III in 1760, Desenfans's plan lacks the concern with early British history that was a salient feature of the debates around the formation of the National Portrait Gallery in the 1860s, but his notion of the social and political

functions of art are worthy of the highly developed ideology of public cultural control contained in Sir Robert Peel's notorious declarations of almost half a century later:

> The revival of the Fine Arts has been a source of more benefits to Great Britain, than a superficial observer, who looks on them as an amusement, would be led to suppose: they not only amuse, but are a profitable occupation: and by opening the mind, and habituating our youth to employment and industry, they ward off vice and dissipation.[26]

Desenfans suggested that Montague House, then home of the British Museum, should be the location for a gallery which would contain national portraits plus works in other genres. Montague House already contained a collection of portraits presented by Dr Gifford in 1758, which grew to 150 by 1855[27] and which was eventually transferred to the National Portrait Gallery. But no steps were taken to adopt Desenfans's suggestions as an overall scheme until the 1850s. Then, as a result of the interest of David Laing of the Society of Antiquaries of Scotland, of Thomas Carlyle, and in London of the Earl Stanhope, the idea of a national portrait gallery was revived. Laing and Carlyle were interested in Scottish biographical history and the latter, whose lectures in 1840 on heroes and hero-worship had already made a considerable impression, wrote to his friend on 3 May 1854:

> It has always struck me that Historical Portrait Galleries far transcend in worth all other kinds of National Collections of Pictures whatever; that in fact they ought to exist . . . in every country, as among the most popular and cherished National Possessions: – and it is not a joyful reflection, but an extremely mournful one, that in no country is there at present such a thing to be found . . . I hope you in Scotland, in the 'new national museum' we hear talk of, will have a good eye to this, and remedy it in your own case! . . . in all my poor Historical investigations it has been, and always is, one of the most primary wants to procure a bodily likeness of the personage enquired after . . . *any* representation, made by a faithful human creature, of that Face and Figure, which *he* saw with his eyes, and which I can never see with mine, is now valuable to me, and much better than none at all.[28]

The correspondence was reported and discussed in the *Athenaeum* in 1855 where, agreeing with Carlyle, one writer suggests that 'if a beginning were once made, it would not be difficult to avert' what is now described as 'a national shame'.[29] Another recalled that the Earl Stanhope, then Lord Mahon, had spoken in the House of Commons and was assured that the question of a national portrait gallery had

been under consideration and would not be forgotten but must be postponed for the present.[30] The following year, speaking in the House of Lords, the Earl Stanhope revived the proposal on precise utilitarian grounds. A national portrait gallery would, he argued, afford not only great pleasure but much instruction of the industrious classes and would also prove of great use to painters who desired to treat subjects from English history. The chamber in which he spoke was already decorated with a fresco by William Dyce, *The Baptism of King Ethelbert*, and with other scenes from English history by C.W. Cope and J.C. Horsley, and the Royal Academy exhibition was annually packed with pictorial renderings of national myths.[31] In support of his case he read a letter from Carlyle in which the latter claimed to have 'found a portrait superior in real instruction to half-a-dozen written biographies . . . or rather . . . the portrait was as a small lighted candle, by which the biographies could for the first time be read, and some human interpretation made of them'.[32]

Carlyle was appointed to the Board of Trustees of the National Portrait Gallery by a resolution passed on 16 February 1857 and published in the *First Report of the Trustees* . . . (5 May 1858). He replaced the Earl of Ellesmere who had died, but, despite his pronounced views on portraiture, Carlyle seems to have shown little active interest in the responsibilities of a trustee. Other trustees drawn from the professional classes were Sir Francis Palgrave,

Benjamin Disraeli and Sir Charles Eastlake. It is tempting to see the appointment of a board of trustees for the National Portrait Gallery as part and parcel of what Janet Minihan has termed the nationalization of culture in nineteenth-century Britain,[33] a process whose landmarks are the opening of the National Gallery in Pall Mall in 1824, the Select Committee of Arts and Manufactures which sat in 1835 and 1836 and which led to the foundation of the School of Design in 1837, the Select Committee on Fine Arts of 1841 which led to the competitions of 1843 and 1844 for the decoration of Barry's new Houses of Parliament, the Museums' Act and Museums' Bill of 1845 which laid down the conditions for the establishment of municipal museums and determined their responsibilities, and last but not least the 1851 Great Exhibition and the subsequent development of South Kensington as a cultural mecca.

The mid-1850s were a most opportune moment to call attention to the need for a national portrait gallery. Sir George Hayter's gigantic portrait of the members of the House of Commons, painted in 1833 was exhibited in 1843 to anyone willing to pay the one shilling entry fee (pl. 272).[34] In 1848 the London Shakespeare Society arranged for the engraving by subscription of the Chandos portrait of Shakespeare (pl. 271).[35] Well-publicized discussions were taking place throughout 1856 about a suitable site for the National Gallery and in 1857 the Sheepshanks deed which effected the bequest of a major collection of British art to South Kensington was laid before the House of Commons.[36] But while the National Portrait Gallery was part of this process, the conditions that allowed the project to be realized by slow stages between 1856 and the opening of its doors in its own building in St Martin's Place in 1896 were produced by the intense preoccupation with the English past on the part of a distinguished group of Victorian historians. The *Builder* described this 'wider influence' in dramatic terms:

> Lately we have been aroused from a deep sleep in regard to historical studies; and we begin to feel that portraiture and sculpture have powerful bearings on these studies. A result of success in the contemplated crowded exhibition will assuredly tend to make historians more and more teachers of true greatness, by associating it more and more with goodness.[37]

In the case of the National Gallery, the practice of connoisseurship and the development of art-historical

272. Sir George Hayter, *The House of Commons, 1833*, oil on canvas, 300.3 × 497.8 cm., 1833–43. National Portrait Gallery, London.

Hayter's enormous group portrait, containing nearly four hundred figures and intended as a spectacular celebratory experience in the manner of a panorama, was purchased by the government and given to the National Portrait Gallery in 1858.

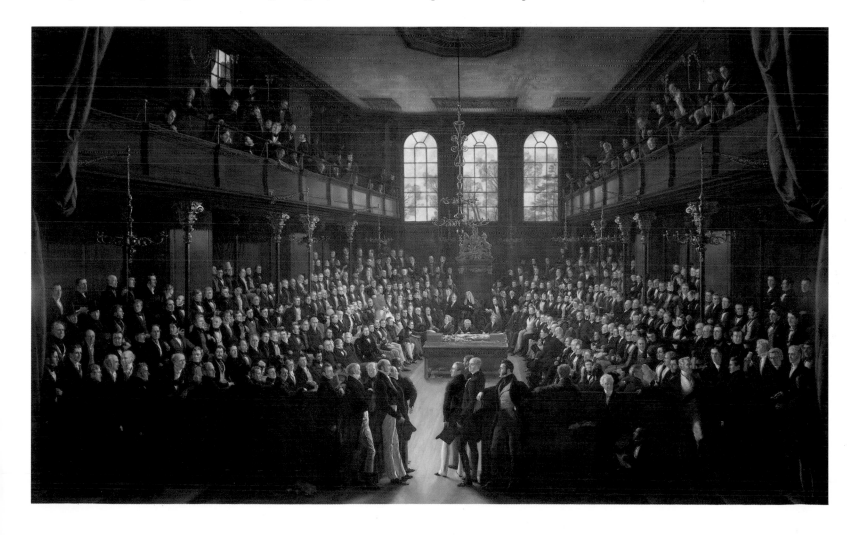

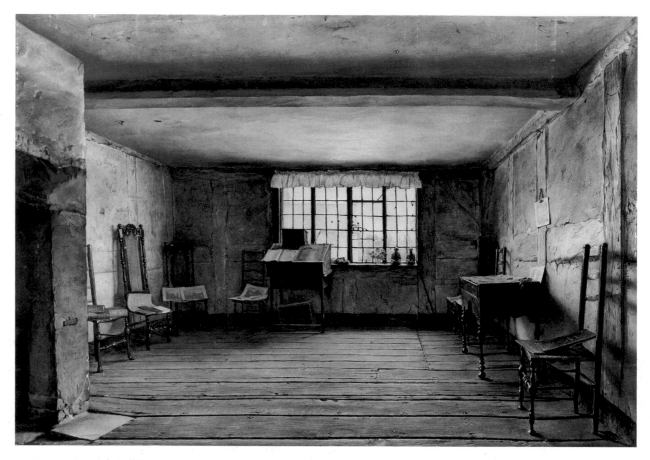

273. Henry Wallis, *The Room in which Shakespeare was Born*, oil on panel, 29.1 × 42.8 cm., 1853. Tate Gallery, London.

The poignantly vacant space depicted in graphic detail by Wallis is one manifestation of the passionate interest in Shakespeariana in the 1850s. As a composition, it invites spectators to fill the empty stage with figures from the past, testifying to the imaginative engagement with the history of a national culture.

methodology in the English language through the writings of Lord Lindsay, Sir Charles and Lady Eastlake, Anna Jameson and others evolved as a consequence of the government's purchase of the Angerstein collection and of the subsequent Beaumont gift which together formed the basis of the National Gallery.[38]

The competition of Britain with other European countries (particularly Germany) in the post-Napoleonic period to acquire what was considered the best of Renaissance art further necessitated the development of specialist professional skills.[39] In the case of the National Portrait Gallery – which was never so generously funded as the National Gallery and the South Kensington Museum but which was passionately supported by a powerful lobby – a series of major publications throughout this period lent authority to appeals for a national portrait gallery and provided the scholarly and imaginative rationale for the project.[40]

Carlyle's 1840 lectures were not confined to English or Scottish subjects, but they established the idea of an ability to see into 'the very marrow of the world's history'[41] through the discerning practice of historical biography. Macaulay's *The History of England from the Accession of James II* was published in five volumes between 1848 and 1861 and went into

many different editions. Dickens's *A Child's History of England* was published 1851–3, and Froude's *History of England from the Fall of Wolsey to the Defeat of the Spanish Armada* was appearing throughout the late 'fifties and early 'sixties and received great attention in the press at that time.[42] Green's *A Short History of the English People* appeared in 1874. With the intention of attracting the popular market, Charles Knight, from 1837 over a period of seven years, published instalments from George Craik's and Charles MacFarlane's *Pictorial History of England*, followed from 1850 on by *The Popular History of England*.[43]

The most poignant claim from a retrospective view is Henry Wallis's painting *The Room in which Shakespeare was Born* (pl. 273). Executed in 1853, this can be construed as part of the discourse that sought to accommodate in visual form the nation's history through its great men, most memorable among whom was understood to be Shakespeare. Wallis shows an upper room utterly, and gleamingly, empty except for a basic chair or two lined against the walls and the busts and the death mask of the poet which lie on the window-sill. There are marks of time's wear and tear: graffitti on the walls, shrunken floor-boards and cracked window-pane, all recorded with Pre-Raphaelite precision. The painting rep-

resents an absence, a space whose significance is dependent on our understanding of the passage of time which has removed the crucial presence that lent the room its meaning. The space is waiting to be filled; it is the embryonic and paradigmatic national portrait-space.

During the course of the nineteenth century there were increasing opportunities to see national portraits. The British Institution showed 183 national portraits loaned from private individuals in 1820, and in 1846 a similar exhibition was organized of 215 international portraits. The Manchester Art Treasures Exhibition of 1857 included a gallery of 386 British portraits arranged by Peter Cunningham in the tradition of Fuller's *Worthies*, the *Baziliwlogia* and the *Herwologia*;[44] George Scharf, from a career as a jobbing illustrator, occasional lecturer and writer, aspiring antiquarian and theatre designer, had been appointed Art Secretary and Director of the Gallery of Old Masters in Manchester. Like Seguier, the first Keeper of the National Gallery (and like Desenfans and Bourgeois), Scharf was a first generation immigrant and relatively self-educated. Power resided then, as now, with the chairman of the trustees and his board, 'men equally distinguished for their social position and for their connexion with literature and art';[45] so when Scharf was appointed Secretary and Keeper to the National Portrait Commission (as the board was first known) in February 1857, his role was essentially that of subordinate administrator. By December 1857 Scharf was installed at 29 Great George Street, Westminster, which would be the temporary home of the National Portrait Gallery until its removal first to South Kensington, then to Bethnal Green and finally to St Martin's Place in 1896.

The first portraits were acquired by the trustees: in 1856 the Chandos portrait of Shakespeare was given by one of their number, Lord Ellesmere, and the anonymous portrait of Sir Walter Raleigh (pl. 274) was bought from the Downton House sale in 1857. Their first meeting had taken place the same year on 9 February when Carlyle had been appointed to fill the gap left by the death of Lord Ellesmere.[46] The trustees' first report, published in May 1858, lays down the regulations that, with some amendments, shaped the formation of the collection. Most significant were the clauses that directed acquisitions policy according to the celebrity of the person and his or her ability to contribute to the illustration of the nation's history without bias to any political or religious party and without consideration of great faults or errors. Anxiety about the ephemeral character of reputation and about the possibility of families off-loading their unwanted heirlooms was reflected in clauses that prevented the admission of portraits of living persons apart from the reigning

sovereign (though this clause was subsequently tempered) and the requirement of a three-quarters majority for approval of a gift. A special case was to be made for accepting a portrait of anyone deceased less than ten years, and no modern copies were to be admitted.[47]

Initially the portrait collection was available for inspection only on application, but this did not prevent the *Art Journal* from conducting a campaign against it throughout 1858. Comparisons were made with the Ritratti dei Pittori at Florence, and the trustees were criticized for failing to spend all of their two thousand pounds purchase fund. As the Gallery still had only thirty-five portraits, the nation was 'just about as far from having a National Portrait Gallery, in any national sense of the word, as it was when the trustees took the matter in hand'.[48]

274. Anon., *Sir Walter Raleigh*, oil on panel, 91.4 × 74.6 cm., 1588. National Portrait Gallery, London.

By the time the Second Report was published on 11 July 1859 the Gallery had, as the *Art Journal* put it, 'at length taken the bolt from its door, in Great George St, and let in the public'.[49] The Gallery was open on Wednesday and Saturday to those who had purchased tickets in advance. Gratification was expressed by the trustees at 'the great numbers of intelligent visitors who have come to view the pictures'.[50] A catalogue had been compiled 'containing short biographical notices, free, it is hoped from the smallest imputation of any party spirit, of all the persons represented in the portraits'.[51] In 1860 over Easter weekend (the national holiday for working

233

275 (facing page left). George Scharf, *View of the National Portrait Gallery at South Kensington*, watercolour on paper, 35.1 × 25.1 cm., 1887. National Portrait Gallery, London.

On the end wall is Winterhalter's portrait of Prince Albert, a replica painted in 1867 of his 1859 portrait and given to the Gallery by the queen in that year. On the left is a large watercolour of Queen Victoria painted by Lady Julia Abercromby in 1883 after Heinrich von Angeli's portrait of 1875 and given by the copyist to the Gallery in that year.

276 (facing page right). George Scharf, *View of the National Portrait Gallery at South Kensington*, watercolour on paper, 35.1 × 25.1 cm., 1880s. National Portrait Gallery, London.

This view shows the Tudor monarchs with the electrotype of Mary Queen of Scots on the immediate right (see pl. 290).

people) the Gallery was open free of charge, and admission figures began to be kept. That Easter Monday saw 771 visitors (with 440 and 426 on the two successive days), and more attendants had to be appointed.[52] In 1862 begins what was to become a seemingly endless series of complaints about lack of space since the collection now numbered 139 works, and attendance figures for the year had leapt from 6,392 in 1860 to 10,907 in 1861.[53] Scharf was always keen to report the presence of well-behaved 'young lads and factory boys',[54] the attentiveness of children, 'even charity children, and those belonging to the humblest classes', and the good conduct of 'working men in rough clothes'.[55]

By 1862 Earl Stanhope, William Smith (one of the most active trustees) and Scharf were working in concert to negotiate space for the National Portrait Gallery at South Kensington in the apartments used for the 1862 International Exhibition.[56] The press was also agitating for more space, greater visibility and for the release of what critics were convinced was a hidden national treasure trove. The 'overcrowded chambers of a private dwelling-house' were considered inappropriate for the nation's 'Walhalla' and, it was felt, if only space were provided, 'the stores of portraits of English worthies on canvas, in marble or plaster . . . lying as it were dormant and unknown' since the last civil war would reappear.[57]

It seems quite possible that the National Portrait Gallery would have continued this twilight existence had it not been for Lord Derby's suggestion, made in a published letter of 6 May 1865, for a chronological series of loan portrait exhibitions, spanning the period from the Plantagenets to the present and 'affording an opportunity of tracing the progress and conditions of British art at various periods . . . and afford[ing] valuable materials for history', to be displayed in the arcades that had served for the Refreshment Room for the 1862 Exhibition.[58] Lord Derby was nearing the end of a colourful career; an ardent supporter of the Reform Bill and a leading whig politician, he had held high office and would again form a ministry in 1866 on the resignation of Russell. His suggestion was supported by (and perhaps instigated by) the Earl Stanhope who, unlike Lord Derby, was an accomplished historian and since the 1840s had occupied himself mainly with cultural matters such as the British Museum, the Royal Literary Fund and the Historical Manuscripts Commission. There were ample precedents for loan exhibitions in the British Institution's activities earlier in the century. Moreover, the Department of Science and Art (which administered South Kensington) had mounted an exhibition of miniatures organized by Samuel Redgrave in 1865, and the success of this encouraged the uniting of the resources of Great George Street with those of the

celebrated ancient families of Britain for a series of large displays.

The first special exhibition in 1866 ended with the reign of James II and contained, therefore, many works that Samuel Redgrave found it diplomatic to describe as 'rude' but none the less 'full of character', able 'to impress us with their truth'. Adopting the discourse of a living past he asserted that 'the persons are before us, wearing the very dress and ornaments of their time; and as we advance, we trace the steps by which with these first qualities, an art was combined, that had not yet been excelled in some of the essential qualities of portraiture'.[59] While doubting attributions of both subject and artist in many instances, the organizers adopted the only practicable measure – to accept the owners' attributions even when they conflicted with those of other exhibited items. The exhibition thus served to promote antiquarian and connoisseurial studies, many of which were published as pamphlets by Scharf. The following year a similar exhibition of works commencing with the reign of William and Mary was put on display, and in 1868 portraits from the reign of George III to 1867 were shown. The exhibitions, Redgrave claimed, not only demonstrated the nation's vast reserves of portraits ('the number seems almost without limit') but also awakened the owners of pictures to the true value of their possessions, many of which were of national interest. The exhibition would be justified if it were to

lead to greater care that the identity of family portraits is not lost by consignment to the housekeeper's room, or even to the attics; if it saves the portraits from destruction by cruel exposure to the sun till all traces of colour and the finer qualities of the art are hopelessly dried out; or by exposure to damp or changes in temperature, so particularly injurious to early portraits on panel; or worst of all, subjection to greater dangers in the hands of incompetent repairers, who, in the attempt to restore what is irretrievable, destroy the only remains of original art which may have been spared.[60]

In general the reception accorded the South Kensington portrait exhibitions favoured the later periods. The Plantagenets to the Stuarts was regarded as 'too extensive for satisfactory illustration' and the art was 'often of inferior quality'.[61] But not everyone was content with the subsequent exhibition; one observer complained that 'the glorification of Sir Joshua Reynolds and Gainsborough' was being achieved at the cost of any serious representation of their contemporaries.[62] But the success of the exhibitions as a popular attraction ensured that from 1870 the National Portrait Gallery would remain at South Kensington (pls 275, 276), where admissions

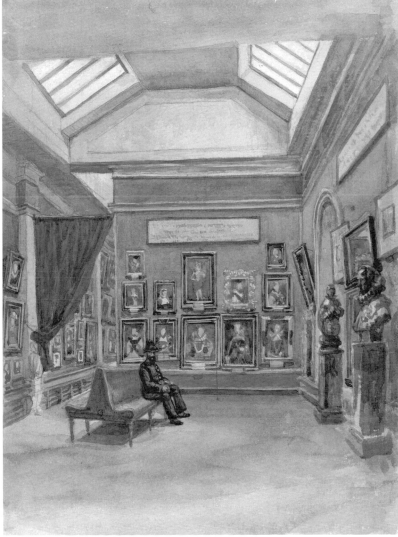

figures rose dramatically. Great George Street had seen 34,497 visitors, now 58,913 would visit South Kensington.[63] The buildings in which it was accommodated were wooden and posed a perpetual fire risk (fires broke out in the complex of sheds, housing not only the National Portrait Gallery but also other South Kensington collections, in 1871 and again in 1885, when part of the Indian Museum was destroyed) (pl. 277).[64] As a result of public concern, the whole collection was moved to Bethnal Green, also run by the Science and Art Department, as a two-year loan. There, however, it was thought to be 'as much out of the reach of the general public, and especially of the student, as if it had been transferred to Kamtchatka, and where it affords no attraction whatever to the surrounding population'.[65] The same kinds of observations on the inappropriateness of locating fine art in the East End of London were voiced when Sir Richard Wallace's collection was housed temporarily in Bethnal Green Museum in 1872 while Hertford House was being renovated.

Whilst everyone agreed on the desirability of well-behaved artisans visiting exhibitions, it was felt in some quarters that extending cultural provisions into the areas actually inhabited by the labouring classes was to overstate the case. This revived a long-standing debate about which publics the national galleries should endeavour to educate, and with which objects. The *Art Journal* in 1859, for example, had pointed out that a courtly master of ceremonies, in attendance on the National Portrait Gallery's worthies, might think that some of the rough aprons and paper caps that made their way to the National Gallery and the British Museum were 'scarcely the fit persons to bring into the presence of La Belle Hamilton, Duchess of Gramont' (pl. 278). On the other hand, the writer says, we should question whether La Belle Hamilton is the sort of person whom 'Parliament intended that the trustees should offer to the working public as one of the first and most illustrious examples of British worth'.[66]

When the National Portrait Gallery did finally

277. George Scharf, *View of the eastern extremity of the National Portrait Gallery at South Kensington with approaches*, pencil on paper, 25 × 35 cm., 1880. National Portrait Gallery Library, London.

The India Museum Shed is the building to the right, and, as though anticipating a conflagration, Scharf has annotated all the wooden structures on his drawing.

move into its own purpose-built accommodation in St Martin's Place in 1896, it was as a consequence of that peculiar compromise between private benefaction and state legislation that characterized the national regulation of culture in the nineteenth century in Britain. In 1889 Mr W.H. Alexander made an offer to the government to build a National Portrait Gallery at his own expense; the building cost ninety-six thousand pounds, of which Mr Alexander provided eighty thousand.[67] The *Athenaeum* complained that the rooms were small and insufficiently lit and that the gallery lacked the spaciousness and the flexible arrangement of bays and screens that Scharf had used at South Kensington.[68] But *Punch* thought these itinerant British celebrities must be glad to have found a permanent home at last and, in the manner of Ruddigore's ancestors in Gilbert and Sullivan's opera, represented Queen Elizabeth I and Sir Walter Raleigh descending from their frames to express their satisfaction with their new premises in London's West End (pl. 279).[69]

* * *

278. (Called) *Elizabeth (Hamilton), Countess of Grammont*, attributed to John Greenhill, oil on canvas, 141 × 139.7 cm., *c.*1665. National Portrait Gallery, London.

Samuel Redgrave justified the National Portrait Exhibition as a state-sponsored intervention in the interests of conserving the nation's patrimony; in so doing he heralded the era of what is now popularly known as 'Heritage'. The development of a conservation-conscious generation of keepers and a class of professional connoisseurs was not confined to portraiture.[70] But since the study of portraits linked the traditional antiquarian enquiries into family and county histories (and back through genealogy to the

236

matter of Britain) to a newly 'scientific' approach to material objects, it can be seen as a branch of art where the controlling discourses of preservation have a particular pertinence. Scholars, adventurers and dilettanti might argue publicly about good or bad Raphaels, but in the case of the National Portrait Gallery the objects concerned were representative of distant cultures and distant times that were crucially British, or more narrowly, English. Moreover, portraits at an emblematic level represent people we might have known – they are signs of the particularity of a known historical individual. At a material level they are also traces of the actual existence of past ages; the artefact is understood to act as a bridge between the mental and physical worlds, between past and present and, as Daniel Miller points out, between consciousness and the unconscious.[71]

The special (magical) properties of portraits surface in myth and in people's attempted management of their surroundings not least in the developed western societies. The naming of the youth-culture magazine *The Face* is hardly accidental, and the destruction by Lady Churchill of her husband's portrait was merely one notorious case in a long tradition of iconoclastic acts perpetrated on portraits by relatives.[72] It is also a sensational example of that iconoclastic action that occurs each time an individual tears up a photograph in temper, or in shame, or transforms a

politician's image by inscribing it with spectacles or a moustache. Jacob Rothschild, it is alleged, was more concerned to have Lucien Freud's portrait of him featured on the front cover of *The Times Saturday Review* (pl. 280)[73] than to engage in a dialogue with a journalist by whom he had agreed to be interviewed. The fact that (as he readily announced) the portrait was hung in his office only because his wife disliked it, further compounds a narrative in which the subject employs the image rejected by his closest relative as a buffer between self and public, an act of manipulation that demonstrates an unreasoned faith in the power of an artefact to stand in for self.

280. Advertisement for *The Times Saturday Review*, 11 August 1990.

279. *Welcome!*, cartoon, from *Punch*, 11 April 1896.

237

281. Anon., *Richard II*, oil on panel, 213.3 × 92.6 cm., last decade of the fourteenth century. Dean and Chapter of Westminster Abbey.

In the search for the origins of English portraiture this particular image has always had a special significance. For Scharf and his colleagues, the process of cleaning permitted a sense of stripping away the layers of history.

The phenomenon of mundane objects becoming so firmly associated with an individual that they are understood as literal extensions of that individual's being is familiar to anthropologists.[74] Portraits as material objects are much less frequently sold by their owners than other genres; they embody ancestral links and are passed from generation to generation ensuring legitimacy. So when Scharf and his contemporaries examined the Westminster Abbey portrait of Richard II (pl. 281), lent to the 1866 exhibition at South Kensington, they were acting in a spirit of filial piety in an age in which the state was in the process of adopting the familial functions of guardianship in respect of the nation's treasures. They approached this ancient panel painting with a mixture of reverence and scientific curiosity. As Scharf reported in the *Athenaeum*:

> [Richard II] was not the genuine picture, but the result of successive coatings of false paint, so laid on as not only to obscure, but materially to alter the drawing and to disguise the character of the original representation. Scarcely any of the colours composing this mask of re-paint seem to have been more than one hundred and fifty years old. It has been entirely removed [by George Richmond]: and I rejoice to state that the real old picture, painted in tempera, and apparently from the life, about the year 1390, has been revealed underneath it in an almost perfect state of preservation.[75]

The expert treatment of the ancient portrait of an early English monarch thus offers a metaphor for stripping back the layers of history to provide access to an authentic past, a process that provides the rationale for the National Portrait Gallery.

The exhibiting in public of portraits from the past brought into play a further level of signification. By objectifying and personifying the past through the arrangement of artefacts that were themselves part of that past and which re-presented persons who had lived in that past, the state-sponsored National Portrait Gallery, through its trustees and their secretary, presented a series of stages in a civilizing trajectory of society and nation. Their declared apolitical acquisitions policy was endorsed by the discourses of objectivity that can be seen to link, for example, the work on evolution and change of Edouard Lartet and Charles Lyell with a narrative of national progress through portraiture.[76] Scharf explains his anxiety over identification of a portrait offered as the Earl of Essex by reference to his 'great dread of being pounced upon by certain out-siders who are far from friendly in feeling to us'.[77] The stakes may not have been so high for Scharf as for Lyell or Darwin, but the risks of public revelation were similar, as were the epistemologies adopted in their work. In this case it was a question of comparing the evidence offered by the moustaches of Essex and Endymion Porter respectively, but the deductive process by which Scharf reached his conclusions would have been recognizible to Darwin and Lyell.

The evolution of human civilization embodied in a classified sequence of historical (predominantly masculine) portraits, scientifically identified and researched, was understood to be publicly gratifying, reassuring and encouraging. 'Where the eye can pass from the portrait of one to another, as each takes the other's place in the history of the world', declared one reviewer in 1865, 'observing differences in appearance physical and moral of men following the same profession; the mind must be more definitely impressed even with the chronological order of their

existence.' As a result of the classification process, we are told, 'the spectator is equally able to trace the changes of custom and dress, and to note the merits and manners of the various artists by whom the portraits were painted'.[78]

The National Portrait Gallery is a Whig invention: Scharf's arrangement of portraits – embryonic at Great George Street and then fully developed across a series of screens erected at South Kensington – represents the sixteenth century as the watershed of the modern world. The emphasis was, from the beginning, upon the great figures of the sixteenth century and upon the achievement of the eighteenth century. For the period from the end of the reign of Queen Elizabeth I in 1603 to the accession of William III in 1689, the Gallery offered a thin account. Out of 292 portraits in the South Kensington Exhibition of 1870 only around 50 represent individuals whose adult lives and achievements were recorded in that period. Moreover, the question of balance had always been controversial: the *Art Journal*, representing a relatively demotic view, expected that 'A National Portrait Gallery of British worthies, when it shall be complete down to a given date, will, of course, represent all degrees of value, on a scale going as high in one direction as we can, – and in the other down to a line below which, of course, we will *not* go . . .'.[79] However, where this line should be drawn was not clear, and in 1860 a complaint had been voiced in the House of Commons that the National Portrait Gallery contained a portrait of Nell Gwyn but that one looked in vain for a statue of Cromwell.[80]

In the official (free) catalogue, the names of subjects were given alphabetically and, occasionally, a summary sentence of biography was supplied which served to 'place' them in the account: Oliver Plunkett (now St Oliver Plunkett) has alongside his name, 'Titular Bishop of Armagh, 1629. Executed at Tyburn, 1681'. Bishop Jewel is described simply as 'Author of the "Apology"'.[81] The narrative that the exhibition conveyed served to reinforce the notion of a constitutional continuity with Crown and Church in beneficial alliance. The optimistic and restorative view of English history – a slow process of chronicling rather than an apocalyptic or Christian view – underpinned Victorian historicism and informed the collecting of portraits on behalf of the nation, and their arrangement for public consumption, in the 1860s and 1870s.[82]

Visitors responded by returning year after year and comparing the lists they had taken away with new lists containing recent acquisitions. 'A slow walk through the gallery conveys', it was said, 'in reality no mean amount of knowledge concerning the distinguished personages in our history.' The process of acquisition year by year seemed to mirror the process

of historical accumulation, lending a seamless continuity, so that 'from Henry VIII to the Prince Consort, life-like and perfectly authentic representations of our monarchs, men of letters, statesmen, judges, generals, admirals, and orators, may be viewed in due line of succession'. The fact that Nell Gwyn's portrait was, after Shakespeare's, the 'British public's' most popular choice suggests a disjuncture between the official narrative offered in the exhibition and verbally translated in the press and the reading of the exhibition by visitors. Such events both functioned ideologically and at the same time provided opportunity for mythologization.[83]

George Scharf's detailed plans of 'hangs' year by year at Great George Street, South Kensington, Bethnal Green and St Martin's Place, augmented by drawings of the later locations (pls 283–8), provide a good deal of evidence not only for the visual effects of the acquisition policy pursued by the trustees but also for the conceptual shifts and changes in historical analysis that the juxtaposition of images allowed. In an 1861 plan of the east wall of the front room at Great George Street (pl. 283) the display is dominated by Tudor and early Stuart figures: Sir Walter Raleigh, William Harvey, Sir Ralph Winwood, the Earls of Southampton and Salisbury and the Marquess of Winchester, James I and his daughter Queen Elizabeth of Bohemia, Wolsey, John Knox, John Fox and two images of Mary Queen of Scots.[84] The trustees had purchased the Gallery's first portrait of Queen Elizabeth I in 1860 (pl. 282), but it does not appear in this display, perhaps on account of its scale.

282. Nicholas Hilliard, *Queen Elizabeth I*, miniature on vellum, 5.1 × 4.8 cm., 1572. National Portrait Gallery, London.

This precious object, purchased in 1860, posed problems of display on account of its size.

By 1863 the wall had been rehung to include not only this portrait of Elizabeth I by Hilliard but also miniatures of Henry VIII and Charles II (pl. 284). Mary Queen of Scots, increasingly an object of fascination following the success of the novels of Walter Scott and the exhibition of portraits and relics

239

283. *East Wall of the National Portrait Gallery, Great George St, front room (facing the fireplace)*, 4 November 1861, George Scharf's notebook. National Portrait Gallery, Library, London.

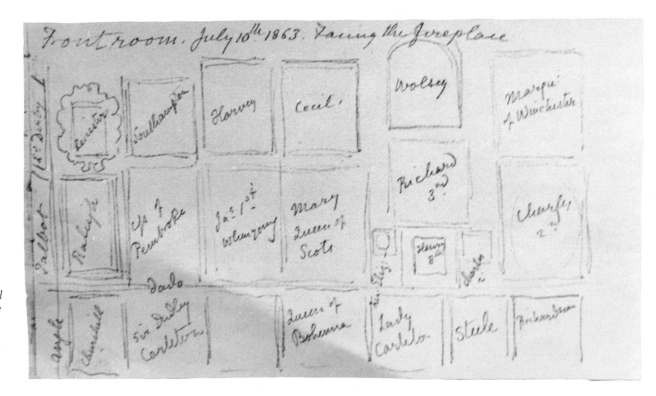

284. *East Wall of the National Portrait Gallery, Great George St, front room (facing the fireplace)*, 10 July 1863, George Scharf's notebook. National Portrait Gallery Library, London.

of Mary Stuart held at the Archaeological Institute (in Edinburgh in 1856, at their rooms in Suffolk Street, London in 1857 and in Peterborough in 1861), is here given a central position which she would hold for many years to come.[85]

This east wall remained broadly the same up to the removal to South Kensington, merely becoming more dense, with Mary Queen of Scots and Elizabeth I holding pride of place, supported by churchmen and courtiers, as can be seen in Scharf's 1866 drawing

240

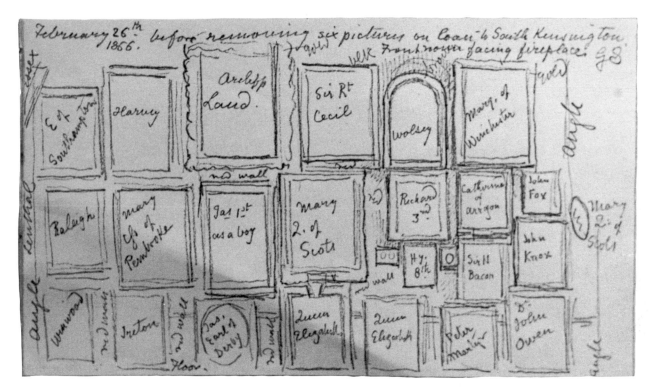

285. *East Wall of the National Portrait Gallery, Great George St, front room (facing the fireplace), before removing six pictures on loan to South Kensington, 26 February 1866, George Scharf's notebook. National Portrait Gallery Library, London.*

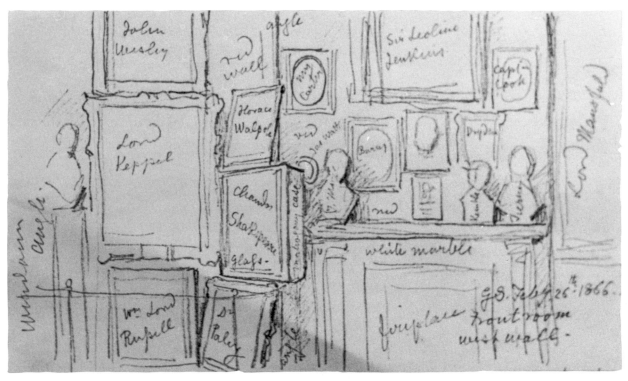

286. *West Wall of the National Portrait Gallery, Great George St, front room (wall with fireplace), 26 February 1866, George Scharf's notebook. National Portrait Gallery Library, London.*

made before six pictures were sent to the South Kensington (pl. 285). On the facing wall were hung the Chandos portrait of Shakespeare in a special case and a group of eighteenth-century figures including Horace Walpole, Lord Keppel and Captain Cook (pl. 286). The Chandos Shakespeare (pl. 271) held the central symbolic position in the gallery – it was the Gallery's first acquisition and its first gift, and it was the subject of an early piece of published research by Scharf.[86] The founders of the American National Portrait Gallery required a portrait of George Washington, Father of the Nation, to justify the Gallery's national aspirations. In London the requirement was fulfilled by the Shakespeare portrait,

287. *East side of the first screen in the Long Gallery facing the entrance, National Portrait Gallery, South Kensington, 14 September 1871, George Scharf's notebook. National Portrait Gallery Library, London.*

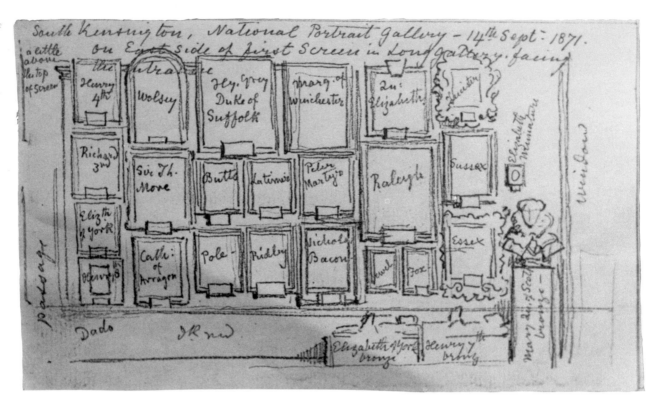

288. *West side of the first screen in the Long Gallery, South Kensington, 14 September 1871, George Scharf's notebook. National Portrait Gallery Library, London.*

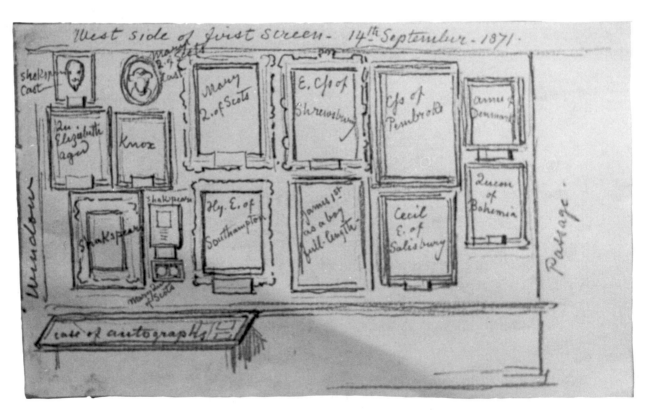

locating the embodiment of national greatness in a culturally recreated past.

In 1871 at South Kensington Scharf was able to hang not only the Chandos portrait but also an example of Droeshout's engraved head and a cast of the head from the Stratford-upon-Avon monument to the poet. Volume seven of Froude's *History*, covering the reign of Elizabeth I, had been published

in 1870, and the two sides of the first screen as hung by Scharf must have read like a visual accompaniment to Froude (pls 287, 288). Elizabeth is hung with the Marquess of Winchester (High Treasurer of Elizabeth's first parliament) on one side and her favourite, Leicester, on the other. Raleigh who, it has been suggested, embodied Victorian admiration for Elizabethan imperialism[87] and who was already printed indelibly on popular consciousness from Millais's *The Boyhood of Raleigh* (exhibited in 1870; pl. 289), hangs immediately beneath Elizabeth. Sir Nicholas Bacon, Keeper of the Great Seal hung at the lowest level with Latimer, Ridley, Jewel and Fox nearby. Mary Queen of Scots was represented in an electrotype of the effigy in Westminster Abbey mounted on a pedestal immediately beneath the miniature of Elizabeth (pl. 290). Around the other side, Elizabeth, in old age this time, hung surrounded by Shakespeare, Knox and, again, Mary Queen of Scots.

The recognition of Scharf's arrangement of portraits does not, of course, explain how people understood them. We can, however, gain some idea of the enormous shift in perceptions about the national past, the rise of an affective historicism and the political implications of constructing the age of Victoria as a second era of Elizabethan expansionism and constitutional power if, rather than, say, contrasting Walpole's Strawberry Hill with Barry's Houses of Parliament, we compare William Cowper's informal views on the past with Dickens, writing about Richard III in *All the Year Round*.

Cowper's view, expressed in 1780, 'that the present century has nothing to do with the mouldy opinions of the last' would have been incomprehensible a hundred years later. Cowper, writing whimsically but none the less revealingly, instructs the 'grave gentleman of the last century' whom he has conjured up for a meditation on history, to step into his picture

frame again 'and look as if you thought for another century, and leave us moderns in the meantime to think when we can, and to write whether we can or not, else we might as well be dead as you are'.[88] Cowper regards his forefathers as utterly strange, almost 'another species'. Their vast rambling mansions with painted casements and gothic porches, smothered in honeysuckle, their gardens surrounded with high walls are in a taste so drastically different from that of his own day that it is hard to appreciate that 'in every other respect a modern is only an ancient in another dress'.[89] For Cowper, then, the externals are all different but the essential man remains the same and, consequently, can tell us little that we don't already know. Dickens, on the other hand, recalling the east wall of the front room at the National Portrait Gallery in Great George Street, draws the attention of his readers to 'a remarkable arrangement of three portraits one above another': Wolsey, Richard III and Henry VIII – and then proceeds to describe these three representations as though they were not images but people. Drawing certainly on physiognomic theory (though later in the same article he questions the use of physiognomy by pointing out that the heroic and wise General Wolfe[90] has the sort of receding chin that the anatomist Petrus Camper would have had much to say about) he works his way from one to the other, comparing and gauging subtle distinctions, registering what is already known against what is novel, and moving all the time towards a transformation in

which the discourse concerns no longer representation but character. It is this process of elision, which seems to come so naturally, that would have been wholly unfamiliar to a man of Cowper's generation. This naturalization of the portrait was at once the cause and the result of an officially sanctioned engagement with the past of which the National Portrait Gallery was a major manifestation:

It is the third portrait [pl. 291], which divides these two, that seizes the attention most forcibly. The picture may or may not be genuine. The internal evidence is strong in favour of its authenticity. The restless misery of this face of Richard absolutely excites a feeling of pity. There is almost deformity

291. Anon., *Richard III*, oil on panel, 63.8 × 47 cm. National Portrait Gallery, London.

Dickens wrote an ekphrastic description of this image, in which the detail of the hands were the object of particular fascination.

in the features of this great criminal; the eye and the mouth are drawn up on the left side, all the parts of the face are contracted in an excess of peevish irritability, which is also expressed with remarkable force in the very peculiar action of the small woman-like hands – tell-tale extremities always. The king has screwed the ring nearly off his right little finger, working the trinket backwards and forwards in nervous anguish with the forefinger and thumb of his left hand.[91]

State involvement in the arts has always differed, as Minihan has pointed out, from bureaucratic efforts to enforce sanitary codes, or to organize industries. Throughout the nineteenth century the debate over the nationalization of culture was inseparable, she argues, from questions of national values, the future of industrialized society, and even of democracy itself.[92] The question of democracy, and by extension also of class, was deeply embedded in the project for a National Portrait Gallery which evolved in the years immediately succeeding the 1832 Reform Bill and the Chartist movement. When Scharf privately divided the visitors into two groups, the gentry on the one hand and on the other the snobs (those of low breeding) who will visit the Gallery in Easter week, 'when the public will be let in without even a snip of a ticket',[93] he was reinscribing into the text of the new National Portrait Gallery the systematized notion of class difference that the discourse of nationalism (within which the Gallery officially functioned) ostensibly worked to erase. This was a Gallery where, in principle, the the walls would be hung with portraits of the important characters of national history irrespective of birth, and this display would (at least on occasions) be open free of charge to the labouring classes.

The past could be recreated on the the walls of Great George Street or on the screens of South Kensington, but the nationalization of ruling-class family culture that this process involved also demanded a price. While the authority of ancient British families was made visible in the hierarchy of an 'historical' arrangement, some of the powerful associations attaching to private property were inevitably diminished. Paradoxically, the very process of opening up and 'democratizing' the historic private collections of the nation, which the South Kensington exhibitions effected, served to produce a nostalgia for the inviolable privacy of the historic English house. In 1889 James Hayllar exhibited at the Royal Academy a painting entitled *The Picture Gallery at the Hall* (pl. 292). The painting shows a room in the artist's own house Castle Priory, Wallingford, in which a labouring man and his wife accompanied by their small son are being shown the family's picture collection by the artist's daughter overseen by an elderly and rosy-cheeked retainer. The girl is in the process of discoursing upon an eighteenth-century portrait of a young girl in a pastoral setting. The well-behaved crowds might flock to the newly opened National Portrait Gallery in St Martin's Place, but in the realm of fantasy, and of popular mythology, the correct location for the portrait remained the historic house, and the rightful interpretation was the property of the subject's descendent.

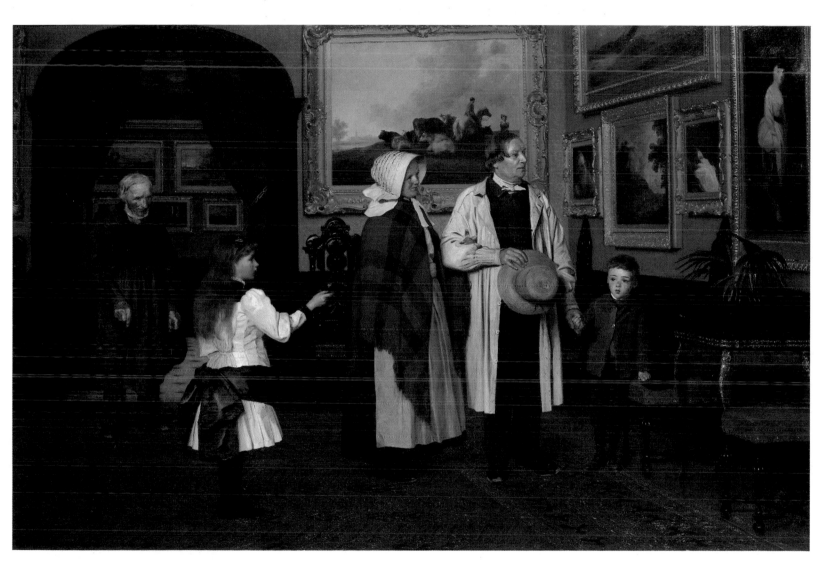

292. James Hayllar, *The Picture Gallery at the Old Hall*, oil on canvas, 102.5 × 153.5 cm. Sotheby's, 21 March 1990 (212).

NOTES

INTRODUCTION

1. J.J. Cartwright, ed., *The Wentworth Papers*, London, 1883, pp. 118–19.
2. J. Woodall, 'An Exemplary Consort: Antonis Mor's Portrait of Mary Tudor', *Art History*, June 1991.
3. R. Portalis, *Henry-Pierre Danloux peintre de portraits et son journal durant l'émigration (1753–1809)*, Paris, 1910.
4. *The Champion*, 1817, quoted in A. Hemingway's study of English art, forthcoming from Cambridge University Press.
5. *Catalogue of the Portraits and Pictures in the different Houses belonging to the Earl of Fife*, n.p., 1798 (inscribed in front of copy in Society of Antiquaries Library 1796).
6. See T. Green, *Extracts from the Diary of a Lover of Literature*, Ipswich, 1810, p. 90, 11 July 1798; A. Earland, *John Opie and his Circle*, London, 1911, p. 78.
7. J. Nichols, *Literary Anecdotes of the Eighteenth Century* . . . (1702), London, 1812, vol. 2, p. 204n.
8. W. von Archenholtz, *A Picture of England*, London, 1797, p. 128.
9. W.K. Wimsatt, *The Portraits of Alexander Pope*, New Haven, 1965.
10. Banks collection of trade cards, British Museum, London.
11. S. Gwynn, *Memorials of an Eighteenth-Century Painter (James Northcote)*, London, 1898, p. 115.
12. Banks Collection.
13. E.K. Waterhouse, *Painting in Britain, 1530–1790*, Harmondsworth, 1953 (1954), pp. 98, 128.
14. See P. Corrigan and D. Sayer, *The Great Arch: English State Formation as Cultural Revolution*, Oxford, 1985, p. 3.
15. I.B. Nadel, *Biography, Fiction, Fact and Form*, London, 1984, p. 6.
16. The standard text for this account was Ellis Waterhouse's pioneering *Painting in Britain 1530–1790*, but it has been followed by many exhibitions and other secondary surveys.
17. Richard Wendorf's recent book *The Elements of Life. Biography and Portrait Painting in Stuart and Georgian England*, Oxford, 1990, offers a much more complex account but one that none the less concerns itself primarily with comparative textual analysis and does not address function.
18. For an interesting account of the mythic power of portraits of Washington, see K.A. Marling, *George Washington Slept Here. Colonial Revivals and American Culture, 1876–1986*, Cambridge, Mass., and London, 1988.
19. D. Mannings, 'Reynolds, Garrick and the Choice of Hercules', *Eighteenth-Century Studies*, 17, 1983–4, pp. 281–2.

20. George Lucy to Mrs Hayes, 12 April 1758, quoted in *Pompeo Batoni and his British Patrons*, Iveagh Bequest, Kenwood, 1982, p. 15; given in full in A.M. Clark, *Pompeo Batoni, A Complete Catalogue of his Works with an Introductory Text*, ed. E.P. Bowron, Oxford, 1985, no. 212.
21. H. Peacham. *The Art of Drawing*, London, 1606, pp. 2–3.
22. *Ibid.*, pp. 16–17.
23. R. Brilliant, 'On Portraits', *Zeitschrift fur Asthetik und Allgemeine Kunst Wissenschaft*, 1971, p. 22.
24. Pliny, *The Natural History*, XXXV, para. 64, *The Elder Pliny's Chapters on the History of Art*, trans. K. Jex-Blake, Chicago, 1976, p. 109.
25. W. Gilpin, *An Essay upon Prints* . . . , 2nd edn, London, 1768, pp. 1–2.
26. J.P. Malcolm, ed., *Letters between the Rev. James Granger, M.A., Rector of Shiplake, and many of the most eminent literary men of his time* . . . , London, 1805, p. 168.
27. See A. Martindale, *Heroes, Ancestors, Relatives and the Birth of the Portrait*, The Hague, 1988, p. 20. Lorne Campbell includes a discussion of definitions of the word portrait in *Renaissance Portraits. European Portrait-Painting in the Fourteenth, Fifteenth and Sixteenth Centuries*, New Haven and London, 1990, introduction.
28. Nichols, *Literary Anecdotes*, vol. 1, p. vii.
29. Anon., 'Contemporary Literature', *Westminster and Foreign Quarterly Review*, October 1857, p. 581, quoted in Nadel, *Biography, Fiction, Fact and Form*, p. 15.
30. See U. Middeldorf, 'Portraits by Francesco da Sangallo', in *Raccolta di Scritti*, vol. 1: *1922–38*, Florence 1979–80, p. 305; J. Brown, 'Enemies of Flattery: Velazquez' Portraits of Philip IV', in R. Rotberg and T.K. Rabb, eds, *Art and History, Images and their Meaning* (1986), Cambridge, 1988, and J. Brown, *Velázquez, Painter and Courtier*, New Haven and London, 1986.
31. R. Lockyer, 'Noble in Defeat', review of the Dobson exhibition at the National Portrait Gallery, London, *Times Literary Supplement*, 25 November 1983, p. 1323.
32. D.R. Smith, *Masks of Wedlock: Seventeenth-Century Dutch Marriage Portraiture*, Ann Arbor, 1982, p. 34.
33. *The Encyclopedia of World Art* (1958), New York, Toronto, London, 1966, vol. 11. See also Luigi Grassi, 'Lineamenti per una Storia del Concetto di Ritratto', *Arte Antica e Moderna*, 1961.
34. See J.D. Breckenridge, *Likeness: A Conceptual History of Ancient Portraiture*, Evanston, 1969; Brilliant, 'On Portraits'; W. Steiner, *Exact Resemblance to Exact Resemblance. The Literary Portraiture of Gertrude Stein*, New Haven, 1978.
35. Steiner, *Exact Resemblance*, pp. 4–5.

I SPACES OF PORTRAYAL

1. The Great Hall hang at Charlecote is based on a lithotint by F.W. Hulme, after a sketch by J.G. Jackson, published 1 September 1845.
2. T. Veblen, *The Theory of the Leisure Class. An Economic Study of Institutions* (1925), London, 1957.
3. Inventory (vol. 1, no. 5), MS, Muniment Room, Arundel Castle. John Martin Robinson has suggested in conversation that the number of paintings in Norfolk House at this time may have been unusually large owing to building work in progress at another family residence at Worksop. The only serious study of the hanging of paintings is, to the best of my knowledge, F. Russell, 'The Hanging and Display of Pictures, 1700–1850', in G. Jackson-Stops *et al.*, eds, *The Fashioning and Functioning of the British Country House*, Washington, 1989, pp. 133–53. Russell does not, however, interpret the arrangements he documents.
4. P. Bourdieu, *Distinction. A Social Critique of the Judgement of Taste* (1979), trans. R. Nice, London and New York, 1986, pp. 76–7.
5. J. Nichols, *Literary Anecdotes of the Eighteenth Century* . . . , (1782), London, 1812, vol. 6, p. 292; for a discussion of this particular portrait and its background see A. Dobson, *Rosalba's Journal and Other Papers*, London, 1915, pp. 1–15. The eagle was the Boccapadugli eagle allegedly found within the precincts of Caracalla's Baths at Rome.
6. See *A Description of the Villa of Mr. Horace Walpole Youngest Son of Sir Robert Walpole Earl of Orford, at Strawberry-Hill near Twickenham, Middlesex. With an inventory of the Furniture, Pictures, Curiosities, &c.*, Strawberry Hill, 1784, pp. 33–40.
7. In Edward Edwards's view of the Gallery at Strawberry Hill (1774), some portraits are hung at eye level, but no landscapes are hung at the upper level, which is reserved for large-scale portraiture.
8. S. Lambert, *The Image Multiplied: Five Centuries of Printed Reproductions of Paintings and Drawings*, 1987, no. 145.
9. *Ibid.*, p. 176.
10. The most celebrated series of portraits of servants is to be found at Erddig near Wrexham.
11. There is a small but not very interesting literature on Beningborough, see M. Binney, 'Beningborough Hall Revisited', *Country Life*, 3 December 1981, and J. Lees-Milne, *English Country Houses. Baroque*, Country Life Books, 1970, p. 243. Precisely when these overdoors were placed *in situ* is the subject of controversy, Jacob Simon inclining to the view that they are an eighteenth-century arrangement, but Alastair Laing suggesting they were placed there at a later date. I am indebted to both for illuminating

conversations on the subject. Jacob Simon's forthcoming monograph, *Beningbrough Hall, North Yorkshire*, London: the National Trust, 1992, will offer a detailed and highly informative account of the house and its contents.

12. T. Page, Jnr, *The Art of Painting*, Norwich, 1720, p. 84. By paintings in the open air, he presumably has in mind locations like Vauxhall Gardens.

13. *Ibid.*, pp. 81–2. For a discussion of various aspects of Petworth, see *Apollo*, May 1977.

14. G. Jackson-Stops, 'Norton Conyers, Yorkshire–II', *Country Life*, 16 October 1986, p. 1200.

15. R. Portalis, *Henri-Pierre Danloux peintre de portraits et son journal durant l'émigration (1753–1809)*, Paris, 1910, p. 54.

16. G. Waagen, *Treasures of Art in Great Britain*, London, 1854.

17. G.P. Lomazzo, *Trattato del'arte della pittura, scoltura et architettura*, Milan, 1584 (English trans., Oxford, 1598); Sir Henry Wootton, *Elements of Architecture*, 1624; William Salmon, *Polygraphice, or the Arts of Drawing, Engraving, Etching, Limning, etc.*, London, 1675.

18. *Stowe. A Description of the House and Gardens of the Most Noble and Puissant Prince, George-Grenville-Nugent-Temple, Marquis of Buckingham*, Buckingham, 1797, pp. 38–41.

19. *Ibid.*, pp. 46–51.

20. *The Times*, 14 August 1848, quoted in F. Herrmann, *The English as Collectors. A Documentary Chrestomathy*, London, 1972, p. 277.

21. *Aedes Walpolianae, or a Description of the Collection of Pictures at Houghton Hall in Norfolk, the seat of the Right Honourable Sir Robert Walpole, Earl of Orford*, 2nd edn, 1752.

22. See Herrmann, *The English as Collectors*, p. 82.

23. *Excursions in the County of Norfolk*, 1818, vol. 1, p. 194.

24. Waagen, *Treasures of Art*, vol. 3, p. 419, 425.

25. M. Brettingham, *The Plans, Elevations, and Sections of Holkham in Norfolk, to which are added, the ceiling and chimney pieces; . . . statues, pictures, and drawings, etc.*, London (1761) 1773, p. 3; *The Stranger's Guide to Holkham*, published by J. Dawson: Burnham, 1817.

26. *Ibid.*; Martin Folkes Rishton met Thomas Coke at the University of Turin and later became involved in Coke's political campaigns. See A.W. Moore, ed., *Norfolk and the Grand Tour*, Norwich, 1985, p. 66.

27. R. Steele, *Spectator*, 5 July 1711.

28. Henry Howard, Earl of Surrey; see R. Strong, *The English Icon: Elizabethan and Jacobean Portraiture*, London and New York, 1969, p. 72, no. 7.

29. J.M. Robinson, 'Triumph of Historical Piety: Antiquarian Taste at Arundel Castle', *Country Life*, 27 January 1983, pp. 196–9; 3 February 1983, pp. 280–2; 10 February 1983, pp. 332–4. All three articles are highly informative; the final article has been drawn upon for this paragraph. The collection continued to accrue throughout the nineteenth century with portraits by Pickersgill, Millais (*Cardinal Newman*) and Hayter (*Queen Victoria*), some of which remain at Arundel in the Victoria Room. The earlier history of the Arundel collection is discussed in D. Howarth, *Lord Arundel and his Circle*, New Haven and London, 1985.

30. Biagio Rebecca entered the Royal Academy as a student in 1769 and was elected A.R.A. in 1771. He abandoned historical and mythological subjects in favour of decorative work. See C.H.S. John, *Bartolozzi, Zoffany and Kauffman, with other foreign members of the Royal Academy 1768–1792*, London, 1924, pp. 94–5.

31. See *Excursions through Essex*, 1824 (title-page missing, Society of Antiquaries Library copy), p. 136. Richard, Lord Braybrooke, *The History of Audley End*, London, 1836, p. 121, gives a list of the portraits and names the copyists as Zeeman and Biagio Rebecca. The latter also worked extensively at Osterley House. Rebecca made copies of a portrait of Henry VIII attributed to Joos Van Cleve and another of Queen Elizabeth I, head and shoulders, based on the Rainbow portrait at Hatfield. The copies were specifically mentioned in an obituary notice of Sir John in 1797. See J.D. Williams, *Audley End. The Restoration of 1762–1797*, Essex Record Office Publications, no. 45, Chelmsford, 1966, pp. 38, 50.

32. Identification of the Gainsborough portrait mentioned here has not been possible. Lord Suffield is not mentioned either in W.T. Whitley, *Thomas Gainsborough*, London, 1915, or E.K. Waterhouse, *Gainsborough* (1958), London, 1966. The 'wretched' portraits of seventeenth-century figures still hang in Blackfriar's Hall on panelling beneath the windows.

33. *Excursions in the County of Norfolk*, vol. 1, p. 28.

34. It is now back in Blackfriar's Hall.

35. Discussed in J.J. Rogers, *Opie and his Works*, London, 1878, pp. 59–60. Opie's ideas were elaborated in his R.A. lectures published in 1809. Opie's interest in these matters, particularly in relation to portraits, was reiterated in his proposal for a naval memorial (first published as a letter in the *True Briton*) which would have incorporated scenes of naval victories, life-size statues of heroes, paintings of trade, commerce and colonization, and portraits of great men and gallant officers. See A. Earland, *John Opie and his Circle*, London, 1911, pp. 153–4.

36. J. Boydell, Speech delivered to the London Court of Common Council, 31 October 1793, MS 198, Guildhall Library, London. As S. Bruntjen ('John Boydell (1719–1804). A Study of Art Patronage and Publishing in Georgian London', unpublished Ph.D. thesis, Stanford University, 1973, ch. 4) points out, this was a draft and may well have been altered before delivery.

37. S. Gwynn, *Memorials of an Eighteenth-Century Painter (James Northcote)*, London, 1898, p. 228.

38. *A Description of Several Pictures presented to the Corporation of London, by John Boydell, Alderman of the Ward of Cheap, and placed in the common-council chamber of the City*, London, 1794.

39. The chamber was demolished in 1908 but is depicted in *The Microcosm of London*, vol. 2; see also Bruntjen, 'John Boydell', ch. 4; on grangerized books, see below, chapter II iii.

40. I would like gratefully to acknowledge the help of Mr N.M. Plumley, Curator and Archivist of Christ's Hospital.

41. It is interesting to contrast the deployment of portraits at Christ's Hospital with the more permanent arrangements possible at Eton and Winchester which remain on their original sites. For an interesting discussion of the commissioning of Eton pupils' portraits, see *Leaving Portraits from Eton College*, Dulwich Picture Gallery, 18 July–20 October 1991.

42. [J.I. Wilson], *A Brief History of Christ's Hospital*, London, 1820, p. 14.

43. The bust of Sir Louis Cavagnari, seen in the drawing at the lower left, is now in the Library.

44. See also p. 161.

45. 'A Regular Ode on Mr. Cotes', reprinted in H. Walpole, *Anecdotes of Painting in England* (1762–80; 1876), New York, Arno Press reprint, 1969, vol. 4, p. 27.

46. As Richard Green has pointed out, the similarities with *Lady Sarah Bunbury sacrificing to the Graces* of 1765 are close. See R. Green '"The Hon. Lady Stanhope and the Countess of Effingham as Diana and her Companion" by Francis Cotes', *National Art Collections Fund Review*, 1988, p. 106.

47. See E.M. Johnson, *Francis Cotes*, Oxford, 1976, no. 250 and Green, '"The Hon. Lady Stanhope and the Countess of Effingham"'.

48. The question of mythological female portraits, *pace* E.H. Gombrich ('Reynolds's Theory and Practice of Imitation: Three Ladies Adorning a Term of Hymen', in *Norm and Form*, London, 1966), awaits a detailed historical and theoretical examination. Some work has been begun by Shelley Bennett of the Huntington Library, San Marino, who has written about Cotes's *Mr and Mrs Thomas Crathorne* (in *British Art 1740–1820: Essays in Honor of Robert Wark*, Huntington Library, forthcoming) and by Ann Bermingham, who has written about the Corinthian Maid theme in J. Barrell, ed., *Painting and the Politics of Culture*, Oxford, 1992.

49. Green, '"The Hon. Lady Stanhope and the Countess of Effingham"', p. 107.

50. H. Ward and W. Roberts, *Romney, A Biographical and Critical Essay*, London, 1904, p. 53.

51. Although Romney was not, as is stated in some accounts, illiterate, his studio accounts book is largely written by his assistants.

52. C.R. Leslie and Tom Taylor, *Life and Times of Sir Joshua Reynolds, with notices of some of his contemporaries*, London, 1865, vol. 2, p. 2.

53. Christie's, 11–14 March 1795.

54. W. Dunlap, *History of the Rise and Progress of the Arts of Design in the United States*, intr. W.P. Campbell, ed. A. Wyckott (1834), London, 1965, vol. 1, p. 118.

55. For details of Reynolds's *ménage* see Gwynn, *Memorials*, p. 49; J. Northcote, *The Life of Sir Joshua Reynolds*, London, 1819, vol. 2, pp. 20–1. In contrast West gave Stuart a room in his house, see Dunlap, *History of the Rise and Progress of the Arts of Design*, vol. 1, p. 215.

56. *Lectures on Painting delivered at the Royal Academy of Arts . . . by John Opie, Esq. to which are prefixed a memoir by Mrs. Opie*, London 1809, pp. 20–1.

57. *The Artist's Repository and Drawing Magazine, exhibiting the Principles of the Polite Arts in their various branches* (preface to 4th edn, vol. 1, dated 1788), vol. 4, pp. 137–8.

58. Bachaumont, quoted in *Portrait et Société en France (1715–1789)*, Palais de Tokyo, Paris, 1980, unpaginated.

59. Quoted in G.W. Fulcher, *Life of Thomas Gainsborough, RA*, London, 1856, p. 126.

60. *Mary Magdalen* and *Jesus* (nos 50 and 51)

61. John Wolcot (Peter Pindar), 'Odes to the Heads', from 'Lyric Odes to the Royal Academicians', 1782–5, in *The Works of Peter Pindar*, vol. 4, London, 1809.

62. Northcote, *Life of Sir Joshua Reynolds*, vol. 2, p. 65.

63. S. Redgrave, *A Dictionary of Artists of the English School*, 2nd edn, 1878.

64. Revd R. Potter to G. Romney, 24 June 1779, MS, National Art Library, London, 86 CC 32.

65. Romney lived at no. 24; see Thomas Saunders to Revd Mr. Romney 19 June 1815, MS, National

Art Library, London, 86 CC 32, and addresses in Royal Academy exhibition catalogues.

66. W.T. Whitley, *Art in England 1800–1820* (1928), New York, 1973, p. 26.

67. Dunlap, *History of the Rise and Progress of the Arts of Design*, vol. 1, pp. 204–5; see also J. Johnston Abraham, *Lettsome–His Life, Times, Friends and Descendents*, London, 1933, and W.H. Curtis, *William Curtis, 1746–1799*, Winchester, 1941.

68. Quoted in *Portrait et Société en France*.

69. Whitley, *Thomas Gainsborough*, p. 39.

70. George Romney's sitters' book, National Portrait Gallery, London.

71. Sir Joshua Reynolds's sitters' book, 6 September 1784, Royal Academy Library, London.

72. Romney's sitters' book.

73. *Ibid.*

74. *The Diary of Joseph Farington*, vol. 1: *July 1793–December 1794*, ed. K. Garlick and A. MacIntyre, New Haven and London, 1978, 15 March 1794. Dance married an extremely wealthy widow in 1790 and eventually gave up painting to devote himself entirely to an active social life.

75. Northcote, *Life of Sir Joshua Reynolds*, vol. 1, p. 83.

76. Thomas Rowlandson, *The Portrait Painter*, British Museum, London; *The New Bath Guide or Memoirs of the B.N.R.D. Family*, Bath, 1807.

77. Whitley, *Thomas Gainsborough*, p. 31, gives £500. Compare this with the prices given in R.S. Neale, *Bath 1680–1850, A Social History*, London, 1981. Whitley must, I think, mean £50.

78. Northcote, *Life of Sir Joshua Reynolds*, vol. 1, p. 102.

79. Whitley, *Art in England 1800–1820*, p. 17; see also Romney's studio sale, Phillips, 22–23 May 1805.

80. *Ibid.*

81. Dunlap, *History of the Rise and Progress of the Arts of Design*, vol. 1, p. 204.

82. Ward and Roberts, *Romney*, pp. 42–3.

83. *Diary of Joseph Farington*, 27 October 1793.

84. Whitley, *Thomas Gainsborough*, p. 108.

85. James Northcote's sitters' book, *c.*1776–1830, MS, National Portrait Gallery.

86. Northcote, *Life of Sir Joshua Reynolds*, vol. 1, p. 120.

87. *Ibid.*, vol. 2, pp. 20–1.

88. Gwynn, *Memorials*, p. 49.

89. Gilbert Stuart was given responsible tasks by West, had his own room, met the master's clients, fenced with his son and seems to have been one of the family. See Dunlap, *History of the Rise and Progress of the Arts of Design*, vol. 1, pp. 212–13, 215.

90. A fragment of the studio accounts has survived, covering the period January to April 1797 (MS, National Art Library, London, 86 CC 32). Romney's sitters' books covering the period 10 October 1786 to 9 April 1796 were purchased by the National Portrait Gallery from Sotheby's, 20 July 1981. Ward and Roberts, *Romney*, contains interesting additional material in transcription.

91. Romney's sitters' book, 7 August 1787.

92. For details of Griffiths, see Whitley, *Art in England 1800–1820*, p. 26.

93. Romney's accounts, National Art Library, London.

94. Quoted in *Portrait et Société en France*.

95. Ward and Roberts, *Romney*, p. 43.

96. Romney's sitters' book, 12 December 1786, 30 January 1787.

97. Whitley, *Thomas Gainsborough*, p. 109.

98. Reynolds's sitters' book, 14 October 1782.

99. *Ibid.*, 16 August 1784.

100. *Ibid.*, 7 November 1757.

101. M. Jouett *Notes from Conversations on painting with Gilbert Stuart, 1816*, in J.W. McCoubrey, ed., *American Art 1700–1960*, Englewood Cliffs, 1965, p. 22.

102. Northcote, *Life of Sir Joshua Reynolds*, vol. 1, p. 102. Further details are given in Northcote's sitters' book where he says there are 12 inches before the feet of the chair, 17½ from the floor to the bottom of the chair and 26 from the centre pin.

103. M. Levey, *Sir Thomas Lawrence 1769–1830*, National Portrait Gallery, London, November 1979–March 1980, pp. 11–12.

104. Christie's, 31 May 1823, lots 6, 8, 69, 70, 71, 91.

105. Foster's, 4 July 1836.

106. Romney's sitters' book, 24 November 1787.

107. Romney's sitters' book.

108. Ward and Roberts, *Romney*, transcript of Romney's diaries.

109. These were first published by Dodsley but in 1777 Reynolds changed to Kearsley's *Gentleman and Tradesman's Pocket Ledger* in the same format but with slightly fuller information.

110. Now in the Fitzwilliam Museum, Cambridge.

111. G.P. Lomazzo, *A Tracte containing the Artes of Curious Paintinge carvinge and buildinge*, trans. Richard Haydocke (Oxford, 1598), Westmead, 1970, p. 41.

112. J. Richardson, *Essay on the Theory of Painting*, 1715, quoted in S. Stevenson, *A Face for Any Occasion*, Scottish National Portrait Gallery, 1976, p. 5.

113. *Diary of Joseph Farington*, 11 October 1793.

114. Gwynn, *Memorials*, p. 234.

115. P. Beaumont to Gainsborough, 4 January 1765, MS, Bedford Estate Office, London.

116. Gainsborough to P. Beaumont, 7 January 1765, MS, Bedford Estate Office, London.

117. Northcote's sitters' book. The book covers the period 1776–1830 and there is no indication when this note may have been written.

118. Sir J.T. Stanley's Household Account Book, 1772, MS, National Art Library, 86 B 96. This book must most probably have belonged to Sir John Stanley, 6th Bt., of Alderley Park, Cheshire.

119. George Romney to John Romney, 17 March 1794, MS, National At Library, London, 86 CC 32.

120. *Diary of Joseph Farington*, 14 November 1793.

121. Ward and Roberts, *Romney*, p. 53.

122. Northcote, *Life of Sir Joshua Reynolds*, vol. 2, p. 25.

123. *Ibid.*, p. 266.

124. Earland, *John Opie*, p. 37.

125. Christie's, 27 April 1807.

126. *Diary of Joseph Farington*, 16 April, 17 April and 7 October 1794.

127. Foster's, 4 July 1836.

128. Dunlap, *History of the Rise and Progress of the Arts of Design*, vol. 1, p. 223.

129. *Pompeo Batoni and his British Patrons*, Iveagh Bequest, Kenwood, 1982, p. 16; Joseph Wright of Derby's account book, MS, National Portrait Gallery, London; Gainsborough's receipts, MS, Bedford Estate Office, London.

130. Sir J.T. Stanley's Household Account Book.

131. Quoted in J.T. Flexner, *America's Old Masters* (1939), rev. edn, New York, 1967, p. 125.

132. Northcote's sitters' book.

133. John Romney to the Marquiss (*sic*) Townshend, 17 April 1800, MS, National Art Library, London, 86 CC 32.

134. Northcote's sitters' book.

135. Whitley, *Thomas Gainsborough*, p. 67.

136. Sir J.T. Stanley's Household Account Book.

137. Household Accounts of the 5th Duke and Duchess of Bedford, MSS, Bedford Estate Office, London.

138. Morley Papers, box 37, Household Accounts, North Devon Record Office, Plymouth; Sir Joshua Reynolds's ledgers, Fitzwilliam Museum, Cambridge. Mr Parker paid £262 10s. in July 1779 for portraits of the Hon. Teresa Parker and son, and for Master and Miss Parker (Earl of Morley). On 31 May 1787 Lord Boringdon paid £52 10s. for the Hon. Teresa Parker (Huntington Library).

139. Household Accounts, Bedford Estate Office, London.

140. Isaac Collivoe to Robert Butcher, 5 March 1763, MS, Bedford Estate Office, London.

II ILLUSTRIOUS HEADS

1. J. Granger, *A Biographical History of England, from Egbert the Great to the Revolution: consisting of Characters disposed in different Classes, and adapted to a Methodical Catalogue of Engraved British Heads, intended as an Essay towards reducing our Biography to System, and a Help to the knowledge of Portraits*, London, 1769, preface.

2. J.P. Malcolm, ed., *Letters between the Rev. James Granger, M.A., Rector of Shiplake, and many of the most eminent literary men of his time . . .*, 1805, pp. 15, 16, 17, 30. Little interest has been shown by art historians in James Granger or, indeed, in engraved historic portraits. The exception is Diana Donald who, in 'Characters and Caricatures', published in *Reynolds*, ed. N. Penny, Royal, Academy of Arts, London, 1986 (p. 356), remarks that 'the vogue for portrait prints . . . represents the serious and growing interest in both physiognomy and English history in the later eighteenth century, which gave a consequence to the art of portraiture that can easily be overlooked if one registers only the more vocal champions of history painting'.

3. There appears to be almost no literature on grangerizing. One useful study, however, is B. Adams, 'A Regency Pastime: the Extra-Illustration of Thomas Pennant's "London"', *London Journal*, 8, 1982, pp. 123–39. An article on Sir William Musgrave by Anthony Griffiths, forthcoming in the *British Library Journal*, also contains much interesting new material on Musgrave's biographical work.

4. F. Braudel, *The Structure of Everyday Life: The Limits of the Possible, Civilisation and Capitalism*, vol 1 (1979), trans. S. Reynolds, 1981, p. 308.

5. See, in particular, N. Elias, *The Civilizing Process. The History of Manners*, trans. E. Jephcott (1939), New York, 1978.

6. R. Starn, 'Reinventing Heroes in Renaissance Italy', in R.I. Rotberg and T.K. Rabb, eds, *Art and History, Images and their Meaning* (1986), Cambridge, 1988, p. 69.

7. J. Nichols, *Literary Anecdotes of the Eighteenth Century . . .*, (1782), 1812, vol. 2, p. 161.

8. See A. Hyatt Mayor, *Prints and People, A Social History of Printed Pictures*, New York, 1971, no. 534.

9. A. Reigl, 'The Modern Cult of Monuments: Its Character and its Origin' (1928), trans. K.W. Forster and D. Ghirardo, *Oppositions*, 25, 1982, pp. 21–51.

10. D. Alexander, 'English Prints and Printmaking', in R.P. Maccubbin and M. Hamilton-Phillips, eds, *The Age of William III and Mary II: Power,*

Politics and Patronage, 1688–1702, The College of William and Mary, Virginia, 1989, p. 279.

11. Figures available on the dissemination of engravings relate largely to caricature and political print, e.g., M. Foss, *The Age of Patronage. The Arts in Society 1660–1750*, London, 1971, p. 164, and J. Brewer, *The Common People and Politics 1750–1790s*, Cambridge, 1986. Roy Porter has called for more extensive study of the culture of pictorial prints but addresses his remarks chiefly to the political genre, R. Porter, 'Seeing the Past', *Past and Present*, 118, February 1988.

12. Richard Powys wrote to Matthew Prior on the subject in 1698/9, quoted in I. Pears, *The Discovery of Painting. The Growth of Interest in the Arts in England, 1680–1768*, New Haven and London, 1988, p. 171, n. 45.

13. *Sculptura-Historico-Technica: or the History and Art of Ingraving*, London, 1747, preface.

14. T. Atkinson, *A Conference between a Painter and an Engraver; containing some useful Hints and necessary instructions, proper for the young Artist*, London, 1736, p. x.

15. *Gentleman's Magazine*, April 1792, pp. 382–3.

16. J. Ames, *A Catalogue of English Heads: or an Account of about Two Thousand Prints . . .*, 1747. According to Joan Evans (*A History of the Society of Antiquaries*, Oxford, 1956, p. 89), because of Ames's background in trade and the fact that he knew neither Latin nor Greek he was not considered worthy of office and acted as secretary without being formally appointed. But it should be noted that a number of distinguished eighteenth-century antiquarians were tradesmen and, also, non-conformist in religious affiliation.

17. The West sale took place at Langfords 19 January to 3 April 1773. This quotation is from catalogue 5, 29 March 1773 and 23 following days, excluding Sundays, preface. The collector, Bull, asked Granger to mediate with his competitor, Gulston, at this sale so that they would not bid against each other, thus effectively setting up a 'ring'. See Bull to Granger, 16 November 1772, Bull-Granger correspondence, MS, Eton College Library.

18. Huntington Library, San Marino, California.

19. See Starn, 'Reinventing Heroes', p. 68: 'Through the great ideological lenses of the Middle Ages, social structures were perceived either as a single body or as a series of corporate groups. In descending hierarchical order, priests were custodians of Christ's body; secular rulers of the body politic temporarily resident in them; and nobles with martial duties, property and epic lore embodied in blood and lineage. This bio-political schema of the corpus Christianum relegated towns to the physical trunk, the sustaining but inferior and dependent zone of the third estate. They were endowed with head, spirit and arms only by virtue of their submission to the higher estates.'

20. Nichols, *Literary Anecdotes of the Eighteenth Century*, vol. 2, p. 161.

21. Braudel, *Structure of Everyday Life*, vol. 1, p. 528 *passim*.

22. See Sotheby's 10 April 1951, catalogue for the sale of the Bull/Bute 'Granger' now in the Huntington Library and J.M. Pinkerton, 'Richard Bull of Ongar, Essex', *The Book Collector*, 27, no. 1, spring 1978, p. 52. I am grateful to Malcolm Baker for drawing my attention to this article.

23. Granger, *Biographical History*, vol. 1, preface.

24. H. Walpole to T. Mann, 6 May 1770, *Horace Walpole's Correspondence*, ed. W.S. Lewis, Oxford and New Haven, 1937–83, vol. 23, p. 465.

25. The continuous records of the present Society begin in 1717, and Vertue was one of the most gifted new members; the engraving project began in 1718 with a commission to Vertue to engrave a drawing of Richard II's portrait at Westminster. See Evans, *History of the Society of Antiquaries*, pp. 51, 62–70.

26. Nichols, *Literary Anecdotes of the Eighteenth Century*, vol. 6, pp. 149–50.

27. Granger, *Biographical History*, vol. 1, preface.

28. No compendium of information on sales of engraved portraits in the period is available. However, sale catalogues in the National Art Library and in the British Library from Richardson's, Walter Shropshire's, John Thane's, Thomas Snelling's and Thomas Dodd's businesses give a clear indication not only of range and price but also of the extensive use of Granger's system.

29. Davies to Granger, 26 February 1774, J.P. Malcolm, ed., Letters, 1805, p. 58. Following publication of the first edition of Granger's *Biographical History* in 1769 in two volumes, a supplement with corrections and additions was issued in 1774. The second edition appeared in four volumes in 1775, the third in 1779 and the fourth in 1804. The fifth edition with upwards of 400 additional lives was published in six volumes in 1824. A continuation of the work from 1688 to the end of the reign of George I was published in 1806, edited by the Revd Mark Noble, F.S.A., claiming to use manuscripts left by Granger. Henry Bromley's *A Catalogue of Engraved British Portraits from Egbert the Great to the Present time . . .* of 1793 was, however, the first publication that attempted to bring Granger up to the present day. Several collections were published in illustration of Granger's work, most notably Samuel Woodburn's *Gallery . . .*, 1816.

30. See entry on Granger in *The Dictionary of National Biography*; Granger to Bull, 9 December 1770; Bull to Granger, 11 March 1774; Bull-Granger correspondence, MSS, Eton College Library.

31. M. Grivel, *Le Commerce de l'Estampe à Paris au XVIIe siècle*, Geneva, 1986, p. 141.

32. Bromley, *Catalogue of Engraved British Portraits*, preface.

33. *Reminiscences of Henry Angelo with Memoirs of his late Father and Friends*, London, 1828, vol. 1, pp. 32–3; Granger's biographical notices were still being recommended for their 'spirit and force' in 1867, see W. Tiffin, *Gossip about Portraits*, London, 1867, p. 187.

34. My italics. In *W. Shropshire's Catalogue of Prints for the year 1774*, the dealer begs leave to inform 'the Nobility and Gentry, Collectors for Portraits belonging to the English School, they will have a very singular opportunity, in this Catalogue, to compleat their Collections . . .'.

35. Malcolm, ed., *Letters*, p. 309, correspondence of Granger concerning a print of Cromwell's wife, Joan.

36. Vertue to the publisher, Johnson *c*.1737, quoted in Nichols, *Literary Anecdotes of the Eighteenth Century*, vol. 6, p. 117.

37. On library portraits, see D. Piper, 'The Chesterfield Library Portraits', in R. Wellek and A. Ribeiro, eds, *Evidence in Literary Scholarship*, Oxford, 1979. Chesterfield House was demolished in 1927; the library with its portraits is the subject of a painting by Richard Jack which now hangs in Lord Harewood's sitting-room at Harewood House, Yorkshire.

38. G. Naudé, *Instructions Concerning Erection of a Library, presented to my Lord the Président de Mesme . . . And now Interpreted by Jo. Evelyn, Esquire*, London, 1661, pp. 84–5.

39. *Catalogue of the Portraits and Pictures in the different Houses belonging to the Early of Fife*, n.p., 1798, preface.

40. The account of the benefits resulting from the fire of London (vol. 1) incorporates a portrait of Charles II, a view of the fire, a portrait of Cibber, a view of the top of the Monument, a view of the whole Monument and two popular allegorical prints, one of which is inscribed 'Now London remember 66'. The date of the grangerizing appears to have been *c*.1796 judging by the dates of material included. British Museum, London, Department of Prints and Drawings.

41. Satiricus Sculptor, Esq., *Chalcographimania; or the portrait-collector and printseller's Chronicle . . . , a humorous poem . . .*, London, 1814, pp. 14–15 and 20–1. The author was in all likelihood James Caulfield who, in his *Calcographiana, the Printseller's Chronicle and Collector's Guide to the Knowledge and Value of Engraved British Portraits*, London, 1814, disclaims authorship (advertisement).

42. Bull 'Granger', Huntington Library, San Marino, California, vol. 5, p. 119.

43. For a useful discussion of social control, see J.A. Mayer, 'Notes towards a Working Definition of Social Control in Historical Analysis', in S. Cohen and A. Scull, eds, *Social Control and the State*, Oxford, 1983.

44. R. Sennett, *The Fall of Public Man*, Cambridge (1974), 1977, p. 56. See also Pears, *Discovery of Painting*, pp. 3–6.

45. Quoted by Sennett, *Fall of Public Man*, p. 63.

46. See L. Colley, 'The Apotheosis of George III: Loyalty, Royalty and the British Nation, 1760–1820', *Past and Present*, 102, February 1984.

47. Quoted in the Carte MSS, vol. 198, Bodleian Library, Oxford, see M. Hamilton-Phillips, 'Painting and Art Patronage in England', in R.P. Maccubbin and M. Hamilton Phillips, *The Age of William III and Mary II*, p. 246.

48. *Natural History*, XXXIV, ii, in *The Elder Pliny's Chapters on the History of Art*, trans. K. Jex-Blake, Chicago, 1976, p. 15.

49. See A. Martindale, *Heroes, Ancesters, Relatives and the Birth of the Portrait*, The Hague, 1988, p. 5, for an account for the gallery of the Castle of Karlstein of 1414.

50. Starn, 'Reinventing Heroes', p. 75. For a detailed account of the importance of Petrarch's *De Viris illustribus*, see T.E. Mommsen, 'Petrarch and the decoration of the Sala Virorum Illustrium in Padua', *Art Bulletin*, 34, 1952, pp. 95–116.

51. Thomas Stothard recalled seeing 'some of the heads of Houbraken' framed and glazed and hanging in the Yorkshire home of his teacher in the early 1760s, A.E. Bray, *The Life of Thomas Stothard, R.A., with Personal Reminiscences*, London, 1851, p. 3.

52. This 'Granger', now in the Guildhall Library, London, was 'illustrated and enlarged' by Revd John Peaviour Johnson. It bears the printer/binder's name and address: John Ranshall Rowe, 34 1/2 Granby Street, Leicester. The Library has no information on its accession but a sale notice, pasted into the front of vol. 1 describes it as 'the folio edition of the text of Granger & the octavo of Noble inlaid in double crown with red lines, interleaved with cartridge paper of the same size sufficient in quantity to contain every portrait

mentioned by Granger and Noble, with considerable allowance for additions'. Notwithstanding the fact the volumes contain many blank, unfilled pages, the collection contains 'upward 8,000 portraits and historical prints; and about 200 articles not mentioned either by Granger or Noble . . . with a number of Biographical sketches in MS'.

53. *Portraits of Characters Illustrious in British History from the beginning of the reign of Henry the Eighth to the end of the reign of James the Second*, published by S. Woodburn. The plates are dated 1810 and 1811, most are after portraits by Lely and Van Dyck.

54. For Blake's portraits see M. Pointon, *Milton and English Art*, Manchester 1970, pp. 135–6; the portraits are in Manchester City Art Gallery.

55. R. Brilliant, 'On Portraits', *Zeitschrift fur Asthetik und Allgemeine Kunst Wissenschaft*, 1971, p. 17.

56. *Ibid.*, p. 24.

57. See J.D. Breckenridge, *Likeness: A Conceptual History of Ancient Portraiture*, ch. 3. Evanston, 1969.

58. P.F.H. D'Hancarville, *Recherches sur l'Origine, l'Esprit et le Progrès des Arts de la Grèce*, London 1785, vol. 2, p. 313n. I am most grateful to John Barrell for drawing my attention to this passage.

59. By extension it stands also in relationship to the subjectivity of the artist, which might explain, for instance, Rembrandt's self-portrait-like 'portrait' of Homer in the Mauritshuis in The Hague.

60. H. Blair, *Lectures on Rhetoric and Belles Lettres* (1783), London, 1830, p. 25.

61. E. Burke, *A Philosophical Inquiry into the Origin of our ideas of the Sublime and Beautiful with an introductory discourse concerning Taste and several other additions*, London, 1756.

62. M. Foucault, *The Order of Things, An Archaeology of the Human Sciences* (1966), London, 1970.

63. *Catalogue of Richardson's Collection of English Portraits, engraved from Rare Prints, or original Pictures: – viz Princes and Princesses, Secretaries of State . . . as described in Granger's Biographical History of England*, London, 1792–9. (The work cannot have been published, in fact, until much later as some of the plates bear the date of 1811.) These volumes simply reproduce in mezzotint and in engraving the images listed by Granger without any attempt to render them uniform in style or format.

64. J. van der Waals, 'The Print Collection of Samuel Pepys', *Print Quarterly*, 1, no. 4, December 1984, p. 251.

65. J. Evelyn, *Numismata. A Discourse of Medals Antient and Modern together with some Account of Heads and Effigies of Illustrious and Famous Persons, in Sculps, and Taille-Douce, of whom we have no Medals extant; and the Use to be derived from them. To which is added A Digression concerning Physiognomy*, 1697, p. 176.

66. Samuel Pepys's collection of portraits is in Magdalen College, Cambridge. A catalogue is in preparation. 'Heads' is a generic term for Pepys who included full-length portraits in some volumes. Many engravings are taken from antiquarian works like Henry Holland's *Baziliwlogia. A Booke of Kings* (London, 1618) and Francis Sandford's *A Genealogical History of the Kings of England and Monarchs of Great Britain* (London, 1677). Pages are arranged often in a fairly haphazard manner with prints mounted sideways and upright on the same page. Little attempt has been made to authenticate portraits and the result is a fascinating web of visual historical fiction. Thus, for example, in the substantial section

on Ladies, the first image is inscribed 'Alathea Talbot – Countess of Arundel. 1497' but is actually Hollar's engraving of an unknown female subject of 1646 after Dürer and dedicated to 'A.T.'

67. S. Piggott, *Ruins in a Landscape: Essays in Antiquarianism*, Edinburgh, 1976, p. 16.

68. *Ibid.*, p. 20.

69. *Ibid.*, p. 21.

70. J. Evelyn, *Sculptura: or the History and Art of Chalcography*, new edn, London, 1769, p. 123.

71. See Grivel, *Le Commerce de l'Estampe*, p. 199.

72. Evelyn, *Sculptura*, p. 119.

73. Evelyn, *Numismata*, p. 257.

74. Cornelius a Beughem, *Bibliographia historica, chronologica & geographica novissima, sive conspectus primus catalogi librorum historicum . . .*, Amsterdam, 1685.

75. P. Bastien, 'Clipeus et Buste Monétaire des Empereurs Romains', *Numismatica e Antichità Classiche*, 10, 1981, pp. 318–22.

76. Joseph Addison's *Dialogues upon the Usefulness of Ancient Medals* was published posthumously with Pope's 'Verses occasioned by Mr. Addison's Treatise on Medals' appended (*The Works of Joseph Addison*, ed. R. Hurd, London, 1903, vol. 1). For a detailed study of the symbolic relations between obverse and reverse, see L. Marin, *Portrait of the King* (1981), Houndsmills, 1988.

77. A. Grabar, 'L'Imago Clipeata Chrétienne', *Comptes Rendus de l'Académie des Inscriptions et Belles Lettres*, Paris, 1957, pp. 210–13.

78. C.J. Smith, *Autographs of Royal, Noble, Learned and Remarkable Personnages conspicuous in English History, from the Reign of Richard the Second to that of Charles the Second . . .*, London, 1829, preface, pp. iii and xiii. The same view is taken by J. Pinkerton, 'Richard Bull of Ongar', but this is an anachronistic view of eighteenth-century collecting.

79. See George Scharf's diagrams, MSS, National Portrait Gallery Archive, London.

80. Smith, *Autographs*, p. iii.

81. Nichols, *Literary Anecdotes of the Eighteenth Century*, vol. 2, p. 248.

82. For an exemplary discussion of the problem of authenticating Milton portraits, see D. Piper, *The Image of the Poet. British Poets and Their Portraits*, Oxford, 1982, p. 32 *passim*.

83. Malcolm, ed., *Letters*, pp. 384–5. Bindley's library, or part of it, found its way into the British Museum. See, for example, *A Catalogue of the Most Valuable Collection of Pictures, Prints, and Drawings late of Charles Jarvis, deceased; Principal Painter to their Majesties King George I and II*, 1739–40, inscribed in front as purchased by James Bindley.

84. Mark Noble, 'The Lives of the Fellows of the Society of Antiquaries in London', 1818, MS, Getty Center for History of Art and the Humanities, Archives of the History of Art.

85. *Ibid.*

86. See J. Caulfield, *Blackguardiana or a Dictionary of Rogues, Bawds, Pimps, Whores . . .*, illustrated with eighteen Portraits of the most remarkable Professors in every Species of Villany, London, 1793(?), unpaginated.

87. J. Caulfield, *Portraits, Memoirs and Characters of Remarkable Persons, from the Reign of Edward the third, to the Revolution, collected from the most authentic accounts extant*, London, 1794; British Museum, 1868-8-8-3207; National Portrait Gallery 334A. See also A.J. Hind, *Engraving in England in the Sixteenth and Seventeenth Centuries*, Cambridge, 1955, part 2, no. 64, pp. 391–2.

88. Bull's grangerized edition of Bishop Burnet's *History of My Own Time* (1723, 1734) and his grangerized edition of Granger's *Biographical History* are now in the Huntington Library, San Marino. For details of Bull's life, see Pinkerton, 'Richard Bull of Ongar', which gives a list of books grangerized by Bull. The difficulty in locating extant grangerized 'Grangers' is hard to explain unless we assume them to have been broken up in the nineteenth century when such forms of collecting were unfashionable and the shelf-space the volumes occupied was needed for other purposes. Three hundred and seventy-two lots from the collection of J. Pickering Ord, Esq. were sold at Sotheby's, 12 December 1827, and the following year the Towneley 'Granger', comprising 1,297 lots and 8 portfolios, was sold by Sotheby's on 25 April and the ten following days. Between October and December 1919, while it was in the possession of the Earl of Bute, 201 engravings were removed from Bull's 'Granger'. Most of these were engravings after Reynolds and though no attempt has been made to replace them, the Huntington Library has compiled a list of missing items. The volumes were originally bound in russia; the volumes have been separated under conservation, the end covers have been kept and the pages are now preserved in boxes. Bull was celebrated by Satiricus Sculptor in *Calchographimania* (p. 31): 'Or B–ll to Granger firmly knit/with daughter decking holy writ', presumably a reference to his grangerizing of Burnet.

89. Vol. 2, p. 96.

90. Vol. 2, p. 59.

91. Vol. 2, p. 76, headed 'Antiquaria', includes an engraving of Jo Lelandus by Grignion and a letter from William Huddesford telling him about it. Bull also incorporated watercolours of tomb sculptures when he was unable to obtain a portrait. I am grateful to Robert Wark for an interesting discussion on this topic.

92. Vol. 4, p. 80.

93. Vol. 4, p. 88.

94. Vol. 4, p. 100.

95. There are variations in the dates on title-pages of the various volumes. For an explanation of this, and for an excellent bibliographical and historical analysis, see G. Roebuck, *Clarendon and Cultural Continuity*, New York and London, 1982, section D.

96. R. Wendorf, *The Elements of Life. Biography and Portrait-Painting in Stuart and Georgian England*, Oxford, 1990, p. 8.

97. See R. Gibson, *Catalogue of Portraits in the Collection of the Earl of Clarendon*, privately published for the Paul Mellon Centre for Studies in British Art, 1977.

98. Evelyn's letters, quoted *ibid.*, p. vii.

99. Evelyn, *Numismata*, p. 265.

100. *The History of the Rebellion and Civil Wars in England, begun in the Year 1641*, Oxford, 1704.

101. *Ibid.*, vol. 3.

102. T. Salmon, *The Chronological Historian: containing a Regular Account of all Material Transactions and Occurrences, ecclesiastical, civil and military, relating to the English Affairs, from the Invasion of the Romans, to the present Time . . .*, London, 1723.

103. *Ibid.*, p. 8.

104. Three volumes in one folio.

105. *History of the Rebellion* (Oxford, 1732), preface.

106. *Lord Clarendon's History of the Grand Rebellion with his Life and Continuation, illustrated with Historical*

Prints, Maps, Portraits, Hieroglyphickes, &c in eight volumes, London, 1796. British Museum, London, Department of Prints and Drawings, C248★. The volumes were, it appears, put together as a commercial speculation and raffled. They were won by the Duke of Gloucester (Caulfield, *Calcographiana*, pp. 118, 138), who bequeathed them in 1834 to the British Library. I am grateful to Anthony Griffiths for this information.
107. *Lord Clarendon's History*, Book 1, p. 7.
108. Bromley, *Catalogue of Engraved British Portraits*.
109. *Dictionary of National Biography*.

III SIGNIFICANT AND INSIGNIFICANT LIVES

1. See L. Partridge and R. Starn, *Renaissance Likeness*, Berkeley and Los Angeles, 1980.
2. On Hogarth's *Captain Coram*, see H. Omberg, *William Hogarth's Portrait of Captain Coram. Studies on Hogarth's Outlook around 1740*, Upsala, 1974.
3. *Easy Rules for Taking a Likeness by the most Practicable Principles of Geometry and Perspective with various analogous Figures. Written in French by Abbé Bonamici, to serve as a supplement to the French Encyclopoedia, translated into English by Abbé Adams*, London, 1792, p. ii.
4. Pepys said they were 'very good, but not like', and Dryden wrote that Lely 'drew many graceful pictures, but few of them were like . . .', quoted in R. Wendorf, *The Elements of Life. Biography and Portrait-Painting in Stuart and Georgian England*, Oxford, 1990, p. 105.
5. A. Pasquin, *A Liberal Critique on the Present Exhibition of the Royal Academy*, London, 1794, p. 6.
6. H. Walpole, *Anecdotes of Painting in England* (1762–80; 1876), New York: Arno Press reprint, 1962, vol. 2, pp. 269–73.
7. J. Nichols, *Literary Anecdotes of the Eighteenth Century . . .* (1782), London, 1812, vol. 3, p. 483.
8. William Whitehead to Lord Harcourt, Bath, 5 December 1758, in W.T. Whitley, *Thomas Gainsborough*, London, 1915, p. 28.
9. A. Earland, *John Opie and his Circle*, London, 1911, pp. 151–2.
10. R. Portalis, *Henry-Pierre Danloux peintre de portraits et son journal durant l'émigration (1753–1809)*, Paris, 1910, pp. 87, 94.
11. J. Richardson, *An Essay on the Theory of Painting*, 2nd edn, London, 1725, p. 23.
12. *Ibid.*, pp. 21–2.
13. There is a very considerable secondary literature on the subject; for a most interesting recent examination of the relationship between the portrait and the biography in this context (and one that contains excellent bibliographical references) see Wendorf, *Elements of Life*.
14. V. Bruce, *Recognising Faces*, Hove, London and Hillsdale, 1988, p. 2.
15. *Ibid.*, p. 61.
16. *Ibid.*
17. J. Ray, *The Wisdom of God manifested in the Works of the Creation* (1691), 2nd edn, London, 1692, pp. 15–20. I am grateful to John Barrell for drawing my attention to this passage.
18. *Parliamentary Portraits; or, Characters of the British Senate, containing the Political History, with Biographical Sketches of the Leading Members of the Lords and Commons . . .*, 2 vols, London, 1795.
19. W. Tiffin, *Gossip about Portraits*, London, 1867, pp. 93–4.

20. Wendorf, *Elements of Life*, p. 21, talks of the 'waxing and waning reliance of one art on the other in order to determine or reinforce meaning' and draws attention to an increasing reluctance to combine word and image in English portraiture.
21. Bruce, *Recognising Faces*, pp. 65–6.
22. R. Barthes, 'Les Romains au Cinema', *Mythologies*, London, 1957, pp. 27–8.
23. Nichols, *Literary Anecdotes of the Eighteenth Century*, vol. 3, p. 582.
24. *The Artist's Repository and Drawing Magazine, exhibiting the Principles of the Polite Arts in their various branches* (preface to 4th edn, vol. 1, dated 1788), vol. 1, p. 120.
25. It was a story that was particularly popular among eighteenth-century artists and is reproduced in engraved form as an illustration to *The Artist's Repository*, vol. 4. For an account of the popularity of this subject see J. Barrell, *The Birth of Pandora and the Division of Knowledge*, London, 1992, pp. 161–2.
26. W. Duff, *An Essay on Original Genius* (1767), New York, 1970, p. 89.
27. *Ibid.*, p. 190.
28. A. Pasquin, *Memoirs of the Royal Academicians, being an attempt to Improve the Natural Taste*, London, 1796, p. 96.
29. T. Wilson, *Ceramic Art of the Italian Renaissance*, London, 1987, on. 182. I am grateful to Sharon Fermor for drawing my attention to this interesting catalogue.
30. It is appropriate to acknowledge at this point the work of Allan Sekula who has proposed for the workings of the photographic portrait in the nineteenth century a double system, a system of representation capable of functioning both honorifically and repressively. Taking a lead from Foucault, Sekula offers the view that social power operates by virtue of a positive therapeutic or reformative chanelling of the body. He associates 'possessive individualism' with the proper portrait and suggests that all such portraits have their lurking, objectifying inverse in the files of the police. Sekula adopts the model of the archive to describe this process: 'The general all-inclusive archive necessarily contains both the traces of the visible bodies of heroes, leaders, moral exemplars, celebrities, and those of the poor, the diseased, the insane, the criminal, the nonwhite, the female, and all other embodiments of the unworthy. The clearest indication of the essential unity of this archive of images of the body lies in the fact that by the mid-nineteenth century a single hermeneutic paradigm had gained widespread prestige. This paradigm had two tightly entwined branches, physiognomy and phrenology. Both shared the belief that the surface of the body, and especially the face and head, bore the outward signs of inner character.' A. Sekula, 'The Body and the Archive', *October*, 39, winter 1986, p. 10. Where I disagree with Sekula is in locating the initiation of such an archive in the nineteenth century and in identifying physiognomy and phrenology as serving to lay emphasis on the head and to legitimate the dominion of intellectual over manual labour (p. 12). The systematization of portraiture and the double function described by Sekula is already evident in the eighteenth century; the pre-eminence of the head has a history that predates the nineteenth-century fashion for these sciences.
31. R. Folkenflik, *The English Hero, 1660–1800*, E. Brunswick, Toronto and London, 1982, p. 9.

32. Samuel Johnson, *The Idler*, no. 284.
33. On William Strahan, Esq., copied from *The Lounger*, 20 August 1785, quoted in Nichols, *Literary Anecdotes of the Eighteenth Century*, vol. 3, pp. 390–1.
34. Ray, *Wisdom of God*, p. 20.
35. J.C, Lavater's *Essays on Physiognomy, designed to promote the knowledge and love of mankind* was translated from the French and published 1789–98, but physiognomic theory was much discussed earlier and James Parsons's *Human Physiognomy explained* of 1746, though crude, offered an introduction to the subject.
36. See, for example, *Owen Farrell, the Irish Dwarf*, engraved by Hulett after Gravelot, 1742; Jacques Laguerre (son of Louis) painted Mary Toft and Sir James Thornhill depicted John Shepherd (engraved by J. Faber and G. White, respectively); Hogarth engraved his own portrait of Sarah Malcolm, who murdered her mistress for money, in 1722/3. He and his father-in-law, Thornhill, had visited her in prison a few days before her execution.
37. C. Le Brun, *Conférences . . . sur l'expression générale et particulière*, Paris, 1698, trans. *The Conference . . . upon Expression*, London, 1701; Gérard de Lairesse, *Het Groot Schilderboek*, Amsterdam, 1707, trans. London, 1738; see J. Brewer, *The Common People and Politics 1750–1790s*, Cambridge, 1986, introduction.
38. *The Artist's Repository and Drawing Magazine* (preface to 4th edn, vol. 1, dated 1788), vol. 3, p. 35.
39. R. Paulson, *Hogarth: his Life, Art, and Times*, New Haven and London, 1971, vol. 2, p. 357.
40. *Ibid.*, vol. 1, pp. 168–70. Paulson outlines the sequence of events; for a detailed analysis of the figures represented in *Cunicularii*, see D. Todd, 'Three Characters in Hogarth's Cunicularii – and some implications', *Eighteenth Century Studies*, 16, no. 1, fall 1982, pp. 26–46. For Henry Fielding's observations, see *Covent Garden Journal*, 11 February 1752, in B.A. Goldgar, ed., *The Covent-Garden Journal and A Plan of the Universal Register-Office*, Oxford, 1988, p. 88.
41. E.g., Huntington Library, San Marino, California; another version was in the Littlecote Sale, Sotheby's, 20–22 November 1985, lot 943, circle of Rosalba Carriera, *Portrait of a Girl*, half-length, holding a hare.
42. Hogarth's *Cunicularii* does seem to have a dead and divided rabbit in the foreground, but our attention is mostly attracted to the many scurrying bunnies. See Paulson, *Hogarth*, vol. 1, pl. 56.
43. *Remarks on a Short Narrative of an Extraordinary Delivery of Rabbets [sic], perform'd by Mr. John Howard, Surgeon at Guilford, as publish'd by Mr. St. André, Anatomist to His Majesty. With a proper Regard to his intended Recantation, by Thomas Braithwaite, Surgeon*, London, 1726, p. 19. The Toft episode must be understood as part of the agitation about the advent of male midwives and the sexual danger they posed to women. See R. Porter, 'A touch of danger: the man-midwife as sexual predator', in G.S. Rousseau and R. Porter, eds, *Sexual Underworlds of the Enlightenment*, Manchester, 1987.
44. *Ibid.*, p. 28.
45. E.g., Cyriacus Ahlers, *Some Observations concerning the Woman of Godlyman in Surrey, made at Guilford on Sunday Nov. 20 1726*, London, 1726; *The Anatomist Dissected or the Man-Midwife finely brought to Bed. Being an Examination of the Conduct of Mr.*

St. André . . . by Lemuel Gulliver, London, 1727; *The Discovery: or The Squire turned Ferret. An Excellent New Ballad*, 2nd edn, London, 1727.

46. *The Anatomist Dissected*, p. 33.
47. *Sculptura-Historico-Technica: or the History and Art of Ingraving*, London, 1747, pp. 46–7.
48. Thornhill's portrait of Shepherd is discussed briefly by E. Wind in an essay on Thornhill's style, *Journal of the Warburg and Courtauld Institutes*, 2, 1938–9, pp. 116–27, and by W.R. Osmun, 'A Study of the Work of Sir James Thornhill', unpublished Ph.D. thesis, University of London, 1950. A drawing for the portrait is in the British Museum. See also *Sir James Thornhill*, Guildhall Art Gallery, London, 4–10 June 1958, nos 109–10.
49. *Particulars of the very Singular and Remarkable Trials, Convictions, and Escapes, of John Shepherd, together with his history from his birth, etc.*, London, 1786.
50. Reprinted in Paulson, *Hogarth*, vol. 1, pp. 137–8.
51. A. Knapp and W. Baldwin, *The Newgate Calendar*, London, 1824, vol. 1.
52. W. Harrison Ainsworth, *Jack Sheppard. A Romance*, London, 1839; I.T. Haines, *Jack Sheppard. A Domestic Drama in Three Acts*, London, 1839.
53. *Daily Journal*, 22 October 1724.
54. *The Newgate Calendar*, vol. 1, p. 217.
55. *Dictionary of National Biography*, where a full list of Caulfield's publications is to be found.
56. Tiffin, *Gossip about Portraits*, p. 180.
57. For an examination of this phenomenon in the following century, see R. Altick, *Victorian Studies in Scarlet*, London, 1970, and T. Gretton, *Murders and Moralities: English Catchpenny Prints, 1800–1860*, London, 1980.
58. See Paulson, *Hogarth*, vol. 1, pl. 112b for Sarah Malcolm.
59. *Blackguardiana*, n.p.
60. *The Artist's Repository and Drawing Magazine*, vol. 1, pp. 206–7.
61. See, for example, J. Parsons, *Human Physiognomy explained in the Crounian Lectures on Muscular Motion for the Year MDCCXLVI read before the Royal Society*, London, 1747.
62. See F. Nivelon, *Rudiments of Genteel Behavior*, London, 1737, n.p.; there is an interesting discussion of deportment in relation to portraiture in A. Smart, 'Dramatic Gesture and Expression in the Age of Hogarth and Reynolds', *Apollo*, 82, August 1965, pp. 90–7.
63. Walpole, *Anecdotes of Painting in England*, vol. 3, p. 184.
64. J. Caulfield, *Portraits, Memoirs and Characters of Remarkable Persons, from the Reign of Edward the third, to the Revolution, collected from the most authentic accounts extant*, London, 1794, vol. 2, opening page.
65. *Ibid.*, f. p. 184.
66. P. Pindar (pseud. of John Wolcot, 1738–1819), 'To a man's Head', in *The Works of Peter Pindar*, vol. 4, London, 1809.
67. Edmund Lodge, 1756–1839, published *Illustrations of British History, Biography, and Manners in the reigns of Henry VIII, Mary, Elizabeth, and James I . . .* (1791; 2nd edn, same year), 3rd edn, 1838; *Imitations of Original Drawings by Hans Holbein*, London, (1792), 1812.
68. E. Lodge, *Portraits of Illustrious Personages of Great Britain, engraved from authentic pictures, in the galleries of the nobility, and the public collections of the country, with biographical and historical memoirs of their lives and actions*, London, 1821, p. 1. This

work was begun in 1814 and issued in parts, the collective edition published 1821–34. Two other editions were published, one in eighty parts from 1821, (collective, edn, 1835) and one in small format, 1849–50.
69. '"Characters and Caricatures": the Satirical View', in *Reynolds*, ed. N. Penny, Royal Academy of Arts, London, 1986, p. 357.
70. H.M. Atherton, *Political Prints in the Age of Hogarth. A Study of the Ideographic Representation of Politics*, Oxford, 1974, p. 2.
71. H.T. Dickinson, *Caricatures and the Constitution 1760–1832*, Cambridge, 1986, pp. 13–16.
72. *Ibid.*, p. 14.
73. R. Brilliant, *Gesture and Rank in Roman Art: the Use of Gesture to Denote Status in Roman Sculpture and Coinage*, New Haven, 1963, p. 12.
74. *The Art of Acting*, London, 1746, dedicated to Philip Earl of Chesterfield, Lord Lieutenant of Ireland, p. iv.
75. See K. Hoffmann, 'Das Profil aus Kunstgeschichtlicher Sicht', in *Fortschritte der Kieferorthopadie*, Munich, 1981.
76. J. Swift, 'Of Mean and Great Figures', in *Miscellaneous and Autobiographical Pieces. Fragments and Marginalia*, Oxford, 1962, pp. 83–6.
77. Sir N. Wraxall, *A Short Review of the Political Stage of Great Britain*, 1787, a book that went into eight editions in one year, quoted in J. Ehrman, *The Younger Pitt*, London, 1969, p. 604.
78. E.H. Gombrich, 'The Mask and the Face: the perception of physiognomic likeness in life and in art', in E.H. Gombrich, J. Hochberg and M. Black, *Art, Perception and Reality*, Baltimore and London, 1972, p. 13.
79. *Ibid.*, p. 24.
80. D. Donald, in *Reynolds*, p. 355; the objects of political satire were also collectors of political prints. Charles James Fox and Robert Peel both built up fine collections, see H.T. Dickinson, *Caricatures and the Constitution*, p. 16.
81. See, for example, the alternative shows cited by D. Solkin in 'The Battle of the Ciceros: Richard Wilson and the Politics of Landscape in the Age of John Wilkes', *Art History*, December 1983, p. 417.
82. George Selwyn, quoted in Lord Rosebery, *Pitt* (1891), London, 1893, p. 27.
83. [G.A. Stevens], *An Essay on Entertainments to which is added Stevens' new Lecture upon Heads, now delivering at the Theatre Royal, Hay-Market, with critical observations*, 3rd edn, London, 1772, pp. 36–7.
84. Published in Edinburgh, n. d.
85. [W. Jones], *A Small Whole-Length of Dr. Priestly, from his Printed Works*, London, 1792. I am grateful to John Barrell for drawing both this and the previous reference to my attention.
86. Prefatory Epistle to the book which contains a frontispiece engraved for the *Carlton House Magazine*.
87. Solkin, 'The Battle of the Ciceros'.
88. *Parliamentary Portraits; or Characters of the British Senate containing the Political History with Biographical Sketches of the Leading Members of the Lords and Commons . . .*, (1783), London, 1795.
89. *Ibid.*, advertisement.
90. *British Public Characters*, 1798, p. vii.
91. *Ibid.*, p. xii. After 1800 the fold-out page was abandoned in favour of single pages, sometimes containing two portraits, bound into the text.
92. Solkin, 'The Battle of the Ciceros', pp. 404–22.
93. *Sketches from Nature in High Preservation . . .*, 10th edn, 1779, no. 1. pp. 14–15.

94. *Ibid.*, p. 8.
95. *Ibid.*, p. 52.
96. Thomas Hickey's dates are 1741–1824; the painting may be unfinished.
97. Quoted in Ehrman, *The Younger Pitt*, p. 613.
98. A list of sources of information on portraits of Pitt is published in A.D. Harvey, *William Pitt the Younger, 1759–1806: a bibliography*, Manchester, 1989, section XI.
99. G. Scharf, 'A Catalogue of all known portraits, busts, engravings from portraits, etc., of William Pitt', 1886, appended to Rt. Hon. Edward Gibson, Lord Ashbourne, *Pitt: some Chapters of his Life and Times*, 2nd edn, London, 1898.
100. [G.A. Stevens], *Essay on Entertainments*, p. 25. See also *The Celebrated Lecture on Heads*, London, 1764, and *A Lecture on Heads*, London, n.d. c.1766.
101. See D. Bindman, *The Shadow of the Guillotine. Britain and the French Revolution*, British Museum, London, 1989, no. 207.
102. Thus the abolitionist image of the chained black is backed by the biblical message, 'Whatsoever ye would that men should do unto you, do ye even so to them.' These tokens are briefly discussed by Bindman, *Shadow of the Guillotine*, The most complete listings are to be found in the catalogues of A.H. Baldwin & Sons Ltd, Numismatics, 11, Adelphi Terr., London W.C.2. Thomas Spence was for a time a dealer in these coins and a major contemporary source is *The Coin Collector's Companion . . .*, published by Spence, London, 1795. I am grateful to John Barrell for alerting me to the importance of these tokens.
103. E.g., *The Wit of the Day or the Honours of Westminster being a complete Collection of the Advertisements, Handbills, Puffs, Paragraphs, Squibs, Songs, Ballads &c which have been written and circulated during the late remarkable Contest for that City*, London, 1784; *The Westminster Election in tne Year 1796 being an accurate State of the Poll each Day: also a Complete Collection of Addresses and Speeches . . .*, London, 1796.
104. W.A. Laprade, 'William Pitt and the Westminster Election', *American Historical Review*, 18, no. 2, January 1913, p. 253.
105. See D.E. Ginter, 'The financing of the Whig party organisation, 1783–1793', *American Historical Review*, 71, no. 2, pp. 424–8; D.E. Ginter, *Whig Organization in the General Election of 1790*, London, 1967.
106. Laprade, 'William Pitt', p. 271.
107. W. Hazlitt, 'Mr. Horne Tooke', in *The Spirit of the Age*, London, 1825.
108. Manchester City Art Galleries, 1913.16. The portrait omits any reference to the subject's blindness in one eye and shows him leaning against a senatorial Roman bust and holding a winged cap. A better-known portrait is that by John Raphael Smith, engraved by W. Ward (29 May 1811), showing Horne Tooke, in old age, working on the third volume of his philological work (reproduced in Bindman, *Shadow of the Guillotine*, no. 166).
109. Laprade, 'William Pitt', p. 270.
110. Following the election, Horne Tooke made representations to the House of Commons in an extremely expensive process which was subsequently deemed unnecessary and wasteful and costs were awarded against him. See *Proceedings in an Action for Debt between the Rt. Hon. Charles James Fox, Plaintiff and John Horne Tooke, Esqr., Defendant*, 1792.
111. *Two Pair of Portraits presented to all the unbiassed*

electors of Great-Britain, & especially to the Electors of Westminster by John Horne Tooke, 1788, p. 7.

112. *Anti-Jacobin Review and Magazine*, November 1798, pp. 574–9 and December 1798, pp. 702–9. The prints are *Two Pair of Portraits . . .* and *Doublures of Characters*.

113. Dorothy George states the print has no relation to the text but, though it is clearly less illustrative than *Two Pair of Portraits*, its participation in the discourse of portraiture is clear. *Catalogue of Political and Personal Satires preserved in the Dept. of Prints and Drawings in the British Museum*, ed. F.G. Stephens and M.D. George, 11 vols., London, 1870–1954, no. 9216.

114. *Ibid.*

115. *The Mirror of Patriotism*, published 20 January 1784, reproduced in Dickinson, *Caricatures and the Constitution*, no. 32.

116. E.g., *The Two Patriotic Duchesses on their Canvass* (the Duchesses of Portland and Devonshire canvassing for Fox) by Rowlandson, 3 April 1784, reproduced in Brewer, *Common People and Politics*, pl. 86.

117. *A New Puzzle of Portraits, invt. pub. & sold by Orme, on. 14 Old Bond St., Jany 18 1794*, the British Library, Banks J11 119–27. David Bindman included in *Shadow of the Guillotine* a mug printed with the puzzle of the kings and queens of England and France, no. 145.

118. See note 68.

119. *An Historical Catalogue of an Exhibition of Portraits of the most Illustrious Personages . . .*, No. 4, Pall Mall East, London, 1829, pp. 1–2.

IV DANGEROUS EXCRESCENCES

1. 'The Battle of the Wigs. An additional Canto to Dr. Garth's Poem of the Dispensary. Occasioned by the disputes between the Fellows and Licentiates of the College of Physicians, London. By Bonnell Thornton, M.B.', *Gentleman's Magazine*, 38, March 1768, p. 132.

2. Mostly by Sir Godfrey Kneller, this group of portraits represents a club formed by men who were committed to upholding the glorious revolution and the Protestant succession. Most of the portraits were executed in the first twelve years of the eighteenth century. More than forty survive at the National Portrait Gallery, London, and at its gallery at Beningborough Hall, Yorkshire.

3. In the portrait of Pope, the subject is crowned with a laurel wreath which he wears on his otherwise undressed head. For paintings of Pope, who was often portrayed in his own hair, see W.K. Wimsatt, *The Portraits of Alexander Pope*, New Haven, 1965, especially no. 54; for portraits of Johnson, see R. Wendorf, *The Elements of Life. Biography and Portrait-Painting in Stuart and Georgian England*, Oxford, 1990.

4. A. Ribeiro, *Dress and Morality*, London, 1986, p. 106, points out that women's hair began to rise in the 1760s, false hair and then feathers were added to give height and bulk in the 1770s. The projected view of society in Swift's and Addison's 'The Indian Kings in London', *Spectator*, 27 April 1711, confirms that women were understood to wear their own hair as opposed to men who wore wigs.

5. D. Ritchie, *A Treatise on the Hair*, London, 1770, p. 78.

6. *Ibid.*, p. 80.

7. J.T. Smith, *Nollekens and his Times* (1828), 2nd edn, ed. W. Whitten, London, 1829, pp. 16–17.

8. [G.A. Stevens], *The Celebrated Lecture on Heads*, London, 1764.

9. [G.A. Stevens], *An Essay on Entertainments, to which is added Stevens's new Lecture upon Heads, now delivering at the Theatre Royal, Hay-Market, with critical observations*, 3rd edn, London, 1772, p. 18.

10. E. Beetham, *Moral Lectures on Heads*, Newcastle-upon-Tyne, 1780, p. 3.

11. A summary of the literature on historic dress in portraiture can be found in R. Simon, *The Portrait in Britain and America*, Oxford, 1987, ch. 2: 'Poses'. One of the most useful overall accounts of the changes in the general appearance of fashionable men and women in the eighteenth century, with particular reference to wigs and hair, remains, D. Piper, *The English Face* (1957), London, 1978, ch. 8: 'The Golden Age of the Society Portrait'.

12. *Manners and Morals: Hogarth and British Painting 1700–1760*, Tate Gallery, London, 1987, no. 160.

13. Ribeiro, *Dress and Morality*, does not seek to justify the title of her work, and, although this book contains extremely useful textual data, the author regards fashion as a force in its own right which expresses general movements in society. The nature of the structural relationship between dress, gender, politics and morality is not examined.

14. E. Goffman, *The Presentation of Self in Everyday Life* (1959), London, 1969. Also useful is Domna Stanton's examination of the aristocrat using the self as his raw material of expression. She deals with a range of references from France in the seventeenth and nineteenth centuries that share the striking characteristic of describing human beings as if they *were* artefacts, not mere resemblances. 'When that passage from simile to metaphor is effected, when the honnête homme or the dandy is described as a painting, an architectural monument, a verbal or musical composition, he is being viewed as a specific kind of thing – a collection of signs situated at the crossroads where esthetics and semiotics intersect', D.C. Stanton, *The Aristocrat as Art: A Study of the Honnête Homme and the Dandy in Seventeenth- and Nineteenth-century Literature*, New York, 1980, p. 108. See also R. Sennett, *The Fall of Public Man*, Cambridge (1974), 1977, pp. 69–70.

15. E. Wilson, *Adorned in Dreams, Fashion and Morality*, London, 1985, p. 2.

16. Cf. T. Veblen, *The Theory of the Leisure Class. An Economic Study of Institutions* (1925), London, 1957, p. 168.

17. Wilson, *Adorned in Dreams*, p. 6.

18. J.H. Fuseli, Lecture 3, in *Lectures on Painting by the Royal Academicians, Barry, Opie, and Fuseli*, ed. Ralph N. Wornum, London, 1848, p. 431.

19. W. Gilpin, *An Essay upon Prints containing Remarks upon the principles of Picturesque Beauty; the different kinds of Prints; and the characters of the most noted masters . . .*, 2nd edn, London, 1768, p. 170. This book went into further editions in 1781, 1792 and 1802, as well as into a French edition in 1800.

20. Gainsborough to Lord Dartmouth, 8, 13 and 18 April 1771, *The Letters of Thomas Gainsborough*, ed. M. Woodall, London, 1961, pp. 51–3.

21. M. de Garsault, *Art du Perruquier, contenant la façon de la Barbe; la Coupe des Cheveux; la Construction des Perruques d'Hommes & de Femmes; le Perruquier en Vieux; & le Baigneur-Etuviste*, Paris, 1767.

22. Victoria and Albert Museum, London, E1652-1926–E1681.

23. D. Hay, *Albion's Fatal Tree. Crime and Society in Eighteenth-Century England*, 1975, p. 27, quoting Blackstone (1793–5).

24. 'The Battle of the Wigs' takes place between Socio and Licentiato, *Gentleman's Magazine*, 38, March 1768, p. 132. I am grateful to Karen Stanworth for this reference.

25. Tailpiece to *The History of British Birds*, vol. 1, London, 1797.

26. C. Cibber, *The Careless Husband*, in *The Plays of Colley Cibber*, vol. 1, ed. R.C. Hayley, New York and London, 1980, p. 390.

27. The connection between castration and the cutting of hair is pointed out by Freud (S. Freud, 'On Sexuality', in *The Pelican Freud Library*, vol. 7, Harmondsworth, 1977, p. 357); Patricia Simons has kindly drawn my attention to an anonymous eighteenth-century watercolour representing Dalilah clipping Samson's pubic hair around his erect penis (*Histoire Universelle*, album, British Museum, London, repr. A. Tilly, *Erotic Drawings*, Oxford, 1986, no. 3).

28. Hair and teeth are linked in discourses of health and fashion as well as by profession. See, for example, *The Lady's Head Dresses; or Beauty's Assistant, for 1772; containing Observations on the Hair . . . also a Dissertation on the Teeth and Gums, by David Ritchie, hair-Dresser, dentist &c.*, London, 1772. The most extensive Freudian exploration of the sexual connotations of dress is to be found in J.C. Flügel, *The Psychology of Clothes*, London, 1930.

29. E.g., see *Reminiscences of Henry Angelo with Memoirs of his Late Father and Friends*, London, 1828, vol. 2, p. 112.

30. Boswell to Revd William Temple, 23 August 1789, *Letters of James Boswell*, coll. and ed. C.B. Tinker, Oxford, 1924, vol. 2, p. 377. T. Smollett, *The Adventures of Roderick Random* (1748–9), ed. P.-G. Boucé, Oxford, 1979, ch. 14, p.68.

31. F. Burney, *Cecilia: Or Memoirs of an Heiress* (1782), 1986, bk 4, ch. 7, pp. 315–16. I am grateful to Nigel Llewellyn for drawing my attention to this passage.

32. *Christ's Teares over Jerusalem*, quoted in J.P. de Castro, 'Wigs and Perukes', ch. 1, typescript, 1945, National Art Library, London.

33. *Ibid.*, ch. 2.

34. The *Oxford English Dictionary* suggests that 'merkin' was a variant of 'malkin' in the sixteenth and seventeenth centuries, meaning the hair of the female pudendum, but that in the eighteenth century it specifically came to mean counterfeit pubic hair (1796: 'counterfeit hair for a woman's privy parts'). It also seems that the merkin was seen as analogous to the beard.

35. *The Early Diary of Frances Burney 1768–1778*, ed. A.R. Ellis, London, 1889: 1773, vol. 1, p. 322; see also *Reynolds*, ed. N. Penny, Royal Academy of Arts, London, 1986, pp. 271–2.

36. De Castro, 'Wigs and Perukes', ch. 1.

37. R.B. Schwartz states that wigs were also made from sheep's wool, goat's hair and from the tails of heifers, but does not give sources. *Daily Life in Johnson's London*, Madison, Wisconsin, 1983, p. 128.

38. See, for example, Pepys's diary, 3 September 1665, *The Diary of Samuel Pepys*, ed. R. Latham

and W. Matthews, vol. 6, London, 1972, p. 210, in which Pepys describes putting on a new periwig which he had bought a while since but did not risk wearing because the plague was in Westminster: 'Nobody will dare buy any haire for fear of the infection – that had been cut off the heads of people dead of the plague.' See also Mr Cringer's reference to 'a penny weight of dead hair', in Smollett, *Roderick Random*, ch. 14, p. 68.

39. H. Hingston Fox, MD, *Dr John Fothergill and his Friends*, London, 1919, p. 96.

40. J. Nichols, *Literary Anecdotes of the Eighteenth Century . . . (1782)*, London, 1812, vol. 6, p. 205.

41. *Spectator*, no. 631, 10 December 1714. I am grateful to Rachel Bowlby for drawing this passage to my attention.

42. De Castro, 'Wigs and Perukes', ch. 2.

43. See Sennett, *Fall of Public Man*, p. 103.

44. Quoted in P. Stallybrass and A. White, *The Politics and Poetics of Transgression*, London, 1986, p. 91.

45. J.T. Smith, *Nollekens and his Times (1828)*, 2nd edn, ed. W. Whitten, London, 1829, vol. 1, pp. 379–81.

46. De Castro, 'Wigs and Perukes', ch. 2.

47. V. Hugo, *Les Misérables*, vol. 2, p. 369. Quoted in Stallybrass and White, *Politics and Poetics of Transgression*, p. 141.

48. J. Ruskin, *Modern Painters*, vol. 3, part 4, ch. 16, §12, in E.T. Cook and A. Wedderburn, *The Works of John Ruskin*, London, 1904, Library Edition, vol. 5, p. 324.

49. Exodus 20:3–5.

50. William Cowper to Revd William Unwin, 3 May 1784, *The Life and Works of William Cowper*, ed. Revd T.S. Grimshaw, London, 1835, p. 266. Face paints contained mercury which destroyed the skin.

51. N. Llewellyn, 'John Weever and English Funeral Monuments of the sixteenth and seventeenth centuries', unpublished Ph.D. thesis, University of London, Warburg Institute, February 1983.

52. See also Ribeiro, *Dress and Morality*, p. 78.

53. A.M. Sutton, *Boardwork or the Art of Wigmaking, etc. A Technical Handbook*, 3rd edn, 1921, p. 213.

54. Thomas Hall's book is discussed as a paradigm of Calvinist doctrine in W. Craven, *Colonial American Portraiture: the Economic, Religious, Social, Cultural, Philosophical, Scientific, and Aesthetic Foundations*, Cambridge, 1986, pp. 31–5.

55. T. Hall, *The Loathsomeness of Long Haire: or a Treatise wherein you have the Question stated, many Arguments against it produced, and the most material Arguments for it repell'd and answer'd, with the concurrent judgement of Divines both old and new against it . . . , (1653)*, London 1654, p. 25.

56. *Ibid.*, p. 8.

57. *Ibid.*, marginal gloss, preface.

58. *Ibid.*

59. *Ibid.*, pp. 12–13.

60. *Ibid.*, p. 15.

61. Diderot's *Encyclopédie* contains detailed descriptions and illustrations.

62. Smith, *Nollekens and his Times*, vol. 1, p. 379 describes the best-dressed men in the early years of the eighteenth century paying the enormous sum of fifty guineas for a wig. He also describes in graphic detail the theft of wigs from gentlemen in the streets of London (p. 380). Trade cards from the same period suggest an average price of thirty pounds for wigs (de Castro, 'Wigs and Perukes', ch. 2). Louise Lippincott indicates the average expenditure on a portrait by the highest

category of spenders (peers) was £28 18s. later in the century (*Selling Art in Georgian London: The Rise of Arthur Pond*, New Haven and London, 1983, p. 69). In 1792, Danloux was advised by the auctioneer, John Greenwood, with whose father he was lodging, to charge twelve to fifteen guineas for a head and shoulders, up to twenty-five for a life-sized half-length and fifty for a full-length. Small heads were eight to ten guineas and small half-lengths thirty (R. Portalis, *Henri-Pierre Danloux peintre de portraits et son journal durant l'émigration (1753–1809)*, Paris, 1910, p. 80). See also a discussion of comparative prices of portraits and other commodities in ch. I, pp. 50–1, above.

63. John Mulliner, *A Testimony against Periwigs and Periwig-Making, and Playing on Instruments of Musick among Christians, or any other in the days of the Gospel . . .* , Northampton, 1677, p. 1.

64. *Ibid.*, pp. 5–6.

65. *Ibid.*, p. 8.

66. *Ibid.*, p. 10.

67. Whilst a peruke formed part of a footman's livery, the wearing of wigs by servants was discouraged by the mid-eighteenth century, de Castro, 'Wigs and Perukes', ch. 1.

68. See Wimsatt, *Portraits of Alexander Pope*, pp. 85–8.

69. I am grateful to Ludmilla Jordanova and Patricia Simons for very helpful comments on this section.

70. *The Flying Dragon and the Man of Heaton*, in *The Works of Tim Bobbin, Esq., in Prose and Verse with a Memoir of the Author by John Corry*, Rochdale, 1819, 'The Argument'.

71. *Ibid.*, p. 400.

72. Freud, 'On Sexuality', p. 353.

73. Piper, *The English Face*, p. 193.

74. I am grateful to Michael Podro for an interesting conversation on this topic.

75. See J. Woodforde, *The Strange Story of False Teeth*, London, 1968, John Furse, to whom I am grateful for this reference, suggests that dental decay and loss of bone may have been a reason why few portrait subjects smile prior to the early twentieth century.

76. T. Page, Jnr, *The Art of Painting*, Norwich, 1720, pp. 75–6.

V GOING TURKISH IN EIGHTEENTH-CENTURY LONDON

1. *Manners and Morals: Hogarth and British Painting 1700–1760*, Tate Gallery, London, 1987, no. 36. The standard topography of Constantinople is encoded through the characteristic mass of the seraglio, St Sophia and the hippodrome as it appears in engravings in travel books from the sixteenth century. Throughout this chapter 'Turkey' and 'Turkish' will be used to denote the European construction of Ottoman history, geography and culture. The term Ottoman was that used by the court society in Constantinople to describe itself; 'Turk' was used to describe the non-urban population.

 It is not the object of this chapter to rescue the reputation of Richardson, but it does seem odd, given this outstanding work, that he should have been described by Wendorf as an unimaginative and conventional painter but a gifted writer. See R. Wendorf, *The Elements of Life: Biography and Portrait-Painting in Stuart and Georgian England*,

Oxford, 1990, pp. 11, 135, 136.

2. J. Addison, 'The Pleasures of the Imagination', no. 9, *Spectator*, no. 418, 30 June 1712.

3. See Montagu to her sister, Lady Mar, June 1725 ('I would fain be ten years younger'); July 1725 ('despising [the world] is of no use but to hasten wrinkles'); May 1727 ('For my part I pretend to be as young as ever'), *The Complete Letters of Lady Mary Wortley Montagu*, ed. R. Halsband, Oxford, 1966, vol. 2, pp. 52, 53, 76.

4. R. Halsband, *The Life of Lady Mary Wortley Montagu*, Oxford, 1956, pp. 51–2, quoting Lady Loudon and other contemporary sources.

5. See *Complete Letters*, numerous references.

6. *The Encyclopaedia Britannica*, 11th edn, Cambridge, 1911, vol. 25.

7. 'Saturday. The Small-Pox. Flavia', stanzas 32, 34, 35, in *Six Town Eclogues with some other Poems by the Rt. Hon. L.M.W.M.*, London, 1747. It is suggested in E. Rothstein, *The Routledge History of English Poetry*, Boston and London, 1981, vol. 3, that *Town Eclogues* was written with the help of Gay, but it is not clear what the evidence for this partial disattribution might be.

8. B. Williams, *The Whig Supremacy 1714–1760*, Oxford, 1939, p. 142.

9. R. Halsband, '"Condemned to Petticoats": Lady Mary Wortley Montagu as Feminist and Writer', in R.B. White, Jnr, ed., *The Dress of Words: Essays on Restoration and Eighteenth-Century Literature in Honor of Richmond P. Bond*, Lawrence, Kansas, 1978, p. 35.

10. *Complete Letters*, introduction by Halsband, p. xiv.

11. I have been assisted in this proposition by reading Joan W. Scott's 'Gender: A Useful Category of Historical Analysis', *American Historical Review*, 91, 1986, pp. 1053–75.

12. For the wearing of patches see J. Addison, *Spectator*, no. 81, 2 June 1711; for the notion of the body as work of art see D.C. Stanton, *The Aristocrat as Art. A Study of the Honnête Homme and the Dandy in Seventeenth- and Nineteenth-Century French Literature*, New York, 1980; R. Sennett, *The Fall of Public Man*, Cambridge (1974), 1977; A. Ribeiro, *Dress and Morality*, London, 1986. At a religious level, the idea of life as a stage is a familiar trope in Shakespeare and formulated with a particular asperity by Erasmus: 'Now what else is the whole life of mortals but a sort of comedy, in which the various actors, disguised by various costumes and masks, walk on and play each one his part, until the manager waves them off the stage?' (Erasmus, *In Praise of Folly* (1510), trans. H.H. Hudson, New York, 1941, p. 37.)

13. The mirror is not only an attribute of Venus and a symbol of self-knowledge but also a more general allusion to the female subject as the object of the viewing subject.

14. In a most interesting article that was published when the writing of this book was complete, Joseph W. Lew discusses Montagu's letters from Constantinople in terms of gender distinct levels of language in relation to multiple discourses of orientalism. He points out that primary distinctions were made by the English aristocracy not between men's space and women's space but between men's space and shared space. Montagu's languages of gossip to female correspondents, he argues, represent an insistence on a 'women's coffee house'. J.W. Lew, 'Lady Mary's Seraglio', *Eighteenth-Century Studies*, 24, no. 4, summer 1991, p. 445. See also Harriet Guest's pertinent discussion of eighteenth-century anxiety about the

display of gender difference in 'A Double Lustre: Femininity and Sociable Commerce, 1730–60', *Eighteenth-Century Studies*, 23, no. 4, summer 1990.

15. J. Addison, 'The Pleasures of the Imagination', no. 2, *Spectator*, no. 411, 21 June 1712.

16. S. Johnson, *The Vanity of Human Wishes*, stanza 8, in *Johnson. Prose and Poetry*, London (1950), 1963.

17. See C. Levi-Strauss, *The Elementary Structures of Kinship* (1949), trans. J.H. Bell and J.R. von Sturmer, and ed. R. Needham, London, 1969; e.g., pp. 32–3; 'It is impossible to approach the study of marriage prohibitions if it is not thoroughly understood from the beginning that such facts [as the system of the scarce product] are in no way exceptional, but represent a particular application, within a given field, of principles and methods encountered whenever the physical or spiritual existence of the group is at stake. The group controls the distribution not only of women, but of a whole collection of valuables. Food, the most easily observed of these, is more than just the most vital commodity it really is, for between it and women there is a whole system of real and symbolic relationships, whose true nature is only gradually emerging, but which, when even superficially understood, are enough to establish the connexion.'

18. For an account of this event, see Halsband, *Life of Lady Mary Wortley Montagu*, p. 4., quoting Lady Stuart: 'At one of their meetings when they wished to elect a beauty as their toast for the year, Lord Kingston nominated Lady Mary; and when other Club members objected to judging a candidate they had never seen, he ordered the girl to be finely dressed and brought to the tavern. There she was unanimously voted the reigning beauty. In this company "she went from the lap of one poet, or patriot, or statesman, to the arms of another, was feasted with sweetmeats, overwhelmed with caresses, and, what perhaps already pleased her better than either, heard her wit and beauty loudly extolled on every side. Pleasure, she said, was too poor a word to express her sensations; they amounted to ecstasy: never again, throughout her whole future life, did she pass so happy a day."'

19. Halsband, *Life of Lady Mary Wortley Montagu*, p. 52, quoting Lady Loudon.

20. Lacanian psychoanalysis with its concern with the mirror metaphor implies the centrality of the human face. For a discussion of the clinical and symbolic importance of the face see M. Eigen, 'On the significance of the face', *Psychoanalytic Review*, 67, part 4, winter 1980–1.

21. Montagu to Lady ——, 17 June 1717, *Complete Letters*, vol. 1, pp. 368–9.

22. See J. Lacan, *Ecrits. A Selection* (1966), trans. A. Sheridan (1977), London, 1982, ch. 1.

23. As, for example, with S. Deuchar, *Sporting Art in Eighteenth-Century England. A Social and Political History*, New Haven and London, 1988, and I. Pears, *The Discovery of Painting. The Growth of Interest in the Arts in England, 1680–1768*, New Haven and London, 1988.

24. Pears, *Discovery of Painting*, p. 143.

25. R. Steele, 'Abnormis Sapiens' *Tatler*, no. 109, 5 July 1711. My italics.

26. Montagu was a collector of antique gems and medals and displayed considerable knowledge when travelling in Europe. The portrait for Algarotti is mentioned in a letter to him of December 1736, *Complete Letters*, vol. 2, p. 110.

27. See J. Scarce, *Women's Costume of the Near and Middle East*, London, 1987, pp. 59–63. Engravings by Le Hay after Jean-Baptiste Vanmour (1671–1737) (variously spelt Vanmor/Vanmoeur/Van Mour) are published in *Recueil de cent estampes représentant les différents nations du Levant tirées sur les tableaux peints d'après nature en 1707 et 1708 par les ordres de M. de Ferriol Ambassadeur du Roi à la Porte. Et gravées en 1712 et 1713 par les soins de M. le Hay*, Paris, 1712 and 1713; the plates then went to Laurent Cars who published a new edition in 1714; the third edition was published in 1715 with a slightly different title, *Explication des Cent Estampes* For Vanmour and other western artists in Constantinople, see A. Boppé, *Les Peintres du Bosphore au dix-huitième Siècle*, Paris, 1911. For eighteenth-century British costume, see A. Ribeiro, *A Visual History of Costume. The Eighteenth Century*, London, 1983.

28. Montagu to Lady Mar, 1 April 1777, *Complete Letters*, vol. 1, pp. 325–30.

29. Corneille Le Bruyn, *A Voyage to the Levant: or Travels in the Principal Parts of Asia Minor, the Islands of Scio, Rhodes, Cyprus, &c. with an Account of the most Considerable Cities of Egypt, Syria and the Holy Land, done into English by W.J.*, London, 1702.

30. D. Defoe, *Roxana. The Fortunate Mistress* (Oxford English Novels), London, 1964, pp. 173–6. Aileen Ribeiro points out that the prominence given to the breasts by the tight-fitting dress, and the thrusting belly emphasized by the girdle would have been thought ungenteel through most of the eighteenth century when the shape of women was well-concealed by boned stays and stiff petticoats (A. Ribeiro, 'Turquerie: Turkish dress and English Fashion in the eighteenth century', *Connoisseur*, 201, no. 807, May 1979, p. 18.). Elsewhere Ribeiro quotes a verse published in 1724 that indicates the risqué nature of the Turkish style in dress: 'O Jesu – Coz – why this fantastick Dress?/I fear som Frenzy does your Head possess;/That thus you sweep along a Turkish Tail,/And let that Robe o'er Modesty prevail.' (J. Arbuthnot, *The Ball, stated in a Dialogue betwixt a Prude and a Coquet*, London, 1724, quoted in A. Ribeiro, *The Dress worn at Masquerades in England 1730–1790, and its Relation to Fancy Dress in Portraiture*, New York and London, 1984, p. 31). Ribeiro is of the view that Richardson (if he was indeed the artist) adapted an earlier portrait of Montagu, attributed to Liotard and also suggests that Montagu brought back dresses, some of which have survived, at the Victoria and Albert Museum, London, and in the possession of the Earl of Harrowby. The craze for Turqueries really caught on only in the 1760s when the Tambour frame facilitated the production at home of Turkish silks and embroideries. Henry Hoare erected a Turkish tent at Stourhead in the 1770s, and for his coming-of-age party in 1781 Beckford transformed Fonthill into a Turkish palace.

31. H. Honour, *The Image of the Black in Western Art*, vol. 4: *From the American Revolution to World War I*, Cambridge, Mass. and London, 1989, vol. 1, pp. 30–1.

32. For an analytical survey of such types see D. Dabydeen, *Hogarth's Blacks. Images of Blacks in Eighteenth-century English Art* (1985) Manchester, 1987.

33. There is a substantial literature on the connotations of such juxtapositions. See, for example, S. Gilman, 'Black Bodies. White Bodies: Towards an Iconography of Female Sexuality in Late Nineteenth-Century Art, Medicine and Literature', *Critical Inquiry*, 12, autumn 1985.

34. Although the Ottoman empire at this time still included North African territories (notably Tripoli and Barca), and the presence of black eunuchs was an essential ingredient of the Turkish narrative. Montagu mocked a correspondent who asked her to bring back a Greek slave, pointing out that the fine slaves that wait upon the great ladies and serve the pleasures of the great men are commonly Circassians who are never sold except as a punishment. Montagu to Lady ——, 17 June 1717, *Complete Letters*, vol. 1, pp. 367–8.

35. The Levant Company which held a monopoly of trade in the area was established in 1512. Trade issues were still significant enough in 1716 for Edward Montagu to be dispatched to Constantinople to prevent Austria's coming to the assistance of the Venetian Republic by going to war on Turkey. The Ottomans had lost their supreme position in central Europe since the relief of Vienna in 1683 by the Polish army led by King John Sobieski.

36. Montesquieu's *Lettres Persanes* was not published until 1721 but may have been known earlier. One popular account of Turkey of the sort that Montagu was at pains to refute was *Nouveau Voyage du Levant par le Sieur D.M. [Dumont] contenant ce qu'il a vu de plus remarquable en Allemagne, France, Italie, Malthe, & Turquie*, The Hague, 1694. Dumont stresses that 'la grande passion des Turques est pour les belles femmes' (p. 214) and describes how dancers 'font mille postures lubriques, que les femmes les plus perdues ne voudroient faire en Europe' (p. 236). Montagu is dismissive of Aaron Hill, *A Full and Just Account of the Present State of the Ottoman Empire in all its Branches*, London, 1709, with much less justification. The identification of Turkey with sensuality and an ongoing collusion with the object of critique persists in popular and 'serious' publications. A. Grosrichard in *Structure du Sérail. La Fiction du Despotisme Asiatique dans l'Occident Classique*, Paris, 1979, concludes: 'cet homme donc, qui est censé être le seul à détenir le pouvoir, n'est que l'instrument de celle qui, comme femme, est censée en être privée. Dans cet univers saturé par le sexe, n'hésitons pas à écrire que celui qui, en apparence *a* le phallus, *est* le phallus pour sa mère' (p. 208) ('So this man, who is regarded as the sole possesser of power, is no more than the instrument of her who, as woman, is considered private being. In this sex-saturated universe, let us not hesitate to write that he who appears to *have* the phallus, *is* his mother's phallus'). See also N. Russell, 'Steamy Nights at the Turkish Baths', *Times Higher Education Supplement*, 28 July 1989.

37. Recent books that deal particularly with cultural relations and that contain bibliographies are J. Raby, *Venice, Dürer and the Oriental Mode*, London: Sotheby Publications, 1982, and *At the Sublime Porte. Ambassadors to the Ottoman Empire (1550–1800)*, exhibition catalogue, Messrs Hazlitt, Gooden and Fox, London, 1988.

38. *The Persian Eclogues*, in *The Poetical Works of William Collins, with the Life of the Author by Samuel Johnson, L.L.D.*, London, 1807. Collins died in 1756, the 1807 edition in *Bell's British Poets* series contains also (pp. 87–92) his 'Observations' on the origins of pastoral.

39. Montagu to Alexander Pope, 1 April 1717, *Complete Letters*, vol. 1, p. 331. John Barrell has

drawn my attention to the fact that Montagu's last remark reflects back to Pope his most famous contribution to pastoral theory, namely that pastoral need not be written in rustic Loamshire because it imitates, a pre-historical patriarchal time 'when the best of men follow'd the employment'. A. Pope, 'A Discourse on Pastoral Poetry', in *The Poems of Alexander Pope*, 1-volume Twickenham edn., London, 1963, p. 120.

40. Halsband's footnotes to *Complete Letters* frequently draw attention to misrepresentations, exaggerations and factual inaccuracies.

41. Halsband's care in footnoting those passages that Ingres copied into his notebooks has the effect of valorizing Montagu by reference to Ingres (see also N. Schlenoff, *Ingres, ses sources littéraires*, Paris, 1986). Most of the secondary literature on orientalist art refers to Montagu's letters; see, for example *The Orientalists: Delacroix to Matisse. European Painters in North Africa and the Near East*, Royal Academy of Arts, London, 1984; W. Leeks, 'Ingres Other-Wise', *Oxford Art Journal*, vol. 9, no. 1, 1986, pp. 29–37.

42. Halsband, 'Condemned to Petticoats', p. 49.

43. D. Murphy and C. Pick, *Embassy to Constantinople. The Travels of Lady Mary Wortley Montagu*, London, 1988, p. 7.

44. E.W. Fernea, 'An Early Ethnographer of Middle Eastern Women: Lady Mary Wortley Montagu 1689–1762', *Journal of Near Eastern Studies*, 40, no. 4, October 1981, p. 330.

45. A.M. Moulin and P. Chauvin, *L'Islam au Péril des Femmes*, Paris, 1981, pp. 20–2.

46. Montagu to Lady ——, 1 April 1717, *Complete Letters*, vol. 1, pp. 312–15.

47. The question of the account's authenticity is dealt with by P. Conner in 'On the Bath: Western Experience of the Hammam', *Journal of Renaissance and Modern Studies*, 31, 1987, pp. 34–41. The most serious analysis to date is that offered by Lew, 'Lady Mary's Seraglio'.

48. As Lew points out, *ibid.*, p. 433, Montagu revised her letters and they present, therefore, a re-thinking, a tranformation from 'natural' to 'fictive' utterance.

49. Montagu loaned the albums containing copies of letters and actual letters to Mary Astell in 1724; Astell's preface was written in the blank pages at the end of the second volume and included in the published version which appeared without the family's permission in 1763, less than a year after her death. Halsband gives a summary of editions in *Complete Letters*, vol. 1, pp. xvii–xix. A row over the ownership of Montagu's manuscripts is recorded in *A Narrative of what passed between General Sir Harry Erskine and Philip Thicknesse, Esq.; in consequence of a Letter written by the latter to the Earl of B – relative to the publication of some Original Letters and Poetry of Lady Mary Wortley Montague's then in Mr. Thicknesse's possession*, London, 1766.

50. J. Kerslake, *Early Georgian Portraits*, National Portrait Gallery, London, 1977, no. 3924.

51. These appear variously as full-length, three-quarter-length and half-length with a variety of backgrounds, e.g., Sotheby's, 13 July 1988 (34); Mappin Art Gallery Sheffield (ex Wharncliffe Collection) as J. Richardson; Boughton Collection (as Duchess of Montague with two small boys to left). Ribeiro (*Dress Worn at Masquerades*, p. 222) attributes to Liotard the miniature of Montagu (coll. Capt. L. Seymour) engraved by Greatbach and frequently reproduced (e.g., in I. Barry,

Portrait of Lady Mary Wortley Montagu, London, 1928, p. 165). E.H. Humbert and A. Revilliod, *La Vie et les Oeuvres de Jean-Etienne Liotard, 1702–1789*, Amsterdam, 1897, refer to a portrait of Montagu (p. 27) but do not include it in their catalogue.

52. M. Astell, 18 December 1724, preface to *Letters of the Right Honourable Lady M--y W---y M----e: written, during her Travels in Europe, Asia and Africa*, London, 1769, vol. 1, pp. viii.

53. There is also a copy of this engraving mounted in *Portraits of English Poetesses*, vol. 2, British Library, London.

54. See also National Portrait Gallery, London, no. 3924, *Lady Mary Wortley Montagu and her son, Edward accompanied by Turkish servants*.

55. See *Recueil de Cent Estampes*, pls 3 and 68; see *A Voyage to the Levant*, pl. 35. For details of publication, see n. 27, above. Le Bruyn draws attention to the grandeur of dress that is particular to the women of Constantinople and describes how 'their *Tarpous*, or Head-dresses, are fasten'd to their Heads with a great many Handkerchiefs of various Colours, all wrought with Gold and Silver, and beset with all manner of precious stones, each according to her Ability' (p. 39).

56. For a discussion of this question see A. Coombes and S. Edwards, 'Site Unseen: Photography in the Colonial Empire: Images of Subconscious Eroticism', *Art History*, 12, no. 4, December 1989, p. 512.

57. S. Faunce and L. Nochlin, *Courbet Reconsidered*, New Haven and London, 1988, pp. 32–3.

58. See, for example, Halsband, 'Condemned to Petticoats'.

59. Montagu to the Countesse of ——, May 1718, *Complete Letters*, vol. 1, pp. 407–8.

60. See, for example, Le Bruyn on Turkish women: 'The Women are very narrowly kept and Eyed, the One in their Service, and the Others in their Apartment . . . The Gardeners and other Officers that chance to meet them in their Walks, are oblig'd immediately to turn on one side, and keep their Eyes fix'd upon the Ground, so that it may be said that not a Man has ever seen the Face of one of the *Sultanas* belonging to the *Seraglio* during her stay there', *A Voyage to the Levant*, pp. 30–1.

61. Montagu to Lady Bristol, 10 April 1718, *Complete Letters*, vol. 1, p. 397.

62. See Montagu to Lady ——, 1 April 1717 (for the account of the Baths) and Montagu to Lady Mar, 18 April 1717 (for the account of the visits to the Grand Vizier's and the Kahya's ladies); for a description of the extremely elaborate dress worn at the Viennese court see Montagu to Lady Mar, 14 September 1716: *Complete Letters*, vol. 1, pp. 312–15; 347–52; 265–9.

63. Leeks in 'Ingres Other-Wise' (p. 31) points out that Montagu's position in the Baths is voyeuristic because she refuses to take off her clothes, a position that is compounded by her status as westerner and diplomat's wife. She argues that Montagu 'is playing a male role in relation to the women of the bath, with whom she does not identify. The power relation existing between her and the bathers is thus analogous in some ways to that of the male spectator and the female nude.' Leeks then goes on to acknowledge that the distance between Montagu and the bathers is broken down because she is also a spectacle that is looked upon, but Leeks does not pursue this line of enquiry because her interest is primarily with Montagu as a source for Ingres. Where I differ

with Leeks is at the assertion that Montagu does not identify with the women of the bath and at the point where she reduces the common element between Montagu and the bathers to 'femaleness'. While acknowledging the ground-breaking aspect of Leeks's work, this form of essentialism is something I wish to question.

64. This process is described by Lacan as follows: 'It is the intersection by which the single signifier functions here in the field of *Lust*, that is to say, in the field of primary narcissistic identification, that is to be found the essential mainspring of the effects of the ego ideal, of that being that he first saw appearing in the form of the parent holding him up before the mirror. By clinging to the reference-point of him who looks at him in a mirror, the subject sees appearing, not his ego ideal, but his ideal ego, that point at which he desires to gratify himself in himself', J. Lacan, *The Four Fundamental Concepts of Psychoanalysis* (1973), ed. J.-A. Miller, trans. A Sheridan, Harmondsworth (1979), 1987, pp. 256–7.

65. Montagu to Lady ——, 1 April 1717, *Complete Letters*, vol. 1, pp. 313–15.

66. *Paradise Lost*, bk IV, ll. 304–11, in *Milton. Complete Poetry and Selected Prose*, ed. E.H. Visiak, London (1938), 1952.

67. For a discussion of the taste for Guido and Titian in the late eighteenth century, see F. Haskell, *Rediscoveries in Art. Some Aspects of Taste, Fashion and Collecting in England and France*, London, 1976, pp. 27–8.

68. Kerslake, *Early Georgian Portraits*, no. 3924, suggests that the portrait of Montagu (Lady Mary Pierrepont) painted before her marriage and showing her as a shepherdess (Bute Collection, Dumfries House) attributed to Kneller is likely to be by Jervas. This would date Montagu's acquaintance with Jervas well before her journey to Constantinople. Other portraits identified as Montagu in Turkish dress are said to be the work of Jervas or his studio (e.g., National Gallery of Ireland and Glynde Place, Sussex). It was to Kneller, however, that Montagu sat for a portrait in Turkish dress in 1720 commissioned by Pope (Bute Collection), engraved by Caroline Watson. Pope's *Epistle to Mr Jervas* was written *c.*1715 and published in 1716; it specifically refers to Guido and Titian, and at line 60 the original referred to 'Wortley's eyes', but Pope changed this to 'Worsley's eyes' after he quarrelled with Montagu in 1729 (*Poems of Alexander Pope*, p. 250n). Horace Walpole's sneering comments on Jervas as a painter of 'wretched daubings' (*Anecdotes of Painting in England* (1762–1780; 1876), New York: Arno Press reprint, 1969, vol. 2, pp. 269–70) have been adopted by most biographers.

69. J.L. Lew in his interesting close reading of this passage defines Jervas as 'The invisible Mr Jervas, the English man observing this tableau (invisible precisely because he is outside the work of art – it would literally be death for him to enter it) may improve his art through analyzing this erotic tableau, through studying the Turkish women's postures', 'Lady Mary's Seraglio', p. 442. I do not, however, agree that Montagu 'escapes being framed by framing the framer' (p. 443). It is rather that Jervas – and what he represents, both of which are treated with contempt – are an irrelevance because Montagu has subsumed the visual and the historical into the personal.

70. *A Catalogue of the Most Valuable Collection of Pictures, Prints, and Drawings late of Charles Jarvis,*

deceased; *Principal Painter to their Majesties King George I and II*, March 1739–40; many of the 'nudities' were Jervas's copies after Raphael, Caracci, Berettoni and others.

71. Montagu to Lady Mar, 18 April 1717, *Complete Letters*, vol. 1, p. 351. The fullest account of a harem is to be found in N.M. Penzer, *The Harem. An Account of the Institution as it existed in the palace of the Turkish Sultans, with a history of the grand seraglio from its foundation to the present time*, London, 1936.

72. Most notably for Reynolds's portrait of Commodore Augustus Keppel of 1752, National Maritime Museum, Greenwich. See, however, D. Solkin, 'Great Pictures of Great Men? Reynolds, Male Portraiture, and the Power of Art', *Oxford Art Journal*, 9, no. 2, 1986, for an elaboration of this question.

73. Sotheby's 13 July 1988 (32), ex Wharncliffe Collection; National Portrait Gallery, London, no. 3924. An account of Vanmour's work is to be found in R. Van Luttervelt, *De 'Turkse' Schilderijen van J.B. Vanmour en zijn School*, Nederlands Historisch-Archaeologisch Instituut in her nabije Oosten, Istanbul, 1958.

74. Montagu to Anne Thistlethwayte, 4 January 1718, *Complete Letters*, vol. 1, pp. 371–2.

75. Montagu to Lady ——, 16 March 1718, *Complete Letters*, vol. 1, pp. 387–91. The Turkish love-letter was originally understood to be composed of flowers or other objects with symbolic significance but the idea seems to have rapidly extended to cover written correspondence. Jean-Etienne Liotard (1702–89) dealt with this theme and it reappears with great frequency in the nineteenth century. See, for example, David Wilkie's *The Turkish Letter Writer*, Aberdeen Art Gallery and Museum, and J.F. Lewis's *An Intercepted Correspondence*, private collection, Houston, Texas, both reproduced in *The Orientalists: Delacroix to Matisse*.

76. See, for example, Vermeer's *Woman Reading a Letter* Rijksmuseum-Stichting, Amsterdam; Metsu's *The Letter Writer Surprised*, Wallace Collection, London; David Wilkie's *The Letter of Introduction*, Edinburgh, National Gallery of Scotland; George Elgar Hicks's *Woman's Mission: Companion to Manhood*, Tate Gallery, London.

VI THE CONVERSATION PIECE

1. R. Strong, *Holbein and Henry VIII*, London, 1967.
2. M. Webster, *Johan Zoffany 1733–1810*, National Portrait Gallery, London, 1976, p. 10.
3. E.K. Waterhouse, *Painting in Britain 1530–1790*, Harmondsworth (1953), 1954, p. 219.
4. R. Edwards, *Early Conversation Pictures from the Middle Ages to about 1730. A Study in Origins*, London, 1954, p. 8.
5. The fullest historical account is M. Praz, *Conversation Pieces. A Survey of the Informal Group Portrait in Europe and America*, Rome and London, 1971. Praz argues for four conditions for the conversation piece: two or more identifiable people, a background that describes the habitat of the family or group, an action or actions signifying conversation or communication, and privacy (i.e., not a public or official function). Earlier publications are Edwards, *Early Conversation Pictures* and G.C. Williamson, *English Conversation Pictures of the Eighteenth and Early Nineteenth Centuries*, New York, 1975. In an unsubstantiated aside, Edgar

Wind remarked that topical group pictures were the '*incunabula* of history painting' (E. Wind, 'The Revolution of History Painting', *Journal of the Warburg and Courtanld Institutes*, 2, 1938–9, pp. 116–127). The exception to this generally unquestioning survey literature is Ellen G. D'Oench's excellent *The Conversation Piece: Arthur Devis and his Contemporaries*, Yale Centre for British Art, New Haven, 1980.

6. D'Oench, *The Conversation Piece*, p. 3, quoting J. Russel, *Letters from a Young Painter Abroad to his Friends in England*, London, 1750.
7. See, for example, John Hayes in his foreword to Webster, *Johan Zoffany*: 'Zoffany, like Canaletto, is one of those artists who have never lost their appeal. His ability to catch a likeness, his passion for detail, the delightful informality of his conversation pieces and the particular flavour of his sentiment have all contributed to ensure that' (p. 5).
8. G.C. Williamson, *John Zoffany, RA, His Life and Works 1735–1810*, London, 1920, p. 153.
9. *Dictionary of National Biography* and [John Iliff Wilson], *A Brief History of Christ's Hospital*, London, 1820, p. 17. See also ch. 1, pp. 33–4, above.
10. See, for example, George Eliot in *Middlemarch* (1871–2) and David Wilkie, *Reading the Will* (1820).
11. Webster, *Johan Zoffany*, pp. 10–11.
12. I.R. Christie, *Stress and Stability in Late Eighteenth-Century Britain. Reflections on the British Avoidance of Revolution*, Oxford, 1984, p. 56.
13. Praz, *Conversation Pieces*, p. 7.
14. W. von Archenholtz, *A Picture of England: containing a description of the laws, customs, and manners of England*, London, 1797, p. 37.
15. J.C.D. Clark, *English Society 1688–1832*, Cambridge, 1985, p. 72.
16. Webster, *Johan Zoffany*, p. 11.
17. See *ibid.*, no. 25, and *The Royal Collection: Paintings from Windsor Castle*, National Museum of Wales, Cardiff, 1990, no. 55.
18. Salignac de la Mothe Fénelon's pedagogic novel *The Adventures of Telemachus* (1st edn, Paris, 1699) appeared in London in 1742 and went into dozens of editions through the century. The interest extended also into opera: Galliard's *Calypso and Telemachus* was first performed in London on 25 May 1712, was revived in 1717 and was highly regarded by Handel.
19. The Congreve family is an Irish branch of the Congreve family of Congreve in Staffordshire. A further portrait of Captain William Congreve and his son has recently been sold to the British Interplanetary Society. I am grateful to Mrs A.H. Tyler and Major Ambrose Congreve for information relating to the family.
20. See C. Geertz: 'Thinking consists not of "happenings in the head" (though happenings there and elsewhere are necessary for it to occur) but of a traffic in what have been called . . . Significant symbols – words for the most part but also gestures, drawings . . . etc. . . . anything, in fact, that is disengaged from mere actuality and used to impose meaning upon experience' (*The Interpretation of Cultures: Collected Essays by Clifford Geertz*, New York, 1973, p. 45).
21. W.Y. Carman, 'Sir William Congreve, 1741–1814', *Journal of the Society for Army Historical Research*, 51, 1973, pp. 63–8; Captain Congreve fought in the Netherlands following the French revolution and left, at his death, a number of

notebooks and manuscripts some of which are now in the National Army Museum, London.

22. The figures have been identified by H. Belsey, 'A Family Portrait by Philip Reinagle', *Apollo*, February 1981, pp. 97–9. I am much indebted to Mr Belsey for his research on the history of these portraits.
23. See National Portrait Gallery, no. 67, Studio of Sir Godfrey Kneller, now hanging in the State Bedroom at Beningborough Hall, Yorks.
24. See Belsey, 'A Family Portrait'.
25. See L. Stone, *The Family, Sex and Marriage in England 1500–1800* (1977), abridged edn, Harmondsworth, 1985, ch. 8, part 6, for discussion of the companionate marriage.
26. See D. Lieberman, *The Province of Legislation Determined. Legal Theory in Eighteenth-Century Britain*, Cambridge, 1989, pp. 134–43.
27. See G.E. Aylmer, 'The Meaning and Definition of "Property" in seventeenth-century England', *Past and Present*, no. 86, February 1980, pp. 87–95; W.R. Cornish and the late G. de N. Clark, *Law and Society in England 1750–1950*, London, 1989.
28. H. Walpole, *Anecdotes of Painting in England* (1762–80; 1876), New York: Arno Press reprint, 1969, vol. 2, p. 273.
29. A frequently repeated anecdote. See, for example, J. Burnet, *Practical Hints on Portrait Painting*, London, 1850, p. 3.
30. *Catalogue of the Portraits and Pictures in the different Houses of the Earl of Fife*, 1798 (copy inscribed 1796, Society of Antiquaries Library), preface, n.p.

VII THE STATE OF A CHILD

1. J. Locke, *An Essay Concerning Human Understanding*, bk 2, ch. 1, section 6, in *The Works of John Locke*, London, 1823, vol. 1, p. 85.
2. Among the most influential of these studies are: P. Ariès, *Centuries of Childhood*, London, 1962; J.L. Flandrin, *Families in Former Times*, London, 1979; T.P.R. Laslett, *Family Life and Illicit Love in Earlier Generations*, London, 1977; A. MacFarlane, *The Origins of English Individualism: The Family, Property and Social Transition*, Oxford, 1978; L. de Mause, ed., *The History of Childhood*, New York, 1974; R. Mitteraur and R. Sieder, *The European Family*, London, 1982; L. Stone, *The Family, Sex and Marriage in England 1500–1800* (1977), abridged edn, Harmondsworth, 1979. Only Ariès deals with visual material to any great extent.
3. See, for example, Simon Schama's discussion of Ariès in chapter 7 of *The Embarrassment of Riches. An Interpretation of Dutch Culture in the Golden Age*, London, 1987. For a useful summary of the various historical approaches see M. Anderson, *Approaches to the History of the Western Family, 1500–1914*, London (1980), 1986.
4. Schama, *Embarrassment of Riches*, p. 484.
5. *Reynolds*, ed. N. Penny, Royal Academy of Arts, London, 1986, p. 33.
6. Historians of the family are generally agreed that the conjugal family (parents and unmarried children) is of relatively recent date. Not only was the family, prior to the nineteenth century, not a clearly discrete group but its members had no significant right to privacy. See Anderson, *Approaches to the History of the Western Family*, pp. 41–2.
7. J.R. Gillis, *Youth and History. Tradition and Change in European Age Relations 1770-Present*, New York, 1981, p. 2.

8. L. Jordanova, 'Objects of Knowledge: A Historical Perspective on Museums', in P. Vergo, ed., *The New Museology*, London, 1989, p. 29.

9. See for example, C. Harvey, *Schola Cordis*, London, 1647.

10. *The Artist's Repository and Drawing Magazine*, vol. 4, [1788?], features children exemplifying many activities such as Design, Colour etc.

11. Gainsborough's 'naturalness' is, of course, demonstrably as artificial as Reynolds's artifice. Moreover, the points that Wind so valuably made concerning the relationship between the genre/child studies and the child-portraits of Reynolds apply equally to Gainsborough's fancy pictures. The structural relationship between the two sets in the work of both artists is explored in terms of wealth and poverty, portrait and genre, in P. Crown, 'Portraits and Fancy Pictures by Gainsborough and Reynolds: contrasting Images of Childhood', *British Journal for Eighteenth-Century Studies*, 7, no. 2, autumn 1984, pp. 159–67. R. Wendorf rightly points out, however, that 'if there is a measure of the tyrant in the boy, so there is also an element of boyishness in the tyrant', R. Wendorf, *The Elements of Life. Biography and Portrait-Painting in Stuart and Georgian England*, Oxford, 1990, p. 249.

12. E. Wind, *Hume and the Heroic Portrait. Studies in Eighteenth-century Imagery*, ed. J. Anderson, Oxford, 1986, pp. 24–5, originally delivered as a lecture in 1932.

13. *Ibid.*, p. 26.

14. See *Reynolds*, no. 145.

15. See S. Tytler, *Modern Painters and their Paintings*, London, 1878 (5th edn; British Library edn, 1880), p. 24. The painting cannot be identified from the resources of the Witt Library.

16. J. Locke, *Two Treatises*, bk 2, ch. 7, sections 77–89, in *Works*, vol. 5, p. 383. M.J.M. Ezell in 'John Locke's Images of Childhood', *Eighteenth-Century Studies*, 17, no. 2, winter 1983–4, p. 140, points out that although Locke spearheaded the movement towards a reidentification of the child in relation to the family, most of his ideas had already been formulated by Evelyn, Aubrey, Eachard and Milton.

17. Wind, *Hume and the Heroic Portrait*, pp. 27–9.

18. F. Burney, *Evelina*, 1778, Letter xxxix.

19. I am deliberately excluding from this discussion the question of women portrait painters. Arguably the reason there are not more women portrait painters in this period (in contrast to our own century) lies in the power relationship between artist and sitter. In wondering why artists like Mrs Grace (a contemporary portrait painter) are exceptions, the writer in *The Artist's Repository* (vol. 4, [1788?], pp. 137–8) suggests that it is not because the arts are difficult of attainment or because the female mind is destitute of the requisite predispositions. The conduct of parents in educating daughters is regarded in this respect as criminal.

20. Chief among these must have been lack of education. Women 'are confined to absolute dependence throughout life, by the cruel negligence of those who should have been their guides, instructors, and examples. In their youth what do they learn to any perfection, so that it may be of lasting service in the after stages of life . . . ?', Burney, *Evelina*, p. 138.

21. As David Solkin, however, has established, male portraiture was open to allegorizing narratives. See D. Solkin, 'The Battle of the Ciceros: Richard Wilson and the politics of landscape in the age of John Wilkes', *Art History*, 6, no. 4, December 1983, pp. 406–22.

22. U. Middeldorf, 'Portraits by Francesco da Sangallo', in *Racolta di Scritti*, vol. 1: *1924–1938*, Florence, 1979–80, p. 313.

23. Professor Giles Robertson, lecture at conference on portraiture, University of Edinburgh, April 1981.

24. D.M. Lubin, *Act of Portrayal: Eakins, Sargent, James*, New Haven and London, 1985, p. 3.

25. 'Il ne s'agit pas de farder une femme, de l'habiller en vestale pour qu'on la croie chaste: c'est corrompre l'essence des choses. On ne devrait peindre un chacun que par ses vertus. Travail incroyable pour les faiseurs de portraits; le beau leur déplaît, le vrai leur semble faux et le naturel les désole' ('It is not a question of varnishing a woman, of dressing her in Vestal's clothing in order to believe her chaste; it is to corrupt the essence of things. One ought not to paint a person except by their virtues. Unbelievable labour for the makers of portraits; beauty displeases them, truth appears false to them, and the natural distresses them'), anonymous review, quoted in J. Loquin, 'La Lutte des Critiques d'Art contre les Portraitistes au XVIIIᵉ siècle', *Nouvelles Archives de l'Art Français*, 7, 1913, p. 314.

26. R. Davies, *Romney*, London, 1914, p. 33.

27. M. Levey, *Sir Thomas Lawrence*, National Portrait Gallery, London, 1979–80; see, for example, statements such as, 'despite her bird of paradise plumes, expanse of fur and heavy bracelets like Jewelled manacles the sitter gazes out with simplicity and sweetness' (pp. 20–1, on Lady Peel).

28. A.M. Clark, *Studies in Roman Eighteenth-Century Painting*, ed. E.P. Bowron, Washington, D.C., 1981, p. 17.

29. E.H. Gombrich, 'The Mask and the Face: the perception of physiognomic likeness in life and in art', in E.H. Gombrich, J. Hochberg and M. Black, *Art, Perception and Reality*, Baltimore and London, 1972, p. 11.

30. J. Burnet, *Practical Hints on Portrait Painting, illustrated by examples from the works of Van Dyck and other masters*, London, 1850, p. 14.

31. L. Nead, *Myths of Sexuality. Representations of Women in Victorian Britain*, Oxford, 1988, p. 13.

32. R. Paulson, *Emblem and Expression*, Cambridge, Mass., 1975, p. 90, commented on the boy's phallic torch and suggestive gesture; Crown, 'Portraits and Fancy Pictures', p. 160, n. 10, draws attention to the sexual exploitation that was one of the hazards of the boy's work as a hired hand to carry torches in the street at night for wealthy clients.

33. C.R. Leslie, *A Handbook for Young Painters*, London, 1855, p. 28. The oscillation between genre and portrait in terms of cultural readings is also evinced by the findings of Edward Hamilton who, in *The Engraved Works of Sir Joshua Reynolds* (1884), new, enlarged edn, Amsterdam, 1973, frequently draws attention to the identification of fancy/genre subjects with named individuals in early catalogues.

34. See, for example, William Dyce's *Puck* (1825), *A Child with a Muff* (c.1835) and *Lowry William Frederick Dyce: 'Who goes there?'* (c.1837), reproduced in M. Pointon, *William Dyce, R.A. 1806–64: A Critical Biography*, Oxford, 1979, pls 14, 31, 35; William Mulready's *Mary Wright, the Daughter of a Carpenter* (1828), reproduced in M.

Pointon, *Mulready*, Victoria and Albert Museum, London, 1986, pl. 43; W. Holman Hunt's *The King of Hearts* (a portrait of Hunt's nephew) 1862–3, reproduced in *The Pre-Raphaelites*, Tate Gallery, London, 1984. Nineteenth-century parodies are discussed further in section iii, below.

35. The Royal Academy institutionalized this process in the eighteenth century by encouraging general names in the catalogue and the real names in a separate list. See Thomas Lawrence to Miss Farren, 1790, G.S. Layard, ed., *Sir Thomas Lawrence's Letter-Bag*, London, 1906, p. 13. Although some male sitters appeared as 'A Gentleman', they did not appear as the male equivalent of, for example, 'Juno' (Annabella Bunbury, 1769, in a painting by Reynolds).

36. See Crown, 'Portraits and Fancy Pictures'. Childrens' literature of the early nineteenth century attempted to articulate the gap that eighteenth-century paintings such as Reynolds's and Gainsborough's child-portraits elided. Narratives involve charitable acts by wealthy children to poor children, and instructions to distinguish between natural high spirits and coarse behaviour which belongs to poor children who 'do not practise more decency and retirement than the beasts of the field' (*The Poor Child's Friend, consisting of narratives founded on fact, and religious and moral subjects*, London, 1825, p. 105). The distinction between the two groups had to be maintained if the charitable acts that defined the well-brought-up child were to be sustained.

37. In the eighteenth-century domestic servants, frequently mere children, were sexually abused (the plots of novels like *Clarissa* bear out the evidence of diaries like that of Samuel Pepys, and of the growth of societies and organizations for the care and protection of girls and young women, orphans and child-labourers). Later, with industrialization, the site of sexual abuse was seen as the mill; see E.P. Thompson, *The Making of the English Working Class* (1963), Harmondsworth, 1982, p. 452 *passim*.

38. Parson Lot, pseud. of C. Kingsley, 'The National Gallery, I', in *Politics for the People*, no. 1, 6 May 1848, pp. 5–6.

39. In eighteenth-century society taste was a male prerogative. Therefore the notional viewer in any theoretical model must be masculine.

40. This is suggested in *Reynolds*, no. 107.

41. T. Hood, 'It was not in the winter', 'Ballad', in *The Complete Poetical Works of Thomas Hood*, ed. W. Jerrold, London, 1906, p. 424.

42. G. de Lorris and J. de Meung, *Roman de la Rose*, c.1240–80.

43. *Othello*, V, ii.

44. *Paradise Lost*, bk ix, l. 78, in *Milton. Complete Poetry and Selected Prose*, ed. E.H. Visiak, London (1938), 1952.

45. Quoted in *Reynolds*, no. 111.

46. *The Letters of Philip Dormer Stanhope, 4th Earl of Chesterfield*, ed. B. Dobré, London, 1932, vol. 2. The letters were excerpted in the *London Chronicle* in 1774.

47. See I. Pinchbeck and M. Hewitt, *Children in English Society*, vol. 1, London and Toronto, 1969, p. 308.

48. Stone, *Family, Sex and Marriage*, p. 114. See also M. Foucault, *The History of Sexuality*, vol. 1 (1976), Harmondsworth, 1981.

49. This pose was also used by John Brett for a photograph of one of his children, in possession of the artist's descendants, kindly shown to me by

David Cordingly. See D. Cordingly, 'The Life of John Brett', unpublished D.Phil. thesis, University of Sussex, 1983.

50. The portrait, collection of Mrs A.E. Osmaston, parodies depictions of collectors and connoisseurs.

51. See R. Cohen, *The Art of Discrimination: Thomson's The Seasons and the Language of Criticism*, London, 1964, for a fascinating series of examples.

52. In fact, there is much evidence for the puerile behaviour of upper-class men who were addicted to childish jokes, of which this painting may perhaps be one. This phenomenon has been attributed to the forced education of some ruling-class boys and their precocity; see R. Bayne-Powell, *The English Child in the Eighteenth Century*, London, 1939.

53. S. Freud, 'The Purposes of Jokes', part 3 of *Jokes and their relation to the Unconscious* (1905), in *The Pelican Freud Library*, vol. 6, Harmondsworth, 1976, p. 144; my italics.

54. E. Einberg, 'Allan Ramsay's Mansel and Blackwood Group', *National Art Collections Fund Annual*, 1990, p. 97. I am grateful to Elizabeth Einberg for a most informative conversation about this painting.

55. Information from Elizabeth Einberg.

56. *Ibid.*

57. J.C. Lavater's first essay on physiognomy, 'Von der Physiognomonik', was published in 1772; *Essais sur la Physiognomie* were published in Zurich 1775–7 (5 vols); *Essays on Physiognomy*, trans. H. Hunter, London, 1789–98.

58. W. Hogarth, *The Analysis of Beauty* (1753), ed. J. Burke, Oxford, 1955, p. 140.

59. *Ibid.*, p. 142–3.

60. I have used the British Library's *Les Quatre Livres d'Albrecht Duerer*, trans. Lys Meigret Lionnois, Arnhem, 1528. See also *Le Livre de Pourtraiture de Maistre Jean Cousin*, Paris, 1618.

61. Hogarth, *Analysis of Beauty*, p. 144.

62. *The Artist's Repository and Drawing Magazine*, vol. 1 (preface to 4th edn, vol. 1, dated 1788), Lecture 5, p. 97.

63. *Ibid.*, p. 100.

64. *Analysis of Beauty*, pp. 158–9.

65. *The Artist's Repository and Drawing Magazine*, vol. 1, p. 101.

66. C. Bell, *The Anatomy and Philosophy of Expression* (1806), 7th edn, London, 1886, p. 42.

67. Gillis, *Youth and History*, p. 3.

68. *The Conference of Monsieur Le Brun, Cheif [sic] Painter to the French King, Chancellor and Director of the Academy of Painting and Sculpture, upon Expression, General and Particular, translated from the French*, London, 1701, p. (3).

69. As exemplified, for example, in the compassionate treatment of bird and animal life in Thomson's *The Seasons*, of which 'Winter' was published first in 1726, and in Hogarth's *Four Stages of Cruelty* (1750–1).

70. Desmond Shawe Taylor's identification of 'the man of feeling' with male portraits featuring dogs and shooting equipment is extremely interesting in relation to this discussion but belongs to a later period in the 1770s (*The Georgians. Eighteenth-Century Portraiture and Society*, London, 1990, pp. 69–70).

71. See, for example, Steele on the education of girls, letter to the *Spectator*, no. 66, 16 May 1711.

72. 'Letter from an Uncle showing his Solicitude for his young Neice', in *The Instructive Letter-Writer and Entertaining Companion, containing Letters on the most interesting Subjects, in an elegant and easy style*,

2nd edn, London, 1765.

73. 'To the Author of the Connoisseur, on the modern Method of Education among People of Fashion', in *ibid.*, pp. 182–3, 184.

74. The age of Mary when the portrait was painted is not known. However, her older brother, Shovel (*c*.1728–1810), was about fourteen (information in a letter from Elizabeth Einberg), and we may assume, therefore, that she was about twelve. The sexualization of the subject in representation does not, of course, depend upon an actual set of historical circumstances. Arguably male as well as female children, long before Lewis Carroll and J.M. Barrie, were constructed as objects of sexual desire in forms of representation both verbal and visual. If, however, we look at the available historical/medical evidence it offers conflicting views. Medical evidence suggests that the age of menarche has been increasingly pushed back with the advance of health care and that girls in the eighteenth century may not have reached this stage until their late teens. (The age of menarche does not, of course, determine the age at which the female child is sexually active). None the less, Laslett has said of the patriarchal household in Stuart England, Colonial America and in France under the ancien regime: 'If fathers were concerned about the chastity of their daughters, it was because they were probably often as capable of producing bastards in their middle teens as they are today' P. Laslett, 'Age of Menarche in Europe since the Eighteenth Century', in T.K. Rabb and R.J. Rotberg, eds, *The Family in History. Interdisciplinary Essays* (1971), New York and Toronto, 1973, p. 42.

75. The painting was reproduced in the 'British Paintings' series of U.K. postage stamps, first day cover 12 August 1968, 1s. 0d. The Keeper of Paintings at the Huntington Library, Robert Wark, was obliged to write on 25 February 1964 in response to one request to reproduce the painting. 'Pinkie and the Blue Boy have suffered from innumerable unauthorized reproductions and travesties' (MS, Huntington Library art files).

76. For documentary details concerning the painting, see P. Kelly and R. Hudson, 'New Light on Sir Thomas Lawrence's "Pinkie"', *Huntington Library Quarterly*, 28, no. 3, May 1965.

77. The possibility that a commission for a portrait of a child proceeds from a conscious or unconscious anxiety about that child's chances of survival and that the portrait may be seen, in some sense, to guard against as well as provide for this eventuality, is explored in the next section. Here it is worth noting the frequency of the occurrence of the death of a child subsequent to a portrait commission or, as in the case of the Graham children, during the painting's execution. Notable cases would be Charles William Lambton (who died in 1831, six years after Lawrence's portrait was completed), Penelope Boothby (who died in 1791, less than three years after Reynolds's portrait) and the wraith-like Mlle Rivière (who was portrayed by Ingres in 1805 shortly before she died).

78. R. Wark, *Ten British Pictures 1740–1840*, Henry E. Huntington Library and Art Gallery, San Marino, 1971, p. 64.

79. J.H. Plumb, 'The New World of Children in Eighteenth-Century England', *Past and Present*, no. 66, February 1975, pp. 72–3, 81, 90.

80. P. Kelly and R. Hudson have identified this almost certainly as Mrs Fenwick's school at Flint House,

Greenwich, an establishment particularly popular with families resident in the West Indies. 'New Light on Lawrence's "Pinkie"', p. 257, n. 6.

81. Judith Barrett to Elizabeth Barrett Williams, 16 November 1793, quoted *ibid.*, p. 257.

82. *Ten British Pictures*, p. 61.

83. Kelly and Hudson establish ('New Light on Lawrence's "Pinkie"', p. 258) that the painting did not arrive in Jamaica as anticipated; the likely reason for this is that Lawrence wanted it in the R.A. show.

84. For an interesting discussion of this relationship, see J. Rose, *The Case of Peter Pan or The Impossibility of Children's Fiction*, London, 1984, ch. 1.

85. Sir T. Elyot, *The Boke named The Governor*, London, 1544, p. 69.

86. See, for example, both the drawing and the painting of the so-called *Ladies of Hastings*, G. Schiff, *Johann Heinrich Fussli, 1741–1825*, Zurich, 1973, vol. 2.

87. Burney, *Evelina*, Letter VI.

88. For a particularly interesting discussion of this question see P.M. Spacks, *Imagining a Self. Autobiography and Novel in Eighteenth-Century England*, Cambridge, Mass., 1976, pp. 174, 178.

89. *Ibid.*, p. 178.

90. Revd James Bean, *The Christian Minister's Affectionate Advice to a New Married Couple*, Greenfield, 1821 (contains an advertisement for the fifth London edition), p. 14.

91. See C. Tomalin, *The Life and Death of Mary Wollstonecraft*, New York and London, 1974, p. 29 *passim*.

92. M. Wollstonecraft, *Vindication of the Rights of Woman* (1792), Harmondsworth, 1983, p. 145.

93. Lawrence was a close friend of William Godwin who, in the year following the exhibition of Lawrence's portrait of Sarah Moulton, was preparing to marry Mary Wollstonecraft. In February 1796, Lawrence was involved in a complicated love affair with Sarah Siddons's daughters, and Godwin was one of his confidants; see Layard, ed., *Sir Thomas Lawrence's Letter-Bag*, pp. 28–9.

94. Burnet, *Practical Hints on Portrait Painting*, p. 16.

95. K. Garlick, *Sir Thomas Lawrence. A Complete Catalogue of the Oil Paintings*, Oxford, 1989, p. 16.

96. Burnet, *Practical Hints on Portrait Painting*, p. 4.

97. Michael Camille discusses the euhemeristic argument, that representation originated in commemorative portraiture in *The Gothic Idol. Ideology and Image-Making in Medieval Art*, Cambridge, 1989, pp. 51–2. He points out that it is also to be found in the Old Testament Book of Wisdom where the filial piety of the son replicating the lost father is reversed but still keeps representation 'within the family'. The relationship between the image as substitution and theories of idolatry in Antiquity and the Middle Ages is expounded by Camille with great clarity.

98. See E. Panofsky, *Tomb Sculpture*, London, 1964; J. Breckenridge, *Likeness: A Conceptual History of Ancient Portraiture*, Evanston, 1969, especially chs 1–3; E.D. Martin, 'On Portraiture: some distinctions', *Journal of Aesthetics and Art Criticism*, 20, 1961.

99. On this incident, see P. Fumerton, '"Secret" Arts: Elizabethan Miniatures and Sonnets', *Representations*, no. 15, summer 1986.

100. W. Benjamin, 'The Work of Art in the Age of Mechanical Reproduction', in H. Arendt, ed., *Illuminations* (1973), London, 1982, p. 228.

101. See, for example, A. Sekula, 'The Body in the Archive', *October*, 39, winter 1986; J. Tagg, *The Burden of Representation. Essays on Photographies and Histories*, London, 1988; C. Metz, 'Photography and Fetish', *October*, 34, fall 1985.

102. On the connection between photography and death see, particularly, R. Barthes, *Camera Lucida* (1980), London, 1982 and Metz 'Photography and Fetish'. On self-portrait photographs see *Staging the Self. Self-Portrait Photography 1840s–1980s*, National Portrait Gallery, London, 1987; particularly interesting is the work of Ralph Eugene Meatyard, Jo Spence, Duane Michals and William Mortensen.

103. D. Collins and J. Onians, 'The Origins of Art', *Art History*, vol. 1, no. 1, March 1978.

104. See N. Llewellyn in *The Art of Death*, London, 1991. It is common for the parents of children who have died in infancy, in cot deaths for example, to be counselled to take photographs. Portraits from earlier periods of dead children are common (as are tomb monuments showing children 'asleep', most notably Francis Chantrey's *The Sleeping Children*, Lichfield cathedral).

105. See particularly Keith Wrightson's refutation of Lawrence Stone in *English Society 1580–1680* (1982), London, 1986.

106. W. Wordsworth, 'My Heart Leaps Up': 'My heart leaps up when I behold/A rainbow in the sky:/So was it when my life began;/So is it now I am a man;/So be it when I shall grow old,/Or let me die!/The Child is father of the Man;/And I could wish my days to be/Bound each to each by natural piety.' *Wordsworth. Poetical Works*, ed. T. Hutchinson, rev. E. de Selincourt, Oxford (1904), 1974.

107. Reprinted in D. Lodge, ed., *Modern Criticism and Theory. A Reader*, London and New York, 1988.

108. J. Austen, *Mansfield Park*, 1814.

109. For details about Conduitt see *Manners and Morals: Hogarth and British Painting 1700–1760*, Tate Gallery, London, 1987, no. 68.

110. *The Works of John Dryden*, Berkeley and Los Angeles, 1966, vol. 9, ed. J. Loftis and V.A. Dearing.

111. R. Paulson, *Hogarth: His Life, Art and Times*, New Haven and London, 1971, vol. 1, pp. 218–24, discusses these two works in terms of Hogarth's development towards a more pyramidal and stable structure. He believes the unrelatedness of the figures is a virtue as it suggests 'something true about childhood, especially about children who are playing at being grown-ups'. He relates the paintings to *The Beggar's Opera* because they are concerned with illusion and reality as the run-of-the-mill conversation piece was not. The pyramidal structure, he thinks, would serve to pull families together.

112. E.g., *Hogarth*, Tate Gallery, London, 1971–2, nos 31 and 32, and Paulson, *Hogarth*.

113. *The Graham Children*, 1742 (pl. 207), *Manners and Morals*, no. 120.

114. *Ibid*. The discovery that the baby (born 18 August 1740, buried 4 February 1741/2) was dead before the portrait of the Graham children (dated by Hogarth to 1742) was finished was made by Mary Webster and published in *Apollo*, 130, September 1989, pp. 171–3. Webster, however, refuses to accept any of the arguments about the portrait's iconographic content.

115. For a further discussion of Hogarth's deployment of emblems in child-portraits, see Wendorf, *Elements of Life*, pp. 182–3.

116. The theme of children playing games like this is particularly prevalent in French eighteenth-century painting. See, for example works by Chardin; Carle Van Loo's *Woman and Child with a House of Cards* (Sotheby Parke-Bernet, 6 March 1984 (1214); C.A. Coypel's *Children Building a House of Cards*, engraved J. Wolff, exhibited *The French Taste in English Painting*, Kenwood House, summer 1968; it is also found in the work of many English artists, such as, for example, Nollekens (see *Manners and Morals*, nos 111, 112) and Gainsborough, whose portrait of John and Henry Truman-Villebois (*c*.1783, on loan to Leicester City Art Gallery) shows boys building a house of cards.

117. J. Baudrillard, *Revenge of the Crystal. Selected Writings on the Modern Object and its Destiny, 1968–1983*, trans. P. Foss and J. Pefanis, London and Concord, Mass., 1990, pp. 36–7.

118. See, for example, *The Wollaston Family*, 1730 (Trustees of the late H.C. Wollaston)

119. I have drawn here upon the work of Melanie Klein, particularly her 'Mourning and its relation to manic-depressive states' (1940), reprinted in *The Selected Melanie Klein*, ed. J. Mitchell, Harmondsworth, 1986, and upon D.W. Winnicott, *Playing and Reality* (1971), Harmondsworth, 1988.

120. Millais's work had been seen year after year at the Royal Academy since 1846; he had an exhibition at the Grosvenor Gallery in 1880, and at the Fine Art Society in 1881. He had major shows at the Manchester Art Treasures exhibition in 1857, at the Grosvenor in 1886 and at the Royal Academy (a retrospective) in 1898.

121. L. Duranty, 'Millais', in F.G. Dumas, ed., *Illustrated Biographies of Modern Masters*, London and Paris, 1882, p. 29. The author was Louis-Emile-Edouard Duranty and the editor François-Guillaume Dumas.

122. J.G. Millais, *The Life and Letters of Sir John Everett Millais*, London, 1899, vol. 2, p. 118.

123. W. Armstrong, 'Sir J.E. Millais, Bart., Royal Academician. His Life and Work', *The Art Annual for 1885* (Christmas number of the *Art Journal*), p. 1.

124. A. Lang, *Notes by Mr. A. Lang on a Collection of Pictures by Mr. J.E. Millais, RA, Exhibited at the Fine Art Society's Rooms, 148, New Bond St.*, London, 1881, p. 16.

125. J. Ruskin, '"Ariadne Florentina": Six Lectures on Wood and Metal Engraving' (1872), in *The Works of John Ruskin*, ed. E.T. Cook and A. Wedderburn, London 1903–12, vol. 22, pp. 392–3. The editors suggest that the modern work referred to is a chromolithograph after Birket Foster. The volume includes, as a frontispiece, 'A Country Girl', engraved by Allen & Co. after Gainsborough.

126. A. Graves and W.V. Cronin, *A History of the Works of Sir Joshua Reynolds, PRA, ded. H.M. Queen*, 4 vols, London, 1849; *Sir Joshua Reynolds, and his Works, Gleanings from his diary, unpublished manuscripts, and from other sources*, ed. J. Burnet, London, 1856. Burnet had edited *The Discourses* in 1842.

127. H.W. Beechy, *The Literary Works of Sir Joshua Reynolds*, 2 vols, London, 1878.

128. Grosvenor Gallery, *Catalogue of the Works of Sir Joshua Reynolds, PRA, exhibited at the Grosvenor Gallery, 1883–4*, London, 1884. The catalogue is illustrated with photo-intaglio plates. The entries tend to include both portrait and subject titles for child-depictions.

129. A.L. Baldry, *Sir John Everett Millais. His Art and Influence*, London 1899.

130. M.H. Spielmann, *Millais and His Works*, Edinburgh and London, 1898, p. 65.

131. See particularly the childrens' books published by the Religious Tract Society.

132. *Mother's Friend. A Monthly Magazine*, 1, 1848, pp. 6, 94.

133. See Gillis, *Youth and History*, pp. 4–5.

134. A.M.W. Stirling, *The Richmond Papers from the correspondence and manuscripts of George Richmond, R.A., and his son Sir William Blake Richmond, R.A., K.C.B.*, London, 1926, p. 190.

135. *Ibid.*, p. 191.

136. Sir William Richmond, *Portrait of Rhoda Liddell*, 85 × 69 cm., exh. the New Gallery Winter Exhibition, 1900–1, no. 144, Sotheby's Belgravia, 6 October 1980.

137. Stirling, *Richmond Papers*, p. 193.

138. L. Smith, 'The Politics of Focus: Feminism and Photography Theory', in I. Armstrong, ed., *New Feminist Discourses*, forthcoming from Routledge.

139. Stirling, *Richmond Papers*, p. 191.

140. *Ibid*.

141. William Dyce prepared a report for the Commissioners on the Fine Arts in 1846, printed as appendix IV to the report, and entitled 'Observations on Fresco-painting', in which he drew particular attention to the colouristic strengths of this artist. For the high esteem in which the nineteenth century held Domenichino, see F. Haskell, *Rediscoveries in Art. Some Aspects of Taste, Fashion and Collecting in England and France*, London, 1976.

142. Stirling, *Richmond Papers*, p. 196.

EPILOGUE

1. T. Carlyle, 'The Hero as Divinity', lecture 1 (Tuesday, 5 May 1840), *On Heroes, Hero-Worship and the Heroic in History*, in *Collected Works of Thomas Carlyle*, London, 1857, vol. 6.

2. W. Tiffin, *Gossip about Portraits*, London, 1867, p. 95.

3. G. Scharf to the 5th Earl Stanhope, 20 June 1864, official printed document headed 'private', National Portrait Gallery Archive, London.

4. G. Scharf, Account Book, 1860–1, National Portrait Gallery Archive, London.

5. Scharf had studied at the R.A. Schools and been employed as government draftsman to the 1843 expedition to Asia Minor. His work, prior to his appointment to the National Portrait Gallery was mainly in wood engraving and woodcut. In 'Notes on his Life written for William Smith' (MS, National Portrait Gallery Archive, London) he lists some of the publications on which he worked, including Macaulay's *Lays of Ancient Rome*, London, 1847, Kügler's *Handbook of Italian Painting*, London, 1851 and Mrs Bray's *Life of Thomas Stothard*, London, 1851.

6. The Notebooks of George Vertue, V. 77, MS, BM. 64 b; pub., vol. 2, *The Walpole Society*, 1931–2.

7. S. Redgrave, *A Dictionary of Artists of the English School*, 1874; Scharf to the Earl Stanhope, 4 April 1874, MS, National Portrait Gallery Archive, London.

8. Lionel Cust, subsequent Director of the National Portrait Gallery, believed that an interest in historical portraiture hardly existed in England

before the publication of Granger's work (*Notes on the Authentic Portraits of Mary Queen of Scots based on the researches of the late Sir George Scharf, KCB, rewritten in the light of new information by Lionel Cust*, London, 1903, p. 7).

9. W.F. Erwin to J. Granger, 20 September 1770, in J.P. Malcolm, ed., *Letters between the Rev. James Granger, M.A., Rector of Shiplake, and many of the most eminent literary men of his time . . .*, London, 1805, pp. 305–6.

10. G. Scharf, official diary, 29 January 1861, MS, National Portrait Gallery Archive, London.

11. See, for example, *Fraser's Magazine*, July 1866, p. 86. 'A Conversation. The Portraits at South Kensington'; Tiffin, *Gossip about Portraits*, pp. 31, 147, 149,

12. *The Granger Society for the publication of Ancient Portraits and Family Pictures*, prospectus, July 1841. The leaflet is prefaced with a quotation from the Revd James Granger. The reference to 'alterations' goes back to complaints in the eighteenth century about the inventiveness of Vertue and other engravers.

13. *Ancient Historical Pictures and Pictures of Illustrious Families by Celebrated Masters*, prospectus, 2 May 1840; *Ancient Historical Pictures*, undated notice stating: 'in consequence of an announcement from the Council of the Granger Society, that their affairs are at an end, dated 1 May, 1843, Mr. G.P. Harding, who possesses a large collection of drawings, and was the first projector of the publication of unengraved Historical Pictures, will, with the assistance and co-operation of Mr. J. Brown, the engraver to the Granger Society, proceed with the series, being convinced that the materials in his possession are of sufficient interest to ensure support and enable him to complete his orginal intention'.

14. H. Smailes, *A Portrait Gallery for Scotland*, National Gallery of Scotland, Edinburgh, 1985, p. 10. For a detailed historical account of the Washington Gallery, see M. Pointon, 'National Identities. The Founding of the National Portrait Gallery, Washington DC, 1968', *Journal of American Studies*, December 1992.

15. For Clarendon, see R. Gibson, *Catalogue of Portraits in the Collection of the Earl of Clarendon*, privately published by the Paul Mellon Centre for Studies in British Art, 1977; Sir Robert Peel's collection of portraits of eminent Englishmen, as the *Builder* reported 5 August 1865, assigned the place of honour in his house at Whitehall to the portrait of Samuel Johnson by Sir Joshua Reynolds. Johnson was first portrayed by Reynolds c.1757; R. Wendorf, *Elements of Life: Biography and Portrait-Painting in Stuart and Georgian England*, Oxford, 1990, p. 250, mentions five portraits of Johnson by Reynolds, but neither he nor Nicholas Penny (*Reynolds*, Royal Academy of Arts, London, 1986) specifies one in Peel's collection.

16. See *Quarterly Review*, 166, January and April 1888, pp. 341–2. This substantial article on the National Portrait Gallery is so well informed it must have been written by or with the assistance of George Scharf, though it is published anonymously.

17. *Report to the Trustees of the National Portrait Gallery by their Secretary upon his Expedition to Paris from August 17th to September 4th 1867*, London, 1868, headed 'for the use of the Trustees only', National Portrait Gallery Archive, London.

18. See G. Waterfield, *Collection for a King: Old Master Paintings from the Dulwich Picture Gallery*, National Gallery of Art, Washington, D.C., and Los Angeles County Museum of Art, 1985–6.

19. N. Desenfans, *A Plan, preceded by a short review of the Fine Arts, to preserve among us, and transmit to posterity, the portraits of the most distinguished characters of England, Scotland and Ireland, since his Majesty's accession to the Throne . . .*, London, 1799.

20. This is not recognized by Waterfield who, while reproducing the title-page of Desenfans's essay, calls it 'A Plan for Establishing a National Gallery' (*Collection for a king*, p. 17), thus perpetuating the impression given in the *Dictionary of National Biography* that portraits were not central to the project.

21. Desenfans, *A Plan*, p. 1. The monuments are to the memory of Major General Dundas, Captain Faulkner and Captain Rundle Burgess; in Westminster Abbey, monuments are to be erected to the memory of Captains Harvey, Hutt and Montague.

22. Desenfans, *A Plan*, pp. 2–3.

23. As John Hayes has kindly pointed out to me, the gallery in the Hermitage, St Petersburg, of portraits of some 300 heroes of the patriotic war of 1812, is exemplary of the gallery of military heroes in this period.

24. J. Gage, *G.F. Watts, The Hall of Fame. Portraits of his famous contemporaries*, National Portrait Gallery, London, 1975, p. 6. Watts presented portraits of Lord Lyndhurst, Admiral Lord Lyons and Lord Stratford of Redcliffe to the National Portrait Gallery in 1883; others were handed over in 1895. Only portraits of those subjects eligible by their decease were accepted, though others came later.

25. C.J. Holmes, *Self and Partners (mostly self). Being the Reminiscences of C.J. Holmes*, London, 1936, p. 291: 'The more democratic we grow, the more perilous, at any crisis, is the absence of a historical sense on the part of the electorate' (written in 1912).

26. *Ibid.*, p. 9. Cf. Sir Robert Peel's speech in the House of Commons, July 1832, *Hansard*, quoted in G. Martin 'The Founding of the National Gallery in London', part 7, *Connoisseur*, 1974: 'In the present times of political excitement, the exacerbation of angry and unsocial feelings might be much softened by the effects which the fine arts had ever produced on the minds of men . . . The erection of the edifice [the National Gallery] would not only contribute to the cultivation of the arts, but also to the cementing of the bonds of union between the richer and poorer orders of state.'

27. *Athenaeum*, 1 December 1855

28. T. Carlyle to D. Laing, 3 May 1854, quoted by Smailes *A Portrait Gallery for Scotland*, p. 16.

29. *Athenaeum*, 17 November 1855.

30. *Athenaeum*, 1 December 1855. In fact, Lord Mahon spoke on 4 June 1842 during a discussion of the estimates. Disraeli, Chancellor of the Exchequer, described the absence of a building for a national portrait gallery as a stain upon the national taste (*Hansard*, June 1842).

31. For a list see R. Strong, *And when did you last see your father? The Victorian Painter and British History*, London, 1978, appendix.

32. Reported in the *Quarterly Review*, 166, January and April 1888, p. 344. The royal assent was given, an annual grant of £2,000 awarded, and a board of thirteen trustees appointed in June 1856.

33. J. Minihan, *The Nationalisation of Culture. The Development of State Subsidies to the Arts in Great Britain*, London, 1977.

34. *A Descriptive Catalogue of the Great Historical Picture of the interior of the British House of Commons, in St. Stephen's Chapel at Westminster, in 1833: painted on one hundred and seventy square feet of canvas and containing nearly four hundred portraits*. London, 1843.

35. The Shakespeare Society, *The Chandos Portrait of Shakespeare, the property of the Earl of Ellesmere*, prospectus, November 1848; the previous year the London Committee for the Purchase of Shakespeare's House had been established.

36. There was extensive coverage in the press; for the Sheepshanks deed, see the *Athenaeum*, 21 February 1857.

37. *Builder*, 23 September 1865.

38. For the early years of the National Gallery see G. Martin, 'The Founding of the National Gallery', *Connoisseur*, 1972, and A. Braham, 'Towards a national gallery', *National Art Collections Fund Review*, 1989.

39. See D. Robertson, *Sir Charles Eastlake and the Victorian Art World*, Princeton, N.J., 1978.

40. The comparative financial provisions for various institutions can be seen from a glance at *Hansard* for August 1860 when, in comparison with the National Portrait Gallery's £2,000 purchase grant, the National Gallery received £8,670 to complete the sum necessary to defray its expenses, including purchases, and a further £15,000 to increase its accommodation in Trafalgar Square, the Royal Society received £1,000, the Royal Geographical Society received £500, the National Gallery of Ireland received £5,000 to defray the expenses of completing its building, and the South Kensington collections received £17,000 to provide safe and permanent accommodation. The lobby was powerful but not sufficiently so, for in 1859 Scharf had still not managed to persuade the British Museum to relinquish its portraits (letter from Scharf to William Smith, 11 March 1859, MS, National Portrait Gallery Archive, London), though by 1888 the British Museum and the National Gallery had both transferred portraits. Despite the support of the Prince Consort, who made a surprise visit to the Gallery in May 1860, the Hampton Court portraits which Scharf and the Earl Stanhope desperately wanted for the National Portrait Gallery were never transferred (letter from Scharf to William Smith, 8 May 1860, MS, National Portrait Gallery Archive, London).

41. Carlyle, *On Heroes, Hero-Worship*, lecture 1.

42. See, for example, *The Times* 31 August–1 September 1860.

43. The range of these histories is discussed by Strong, *And when did you last see your father?*, pp. 32–4.

44. *Catalogue of the Art Treasures of the United Kingdom collected at Manchester in 1857*, p. 109. Thomas Fuller published *The History of the Worthies of England* in 1662. It was reprinted in 1811 and 1840. Henry Holland's *Baziliwlogia. A Booke of Kings . . .* (London, 1618) included thirty-one 'portraits' as well as a title-page illustration and was an extremely rare book. The print dealer, Thomas Dodd, was exultant in 1812 when, visiting Ludlow with his wife, he found in an inn, where the parlour walls were 'adorned with a profusion of prints neatly framed and glazed', a landlord who owned 'Basiloogia' (*sic*) (*Memoirs of Thomas Dodd, William Upcott and George Stubbs, R.A.*, Liverpool, 1879, pp. 26–7). Holland's *Herwologia Anglica . . .*, published in London in 1620 with sixty-five 'portraits', was much less rare. These works offered an account, quasi historical, quasi

45. *Quarterly Review*, 166, January–April 1888, p. 346.
46. The remaining trustees were the Marquess of Landsdowne, the Earl Stanhope (Chairman), the Lord Elcho, the Rt. Hon. Sidney Herbert, the Rt. Hon. Benjamin Disraeli, the Lord Robert Cecil, the Rt. Hon. T.B. Macaulay, Sir Francis Palgrave, Sir Charles Eastlake, P.R.A., William Smith Esq., W.H. Carpenter, Esq.
47. The Gallery's regulations were published in the *First report of the Trustees of the National Portrait Gallery*, 5 May 1858: '1. The rule which the Trustees desire to lay down to themselves, in either making purchases or receiving presents, is to look for the celebrity of the person represented rather than to the merit of the artist. They will attempt to estimate that celebrity without any bias to any political or religious party. Nor will they consider great faults and errors, even though admitted on all sides, as any sufficient ground for excluding any portrait which may be valuable, as illustrating the civil, ecclesiastical, or literary history of the country. 2. No portrait of any person still living, or deceased less than 10 years, shall be admitted except only in the case of the reigning Sovereign, and of his or her Consort, unless all the Trustees in the United Kingdom, and not incapacitated by illness, shall either at a meeting or by letter signify their approval. 3. No portrait shall be admitted by donation, unless three-fourths at least of the Trustees present at a meeting shall approve it.' In 1859 new rules required that no modern copy of an original portrait be admitted, that there should be a quorum of 3 at meetings, and that the amounts paid for portraits should not be divulged. In 1865 a clause concerning the attendance of trustees at meetings was introduced. By 1881 an exception to rule 2 had been introduced in the case of group and collective portraits but in general the rules remained static throughout this period. Later major changes allowed for the admission of portraits of persons still living which now make up many of the acquisitions of the Gallery.
48. *Art Journal*, 1858, pp. 55, 243.
49. *Ibid.*, 1859, p. 56.
50. *Second Report of the Trustees of the National Portrait Gallery*, 11 July 1859. Tickets were available for purchase from Colnaghi's, Graves or J. Smith (all print dealers), which suggests an alliance between the Gallery and the art trade as well as an ingenious mechanism for discouraging undesirables from visiting the Gallery.
51. *Ibid.*
52. *Third Report of the Trustees of the National Portrait Gallery*, 25 May 1860.
53. *Fifth Report of the Trustees of the National Portrait Gallery*, 29 April 1862.
54. *Sixth Report of the Trustees of the National Portrait Gallery*, 22 April 1863.
55. *Seventh Report* (26 April 1864) and *Ninth Report* (19 April 1866) *of the Trustees of the National Portrait Gallery*.
56. Scharf to William Smith, 19 July 1862, MS, National Portrait Gallery Archive, London. Eastlake had proposed one apartment which Scharf said was totally inadequate for the collections as they stood and would allow no ' "growing room" as the makers of frocks and pinaforces would say'.
57. *Standard*, 26 June 1863.
58. Extracts from Lord Derby's letter are quoted in the introduction to *Science and Art Department of the Committee of the Council on Education, Catalogue of the First Special Exhibition of National Portraits*, April 1866, p. ix.; *Builder*, July 1865.
59. *Science and Art Department . . . First Special Exhibition*, p. iv.
60. *Ibid.*
61. *The Times*, 2 May 1867.
62. *Standard*, 23 August 1867 (letter from John Burton of Preston, Lancs).
63. *Quarterly Review*, 166, January–April 1888, p. 350.
64. *Ibid.*, pp. 352–3.
65. *Ibid.*
66. *Art Journal*, 1859, p. 56.
67. Royal Commission on National Museums and Galleries, *Interim report, Parliamentary Papers*, vol. 8, p. 19.
68. *Athenaeum*, 11 April 1896.
69. *Punch*, 11 April 1896.
70. As Francis Haskell has pointed out (*Past and Present in Art and Taste*, New Haven and London, 1987), the case of Morris Moore, a dealer who devoted his life to an aggressive campaign in support of his attribution of the Louvre *Apollo and Marsyas* to Raphael, demonstrates that febrile connoisseurship pre-dated the age of Duveen and Berenson.
71. D. Miller, *Material Culture and Mass Consumption*, Oxford, 1987, p. 99.
72. See, for example, G. Stepny, 'On the University of Cambridge's Burning of the Duke of Monmouth's Picture, 1685', in *Poems on Affairs of State*, vol. 2, 1703, pp. 189–90, quoted in H. Cooper, *Annals of Cambridge*, Cambridge 1842–52, vol. 3, p. 611. I am grateful to Nigel Llewellyn for this reference. See also ch. I ii, above.
73. Interview in *The Times Saturday Review*, 11 August 1990.
74. See Miller, *Material Culture*, p. 119, quoting Levy-Bruhl.
75. *Athenaeum*, 17 November 1866.
76. Edouard Lartet was the author of *The Antiquity of Man in Western Europe* (1860) and *New Researches of the Coexistence of Man and of the Great Fossil Mamifers characteristic of the Last geological Period* (1861). Sir Charles Lyell's *Principles of Geology* appeared in 1830 and was followed by *Elements of Geology* (1838) and *The Antiquity of Man* (1863). Lartet and Lyell are cited in Tiffin, *Gossip about Portraits*, p. 1.
77. Scharf to William Smith, 9 December 1867, MS, National Portrait Gallery Archive, London.
78. M.G.H. writing to the *Daily News*, 27 July 1865.
79. *Art Journal*, 1858, p. 243.
80. Unmarked cutting, August 1860, National Portrait Gallery Archive, London, vol. 1, p. 89 verso.
81. *Alphabetical List of Portraits and Busts in the National Portrait Gallery, Exhibition Road, South Kensington*, March 1870.
82. For an interesting account of the writing of history during this period, see J. Burrow, *A Liberal Descent. Victorian historians and the English past*, Cambridge, 1981.
83. 'Sightseers at the National Portrait Gallery', *Daily News*, 6 April 1872.
84. It is not clear which portrait 'Dudley' indicates, as the Gallery did not acquire a portrait of the Earl of Leicester until 1867. There are similar problems with 'Talbot'. The remaining portraits on the 1861 plan can all be readily identified by reference to the National Portrait Gallery's *Complete Illustrated Catalogue 1856–1979*, London, 1981.
85. For details of contemporary research on Mary, Queen of Scots, see L. Cust, *Notes on the Authentic Portraits of Mary Queen of Scots based on the researches of the late Sir George Scharf, KCB, rewritten in the light of new information by Lionel Cust*, London, 1903.
86. G. Scharf, 'On the Principal Portraits of Shakespeare', *Notes and Queries*, 23 April 1864.
87. Burrow, *A Liberal Descent*, pp. 231–3.
88. W. Cowper to Revd William Unwin, 6 August 1780, *The Life and Works of William Cowper*, ed. Revd T.S. Grimshawe, A.M., 1867, vol. 1, pp. 193–4.
89. *Ibid.*
90. National Portrait Gallery, no. 48, attrib. J.S.C. Schaak.
91. C. Dickens, *All the Year Round*, 7 November 1863.
92. Minihan, *Nationalisation of Culture*, p. x.
93. Scharf to William Smith, Good Friday evening 1860, MS, William Smith Correspondence, National Portrait Gallery Archive, London.

BIBLIOGRAPHY

Abraham, J.J., *Lettsome His Life, Times, Friends and Descendents*, London, 1933

Adams, B., 'A Regency Pastime: The Extra-Illustration of Thomas Pennant's "London"', *London Journal*, 8, 1982

Addison, J., 'The Pleasures of the Imagination', *Spectator*, 1711–12

The Works of Joseph Addison, ed. R. Hurd, London, 1903

Ahlers, C., *Some Observations concerning the Woman of Godlyman in Surrey, made at Guilford on Sunday Nov. 20 1726*, London, 1726

Ainsworth, H., *Jack Sheppard. A Romance*, London, 1839

Alexander, D., 'English Prints and Printmaking', in R.P. Maccubbin and M.Hamilton-Phillips, eds, *The Age of William III and Mary II: Power, Politics and Patronage, 1688–1702*, The College of William and Mary, Virginia, 1989

All the Year Round

Alphabetical List of Portraits and Busts in the National Portrait Gallery, Exhibition Road, South Kensington, March 1870

Altick, R., *Victorian Studies in Scarlet*, London, 1970

Ames. J., *A Catalogue of English Heads: or an Account of about Two Thousand Prints, Describing what is peculiar on each; as the Name, Title, or Office of the Person. The Habit, Posture, Age, or Time when done. The Name of the Painter, Graver, Scraper, &c. and some remarkable particulars relating to their Lives by Joseph Ames, FRS and Secretary to the Society of Antiquaries*, London, 1747

The Anatomist Dissected or the Man-Midwife finely brought to Bed. Being an examination of the Conduct of Mr. St. André . . . by Lemuel Gulliver, London, 1727

Ancient Historical Pictures and Pictures of Illustrious Families by Celebrated Masters, Prospectus, 2 May 1840

Anderson, M., *Approaches to the History of the Western Family, 1500–1914*, London (1980), 1986

Angelo, H., *Reminiscences of Henry Angelo with Memoirs of his late Father and Friends*, London, 1828

Anstey, C., *The New Bath Guide, or Memoirs of the B.N.R.D. Family*, Bath, 1807

Anti-Jacobin Review and Magazine, November 1798

Arbuthnot, J., *The Ball, stated in a Dialogue betwixt a Prude and a Coquet*, London, 1724

Archenholtz, W. von, *A Picture of England: containing a description of the laws, customs, and manners of England, a new translation*, London, 1797

Ariès, P., *Centuries of Childhood*, London, 1962

Armstrong, W., 'Sir J.E. Millais, Bart., Royal Academician. His Life and Work', *The Art Annual for 1885*, London, December 1885

The Art of Acting, London, 1746

Art Journal

The Artist's Repository and Drawing Magazine, exhibiting the Principles of the Polite Arts in their various branches (preface to 4th edn, vol. 1, dated 1788)

Astell, M., *Preface to Letters of the Right Honourable Lady M--y W---y M----e: written, during her Travels in Europe, Asia and Africa*, London, 1769

Athenaeum

Atherton, H.M., *Political Prints in the Age of Hogarth. A Study of the Ideographic Representation of Politics*, Oxford, 1974

Atkinson, T., *A Conference between a Painter and an Engraver; containing some useful Hints and necessary instructions, proper for the young Artist*, London, 1736

Austen, J., *Mansfield Park* (1814)

Aylmer, G.E., 'The Meaning and Definition of "Property" in seventeenth-century England', *Past and Present*, no. 86, February 1980

Baldry, A.L., *Sir John Everett Millais. His Art and Influence*, London, 1898

Barrell, J., *The Political Theory of Painting from Reynolds to Hazlitt. 'The Body of the Public'*, New Haven and London, 1986

Barrell, J., ed., *Painting and the Politics of Culture*, Oxford, 1992

Barry, I., *Portrait of Lady Mary Wortley Montagu*, London, 1928

Barthes, R., 'Les Romains au Cinéma', *Mythologies*, London, 1957

Barthes, R., *Camera Lucida* (1980), London, 1982

Bastien, P., 'Clipeus et Buste Monétaire des Empereurs Romains', *Numismatica e Antichità Classiche*, 10, 1981

Baudrillard, J., *Revenge of the Crystal. Selected Writings on the Modern Object and its Destiny, 1968–1983*, trans. P. Foss and J. Pefanis, London and Concord, Mass., 1990

Dayne-Powell, R., *The English Child in the Eighteenth-Century*, London, 1939

Bean, Revd J., *The Christian Minister's Affectionate Advice to a New Married Couple*, Greenfield, 1821

Beechy, H.W., ed., *The Literary Works of Sir Joshua Reynolds*, 2 vols, London, 1878

Beetham, E., *Moral Lectures on Heads*, Newcastle-upon-Tyne, 1780

Bell, C., *The Anatomy and Philosophy of Expression* (1806), 7th edn, 1886

Belsey, H., 'A Family Portrait by Philip Reinagle', *Apollo*, February 1981

Benjamin, W., 'The Work of Art in the Age of Mechanical Reproduction', in H. Arendt, ed., *Illuminations* (1973), London, 1982

Beughem, C. a, *Bibliographia historica, chronologica & geographica novissima, sive conspectus primus catalogi librorum historicum*, Amsterdam, 1685

Bewick, T., *The History of British Birds*, London, 1797

Bindman, D., *The Shadow of the Guillotine. Britain and the French Revolution*, London: British Museum, 1989

Binney, M., 'Beningborough Hall Revisited', *Country Life*, 3 December 1981

Blair, H., *Lectures on Rhetoric and Belles Lettres* (1783), London, 1830

Bobbin, T., *The Flying Dragon and the Man of Heaton*, in *The Works of Tim Bobbin, Esq., in Prose and Verse with a Memoir of the Author by John Corry*, Rochdale, 1819

The Letters of James Boswell, collected and edited by C.B. Tinker, Oxford, 1924

Bourdieu, P., *Distinction. A Social Critique of the Judgement of Taste* (1979), trans. R. Nice, London and New York, 1986

Braham, A., 'Towards a national gallery', *National Art Collections Fund Review*, 1989

Braithwaite, T., *Remarks on a Short Narrative of an Extraordinary Delivery of Rabbets, perform'd by Mr. John Howard, Surgeon at Guilford, as publish'd by Mr. St. André, Anatomist to His Majesty. With a proper Regard to his intended Recantation, by Thomas Braithwaite, Surgeon*, London, 1726

Braudel, F., *Civilisation and Capitalism . . . The Structures of Everyday Life: the Limits of the Possible*, vol. 1, (1979), trans. S. Reynolds, London, 1981

Bray, A.E., *The Life of Thomas Stothard, R.A.,*

with Personal Reminiscences, London, 1851

Braybrooke, Richard Lord, *The History of Audley End*, London, 1836

Breckenridge, J.D., *Likeness: A Conceptual History of Ancient Portraiture*, Evanston, 1969

Brettingham, M., *The Plans, Elevation, and Sections of Holkham in Norfolk; to which are added, the ceilings and chimney pieces; . . . statues, pictures, and drawings, etc.*, London (1761), 1773

Brewer, J., *The Common People and Politics 1750– 1790s*, Cambridge, 1986

Brilliant, R., *Gesture and Rank in Roman Art: the Use of Gesture to Denote Status in Roman Sculpture and Coinage*, New Haven, 1963

Brilliant, R., 'On Portraits', *Zeitschrift fur Asthetik und Allgemeine Kunst Wissenschaft*, 1971

British Public Characters

Bromley, H., *A Catalogue of Engraved British Portraits from Egbert the Great to the Present Time consisting of the effigies of persons in every walk of human life . . .*, London, 1793

Brown, J., 'Enemies of Flattery: Velàzquez' Portraits of Philip IV', in R.I. Rotberg, and T.K. Rabb, eds, *Art and History, Images and their Meaning* (1986), Cambridge, 1988

Bruce, V., *Recognising Faces*, Hove, London and Hillsdale, 1988

Le Brun, C., *Conférences . . . sur l'expression générale et particulière*, Paris, 1698 (*The Conference of Monsieur Le Brun, Cheif Painter to the French King, Chancellor and Director of the Academy of Painting and Sculpture upon Expression, General and Particular, translated from the French*, London, 1701)

Bruntjen, S., 'John Boydell (1719–1804). A Study of Art Patronage and Publishing in Georgian London', unpublished Ph.D. thesis, Stanford University, 1973

Le Bruyn, C., *A Voyage to the Levant: or Travels in the principal Parts of Asia Minor, the Islands of Scio, Rhodes, Cyprus, &c. with an Account of the most Considerable Cities of Egypt, Syria and the Holy Land, done into English by W.J.*, London, 1702

The Builder

Burke, E., *A Philosophical Inquiry into the Origin of our ideas of the Sublime and Beautiful with an introductory discourse concerning Taste and several other additions*, London, 1756

Burnet, G., *History of My Own Time*, London, vol. 1, 1723, vol. 2, 1734

Burnet, J., *Practical Hints on Portrait Painting, illustrated by examples from the works of Van Dyck and other masters*, London, 1850

Burnet, J., ed., *Sir Joshua Reynolds, and his Works, Gleanings from his diary, unpublished manuscripts, and from other sources*, London, 1856

Burney, F., *Evelina*, London, 1778

Burney, F., *Cecelia: Or Memoirs of an Heiress* (1782), London, 1986

Burney, F., *The Early Diary of Frances Burney 1768–1778*, ed. A.R. Ellis, London, 1889

Burrow, J., *A Liberal Descent. Victorian historians and the English past*, Cambridge, 1981

Camille, M., *The Gothic Idol. Ideology and Image-Making in Medieval Art*, Cambridge, 1989

Campbell, L., *Renaissance Portraits. European Portrait-Painting in the Fourteenth, Fifteenth and Sixteenth Centuries*, New Haven and London, 1990

Carlyle, T., *On Heroes, Hero-Worship and the Heroic in History*, in *Collected Works of Thomas Carlyle*, London, 1857

Cartwright, J.J., ed., *The Wentworth Papers*, London, 1883

Carman, W.Y., 'Sir William Congreve, 1741– 1814', *Journal of the Society for Army Historical Research*, 51, 1973

Castro, J.P. de, 'Wigs and Perukes', typescript, 1945, National Art Library, London

Catalogue of Richardson's Collection of English Portraits, engraved from Rare Prints, or original Pictures: viz Princes and Princesses, Secretaries of State . . . as described in Granger's Biographical History of England, London, 1792–9

Catalogue of the Art Treasures of the United Kingdom collected at Manchester in 1857, London, 1857

A Catalogue of the Most Valuable Collection of Pictures, Prints and Drawings late of Charles Jarvis, deceased; Principal Painter to their Majesties King George I and II, London, March 1739–40

Catalogue of the Portraits and Pictures in the different Houses belonging to the Earl of Fife, 1798 (Society of Antiquaries copy inscribed 1796)

Caulfield, J., *Blackguardiana or a Dictionary of Rogues, Bawds, Pimps, Whores . . .*, illustrated with eighteen Portraits of the most remarkable Professors in every Species of Villainy, London, [1793?]

Caulfield, J., *Portraits, Memoirs and Characters of Remarkable Persons, from the Reign of Edward the third, to the Revolution, collected from the most authentic accounts extant*, London, 1794

Caulfield, James, *Calcographiana, the Printseller's Chronicle and Collector's Guide to the Knowledge and Value of Engraved British Portraits*, London, 1814

The Champion

Chesterfield, Earl of, *The Letters of Philip Dormer Stanhope, 4th Earl of Chesterfield*, ed. B. Dobré, London, 1932

Christie, I.R., *Stress and Stability in Late Eighteenth-Century Britain.Reflections on the British Avoidance of Revolution*, Oxford, 1984

Christ's Teares over Jerusalem

Cibber, C., *The Careless Husband*, *The Plays of Colley Cibber*, vol. 1, ed. R.C. Hayley, New York and London, 1980

Clark, A.M., *Studies in Roman Eighteenth-Century Painting*, ed. E.P. Bowron, Washington, D.C., 1981

Clark, A.M., *Pompeo Batoni. A Complete Catalogue of his Works with an Introductory Text*, ed. E.P. Bowron, Oxford, 1985

Clark, J.C.D., *English Society 1688–1832*, Cambridge, 1985

Cohen R., *The Art of Discrimination: Thomson's The Seasons and the Language of Criticism*, London, 1964

Colley, L., 'The Apotheosis of George III: Loyalty, Royalty and the British Nation, 1760–1820', *Past and Present*, 102, February 1984

Collins, D., and Onians, J., 'The Origins of Art', *Art History*, 1, no. 1, March 1978

Collins, W., *The Poetical Works of William Collins, with the Life of the Author by Samuel Johnson, L.L.D.*, London, 1807

Conner, P., 'On the Bath: Western Experience of the Hammam', *Journal of Renaissance and Modern Studies*, 31, 1987

The Contrast or Two Portraits of the Right Honourable Charles James Fox. The First taken in 1771, the Second in 1792 and 1793, dedicated, without permission, to that Right Honourable Gentleman . . . by a Cleaner of Faded portraits, Edinburgh, n.d.

Coombes, A., and Edwards, S., 'Site Unseen: Photography in the Colonial Empire: Images of Subconscious Eroticism', *Art History*, 12, no. 4, December 1989

Cooper, H., *Annals of Cambridge*, Cambridge 1842–52

Cordingly, D., 'The Life of John Brett', unpublished D. Phil. thesis, University of Sussex, 1983

Cornish, W.R., and the late Clark, G. de N., *Law and Society in England 1750–1950*, London, 1989

Corrigan, P., and Sayer, D., *The Great Arch: English State Formation as Cultural Revolution*, Oxford, 1985

Covent Garden Journal

The Life and Works of William Cowper, ed. Revd T.S. Grimshaw, London, 1835

Craven, W., *Colonial American Portraiture: the Economic, Religious, Social, Cultural, Philosophical, Scientific and Aesthetic Foundations*, Cambridge, 1986

Crown, P., 'Portraits and Fancy Pictures by Gainsborough and Reynolds: contrasting Images of Childhood', *British Journal for Eighteenth-Century Studies*, 7, no. 2, autumn 1984, 159–67

Curtis, W.H., *William Curtis, 1746–1799*, Winchester, 1941

Cust, L., *Notes on the Authentic Portraits of Mary Queen of Scots based on the researches of the late Sir George Scharf, KCB, rewritten in the light of new information by Lionel Cust*, London, 1903

Dabydeen, D., *Hogarth's Blacks. Images of Blacks in Eighteenth-century English Art* (1985), Manchester, 1987

Daily Journal

Daily News

Danloux, H.-P., see Portalis

Davies, R., *Romney*, London, 1914

Defoe, D., *Roxana. The Fortunate Mistress* (Oxford English Novels), London, 1964

A Description of Several Pictures presented to the Corporation of London, by John Boydell, Alderman of the Ward of Cheap, and placed in the common-council chamber of the City, London, 1794

A Descriptive Catalogue of the Great Historical Picture of the interior of the British House of Commons, in St. Stephen's Chapel at Westminster, in 1833: painted on one hundred and

seventy square feet of canvas and containing nearly four hundred portraits, London, 1843

Desenfans, N., *A Plan, preceded by a short review of the Fine Arts, to preserve among us, and transmit to posterity, The Portraits of the most distinguished characters of England, Scotland and Ireland, since his Majesty's accession to the Throne. Also to give Encouragement to British Artists, and to enrich and adorn London with some Galleries of Pictures, Statues, Antiques, Medals and other Valuable Curiosities, without any Expence to Government*, London, 1799

Deuchar, S., *Sporting Art in Eighteenth-Century England. A Social and Political History*, New Haven and London, 1988

Dickinson, H.T., *Caricatures and the Constitution 1760–1832*, Cambridge, 1986

Dictionary of National Biography

Diderot, D., d'Alembert, J., and Rousseau, J.-J., *Encyclopédie*, Paris, 1751–72

The Discovery: or The Squire turned Ferret. An Excellent New Ballad, 2nd edn, London, 1727

Dobson, A., *Rosalba's Journal and Other Papers*, London, 1915

Donald, D., '"Characters and Caricatures": the Satirical View', in *Reynolds*, ed. N. Penny, London: Royal Academy of Arts, 1986

The Works of John Dryden, vol. 9, *Plays*, ed. L. Loftis and V.A. Dearing, Berkeley and Los Angeles, 1966

Duff, W., *An Essay on Original Genius* (1767), New York, 1970

[Dumont], *Nouveau Voyage du Levant par le Sieur D.M. contenant ce qu'il a vu de plus remarquable en Allemagne, France, Italie, Malthe, & Turquie*, The Hague, 1694

Dunlap, W., *History of the Rise and Progress of the Arts of Design in the United States*, intr. W.P. Campbell, ed. A. Wyckott (1834), London, 1965

Duranty, L., 'Millais', in F.G. Dumas, ed., *Illustrated Biographies of Modern Masters*, London and Paris, 1882

Dürer, A., *Les Quatre Livres d'Albrecht Duerer*, trans. Lys Meigret Lionnais, Arnhem, 1528

Earland, A., *John Opie and his Circle*, London, 1911

Easy Rules for Taking a Likeness by the most Practicable Principles of Geometry and Perspective with various analogous Figures. Written in French by Abbé Bonamici, to serve as a supplement to the French Enclopoedia, translated into English by Abbé Adams, London, 1792

Edwards, R., *Early Conversation Pieces from the Middle Ages to about 1730. A Study in origins*, London: Country Life Ltd, 1954

Ehrman, J., *The Younger Pitt*, London, 1969

Eigen, M., 'On the significance of the face', *Psychoanalytic Review*, 67, part 4, winter 1980–1

Einberg, E., 'Allan Ramsay's Mansel and Blackwood Group', *National Art Collections Fund Annual*, 1990

Elias, N., *The Civilizing Process. The History of Manners*, trans. E. Jephcott (1939), New York, 1978

Eliot, G., *Middlemarch*, London, 1871–2

Elyot, Sir T., *The Boke named The Governor*, London, 1544

The Encyclopedia Britannica, 11th edn, Cambridge, 1911

The Encyclopedia of World Art (1958), New York, Toronto, London, 1966

Erasmus, *In Praise of Folly* (1510), trans. H.H. Hudson, New York, 1941

Evans, J., *A History of the Society of Antiquaries*, Oxford, 1956

Evelyn, J., *Sculptura: or the History and Art of Chalcography*, (1662) new edn, London, 1769

Evelyn, J., *Numismata. A Discourse of Medals Antient and Modern together with some Account of Heads and Effigies of Illustrious and Famous Persons, in Sculps, and Taille-Douce, of whom we have no Medals extant; and the Use to be derived from them. To which is added A Digression concerning Physiognomy*, London, 1697

Explication des Cent Estampes représentant les différentes nations du Levant tirées sur les tableaux peints d'après nature en 1707 et 1708 par les ordres de M. de Férriol Ambassadeur du Roi à la Porte. Et gravées en 1712 et 1713 par les soins de M. le Hay, Paris, 1715

Excursions in the County of Norfolk, n.p., 1818

Excursions through Essex, n.p., 1824

Ezell, M.J.M., 'John Locke's Images of Childhood', *Eighteenth-Century Studies*, 17, no. 2, winter 1983–4

Farington, J., *The Diary of Joseph Farington*, vol. 1, ed. K. Garlick and A. MacIntyre, New Haven and London, 1978

Faunce, S., and Nochlin, L., *Courbet Reconsidered*, New Haven and London, 1988

Fénélon, Salignac de la Mothe, *The Adventures of Telemachus* (1699), London 1742

Fernea, E.W., 'An Early Ethnographer of Middle Eastern Women: Lady Mary Wortley Montagu 1689–1762', *Journal of Near Eastern Studies*, 40, no. 4, October 1981

Flandrin, J.L., *Families in Former Times*, London, 1979

Flexner, J.T., *America's Old Masters* (1939) rev. edn, New York, 1967

Flügel, J.C., *The Psychology of Clothes*, London, 1930

Folkenflik, R., *The English Hero, 1660–1800*, E. Brunswick, Toronto and London, 1982

Foss, M., *The Age of Patronage. The Arts in Society 1660–1750*, London, 1971

Foucault, M., *The Order of Things, An Archaeology of the Human Sciences* (1966), London, 1970

Foucault, M., *The History of Sexuality*, vol. 1 (1976), Harmondsworth, 1981

Fraser's Magazine

The French Taste in English Painting, London: Kenwood House, summer 1968

Freud, S., *Jokes and their relation to the Unconscious* (1905), in *The Pelican Freud Library*, 6, Harmondsworth, 1976

Freud, S., 'Fetishism' (1927), in *On Sexuality. The Pelican Freud Library*, 7, Harmondsworth, 1977

Fulcher, G.W., *Life of Thomas Gainsborough, RA*, London, 1856

Fuller, T., *The History of the Worthies of England*, London, 1662

Fumerton, P., '"Secret" Arts: Elizabethan Miniatures and Sonnets', *Representations*, no. 15, summer 1986

Gage, J., *G.F. Watts, The Hall of Fame. Portraits of his famous contemporaries*, London: National Portrait Gallery, 1975

The Letters of Thomas Gainsborough, ed. M. Woodall, London, 1961

Garlick, K., *Sir Thomas Lawrence. A Complete Catalogue of the Oil Paintings*, Oxford, 1989

Garsault, M. de, *Art du Perruquier, contenant la façon de la Barbe; la Coupe des Cheveux; la Construction des Perruques d'Hommes & de Femmes; le Perruquier en Vieux, & le Baigneur-Etuviste*, Paris: Académie des Sciences, 1767

Geertz, C., *The Interpretation of Cultures*, New York, 1973

Gentleman's Magazine

Gibson, E., Lord Ashbourne, *Pitt: some Chapters of his Life and Times*, London, 1898

Gibson, R., *Catalogue of Portraits in the Collection of the Earl of Clarendon*, privately published for the Paul Mellon Centre for Studies in British Art, London, 1977

Gillis, J.R., *Youth and History. Tradition and Change in European Age Relations 1770-Present*, New York, 1981

Gilman, S., 'Black Bodies. White Bodies: Towards an Iconography of Female Sexuality in Late Nineteenth-Century Art, Medicine and Literature', *Critical Inquiry*, 12, autumn 1985

Gilpin, W., *An Essay upon Prints containing Remarks upon the principles of Picturesque Beauty; the different kinds of Prints; and the characters of the most noted masters: illustrated by criticism upon particular pieces: to which are added some cautions that may be useful in collecting prints*, 2nd edn, London, 1768

Ginter, D.E., *Whig Organization in the General Election of 1790*, London, 1967

Goffman, E., *The Presentation of Self in Everyday Life* (1959), London, 1969

Goldgar, B.A., ed., *The Covent Garden Journal and A Plan of the Universal Register-Office*, Oxford, 1988

Gombrich, E.H., 'Reynolds's Theory and Practice of Imitation: Three Ladies Adorning a Term of Hymen' in *Norm and Form*, London, 1966

Gombrich, E.H., 'The Mask and the Face: the perception of physiognomic likeness in life and in art', in E.H. Gombrich, J. Hochberg and M. Black, *Art, Perception and Reality*, Baltimore and London, 1972

Grabar, A., 'L'Imago Clipeata Chrétienne', *Comptes Rendus de l'Académie des Inscriptions et Belles Lettres*, Paris, 1957

Granger, J., *A Biographical History of England, from Egbert the Great to the Revolution: consisting of Characters disposed in different Classes, and adapted to a Methodical Catalogue of Engraved British Heads, intended as an Essay towards reducing our Biography to System, and a Help to the knowledge of Portraits*, London, 1769

The Granger Society for the publication of Ancient Portraits and Family Pictures, Prospectus, July 1841

Grassi, L., 'Lineamenti per una Storia del Concetto di Ritratto', *Arte Antica e Moderna*, 1961

Graves A., and Cronin, W.V., *A History of the Works of Sir Joshua Reynolds, PRA, dedicated to Her majesty the Queen*, 4 vols, London, 1849

Green, R., '"The Hon. Lady Stanhope and the Countess of Effingham as Diana and her Companion" by Francis Cotes', *National Art Collections Fund Review*, 1988

Green, T., *Extracts from the Diary of a Lover of Literature*, Ipswich, 1810

Gretton, T., *Murders and Moralities: English Catchpenny Prints, 1800–1860*, London, 1980

Griffiths, A., 'Sir William Musgrave and British Biography', *British Library Journal*, forthcoming

Grivel, M., *Le Commerce de l'Estampe à Paris au XVIIᵉ siècle*, Geneva, 1986

Grosrichard, A., *Structure du Sérail. La Fiction du Despotisme Asiatique dans l'Occident Classique*, Paris, 1979

Grosvenor Gallery, *Catalogue of the Works of Sir Joshua Reynolds, PRA, exhibited at the Grosvenor Gallery, 1883–4*, London, 1884

Guest, H., 'A Double Lustre: Femininity and Sociable Commerce, 1730–60', *Eighteenth-Century Studies*, 23, no. 4, summer 1990

Gwynn, S., *Memorials of an Eighteenth Century Painter (James Northcote)*, London, 1898

Haines, I.T., *Jack Sheppard. A Domestic Drama in Three Acts, as performed at the London Theatres*, London, 1839

Hall, T., *The Loathsomeness of Long Haire: or a Treatise wherein you have the Question stated, many Arguments against it produced, and the most material Arguments for it repell'd and answer'd, with the concurrent judgement of Divines both old and new against it. With an Appendix against painting Spots, Naked Breasts etc.*, (1653), London 1654

Halsband, R., *The Life of Lady Mary Wortley Montagu*, Oxford, 1956

Halsband, R., '"Condemned to Petticoats": Lady Mary Wortley Montagu as Feminist and Writer', in R.B. White, Jr, ed., *The Dress of Words: Essays on Restoration and Eighteenth Century Literature in Honor of Richmond P. Bond*, Lawrence: Kansas, 1978

Hamilton, E., *The Engraved Works of Sir Joshua Reynolds* (1884), new enlarged edn., Amsterdam, 1973

Hamilton-Phillips, M., 'Painting and Art Patronage in England' in R.P. Maccubbin and M. Hamilton-Phillips, eds, *The Age of William III and Mary II: Power, Politics and Patronage, 1688–1702*, The College of William and Mary, Virginia, 1989

D'Hancarville, P.F.H., *Recherches sur l'Origine, l'Esprit et le Progrès des Arts de la Grèce*, London, 1785

Hansard's Parliamentary Debates

Harcourt-Smith, Sir C., *The Society of Dilettanti. Its Regalia and Pictures, together with an outline of its History*, London, 1932

Harvey, A.D., *William Pitt the Younger, 1759–1806: A Bibliography*, Manchester, 1989

Harvey, C., *Schola Cordis*, London, 1647

Haskell, F., *Rediscoveries in Art. Some Aspects of Taste, Fashion and Collecting in England and France*, London, 1976

Haskell, F., *Past and Present in Art and Taste*, New Haven and London, 1987

Hay, D., *Albion's Fatal Tree. Crime and Society in Eighteenth-Century England*, London, 1975

Hazlitt, W., *The Spirit of the Age*, London, 1825

Herrmann, F., *The English as Collectors. Documentary Chrestomathy*, London, 1972

Hill, A., *A Full and Just Account of the Present State of the Ottoman Empire in all its Branches*, London, 1709

Hind, A.M., *Engraving in England in the Sixteenth and Seventeenth Centuries*, Cambridge, 1955

Hingston Fox, H., *Dr John Fothergill and his Friends*, London, 1919

An Historical Catalogue of an Exhibition of Portraits of the most Illustrious Personages . . ., London, 1829

Hoffmann, 'Das Profil aus Kunstgeschichtlicher Sicht', *Fortschritte der Kieferorthopädie*, Munich, 1981

Hogarth, London: Tate Gallery, December 1971-February 1972

Hogarth, W., *The Analysis of Beauty* (1753), ed. J. Burke, Oxford, 1955

Holmes, C.J., *Self and Partners (mostly self). Being the Reminiscences of C.J. Holmes*, London, 1936

Honour, H., *The Image of the Black in Western Art*, vol. 4: *From the American Revolution to World War I*, Cambridge, Mass. and London, 1989

Holland, H., *Baziliwlogia. A Booke of Kings. Being the true and lively effigies of all our English Kings from the Conquest untill this present*, London, 1618

Holland, H., *Herwologia Anglica, hoc est. Clarissimorum et doctissimorum aliquort Anglorum qui floruerunt ab anno Cristi M.D. usque ad presentum annum MDCXX. Vivae effigies, Vitae, et elogia*, London, 1620

Hood, T., *The Complete Poetical Works of Thomas Hood*, ed. W. Jerrold, London, 1906

Hooper-Greenhill, E.R., 'The National Portrait Gallery: A Case Study in Cultural Reproduction', unpublished Ph.D. thesis, London University Institute of Education, 1980

Howarth, D., *Lord Arundel and his Circle*, New Haven and London, 1985

Humbert, E.H., and Revilliod, A., *La Vie et les Oeuvres de Jean-Etienne Liotard, 1702–1789*, Amsterdam, 1897

Hyatt Mayor, A., *Prints and People, A Social History of Printed Pictures*, New York, 1971

Hyde, E., Earl of Clarendon, *The History of the Rebellion and Civil Wars in England, begun in the Year 1641 . . .*, Oxford (1702–4), 1732

The Idler

The Instructive Letter-Writer and Entertaining Companion, containing Letters on the most interesting Subjects, in an elegant and easy style, 2nd edn, London, 1765

Jackson Stops, G., 'Norton Conyers, Yorkshire II', *Country Life*, 16 October 1986

John, C.H.S., *Bartolozzi, Zoffany, Kauffman, with other foreign members of the Royal Academy 1768–1792*, London, 1924

Johnson, E.M., *Francis Cotes*, Oxford, 1976

Johnson, S., *The Vanity of Human Wishes*, in *Johnson. Prose and Poetry*, London (1950), 1963

[Jones, W.], *A Small Whole-Length of Dr. Priestly, from his Printed Works*, London, 1792

Jordanova, L., 'Objects of Knowledge: A Historical Perspective on Museums', in P. Vergo, ed., *The New Museology*, London, 1989

Kelly, P., and Hudson, R., 'New Light on Sir Thomas Lawrence's "Pinkie"', *Huntington Library Quarterly*, 28, no. 3, May 1965

Kerslake, J., *Early Georgian Portraits*, London: National Portrait Gallery, 1977

Kingsley, C., see Lot, Parson

Klein, M., *The Selected Melanie Klein*, ed. J. Mitchell, Harmondsworth, 1986

Knapp, A., and Baldwin, W., *The Newgate Calendar*, London, 1824

Kügler, F., *Handbook of Italian Painting*, London, 1851

Lacan, J., *The Four Fundamental Concepts of Psychoanalysis* (1973), ed. J.-A. Miller, trans. A. Sheridan, Harmondsworth (1979) 1987

Lacan, J., *Ecrits. A Selection* (1966), trans. A. Sheridan (1977), London, 1982

Lairesse, G. de, *Het Groot Schilderboek*, Amsterdam, 1707, trans., London, 1738

Lambert, S., *The Image Multiplied: Five Centuries of Printed Reproductions of Paintings and Drawings*, London, 1987

Lang, A., *Notes by Mr. A. Lang on a Collection of Pictures by Mr. J.E. Millais, R.A., exhibited at the Fine Art Society's Rooms, 148, New Bond St.*, London, 1881

Laprade, W.T., 'William Pitt and the Westminster Election', *American Historical Review*, 18, no. 2, January 1913

Lartet, E., *The Antiquity of Man in Western Europe*, London, 1860

Lartet, E., *New Researches of the Coexistence of Man and the Great Fossil Mamifers characteristic of the Last Geological Period*, London, 1861

Laslett, P., 'Age of Menarche in Europe since the Eighteenth Century', in T.K. Rabb and R.J. Rotberg, eds, *The Family in History. Interdisciplinary Essays* (1971), New York and Toronto, 1973

Laslett, T.P.R., *Family Life and Illicit Love in Earlier Generations*, London, 1977

Lavater, J.C., *Essays on Physiognomy, designed to promote the knowledge and the love of mankind . . . Illustrated by more than eight hundred engravings accurately copied; and some duplicates copied from originals. executed by or under the inspection of T. Holloway, Translated from the French by H. Hunter*, 3 vols, London, 1789–98, (1st edn., Zurich, 1775–7)

Layard, G.S., ed., *Sir Thomas Lawrence's Letter-Bag*, London, 1906

Leaving Portraits from Eton College, Dulwich

Picture Gallery, 18 July–20 October 1991

Leeks, W., 'Ingres Other-Wise', *Oxford Art Journal*, 9, no. 1, 1986

Lees-Milne, J., *English Country Houses. Baroque*, Country Life Books, 1970

Leslie, C.R., *A Handbook for Young Painters*, London, 1855

Leslie, C.R., and Taylor, T., *Life and Times of Sir Joshua Reynolds, with notices of some of his contemporaries*, London, 1865

Levey, M., *Sir Thomas Lawrence 1769–1830*, London: National Portrait Gallery, 1979–80

Lévi-Strauss, C., *The Elementary Structures of Kinship* (1949), trans. J.H. Bell and J.R. von Sturmer, and ed. R. Needham, London, 1969

Lew, J., 'Lady Mary's Seraglio', *Eighteenth-Century Studies*, 24, no. 4, summer 1991

Lieberman, D., *The Province of Legislation Determined. Legal Theory in Eighteenth-Century Britain*, Cambridge, 1989

Lippincott, L., *Selling Art in Georgian London: The Rise of Arthur Pond*, New Haven and London, 1983

Llewellyn, N., 'John Weever and English Funeral Monuments of the sixteenth and seventeenth centuries', unpublished Ph.D. thesis, University of London, Warburg Institute, February 1983

Llewellyn, N., *The Art of Death*, London, 1991

Locke, J., *Two Treatises*, in *The Works of John Locke*, London, 1823, vol. 5

Lockyer, R., 'Noble in Defeat', *Times Literary Supplement*, 25 November 1983

Lodge, D., ed., *Modern Criticism and Theory. A Reader*, London and New York, 1988

Lodge, E., *Illustrations of British History, Biography, and Manners in the reigns of Henry VIII, Mary, Elizabeth, and James I exhibited in a series of original papers, selected from the manuscripts of the noble families of Howard, Talbot & Cecil; . . . ornamented with portraits etc. . . .*, London, 1791

Lodge, E., *Imitations of Original Drawings by Hans Holbein*, London, 1792

Lodge, E., *Portraits of Illustrious Personages of Great Britain, engraved from authentic pictures, in the galleries of the nobility, and the public collections of the country, with biographical and historical memoirs of their lives and actions*, London, 1821–34

Lomazzo, G.P., *Trattato del'arte della pittura, scoltura et architecttura*, Milan, 1584 (*A Tracte containing the Artes of Curious Paintinge carvinge and buildinge*, trans. R. Haydocke (Oxford, 1598), Westmead reprint, 1970

London Chronicle

Loquin, J., 'La Lutte des Critiques d'Art contre les Portraitistes au XVIIIᵉ siècle', *Nouvelles Archives de l'Art Français*, 7, 1913

Lorris, J. de, and de Meung, J., *Roman de la Rose*, (*The Romance of the Rose*, trans. H.W. Robbins, ed. C.W. Dunn, New York, 1962)

Lot, Parson (pseud. of Charles Kingsley), 'The National Gallery I', in *Politics for the People*, no. 1, 6 May 1848

The Lounger

Lubin, D.M., *Act of Portrayal: Eakins, Sargent, James*, New Haven and London, 1985

Van Luttervelt, R., *De 'Turkse' Schilderijen van J.B. Vanmour en zijn School*, Istanbul: Netherlands Historisch-Archaeologisch Instituut in het nabije Oosten, 1958

Lyell, C., *Principles of Geology*, London, 1838

Lyell, C., *The Antiquity of Man*, London, 1863

Macaulay, T.B., *Lays of Ancient Rome*, London, 1842

MacFarlane, A., *The Origins of English Individualism: The Family, Property and Social Transition*, Oxford, 1978

McCarthy, M., *The Origin of the Gothic Revival*, London, 1987

McCoubrey, J.W., ed., *American Art 1700–1960*, Englewood Cliffs, 1965

Malcolm, J.P., ed., *Letters between the Rev. James Granger, M.A., Rector of Shiplake, and many of the most eminent literary men of his time . . .*, London, 1805

Manners and Morals: Hogarth and British Painting 1700–1760, London: Tate Gallery, 1987

Mannings, D., 'Reynolds, Garrick and the Choice of Hercules', *Eighteenth-Century Studies*, 17, 1983–4

Marin, L., *Portrait of the King* (1981), Houndsmills, 1988

Marling, K.A., *George Washington Slept Here. Colonial Revivals and American Culture*, Cambridge, Mass. and London, 1988

Martin, E.D., 'On Portraiture: some distinctions', *Journal of Aesthetics and Art Criticism*, 20, 1961

Martin, G., 'The Founding of the National Gallery in London', *Connoisseur*, 1974

Martindale, A., *Heroes, Ancestors, Relatives and the Birth of the Portrait*, The Hague, 1988

Mause, L. de, ed., *The History of Childhood*, New York, 1974

Mayer, A.J., 'Notes towards a Working Definition of Social Control in Historical Analysis', in S. Cohen and A. Scull, eds, *Social Control and the State*, Oxford, 1983

Memoirs of Thomas Dodd, William Upcott and George Stubbs, R.A., printed for J. Mayer, F.S.A., Liverpool, 1879

Metz, C., 'Photography and Fetish', *October*, 34, fall 1985

The Microcosm of London, London, 3 vols, 1808

Middeldorf, U., 'Portraits by Francesco da Sangallo', in *Racolta di Scritti*, vol. 1: *1924–1938*, Florence, 1979–80

Millais, J.G., *The Life and Letters of Sir John Everett Millais*, London, 1899

Miller, D., *Material Culture and Mass Consumption*, Oxford, 1987

Milton, J., 'Paradise Lost', in *Milton. Complete Poetry and Selected Prose*, ed. E.H. Visiak, London (1938), 1952

Minihan, J., *The Nationalisation of Culture. The Development of State Subsidies to the Arts in Great Britain*, London, 1977

Mitteraur, R., and Sieder, R., *The European Family*, London, 1982

Mommsen, T., 'Petrarch and the decoration of the Sala Virorum Illustrium in Padua', *Art Bulletin*, 34, 1952

Montagu, Lady Mary Wortley, *Six Town Eclogues with some other Poems by the Rt. Hon. L.M.W.M.*, London, 1747

The Complete Letters of Lady Mary Wortley Montagu, ed. R. Halsband, 3 vols, Oxford, 1966

Montesquieu, C. de. L., *Lettres Persanes*, Paris, 1721

Moore, A.W., *Norfolk and the Grand Tour*, Norfolk Museums Service, 1966

The Mother's Friend. A Monthly Magazine, 1, 1848

Moulin, A.M., and Chauvin, P., *L'Islam au Péril des Femmes*, Paris, 1981

Mulliner, J., *A Testimony against Periwigs and Periwig-Making, and Playing on Instruments of Musick among Christians, or any other in the days of the Gospel. Being several Reasons against those things. By one who for Good Conscience sake hath denyed and forsaken them*, Northampton, 1677

Murphy, D., and Pick, C., *Embassy to Constantinople. The Travels of Lady Mary Wortley Montagu*, London, 1988

Nadel, I.B., *Biography, Fiction, Fact and Form*, London, 1984

A Narrative of what passed between General Sir Harry Erskine and Philip Thicknesse, Esq.; in consequence of a Letter written by the latter to the Earl of B – relative to the publication of some Original Letters and Poetry of Lady Mary Wortley Montague's then in Mr. Thicknesse's possession, London, 1766

National Portrait Gallery, Complete Illustrated Catalogue 1856–1979, London: National Portrait Gallery, 1981

National Portrait Gallery, *First Report of the Trustees of the National Portrait Gallery*, 5 May 1858 (*Second Report*, 11 July 1859; *Third Report*, 25 May 1860; *Fifth Report*, 29 April 1862; *Sixth Report*, 22 April 1863; *Seventh Report*, 26 April 1864; *Ninth Report*, 19 April 1866)

Naudé, G., *Instructions Concerning Erection of a Library, presented to my Lord the Président de Mèsme . . . And now Interpreted by Jo. Evelyn, Esquire*, London, 1661

Neale, R.S., *Bath 1680–1850, A Social History*, London, 1981

Nichols, J., *Literary Anecdotes of the Eighteenth Century; comprising Biographical Memoirs of William Bowyer, Printer, F.S.A., and many of his learned friends; an incidental view of the progress and advancement of literature in this kingdom during the last century; and biographical anecdotes of a considerable number of eminent writers and ingenious artists; with a very copious index* (1782), London, 1812

Nivelon, F., *Rudiments of Genteel Behavior*, London, 1737

Northcote, J., *The Life of Sir Joshua Reynolds*, London, 1819

D'Oench, E.G., *The Conversation Piece: Arthur Devis and his Contemporaries*, New Haven: Yale Centre for British Art, 1980

Omberg, H., *William Hogarth's Portrait of Captain Coram. Studies on Hogarth's Outlook around*

1740, Upsala, 1975

Opie, J., *Lectures on Painting delivered at the Royal Academy of Arts . . . by John Opie, Esq. to which are prefixed a memoir by Mrs. Opie*, London, 1809

The Orientalists: Delacroix to Matisse. European Painters in North Africa and the Near East, London: Royal Academy of Arts, 1984

Osmun, W.R., 'A Study of the Work of Sir James Thornhill', unpublished Ph.D. thesis, University of London, 1950

Oxford English Dictionary, Oxford, 1971

Page, T., Jnr, *The Art of Painting*, Norwich, 1720

Panofsky, E., *Tomb Sculpture*, London, 1964

Parliamentary Portraits; or, Characters of the British Senate, containing the Political History, with Biographical Sketches of the Leading Members of the Lords and Commons to which is prefixed A Review of the Present Administration . . . by the Author of the Beauties of Fox, North, and Burke (1783), 2 vols, London, 1795

Parsons, J., *Human Physiognomy explained in the Crounian Lectures on Muscular Motion for the Year MDCCXLVI read before the Royal Society*, London, 1747

Particulars of the very Singular and Remarkable Trials, Convictions, and Escapes, of John Shepherd, together with his history from his birth, etc., London, 1786

Partridge, L., and Starn, R., *Renaissance Likeness*, Berkeley and Los Angeles, 1980

Pasquin, A., *A Liberal critique on the Present Exhibition of the Royal Academy*, London, 1794

Pasquin, A., *Memoirs of the Royal Academicians, being an attempt to Improve the National Taste*, London, 1796

Paulson, R., *Hogarth: his Life, Art, and Times*, New Haven and London, 1971

Paulson, R., *Emblem and Expression*, Cambridge, Mass., 1975

Peacham, H., *The Art of Drawing*, London, 1606

Pears, I., *The Discovery of Painting. The Growth of Interest in the Arts in England, 1680–1768*, New Haven and London, 1988

Penzer, N.M., *The Harem. An Account of the Institution as it existed in the palace of the Turkish Sultans, with a history of the grand seraglio from its foundation to the present time*, London, 1936

The Diary of Samuel Pepys, ed. R. Latham and W. Matthews, vol. 6, London, 1972

Piggott, S., *Ruins in a Landscape: Essays in Antiquarianism*, Edinburgh, 1976

Pinchbeck, I., and Hewitt, M., *Children in English Society*, vol. 1, London and Toronto, 1969

Pindar, P. (pseud. of John Wolcot), *The Works of Peter Pindar*, London, 1809

Pinkerton, J.M., 'Richard Bull of Ongar, Essex', *The Book Collector*, 27, no. 1, spring 1978

Piper, D., *The English Face* (1957), London, 1978

Piper, D., 'The Chesterfield Library Portraits', in R. Wellek and A. Ribeiro, eds, *Evidence in Literary Scholarship*, Oxford, 1979

Piper, D., *The Image of the Poet. British Poets and Their Portraits*, Oxford, 1982

Pliny, *The Elder Pliny's Chapters on the History of Art*, trans. K. Jex-Blake, Chicago, 1976

Plumb, J.H., 'The New World of Children in Eighteenth-Century England', *Past and Present*, no. 66, February 1975

Pointon, M., *Milton and English Art*, Manchester, 1970

Pointon, M., *William Dyce, R.A. 1806–64: A Critical Biography*, Oxford, 1979

Pointon, M., *Mulready*, London: Victoria and Albert Museum, 1986

Pompeo Batoni and his British Patrons, Iveagh Bequest, Kenwood, 1982

The Poor Child's Friend, consisting of narratives founded on fact, and religious and moral subjects, London, 1825

Pope, A., 'A Discourse on Pastoral Poetry', in *The Poems of Alexander Pope* (1-vol. Twickenham edn), ed. J. Butt, London, 1963

Portalis, R., *Henri-Pierre Danloux peintre de portraits et son journal durant l'émigration (1753–1809)*, Paris, 1910

Porter, R., 'A touch of danger: the man-midwife as sexual predator', in G.S. Rousseau and R. Porter, eds, *Sexual Underworlds of the Enlightenment*, Manchester, 1987

Porter, R., 'Seeing the Past', *Past and Present*, no. 118, February 1988

Portrait et Société en France (1715–1789), Paris: Palais de Tokyo, 1980

Portraits of Characters Illustrious in British History from the beginning of the reign of Henry the Eighth to the end of the reign of James the Second, published by S. Woodburn, London, 1811

Praz, M., *Conversation Pieces. A Survey of the Informal Group Portrait in Europe and America*, Rome and London, 1971

The Pre-Raphaelites, London: Tate Gallery, 1984

Proceedings in an Action for Debt between the Rt. Hon. Charles James Fox, Plaintiff and John Horne Tooke, Esqr., Defendant, London, 1792

Punch

Quarterly Review

Raby, J., *Venice, Dürer and the Oriental Mode*, London, 1982

Ray, J., *The Wisdom of God manifested in the Works of the Creation* (1691), 2nd edn. very much enlarged, London, 1692

Recueil de Cent Estampes représentant les différentes nations du Levant tirées sur les tableaux peints d'après nature en 1707 et 1708 par les ordres de M. de Férriol Ambassadeur du Roi à la Porte, Et gravées en 1712 et 1713 par les soins de M. le Hay, Paris, 1712 and 1713

Redgrave, S., *A Dictionary of Artists of the English School*, 2nd edn., London, 1878

Reigl, A., 'The Modern Cult of Monuments: Its Character and its Origin' (1928), trans. K.W. Forster and D. Ghirardo, *Oppositions*, 25, 1982

Report to the Trustees of the National Portrait Gallery by their Secretary upon his Expedition to Paris from August 17th to September 4th 1867, London, 1868

Reynolds, ed. N. Penny, London: Royal Academy of Arts, 1986

Ribeiro, 'Turquerie: Turkish dress and English Fashion in the eighteenth century', *Connoisseur*, 201, no. 807, May 1979

Ribeiro, A., *A Visual History of Costume. The Eighteenth Century*, London, 1983

Ribeiro, A., *The Dress worn at Masquerades in England 1730–1790, and its Relation to Fancy Dress in Portraiture*, New York and London, 1984

Ribeiro, A., *Dress and Morality*, London, 1986

Richardson, J., *An Essay on the Theory of Painting*, 1715

Richardson, S., *Clarissa or the History of a Young Lady* (1747–8), ed. A. Ross, Harmondsworth, 1985

Ritchie, D., *The Lady's Head Dresses; or Beauty's Assistant, for 1772; containing Observations on the Hair . . . also a Dissertation on the Teeth and Gums, by David Ritchie, hair-Dresser, dentist &c.*, London, 1772

Ritchie, D., *A Treatise on the Hair*, London, 1770

Robertson, D., *Sir Charles Eastlake and the Victorian Art World*, Princeton, N.J., 1978

Robinson, J.M., 'Triumph of Historical Piety: Antiquarian Taste at Arundel Castle', *Country Life*, 27 January 1983; 3 February 1983; 10 February 1983

Roebuck, G., *Clarendon and Cultural Continuity*, New York and London, 1982

Rogers, J.J., *Opie and his Works*, London, 1878

Rose, J., *The Case of Peter Pan or The Impossibility of Children's Fiction*, London, 1984

Rosebery, Lord, *Pitt* (1891), London, 1893

Rotberg, R.I., and Rabb, T.K., eds, *Art and History, Images and their Meaning* (1986), Cambridge, 1988

Rothstein, E., *The Routledge History of English Poetry*, Boston and London, 1981

Royal Commission on National Museums and Galleries, *Interim Report, Parliamentary Papers*, vol. 8, 1928–9

Ruskin, J., *Modern Painters* (1843–6), *The Works of John Ruskin*, ed. E.T. Cook and A. Wedderburn, London, 1903–12

Ruskin, J., '"Ariadne Florentina": Six Lectures on Wood and Metal Engraving' (1872), *The Works of John Ruskin*, ed. E.T. Cook and A. Wedderburn, London, 1903–12

Russell, F., 'The Hanging and Display of Pictures 1700–1850', in G. Jackson Stops *et al.*, eds, *The Fashioning and Functioning of the British Country House*, Washington, D.C., 1989

Russell, N., 'Steamy Nights at the Turkish Baths', *Times Higher Education Supplement*, 28 July 1989

Salmon, T., *The Chronological Historian: containing a Regular Account of all Material Transactions and Occurrences, ecclesiastical, civil and military, relating to the English Affairs, from the Invasion of the Romans, to the present Time . . . by Mr. Salmon illustrated with the Effigies of all our English Monarchs, curiously Engraven from Original Paintings by Mr. Vertue*, London, 1733

Salmon, W., *Polygraphice, or the Arts of Drawing, Engraving, Etching, Limning, etc.*, London, 1675

Sandford, F., *A Genealogical History of the Kings of England and Monarchs of Great Britain &c. from the Conquest, anno 1066, to the year 1677,*

in seven parts or books, containing Monumental Inscriptions with their Effigies, Seals, Tombs, Cenotaph, Devises, Arms, Quarterings, Crests and Supporters, all engraven in copper-plates, furnished with several Remarques and Annotations, London, 1677

Satiricus Sculptor, Esq., Chalcographimania; or the portrait-collector and printseller's Chronicle . . . , a humorous poem . . . , London, 1814

Scarce, J., Women's Costume of the Near and Middle East, London, 1987

Schama, S., The Embarrassment of Riches. An Interpretation of Dutch Culture in the Golden Age, London, 1987

Scharf, G., 'On the Principal Portraits of Shakespeare', Notes and Queries, 23 April 1864

Scharf, G., 'A Catalogue of all known portraits, busts, engravings from portraits, etc., of William Pitt', 1886, appended to Rt. Hon. Edward Gibson, Lord Ashbourne, Pitt: some Chapters of his Life and Times, 2nd edn, London, 1898

Schiff, G., Johann Heinrich Füssli, 1741–1825, Zurich, 1973

Schlenoff, N., Ingres, ses sources littéraires, Paris, 1956

Science and Art Department of the Committee of the Council on Education, Catalogue of the First Special Exhibition of National Portraits, April, 1866

Scott, W., 'Gender: A Useful Category of Historical Analysis', American Historical Review, 91, 1986

Sculptura-Historico-Technica: or the History and Art of Ingraving, London, 1747

Schwartz, R., Daily Life in Johnson's London, Madison, Wisconsin, 1983

Sekula, A., 'The Body in the Archive', October, 39, winter 1986

Sennett, R., The Fall of Public Man, Cambridge (1974), 1977

Shakespeare, W., Othello, The Tragedies of Shakespeare, ed. W.J. Craig and E. Dowden (1912), Oxford, 1956

The Shakespeare Society, The Chandos Portrait of Shakespeare, the property of the Earl of Ellesmere, Prospectus, London, November 1848

Shawe Taylor, D., The Georgians. Eighteenth-Century Portraiture and Society, London, 1990

Shropshire, W., W. Shropshire's Catalogue of Prints for the year 1774, London, 1774

Simon, J., Beningbrough Hall, North Yorkshire, London, 1992

Simon, R., The Portrait in Britain and America, Oxford, 1987

Sketches from Nature in High Preservation by the Most Honorable Masters, containing upwards of one Hundred Portraits, or characters of the most conspicuous persons in the kingdom, London, 1779

Smailes, H., A Portrait Gallery for Scotland, Edinburgh: National Gallery of Scotland, 1985

Smart, A., 'Dramatic Gesture and Expression in the Age of Hogarth and Reynolds', Apollo, 82, August 1965

Smith, C.J., Autographs of Royal, Noble, learned and Remarkable Personnages conspicuous in English History, from the Reign of Richard the Second to that of Charles the Second; with some illustrious foreigners containing many passages from important letters engraved under the direction of Charles John Smith, accompanied by concise Biographical Memoirs, and interesting extracts from the original documents . . . , London, 1829

Smith, D.R., Masks of Wedlock: Seventeenth-Century Dutch Marriage Portraiture, Ann Arbor, 1982

Smith, J.T., Nollekens and his Times (1828), 2nd edn, ed. W. Whitten, London, 1829

Smith, L., 'The Politics of Focus: Feminism and Photography Theory', in I. Armstrong, ed., New Feminist Discourses, London (Routledge), forthcoming

Smollett, T., Roderick Random (1748–9), ed. P.-G. Boucé, Oxford, 1979

Solkin, D., 'The Battle of the Ciceros: Richard Wilson and the politics of landscape in the age of John Wilkes', Art History, 6, no. 4, December 1983

Solkin, D., 'Great Pictures of Great Men? Reynolds, Male Portraiture, and the Power of Art', Oxford Art Journal, 9, no. 2, 1986

Spacks, P.M., Imagining a Self. Autobiography and Novel in Eighteenth-Century England, Cambridge, Mass., 1976

Spectator

Spence, T., The Coin Collector's Companion . . . , London, 1795

Spielmann, M.H., Millais and His Works, Edinburgh and London, 1898

Staging the Self. Self-Portrait Photography 1840s–1980s, London: National Portrait Gallery, 1987

Stallybrass, P., and White, A., The Politics and Poetics of Transgression, London, 1986

The Standard

Stanton, D.C., The Aristocrat as Art: A Study of the Honnête Homme and the Dandy in Seventeenth-and Nineteenth-century Literature, New York, 1980

Starn, R., 'Reinventing Heroes in Renaissance Italy', in R.I. Rotberg and T.K. Rabb, eds, Art and History, Images and their Meaning (1986), Cambridge, 1988

Steele, R., 'Abnormis Sapiens . . .', Tatler, no. 109, 5 July 1711

Steiner, W., Exact Resemblance to Exact Resemblance. The Literary Portraiture of Gertrude Stein, New Haven, 1978

Stephens, F.G., and George, M.D., Catalogue of Political and Personal Satires preserved in the Dept. of Prints and Drawings in the British Museum, 11 vols, 1870–1954

Stepney, G., 'On the University of Cambridge's Burning of the Duke of Monmouth's Picture, 1685', in Poems on Affairs of State, 2, 1703, 189–90

[Stevens, G.A.], The Celebrated Lecture on Heads, London, 1764

[Stevens, G.A.], A Lecture on Heads, n.d. (c.1766)

[Stevens, G.A.], An Essay on Entertainments to which is added Stevens' new Lecture upon Heads, now delivering at the Theatre Royal, Hay-Market, with critical observations, 3rd edition, London, 1772

Stevenson, S., A Face for Any Occasion, Edinburgh: Scottish National Portrait Gallery, 1976

Stirling, A.M.W., The Richmond Papers from the correspondence and manuscripts of George Richmond, R.A., and his son Sir William Blake Richmond, R.A., K.C.B., London, 1926

Stone, L., The Family, Sex and Marriage in England 1500–1800 (1977), abridged edn, Harmondsworth (1979), 1985

Stowe, A Description of the House and Gardens of the Most Noble and Puissant Prince, George-Grenville-Nugent-Temple, Marquis of Buckingham, Buckingham, 1797

The Stranger's Guide to Holkham, Burnham, 1817

Strong, R., Holbein and Henry VIII, London, 1967

Strong, R., The English Icon: Elizabethan and Jacobean Portraiture, London and New York, 1969

Strong, R., And when did you last see your father? The Victorian Painter and British History, London, 1978

Sutton, A.M., Boardwork or the Art of Wigmaking, etc. A Technical Handbook, 3rd edn, 1921

Swift, J., 'Of Mean and Great Figures', Miscellaneous and Autobiographical Pieces. Fragments and Marginalia, Oxford, 1962

Tagg, J., The Burden of Representation. Essays on Photographies and Histories, London, 1988

Tatler

Teachwell, Mrs., Fables in Monosyllables by Mrs. Teachwell, to which are added Morals in Dialogues between a Mother and Children, London, 1787

Tennyson, A., Enoch Arden (1864), London, 1866

Thomson, J., The Seasons, ed. J. Sambrook, Oxford, 1972

Thompson, E.P., The Making of the English Working Class (1963), Harmondsworth, 1982

Sir James Thornhill, London: Guildhall Art Gallery, 4–10 June 1958

Tiffin, W., Gossip about Portraits, London, 1867

Tilly, A., Erotic Drawings, Oxford, 1986

The Times

The Times Saturday Review

Todd, D., 'Three Characters in Hogarth's Cunicularii–, and some implications', Eighteenth-Century Studies, 16, no. 1, fall 1982

Tomalin, C., The Life and Death of Mary Wollstonecraft, New York and London, 1974

Tooke, J.H., Two Pair of Portraits presented to all the unbiassed electors of Great-Britain, & especially to the Electors of Westminster, London, 1788

Tytler, S., Modern Painters and their Paintings, London, 1878

Veblen, T., The Theory of the Leisure Class. An Economic Study of Institutions (1925), London, 1957

Vertue, G., The Notebooks of George Vertue, The Walpole Society, 1931–2

Waagen, G., Treasures of Art in Great Britain, London, 1854

Waals, Jan van der, 'The Print Collection of Samuel Pepys', Print Quarterly, 1, no. 4, December 1984

Walpole, H., *Aedes Walpolianae or a Description of the Collection of Pictures at Houghton Hall in Norfolk, the seat of the Right Honourable Sir Robert Walpole, Earl of Orford*, 2nd edn, 1752

Walpole, H., *A Description of the Villa of Mr. Horace Walpole Youngest Son of Sir Robert Walpole Earl of Orford, at Strawberry-Hill near Twickenham, Middlesex. With an inventory of the Furniture, Pictures, Curiosities, &c.*, Strawberry Hill, 1784

Walpole, H., *Anecdotes of Painting in England* (1762–80; 1876), New York: Arno Press reprint, 1969

Horace Walpole's Correspondence, ed. W.S. Lewis, Oxford and New Haven, 1937–1983

Ward, H., and Roberts, W., *Romney, a Biographical and Critical Essay*, London, 1904

Wark, R., *Ten British Pictures 1740–1840*, San Marino, California: Henry E. Huntington Library and Art Gallery, 1971

Waterfield, G., *Collection for a King: Old Master Paintings from the Dulwich Picture Gallery*, Washington, D.C.: National Gallery of Art, and Los Angeles County Museum of Art, 1985–6

Waterhouse, E.K., *Painting in Britain 1530–1790* (1953), Harmondsworth, 1954

Waterhouse, E.K., *Gainsborough* (1958), London, 1966

Webster, M., 'An Eighteenth-century Family, Hogarth's Portrait of the Graham Children', *Apollo*, 130, September 1989

Webster, M., *Johan Zoffany 1733–1810*, London: National Portrait Gallery, 1976

Wendorf, R., *The Elements of Life. Biography and Portrait-Painting in Stuart and Georgian England*, Oxford, 1990

West, S., 'Polemic and Passions: Dr James Parsons' Human Physiognomy Explained and Hogarth's Aspirations for British History Painting', *British Journal for Eighteenth-Century Studies*, 13, no. 1, spring 1990.

West, S., 'Thomas Lawrence's Half-History Portraits and the Politics of Theatre', *Art History*, 14, no. 2, June 1991.

Westminster and Foreign Quarterly Review

The Westminster Election in the Year 1796 being an accurate State of the Poll each Day: also a Complete Collection of Addresses and Speeches . . ., London, 1796

Whitley, W.T., *Thomas Gainsborough*, London, 1915

Whitley, W.T., *Art in England 1800–1820* (1928), New York, 1973

Williams, B., *The Whig Supremacy 1714–1760*, Oxford, 1939

Williams, J.D., *Audley End. The Restoration of 1762–1797*, Chelmsford, 1966

Williamson, G.C., *English Conversation Pictures of the Eighteenth and Early Nineteenth Centuries*, New York, 1975

Wilson, E., *Adorned in Dreams, Fashion and Morality*, London, 1985

[Wilson, J.I.], *A Brief History of Christ's Hospital*, London, 1820

Wilson, T., *Ceramic Art of the Italian Renaissance*, 1987

Wimsatt, W.K., *The Portraits of Alexander Pope*, New Haven, 1965

Wind, E., *Hume and the Heroic Portrait. Studies in Eighteenth-century Imagery*, ed. J. Anderson, Oxford, 1986

Wind, E., 'The Revolution of History Painting', *Journal of the Warburg and Courtauld Institutes*, 2, 1938–9

Winnicott, D.W., *Playing and Reality* (1971), Harmondsworth, 1988

The Wit of the Day or the Honours of Westminster being a complete Collection of the Advertisements, Handbills, Puffs, Paragraphs, Squibs, Songs, Ballads &c which have been written and circulated during the late remarkable Contest for that City, London, 1784

Wolcot, J., see Pindar, P.

Wollstonecraft, M., *Vindication of the Rights of Woman* (1792), Harmondsworth, 1983

Woodall, J., 'An Exemplary Consort: Antonis Mor's Portrait of Mary Tudor', *Art History*, June 1991

Woodforde, J., *The Strange Story of False Teeth*, London, 1968

Wootton, Sir H., *Elements of Architecture*, London, 1624

Wordsworth, W., *Poetical Works*, ed. T. Hutchinson, rev. edn, E. de Selincourt, Oxford (1904), 1974

Wornum, R. ed., *Lectures on Painting by the Royal Academicians, Barry, Opie, and Fuseli*, London, 1848

Wraxall, Sir N., *A Short Review of the Political Stage of Great Britain*, London, 1787

Wrightson, K., *English Society 1580–1680* (1982), London, 1986

INDEX

PHOTOGRAPH CREDITS

In most cases the illustrations have been made from photographs and transparencies provided by the owners or custodians of the works. Those plates for which further credit is due are listed below:

Author: 8, 26, 69, 70, 71, 75, 101, 107, 148, 149, 150, 171, 212, 217, 218, 231, 239, 279, 280
Richard Carafelli: 206
Country Life: 28
Courtauld Institute of Art, Conway Library: 29, 76, 98
Courtauld Institute of Art, Witt Library: 36, 65, 162, 170, 189, 210, 233

A.C. Cooper: 166, 192
Prudence Cuming Associates: 261
J. Arthur Dixon: 49
English Heritage: 37, 174
FSIA: 10
Robin Laurence: 9
Paul Mellon Centre for Studies in British Art: 4, 5, 6, 7, 56, 63, 68, 91, 92, 93, 94, 96
National Trust Photographic Library/A.C. Cooper: 186, 226
Phaidon Press Ltd: 265

Royal Academy of Arts, London: 164, 165, 184, 213, 261
Royal Commission on the Historical Monuments of England: 15, 16, 23, 24, 25, 31, 33, 45
Sotheby's, London: 22
Stowe School Archives, Buckingham: 30
John Webb: 214, 215
Rodney Todd White: 77, 190